# ORIENTAL RUGS

## A Complete Guide

# ORIENTAL RUGS
## *A Complete Guide*

by

CHARLES W. JACOBSEN

CHARLES E. TUTTLE COMPANY, INC.: PUBLISHERS
*Tokyo, Japan & Rutland, Vermont*

European Representatives
    Continent
BOXERBOOKS, Inc., Zurich
    British Isles
PRENTICE-HALL INTERNATIONAL, INC.,
    London

Published by the Charles E. Tuttle Company, Inc. of
Rutland, Vermont and Tokyo, Japan with editorial
offices at 15 Edogawa-cho, Bunkyo-ku, Tokyo

Copyright in Japan, 1962

Library of Congress Catalog Card No. 62-14117
First edition, 1962

Printed in Japan

# TABLE OF CONTENTS

# LIST OF ILLUSTRATIONS

"Figs." are in Part I. "Plates" are in Part III. An asterisk (*) indicates a color plate.

9

# PREFACE

MY FIRST EFFORT at book writing in 1931, *Facts about Oriental Rugs,* met with a warm reception throughout the country. Many changes occurred in the next twenty years, and so in 1952 I wrote another small book, under the same title, *Facts about Oriental Rugs.* This edition was quickly exhausted and has been reprinted.

This is my first effort at a large book, intended as the most complete coverage of the subject ever attempted by any writer anywhere. It is offered in the belief that it is needed to fill a great void. It should be helpful to those seeking basic information, as well as to the student and art lovers, the collector, and the expert. I am confident that the importers and the retail dealers throughout the country will welcome this dissemination of information.

Certainly, no subject of equal prominence has been so neglected in print. There is not a book on Oriental Rugs on the market, with the exception of my small book. Every book discussed below, and in my chapter on "Rug Books," is out of print. Only at the public library can one find a few books on Oriental Rugs.

John Kimberly Mumford's book, *Oriental Rugs,* published in 1900, was the first book on Oriental Rugs ever written by an American. Between 1900 and 1917 several other books on the subject were published. All of these books followed Mumford's facts. I am indebted to Mr. Mumford, from whose estate I received all of his books, his writings, and volumes of personal, hand written notes. Incidentally, Mr. Mumford was a Syracusan before he moved to New York City.

I am also indebted to another Syracusan, Dr. G. Griffin Lewis, author of the book *The Practical Book of Oriental Rugs,* whose first edition was published in 1911. He left me much of his material in his will. I had the privilege of helping him on his sixth revised edition published in 1945.

But without detracting from these excellent books, it is only correct to state that most of them are out of date as far as assisting those interested in determining what type of rug they should buy. They dealt with types available around 1900 to 1915, and more often described rugs made from 1700 to 1900. The old types discussed in these books have seldom been imported during the past thirty years. I re-emphasize the point that these books, even in the period 1920–30, covered

less than half the rugs imported in that period. Those few that are found in the trade have come from private collections and estates and were imported fifty to eighty years ago. However, I urge every one to read one of these books as background.

My principal source of information is from actual experience. I have been a hobbyist, collector, writer, lecturer on the subject, and a dealer for thirty-eight years. Except for the period of three years during the last war, when I was in the Army, I have visited the New York wholesale market at least once every month, visiting most of the importing houses; which enabled me to see a large portion of all rugs imported to America. I have made over thirty buying trips abroad.

I have seen most of the collections in the different museums, not only in America, but throughout Europe. I have seen hundreds of private collections in America and abroad, and have also supplied rugs for many of the great collections throughout the country. Finally, I might add that it is possible I have bought more Oriental Rugs than any living, active buyer. While I cannot hope to make the reader know rugs, I can arm the prospective buyer with a certain amount of elementary knowledge.

But there is no way to really learn rugs without association with the actual rugs. Seeing the rugs, taking them in hand, evaluating their designs and colors, is the only way to acquire a basic knowledge.

In a chapter devoted to listing and discussing Oriental Rug books, I will list and classify other Oriental Rug books. The best and most authoritative book ever written on the subject is by an Englishman, A. Cecil Edwards', *The Persian Carpet,* first published in 1953. It is devoted almost exclusively to Modern Persian Rugs. It devotes only seven pages of description and five pages to plates of eight individual antique rugs in the museums. He does not touch on rugs from other countries.

My chapter on "Difference between European Market and the American Markets," explains this in detail. Having visited the London market or the Free Port of London, Culver Street warehouse, once or twice a year for over thirty years, I appreciate both points of view.

I know that as I write, I will have to delete and omit many discussions that I would like to present. I will sacrifice much of the history of the countries, towns, and tribes, because this has already been covered in detail by other authors. I will briefly touch on those changes that have occurred since 1900.

Mr. Edwards covers only modern Persian rugs in his great volume which sells for $30 in America. My publishers will be able to offer this volume for $10.00.

# PART I

## General Discussion

*Chapter One*

# *IN GENERAL*

DESPITE the widespread sales, and the general use of Oriental Rugs that has been going on in the last fifty years, there is a suprisingly small number of people who know anything at all about Oriental Rugs; and still fewer who have absorbed a real appreciation and true understanding of them as works of art, or of their artistic value and place in the decorative treatment of a room.

Some prospective buyers do not even know what a real Oriental Rug is. They are confused by the term American Oriental Rug. Fortunately, today the Federal Government requires the latter to be designated and advertised as Oriental Designs, instead of the old way of calling them American Oriental Rugs. To be classed as an Oriental Rug, the rug must be hand knotted, while the so-called Oriental Design Rug is machine made in America. It takes months and even years to tie the thousands, yes, even millions of hand tied knots that make up one Oriental Rug. No machine has yet been devised to tie the individual knots that characterize a handmade Oriental Rug. If and when one is devised, much of the interest and charm of the Oriental will be lost, because each design will be stamped out in a regularity that will take away much of its character. Have you ever closely examined, for example, the border design of a rug? You will detect that no two of the same design (the turtle design for instance) are identical. Each is a little different from the other.

If you look into a Persian rug, you will discover that each figure is bounded by a line of another color, sometimes so fine as to be almost imperceptible. Yet, this inconspicuous outline has an extraordinary effect on the field of color it encloses. The same tint will have an entirely different look, or shade into different directions of the spectrum, according to the color of its outline. No machine made rug can possibly achieve these effects. But I cover Oriental copies under that heading. Anyone who cannot see the difference between a real handmade Oriental Rug has just never looked or is just downright stubborn. Modern tools and science have done nothing to improve the handmade rug, just as printed copies will never replace the brush of a great painter.

Oriental Rugs were first imported to America in numbers about 1875. In the period 1900 to 1915 almost any and everyone who had the price wanted Oriental

Rugs. By 1905 the demand became so great that Persia began weaving rugs in tremendous numbers. Factories were set up in all the large cities. A rug factory was any place where the merchant could set up a number of looms and hire weavers. The process was the same and all work was done by hand.

After World War I, in the lush twenties, again Oriental Rugs were the most prized and sought after of all rugs. While there were thousands of so-called hobbyists and collectors until the great depression of 1929, still most of the hundreds of thousands of people who bought Oriental Rugs seldom took the time to gain even the most elementary knowledge about the rugs they bought or proposed to buy. Even today, when I wait on a customer in my store, I find that not one out of ten know the following simple facts. I might add that they are keenly interested in the facts I tell them. The amazing thing is that my managers and salesmen whom I have trained for many years, and who have heard me relate these details hundreds of times, seldom take the time to tell these facts to the customer.

I relate "Originally all rugs brought to America prior to 1905, were rugs that had been used in the homes of the Oriental who made them. To be sure, many of them had been walked on, but the Orientals remove their shoes before entering their dwellings. Some rugs were used as beds, as bed covers, as hangings and many other practical uses, since the rug was the Oriental's principal furnishing." I further explain that a new rug is quite bright; but usually, exposure to the light and atmosphere mellows the colors; that whoever bought these old rugs, whether perfect or slightly worn, had a rug for a great many years. The rug lasted the buyer's lifetime and often went to the second generation.

I further relate that by 1905 the supply of antique and semi-antique rugs, or in other words, rugs with soft colors, were already becoming scarce. A way ha 1 to be found to get soft colored rugs overnight. To accomplish this, plants were set up in and around New York City for chemically bleaching of these rugs after they arrived in this country. The final result was that not only were the rugs bleached, but in most cases the rugs were retouched by a painting process, then waxed and run through hot rolls to give the rug a high glossy finish. Needless to say, this treatment not only reduced the thickness of the rug, but injured the wearing quality as well.

I go further and explain: "that this was not the exception but rather the general rule; that 75% of all Oriental Rugs offered throughout America by small dealers or large department stores were the chemically washed and painted variety. There were small dealers who sold only natural colored rugs, but they were few in numbers." I think if one asked me why we have reached our present position in the Oriental Rug field, I would answer that it was due to my refusal to sell the chemically washed rugs. After you explain this, they quickly ask "Then why did good stores sell chemically treated Oriental Rugs when it reduced the life of the rug?" The answer is that it is difficult to find enough new rugs in different sizes in beautiful colors, and that this treatment turned a very crude rug to soft colors and gave the rug a silky finish, making it more salable to the person who knew little about rugs. A bright new rug will soften with use and acquire its own natural sheen and lustre. But the beginner wants the maximum in beauty at once. However, I do not believe that one prospective buyer in one hundred would have bought the treated and painted rug if he had known the full facts.

It was a sad commentary when the public went to one of our great department

stores with which they had dealt for years, believing this to be the surest way to eliminate the element of gamble in buying an Oriental Rug. Generally, they were shown only the chemically treated types and, naturally, ended up by buying one of them. There was seldom a word said about the rug having been treated, unless the prospective buyer knew something about rugs and specified that he did not want a treated rug. Many stores actually advertised that the rugs were beautifully washed (not a soap and water wash—but a chemical bath).

You will notice that I have used the past tense. I am glad that our high wages in America (since about 1955) has made the painting process too expensive. Today very few rugs are both chemically washed and painted in New York, but rather are given only a light lime wash. The vast majority are being lightly washed in Iran, where the labor is still a few cents a day, instead of a hundred dollars a week that the workers in Jersey City demanded.

*Far reaching changes in the past eight years*

I could have made this heading "Tremendous Changes During the Past Two Years." Last spring, 1961, I wrote Part I of this book, and detailed the many changes that had transpired in the Oriental Rug field. Now, as we go to press in 1962, I find it necessary to rewrite Part I because of the changes that have occurred in the past year.

At this point we list these changes, and later we discuss these under their proper heading—*i.e.,* Chapter "Persian Rugs," Chapter "Turkish Rugs," etc.

1. Shortages in supply of Persian rugs in every category. The supply has been cut in half in the past eight years. The supply of Sarouks coming to America has been reduced to half.

2. Great changes in Iran. The improved or higher standard of living in Iran has increased prices and reduced the number of rugs woven. Many weavers, especially the grown-ups, find they can make more money at other jobs. The Persians themselves are buying Oriental Rugs in great numbers. The quality of Persian Rugs as a class is deteriorating. It is in Iran that the most radical of changes are taking place. All Near East countries are buying large numbers of Persian Rugs.

3. European countries, especially West Germany, are buying heavily and out-bidding Americans for Persian Rugs. They are actually buying more than Americans and are willing to pay more than our American buyers.

4. Many European dealers are coming to America and buying antique rugs in large numbers. Remember that the Orient had been stripped of real antiques (except those in Mosques) for the past 30 years. Rare rugs from estates and collectors fall into the hands of dealers. The European dealers have bought hundreds of thousands of dollars worth of these choice rugs in America and have taken them back to Europe. My own personal experience is that a wholesaler from Europe will, at the present time, pay more for a good antique than will most Americans. I have wondered how this dealer, a wholesaler, can hope to sell these to a retail store; and then, how the retail store can add a profit. Europeans have not had the money in fifty years to buy these rugs in numbers; but never in the history of Oriental Rugs has there been such a sellers' market as exists in Europe (excluding the English, who do not have the money and buy very few). Until a few years ago I could buy from a few small dealers in the wholesale market a number of

choice old rugs each month. Today I hardly visit these small places, knowing that they can get much more from European buyers than I can possibly pay.

5.  Japan has entered the rug weaving field. They are weaving and sending to America a number of excellent type rugs. The costliest and best quality of the Japanese rugs is the Imperial, made in both French Savonerrie design (Aubusson design) and the China design. These rugs are finding a very good market, but with the wholesale price at this time having risen so high, they have pretty well priced themselves out of the market. A $9 \times 12$ Imperial at $1,000 has less than 33% gross mark-up. The second quality, a very excellent rug named the Fuigi Royal is not being brought to America in numbers because the cost is too great to sell in volume. The Peking rugs in antique Chinese design (made in Japan) in light and mostly pastel colors, has been brought in by one importing house in numbers. The prices on these remain quite moderate, though they have risen in the past two years.

6.  Afghanistan has entered the rug weaving field in the past eight years, and is producing many types of Bokhara rugs. Most of these go to Europe. The demand in Europe and especially in Germany for this type of rug sent prices up at least 40% from 1959 to 1960. So far I have been the sole importer of these to America.

7.  West Pakistan has entered the rug weaving field in the past three years, and is making two general types. One type copies the Tekke or Royal Bokhara rugs, while a second type employs designs usually found in Persian Tabriz rugs. The first type in Bokhara designs should meet with success, but I predict that those in Tabriz design will not find favor in America. They may do well in Europe.

8.  India has increased her output greatly during the past eight years. In and around Mirzapur are some 2,000,000 persons in the rug weaving industry. As Persia, with her limited population of some 15,000,000, weaves fewer and fewer rugs (and on the whole, rugs of poorer quality), India with her 300,000,000 people may supplant Iran as the Number One rug weaving country.

9.  In my 1952 Edition, I said that no Chinese rugs had been made since about 1932 and that it was doubtful if Chinese rugs would be made for many years to come. Imagine my surprise to find new Chinese rugs of very superior quality in the Free Port of London, Culver Street warehouse, for sale in 1960! We do not trade with Communist China and so they cannot be brought to America. These were better than any Chinese rugs I have ever seen. They were about the same quality as the superior Japanese Imperial rugs. I predict that when and if we ever trade with Communist China, and these can be imported, they will not be sold in numbers. The wholesale price in London was about $5 per square foot. With duty and shipping charges to be added, it is safe to say that the retail price at the moment would be at least $850 for a $9 \times 12$ rug. This price precludes any real volume. Perhaps they will produce a good, moderately priced rug.

10.  In my 1952 edition, I said that Turkey had been out of the rug weaving business for over twenty years. In 1960 small numbers of new Turkish rugs in sizes about $7 \times 4$ ft. made their appearance in New York at one importing house. I also saw some silk family prayer rugs in quantity (all having exactly the same design) in the London warehouse. The first type will most certainly not meet with any success in the American market. They are lacking in beauty, and even if the prices

*18*

were not too high compared to Persian rugs, they would still not become popular in America. The second is purely novelty and would not fit in as floor covering.

11. In 1952 I said that no Caucasian rugs of any type were being imported and I doubted if any were being made. In 1960, Russia has again set up looms in the Caucasus (now Soviet States of Armenia, Azerbaijan and Georgia). I recently saw the first of some 25 designs which they are going to make in the old Caucasian designs; Kubas, Kazaks, Shirvans, Erivans, and others. The reason is obvious. With Europe on the wildest spending spree for Oriental Rugs, Russia and all these countries are trying to cash in on the demand. These new Caucasian rugs may find a market in Germany and European countries, provided they can compete in price with the Persian Ardebil rugs (Persian rugs in Caucasian designs). Much of this renewal may be ascribed to the fact that Germans, Italians, and others have been buying, by the thousands, our old estate and antique Caucasian rugs. These are their preferred types at the moment. They are stripping all wholesalers and small jobbers, and are even paying retail dealers more for these than he, the American dealer, can hope to get from his wealthier clients in America. Again, I predict that these new rugs will fail in America.

13. Another amazing fact is the appearance of large numbers of Oriental Rugs that are being woven in Bulgaria. These are excellent quality rugs in Tabriz designs. They are actually as good or better in quality and conception than the average, better quality Persian Tabriz rug. They are too mechanical in appearance and will be too costly for any general selling in America.

Thus after my 1952 prediction that fewer and fewer rugs would be made each succeeding year in Iran, I find that the pattern was true in Iran, and is true today. With the demand in Europe exceeding the supply, even as the Europeans take away much of the supply that formerly came to America, other countries have seen an opportunity to enter the field. Unless Europe, and especially West Germany, continues on her spending spree for Orientals, I predict that these new ventures will be short-lived. It is only the sharp increase in prices that made it possible for these countries with higher wages than Iran enjoys, to enter the field.

The greatest change of all is the unprecedented demand and buying power of the Europeans. Never in the history of Oriental Rugs have they been in such demand by Europe. The German buyers buy with much abandon. They turn a few rugs in a large group and then buy the entire group, involving many thousands of dollars. Whether the rug is thick, worn, or crooked doesn't seem to make any difference. Any American buyer who did this would be fired by his store; and if I bought in the same inefficient way, I would be out of business in short order.

*Chapter Two*

# GENERAL CLASSIFICATION

*Classification by countries*

WHEN most people think of an Oriental Rug, they have in mind a Persian rug (Persia is now called Iran); and although Iran has always been the largest weaver of Oriental Rugs, there have been and are many other rug weaving countries. India is increasing her output of handmade rugs, and may one day supplant Persia. Japan, Afghanistan, and Pakistan have entered the rug weaving field and are producing many excellent Oriental Rugs.

Rugs are grouped according to the country in which they are made. We refer to the country as the Family of the rug. The name of a rug may be derived from the city in which it is made, or from the district, or from the Nomad tribe by whom the rug is woven. Others simply have trade names. As you read Part II, you will find many infringements on famous names by new, cheap rugs. Below are listed all the countries that have made them in the past or are making them today.

1. Iran (Persia)
2. India
3. Caucasia—now several Soviet States
4. Turkey
5. Turkestan or Turkoman group—also called Central Asiatic group (now Soviet States of Turkmen, Uzbek, and Kazakh.)
6. China
7. Japan
8. Afghanistan
9. Pakistan
10. Balkan rugs—hand woven in Bulgaria
11. Greece (made only during the period 1923–1931)

I do not devote a chapter to rugs from Greece, as they are the identical types described under the heading of Group III, Chapter on "Turkish Rugs." We refer to the Sarouk made in Persia as a Sarouk, or a Sarouk from Persia (Iran),

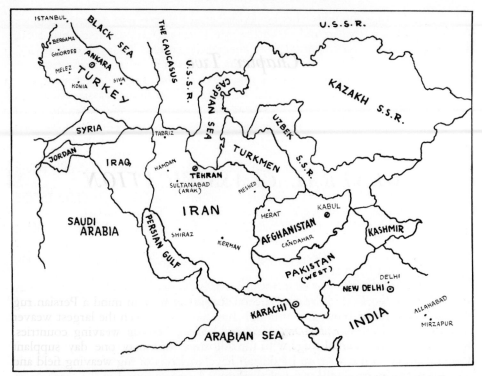

MAP 1. GENERAL MAP OF AN IMPORTANT RUG WEAVING AREA.

or a Persian Sarouk. The name of the rug is Sarouk. The family or country is Persian or Iranian.

*Classification according to age*

A second classification may be made according to the age of the rug.

<div style="text-align:center">

Antiques
Semi-Antiques
Modern

</div>

Antique rugs may be further divided into Classical Antique Rugs of museum quality—100 to 400 years old—and later day Antique—50 years or more of age. See the chapter on Antique Rugs.

We refer to a rug as being semi-antique if it is from ten to fifty years old. This indicates three things: that the rug has been used; that the colors are more refined than a new rug; and that the crudity of a new rug is gone and the colors are somewhat mellow.

Modern or New Oriental Rugs may be further classified as those which employ the traditional old designs and those like most Modern Sarouks, which employ a design that was completely new some 40 years ago when these designs were first used.

*21*

The modern rugs should further be divided after they come to America as those that are chemically treated and those that are sold in natural colors. Until 1950, 90% of all Persian rugs imported were chemically treated. Today, less than 5% are chemically treated and painted. We can make many other classifications of Oriental Rugs. We call a scatter size a rug, and a 6×9 ft. rug or larger a carpet.

Most of the early writers delighted in using "dimensional classification." A small mat was called a "Pushti." A Dozar was a scatter size rug, meaning "two square meters," and referring to a rug approximately 6×3½. This term has survived and is still used in the trade, *i.e.*, Sarouk Dozar, or Hamadan Dozar. But, Dozar for the past 40 years has meant a slightly larger rug—a size 6×4 to 7×5 ft.

Kenari refers to runners. Kelai, Kali, Kelei (originally spelled "Ghali") refers to long narrow carpets, about 5×10 to 6×18 ft.

Odjalik or Ojaklik refers to a hearth design in a rug about 6×4 ft. In the Orient a hearth rug is nothing more than a bed. See Ojaklik, Part II.

Sedjadeb and Namizlik are both one and the same; namely a Prayer rug. Most of these "names" have been discarded. Only Dozar has general usage today. The terms, "runner" and "prayer rug" and "mat" are less confusing and more easily understood by everyone.

Mr. Mumford was the first to introduce words ending in "lik." All such names are taken from the Turkish language. Some names such as Ojaklik, Sedjalik, and Namazlik refer more to usage.

The *Guide to Victoria and Albert Museum*, London, England covers the subject of classification of Oriental Rugs with the following information: "The historical study of carpets is not without its difficulties. The lands of Western Asia, which have for centuries produced most of the knotted carpets found in the markets of the world, have frequently been overrun by the invader; and when, in addition to this, we reflect that many carpet-weaving peoples are migratory, and that the carpet is not only the principal item of the Oriental's domestic furniture, but is also liable to follow him wherever he goes, we cannot be suprised that the classification of Oriental carpets has many pitfalls." This is as true today as when the above was first written in 1915. Witness the many Turkoman Tribes and weavers that have crossed from Soviet Russian States into northwestern section of Iran and into Afghanistan and West Pakistan. Each of these are reproducing rugs in the same general design as they wove when they lived in Turkestan (now S.S. States of Turkmen, Uzbek, and Kazakh).

# Chapter Three

# PERSIAN RUGS

EVEN THOUGH the name Iran has been well known for a generation, I do not wish to completely substitute the name "Iranian" for Persian. I will use Iranian and Persian interchangeably.

When most people think of an Oriental Rug, they visualize only the Persian Rug and think of it as having only the Persian design. Persia is now called Iran. The people in Iran have always called themselves Iranians and not Persians, but it is only in recent years that we say Iran and not Persia. Ninety percent of all Oriental Rugs sold in America and in Europe are from Iran.

In general the Persians prefer a floral to a formal design, and a graceful curve to a geometric pattern. Rugs from Iran are thought of as having distinctly floral patterns. The leaves, flowers, palmettes, rosettes, and other graceful and intricate patterns are found in the majority of rugs made in Iran. In contrast to the rugs from Iran, the rugs from Caucasia, Turkey, and Central Asia have designs that are mostly geometric and highly conventionalized floral designs (the designs of flowers and vines in stiff straight lines, in contrast to the curving and realistic lines of the Persian Rugs).

But to say that all rugs from Iran are floral in design is incorrect. The rugs from northern Iran adjacent to Russia's Caucasia have the highly conventionalized floral designs. These show a marked Caucasian influence and are always geometric in design. The Herez, Gorevans, Serabs, and Karaja are more geometric than floral. Some of the Shirazes from Southern Iran have the geometric effect as do many Bahktiaris, Afshars, and others.

The boundaries of Persia have changed in the course of history. A majority of the Nomad Tribes in many sections were once Turkish, and Turkish is still the language spoken by them. An interesting design of Persian rugs is the prevalence of Chinese motifs and especially the Chinese cloud bank design. The Mongols overran Persia in the 13th century and the Chinese influence has appeared in Persian art since that time. The Persian's love of flowers and gardens is often depicted in his weaving, in the form of compartment carpets and other designs believed to represent their gardens. Animals and human forms were also used in the old Persian rugs. Few of these human forms are used today, except in some of the Ispahans and Teherans.

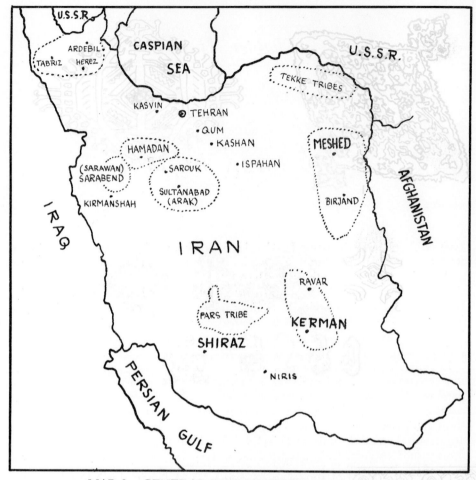

MAP 2.   GENERAL MAP OF PERSIA (OR IRAN).

Today Iran and India are the only two countries producing rugs in great numbers. These countries are making entirely different types. The Persians are, as a class, colorful rugs; while the rugs from India are almost entirely in light pastel colors. Persia is probably the cradle of all rug weaving, but there are no definite examples available earlier than the 15th century. Inasmuch as we cover early Persian rugs in the chapter on Antique Rugs, I will not discuss it here.

You need not be dismayed if I have spelled some name differently from the way you believe it should be spelled. Even *National Geographic* spells the same town slightly different on their maps appearing only a few months apart. One map spells Mehrevan (Herez district) and another spells it Mehreban (Herez district). On their maps they spell the town Qom and later Qum. Most importers spell it Gum. Many people spell Sarouk without the "o," or Saruk. Kerman or Kirman, Keshan or Kashan, the one is perhaps as correct as the other.

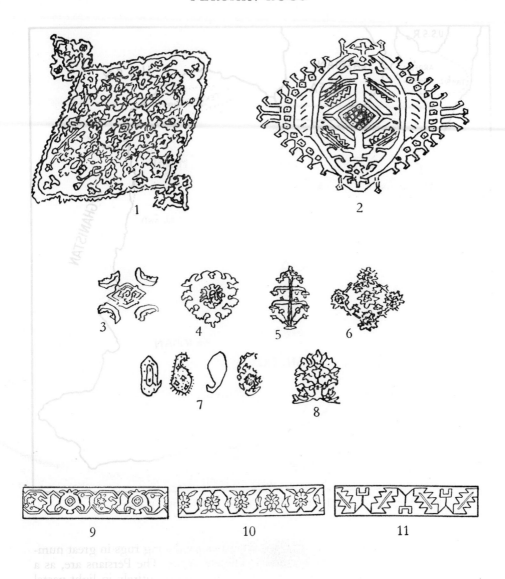

FIG. 1.   (1) Typical floral center found in most Persian rugs.   (2) Large motif with more geometric lines typical of designs found in Karajas. (Scatter sizes and runners.) (3) Herati design—often called the fish design—also the Feraghan design.   (4) Shah Abbas design. There are a number of variations of this design.   (5) Gula Hinnai design. Varies slightly in detail in many rugs.   (6) Mina Khani design.   (7) So-called pear design. Also called palm design.   (8) Persian Palmette. Used in both field and borders. (9) Turtle design.   (10) Rosette design.   (11) Wine Cup and Serrated Leaf design. These final three designs are found in many Persian rugs.

FIG. 2. Rug on the left shows the Herati (also called Feraghan) design found in many Persian rugs of different types, but principally in Hamadans and Sena Kurds. Picture is of an Ingeles rug, finest of Sena Kurds. Field is red. Rug on the right shows general design with many variations found in about half of all new runners imported, and a great many small rugs. Field is either a bright red or ivory. Designs are colorful.

*List of Persian Rugs*

| | | |
|---|---|---|
| Afshar (Afshari) | Joshigan | Niris |
| Ainabad | Kashan (Keshan) | Polonaise |
| Arak (Arac) | Kasvin (Kazvin) | Qashqai (Kashkai) (Ghasgai) |
| Ardabil | Karadagh | Qum (Qom) (Gum) |
| Bahktiari | Karaja | Saraband |
| Bahkshis (Bakshaish) | Karaje | Savalan |
| Baluchistan (Beloochis-tan) | Kaputarhang | Sarouk (Saruk) |
| | Kirman (Kerman) | Sena (Senna) (Senneh) |
| Bibikabad | Kirmanshah (Kerman-shah) | Sena-Kelim |
| Bijar | | Sena-Kurd |
| Birjand | Khorasan (Khursan) | Serapi |
| Borchalu | Kurdistan | Serab |
| Dargazine | Lillihan | Shiraz |
| Feraghan | Mahal | Suj-Bulak |
| Gorevan | Mecca Shiraz (Qashqai) | Sultanabad |
| Hamadan | Melayer | Tabriz |
| Herat | Meshed | Teheran (Tehran) |
| Herez (Heriz) | Mehreban | Turkbaff (Turkibaff) |
| Ingelas | Mir-Sarabend | Veramin |
| Ispahan | Mosul | Yezd |
| Ispahan Meshed | Muskabad | Zanjan |
| Josan | Nain | Zeli-Sultan |

Each week in the New York papers I find many standard names spelled differently from anything in any book or any previous, crazy spelling. Recently a famous store spelled the famous name Bokhara with a "u," "Bukara." That was a first as far as I know. Many slight variations in spelling, such as Sarouk or Heriz instead of Herez, and others are logical, and one spelling is as good as the other. If we followed exactly the Iranian spelling of all towns we would also make some changes. The British spell some of these names slightly different, and so do the German authors when their names are translated into English. But, none of these are confusing. It is only when I see some crazy name in an advertisement in a New York paper, that I get upset. Why such names are used or where they come from, I do not know. Recently an ad in the *New York Times,* by one of the best stores, listed "Mazleghan, Ghafghaz, Talfresh and Saveh." These names are absolutely unknown to me. The ad caption was "Old Oriental Rugs," so these could not be trade names, and they certainly are not listed in any book I have read. I can understand spelling Turkman "Torkoman" and similar errors.

The young man who heads this department is a fine, enterprising young buyer, who has to make up for his inexperience by his natural ability and initiative. It is only when stores drag in phony names to cover up a well-established name that I become irked. I object to a Turkibaff being called an Ispahan. No one must be surprised at the appearance of many new trade names from India.

*Seven large rug weaving districts in Iran*

The capital of Iran is Teheran. The six large rug weaving districts have as their market center, the cities of Hamadan, Tabriz, Sultanabad (also called Arak), Kirman, Meshed, and Shiraz. I have included the three Bokhara tribes which have settled in northeast Iran and are now producing rugs in the Tekke Bokhara design.

It is in the above cities, excluding Shiraz, that most of the looms for making large carpet sizes exist. In addition to these large weaving districts, there are many smaller districts, individual cities and towns and nomad tribes producing many rugs. I have tried to list each and every known weave, and group them into districts where made. That I will inadvertently omit some unimportant name is quite possible.

| | | |
|---|---|---|
| | City of Tabriz | Many different types and qualities of Tabriz rugs |
| | Herez and Gorevan rugs are woven in | Herez, Gorevan, Bakshaish, Ahar, Mehrivan, and other small towns |
| TABRIZ DISTRICT<br>The rugs listed are marketed in Tabriz | Karaja Rugs often sold as Herez | Woven in a half dozen villages just north of Herez area, largest being Karaja |
| | Serab | In town by that name |
| | Ardebil | Rugs are so entirely from Tabriz and Herez |
| | Ainabads & Bibikabads | Towns N. E. of city weave one type, all sold as Bibikabads |
| | Kasvin | Woven in the city |
| | Dergezin | Dergezin District, many villages |
| HAMADAN DISTRICT<br>The large city named Hamadan is the market center for all these types within some 50 mile radius of the city | Kabutarhang | Together with many other villages weave this rug |
| | Mehriband | Mehriband District—includes many villages and farms |
| | Borchalu | Borchalu District—a large area south of the city |
| | Ingelas | Ingelas—town and district, and hundreds of other villages known as Hamadan, some quite important |

The rug of Kasvin city is different from all other rugs woven in the Hamadan district. It is tightly woven and more like a Sarouk in weave and thickness.

Bibikabads, Ingeles, and Borchalu are sold under these names. Before roads

were opened up, and when there was little information on these, we called them Sena Kurds. I am gradually discarding the name "Sena Kurd" for these three types. Kabutarhang are sold as such, or as Hamadans; so are Dargezins sold under their own name today.

## Arak or Sultanabad District

| | | |
|---|---|---|
| A large city where most Sarouks are woven; formerly called Sultanabad; today Arak is more in use. | Woven in the city and towns are three general types, or rather, qualities: Sarouks, Araks, and Mahals (or Muskabads or Sultanabads); these last three named according to quality. | Sarouk (town) |
| | | Feraghan (district) |
| | | Muskabad (town) |
| | | Arak (Sultanabad) (city) |

Sarouks are woven in all these towns and districts. Sarouk is a small village and could weave only a fraction of the Sarouks made. Actually, the Feraghan district, which includes the village of Sarouk, weaves all three types. Muskabad weaves mostly rugs offered by that name, but has turned to weaving some Sarouks. There are many other villages in the area, all weaving the three general types.

## Kirman District

| | |
|---|---|
| Many rug weaving factories in the city of Kirman | All rugs made in the many towns and outlying districts are in Kirman designs and sold as Kirmans. Many qualities and designs are found. |
| Kirman district embraces the city of Kirman and an area for perhaps 100 miles north and south of the city, and 50 miles east and west. | The exception is the Afshari—a tribal rug woven in many nearby villages. |

Kirmanshah—no rugs made by this name. Kirmanshah is 800 miles to the West of Kirman. See Part II discussion of this.

## Meshed—Principal city in the large Khurasan District in Eastern Iran

1. Turkibaff—sold as Ispahan and made only in the city of Meshed. Uses Turkish knot.
2. Meshed—rugs made in many towns are Mesheds. The large Khurasan district makes both Mesheds and Birjands. Uses Sena knot.
3. Khurasan—made in many villages. Birjand, city where many rugs are made and marketed as Birjands. Uses Sena knot.

   When one reads this list he must not get the idea that all of the named rugs are available today. Also, he should remember that all sizes are not made in all types. Certain types are made only in certain sizes. For instance, the Serab comes only in camels hair fields about $5 \times 3$ ft. to $7 \times 3$ ft., 8 to 18 ft. lengths $\times$ 3.3 ft. widths. They make no carpet sizes and no scatter sizes excepting the $5 \times 3$ ft. sizes. Rare exceptions do exist.

There are many villages weaving rugs offered as Mesheds and Birjands. These rugs vary greatly in quality. Note that I refuse to call the city made rug, the Turki-baff, and best rug woven in the entire district, Ispahan. Practically every dealer and importer alike gives these that name. They are wrong to do so. I have adopted the name Ispahan Meshed in order to try to link these names for business reasons. I refuse to infringe on the great name Ispahan. The new Ispahan is a fine and very short nap rug, while the Turkibaff is a thick, tightly woven rug with about one third as many knots to the inch.

The Beluchistans are marketed in Meshed or Birjand, but I did not list them under this heading. See Part II.

### Shiraz District

The City of Shiraz is the market place for all the Shiraz types, woven by the several large Fars Tribes (280,000 in number), occupying an area 150 miles by 150 miles, with scores of villages in the area. The City of Shiraz has not woven rugs; but with the increase in prices, looms may have been set up there during the past few years. The Qashqai (also spelled Kashkai and Ghasgai) comprises several tribes and weaves rugs known by this name, but better known in America and Europe as Mecca Shiraz.

### Bokhara District

The other sizeable rug weaving area in Iran might be classed as the Turkoman weaving area. It is adjacent to Russia's Turkmen S.S.R. and occupies a large area beginning on the east of the Caspian Sea, extending along the Persian-Russian border, all the way east and north of the Khurasan district. The three tribes are the Jafarbai, the Atabai and the Tekkeh. They weave rugs in the Tekke or Royal Bokhara designs. See Bokhara Part II and Plate 20.

If you walk into most stores and are looking for a 9 × 12 ft. Oriental rug, you will generally find only Gorevans, Herez, Kirmans, Sarouks, Mahals, Bibikabads, Araks, Kasvins, and Kaputarhang. As a rule, all will be new. In extra large sizes most of the rugs are Kirmans, Kaputarhangs, Sarouks, Kasvins, Herez, Bibikabads, Ispahan, Mesheds, and Mahals. A limited number in semi-old Bijars, Kashans, Tabriz, and Sultanabads may be found. Also, one will find a few large sizes in semi-antique Kashans and Bibikabads (Sena Kurds). In scatter sizes, more than half of all available come from an area in and around Hamadan. Many scatter sizes are available in Sarouks, Kirmans, Karajas, Herez, and Kasvins.

In new runners, the vast majority will be Dergazins or Hamadans. These two with Karaja (Herez) runners comprise 90 percent of all runners available today.

A check on each type of rug in Part II, will give full details on each rug.

While there is a great difference and a wide variety of designs among Persian Rugs, still they have enough similarity and enough in common to use most different type rugs together. Remember above all else. *Name does not definitely determine the quality of an Oriental Rug. Rugs by the same name vary greatly in quality and beauty.*

The few Lillihans made are marketed in Arak (Sultanabad); but they are an individual item, more like a fine Hamadan than the Sarouk, Arak, or Sultanabad.

The Sarabend district is only some 30 miles from Arak, and their rugs are marketed there, but I did not class them under that group since they are so different in design and weave. I may have to withdraw this statement in time, as some of the finest new Sarouks are appearing with the small Sarabend Pear design.

### The changes in Iran are many and of great consequence since 1952

It is only by reason of the sub-standard living scale that handmade rugs can be sold at prices within reason. Until recent years, there were millions of weavers in Iran. Much of the present day weaving is being done by small children, at fifteen to twenty-five cents a day, perhaps for even less. The grown women are finding that they can get a dollar a day or more in the larger cities. Most of the weaving, in outlying districts and small villages, amounts to fifteen to twenty-five cents. We are beginning to realize that the much talked-of "end of the great art of rug weaving" will likely come to be realized in Iran in our lifetime. Certainly fewer and fewer are being made.

A dollar a day wages for all rug weaving in Iran will increase the present day prices of most Persian rugs from three to six times the present prices. I made a very similar statement in my 1952 edition, and my estimate was rather accurate. Much of what I predicted has come to pass, and perhaps there are less than half the numbers of weavers in Iran, today 1962, as in 1952.

### The shortage in supply from Persia (Iran) is real

Shortages and improvement in standard of living are tied to each other. With Persia (Iran) supplying perhaps 75% of all Oriental Rugs offered in America, it is a serious matter to rug dealers, and the public in general, when the supply is cut in half over the past few years. A more correct statement would be to make the following three estimates:

*First*) that the supply of new Persian rugs coming to America has been reduced 50%.

*Second*) the supply of semi-antique Persian rugs has been reduced by 90% from the number of semi-antiques that came here in 1950.

*Third*) the supply of antique Persian rugs coming from Iran has been reduced 99% from the number that came ten years ago.

Ten years ago I could buy two hundred semi-antique Persian rugs in the New York market in one day. I could select these from many hundreds of semi-antique Persian rugs. Today we can buy practically none. Where we could find and buy twenty suitable, semi-old rugs in nice soft colors, today we are fortunate to find one. Very few real antiques have come from Iran in many years. Now, hardly a single antique comes from there.

The hard cold facts are that the United States imported only about four million dollars worth of Persian rugs in 1960. All of this has happened when there is a greatly increased demand for Oriental Rugs in America. It is the first general revival of interest over the country in twenty-nine years.

We here in Central New York and in a few other sections, such as Massachu-

*31*

setts, have never had a let-up in the demand. But even here, where the demand has always remained, it is much greater today.

### Europeans buying heavily

Part of our shortage is due to the fact that Europe, particularly West Germany, is again prosperous, and is buying over twice as many Persian rugs as America is buying. Added to this is the fact that Persians themselves, especially in the large capital city of Teheran, are buying rugs in great numbers. I will devote a short chapter to this subject in later pages.

The demand by the Persians and Europeans has influenced some of the great changes. One of the startling changes in the supply to America in the type of rug being produced, is to be found in Sarouks and Kirmans. These two types have been the two main items to fill the demand for the higher priced new rugs. The Kirman, with its light field and pastel colors, has become our costliest rug since World War II. It has been a favorite with the decorator trade. The hobbyist and lover of antiques does not generally like the modern Kirman. But Kirmans must certainly be classed as the most salable of modern Persian rugs. Of course, the cost of these prevented most from buying them.

There were two general qualities. One, the family-made Kirman, which is generally referred to as the Bazaar quality. While it is rather finely woven, it is not as fine nor as heavy or as tightly woven as the better qualities of Kirman. The wool in these Bazaar quality Kirman is, as a rule, not very durable. The better quality is generally referred to as Contract quality Kirman.

A few American importers own a good number of looms and control the quality, and bring in a better grade of wool than the local market affords. Many other looms are owned by rich Persians, who contract with American importers or other dealers to weave Kirmans for them in a superior quality. In the City of Arak (also called Sultanabad) and in the surrounding villages, a good many thousand Sarouks have been woven each year, especially for the American market. This was true until a year or two ago. In the fall of 1959 the number of Kirmans and Sarouks that came to America was very small as compared to the number brought here during previous years.

The facts are, the owners of these looms in Kirman and Sultanabad found a better demand and a better price from the European buyers, and also from Teheran dealers. Instead of the very thick Kirman and Sarouk that had been made for Americans, they are making slightly finer and thinner rugs for the Germans and Persians. These rugs are more appreciated in Germany and Persia than in America. Give Europeans and Persians prosperity and they will pay well for their rugs.

### Hamadan rugs in short supply

In 1959 and 1960 there was a real shortage of Kaputarhangs in the New York market. Where in previous years there were many hundreds available in the 8 × 10 ft. and 9 × 12 ft. sizes, there are now less than one-third of the number available. These come with a bright red field or with the ivory field. They are the best rugs available, at a low price, in Persian rugs coming to America today. The Persians in the Kabutarhang district almost stopped weaving them overnight.

In 1960 practically every weaver here was working on a new air field. The pay was double that of rug weaving wages. Not only is there a shortage of Hamadan goods, but the quality of many of these rugs has deteriorated. This may be ascribed to the use of the Jufti knot. What has been said about the great rug center of Hamadan is equally true, or true to an even greater extent, in Tabriz. Tabriz is the market, not only for Tabriz rugs, but also for all the rugs from the Herez districts. The dozen or more towns and villages, some thirty miles east of Tabriz, weave thousands of carpet sizes in many qualities. The half dozen villages in the Karaja district also send a great number of small rugs to the Tabriz market. The Tabriz rugs were never a big factor in the New York market since the last war. Until West Germany and Europe entered the market several years ago, practically the entire output of Gorevans and Herez was sent to America.

While Tabriz rugs are made in many different qualities, most of the new Tabriz have too stiff a look when new to be good sellers in the American market. For instance, the small, all over repetitive Herati (Feraghan) design, that looks so well in most Persian rugs, especially in the Hamadan types; and which is one of the principal designs to be found in Tabriz carpets, looks too angular. The short to medium clipped pile makes most Tabriz have a somewhat domestic or machine-made look. These same rugs with a little use, lose this effect and become much more attractive.

We do miss the limited number of semi-antiques that came to America until Germany entered the market. It is in the Herez and Gorevan types that American dealers are hardest hit. The cheaper qualities in approximately 9 × 12 ft. sizes, were, for several years after the last war, the No. 1 promotion item for sales in America. The rug we could sell for $195 to $225 in 1952 and was a better rug than the dealers can buy wholesale for that price today.

My guess is that Europeans are taking seventy-five percent of the output from the Herez districts. The same is true of the thousands of scatter sizes and runners sold as Karajas.

## Will Kirmans price themselves out of the market?

They have pretty much done that already. A good contract quality Kirman today is very high. The Bazaar quality Kirman, even if rather finely woven, wears down thin too quickly. Kirmans today are at an all time high. Fewer and fewer are being imported. Retail stores find they can sell a few of these but that the number of sales possible at the price does not permit stocking them in numbers. The Persians themselves are buying Kirmans in great numbers. They do not like our ivory pastel Kirman, but want the bright red.

## Europe has taken the Sarouk market

For 55 years Americans have had full control of the Sarouk (Sultanabad) market. Thousands of Sarouks came to America every year. In 1960, the European buyers, and especially the West German buyers, in effect took over the Sarouk market. Less than one-third the number of Sarouks were imported to America. I personally like the designs that the Europeans have made, and will undoubtedly buy some of these.

*33*

Never has there been anything in the Oriental Rug field as the mad, almost reckless buying of Oriental Rugs by Europeans. Talk to any American (Persian importer) buyer who has been to Iran, and you will be amazed. The Persians themselves are not only buying for use in their homes, but buying rugs in numbers and putting them away as an investment, knowing that the mass modernization in Iran will inevitably increase the cost of making rugs each succeeding year.

Not only have we poured hundreds of millions into Iran on Point 4 Projects, but we have spent millions building up their military strength. With the government determination to make compulsory education work, we can expect this to cut the supply still further, because most of the weavers are children.

### Pakistan rugs and rugs from Bulgaria will confuse many people

Yes, Pakistan rugs from West Pakistan, and also handmade rugs from Bulgaria, are copying the Persian Tabriz design and their texture as well. Both of these make different qualities, but on the whole they are better than the average Tabriz rugs. What has happened is that both of these countries have bought and adopted some paper scale patterns of Tabriz Rugs and are producing rugs which make it difficult for many dealers to know exactly where the rugs are made. Americans are not yet too involved and have, to date, not brought these in. I rejected both types on my trip abroad last spring for the same reason that I reject most Tabriz rugs; namely, that they are too mechanical. The old Tabriz rugs were more curvilinear in design with graceful curving lines, but the new Tabriz rugs and their followers are too mechanical and angular to please most Americans. They have a certain machine-made look in spite of their handmade honesty. Europeans do not object to this. In fact, the Tabriz are a favorite with the Germans.

### Deterioration of Persian rugs

My considered judgment is that there is a great decline in the merits of most Persian rugs. We will discuss this in more detail under Chapters on Material and Dyes. This does not mean that there are not excellent rugs being woven today, but it does mean that, to secure the best rug of the type, one has to do a lot of good screening. Rugs by the same name vary greatly. As carefully as we select abroad, we get stuck with some that are too crooked, and some that have other faults. Our method of buying from New York importers is to carefully select a dozen small rugs from a large group. We check these carefully for wool quality, stains, loose colors, and dead wool; and to see if the rug is too crooked. Half of all Persian rugs are irregular in shape. After the rugs arrive in my showrooms, we again lay these out and have our three managers approve each rug, and in the end return 10 to 20 percent of these we had carefully chosen at the importer's showrooms.

Our friends, the importers, tell us that we are too particular and that no one else is quite so particular. I reply that each and every one of my customers are more particular than we are.

*The future of Persian rugs*

At the moment it is hard to predict what will happen to Persian weaving. If we continue to pour millions into Iran, if the mass modernization continues, if the education of the children takes them away from weaving, and if Europeans continue to be as prosperous as they have been during the past few years, then the picture, as far as America is concerned, is indeed gloomy in regard to Persian rugs.

The law of supply and demand will continue to function. Rugs will be scarcer and prices will continue to mount. High prices mean fewer and fewer sales in America and less dollar volume. When the large stores find that their costly ads and overhead are not being met, many of them are going to drop out of the Oriental Rug business, just as they did in the 1930–1945 period. I frankly look for many of the department stores, who reentered the field only recently, to drop out entirely in the next year or two. Many of these will start to feature some of the less expensive rugs from India. Even the choicest and best qualities from India are reasonable and they are more honest, as a general rule, than the Persian rug. I look for these rugs to supplant Iran as the No. 1 weaving country. The small dealer with his cleaning plant paying much of his expenses will continue to sell a few Persian rugs.

*New weave—Ardabil Rug*

Tabriz is also the market for an entirely new type of Persian rug. Even the rug student would mistake these for Cabistans, Daghestans, Shirvans, and Kubas. These names are Caucasian rugs which formerly came from Caucasia (north of Iran and part of Russia). Ardabil is some 90 miles east of Tabriz and some 20 miles south of the Iranian-Azerbaijan border (an S.S. state adjoining Iran).

All of these so-called Ardabils are in geometric Caucasian design and with the same general characteristics as to weave and thickness that the Caucasian rugs have. I first found these in the London market. Later they were imported into the New York market in great numbers, sizes varying from $2\frac{1}{2} \times 3\frac{1}{2}$ ft. to $10 \times 6$ ft., with the majority approximately $7 \times 4\frac{1}{2}$ ft. and $9 \times 5$ ft. A few come as large as $8 \times 11$ ft. This past fall saw fewer of these come to the New York market. I can only surmise that the Germans and Persians have also entered this market heavily.

*Bokhara rugs from Iran*

For several years we have been finding at New York importers a new type of Bokhara in the Tekke or Royal Bokhara design. They were bright new rugs in sizes about $3 \times 5$, $6 \times 4$, $6 \times 9$, and $7\frac{1}{2} \times 10$ ft. These are woven in the mountains of northern Persia by women of the Turkoman tribes that formerly lived in parts of Russia and who had crossed into Iran. These are not as fine as the real old Tekke rugs, their predecessors woven in Central Asia, but they are very excellent rugs.

There are three different tribes weaving: the Yomuts, the Tekke, and the Atabas. All are weaving rugs in the Tekke or Royal Bokhara design. These rugs are described under Turkoman rugs and "Bokharas from Iran."

*35*

## Nain Rugs and Qum Rugs

Rugs by these two names have appeared only since World War II. They are perhaps the two finest types being woven in Iran today. See Chapter "Difference Between European Market and American Market." and Part II. Only a few of these reach America. Persians and Europeans in effect grab these even at their high cost.

## Changes in color used

Eight years ago, ninety percent of the Kaputarhangs imported employed the very bright red field. Today over half of these come with an ivory background.

## Kasvin in Kirman designs and colors

Kasvin is one of the heaviest and most durable rugs ever made in Iran. Most of them come in carpet sizes (6 × 9 ft. and larger). Unfortunately, the vast majority of these came with the principal colors or background a very vivid red. While many people bought these bright colored rugs, they were much too bright for the vast majority of buyers.

In the fall of 1959, I saw and bought, for the first time, a number of large size Kasvins with the ivory background and many of them in Kirman colors and Kirman designs. Only three or four had the designs and pale colors found in Kirmans. The others had a slightly more colorful design but were a great change and improvement from the bright red fields. If the importers and owners of the factories can continue to improve Kasvin in colors, the Kasvin will find a warm welcome by American dealers and the buying public. With Kirmans pricing themselves out of the market, the Kasvin as a class is a more durable rug than Kirman. This statement would not hold true for the best contract quality Kirman, which is one of the two or three finest qualities of rug made. The Kasvin will wear, in my opinion, as long as a high grade Kirman; and it will wear two or three times as long as the Kirman costing the same as a Kasvin.

## Jufti Knot (or False Knot)

The Jufti Knot means that one hand tied knot is on four strings of warp instead of two. That means that only half as many knots are tied in a given area and the rug will be about half as good or as compact. This malpractice is not general, but much of it is done.

The above does not mean that all rugs have deteriorated; but I would say that more than half of our importations are decidedly poorer in quality than the same rugs were eight years ago. Some rugs of each type actually are better, but any dealer who is interested in his reputation must choose carefully. I feel sorry for many large stores and dealers whose sales are based on price and promotion. The many stores who offered thousands of cheap grade (and sometimes some very good old Herez rugs) at retail for $195 to $250 (in the 9 × 12 size) are now finding that they can only buy the poorest, junkiest type at wholesale for $200.

FIG. 3. SULTANABAD RUG FROM IRAN. This figure is typical of many Sultana-
bads—an overall—floral design combined with the Shah Abbas design. The field is
usually in some shade of rose, rust, or red, but some few come in blue. For full details
as to other designs, colors, qualities, and characteristics, see "Sultanabad" under the
alphabetical listing in Part II. The same general design can be found in Mahals, Muska-
bads, Araks, and Sarouks.

FIG. 4. HEREZ RUG FROM IRAN. A medallion design which is typical of the thousands of Herez and Gorevan carpets. The medallion may be geometric but the floral influence is present. The design over the rest of the field is in the conventionalized floral, the term I use to describe the stiff and angular floral design found in so many Persian rugs. Ninety-nine out of one hundred Herez and Gorevan rugs are made in this same general design. All are very similar, but no two are exactly alike. The main border is in the turtle and rosette design. Tabriz is the market for these types.

FIG. 5. BIBIKABAD RUG FROM IRAN. We class this as a Sena Kurd. Invariably it is in the above general design. Main part of the field is usually in a shade of light wine or red. Centerpiece is in ivory, and corners in navy, ivory, and light blue. The entire field is covered with the small, overall Herati (Feraghan) design in green, pink, flecks of ivory, and other colors. The rug usually has about eleven borders, but may have as few as seven. Two of the narrow borders will usually be in green. For full details see the alphabetical listing in Part II. Occasionally this rug comes with a blue field. It is a heavy quality rug with superior wool.

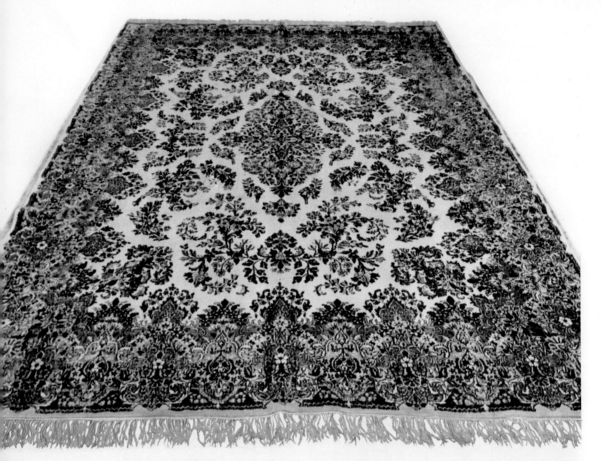

FIG. 6.   KIRMAN RUG FROM IRAN. The above plate is typical of approximately two-thirds of the Kirmans that come to America today. The small floral center does not stand out as prominently as in this picture, but gives an overall effect. One-third of the Kirmans imported today have a centerpiece and corner design, but the main part of the field is a plain color. The border shown is the so-called Aubusson type border. Some refer to it as the broken border as it merges with the design in the field. The vast majority of modern Kirmans have an ivory or cream field, with most of the design in pastel shades of blue and rose.

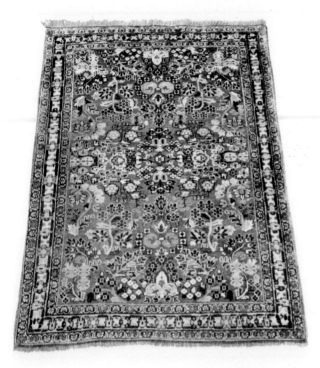

FIG. 7. MODERN DESIGN SAROUK FROM IRAN. Size approximately 7 × 4 ft. Most of the new Sarouks come with a red field and overall floral design similar to this rug. Most of the carpet sizes—9 × 12 feet and larger—will show more open ground and less design. There are scores of rugs in this general design.

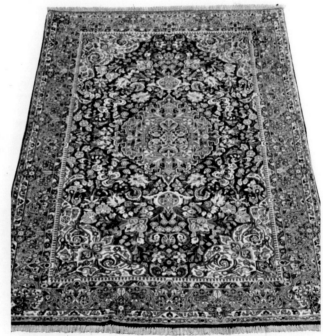

FIG. 8. TRADITIONAL DESIGN SAROUK FROM IRAN. Size approximately 6.6 × 4.6 feet. This rug with a central floral design (some would call it medallion, but that is unimportant) and its matching corners with the rest of the field covered with palmettes, tulips, rosette and floral sprays, is typical of the design of Sarouks of thirty-five years ago and even later. This is a new rug employing the traditional design.

41

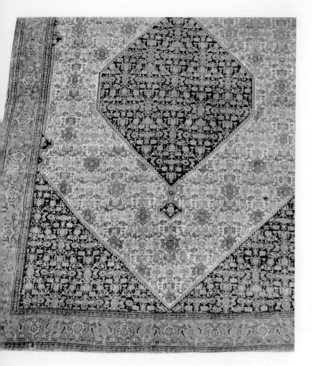

FIG. 9. ANTIQUE SENA FROM IRAN. Size approximately 7×5 feet. The Sena is one of the three or four rarest antique type rugs from Persia. This Sena has the so-called repetitive Herati (Feraghan) design which is the design employed by more rugs than any other general design. The well-known turtle design is used in the main border. There are hundreds of variations of both these well-known designs in the Hamadans, Sena Kurds, Sultanabads, Bijars, Kurdistans, Biblikabads, and many others.

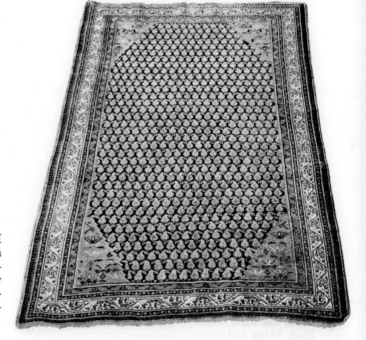

FIG. 10. ANTIQUE SARABEND FROM IRAN. Typical of the old Sarabend design which consists of a small, overall pear design. The border of the Sarabend invariably has the ivory background with the conventionalized vine and pendant pear design. This old rug has a blue field.

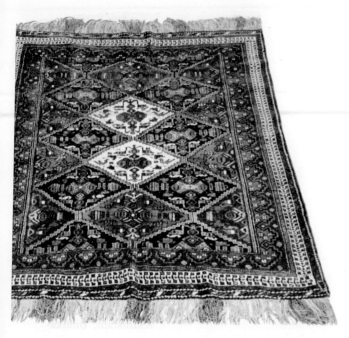

FIG. 11. ANTIQUE SHIRAZ FROM IRAN. Size 6.1 × 5.3 feet. The typical design of many Shiraz. The same general design is used by Afshars (often referred to as Shiraz). The field would be called a compartment design by some, while others would refer to it as a garden design. It is definitely a series of serrated, sided sexagons —each of which is covered with many small nightingales (birds). Nightingales stand for contentment and happiness to the Iranian.

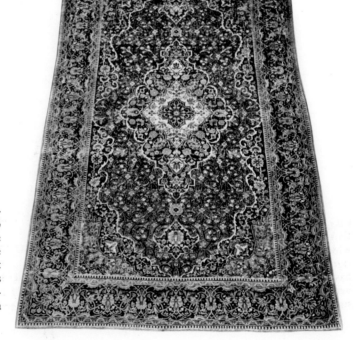

Fig. 12. SEMI-ANTIQUE KASHAN FROM IRAN. Size 7 × 4.6 feet. The old Kashan is of very fine weave. The field has an intricate centerpiece and corners. Main part of the field is in a rich red and is covered with detailed floral designs. The main border is blue with Shah Abbas and intricate designs.

*43*

CAUCASIAN RUGS

A very few runners came in sizes approximately 3½ × 12 ft. A few of the oldest
Caucasian rugs did come in unusual sizes, 6 × 15, 7 × 18, and other long narrow
carpet sizes. None of these have been imported the past 40 years.

Ancient Caucasian Rugs not available

Here is what the British Museum Guide Book says, and I quote verbatim
to this statement which might be questioned by some: "The Caucasus now
has a 15th century Kuba wc... whic... of 100... ...n... wh...
have doubtless been made in that region for cen... ...mo... ...
ductions are included in... ...s... ...
Turkish carpets. It is... ...
the district Caucasian Gh...

Names of Caucasian Rugs

Baku

Karabagh (Carabagh)

...
...rmish...
rugs (rugs woven with...
loose on the back. The...
rugs, being woven like...

...lish, and Tiflis B...
Kabistans, Kubas, Shirvans, Daghestans,
...
...
...

# Chapter Four

# CAUCASIAN RUGS

NORTH OF IRAN (Persia) is a large rug weaving district, which has been re-
ferred to in all rug books as "The Caucasus." It extends from the Black Sea on
the west to the Caspian Sea on the east, and lies on both the southern and northern
slopes of the Caucasus Mountains. This section now lies wholly within Soviet
Russia. The three southernmost states nearest Iran are, Armenian S.S.R., Azer-
baijan S.S.R., and Georgian S.S.R. North of the Caucasus Mountains is the Russian
Soviet Federated Republic.

This section at one time numbered forty distinct races, each speaking a different
tongue and each having a slightly different fashion in rugs. The Caucasus has had a
varied political history, having been overrun by armies of nearby countries which
left their imprint as well as many of the conquerers there.

*Geometric Designs*

While it is true that the geometric Turkish and the floral Persian merge to a
degree, the Caucasian rugs have characteristics which mark them as a distinct
and separate group. The majority of these are strictly geometric in design. Dia-
monds, large stars, polygons, and many other geometric figures are used. Angular
or geometric figures of men, animals, and birds in small sizes are often used be-
tween the larger geometric figures. In the borders we find the small crab design,
the wine cup and leaf design, diagonal stripes, and some Persian border designs,
each of which are stiffened into angular shapes. Many of the designs show resem-
blance to Turkish rugs. Others appear to be a stiff rendering of old Persian designs.

This is especially true of those made nearest the Persian borders. The Karabaghs,
Bakus, and Shirvans show Persian influence. The first two show this even more
than the Shirvans.

I like to divide Caucasian rugs into two categories: the thick heavy type rugs,
which include Kazaks, Karabaghs, Tcherkess, and Geunge; and the thin finely
woven short pile rugs, which include the Kabistans, Kubas, Shirvans, Daghestans,
Baku, Lesghian, Chichi, and Talish. Practically all Caucasian rugs, new or old,
are in scatter sizes. A good many came in sizes approximately 9 × 4 ft. and 9 × 5 ft.

A very few runners came in sizes approximately $3\frac{1}{2} \times 12$ ft. A few of the oldest Caucasian rugs did come in unusual sizes, $6 \times 15$, $7 \times 18$, and other long narrow carpet sizes. None of these have been imported in the past 40 years.

*Ancient Caucasian Rugs not available*

Here is what the British Museum *Guide Book* says, and I quote to lend weight to this statement which might be questioned by some collector who thinks he has a 15th century Kuba or other 300 or 400 year old Caucasian rug: "Carpets have doubtless been made in this region for many centuries, but the earlier productions are included in the classification of the older Persian, Armenian, and Turkish carpets. It is not before the 17th, or perhaps the early 18th century, that the distinct Caucasian Group is recognized."

*Names of Caucasian Rugs*

| | |
|---|---|
| Baku | Kuba (Kubistan) |
| Chichi (Tzi-Tzi) | Kutais |
| Daghestan | Lesghian |
| Derbend | Shirvan |
| Geunge (Genghis) (Ganja) | Soumak (Sumak) (Kashmir) |
| Kazak | Shemakha |
| Kabistan (Cabistan) | Talish |
| Karabagh (Carabagh) | Tcherkess |
| | Tiflis |

Kashmir, Sumak, and Soumak are one and the same. These are the flat stitched rugs (rugs woven without a pile) with the colored ends of the wool hanging loose on the back. The first Oriental Rugs that history recorded were these napless rugs, being woven like a tapestry.

The names best known to Americans or Europeans, are the Kazaks, Kabistans, Karabaghs, Daghestans, Shirvans, Kubas, and Chichis. The Kazaks, Kabistans, and Daghestans are the best known of these. The Chichis are usually different in design in that they employ a small all-over design. Many of the Daghestans are in Prayer design.

Both John Kimberly Mumford, in his first edition published November 15, 1900, and the Soviets, in their booklet on Oriental Rugs published by the Armtog Trading Corporation about 1930, insist that most of the rugs that we have called Kabistans were, in reality, made in and around Kuba, and they should be called Kubistan. To me, one of these names is as good as the other.

I have listed the names of Kutais, Lesghian, Shemakha, Derbend, Geunge, Talish, and Tiflis; but unless you are a collector with more knowledge than the average expert, these names can be discarded. No doubt rugs have been made in these towns and districts, and the correct name would be one of the above. But I have never met a rug dealer or expert who could give definite information on these. None have been imported under these names during the past thirty-five years. And, if a collector has one, he has accepted the statement of a dealer who

*45*

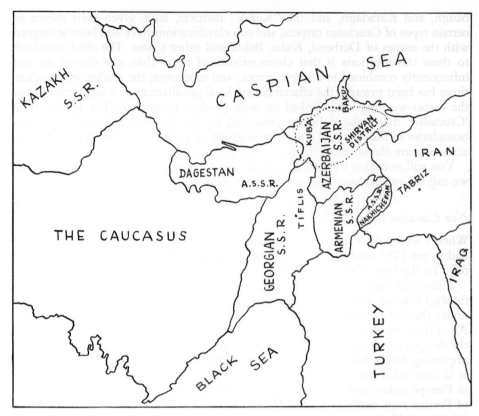

MAP 3.   GENERAL MAP OF THE CAUCASUS (or Caucasian rug weaving states).

has never been to Caucasia, and who has bought a number of Kabistan, Daghestan, Shirvan or other type and convinced himself that it is one of these types.

The lack of rugs by these names has not made them the object of search by collectors, nor has it made them any more valuable than the other types. The exception is the Talish rug which is a collector's prize.

### Definite names of different types is difficult

One will often have a difficult time deciding which name to give to some of these Caucasian rugs. Often it is not possible to definitely decide between the following names for a particular rug—Daghestan, Shirvan, Kubistan or Kuba. In Part II, I have gone into great detail for those who wish the best thumb rule I know for a line of demarcation between these different types. See Kabistan, Kuba, Daghestan, and other Caucasian weaves in Part II.

The museums are often satisfied to call these Caucasian rugs. Here is what is stated in the *Guide to the Collection of Carpets* of the Victoria and Albert Museum, London, revised edition of 1920: "The territories of Daghestan, Shirvan, Kara-

baugh, and Karadagh, and the "Kazak" districts, have given their names to certain types of Caucasian carpets, and sub-classifications have also been attempted with the names of Derbend, Kuba, Baku, and other towns. The chief drawback to these classifications is that characteristics of more than one district are not infrequently combined in a single carpet; and moreover, the tendency of modern times has been towards the effacement of local peculiarities to a large extent over the carpet-weaving lands linked up with modern commerce. The general term 'Caucasian' meets the difficulty presented by the frequent shifting of political boundaries in the past and comprises a group of carpets in which the main characteristics are the same."

You will note that the British always refer to all size Orientals as carpets, while we call the smaller sizes rugs and all large sizes carpets.

## New Caucasian rug in 1960

When I wrote the Chapter on Caucasian rugs in the spring of 1960, I said, as I had in my 1952 edition, "There are no Caucasian rugs exported from Russia today. To the best of my knowledge, none are being woven there."

Time after time I have expressed the opinion that rug weaving in Russia was finished forever. Imagine my suprise to see a handful of new rugs from Caucasia under the old names, and with one or two new names added, such as Erivan. All of these were in sizes about $4\frac{1}{2} \times 6\frac{1}{2}$ ft. There are five new booklets out showing the designs in which these rugs will be, or are being, made. So far, only one small importing house has shown these, and it had not more than a dozen in stock. It is clear what has happened. With the tremendous demand for Oriental Rugs in Europe today, and with the shortage in Persian rugs, and especially with prices of Persian rugs rising every month, many countries are trying to re-enter the rug weaving field.

It is impossible to convey to Americans, who have not witnessed the buying spree of Oriental Rugs by most all European countries (except England), the tremendous demand for rugs there, which is unbelievable. Certainly no such demand has ever existed in America. West Germany is buying many more rugs than America.

## Predict rejection of new Caucasian rugs in America

It is too early to pass definite judgment or perhaps even a sound opinion on the outcome of these new rugs. However, I doubt if they will sell in numbers in America. First, they are new and bright, and lack the charm of old Caucasian rugs. Also, their cost of weaving will be higher that the cost in Iran, even with the mass modernization in progress in Iran. Importers will have to pay at least 45% duty, as against $22\frac{1}{2}\%$ duty from most rug weaving countries. Those that I saw, were higher in price than most Americans will pay for such new rugs. They also have to compete with the Ardebil rugs made in the same general design, which are made in northern Iran.

If the European prosperity and buying spree continues, these may be sold in Germany and other European countries. I predict they will again cease to weave these rugs after a year or two.

*47*

*Old Caucasian rugs from American estates going to Europe*

Any good Caucasian rug bought today will be one that comes from some estate or collection. If it is in the hands of a dealer, he has bought it from an estate, or most likely from some small importer in New York City who has obtained it from some home. One sees these types, but most of them will be a worn out variety, and only about one out of fifty such rugs will be in good condition. Yes, there are perhaps one hundred good Caucasian Rugs in American homes today to every good one remaining in all Caucasia and Russia. The figure might well be one thousand to one.

During the past several years, scores of European rug buyers have bought thousands of our choicest old Caucasian rugs and shipped them to Europe. Neither American dealers nor the public have been able to compete with the prices these European buyers are willing to pay for these very old Caucasian rugs.

For several years after World War II, I could always find a good number of excellent antique Caucasian rugs on each trip to New York. I invariably rejected the worn rugs of this type. During the past five years I have not bought a single Caucasian rug from any of the many small dealers (not retailers, but small jobbers who also import a few Persian rugs). I have not even bothered to visit the many small places I formerly habitually visited at least once a month, because I know so well that they have been completely spoiled by these European buyers. Nor have these European buyers limited their buying to these small jobbers in New York City, but they have travelled all over America, visiting each retail store. They have not only cleaned out the wholesalers, but most of the desirable Caucasian rugs throughout the country.

I have fallen victim to their visits and have sold thousands of dollars worth of Caucasian rugs to these European buyers. Why? Because they are willing to pay more than the American public will pay. The astonishing fact is that these are wholesale dealers who buy from us. They in turn sell to retail dealers, who in turn must make a profit when they sell to an individual. So, it would seem that the individual in Europe is paying double the price Americans are willing to pay for these old Caucasian rugs. There has been a real demand and a big demand for these old Caucasian rugs by the American public during the past ten years. No one can blame a retail dealer when he can sell many thousand dollars in these old Caucasian rugs in a half hour, if he has such a supply.

*Few good Caucasian rugs made since 1915*

During the period 1924 to 1935 a great many good Kazaks and Kabistans came to America. Then, they were no higher than the average good Persian rug. I have bought many from the Armtog Trading Corporation in New York City and still more from the Russian Agency in London, England. During the above period, thousands of Caucasian rugs were confiscated by the Soviets from all the great homes in Russia. In the Port of London Authority docks (The Free Port of London), I have examined thousands of these Caucasians, as well as Persians, French Aubusson rugs, and everything salable the Soviets could get their hands on to sell. I have seen thousands of Aubusson type chair covers and Aubusson tapestry settee covers, which had simply been ripped from old furniture and sent to

London in bales—in addition to hand woven great draperies by the hundreds, and many other items by the thousands—which would convince one that all these things had been confiscated from the better homes in Russia. Year after year they came, until about 1938, which leads me to believe that they no longer exist even in the Russian homes.

Many new Caucasian rugs were made during the various Russian Five Year Programs. These were mostly new Kazaks and new Kabistans (which they call Kubistans). From about 1929 to 1935, they were indeed very cheap, and many a Kabistan about 7 × 4 feet was bought at retail for $50.00 to $100.00. I have seen many of these after twenty-five years in this country, that are today good values at $200.00. They, of course, have mellowed and are now beautiful.

Also, at the same time, many Kabistans (Kubistans) appeared that were more finely woven than even the finest of the old ones. These were woven under Soviet control, and for the first time the warp used was cotton or linen, but mostly cotton. They were as finely woven as the fine old type Kashan, being so fine and new they were not the least bit attractive to me and I did not buy them. A light chemical wash made them quite salable in London and no doubt in New York (though not many of these ever reached America). I was more interested in the lovely, perfect old ones, which at the time actually cost less than these fine new ones. With thirty years use, these Kabistans—both those sold in their stiff new form and those also lightly treated—have undoubtedly developed into very beautiful rugs. I have seen a few of these from estates in New York and they are quite salable after thirty years use; much prettier than they were thirty years ago. None of these fine new ones, however, have appeared since about 1938.

New Kazaks at that time started using cotton warp, which permits a more finely woven rug, as a rule, than the woolen warp. For complete information on Caucasian Rugs, you should read the full discussion on each type of rug in Part II.

Again, remember that each rug by each name varies greatly as to the beauty, weave, wool quality, and condition. Each, therefore, varies as to value.

## Persian rug in Caucasian design

Persian rugs made in the town of Ardebil (in northern Iran), which is twenty miles south of the old Caucasian border, are being made in the same general design as the old Kabistans, Kubas, Daghestans, Shirvans, and Bakus. The designs, weave, thickness, colors, and general characteristics adhere to those of the old Caucasian rugs. They, as a class, are not quite as fine as the old Caucasian; and, of course, they are bright new rugs. Refer to Ardebil in the alphabetical list of rugs.

TYPICAL DESIGNS FOUND IN FIELD

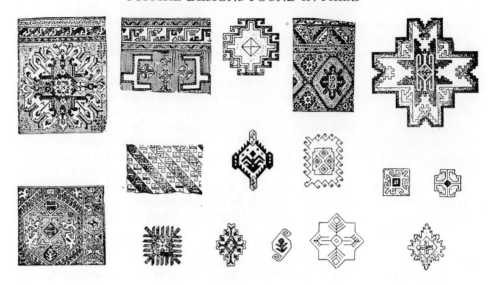

TYPICAL DESIGNS FOUND IN BORDERS

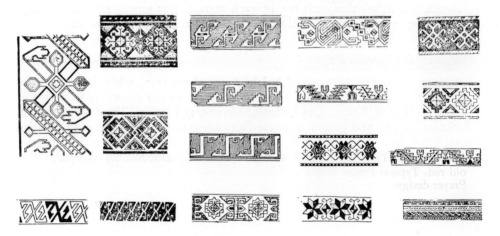

FIG. 13.   CAUCASIAN DESIGN CHARACTERISTICS

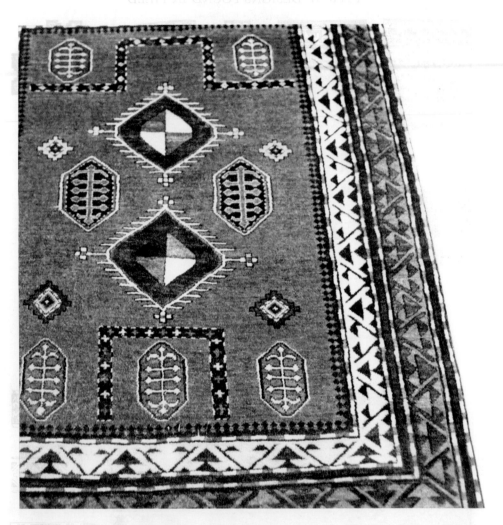

FIG. 14.   ANTIQUE PRAYER KAZAK. From Caucasia. Size 5.4×4.4 feet. Field is old red. Typical Prayer Niche of Kazaks is shown in this rug. Very few come in the Prayer design.

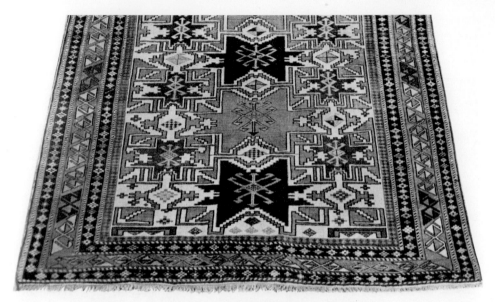

FIG. 15. ANTIQUE CABISTAN RUG FROM CAUCASIA. Size 6.2×4.3 feet. These are finely woven rugs which have a short nap even when new.

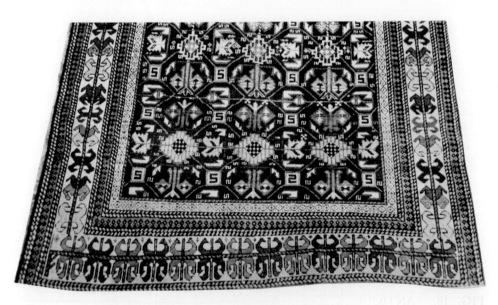

FIG. 16. ANTIQUE SHIRVAN RUG FROM CAUCASIA. Size 5.9×4 feet. These are also finely woven rugs and they always come with a short nap.

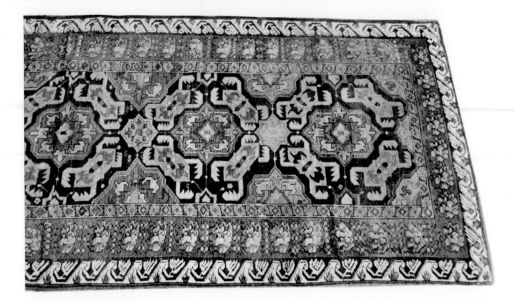

FIG. 17. ANTIQUE KUBA RUG FROM CAUCASIA. Size 6.3×4 feet. The geometric design in the center is typical of these rugs. The realistic roses in the border are found principally in Carabaghs. This design is unusual in a Kuba. The outside border is an old Georgian design.

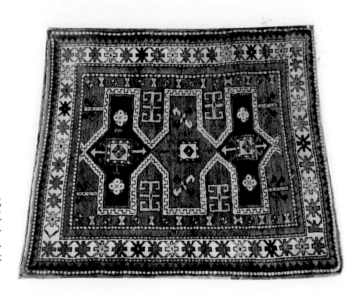

FIG. 18. ANTIQUE PRAYER KAZAK RUG FROM CAUCASIA: Size 5.6×3.9 feet. This is a typical Kazak rug.

TURKISH RUGS

# Chapter Five

# TURKISH RUGS

*(Also Called Anatolian Rugs and Asia Minor Rugs)*

IN 1952 I said that rug weaving in Turkey was forever finished on any commercial scale. I wrote, "Rug weaving in Turkey has already become a lost art. This country, which has produced millions of hand woven rugs in many of the towns which we know from our Bible, has done little weaving since 1935. Mustapha Kemal, the ruler of Turkey until his death, modernized his country or at least improved the standard of living above the few cents a day that still exists in Iran (Persia). Weaving wages there rose from 50 cents to $1.50 a day, and thus rugs made in Turkey became several times costlier than those from Iran. The result was the end of rug weaving in Turkey."

In the spring of 1960 I wrote, "There has been little change in the Turkish rug situation during the past eight years."

*A few new Turkish rugs in 1960*

With the great demand for Oriental Rugs in European and Near East countries, with Iran weaving fewer and fewer rugs, and with prices having risen sharply, the Turks evidently think that they can once again weave rugs for sale. I have seen only a handful of these new rugs, which are the first brought to America in years. They were in sizes approximately 7×4 ft. The name given these new rugs was Kula, the name of a famous type of Turkish Prayer rug. But there was not a single point of similarity. They were not even salable to the average American buyer. I doubt if many of these will be imported. If they meet with any limited success, it will be in Europe.

I saw another type of new Turkish rug in the London market, at the Culver St. warehouse. There were perhaps a hundred of these, all very much alike, if not exactly alike. All were in family prayer design, with several prayer niches, several separate prayer rugs all combined in one rug about 6×2½ ft. The field of these separate sections rotated from blue to green to plum to blue to light red. The nap is silk. I have before me the plate of the rug from which the many duplicates were

*54*

copied. It was featured in a booklet written by Henry Jacoby for a New York firm in the early twenties, and it was formerly in a Turkish Mosque. The new ones looked machine made, but were hand woven. How ridiculous it is to make so many rugs exactly alike. There is little chance of these being a success. One might buy the rug as a novelty.

A few rather inferior new carpets have been made in Turkey in the last few years. They have been very poor rugs and have not reappeared in America, after costing one store a handsome loss.

*List of Antique and Semi-antique Turkish rugs*

| | | |
|---|---|---|
| Anatolian | Kula (Kulah) | Rhodian or Makri |
| Ak-Hissar | Ladik | Sparta |
| Bergamo | Madan | Sivas |
| Dirmirdji | Melez | Smyrna |
| Ghiordes | Mudjar | Yuruk |
| Hereke | Oushak (Ushak) | Zara |
| Kershehr | Pergamo | |

I remember my first trip to Constantinople in 1929 to buy rugs. No choice rugs were being woven then, and had not been since prior to World War I. But in the old City of Stamboul across the bridge from the modern City of Pera (the two being known today as Istanbul or Constantinople) there was a tremendous warehouse known as the Free Port. Here thousands of Persian rugs were shipped in bond for sale to importers and dealers who came there to buy for large stores in America and Europe. Because it required some ten days to go from Turkey

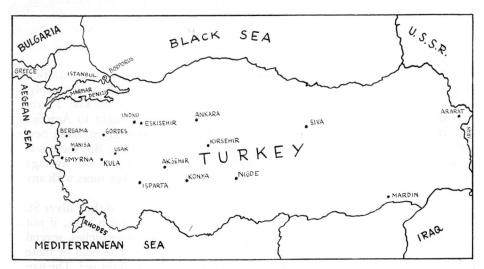

MAP 4.   GENERAL MAP OF THE TURKISH RUG WEAVING AREA.

to Persia in those days, Constantinople was the largest market in the world at that time. With the advent of the airplane and better roads in Iran, Constantinople ceased to be a market, and practically no Persian rugs are shipped there, except for local sales in the Bazaars to tourists.

A discussion of Turkish rugs is in order for several reasons. When one thinks of the old rare Prayer rugs, he knows most of them are Turkish. There are very few Persian rugs in prayer designs. Rare old Turkish rugs appear in every museum of the world. As a rule, the Turkish rugs are not finely woven. Their chief characteristics are geometric designs and prayer designs. Most Turkish rugs are more colorful than old Persian rugs, and they employ more yellow, mauve, and lavender. They also mass colors and never use animals or human beings.

An unusual type of rug is the very finely woven silk rug—probably made in Ak-Hissar where silk is available. Originally, Persian weavers were imported and these rugs are often mistaken for the finest Persian silk rugs. Mr. Norell's Plate 64 shows one of the finest silk rugs ever woven. I would have called it a Polonaise rug except for the definite proof he has that it was woven in Turkey. There are some 800 knots or more to the square inch in this rug.

*Earliest antique Turkish rugs*

Rug weaving has been practiced in Turkey for hundreds of years. The oldest known rugs in the world are the three rugs in the Mosque of Alaed-Din at Konieh, which are believed to have been made in the 13th century. The dragon and phoenix carpet in the Kaiser Frederick Museum, Berlin, were probably woven in the 14th or 15th century.

The so-called Holbein rugs and the Oushaks are the best known of the very old Turkish rugs. The Holbein rugs acquired this name when they appeared in paintings by Holbein and other artists of that period. These rugs had definite geometric designs, consisting of squares and stars. They remind one of the later day Bergamos.

The Oushaks are also to be found in many paintings of the 16th and 17th century. Places such as Williamsburg had one of these, and they are able to determine the definite period in which these were made only from the many paintings in which these occur. Dutch, Flemish, and Italian painters all used these old Turkish rugs as backgrounds. We will add a little more information on these ancient rugs in our chapter on Antique Rugs, and in Part II.

It is the 17th and 18th century Turkish or Asia Minor rugs that have interested the collectors of the past 60 years. In addition to these very ancient Turkish rugs which have not been a factor for the past 50 years, and have not been of interest to anyone except the very wealthy collector or Museum, I like to divide the rugs that we know (or have known) into three different groups. The first and second groups listed below have something in common in design, but are as different as day and night in quality and choiceness. The third group is distinct and has no similarity at all to Turkish rugs in design, size, weave, or colors. This third group simply copied the Persian rugs in design.

*Group I*

Antique and semi-antique rugs made prior to World War I. These are the only types discussed in the old Oriental Rug books. All of the types in these books, with the exception of the Pergamo, belong in this group. They are mostly good to very choice rugs. Very few of them were as finely woven as the Persians, but today are more valuable than most of the finest woven Persian rugs in the same general size. This is due to their rarity, and to their being classified as objects of art. I recently supplied a museum in a South American city with a number of these rugs. They, of course, had come from estates. On my first visit to Constantinople in 1929, I did not find a single good antique Turkish rug in any one of these rare weaves. The good examples that appear from collectors' estates, and which I buy if in good condition, would, I believe, sell for a higher price in Istanbul today than they sell for here in America. They do not exist in Turkey.

*Characteristics of Turkish rugs*

The distinguishing characteristics of these old Turkish rugs are the bright color effect—in general brighter than the Persian rugs—and the employment of much canary, lavender, and mauve, with the reds and light blues. These rugs use rectangular lines and a great massing of colors. Animal or human motifs were never used because it was against their religion. Perhaps half of these old rugs were in Prayer designs. Each type has a Prayer niche, which, with a few exceptions, is always similar in the same weave but different in each type of Prayer rug. There are more variations in the Konieh (Konia) than in any other Prayer rug.

*Group II*

This group comprises the hundred of thousands cheap copies of the old types that were made after World War I and up to about 1932. They had some resemblance to the old designs, but most of them were atrocious. They were crude, little Prayer rugs, about 5×3 feet, that retailed from $19.00 to $49.00. The dyes were very poor and loose and they would readily bleed when washed. Even a beginner should have known that they were junk. Very few of these appear today, even in second hand dealers' showrooms. I surmise that they have worn out quite readily, and that very few of them are in salable condition, even to the second hand dealer. Occasionally, I have to use the utmost tact in telling some customer that his cheap example is not one of the famous old Ghiordes, Mudjars, or other type. A good many people did pay fanciful prices for one of the better types of these rugs, in the belief that they were acquiring a rare old Turkish Prayer Rug. The fact that it was a Prayer design did not make it valuable. It might well have been a $39.00 value instead of the $2000.00 Prayer Ghiordes. But these ceased being made about 1932, and if one of these $39.00 Prayer Rugs were made in Turkey today at a dollar a day wages, it would cost some $300.00. A much choicer rug from Iran can still be had for about $50.00 in the 5×3 foot size. Again it is my observation that not all Oriental Rugs are beautiful and that rugs by the same name vary tremendously in quality.

*57*

*Group III*

These are rugs made in Turkey after World War I in carpet sizes that copied, or attempted to copy, the Persian designs. With the tremendous demand for Oriental Rugs that existed at that time, a number of importers set up rug weaving factories in Turkey and in Greece and produced handmade rugs that copied the Persian designs mostly in large sizes—from 6×9 feet to giant sizes. Although these rugs employed the Persian floral design for the most part, they lacked the art of the true Persian rugs. My principal objection to them was that they had a domestic look; and, as a rule, were not long lived. The prospective buyer often asked if they were Orientals. Thousands of these were made and sold in the period from 1921 to 1930. They sold readily because they were not expensive. At that time they could produce these for less than any Persian rug except the Gorevans, Muskabads, Aracs, and the cheap quality of the Chinese rugs. Rugs in this group (III) were from fairly coarse to medium weaves, but the better ones were compactly woven and all had a long, high nap and soft colors (due to bleaching) which made them more salable. The wholesale price of these ranged from $1.25 to $2.50 per square foot. They were sold simply as Anatolians or Spartas, or under the importers trade name. One importer called his first quality Erskershehr, his second quality another name, and his poorest quality still another name. Dealers used their own trade names. Most of these names would confuse anyone who read the rug books because they were new names. But the poorest quality of all were sold in London as Ghiordes. Here the poorest handmade rug I have ever seen used the name of the most valuable old Turkish rug. Of course, I didn't bring these cheap Ghiordes to America because, even though they cost only $30.00 in London at that time, the tariff on these was not less than 50¢ a square foot or $54.00 for a 9×12 feet size. To land these at about $90.00 would not have made them salable even at $125.00. They sold in London and South Africa by the thousands where the tariff was very low.

I will forget the rugs in Group III because they are gone forever. There are many thousands in American homes but my guess is that most of them are pretty well worn out. They wore out much more quickly than the average Persian rug. I have seen a very few of these still in good condition, after thirty years. The fact that the rugs in Group II and Group III are no longer made does not make them valuable. This is true because more beautiful rugs from Iran (Persia) are still being woven at a few cents a day.

A great many small rugs were made and marketed as Pergamos. They were very inexpensive and not readily salable. They, too, lacked the fineness of the Persian rugs. Again these "Pergamos" sold at very low prices. The name or type is not to be confused with the rare, old choice Bergamos made from the 18th century up to World War I. Except for Group III types, Turkish rugs were not chemically treated. The dyes in those made prior to World War I were almost invariably the fine old vegetable dyes. And now the big question is, are we to have a fourth new type of rug from Turkey? I think that when you inquire a year or two years from now, you will find that these are not being made. If they meet with limited success, it will have to be in Europe, and probably on a barter basis.

*In conclusion*

When one used the name Turkish rug, Anatolian rug or Asia Minor rug, it could mean anything from junk to the rarest of all small Antique Prayer Rugs. But rug weaving is forever finished in Turkey on any commercial scale.

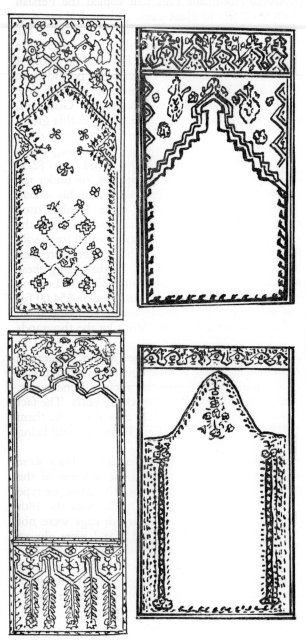

FIG. 19. TURKISH PRAY-ER DESIGNS. *Upper left:* Melez Prayer Rug; *Upper right:* Mudjar Prayer Rug; *Lower left:* Ladik Prayer Rug; *Lower right:* Ghiordes Prayer Rug. These drawings are of the field only. The borders are not shown.

## TYPICAL DESIGNS FOUND IN FIELDS OF TURKISH RUGS

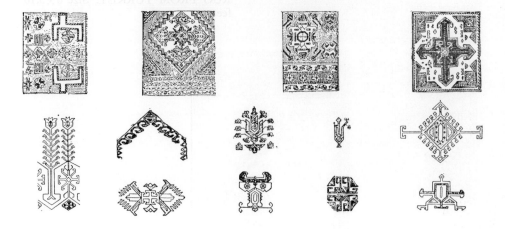

## TYPICAL BORDER DESIGNS IN TURKISH RUGS

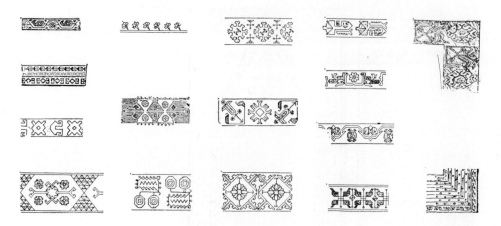

FIG. 20.   CAUCASIAN DESIGN CHARACTERISTICS

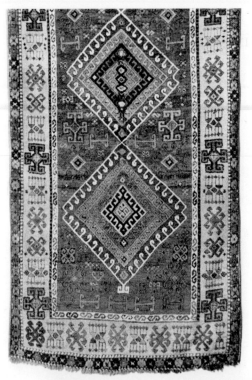

FIG. 21. *Upper:* ANTIQUE YURAK RUG FROM TURKEY. Size 8×3.10 feet.

FIG. 22. *Lower:* ANTIQUE BER-GAMO RUG FROM TURKEY. Size 4.6×3.6 feet.

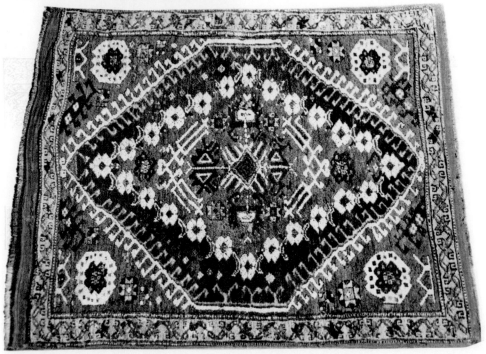

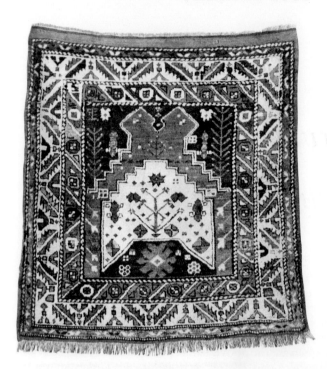

FIG. 23. ANTIQUE PRAY-
ER BERGAMO FROM
TURKEY. Size 3.8×3.6 feet.

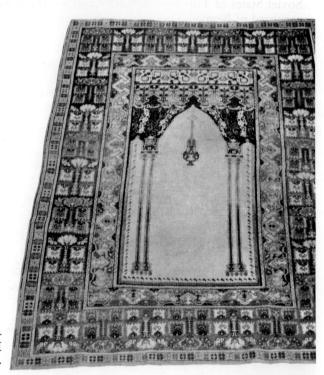

FIG. 24. ANTIQUE PRAY-
ER GHIORDES FROM
TURKEY. Size 6.6×4.7 feet.

## Chapter Six

# TURKOMAN RUGS

## or

# THE BOKHARA FAMILY OF RUGS

THESE have been known also as Turkestan rugs and some have referred to these as the Central Asiatic group of rugs. Turkoman is often spelled Turcoman.

From the Caspian Sea eastward for over 1500 miles to the Western edge of China and from the Arabian Sea on the South, northward for over 1500 miles, lies an area occupied by many peoples and formerly many tribes from whence came most of the rugs known by the above names. This area was formerly called Turkestan. Today the Southern and central sections of old Turkestan are three Soviet States of Turkmen, Uzbek, Kazakh. (The population of this area formerly consisted of Nomad Turkoman Tribes, most of whom were skilled carpet weavers).

From these sections formerly came most of the rugs best known as Bokharas but which the books insisted on calling by their tribal names such as Tekke, Salor, Yomut, Ersari, and others.

Up until 1940, all rugs known as Turkomans or Bokharas with the exception of a limited number of rugs from Afghanistan and Baluchistan came from Turkestan.

*Today no rugs are available from this main Turkestan section* (S.S. States of Turkmen Uzbek, and Kazakh).

But there are many types of new Bokharas being made today in Persia, in Afghanistan, and in Pakistan.

The question arises shall we discard the Turkoman group and classify these new rugs under Persian rugs, Afghanistan rugs and Pakistan rugs.

My solution is to retain the Turkoman Family because these new Bokharas get their design and colors from the old Turkoman type. Many of the weavers have migrated from these Russian states to Iran, Afghanistan, and Pakistan. At the same time we will cover these same rugs under Persian rugs, Afghanistan rugs and Pakistan rugs.

In spite of Hartley Clark's book, *Turkoman Bokhara and Afghan Rugs* and Amos Bateman Thatcher's book on Turkoman Rugs, wherein they insisted that the

*63*

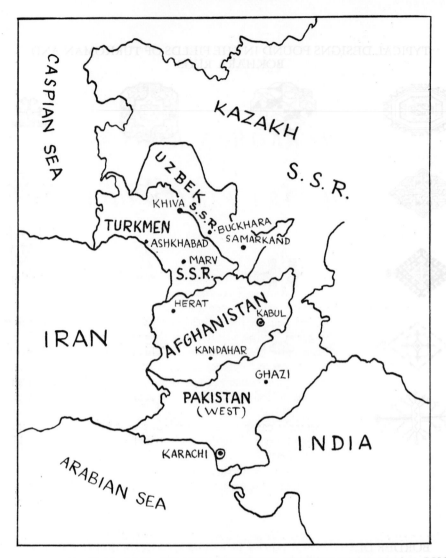

MAP 5. GENERAL MAP OF THE DISTRICT WHERE TURKOMAN RUGS (BOKHARA RUGS) ARE WOVEN.

Tekke rugs be called only Tekke and not Royal Bokhara as this rug has become known everywhere, Bokhara is more fitting and correct name today.

*Recommend name "Bokhara Family of Rugs"*

With no rugs having come from countries that formerly produced most of these rugs during the past 20 years, and with the public in general as well as most

TYPICAL DESIGNS FOUND IN THE FIELDS OF TURKOMAN AND
BOKHARA RUGS

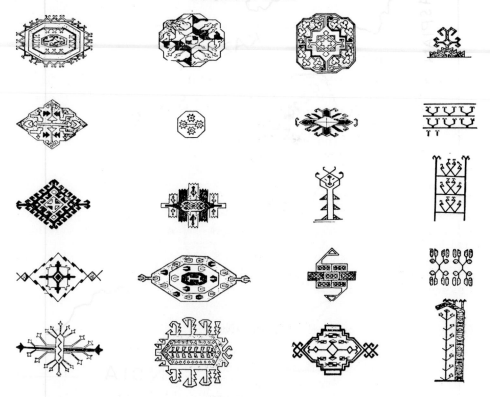

BORDER DESIGNS FOUND IN TURKOMAN AND BOKHARA RUGS

FIG. 25.   TURKOMAN DESIGN CHARACTERISTICS

collectors having for sixty years referred to these as some type of Bokhara, it would seem that the name BOKHARA FAMILY OF RUGS is more suitable today than the name Turkoman Family or Turkestan group or Central Asiatic family of rugs.

Any name that has such general usage for many years should be adopted just as usage of a word for years is incorporated in the dictionary.

*Designs and colors*

The prevailing tones of the Turkoman rugs and their simple geometric designs are those which would naturally be used by a people with primitive ideas of ornamentation. These rugs have used the same designs and color schemes with only slight modifications for many centuries.

In spite of dozens of conquests, Turkoman rugs still show the same definite type. With the exception of Afghan types, their nap is short, and in most of them, one finds some form of octagon designs.

No other types of rugs adhere so strictly to the uniformity of designs as the different types of rugs known as Bokharas. All are brick, deep brown, red, rose, copper, wine, liver color, or mulberry with tinges of other colors intermixed; (other colors—blue and white and deep green—yellow and black are sometimes used in the design).

The Salors, Tekkes, and Pindes are the choicest. Octagons, hexagons, and eight pointed star are the principal designs used. The Prayer Tekke is said to symbolize a mosque in its design.

*Grouping of these rugs made prior to 1940 by countries*

*From Turkestan*   (Now SS States of Turkmen, Uzbek, Kazakh) came
 Beshire (or Beshire Bokharas) rugs
 Ersari Rugs
 Tekke Rugs (better known as Royal Bokharas)
 Tekke Prayer Rugs (better known as Princess Bokharas)
  The design in the Prayer Tekke is also known as the Katchli design.

 Yomut Rugs (or Yomud Bokharas)
 Pinde Rugs (or Pinde Bokharas)
 Salor Rugs (Salor Bokharas)
 Khiva Rugs (or Khiva Bokharas)   Three types belong to this group even if not well known
      Chodor (type of Yomut)
      Kashgar
      Samarkand

*From Afghanistan* came rugs known as Afghans or Afghan Bokharas.

*From Baluchistan* (Beloochistan) came only Baluchistan rugs. Many of these did come from Baluchistan but the majority of these were woven in Persia (the Persian district of Khurasan is adjacent to Baluchistan).

*66*

*Bokhara types made today*

IN TURKESTAN (S.S. Soviet States Turkmen, Uzbek, and Kazakh. None for 20 years.

Note: It is possible that Russia will revive rug weaving in the above states in 1961, since she has started anew in Caucasia in 1960.

IN AFGHANISTAN—Scores of different types.

1. Afghans
   a. Afghans in carpet sizes
   b. In small and scatter rugs
   c. Many in Prayer designs
   d. In Katchli designs approximately 7×5 ft

2. In Yomut Rugs
   a. Yomut types in scatter sizes
   b. In Tekke Designs—small sizes and carpet sizes
   c. Ersaris
   d. Beshir and Pinde design
   e. Katchli designs employing Princess Bokhara (Tekke Prayer) design.

In addition to the above types in new rugs, good number of old and semi-old rugs are to be had in most of the above types from Afghanistan.

IN IRAN—Tekke Bokhara Rugs (See Bokhara Part II)—in scatter sizes and sizes up to $8\frac{1}{2}\times11\frac{1}{2}$ ft. Scatter size Baluchistans from Eastern Iran Khurasan District.

IN PAKISTAN—Rugs in Tekke Bokhara (Royal Bokhara) designs with nap of cashmere wool.

Among the older Turkoman rugs the finest and rarest are the Salor, the Tekkes (Royal Bokharas), the Tekke Prayer rugs (Princess Bokhara), the Pinde Prayer rugs, Beshires, and the oldest types of Yomuts.

The Khivas and Afghans, which are lovely rugs, were never as finely woven as the other types of Bokharas. These last two types came principally in carpet sizes—mostly in sizes about 6×9 feet to 8×11 feet—but a limited number of larger rugs in these two types have come to America.

*Very scarce*

No Bokharas of the rarer type have been imported in some twenty-five years. The only good ones to be had are those from estates or private collections, and any of these in the hands of your dealers have not been imported .   . at least no good ones have been imported in recent years. Most of those found in the small dealers hands have come from estates or private parties and they are rather badly worn. A very nearly perfect old one can be had from time to time.

The last sizable supply of good old ones came when the Russians either confiscated these from the great Russian homes or collected them from the different tribes to raise Dollars and Pounds during one of their Five Year Plans. In the period from 1924 to 1935, a good many were to be had in the New York wholesale market and great numbers in the London market where I screened out many

lovely Bokharas from the great piles of Bokhara Tent Bags and other Turkoman rugs. Not all of the old ones were beautiful and many of the old ones had bled or had loose colors—rugs that anyone who had the least bit of rug knowledge would reject.

## The new types

These new Bokhara types are maintaining rather high standards.

The Mori rugs from Pakistan in Tekke designs are the finest of all Bokharas that have come in the market in 30 years. Sizes are principally $5 \times 3$ ft, $6 \times 4$ ft, $5 \times 8$ ft. to $9 \times 12$ ft. Vast majority are in approximately $6 \times 4$ ft. size.

The nap of these Mori rugs are entirely of Kashmir wool.

The Bokharas from the three tribes that have settled in Northeast Iranian mountains are very excellent rugs and are all in same traditional Tekke design and colors in sizes $5 \times 3$ to $9 \times 12$ ft. The largest number of Bokhara types are coming from Afghanistan. The typical carpet sizes are not as fine as most of the other types of Bokharas.

In recent years I have found antique and semi-antique carpets from Afghanistan which were the heaviest I have ever seen and the most compactly woven.

Many of the new carpet size Afghans and Khiva types are much heavier and more compactly woven than most of the Afghans I had seen before World War II. To save repetition turn to Afghan rugs in Part II. Also read in part II each of the Turkoman rugs listed.

Before ending this chapter one must remember that not all the old rugs were woven for floors. The rug was almost the only furnishing for large tents. Rugs for sitting on, sleeping on, for prayer, for tent entrances, portieres, fringes, decorations for tent entrances, tent bags in many sizes to be hung on walls of tent or used on camels to hold household goods when moving, were woven by Turkomen women. The designs of the early rug were tribal.

The rugs made in Eastern Turkestan such as Samarkand and Kashgar show Chinese influence and some Chinese colors.

## Private collections

There are more good rare old Bokharas in the United States than in all the rest of the world combined. These are in private collections and homes.

I know of a number of great collections of Bokhara types—Choicer Tekke, Tekke Prayers, and Salors and others do not exist than those in hands of Mr. Shearer, Dr. Compton, and Mr. McCoy Jones. My old friend Tom Douglas in Denver, has a Tekke and Prayer Tekke that are the equal of any.

McCoy Jones of Washington, D.C. and California, has spent forty years collect-int Turkoman and Bokhara rugs all over the world. He once loaded his entire collection of perhaps 100 rugs in cars and brought them to Syracuse for my evaluation. I believe his collection to be the largest collection of Turkoman in existence. I regret that at the time the plates were being assembled for this volume I had temporarily lost contact with McCoy Jones. I should have used some of his rugs as plates.

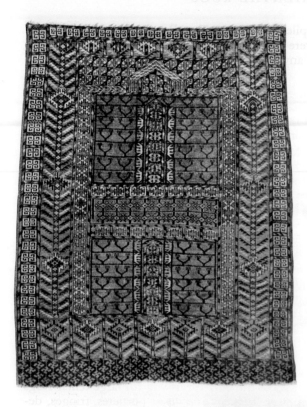

FIG. 26. ANTIQUE PRAYER TEKKE. From Central Asia (Turkoman group). Size 4.6 × 3.6 feet. A typical antique Prayer Tekke woven by Tekke Tribes in the Akhol Tekke District.

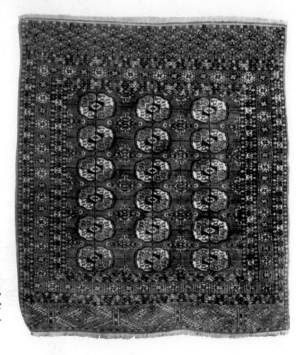

FIG. 27. ANTIQUE TEKKE FROM CENTRAL ASIA. Better known in America as Royal Bokhara. Size 4.6 × 3.10 feet.

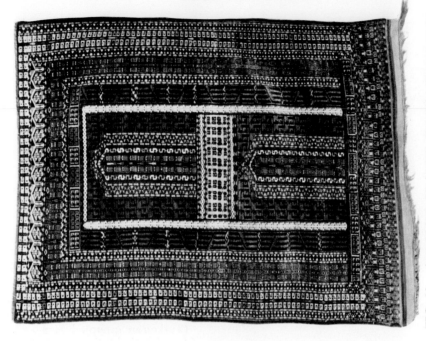

FIG. 29. ANTIQUE PRAYER PINDE FROM CEN-
TRAL ASIA. Turkoman Group. Size 6.11 × 4.4 feet.

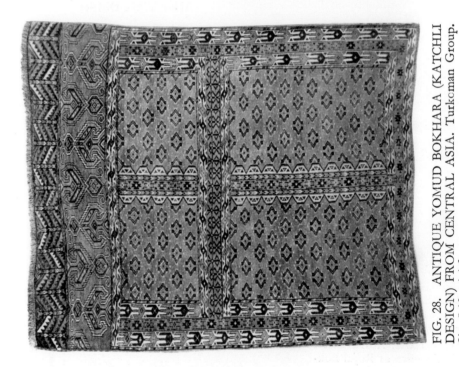

FIG. 28. ANTIQUE YOMUD BOKHARA (KATCHLI
DESIGN) FROM CENTRAL ASIA. Turkoman Group.
Size 5.10 × 4.4 feet.

70

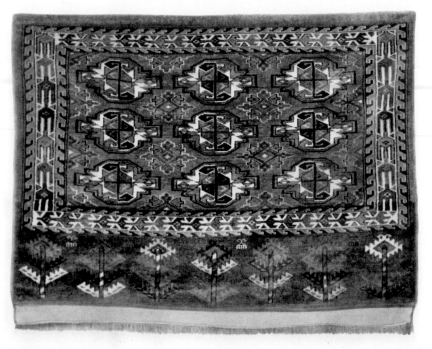

FIG. 31. ANTIQUE YOMUD TENT BAG FROM AFGHANISTAN. Size 4.6 × 3 feet.

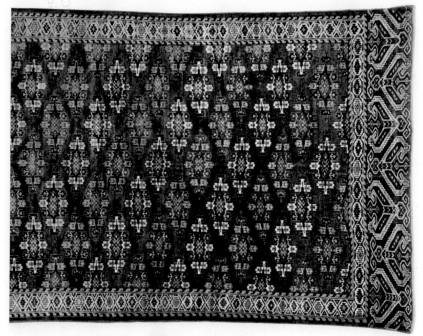

FIG. 30. ANTIQUE YOMUD FROM CENTRAL ASIA. Size 10.8 × 5.6 feet.

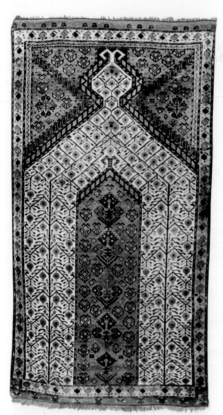

FIG. 32. *Upper:* ANTIQUE PRAYER BE-SHIRE FROM CENTRAL ASIA. Size 6.1 × 3.3 feet.

FIG. 33. *Lower:* ANTIQUE AFGHAN FROM CENTRAL ASIA. Size 3.11 × 2.8 feet. Generally comes in carpet size with about three rows of octagons as shown in this rug.

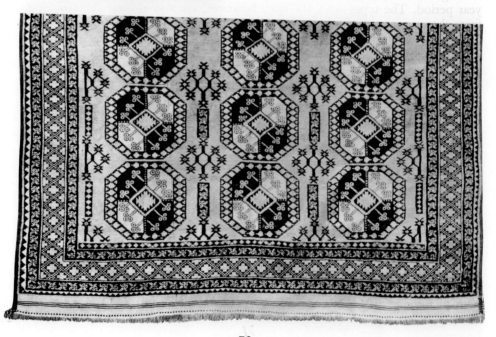

# *INDIAN RUGS*

MORE handmade rugs are imported from India today than from any other country except Iran. It should be noted that India has supplanted China, Turkey, Caucasia, and Central Asia in this field. It should also be remembered that most of the poorer qualities made in India go to England, Europe, and South African countries. Canada also takes a large quantity of rugs from India.

The Indian rugs coming to America today are entirely different from those imported before 1942. To read the old rug books written twenty to fifty years ago on this subject would be a complete loss even for the expert collector. The types available from 1920 to 1939 are entirely different from anything mentioned in all the rug books. There were many changes in types and designs during that nineteen year period. The types since the war, however, are also entirely different even from these.

*Complete revolution in types*

Instead of the names listed in all the rug books written between 1900 and 1920, names of types of rugs which few if any of these writers had ever seen, and again instead of the names of rugs that were made between 1920 and 1940; such as Indo-Sarouk, Indo-Kirman, Laristans, and others employing the Persian Floral designs; we find none of these being made today but have completely different types of rugs from India both in design and colors.

Later we give you full details on these. The principal characteristics are light pastel colors in French Aubusson and French Savonnerie designs and in Chinese designs. Many handmade rugs without design are made. Many are one-tone rugs with hand carved borders and designs. See Plates 1, 6, 11, 183, 184, 188, 189, and 190.

Today, there are some 2,000,000 workers in India engaged in the rug industry. I look for India to expand its weaving and to replace Iran as the largest producer of Oriental Rugs.

The October 1960 Issue of *National Geographic* gives an excellent discussion with pictures of Rug Weaving in India under the title *Miracle of Mirzapur: the*

*art of rugs.* The Mirzapur area supports the world's largest hand-loomed rug industry. Sixty thousand weavers work in their homes from morning to dusk, women spinning yarn, men toiling at the looms, and children serving as apprentices. In all India hand-weaving of rugs and fabrics engage more than two million people. Spinners, dyers, merchants, salesmen, inspectors, carpenters, and smiths in turn depend on the weavers. Were India's looms to stop, every twentieth man would lose his daily wage.

## Old names prior to World War I

Rug weaving in India dates back to perhaps the 16th century. All authorities seem to be agreed that Persian weavers were imported in the beginning. This fact accounts for Indian rugs employing the Persian or the floral designs. Thus you will find nothing but Persian knots in the Indian weaves. This was up to 1945.

In each of the old books you will find the following rugs described and discussed. Multan, Vellore, Spinagar, Mirzapur, Lahore, Jubbulpur, Jaipur, Amritsar, Agra, and others. I have never seen a rug by any of the above names for sale anywhere in the world except the Agra. I have never seen one in any private collection. A few are to be found in the museums.

Mr. John Mumford, in his famous and great book published in 1900, says "The antique fabrics, many of which were admirable, are no longer to be had and scarcely to be seen, least of all in American Markets. Such genuine old time examples as remained after the English exploitations of the Indian Arts were obtained by English and European collectors and have disappeared from view. There are preserved in the Museum of Jaipur a number of old Indian carpets found at the time of the British occupation. All give proof of Persian derivation."

My good friend, Dr. G. Griffin Lewis, devoted many pages to Indian rugs. In his 6th revised edition, published in 1945 at my urging, he eliminated scores of pages about these non-existent rugs of which he and the other writers of rug books had never seen a single example except possibly the Agras. Dr. Lewis' book was up-to-date on Indian rugs in his 1945 edition, but it does not cover the present day rugs from India.

## 1920–1940 period

Two large concerns in New York imported many rugs from India. Up to 1940 the four principal types were:

<div align="center">

Indo-Sarouk    Indo-Kirman    Kandahar    Laristan

</div>

The Indo-Sarouk copied the designs of Persian rugs, but lacked the delicate lines of the Persian Sarouks. They almost invariably came with rose fields in sizes $8 \times 10$ feet and larger. They were, as a rule, not as finely woven as the better quality of Sarouks, though finer than the poorer quality. Unlike the Persian Sarouks, they were seldom painted or heavily treated but had been treated only with a light lime wash. They sold for about half the price of the Persian Sarouks. This rug ceased being made about 1944.

The Indo-Kirman was very much like the Persian Kirman of the same period.

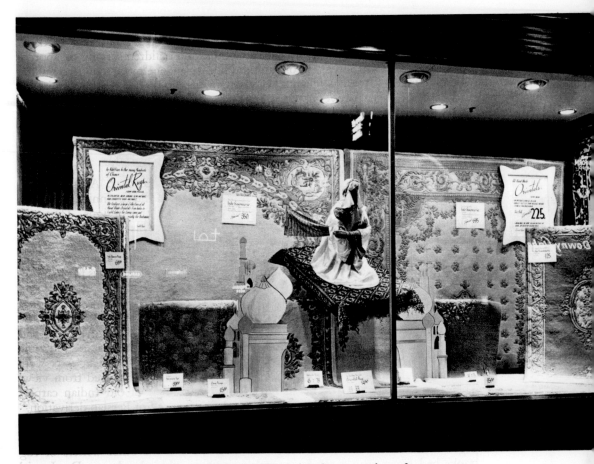

FIG. 34.   A picture of one of our display windows showing a number of present rugs from India. Most of the rugs shown are in the Savonnerie design. One corner of a Chinese design rug, made in India, is shown in the upper right hand corner of the window.

This picture was taken late at night which explains the reflections of signs from across the street.

FIG. 35. *Upper:* HAND CARVED ORI-
ENTAL RUG FROM INDIA.

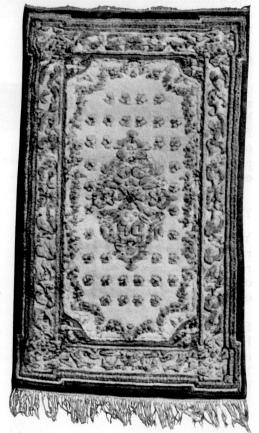

FIG. 36. *Lower:* INDO-SAVONNERIE
FROM INDIA. The rug has the general
colors of a Kirman. Field is a creamy ivory
with design in much light blue and two
shades of soft green. Small fleur de lis is in
burnt almond. Large sizes in this rug are
not as crowded with design. Known as
design number 9612.

An ivory background with an all floral design or with the Floral combined with a small center piece. And the Indo-Kirman ceased being made about 1945.

The Kandahar did not meet with much success. They were made only in carpet sizes—8 × 10 feet and larger. They invariably employed the Minna Khani design (Persian design) on a rose or a pink field. A certain stiff design, or domestic rug appearance to these rugs, made them difficult to sell. They ceased coming to America about 1935.

The Laristan, a trade name (copying Persian rug name), was a very good type of rug. It came only in large sizes, with very few in sizes as small as 9 × 12 feet but most of them were in extra sizes such as 10 × 20 feet. They came in ivory, rose, and blue backgrounds. There were two qualities and they compared very favorably with the Kirmans. At the time I preferred these to most Kirmans then available since the wool was much better. They were never painted but had only a light lime wash. They ceased being made about 1932.

The Temeriz, a fine quality rug, came mostly in carpet sizes. Almost invariably designed in the navy blue field with the small all over Persian Herati design in gold and green. At one time many runners came in this type.

Other rugs sold to me as Indo-Feraghan or Indo-Ispahan were very choice rugs. Since World War II, I bought two large rugs, the so-called Indo-Feraghan, which were the most beautiful new rugs of any type (including all the Persian types) that I have seen in many years. The colors were soft enough to go with any semi-antique rug. The texture was fine, the nap heavy, and we could handle many of these rugs if they were available.

I am confident that the Laristans, the Tamerizs Indo-Ispahans, and Indo-Feraghans would be sold in numbers in America if they were available.

During the period 1920–1940, hundreds of thousands of the very coarse type of handmade rugs from India were found in the London market. They wholesaled from 25¢ to $1.00 per square foot and thus they found a ready market. I have seen literally 500 bales of these in one shipment from London to South African countries. And the English, who did not produce enough rugs for their own use, bought them by the thousands. They might have sold in America at the prices at which they could be sold in England. Our tariff (duty) kept these cheapest qualities out.

## Today

You will find none of the types that were made prior to 1940. Where nearly every rug from India has copied or employed the Persian designs up to 1940, hardly a rug is seen in any of these old designs. The whole scheme of their rugs have changed. The designs are different and the colors are entirely different. The entire output is made in the following general types:

1. Savonnerie designs in soft pastel shades. These are rugs which use the old French designs in rugs that we have known for two or three hundred years as French Savonneries or French Aubussons. These may have considerable design or be almost plain except for the border design. See Plates 1,6 and 11 and Plates 182 and 184. There are scores of other Savonnerie designs in which these rugs are being made. Read Kandahar, Kalabar, and Indo-Savonnerie in Part II.

2. Rugs in Chinese designs. Many of these are being made in typical antique

Chinese designs and in many different color combinations. One of the best of these is the Bengali, which is a trade name of a large importing house that brings in this rug. Plate 190. See Bengali, Part II.

Another large importer who has been making rugs in India for some 50 years, has just brought in a new line in antique Chinese designs, with the background in ivory, tan, blue and one or two other colors. Perhaps the best of the rugs in Chinese designs is the Chinda, (a trade name) a very superior rug. See Chinda, Part II.

3. Another design I will call the China design, only because that is the name under which I had some rather medium qualities woven in India a few years ago. But most dealers will call this a modern Chinese design. The field is completely plain with only a floral spray in the corners, and more often in only two of the four corners.

4. A fourth type is the completely plain handmade rug with handcarved borders or carved design on the plain rug. There are a number of qualities of this type. One importing house brings in a very excellent quality under the trade name of Sirdar.

5. The fifth principal type is handmade broadloom rugs, which are made in 60 ft. rolls in several widths from 9 to 15 ft. wide and occasionally in 18 ft. width. I have been amazed at how this handwoven plain rug stands up under heavy traffic. My own table of experience shows some rather high priced plain domestic rug worn out and replaced where this handmade plain rug at not too greater cost shows no wear at all in the same period. My next door neighbor, a doctor, and close friend for years, insisted on this plain Oriental broadloom in white. At least his wife did. I recall saying to him "Jack, Dolly will kill me if I sell her this white rug." But they are my close friends and I knew I could have the rug dyed if it proved impracticable. So the white rug was put down in the hall, on the stairs and in the dining room. That was some ten years ago, and to my surprise and delight, the rug has not had to be washed and it does not look soiled. My friends live in their house and have not exercised any extra care. I can only attribute this to good wool quality and the hand-clipped nap. The above types refer to the rugs that are being made for the American market.

Still greater numbers of rugs are being made in India for sale to England. In the free port of London, the Culver Street warehouse, there are many thousands of cheaper grade rugs from India, all handmade Orientals. The vast majority of these are in pure white without design and in sizes approximately $7 \times 10$ ft. and $9 \times 12$ ft. Most of these will not be 100 percent wool but will contain much jute.

It has amazed me no little, year after year since World War II, to visit this great European market and to find that the English people with rare exception can afford to buy only the lesser qualities of these rugs from India. Their best quality will be about the same as the poorest quality coming to America. It always distresses me to find our Great Ally, who with us won the last war, too poor to buy the more expensive rugs, while all the other European countries are buying most of the better Oriental Rugs.

*Other rugs from India*

In addition to the above rugs, there are many different qualities of Savonnerie design rugs being imported by a number of other importers. Many of the large

importing houses are being compelled to go into the India rug business if they are to survive. This is due to the shortages and high prices for Persian rugs. The latter is due mainly to heavy local buying of rugs in Iran and the tremendous demand in Europe.

But at the moment the best trade names are the Chinda, the Kandahar, the Kalabar, the Indo-Aubusson, the Bengali and the Sirdar.

You may be sure that there will be scores of new trade names and new innovations of rugs from India during the next ten years. It is my belief that in that time India will have outstripped Iran in rug weaving.

## New Aubusson types

For some years, rugs of tapestry-like construction, on the order of the old French Aubussons, have been made in Kashmir and India and marketed in America under the trade name of JEWEL OF KASHMIR. See Kashmir Part II, and Plate 183, Part III.

# Chapter Eight

# CHINESE RUGS

BEFORE going into the detailed discussion of rugs from China, it must be remembered that no Chinese rugs have been imported from China in approximately 25 years.

The only Chinese rugs that were made in China and available in any rug store in this country since World War II, are used Chinese rugs that came from estates or private homes. The exceptions were a few new rugs that came right after World War II, 1945–48. None of these were direct imports from China but were rugs that were in stores in Hongkong, Panama, Hawaii, and similar places and the shortages and high prices brought them to New York.

The only Chinese rugs—or a more correct statement, the only Oriental Rugs in Chinese designs—have been Oriental Rugs made in Japan and India in typical Chinese designs. Indeed, it would be impossible for the average rug student to tell some or many of these from the real Chinese rugs. They are all handmade and in the same authentic Chinese designs.

In a new rug, it would seem that one would prefer to buy one of the excellent rugs being made in Japan today because Japan is more of a friend than Communist China. No Chinese rug has ever been made that was superior to the Imperial (in Chinese design) rug made in Japan, or the Chinda, in Chinese design which is made in India. Refer to the above names in Part II. See Peking rugs and Bengali rugs. Also see Plates 187, 188, 189, and 190.

So, in America today the only real Chinese rugs to be had are used Chinese rugs. Some of these are in excellent condition and lovely. The prices as a rule are usually out of line for used rugs of this type.

*A few new Chinese rugs being made*

Before discussing the history of Chinese rugs, we should add that for the first time in over twenty years rugs are being made in China. On my trip to the London market in 1960 I saw over one hundred superior Chinese rugs that had been woven in China. They were superior type rugs. I have never seen better quality rugs from China. The price was high, being about $5 per sq. ft., which would

mean that they would land in America after paying duty at around $7 per sq. ft. or $750 wholesale for a $9 \times 12$ ft. This would mean around $1,000 or more at retail and there would be little market for these rugs at this price. They were about the same quality as the Imperials from Japan.

Since America does not trade with China and nothing made in China can be imported to the United States, these are of no interest at the moment. I do predict that if we ever recognize China, she is going to produce great numbers of rugs for export to us. But the prices will certainly have to be lower to hope for any volume in sales of these. The import duty on the same quality from Japan would be twenty-two and a half percent, while the duty on real Chinese, when we finally trade with them will be forty-five percent. So the same quality from Japan should be less expensive.

*Changes—changes and more changes*

Very few Chinese rugs came to America prior to World War I. If you have seen a few antique Chinese rugs (and there have been very few imported to America at any time and none have come for forty years), you will note that they have a great deal of design. Many people, who have seen only hundreds of modern Chinese with the plain effect or much open field, would probably not even recognize the antique Chinese as being a Chinese. One glance at plates of antique Chinese rugs tells the difference. Old Chinese and new Chinese are radically different.

Having seen comparatively few antique Chinese rugs, and personally never having liked many of the old Chinese as compared to the new ones, I am not going to set myself up as an expert of antique Chinese rugs. I should add that I have probably seen more antique Chinese rugs than most authors of rug books. I have seen those in the museums and in private collections. At the risk of showing bad taste, I must admit that some of the modern Chinese (not the completely plain ones), but especially those that copy the French Aubusson designs, are more beautiful. I have seen and have had a few old Chinese rugs that were indescribably beautiful and I have in mind a large light blue one that I sold to a doctor's wife in Troy, Ohio. It is the most beautiful Chinese I ever saw; and if all the old ones had its beauty, I would be an antique Chinese rug enthusiast.

I could write in detail about antique Chinese rugs, but if I discussed the Ming period—14th to 17th century rugs—or the Ching rugs from the 17th century to late 18th century (which includes the K'ang Hsi, the Yung Cheng and the Ch'ien Lung rugs), I would have to take much information from the rugs in the Japanese Imperial Household, Japanese Museums, Metropolitan Museum in New York, and the Victoria and Albert Museum in London. I have seen the ones in other museums, except those in Japan, but again do not find the interest in them that I do in the other types of Orientals. There have been a few that had great appeal.

Old type Chinese were from quite finely woven to very coarsely woven (many of those in museums are very, very coarse), and they had the short pile but never the heavy, tight, compact nap of the best of the modern Chinese. When you think of the antique Chinese, you must think of the Chinese with the field well covered. The Chinese have always used blue and tan, but many of the old ones used cherry, apricot, and yellow.

*1920–1931*

This was the period of greatest transition and most confusion. Still to be had were the Peking quality of Chinese rugs in old designs and a limited number of semi-old Chinese rugs, all highly figured. The Peking were, as a class, much inferior to the factory made heavy Chinese Rugs of Tientsin.

Many of the best Chinese rugs were still using the typical old Chinese weave, a rather finely woven rug of good wool but not the heavy, thick pile that began to appear about 1925.

There were Chinese rugs and Chinese rugs in many different qualities at that time, from the best to one of the very poor quality which I found everywhere in the market, and which one of the most famous stores on Fifth Avenue sold for $195.00. I often wondered how a great name store like this could afford to offer such an inferior rug. The nap was of very poor quality wool mixed with jute. Anyone who felt the nap should have sensed the inferior quality. Of course, price merchandise meant volume, and all too many of the great name stores depend on price of rugs rather than quality.

About 1925, factories began to multiply in China and a much heavier, tighter Chinese rug began to appear. The Chinese employed the double Persian knot. Immediately Chinese rugs became tighter woven with more compact pile and a very heavy nap. The factory industry was located chiefly in Peking and Tientsin, the latter being the seaport of the former. But the rugs made in these two cities were quite different in quality and design.

To describe the color combinations used in Chinese rugs of this period would be to picture every combination imaginable. The more conservative patterns had a blue or tan field with a rose, blue, or tan border. But they also came with green, gold, rose, and lavender fields.

Each succeeding year less design over the field seemed to be used. Many continued to use sprays in the corners and in the borders, but the majority gradually went to a plain field with a different colored border without design.

One particular type of Chinese rug that I especially liked was the so-called Fette Rug. These were very finely woven and never adopted the heavy thick pile of the other modern Chinese rugs that were made during this period. Nor were these ever lightly lime washed as were most of the other Chinese rugs brought to America. The Fette's were the favorite of most Army Officers and Naval Officers stationed in China. Most of these continued to employ old Chinese motifs with more design than most other Chinese rugs then being made in China.

*1930–1935*

The depression very quickly put most of the six hundred rug weaving factories out of business. There were perhaps less than twenty so-called factories by the time the Japanese invaded China. The depression did one thing for the Chinese rug however. It eliminated the cheap, junky, jute like quality that had wholesaled for $1.10 to $1.25 per square foot in the New York market. And the Chinese rug of the depression years became a very heavy article of excellent wool. The prices were ridiculously low. A good 9×12 foot Chinese rug could be had from about $225.00 to $375.00 (maximum). During this period many came with the com-

pletely plain fields without borders and without designs, except for three or four small Chinese sprays or motifs.

## 1935–1945

Very few Chinese rugs were made after the Japanese took over China. On each trip abroad I saw several hundred in the warehouse of the Port of London Authority up to 1940, but they were the Peking quality and not the fine, heavy quality that had come to America. The wool in these was seldom of excellent quality.

## 1945—Present time

Very few Chinese rugs have come to America since the close of the war. Most of the machinery for spinning wool, the looms, etc. were destroyed. American firms found it impossible to start up again for many reasons. But a limited number of Chinese rugs, mostly in the $9 \times 12$ foot size, did come to New York.

As stated above, these were rugs that had accumulated in dealers' hands in Hongkong, in the Philippines, in Hawaii, and elsewhere. It is also barely possible that some few of these had been woven in the British Crown Colony of Hongkong. Certainly, it was known beyond any shadow of doubt that the looms in China had been destroyed by the Japanese Invasion Forces, and that no Chinese rugs had been woven since about 1935.

I have already predicted that if we trade with China in the future, Chinese rugs will again be made in numbers in China.

## Chrome dyes in Chinese rugs

For years I have contended that good chrome dyes are better than many of the vegetable dyes. The proof of the pudding is the eating. Practically all rugs made in China and in India during the past 40 years have used only chrome dyes. These dyes have proven themselves. The Oriental Rug books harped on the subject of vegetable dyes and rightly so 60 years ago, but one has only to see the hundreds of used Chinese rugs that have been exposed to heavy foot traffic, sun, and rug cleaning establishments, and all the abuses that a rug receives in the average American home, and note that with the exception of one or two colors such as pink and lavender, they have not faded. Where the rose and lavender has faded, they have generally faded to a better shade than their original colors.

For the present the seeker of Chinese rugs will do well to consider the rug in Chinese design from Japan and India. When the three types are available at the same time, one may find that the Japanese weaver and the Indian weaver will do a better and a more honest job than the Chinese.

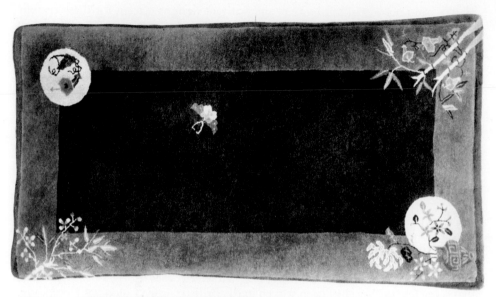

FIG. 37. MODERN TYPE CHINESE RUG. This type of rug was first woven about 1928. It is a tightly woven rug with a heavy pile.

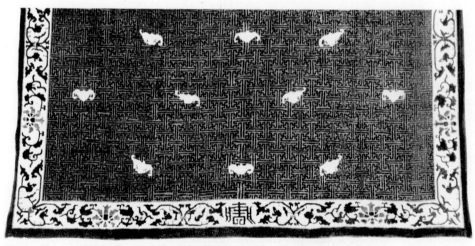

FIG. 38. ANTIQUE TYPE CHINESE RUG. Commonly called the "Happiness Rug." This is a typical antique design. It was made during the 1900–1920 period. This design ceased being made about 1924.

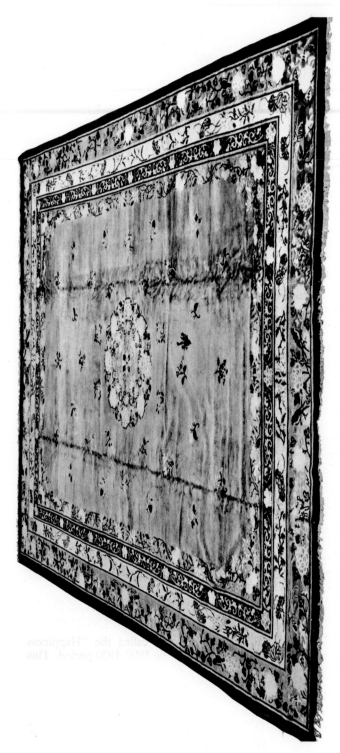

FIG. 39. ANTIQUE CHINESE RUG FROM CHINA. Size approximately 10.6 × 13.6 feet. This rug is the property of Dr. and Mrs. E. R. Torrence of Troy, Ohio.

# AFGHANISTAN RUGS

SINCE 1945 Afghanistan has been weaving and exporting large numbers of Oriental Rugs in many different Bokhara designs.

Afghan rugs or rugs made in Afghanistan have always been listed under Turkoman rugs (Turkestan rugs). When one goes to any of the old rug books, they will get the impression that the vast majority of rugs by this name are in carpet sizes 6 × 9 ft. and larger. All are in some shade of wine red, and most of these will have three rows of large octagons. Each large octagon will be outlined in deep blue or deep green and each will be quartered and in wine red, turkoman rose (an apricot or almost at times a yellow gold), deep blue or green, and occasionally there will be some ivory.

It has always been a mystery to even the dealer as to the difference between the Afghan Bokhara and the rugs known as Khiva or Khiva Bokharas. Actually most of these have always been made in Afghanistan, and dealers and hobbyists alike have used the two names for slightly different Afghan carpets for variety or to have the two names.

The other two types that the hobbyist knew as Afghans, and correctly so, were the tent bag rugs, approximately 3 × 5 ft. See Plate 176 and the Afghan in Katchli design, approximately 5 × 7 ft. See Plate 175.

I shall write the details on Afghan rugs in Part II, and since what I will say there will cover most of what should be said here, please turn to Afghans in Part II. Also read Chapter on Turkoman Rugs. There will be further coverage of this subject in the Chapter Oriental Rug Books.

Afghanistan today occupies much of the territory that was once part of Persia. The famous city of Herat is now part of this country. The country of Beloochistan no longer exists but is part of Afghanistan.

Very little space was devoted to Afghanistan rugs in the old rug books. Hartley Clark in his quite technical book *Bokhara, Turkoman and Afghan Rugs* first printed in England in 1922, and now out of print, gave more information on the subject but also complicated the subject by the introduction of a number of new names and ideas.

Today Afghanistan is producing more Turkoman rugs than all the other

sources combined. Iran and Pakistan are large producers of new Bokhara types. As we tell you under Afghan rugs, many thousands of small rugs are being produced and many small antiques and semi-antiques are coming from Afghanistan to the European market. See Plates 170, 171, 172, 173, and 174. Today I am the only dealer that is importing these in numbers each year.

No rugs are being made today in Turkoman proper, that is in the Soviet states of Turkmen, Uzbek, or Kazakh, the three states which formerly comprised the section known as Turkestan and from which came most of the Turkoman or Bokhara types.

With Afghanistan producing large number of rugs, not only in Afghan and Khiva types, but in Yomud (Yomut) types in many sizes and designs to include the Tekke (or Royal Bokhara) design, in Ersari designs and many others; and with Iran (Persia) now the home of three large Tekke or Yomut Tribes which are weaving many Bokharas in the Tekke design; and with West Pakistan embarking in the rug weaving field and with large numbers of these in the Tekke design, I am wondering if we should continue to group all of these as Turkoman rugs.

I have thought that these many types of rugs would be more correctly grouped as the Bokhara family, leaving the antique collectors (and properly so) to call their old rug a Salor, a Tekke, a Tekke Prayer Rug, and others by their old tribal names.

It is very likely that with the great demand for rugs by European countries, that within the year, we will find that Russia will renew the weaving of different types of Bokhara or Turkoman rugs. Since these will be under government ownership, it will be interesting to see what they bring forth.

Finally, you may group your rugs from Afghanistan as Bokhara rugs, or Turkoman rugs, or Afghanistan rugs. The chapter on Turkoman rugs includes information on Afghan rugs.

*Chapter Ten*

# JAPANESE ORIENTAL RUGS

BEGINNING about 1950 Japan began weaving Oriental Rugs and most of these have come to America.

These rugs are made in two general types; those employing the French Savonnerie and French Aubusson designs and those using the Chinese designs.

There are three specific types or qualities. All three types are of course hand woven and each has a 100% wool nap. The warp and weft are cotton.

The best of these is the "Imperial" which is a very heavy, tightly woven rug of excellent New Zealand wool. It comes in both the French Aubusson and French Savonnerie designs, as well as in a two-corner floral design on a nearly plain field. There is much hand carving on these rugs. They are in four soft basic colors; rose, light blue, green, and beige. A 9×12 ft. rug of this type weighs anywhere from 125 to 135 lbs. I have never seen a heavier rug. See Imperial, Part II and Plates 185, 186, 187.

These are expensive rugs and now sell at prices near the price of Kirmans. They will outwear most Kirmans.

The other two types are in Chinese designs. The most popular and less expensive of these types from Japan is the Peking. It is a good rug with 100% New Zealand wool. Most of these come in light pastel colors and in antique Chinese designs. See Peking Rugs, Part II, and Plates 188 and 189.

The third type of Japanese rug is the Fuigi Royal, also in Chinese design and in a quality slightly better than the Peking. See Plate 194. The first shipments of these were made in round rugs 3×3 ft. and 4×4 ft. Rectangular shape rugs in carpet sizes are available in limited numbers. One of my close friends who brings these to America, was about to place a large order for the Fuigi Royal but an increase in price influenced him to order only a few. Most of these are made in light colors.

These Japanese rugs are a very honest product. I predict that when and if Chinese rugs are again made in numbers and permitted into America, that when given the choice between a Japanese rug and a Chinese rug, most customers are going to choose the Japanese rug in Chinese design. There have been no shoddy or poor Japanese rugs. When the Chinese rugs were available in numbers

years ago, at least a third of these rugs were inferior, and some of the most horrible colors ever offered for sale came in these Chinese rugs.

The only reason the Chinese rug might outsell the Japanese rug will be if they are able to offer a good rug for less money.

Judging by the $5 a square foot wholesale price I saw in the London market, my guess is that they will not sell for less than the rugs from Japan.

# Chapter Eleven

# PAKISTAN, BULGARIAN, AND GRECIAN RUGS

*Pakistan rugs*

For the first time beginning about 1957, hand-knotted Oriental Rugs were woven in Pakistan on a large scale for export. Some of the weaving is done in the homes but much of it is done under supervision in so-called factories.

There are two principal or general types in the London market in 1960, *i.e.,* the Mori Rugs and the Pakistani Rugs.

Mori Rugs are very finely woven rugs in the Tekke Bokhara (Royal Bokhara) design. The nap of these rugs are Cashmere wool which gives them a wonderful soft, silky appearance. Read Mori Rugs, Part II and see Plate 88.

Mori Rugs must be grouped with the Turkoman or Bokhara family. The second type of rug being woven in Pakistan is known in the trade as Pakistani Rugs, and are very much like the Persian Tabriz and some of the colorful Kirman or Yezd rugs made for the Iranian trade at home. See Pakistani Rugs in Part II.

*Bulgarian rugs*

As strange as it may sound, Bulgaria is producing hand-knotted rugs which have to be classed as Oriental Rugs even though they are woven in Europe.

I have seen these only in the London market. Most of them have the appearance of a Persian Tabriz and there is no doubt that the paper scale patterns from which these were woven were secured from Tabriz artists or Tabriz merchants. All I have seen were in carpet sizes approximately 7 × 10 ft., 9 × 12 ft., and 10 × 14 ft.

They are excellent woven rugs, being tightly woven, usually about the same finesse as a Sarouk and good medium thick nap about that of a Sarouk. The prices were reasonable, also being about the same as a Sarouk.

But these rugs will hardly meet with favor in America. The most serious and fatal objection is their design which is too mechanical and domestic-rug looking. True, they are handmade, but for the same reason that most new Tabriz rugs are not liked in America, these will not be liked.

The next objection is that government import duty on these would be 45%,

double the 22½% charge on Persian and Pakistan rugs. Bulgaria being a Russian satellite, would pay full duty, while nations enjoying "the most favored nation clause" would pay half as much.

These have been on the European market for several years. I cannot report what success they are having. None have been brought to America. When one of the officers of the Bulgarian company came to see me a few years ago (with colored plates), I saw no success for them here. Each time I am abroad I inspect some of these but I do not buy them.

The tremendous demand for Oriental Rugs in Europe has revived weaving in countries that had ceased making rugs 25 years ago, and stimulated the new creations in countries that were not previously rug weaving countries. See Bulgarian Rugs, Part II.

## Grecian rugs

There are no rugs being made in Greece today on a commercial scale. Perhaps a little weaving is done by a very few for their own use.

Rugs were never woven in Greece until right after World War I and up to about 1932, when American interests set up small factories in Piraeus (right outside of Athens) among the 100,000 Armenian refugees that had fled from Turkey. Considerable weaving was also done in and around Salonika.

These were generally known as Sparta rugs. They were sold in America under many trade names. There were several qualities from very poor to good average. They employed the same designs as the Turkish carpets of that day fashioned after Persian designs. See chapter on Turkish rugs and Plate 132. Most of these were in the same general design as shown in this plate.

Like the so-called Anatolians in the Persian designs, they did not have the real Oriental look that the Persian rugs had, even though they were real handmade Oriental Rugs. That mechanical and domestic look was very much against these.

Some few appear from estates. They will usually be worn but even if perfect they should not command high prices. Perhaps the very maximum for a perfect and best quality rug of this type should not be over $3.00 per sq. ft. and that is being generous.

# Chapter Twelve

# ANTIQUE ORIENTAL RUGS

IT IS AGE which produces that exquisite softness, mellowness, and purity of tone which gives to the antique rug its immeasurable superiority over the new rug of the same type.

Whoever buys Oriental Rugs must decide whether they merely wish to buy beautiful and durable Oriental Rugs as floor covering, or whether they are interested in rugs from the standpoint of the art collector.

There are several different points of view, the two main groups being those who seek rare antique rugs, the best specimens to be had to go into a collection. Some few of these may be used in the collectors home but most of his great rugs will be put in his collection and not walked upon. Eventually these collectors give their collections to their favorite museum or to some museum where it will do the most good. Other seekers of rare old choice examples use them in their homes, and want rare rugs to complement other furnishings.

Museums and historical houses also seek certain types of rugs typical of the rugs that were available at the time the historical house was built by the owner. But the vast majority of people who seek antiques or semi-antique rugs, simply prefer them for their old refined colors to the brighter new rugs. They are also seeking the most authentic types.

And unlike many pieces of antique furniture, an antique or semi-antique rug in good condition, or even slightly thin, will as a rule outwear the new rugs of the same type. This is not true in all cases, but it is certainly true if the antique has a good nap because the chances are that the wool is better in the old rug, and that it was, as a rule, better woven than the average new rug of the same type. I could devote a volume larger than this entire book to antique rugs.

*Different categories of Antique Oriental Rugs*

For the purpose of discussion I shall divide these into four groups, based principally on age.

I. *13th through 17th century rugs.* Classical old rugs of great antiquity. These oldest rugs are exceedingly rare and have never been imported to America in

numbers, nor are there many in the American museums. They have not existed in the Orient except in Mosque and government buildings for over 100 years. The few that have been acquired by American collectors and Museums, came from private collections in Europe.

These rugs are of no interest to the seeker of floor covering. They are invariably worn thin and are objects of art. Not even the wealthy collector has had too much interest in these ancient rugs as far as seeking them for his private collection.

II. *Latter part of 17th century, but mainly 18th and 19th century rugs.* These are the rare old rugs that our Museums and Collectors have sought. They are the types that our Oriental Rug books, beginning with Mumford's First Edition in 1900, devote 95 percent of their pages to describing. None of these have been imported since about 1925. They were rare at the turn of the century.

III. *Antique Rugs of the period 1850 to 1900.*

IV. *Semi-Antiques 1900 to 1960.*

V. The discussion would not be complete without including the rugs made between 1900 to World War II, which we will class as Semi-Antiques.

To the FIRST CLASS OF ANCIENT RUGS belong such rugs from Turkey as the Holbein rugs, the so-called Damascus rugs, and the Ushak (Oushak) rugs.

The Holbein rugs from Turkey, which so many rug writers like to refer to as Asia Minor, as though it was not a part of Turkey, got this name when they were shown in paintings by Holbein and other artists of that time. These were purely geometric and the principal designs were squares and stars. Other Flemish painters such as Jan van Eyck, Memling, Gerard David, and many Italian masters of the same period used Turkish rugs as background in their paintings.

Another class of rugs woven in the 16th and 17th centuries is the Ushak (Oushak). Rugs have been produced in Ushak for hundreds of years up to 30 years ago, but none have approached these of this early period.

These rugs are often depicted in Venetian Paintings of the 16th century and in Flemish and Dutch Paintings of the 17th century.

At Williamsburg, Virginia, you will find an old Ushak in the Governor's Mansion, and you can well guess why such a rug was chosen; the fact that the paintings of that day show such rugs.

The third class of rugs from Turkey was the so-called Damascus rugs, which were shown in Venetian Paintings and at that time called "tapeti damasceni." It is generally agreed by experts that Damascus was the place of export and that the rugs were woven in Turkey.

These were the three principal types of the very old Turkish rugs, with their purely geometric lines.

Our earliest dated and known rugs from Persia belong to the 16th century and it is not until this time that definite evidence of a date being woven in a carpet itself. I refer to the famous Ardebil Carpet in the Victoria and Albert Museum in London which has the date 946 of the Hegira (A.D. 1540). Many other great rugs have come down to us from this great period, the golden period of rug weaving.

Most authorities ascribe to the latter part of the 15th century, the Animal and Hunting Carpets.

To the first half of the 17th century belong the Polonaise carpets and most of the so-called Ispahans. (After the 15th century few animals were found in any of the choice old carpets.)

*93*

For additional details on these very ancient types, see Part II. For those interested in a study of rugs made prior to 1800, in my Chapter on Oriental Rug Books, I refer you to a number of books by European writers, especially Dr. Bode of Leipzig and Dr. Martin of Sweden.

I cannot hope to give you full information on the above types.

These have claimed the interest of very few in America. Not even the best known collections of the last fifty years, if we exclude Mr. Ballard's collection (Mr. James F. Ballard of St. Louis who gave his fine collection of predominantly 18th century rugs to the Metropolitan Museum of Art in New York City in the early twenties) and very few other collectors of the period 1890 to 1910.

### 18th and 19th century rugs

The best of these two centuries are the types that have claimed the interest of most of the collectors of the past 50 years as well as the interest of the Museums.

From Turkey we have the Ghiordes, Kulahs, Ladiks, Bergamos, Melez, Herekes, Mudjars, Konias, Makris, Kerskehrs, and others.

From Persia, the types that were perhaps most sought after were the Feraghans, Laver Kirmans, Senas, Joshigans, Tabriz, Sarouks, Shiraz, Sub-bulaks, and others.

From Caucasia, we have many wonderful old examples in Kubas, Kabistans, Karabaghs, Chichis, Bakus, Kazaks, Tckerkees, Genjas (Geunge), and others.

From Central Asia came fine old examples of Tekkes, Salors, Pindes, Yomuds, Beshire, and others.

These are the types of which a good old example had already become rare and a collector's item in the period 1900–1915. Yet after World War I many wonderful old rugs of most of these types were available. True the Ladiks, Ghiordes, and Kulahs no longer came from Turkey, yet they appeared from private collections.

A good old Feraghan, Sarouk, Sarabend, Sena, Kirman, and others were very rare. There did come many wonderful Bijars, Shirazs, Kurdistans, Suj-Bulaks, Herez, Bahkatiaris, and many rugs from the Hamadan District.

Great numbers of wonderful old Caucasian rugs and old Turkoman rugs became available only because the Russians in their Five Year Plans confiscated all the furnishings from great Russian homes and sent them to the New York market and the London market to raise gold. I personally bought hundreds of these rugs both in the New York market and in the London market. In passing, I recall not only the rugs but thousands of regal draperies, handwoven chair seats (Aubusson types) after our petit point, which had been taken from the palaces and great homes. Some few rare old Persian rugs came from the same source. The period 1850–1910 was one of great activity for these rug weaving countries, because Europeans and Americans had become interested in these rugs as floor covering and the demand increased each year.

It might be said that all the types listed under II were made in this period except the Ghiordes, Kulahs, and Ladiks. These were also made, but those made after 1850 in the above three types were inferior to the earlier rugs of this type, but they were not poor rugs.

It is to the last type, rugs of the latest period that we class as Antiques, those made between 1850–1900, that collectors and seekers of choice old rugs must turn. And these are no longer imported but must be obtained from private sales.

*How old is an antique rug?*

To be called antique, a rug should be fifty or more years old. To be antique from the point of view of being duty free (no import duty) or for a museum collection, a rug should be one hundred years old. But the collector, hobbyist, and dealer refers to the practical antique as being at least fifty years old. Very few rugs are dated. Except for a certain few which can be definitely placed in certain periods, such as the Old Ispahan, Garden carpet, Polonaise, Ghiordes, and a few others, it is usually very difficult for even an expert to fix accurately the age of a rug. While the Orientals took their shoes off before entering their homes, still it is evident that a rug near their entrance would look older and softer in twenty five years than the same rug in a sleeping room, or a rug that they slept on, and older than one that they hung as a partition. Therefore, with few exceptions, age can only be approximated. It is true that many of the Persians have changed their colors and have deserted some of the old designs to the extent that we know that the Sarouks made prior to 1910 are entirely different from 99 out of 100 made after World War I. We know that the old Tabriz prior to 1900 usually came in bronze or copper field, at least most of them did, and we further know that the Tabriz since World War I has not used these colors to any extent.

But it would be hard to distinguish between a Bijar of forty years ago and one of one hundred years ago. The same is true of many other Persians, such as Sarabends, Hamadans, Shirazes, Kurdistans, and others.

The Kazaks, Cabistans, and others from Caucasia have never changed their design, and it would be difficult to distinguish between one of these one-hundred-and-twenty-five years old and one fifty years old. Nor have the Bokharas altered their designs and colorings for hundreds of years. So, again, one of the Bokharas of one hundred and one of fifty years of age would be very close, and an expert might have difficulty in saying which was the older.

Mr. Arthur Upham Pope, of the Art Institute of Chicago, says in discussing what might be called an antique rug, "Ignoring dates we can say that an antique rug is one that has not been chemically washed, that has an unrestored pile and was woven according to local methods and design before the latter was extensively modified by European influence."

I think Mr. Pope should have used the words "American influence" instead of "European influence" because I have always found the Europeans rejecting the modern designs, which were so popular in the big cities in America, and preferring the old designs. As a whole, the European actually knows a great deal more about rugs than an American.

Ten years after most of the best known rug books were published (after World War I), one could still find many lovely old Caucasian rugs, many choice old rugs from Central Asia (Bokharas, Afghans etc.) and most of the Persian rugs we have listed. There were still available many choice old Turkish rugs, though the Ghiordes, Ladiks, Kulahs, and Bergamos had already ceased to come. A few of the above four weaves could be found only by reason of resale. But good Yuruks, Melez, Mudjars, Konias, and other old Turkish rugs could be had, even though at that time good ones were at a premium.

*Semi-antique rugs 1900–1960 Period*

Oriental Rugs take on with age, a softening and blending together of colors and a natural patina (a natural sheen).

In the Orient these rugs are not walked on with shoes but in stocking feet, and so the life of a rug is very different from what it is under heavy shoes in America.

Use by unshod feet, together with exposure to sun, air etc. and the passage of time, produces the soft tones and a wonderful natural sheen on old rugs that have good wool.

A semi-antique is one that follows the traditional old designs and one which has been used in Iran (Persia) long enough to have somewhat mellowed colors. Most new rugs are simply too bright. The finest woven new rugs are less attractive in their new state than the new rug or coarser texture with a longer nap.

Sometimes a rug has the date recorded in Arabic numbers woven in the rug. If the rug was woven before 1900, the dates will most likely be correct. But if the rug was woven in the past 60 years, there is a good chance that the rug will be antedated to give the impression of greater age.

FIG. 40.   ARABIC NUMBERS.

These Arabic numbers represent the Mohammedan year, dating from the time of the Hegira (July 622). The Lunar and not the Solar year is used in the Moslem chronology. Their lunar year gains about one year in every 33 7/10 years.

Therefore, to arrive at the Christian year in question is rather complicated. Assuming the date woven into the rug is 1247, our date would be 1247 less 37 (1210) plus 622 or 1832. You arrive at the 37 figure by dividing 1247 by 33 7/10.

*Choice Antique rugs are works of art*

Rare old Oriental Rugs are ranked with paintings, music, and sculpture as one of the great arts. There are many who do not appreciate Oriental Rugs, nor can they appreciate the great paintings of Rubens, Rembrandt, and Michelangelo.

As Mr. Arthur Upham Pope, Advisory Curator of the Art Institute of Chicago, says in his article on Oriental Rugs in the February, 1928 issue of the *Arts and Decoration,* "The indifference to them which one occasionally meets is now everywhere recognized as a mark of ignorance."

The October, 1930 issue of *Fortune Magazine* in classing antique Oriental Rugs as objects of art, says, "There are also four good reasons why collectors do collect antique Persian rugs. And they are the same—with opposite effects. Persian rugs

are not only collector's objects: they are the greatest of all collectors' objects. They provide the amateur with every possible thrill. Their value is very high: somewhere between the square foot price of New York real estate and the square foot price of the Blue Boy. They are extremely beautiful and the archaistic, formal quality of designs of the oldest pieces is peculiarly appealing to our generation. They are, as a class, the rarest of all seriously collectible works of great art. There are sub-divisions of ancient work, instances of which are, of course, harder to pick up. But there is no other case where the major artistic production of a great nation is at once so well known and so hard to find. And as for the lore of the Persian rug—there is a body of erudition into which the specialist can disappear from the vulgar eye like a porpoise plumping into a bed of kelp. There never was so deep a sea of learning."

Rare old rugs are at a premium today. A glance at prices paid will be illuminating. The V. and L. Benguiat rug collection was auctioned off in 1925 for $637,350.00

Here is what the *Art News* said about the sale: "Two records for auction price of rugs were made during the sale at American Art Association. The V. and L. Benguiat collection of rare old rugs was sold at auction at the galleries of the American Art Association on the afternoons of December 4th and 5th. The price realized in Saturday's sale of thirty-five rugs, namely, $513,300.00 is a record total for so small a number. The two rugs, numbers 71 and 72, which sold for $78,000.00 and $75,000.00 respectively, are also records."

*Merely being old does not make it a choice or valuable rug*

There were poor rugs woven many years ago just as there are poor rugs woven today. It is a fact, however, that these poor rugs of yesteryear have worn out, and the good ones have survived. This is generally true. It is also a fact that fewer poor rugs were made in the old days.

Weavers of antique rugs wove them for their own use without any idea of selling them. The rug was their floor, their bed, their dining room table, their door, and often their partition between rooms. The tent bag was their trunk and wardrobe, the pillow was their suitcase, and the saddlebag on their donkeys and camels practically their only means of transportation. Since there were few wagons and very few roads thirty-five years ago over which a two wheel vehicle could pass, they wove into the rugs objects associated with their daily lives and designs of religious significance.

Actually, the rarest and most ancient rugs are not suitable for floor use, but only for museums and private collections.

But one must not get the idea that old rugs fifty to two hundred years old are available in numbers. The Orient has been stripped of these and the only rare rugs with considerable age available today are those which are acquired from estates and private collections.

These practical antique rugs have the advantage over the rarest rugs in that they are in a much better state of preservation and can be put to actual use. In Caucasian and Turkoman rugs, the semi-old rug of exceptional quality is as good as the ancient rug because for centuries there have been scarcely any changes in pattern or coloration.

*97*

There is little difference as to whether one of these is fifty or one hundred years old and the honest expert cannot with certainty determine the age of these rugs.

It is hard to estimate the age of any carpet with accuracy. Many Persian carpets can be dated by some peculiarity of design, weave, or color scheme.

### Neither Antiques nor Semi-antiques are imported today

The rare types have not been imported for 30 years. Until about 1955, we did import a great many antiques and semi-antiques, made between 1875 and 1940 in a number of the less rare types—Shirazes, many types of Hamadans, Sena-Kurds (Ingeles, Bibikabads, Borchalus) Tabrizes, Herez, Gorevans, Sultanabads, Mahals, Sarabends, Josan, Sarouks, Turkibaffs, Bahktiari, Karajas, Bijars, Senas, and a very few other types.

As late as 1955 I could go to New York and buy from four or five of the importing houses 100 to 500 old and semi-old rugs from the Hamadan district in scatter sizes and runners. I would usually buy each month three or four old Hamadan Carpets approximately $8\frac{1}{2} \times 12$ ft., and every month or two an exquisite old thick Hamadan about $12 \times 18$ ft.

It was a matter of going through several piles of semi-old rugs in the $3.6 \times 5$ ft. size and the approximately $4.6 \times 6.6$ ft. size and selecting at each show room the most desirable at quite low prices—actually for less than new rugs of the same type. These were thicker in many cases than new rugs (and I did not have to consider any that were slightly thin at that time).

During the past 5 or 6 years I seldom find one semi-antique even among the large groups of Hamadans. Where only five years ago I could buy hundreds, today I have great difficulty in buying six semi-old Hamadans in the two sizes listed above.

Five years ago, I could buy on any two day trip to the New York wholesale market, as many as 100 antique and semi-antique Herez carpets. In the largest importing house in New York where I have bought many hundreds of these since 1945, I have bought very few semi-antique Herez rugs in the past five years.

All of my New York importing friends say that they simply are not available in Iran. They are wrong, they are available but our New York importers and American buyers cannot compete with the West German buyers or other European buyers for these semi-old Herez rugs.

### The real facts as learned on recent trips abroad

In the Free Port of London, there are a good many old rugs intermixed with most lots of new rugs. This is especially true with Hamadan rugs in the Dozar sizes (approximately $4.6 \times 6.6$ ft.). The dealer wants to sell these by the lot. A lot of some 100 rugs will contain 50 new rugs and perhaps 50 old rugs. Among the new rugs there will be at least half in colors, designs, and qualities which I and most American buyers could not afford to buy. Our public would not accept the horrible colors in many of these. Among the 50 antique rugs in the lot, there would perhaps be 15 that I would like to buy. These would be in good condition and have colors that my customers would like. Some 15 others would be in good condition with nap but they would be ugly rugs. Being antique does not necessarily

make them beautiful. Twenty other old rugs would be worn badly and perhaps in horrible colors.

Now the picture becomes clear. In Persia the dealer in Hamadan buys these one at the time or two or three at a time as the farmer or villager brings them in. The old worn rug costs him perhaps $5 or $10, and the new rug costs him $25. He has learned that if he allows the American to pick out 30 of these rugs, even at a slightly higher price than the lot price, he is left with those old, worn out rugs and other hard sellers for a long time.

But to his delight, he finds that the European buyer will come and buy the entire group. I have had this identical experience a number of times. I inspect the group and try to buy a selection, to pick out say one third of the lot at a slightly higher price. I see a German buyer come along, flip over fifteen of these rugs and buy the lot. So many Europeans actually prefer the old worn rug to the antique with a good nap. They don't seem to mind whether they are crooked or whether they lie flat. I have already stated that any American dealer who bought the groups that the Europeans buy would go broke in short order.

I have managed to select a few semi-old and old rugs abroad but none of very rare types exist in these foreign markets.

*European buyers coming to America and buying our Antique estate rugs*

The only rare antiques that are found for sale come from estates and collectors' liquidation of their collections. You will find very few rare old rugs from private estates, but you will find many old Rugs that are quite desirable and lovely.

The real choice old rare types that appear will usually come from the estates of the expert collector. Sometimes the collector decides to liquidate his collection while he is still alive. Most of these rugs will have received tender care and only a small percentage will have been walked on during the past 20 to 50 years the collector has owned these rugs. A collector in Pittsburgh wrote me a few years ago that he was 82 years old and had 135 Oriental Rugs, and even though he could use only three of these in his apartment, he was still unable to resist a rare old beautiful specimen from time to time.

During the past 60 years, Europe could afford to spend only a tiny fraction of the millions of dollars spent by Americans for Oriental Rugs over these years. Today, they have the means for the first time in their lifetime and they are surely buying with abandon.

Dealers from West Germany, Switzerland, Italy, and other countries are coming to America in numbers and buying hundreds of thousands of dollars worth of our rare old rugs that come from estates each year. They are not buying the worn out junk that we find at so many sales, but are buying the good specimens and they do not care if these are worn thin or even worn badly. Not only are they buying all that appear at the small New York jobbers (dealers in used rugs) but they are going all over the country and buying from the retailer in all the cities throughout America. The local retail dealer finds that he can get more from these European buyers than from most of his customers. He can't turn down an offer of $1,000 to $20,000 (if he has that number of antique rugs) in an hour when it would take hard work and real selling to dispose of the same rugs to his local customer in the next six months.

I myself have told these buyers that I could spare none of my antiques and yet they have stopped by my place and time after time have bought $5,000 worth of rugs in 30 minutes. The sale could have been much larger but as a rule I would not sell them antiques in good condition even though they would pay me my price.

### Cherish your Antique rugs

The owners of good antique rugs will find that they have good property which cannot be easily replaced.

The owner of any good Oriental Rug, new or old, will find that these are likely to become more valuable and more difficult to replace each succeeding year.

### Only Antique interest the European buyers

European buyers come to America for their antique Orientals only because they do not exist elsewhere. Remember, they are buying these new rugs in Iran, India, Afghanistan, Pakistan, and elsewhere just as we are, but these antiques do not exist in these countries and have not in many years.

### The difference between used rugs and Antique or semi-antique rugs

To be sure, an antique or semi-antique is a used rug, but there is a distinction between used rugs and antique rugs. We used to think of an antique rug as being one that came directly from the Orient or which was in a Museum or in a private collection or in private homes. To the uninitiated, any time a rug is offered for re-sale it is a used rug. The same rule could be applied to all types of rare antique furnishings.

An antique rug is still an antique, no matter how many times it changes hands. A semi-antique may in time become an antique. A rug bought many years ago when new, may become an antique or semi-antique.

There is one type of new rug that never becomes antique or semi-antique, and that is the Oriental Rug that is a chemically treated and painted rug. It will be a used rug a month after it is purchased.

Most of our antiques and semi-antiques will come from private collections and estates. We have told you that European buyers are coming to America to buy antique rugs from estates as the principal source in existence in the world today. Read the chapter on Used Rug Sales which ties into this subject.

*100*

# Chapter Thirteen

# DESIGNS

THERE WAS a time when the design of an Oriental Rug told, with some degree of certainty, the country and city, village, or district where the rugs were woven. That is only partially true today.

The same design is used in so many different rugs. This is especially true with different types of Persian rugs. The Herati or Feraghan design is found in more than twenty different types of Hamadans, and is a favorite design with the Tabriz weavers. It is also used in many of the Nains, Bijars, Senas, Khorassans, Yezds, Suj-Bulaks, Mahals, and many others. It gets its name from the old Herat carpets of the 16th and 17th century, which are the oldest rugs in Museums that have this design.

This design will vary in each of these types, and even in the same type of rugs there will be many variations in many different sizes. You can probably find fifty variations of the Herati design in the Hamadans from the many villages.

In spite of this design being used by many different rugs, it does not as a rule make it difficult to *identify* the different rugs. Most beginners can quickly know the difference between a Hamadan, a Tabriz, a Bijar, or a Sena. The thickness, the texture, in fact a casual glance will usually tell the difference. One can generally name the rug from a black and white picture, but this is not invariably true. There are different general types of designs.

The two principal designs to be found in Persian rugs are the repetitive or so-called all over design and the medallion designs. We have discussed the Herati or Feraghan design.

Another well known all over design is the Pear design. The six different forms of pear designs shown in the illustrations of six of Professor Fisher's rugs, are only a few of the many variations of this design. If this book could have a thousand pages, we could give you many similar illustrations of other designs.

Other all over designs are the Gula Henna, the Mina Khani, and the all over floral designs.

Many of the rugs with an all over floral design are combined with other designs and motifs, such as the Shah Abbas, Chinese motifs, animals, birds, and flower pots with realistic flowers and many others.

We do know the origin of some of the designs found in Persian rugs, which is the so-called garden design. It is recorded in many places that a favorite subject for the Persian weaver was a map-like representation of a garden filled with different types of flowers. The floral designs are either with an all over floral design or with a large or small center floral medallion and the remainder of the field is covered with small motifs.

Many of the old Persians also had the medallion on a plain field. The geometric designs are typical of the old Turkish rugs as well as most of the Caucasian rugs and most Turkoman rugs.

Most of the small Prayer rugs came from Turkey. There are very few Persian rugs or rugs from Central Asia in the Prayer design. The design in a rug will usually tell you its name. That is still true today provided you are a dealer and have kept up with the changing situation and many changes of designs.

If you looked at the plates of Kirman rugs in the books written from 1900–1915, you would hardly recognize the thousands of Kirmans that came in right after World War I and up until about 1935. Now, if you look at the Kirmans of today, you will find their designs so very different from both the Kirmans of the 1900–1915 period and the Kirmans of 1921–1935 period. They are also different in color combinations.

The designs of the Sarouks have changed many times during the past one hundred years. They do continue to use the designs that were used after World War I and these were also very different in designs, texture, and color from the Sarouks you read about in the books written in the 1900–1920 period. New types and designs are appearing in Sarouks in 1961. See Sarouks, Part II.

FIG. 41. PEAR DESIGN in Mir-Sarabend (Persian).

FIG. 42. PEAR DESIGN in Sihraz (Persian).

FIG. 43.  PEAR DESIGN in a Sena with a silk warp (Persian).

FIG. 44.  PEAR DESIGN Khorassan (Persian).

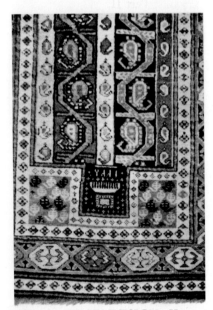

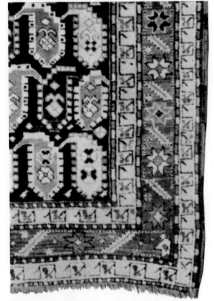

FIG. 45.  PEAR DESIGN Karabagh (Caucasian).

FIG. 46.  PEAR DESIGN Karabagh (Caucasian).

All six rugs shown on these two pages are from the collection of Professor Robert Fisher, Blacksburg, Virginia.

In general, the Caucasian rugs and the rugs from Central Asia (Bokhara types) have adhered to the same designs from time immemorial. The Turkish rugs discarded their old designs after World War I. See the chapter on Turkish Rugs.

Many of the Persians still follow the traditional designs used by their ancestors hundreds of years ago. This is especially true of the Hamadans, Sena Kurds, Bijars, Shiraz, Herez, Gorevans, and many other types. The Kirmans and Sarouks are the ones that have continually changed their designs, colorings, and types.

Perhaps the most interesting thing about design is the fact that no two similar designs in the same rug are exactly alike. It is the many little differences and changes that make the Oriental Rug so interesting and beautiful. If each design were exact, the rug would look more machine made and lose much of its charm. One of the most interesting points about design is the manner in which the Persian weavers obtain certain color effects. If you will examine a Persian rug closely, you will discover that each design is bounded by a color, sometimes so fine as to be almost imperceptible. Yet, this inconspicuous outline has an extraordinary effect on the field of color it encloses. The same color will have an entirely different look or shade, according to the color of the tiny outline.

I could devote a whole book to discussing the many individual designs. Much has been written about the meaning of the Pear design (also called Palm Leaf and many other names), the Tree of Life design, the Swastika (a design that has been found in every land—even in the Americas long before Columbus crossed the Atlantic), the Lotus Flower, Bird of Paradise, Knot of Destiny, Stars of Medes and many others. Much misinformation and much guess work has been written about these.

I could repeat much I have read in all the old books, but I have never met a Persian who had lived there for many years who knew the meaning of most of the designs. Much has been written to the effect that the Tree symbolizes divine power and bounty, that the Circle is said to represent eternity, the Palm a blessing and benediction, and the Lotus Flower means immortality. The Swastika is said to represent deity of the Aryans and the motion of the earth on its axis, health, happiness, and good luck. You will find this statement in the books written after 1920: "No wonder Hitler adopted the Swastika."

And of course many lines from the Persian poets are often woven into the rugs. Originally (hundreds of years ago), I am sure that each one of these designs had some real significance and that they were passed down from father to son for many generations. Usually the weaver is simply copying the design that his family has always used.

*New designs*

You have read in the preceding chapters how the designs have completely changed in countries like India and Turkey.

Prior to World War II, the rugs from India were Persian designs. These have been completely discarded in favor of the pastel colored rugs of French Savonnerie and French Aubusson designs and Chinese designs. Also, many rugs in one tone with much hand carving are made. Refer to the chapter on Indian Rugs.

We have already told you that rugs are being made in Afghanistan in nearly all the different designs that formerly came in the many types of so-called Bokharas

FIG. 47. PAPER SCALE DRAWINGS. The paper scale model is of the Shah Abbas design. While many Persian rugs are woven without these paper scale models, most of the finer large rugs—especially Kirmans, Turkibaffs, Tabriz, Sarouks, and others—use full paper scale models. In the above design model, each square represents a knot. In Kirman and many other places, full paper scale models are drawn in color; each square representing an individual knot to be tied is drawn in the proper colors. These are supervised rugs. Oftentimes severa rugs in the exact design are woven at the same time, and the supervisor will call off the colors of the knots to the weavers. In some sections like Kashan, where there are no real factories but usually two looms in each house, the large paper scale patterns are often cut in small sections and used by weavers as the rugs progress.

NOTE: There are many variations of the Shah Abbas design. This, perhaps, is the most typical of these.

from Turkestan. Also, Pakistan is making many rugs in the Tekke (Royal Bokhara) design and others in Persian Tabriz designs.

It will be interesting to see what designs are used by the Russians who have resumed weaving in Southern Caucasia.

The designs in the few new Turkish rugs that first appeared in the New York market in 1960, were different from any designs that I have seen in Turkish rugs. I am quite sure that the large firm that brought them here, the mere handful, did not order any more of these.

It is the European buying spree that is responsible for these new developments, and it remains to be seen if they will be successful. I venture the guess that these new ventures by Russia, Turkey, and Bulgaria, will not last very long.

Rugs from Pakistan and Afghanistan will no doubt find a ready market in Europe. The Mori rugs in Royal Bokhara designs (Tekke) are being well received in America. The Pakistani rugs which are copying the angular Tabriz designs may sell in Europe, but they will have to change their designs before they will sell in America.

*Chapter Fourteen*

# MATERIALS AND METHODS

TO BE a real Oriental Rug, the rug must be handmade. No machine has been invented to tie the individual knots which the hands tie in these rugs.

The same type materials and the same few tools that were used hundreds of years ago are still used today. The only changes have been some slight improvement in the looms in the larger weaving centers, the spinning of a small amount of the wool yarn by machine instead of by hand, and the buying of most of the cotton warp and weft threads instead of spinning these by hand.

Frequently someone says to me "Is it true that they are now making these Oriental Rugs down in New Jersey or elsewhere?" The question is so absurd that it hardly merits an answer. To be sure they *could* make such a rug in the United States, but if the weaving wages were the minimum of $1.25 per hour or $10.00 a day, instead of the few cents a day weaving wages in Iran, India, Pakistan, and other rug weaving countries, you may be sure that the small 2.6 × 4 ft. Persian rug that sells at retail stores for $35.00, would have to sell for a minimum of $700.00 if made in America. The 9 × 12 ft. medium priced rug from India that sells for about $500.00 would, if made in America, sell for some $10,000.00. No, Oriental Rugs are not made in New Jersey.

Sheep's wool is the principal material of all Oriental Rugs. The nap in over 95% of all Oriental Rugs is of sheep's wool. The other 5% (perhaps less than 5%) is camel's wool, silk, and goat's wool.

The warp and weft of most Persian rugs have always been cotton. In fact, all the finely woven Persian rugs from time immemorial used cotton warp and weft as it permits a more closely woven rug. Only the Nomad tribes used wool for warp. These comprised only a fraction of the rugs from Iran (Persia). That is an unimportant point, since the nap is the part of the rug that takes the wear, but we mention it because so many people become frightened when they notice the cotton warp. Of course, that is due to their lack of knowledge of Oriental Rugs. Long before cotton ever came to America, fine Persian rugs used it as a base and one had only to look at the ancient rugs in museums to learn this. The Kirmans, the Sena, Kashans, Feraghans, Hamadans, Sarouks, and most of the other Persian rugs have always used cotton warp. Only the Kurdistans, which included the Shiraz,

Bahktiaris, Mosuls, Bijars, Suj-Bulaks, and one or two others ever used woolen warp. The old Turkish rugs, the Caucasian rugs, the Bokharas and other rugs from Central Asia did use only the woolen warp until about 1930, when most of them began to use the cotton warp. *The advantage actually lies with cotton over wool as warp.* It permits a more finely woven rug. The rug with the woolen warp has a tendency to wrinkle and not lie flat, especially after being washed. Linen and silk have been occasionally used as warp. The question of warp is of minor importance as compared to the quality of wool that goes to make up the pile of the rug.

## *Wool quality*

The quality of an Oriental Rug is based primarily on the quality of the wool and in a very old rug on the pigment with which it is dyed. Good wool means longer life and a more beautiful natural patina. Also, the fact that the wool is spun by hand—the raw wool is not torn into the smallest threads in a willowing machine as in most machine made rugs—makes for durability.

Wool in different sections of Iran varies greatly. In the desert and dry lands the sheep do not grow the thick, heavy crops that the sheep of the colder mountainous districts and the well-watered plains of Northern Iran grow. Also, the shearing and sorting of wool is an important item, since the quality varies even on the same animal. Sheep's wool and lamb's wool also vary greatly in quality. Wool is actually modified hair. Each fiber contains certain cells. As seen under the microscope, a wool fiber has a diameter from about 1/280 inch in the lowest quality to about 1/2800 inch in the finest grade.

Many other points enter into determining the quality of the wool. For instance, as a rule, the Spring clipping is usually a better and stronger wool than the Fall clipping.

## *Types of looms*

There are two general types of looms. One is the small Horizontal loom used by the Normal Tribal weavers, which weave mostly small rugs. The Fars Tribes north of Shiraz and the Afshars near Kirmans are perhaps the only weavers still using the Horizontal looms to any extent. The villages in these areas will have the upright looms. These small Horizontal looms are easily moved and are essential for the Tribal weavers that are moving from place to place with their herds.

There are three different types of upright looms. The old Village type is still used in many places. The upright poles of most looms are made of poplar, which is the straightest tree to be found in Iran. The warp threads are fastened to the upright horizontal beam and to the lower beam by different methods. The Village method has the three of four weavers sitting on a plank which is raised as the weaving progresses.

The Tabriz loom works on the same principle but has refinements that permit the woven sections to be moved as if on a belt and the nap or woven section can be inspected from the rear side.

The Roller beam type of loom permits the lower end, the woven section, to be rolled on the lower beam as the work progresses. In India and Japan, you will find even greater refinements to these looms.

The warp threads are strung up in vertical rows. The warp threads must be strained. Each type of loom has a simple method which permits the weaver to separate alternate warp threads in two sets of two each, which gives the weaver room in which to draw the threads.

After each row of knots are tied, weft threads are run through the warps so as to hold the knots in position. These weft threads, like the warp threads, are hidden from sight by the nap. Some rugs have only one weft thread between each row of knots but others have two or three weft threads between each row. A large comb, somewhat in the shape of a shovel, is used to beat the weft threads down.

## The Sena or Persian knot and the Ghiordes or Turkish knot

These are the two principal types of knots. (See drawings of these knots). In the Turkish or Ghiordes knot, the length to form the knot is laid over two warp threads and the ends are then passed behind and brought between these two warp threads.

In the Persian or Sena knot, one end is left outside the two warp threads, and the other thread is passed under the first warp, and over and under the second, and is then drawn between the two warps.

## Jufti or false knots

The illustration showing these two types of knots tied on four warp threads instead of two, is the so-called Jufti or false knot. It is the curse of rug weaving in Iran today. I know of no other country which uses this false knot. The purpose is clear; it permits the weaving of a rug in half the time that would be required to weave the same rug with an honest knot on two warp threads. It makes for a much poorer quality rug since obviously there will be half as many knots to the given area and the nap will contain half as much wool in a given area. Few of the rugs will contain all Jufti knots but the practice is widespread in Iran and it has lead to a general deterioration in all types that have succumbed to this evil practice.

Good rugs of nearly every type can be found however, even among the types where the practice of false knots is rather general. It takes a little more knowing and a little more reliance on the store selling Oriental Rugs.

The Jufti knot, the dead wool (butchered sheep wool) and the Swiss dyes are three danger points in the rugs being made in Iran today. Just as we get rid of the great evil of chemical washing and painting of rugs, we have these three things raise their evil heads. The practice is not general as to Swiss dyes or dead wool, but the Jufti knot is becoming widespread. A few more words about these practices later.

About the only other equipment used by the weaver is a knife to cut the yarn after the knot is tied, and a pair of shears for trimming the nap evenly. The Tabriz weavers use a hook to tie the knots instead of their fingers.

## Rug factories

Most of the large size rugs brought to America today are made in so-called fac-

tories. They are still all handmade. Some of the wool may be spun by machinery and the cotton warp is probably machine made, but the knots are all hand tied and there are no differences in the methods used hundreds of years ago except that the making of the rug is more closely supervised. In the large weaving districts in and around Sultanabad, Hamadan, Tabriz, Kirman, and Meshed, there are many of these so-called factories. The main difference in the factory made rug lies in the fact that the wool for one rug will usually be on hand when the rug is begun, and thus there is less chance of the many changes of colors that occur in so many rugs and to which the beginner of novice objects.

These factories will have a number of large looms where one master weaver, or Mirza, supervises. There may be several rugs of the same design being woven at the same time. Usually three or four weavers work on one rug at the same time. The master weaver, or big Mirza, actually paints entire designs in the exact colors which the weavers are to use. Assistants, or little Mirzas, will paint the actual working patterns, copying the enlarged sections of the design on paper of which each square stands for a knot or fixed number of knots. The miniature design in colors is given to the weavers. Most of the weavers are familiar with designs used but this is an additional safeguard. Technically speaking, the rug is not woven—it is tied.

Most of the discussion so far has referred to rugs from Iran. The wool being used in the rugs from Japan—the Imperials, the Fuigi Royals, and the Pekings—is an excellent quality wool from New Zealand or Australia. The wool used in the better qualities from India is 100% wool and of excellent quality.

The U. S. Federal Government requires that all types of rugs, both domestic and Orientals, have a tag or label stating the contents of the pile or nap. This is done for your protection. Stating the type of warp and weft is not required because they obviously do not effect the durability of the rug.

Some of the cheaper quality rugs from India will contain some jute; oftentimes as much as 50% of the nap. The other 50% will be wool. Strange to say, this quality seems to have worn very well. However, most of the rugs from India that come to America have a 100% wool pile. There is no danger that the tag on any rug will state other than its true makeup. But 75% of all the rugs made for the English market that come from India will have much jute in them. They are amazingly low in price, and give very good service.

*Skin wool or dead wool*

This means wool taken from a sheep that has been butchered. The method often used is to use lye which permits the wool to be scraped off with a knife with ease. Naturally, the wool fibers are damaged and a rug made up of such wool will wear thin in a few years. This wool has a dry and dead feel to the touch and can be quickly detected if used extensively in a rug. If used only in a portion of the rug, even the expert dealer may miss it and you may find your rug getting thin in spots in two to five years. If this skin wool is used, you may be sure that the wear and thinness will show up in that period. If it doesn't, you need not be concerned about this.

110

*Dangerous wool elsewhere*

Even the coarsest wool produced in Iran, when used honestly, is going to wear indefinitely—usually a lifetime or longer. One other practice that shortens the life of many of the rugs that come from the Khurasan districts, and which will usually be offered to you as Meshed, Birjands, or Ispahans, is the process used by the dyers in this section of Eastern Iran. This is an honest procedure and they have done this for years. They steep their wool in lime water for 24 hours in order to get the cochineal red (a red with a plum or magenta shade). Why they insist on this cochineal red as the principal color for the background of their rugs is hard to understand.

They have also used the Jufti knot for years as their standard. These two factors tend to make most of these rugs very perishable under heavy traffic. See Meshed, Khurasan, and Ispahan Meshed.

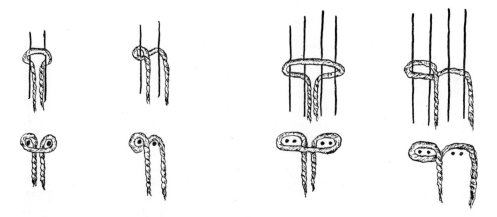

FIG. 48. First column from the left. Turkish or Ghiordes knot. Upper, top view; lower, side view. Second column. Persian or Sena knot. Upper, top view; lower, side view. Third column. Turkish Jufti (false) knot. Upper, top view; lower, side view. Fourth column. Persian Jufti (false) knot. Upper, top view; lower, side view.

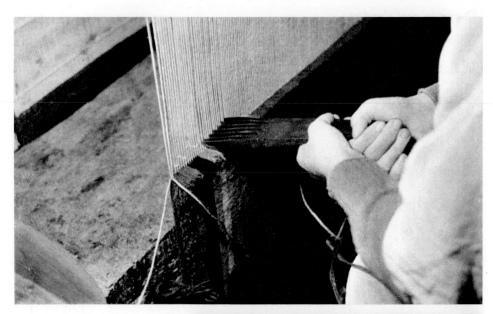

FIG. 49. *Upper:* Once the warp threads are strung, the weaver of an Oriental Rug, whether in Iran, India, or Japan, uses three instruments in the entire operation. The knot is tied by hand. No needles are used. A knife is used to clip the yarn after the knot is tied. Large scissors are used to clip the knot evenly, and the large comb instrument is used to press down the knots.

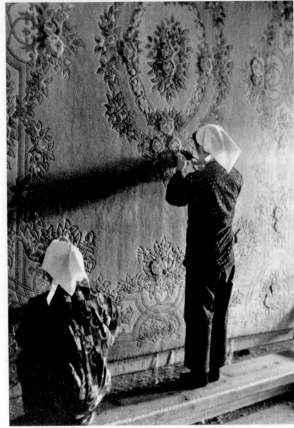

FIG. 50. *Lower:* This picture shows two craftsmen cutting the hand carved designs on an Imperial rug in Japan.

*Chapter Fifteen*

# DYES

THERE ARE three general types of dyes used in dyeing the wool with which rugs are woven. The old vegetable dyes which were used exclusively in Persia until about 1890 are well known. There are two types of imported dyes used in Iran. One type is generally known as Aniline dyes and the other is known under the generic term of chrome dyes.

The aniline dyes are, as a rule, cheap acid dyes and the only type among these three that is dangerous. They are dangerous in that they will fade badly, will run and bleed when wet, and do not produce clean colors. The chrome dyes are generally superior synthetic dyes and have proven to be satisfactory beyond any question.

It is *only* in Iran that we meet with all three of these dyes. India and Japan are using chrome dyes exclusively. The results have been most satisfactory. There is no fading of any of the colors, no bleeding at all, and no shadings. During the past year I have had woven in India over one thousand Savonnerie rugs. As incredible as it may sound, not one of these came with any change of colors or any off colors. The chrome dyes have proven themselves in both India and Japan. Chrome dyes have been used exclusively in India for many years.

And they have a longer history. Most of the Chinese rugs woven during the period 1921 to 1934, used chrome dyes. The use of these in thousands of Chinese rugs made 25 to 35 years ago conclusively prove that these dyes are good. The only dyes that I have seen fade somewhat are the rose and the wisteria in Chinese rugs.

I can assure you that if you inspect hundreds of rugs from Iran, where we are confronted with the use of the three types of dyes, similar results will be impossible. Many rugs will have some change of colors, and you will certainly detect a little bleeding among a few of these. Also when these are lightly washed by the New York process, hairbrushes (fading out in sections) will be present. The dyes used in Afghanistan are undoubtedly still vegetable dyes.

At this writing I am not prepared to say whether the dyes in the rugs from Pakistan are vegetable or chrome, but I have seen enough of these to say that they are not aniline. So, our main concern is with the rugs from Iran.

Before entering a slightly detailed discussion of dyes, I will try to pinpoint the extent of the danger in buying a Persian rug today.

*The danger from aniline dyes in buying an Antique or semi-antique Persian rug is nil today*

The dangerous aniline period was in rugs made between 1890 and 1910. You may be sure that most of these have worn out. If one should appear from an estate, any and everyone will quickly recognize it and see its imperfections, *i.e.,* the red will have bled badly into the white. The colors will have faded badly in others. These have long since gone into the trash barrel. But again, the novice will need no knowledge of rugs, no special insight, to reject any old rug with aniline dyes. He isn't likely to ever see one but even if he did, he would not buy it.

When I first started in the business in 1924, the first thing any hobbyist or any-one who had read one of the books wanted to know was: if the rug they were considering had only vegetable dyes. It was only a slight issue at that time be-cause seldom did one of the rugs with aniline dyes appear. Most of the few rugs with aniline dyes that I saw over the years were in private homes.

In all the intervening years up to about 1950, there has been no problem of dyes in Persian rugs—at least not until the last ten years. I was always amused in those early days to hear someone talk about the danger from aniline dyes when there was so little danger and yet that same person had never heard about the chemical washing and painting of rugs, which was real danger. Three out of four Persian rugs offered at that time were both chlorine washed and painted.

There is an explanation for this because at the time of Mumford's 1st edition, this washing and painting process was not as well known and was not so generally used as it was a few years later. And since it is generally recognized that most of the authors of rug books of that period got their facts from Mumford's book, it is understandable why all the hullabaloo on dyes and so little about the greatest evil. I have already boasted (and I don't mind using that term) that I was the only person in all America to write article after article against this chemical treatment and painting process, and to decry it in each book I have written over the last 31 years.

When the prospective buyer asked a dealer during the past 40 years if the rug had only vegetable dyes, that dealer could not answer yes in most cases, because it is generally agreed that much aniline red has been used in making Sarouks and that much of the red in other types could be aniline red. It should remind me that people believe what they read and that I must be sure of any statement I make in this book.

There was no danger from poor dyes in those intervening years. I say this even though I am sure that some aniline dyes were used in many of the rugs. Perhaps as much as 10% of the wool in some rugs was dyed with aniline dyes. In my operation I have a rug cleaning plant and each year we wash in soap and water (and use great quantities of water to rinse) a good many thousand Oriental Rugs of every description. Over these years some 100,000 rugs have gone through our plant. I do not recall a bad incident on even our least expensive rug, except for those which had been chemically washed. Nor have I seen a single case of fading out of the colors of any of these rugs, except the chemically washed and painted rugs. Remember that the majority of rugs we cleaned over those years were rugs

*114*

made during the period 1900 to the present time. So what I am telling you is an actual table of experience.

Except for the bleaching out of some of the colors in Sarouks in the chemical washing process (that would have to be painted back in), a wide table of experience has shown that dyes—covering all types, categories, and price ranges—have proven satisfactory in the fifty years period between 1900–1950.

The dyes in thousands of inexpensive Turkish rugs in the Persian design—the so-called Anatolians and Sparta types made between 1920 and 1930—have proven satisfactory. I disliked these rugs and yet, the many used rugs of the types that have shown up during the past 30 years have been satisfactory from the point of view of dyes.

The cheap Turkish rugs in the small, bright prayer rugs and small, cheap, bright Turkish mats that came by the thousands right after World War I (1920–1930), certainly used little else but aniline dyes. These are not an issue today. None have been made for 30 years and seldom does one appear in an estate. When one does, it is usually worn out.

### Recapitulation on rugs up to 1950

There is very little danger to the unwary or to the beginner on any used rug you will find for sale in a store whether an antique, a semi-antique, or any other rug made prior to 1950.

There is, however, one big danger which is discussed in the chapter "Beware of the Used Rug Sale," and that is for the beginner to buy a used rug that has been both chemically washed and painted. This is not a question of dye which we are now discussing, but it is a far bigger danger for the beginner in buying from a home or in buying a used rug.

### New Swiss dyes are a real danger today

After reassuring you that the past was not dangerous, I regret to have to alarm you about the present day Swiss Dyes that are being used rather extensively in Iran today. They first appeared in Persian rugs around 1950.

### Poorest dyes to ever degrade a handwoven Oriental Rug

Why the Iranian Government ever permitted the use of these dyes is hard to understand. The Iranian Government is at present attempting to do something about eliminating them. The only reason these dyes are used is because they are so cheap and so easy to get.

While these are not in general use all over Iran they have been used extensively in some of the Hamadan goods and in some of the cheaper grade Gorevan rugs (sold as Herez in America).

### This is no issue in any country where only chrome or vegetable dyes are used

Beginning about 1951, we found our first evidence of the use of the cheap Swiss dyes in the cheap grade of Gorevan carpets and in some of the rugs from the

*115*

Hamadan district. The greatest danger was from the small rugs about $2\frac{1}{2} \times 4$ ft. made in some of the Hamadan villages.

The chief effect on the Gorevans was the dirty brownish-red field and dirty looking blues that characterized these carpets. I am glad to report that this situation as to the lower grade of Gorevans has improved during the past few years and that these rugs are coming with a brighter, clearer red. Either the weavers quit these dyes when they found the American buyers rejecting such rugs based on a bad experience with them, or they are going to the Teheran Market.

Actually, in spite of what I have said, during the past five years the quality in general of the many different types of rugs from the Herez district has improved greatly. Credit for this no doubt is due to West German buyers who prefer Herez carpets to many finer and more expensive rugs.

The only rugs that have been seen in numbers with the Swiss dyes or bad dyes are the inexpensive Hamadans in the $2\frac{1}{2} \times 4$ ft. size. It is strange that no other size is so generally affected. You will seldom find these dyes in the $3 \times 2$ ft., the $5 \times 3$ ft. size, or the $6.6 \times 4.6$ ft. size.

During the past several years I have inspected hundreds of lots of $2\frac{1}{2} \times 4$ ft. Hamadans, totaling thousands of these small rugs, and found many hundreds of rugs with bad discoloration. These small rugs had been given the light wash (undoubtedly a lime water wash), and the ivory corners and centers and sometimes the rose section of the nap would have a bluish-white, bleeding appearance. Looking into the lower part of the nap that was white or bluish-white on top, one discovers that the nap beneath the surface is actually blue.

Later I came to the conclusion that this was the result of the blue weft thread bleeding, rather than the wool yarn and dyes of the wool proper. I am sure that it is not all due to the poor Swiss dyes but that part of it is due to the weft thread.

Again, how unusual that this should be found mainly in the one small size. Occasionally I have seen slight evidence of these bad Swiss dyes in a few other types of rugs from the Hamadan district—even in the heavy, excellent quality Kasvin and a few times in Sarouk rugs. That there has been some improvement in this situation is clear. During the past year, there have been comparatively few of these small Hamadans ($2\frac{1}{2} \times 4$ ft.) with the discoloration imported to the New York market.

How and to whom these stained rugs are sold, by the thousands, is beyond me. Somebody bought them. Many of them undoubtedly went in used rug sales which often contain new rugs, many of which are rejects.

*Proposals for eliminating Swiss dyes*

One proposal is to prohibit the importation of any dyes to be used on wool. The objection to this is that there is not enough natural madder of red grown in Iran and that it would take years to overcome this shortage by growing natural madder. Again, even when it was formerly unlawful to bring aniline or synthetic dyes into Iran, they were entered illegally.

Another proposal is to permit the use of only chrome dyes of proven quality. This would be ideal, but anyone who knows the Persian custom officials knows that this would throw the door wide open.

The third proposal which will probably be adopted one day is to prohibit the

use of all imported dyes except indigo and synthetic madder; all other dyestuff to be native Persian vegetable dyes.

Here is what A. Cecil Edwards, the English author, has to say in his great book about this last proposal and I quote in part as follows: "It is in keeping with Persian tradition. From time immemorial, indigo alone has been used for dyeing blues and greens; and (until recently) only madder and cochineal was used for dyeing reds. By prohibiting the use of all chemical dyes except indigo and synthetic madder this tradition would be preserved; because natural and manufactured indigo are chemically the same, and so are natural and synthetic madder."

Mr. Edwards goes into great detail as to how the formula with alum, oxalic acid, Superramine, and Alizarine red dry paste, should be prepared. He goes on to explain that if this is adopted all shades except these two shades would be dyed with natural Persian dyestuffs—and cochineal. He further explains that there would be no difficulty in enforcing the use of these common Persian dyestuffs, because they are cheaper than synthetic dyes and just as easy to apply.

The other dyes besides these two colors of Madder and Indigo would be:

*Brown dyes*—from walnut husks, oak bark.
*For Black*—combinations of indigo and henna.
*For Tans*—walnut husks; pomegranate rind.
*For Greens*—indigo on vine leaves or on weld.
*For Yellows*—vine leaves or weld.
*For Orange*—henna; vine leaves and madder.

And almost any shade can be obtained by a combination of the above dyestuffs.

I have perhaps gone into too many details on this dye question, but it was the one question in my early days that irritated me. Perhaps, because I couldn't say definitely that a rug was made entirely of vegetable dyes. Today we know that some synthetic dyes have been used in hundreds of thousands of rugs that have been sold and used in this country and that these have proved satisfactory.

And before leaving the discussion of poor dyes of recent years, I should add one very important line. I have noted that the worst of these small rugs with all the stains and loose colors, came out well with a soap and water washing. Our process in our cleaning plant consists of thorough washing and lots of rinsing, and it has been a great comfort to find that these rugs—these badly stained rugs, actually were better after all the surplus dye stuff was washed and rinsed out.

I do not advise you to buy these rugs, nor will I ever knowingly buy one, but the above will comfort some of those who have bought the cheapest and poorest rugs which often have these defects.

*Chrome dyes versus vegetable dyes*

With chrome dyes as good or better than the old vegetable dyes, it may be like insisting on a horse and buggy in preference to the modern automobile. But it is not my intention to tear down the reputation of the old vegetable dyes. Without them, we would not have the wonderful old masterpieces in the museums throughout the world, nor would many of the wonderful old rugs from 50 to 200 years old be such valuable property.

*117*

What I am pointing out is that 99.9 per cent of all Oriental Rugs being woven today are for use on our floors and the Persian floors for hard, everyday usage. Hardly a rug is being bought with the idea that it will become a collector's item or be suitable for a museum a hundred years hence. Many people like to think that when they buy a choice rug it will be valuable property all their lives and that it will be used by their children. But not one in a million today are interested in what their rug will be a hundred years from now.

If any rugs worthy of being preserved for future generations are to be woven with the old dyes, the chances are that it will have to come from government subsidized factories, where rugs might be made to be presented to foreign governments as good will ambassadors.

For present day use, I believe that the chrome dyes are more satisfactory. Examine the hundreds of thousands of rugs from India and Japan using softer and more desirable shades, and we find none of the bad shadings and hairbrushes. Go further and inspect a number of these rugs that have been used for 10 to 15 years and there is no fading out of colors, but rather, they mellow and improve with use. Sections exposed to sunlight from windows have not faded. And we have a wider table of experience from the old Chinese rugs that used chrome dyes 35 years ago. Though these have proven satisfactory, chrome dyes and knowledge of their use have improved greatly.

Now I do not expect the Iranians and many Europeans to agree with me on the using of softer chrome colors, because they (especially the Iranians) like brilliant colors. But bear in mind that today, when Kirmans are made for sale to Persians in Teheran, they are not made in the soft, light pastel tones so popular in America, but are made in backgrounds of brilliant red, often a bright cochineal red—the brighter the better.

I of course do not expect everyone to agree with me on this point. But those who have the idea that the old vegetable dyes were perfection have not studied the subject. I could write at greater length on the dye question and quote many writers, but space does not permit this.

# THE CHEMICAL TREATING OR BLEACHING OF ORIENTAL RUGS

SINCE my first entry into the Oriental Rug business in 1924, I have been the most ardent opponent of the chemical treatment of Oriental Rugs. I have written books decrying this process and hundreds of articles opposing it. I know of no other dealer in the entire country who has opposed this process by writing even one article. Perhaps articles have been written and perhaps some of the small dealers have been as much against it as I have, but they are few and far between. None of our great name stores in any city have, to the best of my knowledge, ever opposed it, but rather, have carried for 50 years Oriental Rugs that were both chemically washed and painted.

The time has now come for me to modify my position and clarify my opposition because there have been tremendous changes in the chemical bleaching of Oriental Rugs since World War II. I could never alter my dislike for the chemical treating and painting of the Oriental Rug. I have never sold the first one—no, not one—in the hundreds of thousands of Oriental Rugs that I have bought and sold, and I never shall sell one.

But the situation has changed. Whereas, prior to 1941 the vast majority of all types of Oriental Rugs were both chemically treated and painted, since World War II the cost of labor has made this prohibitive. Formerly, practically all the Sarouks, Lillihans, Araks, Sultanabads, Kashans, Hamadans, Tabriz, Kirmans, and many others were heavily treated and then painted. Today, no Oriental Rugs (with rare exceptions) except Sarouk rugs, are both washed and painted—the exception being a small percentage of the many Dargazine runners imported, and a number of modern Sarouks only. Some 25% of all Sarouks are still both chemically washed and painted. Now, for the first time, we can find lovely Sarouks with only the light Persian wash, the desirable London wash, or the New York very light lime wash. I now recommend rugs with any one of the types of light wash and can assure you that the light wash does little harm and it certainly improves the looks of most of the new rugs from Iran.

So for the first time I am on record as actually recommending the Persian wash, the London wash, and the New York light lime wash. I actually prefer most new rugs with this treatment to one that has not had it.

The high cost of labor has accomplished something worthwhile when it eliminated the regular chemical treatment and painting process which has been in vogue during the past 50 years.

*What is meant by the chemical washing and painting process?*

When Europe and America first began buying rugs in numbers from Persia and other rug weaving countries along about 1870, the only rugs imported were rugs which the weavers had woven for their own use. In the Orient, the handmade rug was the principal furnishing and took the place of many types of furniture and furnishings that we have. It was not only their rug for use on the ground or tile floor (no wood floors) but it was their bed, their table, and their room partitions. Their trunk or sideboard was a tent bag, the front side being a regular woven rug with the back being a handwoven back like the Navajo Indians weave (only this back was more finely woven). The saddlebag used on donkeys and on camels was their principal means of transporting anything. Their decorations for their camels, and decorations for State occasions, were hand woven rugs. Their baby hammocks and their powder horns were hand woven rugs. The Prayer Rugs were used by Moslems in their daily worship. And we could go on and on, but suffice to say that rugs were 90 per cent of all their furnishings.

The rugs brought to Europe and America had been used for a few years, some as many as one hundred years. The walking on without shoes and the exposure to light mellowed the colors of these rugs and gave them a natural patina or sheen. The better the wool quality the silkier and more beautiful the rug became with use. The old idea that vegetable dyes did not fade is wrong. It is the fact that they did fade, or perhaps a better word is "mellow" that gave the old rug its beauty.

By 1900 Oriental Rugs were very popular and in great demand in Europe and America. Whoever bought these rugs, whether new, semi-old, or antique (and be sure most of them were old), got rugs that lasted a lifetime. Usually they were passed on to the second generation and many of those old rugs (and remember, even though old, most of them still had a good nap as they had not received hard usage like they do in American homes) are still in use. Even those rugs that were somewhat thin wore a lifetime.

To meet the demand in Europe and America, many new rugs were made. Industrious Persians and Turks, with a little capital, set up factories to make rugs. A factory simply meant that they hired a number of weavers, as the rugs were not only made by hand, but the wool yarn was hand spun. The new rug, as a rule, was brighter and often too bright for the European and American homes. Also, at that time the Americans had seen only old, mellowed rugs. The need to soften these rugs immediately upon their arrival in America resulted in the chemical baths to bleach them. There were different processes, but by and large they all had the same effect of toning down the bright colors and of giving the rug a silky sheen.

The methods and chemicals used resulted in the rug having a dull look, so it was necessary to touch up the nap in order to enrich the rug. This is what we call the painting process. When I first started in business I was convinced that the chemicals destroyed the natural oils in the wool and made it more brittle, and I

objected to the paint, not only as a travesty on the rug but also because it gave it a highly artificial gloss. I had seen enough painted rugs to know that after a few years they lost much of their beauty, whereas I knew a new rug became more beautiful with use up to a certain point.

The treatment that most Oriental Rugs received from 1900 to 1945 was a heavy chemical bath, plus a painting process, plus an additional chemical bath after being painted, plus wax and hot rollers to give it a high sheen.

When I started in the business in 1924, the vast majority of all Orientals imported were both chemically treated and painted. Practically all Sarouks, Kirmans, Kashans, Lillihans, Hamadans, Araks, Mahals, and even many of the Herez, were washed and painted.

The damage this heavy treatment did to the Oriental Rugs is now a matter of record. Most of the Hamadans, Lillihans, Sultanabads, Araks, Mahals, Kirmans, and Shiraz bought from 1920 to 1930 are pretty well worn out and shabby because of this treatment. The Sarouks, Kashans, and the few Bijars that were washed and painted, have stood up rather well. A heavily treated and painted Sarouk looks very good at the end of 25 years if you like the artificial colors the painting has given it. But in spite of the fact that the owner of such a rug will say it is still about perfect, a close examination will show that the nap is quite thin in places, and you know that in another 5 or 10 years it is going to be pretty well finished. And the mugginess and indistinctness is apparent on these as the paint fades out. And if you bought a Hamadan, Lillihan, or Kirman that was washed and painted, the chances are it is threadbare and on its last legs if not already discarded.

I have had hundreds upon hundreds of examples of these painted rugs come to my Rug Cleaning Plant that were bought in the 1924–1935 period, and they are worthless, or nearly so. On the other hand, the same quality rug that I sold untreated, or in natural colors during those same years, is well nigh perfect, and instead of having gone backward in looks, the natural colored rug has become more beautiful with use, and it is going to be good for many more years.

I must admit that I have been surprised at how well those rugs with the light wash—the light lime wash—have stood up and how beautiful they are after 25 years of use. The fine rugs that were only lightly washed in 1900 to 1920 are, as a rule, very beautiful rugs, and as a rule, in good salable condition. The medium qualities bought in the 1920–1935 period have held up well. At least a good number of these come on the market from estates from time to time.

We wish to repeat that the danger of your buying both chemically washed and painted rugs today is practically nil unless you are buying only one type—namely Sarouk—and less than half of these are still treated in this manner.

We have reproduced the feature article appearing in the March, 1953 issue of the *Oriental Rug* magazine. This is the official organ of the importers in New York. I have the temerity to believe that it was written to offset some of the prejudice I had created throughout the country against chemically washed and painted rugs. We would still be happy to send you a copy of this article upon request, as long as the several thousand copies we had printed are still available. The heading of this article reads: HOW ORIENTALS ARE CHEMICALLY WASHED AND PAINTED. The following is an exact quote from this article:

"ALMOST EVERYONE in the trade knows that a very high percentage of the

modern Sarouks, Kirmans, Dargazines, and Hamadans imported are chemically treated before they are sold. Why they are so treated, and especially what this treatment consists of, is not so generally known. Anyone whose business is to sell Oriental rugs should be familiar with the subject, and it is hoped that this article will serve the purpose. Chemical washing is to Orientals, roughly, what mercerizing is to cotton. It does two things—it softens the colors, and imparts a luster or sheen to the woolen pile yarns. (The same effect can be obtained by 15 or 20 years of good care and gentle use, but few customers are interested in waiting that long for the natural beauty to appear.)

The washing process itself is rather complicated. It is accomplished in huge, laundry-type washwheels. Dilute concentrations of caustic soda and lime are the principal active chemicals, with dilute acetic acid being used to neutralize the alkali. It is not simply an in-and-out proposition. Depending on the type and quality of the rug, as many as seven separate baths and rinses may be needed, with two or three centrifugal extractions. Some types, it should be pointed out, require only a lime wash.

An extra step is required for Sarouks. The washing process, with this type of rug, reduces the color intensity to a point where many of the colors must be replaced. Hence the 'Painted' Sarouks. The most common colors replaced are the reds, blues, greens, browns and pinks. 'Painted' is actually a misnomer. Painting, to most of us, implies the use of a brush and paint. This way the 'paints' are top quality dyes, and the brush is a short glass tube with a pointed end.

The dyes are kept in enameled cans on a shelf several feet above the long work table, and are fed to the glass applicators by rubber tubes. The women who do this exacting work hold the applicator in one hand and a pinch-clamp in the other. The dyes are applied with a sort of stippling or tapping motion. After the dyes have dried, the rugs go through a final rinse, are dried and sheared. Now, the Sarouks are ready for inspection and shipment." (End of quotation.)

As you can see, it is the heavy washings and painting that I object to. When the article states that the same effect can be had by 15 to 20 years of gentle care and use, it overstates the case. A light wash will tone it down nicely, but the heavy wash and paint takes away much of the life of the rug. On a medium quality rug, I have observed that it shortened the life of the rug by as much as 50 per cent, and often more. On a heavy Sarouk, even though the Sarouk will look good for 25 years and even longer, I will still say it takes away close to 50 per cent of its wearing quality.

*But again I repeat,* the Sarouk is the only rug you will find both chemically washed and painted, and you can buy the same quality Sarouk with only the light Persian wash and the light lime wash. Anyone with a little knowledge is going to prefer the light wash. You may ask "How can I tell if a rug is washed and painted?" (See Chapter on Sarouk Rugs.)

*Light bleaching recommended*

You may wonder why I have come around to recommending the light washing or light treatment of new rugs when I opposed it for many years. There are several good reasons for this. Before stating these reasons I must remind you that all

the great authorities since 1900 have recommended, or at least not opposed, this light treatment. I shall quote them shortly.

The most important reasons for recommending the light wash are: First— over thirty years of observing and inspecting rugs that had only the light wash many years ago. Second—the fact that the light washing methods have been greatly improved: especially the Persian wash. Third—the observation that most of these rugs have withstood hard usage in spite of the light wash. In other words, the proof of the pudding story. Fourth—in order to have rugs with slightly soften- ed colors in carpet sizes, $6 \times 9$ ft. size, $8 \times 10$ ft. size, $9 \times 12$ ft. size and larger, it is a necessity because most of the new Persian rugs are very colorful. The above sizes in semi-antiques and antiques are practically nonexistent.

I do not expect the connoisseur or collector to want anything but antiques and semi-antiques, and perhaps a few fine examples of new untreated rugs. I myself started my business and built it up on antiques and semi-antiques. In the begin- ning, I felt that while violently opposing the heavy treatment and painting pro- cess, to approve the light wash would be straddling the fence. I did this in spite of what all the authorities and book writers said on the subject.

I did straddle the fence when I sold Chinese rugs with the light New York lime wash, but I did so with some misgivings. All Chinese rugs in the New York wholesale market were lightly lime washed. I have taken in trade many Chinese rugs with the light wash that I sold in the 1924–1935 period and find 75 per cent of them in top condition after many year's use. We have cleaned many hundreds of Chinese rugs that had been lightly treated (and all that were brought to the New York market were without exception so treated) and find the same good report on the light New York lime wash.

Also, in our cleaning plant we have cleaned hundreds of thousands of Orientals of all types. We find good lightly treated rugs of the 1920–1935 vintage standing up well, and as a rule find it difficult to tell that they were lightly treated. An expert can always tell, because the old dyes did not mellow beyond a certain point. The colors became more beautiful with age, but the old dyes never had the pastel faded effect. A funny thing is that many thousands of people seeking an antique are looking for only the colors that a rug lightly washed in America some twenty to forty years ago has. The expert and hobbyist do not seek these soft pastel shades, but rather, old, mellowed rugs with clear colors.

But before quoting the old books, even though they are out of date except on antique rugs, let me repeat that the Persian wash really adds something to the looks of a new rug and does no harm to the wearing quality.

The London wash is pretty much the same and I like to buy a new rug at the Free Port of London which has been washed in England. The New York light wash, even if more expensive by reason of our higher standard of living, is only slightly stronger and I can assure you does little if any harm. If we want to be ultra con- servative, we can say that a rug that is going to last fifty years might have its life shortened by five years. However, the softer, nicer colors are worth the few years since the rug is going to last a lifetime in any event.

Now, to quote what many of the world's best authorities of yesteryear said about the treatment of Oriental Rugs. Here is what no less an authority than Mr. Walter A. Hawley says in 1913 in his book, which is considered one of the best

ever written: "Whatever may be their character, the methods employed to give softened effects to the colors are known as 'washing.' Most of those in vogue in the Orient, such as washing with lime water, do little real injury. In this country artificial mellowing of the colors has become regular business of firms. Some use ammonia, borax and soap, which do very little injury to the rug. Others use chloride of lime, boracic acid, vinegar or oxalic acid that remove some of the natural oils of the wool, accordingly impairing its qualities for wear. Nevertheless, it does not necessarily follow that all rugs washed with an acid solution have been seriously injured. To be sure, rugs that have been washed are often more attractive than they were in their raw colors. Over 90 per cent of the Kashans, Sarouks, Lilihans, Muskabads, Mahals and a large percentage of other rugs in this country have been treated by some artificial process to soften their colors."

The German authority, Werner Grote-Hasenbalg, while decrying a heavy wash, says: "A weak bath of only 2 per cent of chlorine does no harm at all, and on the other hand, gives the carpet a certain patina."

The great gamble of buying a rug which has been both heavily treated and painted has been eliminated for you. This has come about mainly because the cost has made it prohibitive. The only rug you have to be careful about buying is the Sarouk. I think that you are safe in buying a Sarouk because any dealer will probably tell you that it is painted if you ask. You should not have to ask, but do so by all means. Perhaps I should not make this last statement, because I have found thousands of people who own the painted Sarouk and did not know it. Actually it is a hundred to one bet that every Sarouk you or your friends own or have bought since 1910 up to 1945 has been both chemically washed and painted. The stock answer from each owner is that "mine can't be painted because I have owned it for 25 to 30 years." Unfortunately, it will generally be painted.

And finally, you ask for the sixth time, why would anyone want to paint these rugs. It does seem ridiculous until you know the business and are in the trade. It came about because first in treating the rugs they came out of the chlorine bath in dull  and often sickish looking colors. So the colors had to be killed and then restored to some degree. Again the changes of colors were painted to one tone. And again, so many people who do not know rugs want the very deep reds, the mulberry (that is never present except on a painted rug) and it was only by painting that these dark, deep, silky colors could be had in new Sarouks.

Yes, you can now buy a good quality Sarouk with the light Persian wash and it should be much preferred to other Sarouks. Another year or two will perhaps bring an end to the painting of even Sarouks. As a matter of fact, most of those painted today are painted only to eliminate very radical changes of colors or so-called hairbrush. Many of these Sarouks will have these radical changes and are not salable without being painted. You must not object to slight shadings because that is to be expected in most Oriental Rugs. No one is happier over this turn of events than I am. My books and writings have been a thorn in the side of many dealers for many years on this score.

*Chapter Seventeen*

# CHANGES OF COLOR AND
# IRREGULARITIES IN SHAPE

MANY RUGS have changes of color—such as a blue field changing from one shade of blue to another, and often to many shades of blue. Often the effect is that one end of the rug is much darker than the other. Again this change of color may be in the design. I have heard many absurd theories in explanation of this, but the most absurd is that the weaver died and another member of the family finished the rug.

I am sure that in most cases the variation in tint is the result of the weaver running out of wool dyed in the exact color. A rug is not woven in one month, and it is doubtful if the full amount of dyed wool yarn is on hand when the rug is begun. This contention of mine is borne out by the fact that most new rugs have these same changes of color.

Another correct explanation for this shading of color in many antique rugs is that the rug might have had none of these changes when new, but that the wool used six months after the rug was begun was dyed with different dyes, and that the dyes might have been obtained by a mixture of colors—one of which was a fugitive color. I have seen some very choice antique rugs where the nap is blue and the back green. The green dyes were obtained by a mixture of yellow and blue, with the yellow in this particular case being fugitive. This is evident on many old saddlebags and tent bags—the nap having been exposed to the sun, while the back has been covered by the back part of the bag (Kelim-like back).

But after all, the main thing to consider in any rug with such changes of color is, "Does it detract from the beauty of the rug?" If it does, it is very much against the rug and hurts the value. But in a still greater number of cases, you will find that this change of colors actually adds to the beauty of the rug. The above is simply a criterion and the purchaser of a rug should be his own judge on this point.

The term hairbrush is almost synonymous with changes of color, but it is generally applied to new rugs that have been treated so that streaks and changes show up. In most cases of washed rugs, the hairbrushes are painted by the importers so that they cannot be detected by the buyer.

The wool is never dyed loose, but only after it is spun into wool yarn (thread).

125

Hence, it is only natural that the wool yarn never comes out dyed perfectly even in color, which explains one reason for the change in tone of the same color in most carpets. Herr Werner Grote-Hasenbalg says this makes the rug more beautiful, and writes as follows: "Thereby the carpets gain in richness of colors, whereas through the more even dyeing with chemical color the effect is more uniform and therefore, dull and dead. The essential thing in the Persian carpets is multiplicity of coloration with a fine graduation of different colors, in contradistinction to the occidental presentation of colors, where in general wide uncolored patches are imposed in close proximity to one another or where the chief effect is produced by one color."

But the facts are that most all rugs have some change of color. If you will examine the plates in all of the rug books, you will note shadings and changes of color in most of these rugs. If you visit the museums, you will find many

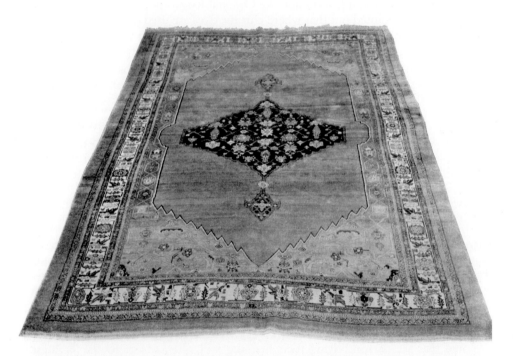

FIG. 51.   ANTIQUE BIJAR FROM IRAN. Size $7 \times 12.3$ feet. Changes of colors or shadings in the plain red (rose) field adds much to the beauty of the Antique Bijar rug in the above figure. The plain fields always have these changes and they are an addition to the beauty of the rug if not too decided.

changes of color in nearly every one of the rugs displayed. The Oriental Rugs in your friends' homes have these changes of color.

The book or guide of the Victoria and Albert Museum in London by Mr. A. D. Kendrick, the keeper of the Department of Textiles, says, "A conspicuous feature of the many Eastern carpets is the irregularity of the tone, where one color is used to any considerable extent, as in the ground. The native dyes vary much in tones, and when the supply of one particular shade is used up before the carpet is all finished, more wool is dyed, or the nearest shade available is taken—and this may be more fugitive than the first—so that the contrast becomes accentuated by fading."

What Mr. Kendrick has said is true, but there are changes and shadings in almost every new rug. So these changes are present in both new and old Oriental Rugs. I repeat that the only advantage or objection to these changes is the manner in which it effects the beauty of the rug. In some it adds much to the rug and in others, radical changes detract from the beauty of the rug. To object to all changes of colors, means that you just do not like Oriental Rugs—period.

I have already pointed out that where chrome dyes are used (in India and Japan) there are no shadings, hairbrushes, or changes of colors.

*Irregularities in shape*

Very few Oriental Rugs come perfectly straight and the beginner often insists that the rug be perfectly straight. When it is remembered that all work is done by hand, even the strands of warp are put up by hand and in most cases the design is carried in the mind, one can appreciate how well nigh impossible it is to have Oriental Rugs perfectly straight.

I do not mean to say that a very crooked rug is not objectionable, but one only has to go to the museums and to the plates in any rug book to observe that few of them were perfectly straight. My contention is that if a rug lies flat, a slight irregularity on the sides and ends is not a serious objection.

Most small rugs will vary an inch or two in width from one end to the other. Most carpet sizes will vary three to six inches in width. Three inches is no objection, and to many people a six inch variation will not be objectionable. It is not, as a rule, noticeable in a room of a home. Extreme irregularities are objectionable to most people. I have seen many old rugs vary one foot in width and that is objectionable to most people.

The main thing is to have the rugs lie flat on the floor and not too irregular. They are handmade and will seldom be exactly true to the inch.

I find that the person buying their first rug will often object to the slightest variation. Perhaps such variation will be eliminated when and if Iran replaces the old looms that have been used for generations with iron looms. This can happen only in the large weaving centers in Iran.

With modern looms in India and Japan, practically all of the rugs from these two countries are perfectly straight.

*127*

*Chapter Eighteen*

# THE DIFFERENCE BETWEEN THE EUROPEAN AND AMERICAN MARKETS

HERE is a story never recorded in any rug book. Each time I go to the London market I am struck with the many differences between the two markets. I am recording this because I am probably the only American dealer that has visited the London market (which is the European market) regularly for the past 32 years (except during the war years).

The type of rugs, the designs in most rugs, the sizes most popular, the texture as to thick and thin types, and the method of operation are all so entirely different.

In the New York wholesale market, the importers pay duty on the rugs, and show them to you in their showroom. One can as a rule buy a selection and not have to buy the entire lot. Rarely does a dealer have a group or lot from which he will not let you select one or more rugs of your choice. One pays a little more for the selection per foot, for the importer has already graded these at different prices, so as not to be left with the less desirable rugs.

There was a time when many lots in New York would not be broken and you had to buy the entire group. I never in all my life bought a half dozen such lots and I doubt if I would have lasted had I succumbed to the pressure to buy such lots.

In London, the sales are conducted very much like the selling in Iran. American buyers formerly went to Constantinople (Istanbul) to buy Persian rugs which had been brought overland by camel caravans most of the way from Iran and placed in a Government warehouse, in Istanbul, for Persian rugs (a Free Port on the same order as the Culver St. warehouse, Port of London Authority, is today). Because it was a tortuous ten days trip from Turkey to Iran in those days, these rugs were brought by large Persian dealers to Istanbul which was more accessible to European and American buyers. The London market replaced the Constantinople market for Europe and with the airplane placing Iran in easy reach, the Istanbul market ceased to be a factor, and very few American buyers visit the London market.

Today I buy rugs in the London market and have them shipped in bond directly to Syracuse and pay the duty in Syracuse.

128

*The great differences*

The two markets offer entirely different types of rugs. With the exception of the Hamadans and the Herez rugs which are to be found in both markets, in general the names, designs, and sizes are different. The many types of Hamadans and rugs from the Hamadan district such as Ingeles, Bibikabad, Dergezin, Husianabads, and Kasvins are in the London market in limited numbers while most of these come to the New York market.

There are as many or more Herez types in the London market than in the New York market. You will not find in London the very coarse cheapest grade of Gorevans that are characteristic of so many that come to New York for sales promotion.

The great differences as far as the Herez and Gorevans are concerned are the sizes and qualities. Europeans want and require rugs about $7 \times 10$ ft. and more than half of the entire supply there will be in this size and most of the others approximately $9 \times 12$ ft. in size. As a class, the qualities are better than the Herez coming to America.

In London you will find great numbers of Bokhara types from Afghanistan and Pakistan which have not come to America. There are very few of the Bokharas which are made in Persia and which are plentiful in the New York market. The Mori Bokharas were seen in New York market in limited numbers in 1960, but only in $6 \times 4$ ft. size.

While practically no Tabriz rugs are being brought to New York, there are great numbers of these in the London market. There are three reasons for this. The best Tabriz are too costly (one small New York importer has a fine selection of these at $5. to $10. a foot wholesale). Next the Tabriz as a class are too mechanical or machine made looking even though they are all handmade. Lastly, the cheaper qualities are too thin and too coarse to stand even the light New York wash.

In the same category with the Tabriz are the Pakistani rugs from Pakistan which copy the Tabriz designs and the red field Kirman design, which will not be easily sold to Americans.

The handwoven rugs from Bulgaria are in London in good numbers, but they too, in spite of their excellent quality are too mechanical looking to interest the American dealer.

In London, we find many more Kashans, so called European Kashans in dozar sizes and carpet sizes approximately $9 \times 12$ ft., $7 \times 10$ ft., and $10\frac{1}{2} \times 14$ ft. The London dealers actually control most of the weaving in Kashan. This came about over a period of many years. The Kashan is a thin to medium nap rug and New York importers found their best success with the chemically washed types. Why buy a Kashan which usually had the medallion and corners, when the all over design Sarouk was much thicker and could be chemically washed and toned down and usually painted to the much liked deep, velvety shades. In London I could find among these new rugs a good number of semi-antique Kashans which seldom came to America.

Great numbers of finely woven, thin, short nap rugs in the following weaves are to be found in the London market: Nains, Qum (Gums), Joshigans, Ispahans, Tehrans and Qashqais. These are thin type rugs in antique designs. Remember

129

this: a finely woven new rug has a set look and its new, natural colors are not as Oriental looking or as appealing as thicker, less finely woven rug.

Nor could this thin rug be washed by the New York washers with great success. Europeans for the most part do not object to these brighter colors so there is no need to wash them. I do not mean to say that all Europeans like these new colors. We have to remember that they are coming to America and buying thousands of our real antique Oriental Rugs, (estate rugs) and taking them back to Europe and selling them for very high prices.

Until two years ago, practically all the thousands of Shiraz rugs that were not taken by the Teheran market or by the many Near East countries other than Iran, were in the London market. These are not as a rule a heavy type rug, nor with the exception of the Qashqai (Mecca Shiraz), a finely woven rug.

Another factor that led to the thinner types going to the European market is the fact that Germany and most European countries pay duty on weight, while we pay duty mainly on cost and price of the rug.

I could point out other different features of the two markets. Another great difference is that there are comparatively few carpets larger than $10 \times 14$ ft. in the London market. The American buying a rug for a living room today wants the one rug in the perfect large size for the room. Europeans seldom want a rug larger than $9 \times 12$ ft.; in fact they come in and buy a $7 \times 10$ ft. size rug regardless of the size of their room and put it down in front of the divan or the fireplace and later fill in with other rugs.

To recapitulate, the fine, thin rugs are there in greater numbers. The great number of rugs in $7 \times 10$ ft. size are to be found there. One must remember that from time immemorial the looms in Iran were for this size and not for $8 \times 10$ ft. rugs. Since American buyers have many calls for the 8 ft. wide rug to a comparatively few in the $7 \times 10$ ft. size, it is logical that these went to Europe. Each time I go to the London market I come home with a dozen or more choice rugs in the approximate $7 \times 10$ ft. size, and seldom a one in the $8 \times 10$ ft. size. It is always difficult to keep from buying many more in the $7 \times 10$ ft. size because there will be scores of appealing rugs. I know how many customers come in looking for the $8 \times 10$ ft. size to the one that will want the $7 \times 10$ ft. rug.

Again the fact that most rugs were being chemically bleached in the New York market up to five years ago, and the fact that thinner rugs would not withstand this treatment, eliminated many of the rugs found in the London market for importation to America.

One of the great differences is in the design of Sarouks. Until five years ago practically all Sarouks came to the American market. Ninety-five percent of these would have the rose, rosy red, or red field with the all over floral design. How the European dealers disliked this type Sarouk may be gauged by the fact that I never saw one for sale in the Government warehouse in London on many trips and by what A. Cecil Edwards said in his great rug book, which I quote in part as follows: "That early type Sarouk was not what the New York Importers required . . . Thus, thirty years ago (his book was published in 1948) . . . the modern Sarouk was born. Their interpretations of American demands prescribed three things, (1) a sturdy construction, with a pile 11–12 millimeters thick, to stand a double wash with alkalis; (2) floral designs covering the whole field of the carpet; (3) 90 per cent rose ground. Thus, thirty years ago . . . the modern Sarouk was

born. . . . Although the design was hardly Persian, it was good; it was successful beyond its creators fondest imaginations.

For twenty-five years the same type of design has persisted—almost unchanged —in the Sarouk quality.

Who is responsible for the strange monomania? The American public—which loves variety—which makes a fetish of change, and is always interested in hand-woven fabrics of character and individuality? Surely not. The American public must be bored to see displayed in the stores, year after year, the same rose ground Sarouks, in the same type of floral pattern.

The public puts this down, perhaps to the imbecility of the Persian weaver. But the Persian weaver (however much he may be pleased to receive orders in the same design, year in, year out) is certainly not to blame.

The responsibility, I fear, must rest squarely on the shoulders of the importers of New York. They have failed to make use of the immense range and variety of designs and colours which the Persian weavers have paraded at their feet." (End of quote of extracts from Edwards' book).

Of course, Mr. Edwards' book as I point out in the chapter About Rug Books, is written from the European point of view.

I have given you this long quotation from his book because European dealers have taken over much of the contracts for Sarouks in Iran and they are discarding the typical American type Sarouk, the rose or red field with the all over floral design. They have also pushed the price of Sarouks up.

So you see the entirely different points of view. I appreciate why the American buyers have stuck to their type Sarouk. It is one of the very few rugs in carpet sizes in a good heavy quality rug to be had in an all over design. Practically every one of the old type rugs that were made in $9 \times 12$ ft. and larger sizes used the medallion designs. For the living room, American women have generally preferred an all over design. The Europeans haven't as a rule tried to buy the one large rug for the living room, and still prefer the old medallion designs.

But I am inclined to agree with Mr. Edwards after seeing some of the new Sarouks that have come to the London market during the past few years. Most of these have come with an all over design, but instead of the all over floral design, they have employed many of the old motifs. For example, when the floral is used, it will be combined with such old motifs as the Shah Abbas, Chinese cloud bank, and others. Actually many of the Sarouks being made for the European market are copying the designs of famous old Ispahan carpets in the museums and designs of the old Classical rugs.

Instead of all being on a rose or red field, the majority are being made on an ivory field, some few on a green field, and of course some with the rose field. None have come with blue fields for many years. Yes, I agree with Mr. Edwards, they are a relief from the American type Sarouk. And those I have seen have been somewhat better quality than most of the Sarouks that came to America.

With the Europeans and Iranians themselves taking much of the Sarouk import market, we are going to find many great changes. I predict that the Sarouks made for the Teheran market and the European market are going to be made slightly finer and have a shorter nap. Since the European market takes few rugs larger than $10.6 \times 14$ ft. it is going to result in a real shortage of large size Sarouks in the New York market.

Many of these new type Sarouks (Sarouks in antique designs on ivory fields) are going to find their way to America and they are going to be liked by the American public. I have been bringing a few of these in over the past four years. The big point is that Europeans have run the price of Sarouks up too high already. In 1960 less than half the Sarouks were available in the New York market as were there in 1959.

Another big difference between the two markets are the hundreds of old worn rugs among the lots and group—especially is this true of the Hamadan dozar size ($4\frac{1}{2} \times 6\frac{1}{2}$ ft.). A few are in good condition but most of these are badly worn and unsalable in America at the prices asked.

# ORIENTAL RUGS VS. DOMESTIC RUGS

THERE is no real competition or argument between our domestic rug and the Oriental Rug. There will always be many times as many domestic rugs sold each year in America as there will be Oriental Rugs sold. People who love Oriental Rugs should be happy about this because if too many people began to purchase Oriental Rugs, the law of supply and demand would make them prohibitive in price.

Actually, there has been only about five to eight million dollars worth of Oriental Rugs imported to America during the past several years.

American manufacturers produce somewhere around $500,000,000 to $600,000,000 in rugs, thus the percentage of Oriental Rugs to domestic rugs sold is about 5 per cent, perhaps even less. The total accumulated stock piles of Oriental Rugs in the New York importers showrooms and warehouses will be ten to twenty million dollars in value. In 1929, the stockpiles of accumulated stock in America no doubt amounted to one hundred million in value.

I am glad that Oriental Rugs are no threat to our local industry as is true of so many other lines of business in America which are currently plagued by foreign imports.

*More homes use Oriental Rugs today than ever before*

This is true because the *good* Oriental Rugs sold each year over the past forty years are, for the most part, still being used by their owners. I said *good* rugs as this does not apply to all the rugs sold over the past forty years.

No other floor covering has ever been produced that claims the loyalty and partiality of their owners as do good Oriental Rugs. Very few possessors of such rugs have ever become tired of them. Wherever you find anyone not interested in Oriental Rugs, disliking them, or discarding them, they will fall into one of these three categories almost without exception:

1. The rugs they disliked were the chemically treated and painted variety.

*133*

2. The rugs they are discarding are unsuitable in size and/or are worn out (and any type rug is more pleasing than a worn out rug).
3. Their dislike is based on never having owned and lived with a beautiful Oriental Rug. Most of these same people will have little appreciation of good music, of great paintings, or other works of art.

*Chapter Twenty*

# USED RUGS SALES

PERHAPS a better title would be "BEWARE OF USED RUGS SALES."

The one type of Oriental Rug sales that has been successful in producing volume sales is the ads like:

## SALE OF USED ORIENTAL RUGS

I am not against the sale of used rugs. I have a section in my own descriptive list offering the used rugs that we acquire. Our used rugs are the first rugs sold.

The best antique rugs and the only antique rugs to be had must come from estates or private collections. There is no other source. The best semi-antique rugs are from the closing of estates or from stores that have taken rugs in trade when their customers have moved to a new home.

A used rug of any description in good condition is worth more than the new unused rug of the same type and quality. It has mellowed and will as a rule have nicer colors. Many people write me that they would "just as soon have a good used rug provided it is thick and perfect," and of course my answer to this is "most everyone has the same idea."

So, it is not to discredit these used rug sales that I present this chapter, but to point out to my readers and especially the beginners some of the pitfalls that are generally present in these large used rug sales. Many people have brought to my attention many disappointments on the part of people who have bought at such sales. It is the deception and overstatement of the facts that is present in so many of these advertisements which is wrong and which the public should be warned against.

Beware such statements as: From Fabulous Estates—Heirloom Rugs; also, lists of rugs that are not rare types but the least expensive of types—Mahals, Sparta, Savalan, and Lillihan. "All Sales Final"—meaning and often adding no exchanges; no returns.

If you can't return an Oriental Rug you buy within a few days after it is purchased, you should be a better expert than anyone I know. Any store that will not

take back or exchange an Oriental Rug that the customer doesn't like or finds something objectionable after they get it home, should not sell Oriental Rugs.

I myself, after nearly forty years in the business have after many bad experiences in buying rugs or taking them in trade, adopted the policy of first bringing the rug to my store and examining the rug there and having one or two of my managers look it over before definitely deciding on the rug or the value. Almost without exception, many defects will show up that we had not seen in the home.

It would take a sizeable volume to relate the hundreds of cases and disappointments that people have told me about in buying from these used sales. I wish space permitted the relating of many cases where rugs have been sent to me for repairs after they have been bought and the purchaser discovered the store would not take the rug back.

Only recently, a customer from Charleston, W. Va. wrote me a beautiful résumé of his sad experience and the lessons he had learned about buying used rugs. Originally, he had written to me seeking a good used Kirman for very little money. I told him it was impossible and wrote him the pitfalls he faced in thinking he might get such a rug—of the name and quality and size he wanted for $500. Later, he wrote that he had bought two rugs from a famous store in Washington, one a Sarouk about $10 \times 14$ ft. for $500. and one a Kashan about $10 \times 15$ ft. for $500. Both rugs were sent to me for renovation, and both rugs were the washed and painted type, and were in very worn condition. Places worn right down to the warp threads had been painted heavily. The edges and ends had not been renovated. He sent these rugs to me with the idea of trading them in—but I was not interested in them at even $200 each, instead of the $500 each he had paid for them.

In the meantime, I sold him a large used Kirman in very good shape. Two months later, he wanted to know if I would take this rug back in trade on another perfect thick Kirman that he had previously considered and of course, we made the exchange.

Our chief warning is not to stay away from used rugs sales, but to beware of deception. Never, in my memory, have some large stores in New York City and elsewhere reached such a low level in offerings of Oriental Rugs. The worst thing they do is to include many new rugs of inferior qualities, oftentimes what might be termed rejects, and to indicate to the public that these are used rugs. In each of the ads will be intermixed many new rugs that have never been stepped on, and the ad would indicate that they are used rugs.

Such items in small boxes as:

| Just 20 scatter rugs |
| --- |
| $49. $4 \times 2.6$, $5 \times 3$ ft. condition Good, Excellent |

By the very inclusion of these items in the used rug headline, one would assume that these were used rugs. And by the words Good, Excellent, (in other places they use W, for worn, G for Good, etc.), anyone would assume that these were used rugs in Good to Excellent condition. There will usually be several such groups, practically every one of which are new rugs. Also intermixed with the $9 \times 12$ ft. group and the extra large sizes, will be many new rugs.

I could relate many inspections of these sales with my own eyes, and it is definite

that many leading Persian importers in the New York wholesale market would confirm the above.

To give just one of many cases—an Episcopalian Minister who had bought an old perfect antique Herez from me moved to New York City and seeing the advertisement of used rugs by one of the famous stores in New York City, he bought a Herez for his dining room. He contacted me for furnishing the other rugs. Instead of being a used Herez, it was a new one for which they paid $550. The quality was excellent but the border at one end was so crooked that no retail dealer was going to buy it. The tragedy of this purchase is the fact that they could have selected the best new Herez in the size for $350 to $450 (maximum) and they could have bought the perfect old semi-antique for much less than the $550 price.

Without going into a full discussion of the Used Rug Sale, because here again I could write a 300 page book on the subject, let me tell you how most of these large stores in New York City handle such a sale, and I have in mind the three well-known stores that have run them in the manner I describe below.

One importer or wholesale dealer makes this operation his specialty, to the extent that he sends his agents all over the country buying used rugs and he acquires them from many sources. Let's assume that he agrees with X store to conduct a used rug sale for that store. He delivers the rugs from his showroom, *after the rugs have been tagged and priced by him and not by the store*. Store X advertises the sale and furnishes the salesmen but has nothing to do with the tagging or pricing. The usual agreement is that Store X will take 33 1/3% (one third of the gross sales) and return the other 2/3 to the dealer who owns the rugs. For example, on a rug sold for $150, Store X retains $50 and the owner takes the $100.

A rather good mark up on worn rugs I would say and of course, remember only part of them are used though the implication is that all are used rugs. And don't forget the dealer who furnishes them and gets the two-thirds has to make a profit. Now you begin to see how little prospect there is to get a choice rug for less than you would pay elsewhere.

Thus, you see that these are not rugs that Store X has taken in trade, but rather rugs that have been brought in especially for the sale. Why does the management of large stores permit this? I too wonder if the directing heads of the great stores are aware of the details of this operation.

The fact remains that they have been producing the greatest volume of sales for the Oriental Rug Department, the manager of which must bend every effort to show the proper volume in his department, especially since so many of the rugs like Sarouks and Kirmans are going so high as to limit the number of sales on these types.

Not only has this dealer operated this same type of sale in three of the best Oriental Rug Departments in New York, but he has held these same type of used rug sales in Philadelphia, Baltimore, and other cities across the country.

The facts are that most of these large stores seldom take any rugs in trade. They as a rule forbid this. I have always taken rugs in trade and so have some stores and many of the smaller dealers throughout the country. My belief is that you can get a better rug and better value from the store that actually acquires them by trade than the large operation described above. If we (my store) take in a used rug and allow $100 for it, we immediately take that percentage of the cost of the rug

we have sold as the cost in our stock record book. A $100 rug will figure about $65 at cost. We take into consideration what we can sell it for after it is cleaned (cost of cleaning) and after it is put in good condition; sides refinished, ends bound, any small breaks restored and the rug put in the best possible condition without spending more than the condition or value of the rug warrants. If it is an old, thin $9 \times 12$ ft. rug and our cost is $65 (we have allowed $100 on exchange, and we do not try to figure our cost at the allowance), and it cost $10 to clean and $15 to refinish sides and ends, we have a total cost of $90 invested. We now offer that rug at $115 to $135 depending upon the rug.

So, I have no advice against buying the used rug from your dealer who actually takes these in trade, nor from these large city "Used Rugs Operation." But if this book is to be of any value to the beginner, I feel impelled to point out the above details.

*Finally to recapitulate*

1. Buy one of these worn, used rugs only if you are looking for a bargain for one-half to one-tenth the price and you do not care if it does not last but a few years.

2. Do not expect to find a rare, choice antique for very little money. You will do as well by going to a reliable dealer for a good antique or semi-antique.

3. Don't buy any rug, used, antique, or new anywhere, if you cannot return it within a week after date of purchase. The reason for the all sales final is clear. The dealer who puts on the sale does not keep his stock there in the store after the sale but moves the rugs back to his place and gets ready for another sale in another store.

4. If you are looking for a very cheap rug and do not mind it being quite thin and worn, be sure to examine the sides and ends to make sure you do not have to immediately spend considerable money to make it usable. ABOVE ALL EXAMINE THE NAP TO SEE IF THE RUG IS DOWN TO THE WARP THREADS AND IF THESE THREAD-BARE SPOTS HAVE BEEN PAINTED TO HIDE THIS.

Most important, examine the rug on the underside to see if there are moth-eaten places where the nap has been cut (as is often the case) on the underside. Make sure that these have not been painted in on the underside. You will be amazed how a little red and blue ink or dye can hide places that are badly moth-eaten.

Even in regular rugs, new and old, this is an old trick and we ourselves have returned many rugs we have purchased because some Persian in Iran or importer's service department took this easy method. Where this has been done, the nap will readily come out if you will pull the nap opposite the spots so touched.

Another thing to watch is rewoven spots in the nap. Pull these on the nap side and see if they come out readily. Often worn places are filled in a false manner and the knots have not actually been tied. Your electric cleaner is going to pull much of it out in short order if the knots are not properly woven.

Again, when you are buying a used rug in a private sale you ought to have some idea of what it will cost to renovate the rug if the sides are worn and the ends are frayed. The above is not terribly expensive, but beware of badly moth-eaten rugs. A close examination on the underside is where you will usually discover this.

I have heard of sensational rugs being bought for little or nothing, but in most cases this is a one-in-a-thousand purchase. If you can buy an old, thin rug for so very little at a private sale, then of course it is fun to take the gamble. But today, except in rare instances, rugs are too much appreciated to sell for nothing.

And finally remember that a rug with a good nap and in good condition, regardless of its age, is worth as much or more than the new rug of the same type—at least it is to me and my customers.

# CARE OF RUGS

THE CARE of rugs falls into two general categories: the *first* is routine care by the owner in the home and the *second* is professional care, *i.e.,* sending the rugs to a cleaning plant for a thorough soap and water cleaning and having the rugs looked over for slight repairs. Important points to be considered in home care are:

1. Electric cleaners
2. Protection against moths
3. Home cleaning
4. Keeping your rug flat
5. Use of non-skid materials
6. A few "Dont's"

*Electric cleaners*

We are often asked: "What type electric cleaner do you recommend for Oriental Rugs?" Our answer is: "So long as your Oriental Rugs are not chemically treated, use any type of electric cleaner you prefer."

With the heavy chemical washing and painting process nearly a thing of the past, this question is not any longer an issue *except* for about one-third of the new Sarouks being sold today and for those chemically washed and painted rugs you already own. Remember that for 40 years, until about 1950, the majority of all Oriental Rugs sold in America were both chemically washed and painted.

Today, not two percent of the rugs have this treatment. Your Persian washed rug, the London washed rug, and the present-day light New York wash should be put in the same category as the unwashed rug when discussing the care of Oriental Rugs.

How often should one use the vacuum cleaner? Once or twice a week with the heaviest type cleaner with a brush action is a good average. A suction-type cleaner can be used as often as you wish—every day if necessary. This does not mean I prefer the suction type though it is, in my opinion, less powerful. Personally, I prefer a powerful brush-type cleaner.

If your rugs are real old and worn thin, the suction type is better. A carpet sweeper can be used as often as you wish to supplement the electric cleaner.

*Protection against moths*

There is no excuse whatever for a rug being damaged by moths. An hour every six months spraying or applying moth preventatives and moth killers eliminates the danger completely. I can understand how difficult it is to prevent woolen sweaters and other woolen clothing from some moth damage, but it is ten times easier to avoid damage to rugs. Thirty years ago this was not true as our sprays and other materials were not always as efficient as they are today.

If a rug is vacuumed once a week, there will never be moths in that part of the rug. But I would go further and say that if the underside of the rug (outer edge for one foot width) is vacuumed once a month, the danger would be eliminated.

However, many homes have large davenports and other heavy pieces of furniture that cannot be moved very often and it is here that the moths lay eggs. Any good moth killer and moth preventative (and I am not sure that all of them kill or destroy the eggs) will prevent moths. Once the moths have laid eggs, the surest way of eliminating them is to use a moth spray (which can be applied with a sprayer or with a damp cloth) which contains a solvent as a base. I believe that this is more important than DDT and other ingredients because it destroys the eggs on contact.

If every six months you will spray the underside of the rug about one foot in along the border and all the front side of the rug wherever it is covered with furniture, the chances of moth damage are nil. Of course, the perfect job would be to spray both sides of the rug completely once a year. If you would spray the front side and rub it off with a cloth, it would be almost as good as any dry cleaning with gasoline. Except for the danger of gasoline, there is no better moth killer. Many people add one part of tetrachloride (a spot remover and chemical used in fire extinguishers) to four to seven parts of dry cleaning gasoline. It is excellent, but too dangerous for general use.

Actually there is little danger of moths if the rug is walked on daily. My own rug cleaning plant handles several thousand Oriental Rugs yearly, and I have sold many thousand Oriental Rugs locally since the war. Of all this number, I know of only six rugs that have incurred moth damage and in each case the owners worked and had no help at home. We have had moth damage cases but not in any of the rugs sold since the war.

I am going to break with a rule and list *Keyspray*—a liquid spray made in Cleveland, Ohio, which we have used with great success for 30 years. I don't know a single person connected with this company, not even the local salesman, but so complete is the protection that I list the name. Some of the large oil companies have similar products which are excellent. Our continued use of the higher priced *Keyspray* is due to the fact that it is practically odorless and it has proved to be effective for the past 30 years.

If you detect moth webs on the underside of the rug, saturate that section with *Keyspray* or another material with a solvent base. A good spraying is a sure preventative. If you are going away for six months, it is best to spray rather heavily and then you can leave the rugs on the floor with no risk.

But demothing once moths are in the rug means saturating that section of the rug or the entire rug if necessary with *Keyspray* or other materials.

*141*

*Home cleaning*

Oriental Rugs do not have to be sent to professional cleaners every year. I would definitely advise against yearly washing. No definite rule can be put down as to how often a rug should be sent out for a thorough soap and water washing. Once every two or three years would be a good general rule. In some homes once in five years would be sufficient. When a rug is really soiled, it should be thoroughly washed and rinsed.

Superficial cleaning at home with one of the good oil base soaps can be done as often as necessary. The rug is simply sponged with the lather and no rinsing is necessary. This of course is only superficial but, with a good soap, you will be surprised how good a job it does. It is as good a washing as you would get from one of the cleaners who merely shampoo your rug with soap and remove the suds with a suction machine. A professional cleaning should include a thorough rinsing.

Again I mention one product, a soap called *Marvella* which is made by the same company that makes *Keyspray*. We have tried many of the new soaps, but we have never found one that we like as well as *Marvella*. Undoubtedly there are other excellent soaps on the same order.

We mix one part of *Marvella* to 20 or 25 parts of water. Using a synthetic sponge, we squeeze the water out and rub the rug with suds. There is no prescribed manner of rubbing; either with the nap or against it seems to work equally well. If the lather is not thick when you squeeze the sponge, add more soap. *This material and the application is fool proof.* Too much soap or too much water on the rug will do no harm. There is no risk even if you do a poor job. Do not remove the suds or residue by rinsing. The base of the soap is oil and it is good for the wool.

By doing this once a year, twice a year, or even every month if you wish, you eliminate the need for sending your rug out to be cleaned. This is a far safer procedure than having cleaners come to your home with a rotating scrubbing brush and in effect do the same thing. Carelessness with that brush can do harm, and you are not sure what type soap they will use.

However, as a rule there is little danger from soap. Be sure you know the contents of the soap you use; that is, make sure the soap has an oil base. One or two cleanings with a poor soap will hardly harm a good Oriental, but continuous use of an alkali or strong soap could damage the wool.

*Keeping your rug flat*

The surest way to keep your rug flat is to make sure it lies flat when it is first purchased and laid on your floor. Do not allow any salesman or manager tell you that you will walk out the wrinkles with use. This will seldom happen.

We size every single rug we sell to insure its being perfectly flat. Not one in ten of the large stores do this, and I regret to say that most all dealers do not size many of their rugs.

*Use of non-skid materials*

After the rug is sized you should place a rubber cushion of some type under your

large sized rugs and either a rubber cushion or some non-skid material under small sized rugs. If you do this, your rugs will be in much better condition at the end of any given period of time. A rug wears through wrinkled sections quickly.

## A few "Dont's"

Don't take your rug out and beat it. It is better to turn the rug upside-down and vacuum the back side to dislodge gravel and imbedded dirt.

Don't send your rugs out to be soap and water washed too often or the fringe will break off to some extent. Cotton warp swells and pulverizes with too frequent washing.

Don't permit breaks on ends and sides to go over a month or two without repair. If the breaks are small, any dealer will show you how to catch the edge or do a little overcasting with wool on the sides. Anyone can do simple work on the edges and ends of rugs.

## Professional care

When your rugs are soiled and your own home cleaning does not make them look good, then it is time to send them out for a good, thorough cleaning. It is most important that you know something about the company or plant to which you entrust your valuable rugs.

Based upon knowledge of scores of plants all over the country, my estimate is that over 50 per cent of the rug cleaning plants do a poor, inferior job. Actually many do not wash your rugs, they merely shampoo with soap and scrape or suction off the surplus soap. Then they vacuum out as much soap as possible. A good home cleaning job would have been just as good.

I advise most of my customers to avoid the old fashioned rotary brush method. A good plant should have a wringer—two large rubberized rolls through which the rug is passed after being washed. This insures that the water is extracted evenly.

The latest method is to apply soap with a fan-like power spray—soap solution applied under pressure—and then thoroughly rinse with lots of water with the same fan-like spray. The rug is then passed through the wringer and goes to the controlled drying room.

This jet spray is, in my opinion, the very best method. Other satisfactory methods are also used. Above all, make sure the plant does more than merely the "shampoo method" without rinsing. Make sure that a large amount of water is used in a thorough rinsing.

# Chapter Twenty-two

# ABOUT RUG BOOKS

WHEN I assigned a chapter in this book to Rug Books, I intended to point out hundreds of mistakes made by rug book authors in the early years. These mistakes are readily recognizable to present-day dealers, importers, and collectors.

But I have changed my intended purpose for many reasons. If I wished to record all the discrepancies and differences of opinion, it would take a sizeable book for this alone. I am too indebted to Mr. Mumford and to Dr. Lewis to seriously criticize their books. I know well that if either Mumford, Lewis, or Hawley had had the experience of seeing and buying as many rugs as I have, or if the modern means of transportation to the Orient and the rug weaving countries existed at the time their books were being written, their literary ability would put my best effort to shame. Each of these books have been very helpful.

I am indebted to a hundred other authors of booklets and pamphlets, each of which broadened my knowledge. Many contained mistakes which would not have been present had they been writing today. So this chapter now has three purposes.

First: To point out that when you read one of these old books (most of which were witten between 1900 and 1917), they are completely out of date on present-day rugs or on any rugs that are imported today. These books deal with rugs made prior to 1900 and since none of these are imported today, they deal only with antique rugs from estates or rugs in private collections.

Second: To urge you to read one or more of these books for background. If you want to purchase an antique or semi-antique rug, and if you would like to know something of the pioneers in one of the great arts, you should read one or more of these books. I need not urge the collector or hobbyist to do this because he acquires a copy of every rug book he can buy.

Third: To furnish you with a bibliography of rug books. Below is a list I would recommend, broken into convenient categories. Later in this chapter I shall more fully discuss some of the books in each category. Since most of these books are out of print and can be obtained only from estates and second hand book stores, I do not give the publisher for all of these.

# ABOUT RUG BOOKS

*The three standard books*

HAWLEY, WALTER A. *Oriental Rugs—Antiques and Modern.* New York: John Lane Co., 1913.

LEWIS, DR. G. GRIFFIN. *The Practical Book of Oriental Rugs.* Philadelphia: J. B. Lippincott Co., n.d.

MUMFORD, JOHN KIMBERLY. *Oriental Rugs.* New York: Scribner & Sons, 1900.

*New book on Persian rugs*

EDWARDS, A. CECIL. *The Persian Carpet.* London: Gerald Duckworth & Co., 1953.

CLARK, HARTLEY. *Bokhara Turkoman and Afghan Rugs.* London: John Lane Co., 1922.

LEITCH, GORDON B. *Chinese Rugs.* New York: Dodd, Mead & Co., 1928.

THATCHER, AMOS BATEMAN, *Turkomen Rugs,* New York, E. Weyhe, 1940.

*The old rugs*

MARTIN, P. R. *A History of Oriental Carpets before 1800.* Vienna: I. R. Court and State Printing Office, 1908.

VON BODE, WILHELM. *Antique Rugs from the Near East.* New York: E. Wyke Co., 1922.

*Other books by Americans*

DILLEY, ARTHUR U. *Oriental Rugs and Carpets.* New York: Scribner & Sons, 1931.

ELLWANGER, W. D. *The Oriental Rug. A Monograph on Eastern rugs and carpets.* n.p., 1906.

HOLT, ROSA BELLE. *Rugs, Oriental and Occidental, Antique and Modern.* n.p., 1901.

JACOBSEN, CHARLES W. *Facts about Oriental Rugs.* Syracuse: Privately printed, 1931 (revised, 1952).

*The Yerkes Collection of Oriental Carpets.* London: B. T. Batsford, 1910.

*English books*

HENDLEY, COL. THOMAS H. *Asian Carpets 16th and 17th Century Designs from the Jaipur Palaces.* London: W. Criggs, 1905.

KENDRICK, A. F. and TATTERSALL, C. E. C. *Handwoven Carpets—Oriental and European.* 2 vols. n.p., 1922.

POPE, ARTHUR UPTON. *A Survey of Persian Art.* 7 vols. London: Oxford University Press, 1938.

*German books*

JACOBY, HEINRICK. *Eine Sammlung Orientalischer Teppiche.* n.p., 1923.
——. *Samling Orientaliska Mattor.* Stockholm: 1935.
——. *How to Know Oriental Carpets and Rugs.* London: Allen & Unwin Ltd., 1952.
RIEFSTAHL, RUDOLF M. *A Short Bibliography for the Student of Oriental and Western Hand-knotted Carpets.* New York: N.Y.U. Bookstore, n.d.

*A "must" for collectors*

DWIGHT, H. G. *Persian Miniatures.* New York: Doubleday, Page & Co., 1917.

*The three standard books*

Dr. Lewis was a Syracusan and I had the honor of being asked by Dr. Lewis to assist in the revision of his last (1945) edition. Dr. Lewis was my dear friend for many years. You will be fortunate indeed if you are able to purchase his book, or any of the above, for as little as $10.00.

Below is a letter from Dr. Lewis, written when he retired and I took over his collection of rugs for sale:

*Syracuse, New York, April 3, 1939*

*Mr. Charles W. Jacobsen*
*Dey Brothers & Company*
*Syracuse, New York*

*Dear Mr. Jacobsen:*

*Inclosed herewith is a list of my rugs—forty-nine in all—which I am turning over to you for sale.*

*As you know, I am retiring from practice, disposing of my home and moving out of the city. I have been interested in Oriental rugs for forty years, in fact, it has been a hobby of mine. Naturally I have accumulated many Oriental rugs and in the future will have use for only a few of these. Many of these are rare gems while others are just utility rugs—beautiful floor covering.*

*During the past several years, I have recommended you to those who asked my advice on Oriental rugs. I am glad to turn my rugs over to you—who I consider one of the best experts in the country. Syracuse and Central New York is particularly fortunate in having an Oriental rug dealer of your standing and reputation.*

*Cordially,*
*GGL/*                                  *G. Griffin Lewis*

All three of the above books cover the same ground, so you need read only one. Mumford's book was the first and you will find the same facts in the others. Hawley's did add some additional information, and is one of the best books ever published.

*New book on Persian rugs*

Everyone should read Cecil Edwards' book. It is a large volume, and sells for $30 in America. It deals only with new Persian rugs and is written from an English point of view; or rather, on Persian rugs made for the European market and not those made for the American market. There are only 4 color plates but it has hundreds of black-and-white illustrations and plates of rugs. It devotes only 6 pages to a discussion of 8 different famous antique carpets and shows black-and white plates of these. It is the best book every published on Persian rugs even though it deals principally with present-day rugs. It does *not* cover any of the scores of types from Turkey, Caucasia, Turkestan, China, India, or Afghanistan. Yet it is a must for everyone who can borrow a copy. Very few libraries will have it.

If you cannot obtain any of the books mentioned so far, write to the Victoria and Albert Museum, Department of Textiles, London, England, for their *Guide to the Collection of Carpets,* 1931 edition. A few years ago this sold for three shillings sixpence ($.49). It contains 68 pages plus some 55 black-and-white plates. My guess is that even today it will not cost more than $1.50. It is an excellent work and covers rugs from Persia, Turkey, Caucasia, Central Asia, China, and others.

*Turkoman and Chinese rugs*

Your basic knowledge should include a book on Turkoman rugs and Chinese rugs. The two books listed under this category are outstanding on the subject.

*The old rugs*

For those who wish to study the very oldest rugs—those made prior to 1800, you may find the two books listed under this heading in some few libraries in America.

*Other books by Americans*

Mr. Dilley's book dealt principally with antique rugs in 1931, and added nothing to Mumford's, Hawley's or Lewis'.

I knew W. D. Ellwanger and his collection well. One of my relatives sold him many rare rugs. Ellwanger's adviser on rugs was one of my best teachers and dear friends. I later acquired many rugs from the Ellwanger collection.

Amos Bateman Thatcher's book is devoted exclusively to Turkoman rugs. It follows in the footsteps of Englishman Hartley Clark's book. It is a little over-technical in its use of names such as Torba and Juval, instead of the simpler name of Tent bags, and it refuses to recognize the old, well established names of Royal Bokhara for Tekke rugs, or Princess Bokhara for Prayer rugs. Nevertheless, it is a fine book and a valuable contribution to the subject, especially since there are so few copies of Clark's book in America. The book has been out of print in England for many years.

*English books*

Arthur Upham was the Pope of the Art Institute of Chicago. The six chapters in this book which are devoted to rugs, have excellent plates on antique rugs. Col. Hendley's book deals with early Indian rugs.

*German books*

There are many other rug books by German authors which I shall not attempt to list here. Of major interest is Jacoby's 1952 English edition which is intended to be a small encyclopedia. It will interest the collector in America, but I cannot overlook my suspicion that this small book draws heavily from Mr. Jacoby's 1923 German edition. Thus, like most of the American books published between 1900 and 1920, it is out of date except for the discussion of antique rugs. Although published in 1952, Jacoby does not mention such standard names as Bibikabads, Borchalus, Engeles (Ingeles), Dergezins, Kaputarhang, new Ardebil rugs or Bokharas from Persia as well as many other names that have been known to every dealer for 30 years. One has only to read A. Cecil Edward's fine book and compare it with Jacoby's and the same conclusion I reached is inescapable.

Riefstahl's book is a bibliography which contains a rather complete listing of books that would be of interest to the student of rugs.

*A "must" for collectors*

Mr. Dwight's book contains one chapter entitled "About Rug Books." This is a "must" for collectors who are not afraid to be disillusioned by many statements made in rug books. The entire chapter is devoted to a review. Actually it is a critical review of the incorrect information in rug books. I include below some of his criticism—not that I completely agree with him—to substantiate my point that the old rug books are not always correct, and are badly out of date.

If this was true 43 years ago, when Mr. Dwight's book was first published, then it is true to an even greater degree today. Yet there were no up-to-date books published until Edwards' 1953 edition on New Rugs from Persia. Mr. Dwight begins by giving Mr. Mumford full credit, but adds:

"Mr. Mumford is by no means infallible. But his limitations have been those of opportunity rather than of good faith. To him alone is due, in our country, the credit of having made some sort of order out of a picturesque chaos. He inquired, he studied, he travelled; and his book remains the most informing that has hitherto been published in America. If he pays the penalty, so does he deserve the glory, of the pioneer. And I hereby offer him a humble tribute of respect for having blazed out a way which many followers have done almost nothing to widen . . . But it is hard to escape the conviction that without Mr. Mumford, the names of few of these ladies and gentlemen (author's of rug books) would ever have seen print. . . . One recognizes again and again Mr. Mumford's general plan, Mr. Mumford's facts, Mr. Mumford's textile tables and Mr. Mumford's mistakes, down to his very quotations and turns of phrase."

Dwight continues his blast at Mumford's followers when he states: "To make a complete catalogue of the misinformation which the rug fraternity hand on from one to another would need 'a painful man with his pen.' "

After pointing out patent mistakes by the many authors, Dwight hits Mumford's followers rather too hard when he says: "Their method, one gathers from their books, is to sit down with Mr. Mumford in the one hand and the school geography in the other."

Continuing, Dwight informs: ". . . of all the gibberish that has been written on the subject, it would be hard to find more crowded into one page than may be read in (name omitted here) book." Dwight then points out many statements made by this particular author and then concludes: "Now hardly one of these statements is true."

In his book, Dwight points out many errors in all the American rug books published up to 1917. It would serve no purpose here to list them in number, but to cite one example as typical should suffice. Says Dwight: ". . . Eliza Dunn makes a less pardonable confusion when she speaks of 'Meshed or Muskabad' (pp. 103–117). Meshed is in Eastern Persia and Muskabad in Western Persia. The two rugs are entirely different in every way."

*Conclusion*

I stated in the preface that this book was based principally on my own table of experience, but in the course of preparation I have read and reread scores of books and booklets. I made notes of hundreds of points and statements written by the authors 45 to 75 years ago. I intended to list these errors because today every importer and collector knows differently.

The mistakes were due to lack of opportunity. In their time it took a month to get to Iran and the only means of moving from one town to another in Persia was by camel or donkey trails. Today, one can fly to Iran in 24 hours and there are fairly good roads between the larger cities. Teheran, today a city of 3,000,000 people, has 100,000 automobiles and incidentally, has over 1,000 stores selling Oriental Rugs. There is a fine, up-to-date hotel in the city of Hamadan.

So I repeat, when one goes to the public library and finds 2 or 3 Oriental Rug books, all written between 1900 and 1920, and all based on Mr. Mumford's facts and on rugs which were made prior to 1900, these books do not tell you about the present day possibilities. They are completely out of date except for their discussions of antique rugs.

# ADVICE FOR THE RUG PURCHASER

I COULD NEVER hope to give full coverage to this topic, but I list below a few vital points that should be of great help.

1. Above all, remember that name does not necessarily determine quality. Rugs by the same name vary tremendously in quality, beauty, and value.

2. There is at present no danger of buying a new rug which has been chemically washed and painted unless you buy a new Sarouk. Today, only about one-third of these are so treated.

3. Do not buy Oriental Rugs from itinerant salesmen. Buy from a reliable store that has been selling Oriental Rugs for some time.

4. Do not buy from a department store which is in and out of the business. Stores often enter the Oriental Rug business from time to time, for two or three years, and then drop out again. This can cause complications. For example, in my town a department store went into the business for a few years. A religious organization purchased two rugs from this store. Two years later the rugs were wrinkled and the ends were pulling out. The store had not sized or serviced the rugs when they were purchased. When the purchaser returned to the store in question, he was informed that they no longer carried Oriental Rugs and they could offer no help or suggestions. The rug owner then came to me for help. We bound the ends (had this been done before the rugs were sold it would not have been necessary for 10 or 15 years) and we sized the rugs. That was seven years ago. They are still flat and the ends are fine.

5. Be sure the rug you buy is properly serviced, which means that every rug should be sized flat when sold and the ends should be overcast. No gaps should appear in the wrapping on the sides. Many stores sell rugs just as they buy them from importers and nine out of ten new rugs need some attention to the ends and sides, and they need to be sized.

6. Above all, do not buy any Oriental Rug from any store that advertises a sale with "No Returns" and/or "No Exchanges." If you cannot return a rug for credit or at least an exchange, you would be wiser to buy elsewhere.

7. Do not buy a rug just because it is antique. There were poor rugs made

many years ago too. However, time and wear will have eliminated most of the poor antiques, and the good rugs remain.

8. Do not let anyone tell you that the more an antique is worn the more valuable the rug is. The better the condition, the more valuable the rug, regardless of type.

9. Do not try to buy a good Kirman rug unless you are willing to pay $900 and up for a $9 \times 12$ ft. Other good Kirmans are in the same proportion per square foot. The better to best Kirmans cannot be bought for $800 ($9 \times 12$ ft. size). Better for you to buy a good grade rug from India or Japan for $500 to $800 in the same general colors. If you prefer Persian, buy the slightly more colorful Kasvin or Sarouk with the ivory ground. These will last a lifetime, whereas the $800 Kirman will most likely wear thin in 8 to 15 years.

10. Do not expect the cheapest grade of rugs—Persian or Indian—to wear a lifetime.

11. Do not buy an expensive rug at a "Used Rug Sale." You can generally buy a better rug—clean cut merchandise from the regular stock of the same store —at the same price. If you pay $50 or $100 more for a $9 \times 12$ ft. of the same type, you have a better value than the bargain rug.

12. Do not buy an old, worn, chemically washed and painted rug. The chances are that when you have it cleaned, the poor dyes with which such a rug has been painted will smear and come off and you would have to discard it or spend more than it is worth to make it presentable.

13. Do not buy rugs at auction houses unless you know rugs well and have carefully examined them before the sale. Auction of private estates in the home itself is alright provided you have examined the rugs carefully. We see too many tragic cases as a result of such purchases.

14. In buying a worn or used rug, get down on the rug and examine it carefully on back and front. Take the rug to full daylight if possible.

15. Buy as good a rug as you can possibly finance with the idea that it is going to be valuable property and represents an investment—just as the home you buy. A good rug is going to last a lifetime and it seems practically certain that very few rugs will be available from Iran in another decade.

# Chapter Twenty-four

# THE OUTLOOK FOR THE FUTURE

WHILE no one can foretell with certainty what the future of rug weaving in the Orient will bring, certain developments make some predictions seem less like guess work. Several factors stand out in the Iranian (Persian) situation.

First, we consider that Iran (Persia) has been the principal source of Oriental Rugs for the past hundred years and continues to weave great numbers of rugs today. Turkey, Caucasia, and Turkestan have produced very few rugs during the past twenty-five years. Henceforth there will be fewer and fewer Persian rugs available at higher and higher prices. The reasons are clear and a few of these reasons are: (a) Greatly improved standard of living (b) America has pumped nearly a billion dollars into Iran's economy (c) Children who do much of the weaving are compelled to attend schools (d) New industries and modernization means better jobs at higher pay (e) Increased cost of weaving wages.

Second, prices will continue to increase until they become too high except for the very rich.

Third, quality will deteriorate. New York importers, Teheran dealers, and European dealers are not going to willingly quit when prices slow down sales. The rugs will be made from coarser materials and the quality cheapened.

A. Cecil Edwards, has this to say in his book published in 1953: "It has often been suggested that we are witnessing the beginning of a decline in the carpet-weaving industry in Persia; a decline which (we are told) will continue until the industry reaches the status of an insignificant, *recherche* craft—or perhaps disappears. The protagonists of this idea point to the growth of power-driven industries in Persia which, they declare, are absorbing materials and the labor. In this connection they draw attention to the decline in out-put of carpets in Turkey, and conclude that in Persia like causes will produce like effects.

"I do not share this view. Industrialization, no doubt, accounts in part for the decline in the out-put of carpets in Turkey. But I suggest that it is deceptive to draw a parallel between the two countries; because the position in Persia is, in one important respect, fundamentally different from that which existed in Turkey; in Turkey weaving was concentrated in the towns; in Persia three-quarters of the output is produced in villages and by nomadic tribes. Industrialization in Turkey

was bound, therefore, to affect carpet weaving, because most of her factories were built on urban sites, but a like movement in Persia would hardly touch her peasants in their distant and scattered villages, or her nomadic shepherds. Industrialization might produce a decline in the output of the towns, but it could not, of itself, seriously weaken or destroy a peasant craft.

## "The Decline in Production

"I do not, therefore, consider the present decline in production is an indication of decrepitude. It is due rather to a variety of economic and social causes, foreign and domestic, which will probably prove to be temporary and self-liquidating. Without any doubt, the most important cause is the shrinkage in the demand from Europe. This is indicated by the maintenance of production at a high level in Kerman and Arak—the only two weaving centres which depend for their prosperity on the United States. If and when Europe recovers and orders begin to flow once more from Britain and the Continent in a slowly increasing volume, Persia will, I am persuaded, be able to keep pace with the demand.

"I have been hearing for fifty years about the decline and ultimate extinction of the Persian carpet. Indeed, one of my earliest recollections of this sombre prognostication was a warning from an uncle (shortly after I entered the business) that I had embarked upon a sinking ship. But for half a century this luxury ship of slender tonnage has battered and buffeted her way through one economic gale after another."

Mr. Edwards' book was published about 10 years ago and his facts were gathered earlier. I wonder if he would not change his statements if he were alive and writing a new book today? At the time he wrote (probably 1950), Europe was buying very few rugs. Today, European countries and especially West Germans are buying many more Persian rugs than America. He would hardly believe that the Persians themselves (with over 1,000 rug stores in Teheran) are buying many rugs for their own use and also buying rugs to put aside as investments, believing prices will increase.

Mr. Edwards' point of view on the modernization and improved standard of living not affecting the weaving of rugs in the distant and scattered villages or her nomadic shepherd weavers, may prove partially correct. But already there is ample evidence that even the village weaving is affected. Three years ago, one could buy unlimited numbers of Kabuterhang carpets, a village rug. In 1960–61, they were indeed very scarce and have risen sharply in price. Certainly the villages and tribes will produce some rugs but not as many as in the past.

It is possible that with the Persians themselves buying so heavily and with European buyers willing to pay more than Americans, there will be fewer Persian rugs in America each succeeding year. It is my belief that we will not see any extensive weaving in Iran in another 10 years. As to the good quality Persian rugs in American homes, whether new or old, they seem certain to become more valuable each succeeding year, provided they are kept in good to excellent condition.

*153*

### Future of the rug industry in India

I have already stated that I look for India to supplant Iran as the largest producer of hand woven rugs. More and more people are going to turn to rugs from India in all types of designs—plain rugs, Savonnerie designs, and Chinese designs.

Home owners who do not want as much color as Persians offer, will turn to the pastels in the Savonnerie and Aubusson designs from India for both durability and beauty. When Mrs. A sees her expensive wall to wall carpet become a little threadbare all too soon and then sees Mrs. B's rugs (good quality rugs from India she has owned for 15 years and which are still in perfect condition), Mrs. A is going to buy some type of rug from India. Yes, even the plain, handmade rugs from India and the plain rugs with hand carved designs will grow in favor for their durability and economy.

India has over 300,000,000 people and is not in the same position as Iran with only 15,000,000. I predict greater numbers of rugs from India in the future. I hope India will start anew to weave some of the rugs in Persian designs that she wove before the last war.

### As to Pakistan rugs

We will see increased numbers of these in America in the next 10 years, and prices will continually go higher, as Pakistan is gradually increasing its standard of living.

### As to rugs from Russia

I do not believe the new venture of Russia and her Caucasian and Turkestan States will last. It is the unprecedented, unbelievable demand in Europe, which has never in history been able to buy a fraction of the rugs they are now buying, that influenced Russia and some of her satellites to begin weaving in 1960–1961.

### Expectations for the future

Anyone who has rare old Caucasian rugs, old Bokhara rugs, old Turkish or old Persian rugs, will do well to cherish them. They are a lost art and will never again be available except from estates. Even today no one can say what they are worth, and their value in years to come seems certain to be ever higher.

Japan is sending us three excellent types today, but the Imperials have already priced themselves too high to sell in volume. The Pekings in Chinese design will continue to sell in good numbers at the present prices. If increased wages in Japan do not push these up much over present prices the demand will grow.

Finally, with all the world clamoring for a better standard of living, we will see fewer and fewer real handmade Oriental Rugs. I dare not predict the end of handmade rugs in 10 years, but certainly it seems safe to say many types will cease being made.

*154*

# PART II
## Description of Types

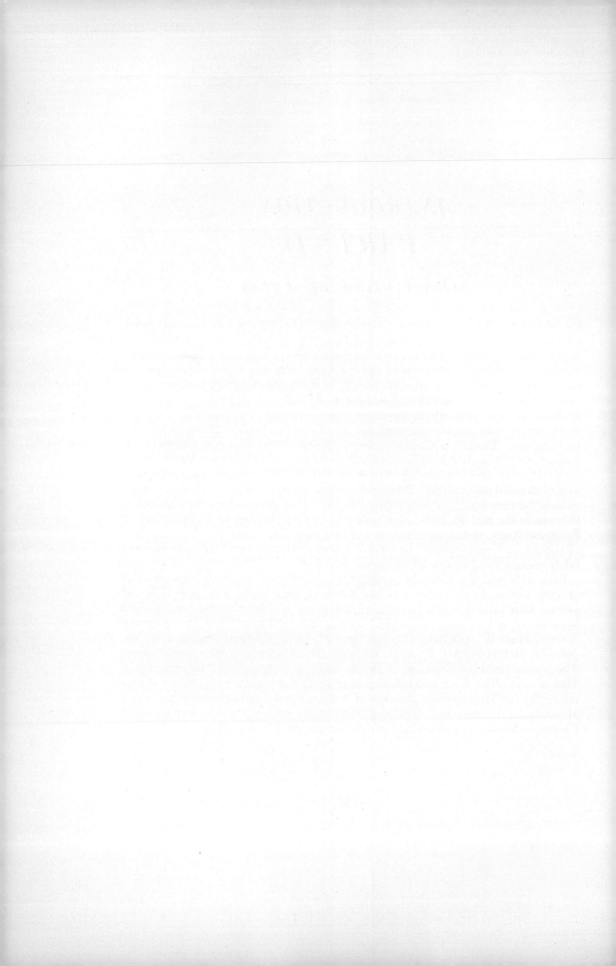

# INTRODUCTION

IN PRESENTING the following alphabetical list of all types of Oriental Rugs, or types that might be in the same category as Oriental Rugs, such as the French Aubussons and French Savonnerie rugs, I have tried to give prominence to what will be most helpful to the general public. Also, I feel sure that most experts and collectors will find the information factual, correct, and helpful. I have not given great space to the classical old rugs of the 15th, 16th and 17th century. If I wrote in detail on these, it would be based on others' writings, much of which is guess work, which they readily acknowledge in all the old books. These include the Goblien rugs, Damascus Carpet, Armenia Carpet of the 15th century, and Ispahans of the 16th and 17th century—which probably includes Herats, Vase Carpets, Animal Carpets and Hunting Carpets of the 15th and 16th century. I have not tried to give detailed information. This for the simple reason that it would be of interest to only the very few. Not even the majority of rich collectors have been interested in these in the past 45 years. Nor have I gone into great detail on the Polish or Polonaise Rugs, woven in Persia in the 16th and 17th century. Seldom has one of the above types appeared in estates. I assume that most all of these are now safely tucked away in the great museums.

Prior to World War I, before our income taxes became so devastating, a number of very well-to-do collectors did buy a few of these large, rare rugs. The last private loan exhibit that I have information on, was held at the Metropolitan Museum of Art in New York, and among the exhibitors were Mr. Benjamin Altman, Hon. W. A. Clark, Mr. Theodore M. Davis, General Brayton Ives, Mr. John D. McIhenny, Mr. P. A. B. Widener, The Museum of Fine Arts, Boston, The Kaiser Friedrich Museum of Berlin, and the Metropolitan Museum of Art. That was in 1910. I am quite sure that most of these great rugs shown in that exhibit by the Metropolitan Museum of Art have now been donated to the larger Museums in America and elsewhere. Most of the rugs of the above types are in European Museums and comparatively few are in our museums.

*157*

*18th and 19th century rugs of most interest to collectors*

During the past 50 years, collectors and experts have had interest in rugs 200 to 400 years old, but so many of these were in large sizes that their interest has been confined to the best specimens made in the 17th, 18th and 19th century. From Turkey, such rugs as Ghiordes, Kulah, Ladik, Bergamo, and others. From Iran, their interest was in a fine or excellent example of any type, the most valuable being a Feraghan, a silk warp Sena, a Laver Kirman, a Zeli Sultan, and others. A fine example of each type from these countries and from other rug weaving countries claimed their interest. We have covered these in detail, and I believe that most experts will agree that I have stated facts, and not a lot of theory and glamor about each rug. It is on the rugs that are still available that I have given the most information. It is the beginner, and the seeker of good Oriental Rugs as floor covering, who needs the most help.

*Some new trade name will be missed*

I have tried to list each and every name of any importance with the exception of some of the new trade names from India that are appearing every few months. You may expect many new trade names of rugs made in India in the next few years. If Turkey, Russia, Bulgaria, and Pakistan succeed in their new effort to make rugs and find a market for them, we may be confident that a rash of new names will appear. These rugs from India and Japan are in French Aubusson and Savonnerie designs, in Chinese designs, in an almost plain field with a floral spray in two or four corners. At the moment, the best of the Savonnerie types from India are under the trade names of Kalabar, Kandahar, Indo-Aubusson, and Indo-Savonnerie and are well known as the best being imported at this time. Others in slightly lesser quality to a much cheaper quality, are beginning to come in numbers. With 2,000,000 people in India now in the rug weaving industry, I look for India to become the largest producer of Oriental Rugs. At the moment Iran still sends more rugs to America, but they now have so much money from America, that their prices are rising too high, and fewer and fewer people are weaving each year.

You may want to buy one of the less expensive rugs from India in one of these types. This is well and good for the bedroom, and for a limited number of years' use in the living room. But, if you are seeking a good quality rug from India or Japan, you should inquire if it is one of the real good qualities made in this type. Without going into more detail, you need only to see the less expensive rugs and the better quality side by side to recognize which is the good quality. This is an important point, because with Iran pricing herself out of the market, and the European countries helping them by being such eager buyers, we can expect many promotional features in the cheaper grade of rugs from India. This is true because these rugs will be the only ones that can be offered as leaders for sales promotion; for volume sales without which many of the large stores will have to discontinue their Oriental Rug department.

In the fall of 1960, sales on $9 \times 12$ ft. rugs from India at $195 were being featured by two New York stores. I, too, bought a few of these and sold them at this price, and then decided that even though these served a purpose for the bedroom, I preferred to let the other dealer sell this quality.

*Omitted details on warp and weft*

I have purposely omitted stating under each rug that the rug has cotton or woolen warp, or cotton or woolen weft. The old books did this for each rug. I doubt if a dozen people have ever inquired whether a rug they were considering had cotton or woolen warp. In all the thousands of letters I have had from collectors, I don't recall this subject ever being mentioned. It is sufficient if we say that the vast majority of all Oriental Rugs today use cotton for warp thread. Certainly it is enough to give details on each country. From Iran, most of the fine Persian rugs have always used cotton as warp. Only the Nomad tribes and a few others, ever used wool for warp. All your finely woven Persians, such as Senna, Kirman, Sarouk, Feraghan, and others, have always used cotton as warp. A few very fine rugs used silk or linen as warp.

The types of Persian rugs that formerly used wool as warp, were members of different Kurdistan Tribes, such as Bijars, Bahktiaris, Suj-Bulaks, Shirazes, Mosuls, and a few others. Today, Bijars, Afshars, Mosuls, and many of the Shiraz and Bahktiaris use cotton as warp. Prior to World War II, all old Turkish rugs used woolen warp. Since then, practically all rugs made in Turkey have changed to cotton warp. Also, prior to World War I, all Caucasian rugs used a woolen warp, but since about 1926 practically all rugs that have been woven in Caucasia employed the cotton warp.

In Iran today, the only rugs using wool as warp are the Bokharas of the Tribes in Northeast Iran in the mountains, most of the Shiraz rugs (Fars Tribal rugs) and a small percentage of the Bakhtiari, and a very, very few others.

The Turkoman rugs have always used woolen warp. The many types of new rugs that we get from Afghanistan today still use wool for warp. All rugs from India, China, and Japan use only cotton as warp. The new rugs from Pakistan are also using cotton warp as are the Balkan rugs.

*Sena knot or Ghiordes knot*

There are two different types of knots used in weaving rugs. The old books refer to these as Sena knots or Ghiordes knots. I will not take the space to tell which knot is employed in describing each rug. Again, I have never had one Persian, layman or expert, inquire as to whether a particular rug employed the Sena knot or the Ghiordes knot. A better name would be the Persian knot instead of the Sena knot, and the Turkish knot instead of the Ghiordes knot. For details and design of these, see Part I. I will not use the space under each rug to give the type of knot used. In general, the Persian rugs use both types of knots. Those Persians or inhabitants of Persia who are of Turkish origin, usually use the Turkish (Ghiordes) knot. Kuristans, Bijars, Herez, Gorevans, Mosuls, Suj-Bulaks, and in fact most all the rugs in Western Iran (nearest Turkey) have used the Ghiordes knot. There are some exceptions. Kirman, Sarouks, Ispahans, Feraghans, Kashans, Senas, and others, use the Sena knot. Two outstanding exceptions to my above statement are the Sena in the Western part of Iran, which uses the Sena knot, and the Turkibaff woven in the City of Meshed. All rugs in the Khurasan district of which Meshed is the capital, use the Sena knot. Explanation is that Tabriz merchants from Western Iran, where the Ghiordes knot is used, set up the weaving

of the Turkibaffs in Meshed. All Turkish rugs and Caucasian rugs have always used the Ghiordes or Turkish knot. Turkoman rugs, all types of Bokharas and Beloochistan have used the Sena knot. The exception being that the Afghans and Khivas use both the Turkish and the Persian. You will not find many people caring which knot is employed.

### Counting the knots to the square inch

I am not going to be so foolish as to try to give you the number of knots to the inch of each rug, *i.e.,* 14 horizontally and 16 vertically. I know some few people ask this, but I have never found a single expert who took the time to count the number of knots, except on some exceptionally fine piece, where it is thought that it might be one of the very finest of a particular finely woven type.

We will give you a few illustrations that should suffice. One has to constantly remember that rugs by the same name vary greatly. One rug may be several times as fine as another rug by the same name. Some of the most valuable rugs are some of the old Turkish rugs that are quite loosely woven, such as Bergamos, Konia, Ladiks, etc. Of course, all other things being equal, the finer a new rug, the more costly it generally is. I think that our description, such as "finely woven with a short clipped pile," or, "thick heavy nap of excellent wool with good medium weave," is a better guide for most people. However, we will give you a good idea of the count on a number of rugs.

### Different spelling of the same names

There are often two or more ways to spell the name of a town district and rug. Sometimes this is due to the difference of the Arabic and English. Whether we spell it Kabistan or Cabistan, Kirman or Kerman, or Qum, Qom or Gum, is not too important. I *do* object to the off-color practice of giving a very poor new rug a trade name of one of the famous old rug names.

# ALPHABETICAL LIST OF TYPES

## AFGHAN RUGS or AFGHAN BOKHARA RUGS

*(Turkoman Family. Also sold as Khiva or Khiva Bokharas—*
*see Khiva Bokhara)*

**Availability:** Are available in large numbers in the Afghanistan and European markets. (Government Warehouse in London.) Very few of these come to the American market. The majority are new, but large numbers of semi-antique and antiques are found in the European market.

**Where made:** In Afghanistan.

**Characteristics:** Run from small rugs $3\frac{1}{2} \times 2\frac{1}{2}$ ft. to extra large size $11 \times 18$ ft. Contrary to what all the books in the past have said, Afghan Rugs are made in many sizes. Small new rugs—approximately $3\frac{1}{2} \times 2\frac{1}{2}$ ft.—are available in great numbers. About half of these are in many different prayer designs. A good number of semi-antiques and antique rugs are available in this size in both prayer and non-prayer design. Many semi-antiques in tent bag rugs $5 \times 3$ ft. and in rugs $6\frac{1}{2} \times 3\frac{1}{2}$ ft., and many other sizes, such as $7 \times 4\frac{1}{2}$ ft., $7\frac{1}{2} \times 12$ ft., and in other sizes up to $11 \times 19$ ft.

They always have a field in some shade of wine red. Just about every shade of wine is used; rose wine, rich burgundy, deep brownish wine red, a red approaching plum, and a red approaching brown. Very little white is used. Generally the design is in a blackish green, deep blues, ivory, and burnt almond to apricot and tinges of yellow.

For 60 years book writers have furnished very little information on Afghan rugs. They almost invariably said that all Afghans were in carpet sizes, and they have been completely wrong. Most of them described the carpet size Afghans correctly (by carpet size I mean $7 \times 10$ ft. and larger). My first book (1932) described the design in these rugs quite accurately: "A distinctive type of Turkoman rug easily distinguished from other Turkoman rugs by its coarser weave, long nap

*161*

and deep warm rich velvety reds; a color seldom produced in any other rug woven." This was true of the carpet sizes. The design invariably consists of parallel rows of large octagons. Usually there are three rows of these large octagons with seven or more in each row. These octagons are quartered and filled with blue, red, plum, and burnt almond (almost an apricot). The octagon and quartered section is outlined in blue, deep green, black, or brown. Between these rows of octagons are rows of smaller diamond shaped designs. These vary greatly—some appear to be clusters of tiny stars. Some few will have part of the octagon in ivory. This is the typical Afghan rug in carpet size. It is also the typical design and characteristic of the so-called Khiva Bokhara rugs. There is no difference at all between the carpet sizes sold as Khiva Bokharas and Afghans. See Khiva Bokhara, Part II, and Fig. 33, Part I.

The entire rug is made of sheeps' wool, or some camels' wool and some goats' wool (usually angora goat). Warp and weft threads are wool and usually greyish in color. In a choice Afghan, the whole effect is rich, harmonious, and pleasing. The ends are finished with a wide, flat web, varying from a few inches to 12 inches, usually in grey or red. Quality of these carpet sizes (large sizes) was excellent in the old rugs that came to America up to 1930. While not finely woven, the wool quality was excellent. With age, they acquired a beautiful natural patina. In the period between 1925 to 1933 a good many new ones were made, but the quality was cheapened somewhat. These were still very good rugs. From that time on, very few of these rugs came to America. There were no representatives of American Importers in Afghanistan. Europeans, especially Germans, appreciate and like this type of rug more than Americans did or do. Today, Germans prefer them even to Persian rugs and are willing to outbid American buyers. The average American would not choose an Afghan when buying his first Oriental Rug. Perhaps most of these were bought by the hobbyist, and people who had studied Oriental Rugs or who had lived with them. I myself have always thought of these as being ideal for the library, dining room, or study. I have seldom recommended them for a living room, but they are suitable in certain types of living rooms. I have many customers who prefer these to any other type of Oriental Rug. When *House Beautiful* carried a full page ad by B. Altman of New York some ten years ago, showing a wine colored Afghan in a library with walls and book cases painted a deep green, many decorators sought this type of rug from me.

I started to explain why the Afghan rugs went to the European market and not to America. Another reason was that the Europeans will take more color than the average American. To repeat, there have been very few of these rugs coming to the American market. I think I have inspected every shipment of these since World War II. About 1946, one large importing house brought in some 40 Afghans, all in sizes about 9×12 ft. They were all superior Afghans and about two-thirds of these were perfect old rugs with a heavy pile. Those were the only good Afghans in carpet sizes that I have seen come to the New York market since World War II. Lots of some 20 (in each lot or parcel) new Afghan rugs of very inferior quality have appeared in the New York market from time to time. They were about as poor a quality as I have ever seen. While the wholesale cost was less than half the cost of a good Afghan, they were poor buys at any price.

In 1958 I bought some 50 exquisite old perfect Afghans abroad in sizes 6×9 ft. up to 11×19 ft. (See Fig. 33, Part I.) I also bought 300 smaller Afghans. They

were the best woven, heaviest quality (being much heavier than even the best made 50 years ago) I have ever seen. The wool quality was superior. In 1959 I was unable to buy a single one of these in this same market abroad. So, we can conclude, that while they are available in good numbers in Afghanistan and in the European markets, they are not available at all times. My failure in 1959 was due to German dealers buying these in great numbers in Afghanistan. In 1960, I purchased some 100 superior Afghan and Yomud rugs in the European market (Free Port of London). See Fig. 33, Part I, and Plates 175, 176, and 177, Part III.

**Scatter size Afghans:** So far the discussion has been about carpet sizes, 6×9 ft. and larger. Practically every rug book tells you that Afghans and Khivas come only in large sizes. Dr. Lewis in his last edition says: "Afghan and Khivas usually come in large sizes only." Mr. Amos B. Thatcher in his book *Turkoman Rugs,* published in 1940 says: "For some mysterious reason, small rugs and tent bags, so common in the weave of other tribes, are very scarce in Afghan weaving." This has been the general line of all rug books. But all these authors have been completely wrong. This has been due to the fact that not one of them has ever been to Afghanistan, and they had to rely on information they gained from American rug dealers, or from Hartley Clark's rug book. Since these American rug dealers (importers) did not have buyers in Afghanistan as they have in Persia (Iran), and since they did not visit the European markets as I did, they could not have known this. Typical of many scatter sizes, both new and old, are Plates 175, 176, and 177, Part III. These and the tent bag (Fig. 31, Part I) are the typical designs.

In my very first edition published in 1932, I said: "We generally think of Afghans as larger rugs from 7×10 ft. to 10×12 ft., but they also come in scatter sizes, about 6½×4½ ft. in the Katchli design and in tent bags about 4×2½ ft. to 5×3 ft." (See Part III, Plates 175, 176, 177.)

I was correct, but I did not go far enough. Afghan rugs are made in scores of sizes. In 1958 I bought over 300 scatter and small sizes (selecting these from some 1500 in the group), all of excellent quality. There were hundreds of small new rugs, mostly in prayer designs, but also with the small, all over octagon designs. The smallest of these were about 3½×4½ ft. There is more white in many than we normally expect to find in these rugs. I also bought a good number of antiques and semi-antiques in both Prayer and Non-prayer designs in the small size.

Another size that was plentiful in old and new rugs, in typical Afghan and Khiva designs and colors, was approximately 6½×3½ ft. up to 7×4 ft. These were in typical Afghan designs and had one row of large to medium size octagons down the center of the field. The borders were usually in the same colors and in a slightly darker shade than the red of the field, and almost invariably in a number of Turkoman geometric designs. The principal color was some shade of wine, with the majority in a deep, rich, silky burgundy. There were some with the almost orange red, which I choose to call Turkoman rose, others in lighter shades, and some few in brown and in almost a mauve background. The octagons were generally outlined in a blackish green, brown, black, or deep blue, and the quartered octagons were in deep, plumish wine, green, burnt almond, brown, and occasionally some in ivory. Many of the octagons were in the same color of wine as that in the field. The borders were in deep burgundy or wine, combined with

green, navy, brown, plum rose, and ivory. Most of these were old, tightly woven, thick rugs. The quality of these was pretty much the same, though a few were somewhat superior to others.

**Katchli designs:** These come in sizes about $6 \times 4\frac{1}{2}$ ft. to $8 \times 5$ ft., with the majority about $7 \times 5$ ft. They are also excellent Afghan rugs. (See Fig. 28, Part I for general design; also Part III, Plate 175.)

The old rugs in this design were of good quality and typical of those that we have always known. The new ones are even more tightly woven and extra heavy; in fact, heavier than any type of Turkoman or Bokhara rugs I have ever seen. They were more closely woven than the old Bijars and nearly as heavy. These varied in price as much as five shillings a square foot, or $1.00 per foot when landed in America (duty paid).

**Yomuds and Ersari rugs from Afghanistan:** In addition to the four general types discussed above, many of the rugs being offered in Afghanistan and in the European markets, are sold as Yomuds (Yomuts), and are in fact woven by members of old Yomut tribes (see Part I, Fig. 31).

The only ones of these that the expert in America would recognize and call Yomuds, would be the large tent bags about $5 \times 3$ ft. in size (See Plate 176). Most of these are old rugs, but in perfect condition as they have been used as containers on camel packs and in Afghanistan tents and homes, and have not been walked on. Most of them are in shades of mahogany and burgundy and brownish wine. They usually have three rows of small octagons with the apron at the lower side being plain without design. For one of the unusual and delightful designs being woven, see Plate 174.

The new innovation is the use of the Tekke (Royal Bokhara) design in these Yomuds. They are not as fine as the Tekke but are very tightly woven and very heavy. They come in many sizes, but mainly in $7 \times 4$ ft., $7 \times 10$ ft., and a few in $9 \times 12$ ft. I saw just three in the $10 \times 14$ ft. size. The best of these approach the finest of the real Tekke, and are much heavier. These Yomuds are the costliest of the rugs coming from Afghanistan. They are heavier than the Tekke Bokharas now being made in Iran.

**Tent bags:** There are also hundreds of long, narrow tent bags, most of them quite old, in sizes from 12 inches by 36 inches, to very unusual sizes such as 2 ft. $\times$ 6 ft. I bought about 100 of these and at least a dozen of the designs which Mr. Amos Thatcher listed as Chordor Juval (Juval meaning small tent bag) in his Plate 31, as Ersari Torba in Plate 43, Ersari Juval in Plate 44, and Ersari Torba in Plate 38. I purchased a number in the identical designs as shown in his book and listed as Yomud Juval in Plates 19 and 22. All of these I bought as Afghans.

We also bought a good number of rugs that were in Afghanistan or came from there that all the books refer to as BESHIRES, and which Hartley Clark's book and Mr. Thatcher's book refer to as Ersari.

How did all these types come to be available in Afghanistan? That I cannot state with certainty, but since the northern border of Afghanistan and the southern part of the Russian States, where the Tekke Tribes, the Salor Tribes, and Yomut Tribes pitched their tents or built their huts, and until recently paid no attention to borders, it seems logical that many members of these Mohammedan Tribes have probably settled in Afghanistan. That is the only way we can account for all these designs, formerly found in only one type of Bokhara or Turkoman rug, now

being found in rugs made in Afghanistan. Many old rugs were, no doubt, brought into Afghanistan by these tribes and might have been made while they were still in that area of Russia. Many of the Afghan rugs employ the Salor Octagon (also called Gul) instead of the typical Afghan octagon.

**Price:** Quality in each type varies somewhat, and so do prices. While the standard of living at the moment is not moving forward as fast in Afghanistan as it is in Iran, it seems quite certain that the supply here will be on the decrease. As stated, if I gave definite price scales, my book would be out of date in a few years. But prices on these are much higher than in 1958. Perfect old Afghan carpets (or Khiva Rugs, which are generally called Khiva Bokharas) range in price from that of a good new Herez to an ordinary average new Sarouk rug. A good new one will cost wholesale just as much as the perfect antique, if not more. The retail dealer will, of course, sell the perfect old one for somewhat more than the new one, regardless of his cost. If he does not, he ought to have his head examined.

The small new and antique rugs will cost no more than the less expensive Persian rugs (and they are better made than the inexpensive Persian), up to the price of the average new Sarouk. The old Yomuds and those in the Ersari design cost no more than a good Hamadan or up to the average new Sarouk. The finest Yomuds in the Tekke design (Royal Bokhara design) wholesale for about two-thirds the price of a good modern Kirman and about the same price as a Sarouk.

These prices are based on prices I found abroad, and not on the prices asked for the very few that appear from estates on the New York market. The few I have seen at small dealers' in New York who operate entirely from estate rugs, are much higher. These are almost invariably worn, some only slightly. When these Afghans are worn they are worth much less. All types from Afghanistan have woolen warp and weft. The wool quality and dyes are excellent.

**Conclusion:** It will not surprise me to find rugs from Afghanistan coming in many different and new designs in the future. One new Afghan (9 × 12 ft.) came with the entire field divided in many square compartments, each containing a small prayer arch and with much more ivory than ever before seen in an Afghan.

# AFSHARI RUGS

## *(Usually called Afshars—from Iran)*

**Availability:** In very limited numbers in the New York market in both new and semi-antiques in sizes about $4\frac{1}{2} \times 6$ ft. Available in great numbers in the European wholesale market and in Iran. Rugs are marketed in the city of Kirman. Sizes vary from saddle bag sizes about $28'' \times 24''$ to $8 \times 10$ ft. Most are in $6\frac{1}{2} \times 4\frac{1}{2}$ ft. size.

**Where made:** By Nomad Tribes which occupy a section some 40 miles south and southwest of the city of Kirman in southeast Iran, a section approximately 50 miles deep and 125 miles wide. There are two large tribes or branches of Afshars, the Afshars and the Buchakchis, totaling several thousand families. These tribes still live as Nomads in their tents, moving their herds from one area to another in winter and summer. There are scores of villages in this area that weave great numbers of the same type of rug in the same general size, and in many different designs. Formerly one village or group of families in the tribe wove only

one design, but today, with communications easier, many different designs are woven all over this section. Since they have only horizontal looms that lie flat on the ground, they can weave only small rugs.

**Characteristics:** The one difference between the village rugs and the tribal rugs is that the former use the Persian knot, while the tribal weaver uses the Turkish knot. The rugs are from fairly coarse to rather finely woven and have a medium to short nap. An attempt to detail the many designs used would require pages. Many of them will be semi-geometric in design and others will be almost geometrical, which we call conventionalized floral designs. A rug may come with an elongated sexagon shape (Hearth design) and have two connected serrated sided octagons which will enclose a diamond in each of these. In the corners and over the rest of the field may be many small stiffly-drawn pear designs.

Another much used design is a central medallion, serrated sided octagon with large serrated sided corners in different colors, but in a contrasting color to the field. Many of these will be covered with stiffly drawn Persian florals or pears. The central medallion will also be covered with conventionalized floral. The borders in this rug will look like geometric flowers or angular vines in another border. (See Plates 7 and 8, Part III.)

The two designs above are usually in red and blue with considerable green, ivory, and canary. In the same general designs will be many of these with a central medallion and with much of the field open ground, plain red, or plain blue. Of course, the corners will be rather large and the borders always approaching the geometric if not truly geometric. Many of these come with ivory fields. One design frequently used is a medium sized angular pear design, with alternate rows facing in opposite directions. These will often be in light blue with tinges of other colors, which is the case in Plate 7.

The same ivory field is used with the pear design superimposed on the pears which will be quite large with five pears in one row and four in the next row to a depth of six rows.

Another design is one that many call the Hen design. This is usually on an ivory field and has an all over design consisting of rows of geometrically drawn hens with adjacent intricate geometric figures. Others have a hearth design effect— a large medallion outlined and covering most of the field, and inclosing an all over design, a modified form of the Shah Abbas alternating with small tree forms. Still others tend toward the floral. I have seen many with the ivory field and a design very much like the Kirmans of the classical period. The field is divided into many compartments but the outline of these is almost hidden by the intricate floral designs within each. (See Fig. 11, Part I.) The effect is a field almost completely covered with small floral designs. Still others come with a large floral design—actually approaching the modern Sarouk design. A very few will come in the realistic cluster of rose designs, formerly found only in Bijars, Suj-Bulaks, Senas and a few other types. So, I can only begin to give you the many designs. You will be able to identify an Afshar once you have examined the back, the weave, the texture, and the general look. It is possible that you might mistake one for a Shiraz, but that would not be too bad an error. Actually, many of these are sold as Shiraz. The Shiraz are also tribal rugs.

Both the wool and dyes used are excellent. Seldom do we find one with poor wool. Occasionally, the villagers will buy some cheap wool in the Kirman market,

but as a rule these people own their own sheep, spin their wool by hand, and dye their own wool with vegetable dyes. Today, the village weavers use cotton warp. Most of the tribal weavers still use woolen warp, but many of these also use the cotton since it is less expensive and is better as warp threads than wool.

**Price:** Afshari rugs are about the same price as a good quality Hamadan. The choicest will not be expensive. These have always gone to the European buyers in great numbers and come to America in small numbers. I believe that this developed over the past 50 years simply because these rugs were not heavy enough to withstand the heavy chemical bleach that was applied to most rugs after they reached America. Another reason is that European countries pay duty on weight and not on size or cost.

**Other rug books:** No mention is made of Afshars in Mumford's first edition. Walter Hawley, in his book published in 1913, says about Afshars: "The pattern incorporated some of the floral features of Persian rugs; they display many Caucasian characteristics. These Afshars bear a close resemblance to the Kazak, from which they may be distinguished by observing a fold as they are bent backwards, which will show the fibres of yarn of a knot standing out at front as a unit. In Kazaks, they have a tendency to bend."

My comment: Mr. Hawley's book is one of the best written, but he faltered badly here as an expert. I must disagree completely with Hawley, as will every expert today. Not even a beginner should mistake an Afshar for a Kazak as the characteristics and differences are too great. They are not as heavy as Kazaks and their weave, texture, and look are entirely different. The only thing that might be said on this point, is that those with geometric designs (or some of them) would go in the same room with Kazaks better than most types of Persian rugs.

# AGRA

## *(From India)*

**Availability:** None made in the last 40 years. Seldom available from estates.

**Characteristics:** Always in sizes $9 \times 12$ ft. and larger, and usually in extra large sizes. They generally have an open (plain) field with small medallion and corners. Fields are in olive green, blue, fawn, and tan. Some with the green or fawn would come with small, delicately colored pineapples, pears or cone-like figures in wisteria, plum, brown, and light blue. The very few that appear from estates will usually be too worn for hard usage. Any and every old rug that appears from an estate in these general colors is usually given the name Agra by the dealer for lack of knowing its exact origin. I have seen just two of these that I thought were really choice in all my years. Warp and weft cotton, nap wool.

**Other rug books:** Even Mumford's first edition of 1900 offered very little information on Agra rugs. The Taj Mahal is in Agra and he quotes an Englishman by the name of Robinson, as follows: "The Indus Valley had always obtained rugs from neighboring Afghans . . . the necessity was found for local manufacture of carpets too large to be carried by camels or even elephants." He goes on to state that they were made by prison labor in Agra. Thirteen years later, Walter Hawley in his book, added nothing to the subject, but in effect repeated what Mumford had said.

**Conclusion:** This rug is of no interest to those seeking floor covering, and it never was of interest to the collector. One could be quite suitable for Williamsburg or one of the old homes in Charleston where the area is roped off. They are very inexpensive except for one or two (choicest) I have seen. They are not as a class rare or considered objects of art, as are many rugs. Since they are not made today and are of no interest to the collector, I cannot allot a Plate to this rug.

# AHAR or AHAR HEREZ

## (Iranian Family)

**Availability:** In good numbers in approximately $9 \times 12$ ft. sizes. Large medallion design—partially geometric with some curvilinear effect.

**Where made:** A superior type of new Herez rug is made in the town by that name just north of the Herez district and marketed in Tabriz. This rug first appeared under this name in 1959. It may be offered as Herez or Ahar. I will probably offer it as Ahar Herez. It is one of the best of all new Herez types. It actually approaches the quality and texture of a good Sarouk. Cost is about fifty dollars more than the better new contract quality Herez. It tends to combine the curvilinear design of the Tabriz with the geometric of the Herez. (See Herez Rugs for further information.) Other sizes in this type will no doubt shortly appear on the market. See Plate 9.

**Characteristics:** All are in medallion designs and each has some shade of red, brick, or rose in the field. One will have rose red, another a red with a slight plum cast. Medallion will have much ivory blues as well as lesser amounts of other colors. Large corners are predominantly ivory. See Plate 9.

# AINABAD RUGS

## (From Iran)

**Availability:** In new carpet sizes only $6 \times 9$ ft. and larger. Most are in $9 \times 12$ ft. rugs. They are the same as Bibikabads in quality, design, and characteristics. All will be sold as Bibikabads, and not as Ainabads. Both towns made rugs in same general designs and qualities.

**Characteristics:** Refer to Bibikabad and Fig. 5, Chapter on Persian Rugs, and Plate 15. The vast majority will be in this general design, but the colors of most of these rugs will be more colorful than shown in Plate 15. Most of the large sizes will have nine to eleven borders.

# AK HISSAR

## (Turkish Family)

**Availability:** None made in past 45 years and none have appeared from private estates in years. Not of real interest to collectors for past 40 years.

**Where made:** In town by this name some 80 miles north of Smyrna.

**Characteristics:** I shall not try to give you definite characteristics of this type as I have never seen one that any dealer or any collector could definitely identify as an Ak-Hissar.

**Other rug books:** Referring to the standard rug books, Mumford in his first edition (1900) gave the only information available. He stated that many were first made with mohair wool (angora wool). He stated: "They were very similar to Ghiordes and Oushah." Later they quit using mohair and used only wool. Hawley in his 1913 edition gave even less information. Henry Jacoby (German author, 1947 edition) gave very little information and no description. Dr. Lewis followed Mumford's line and went on to show a plate of a prayer rug which every expert I have known would call a Kershehr. Too much space for a rug so unimportant. Sizes were about $6 \times 4$ to $6\frac{1}{2} \times 10$ ft.

# ANATOLIAN RUGS

## *(Turkish Family)*

**Availability:** Only from private collections or estates.

**Where made:** Turkish, Asia Minor, and Anatolian are synonymous. We refer to many different rugs from Iran as Persians. The old books referred to all Turkish rugs as Asia Minor rugs. Asia Minor simply means that part of Turkey which is in Asia. Actually only a small part of Turkey is in Europe.

**Characteristics:** The term Anatolian is generally applied to all Turkish rugs. I have always felt that Turkish family was a more correct name than either of the others. You will find some of the museums listing definite types of Turkish rugs, such as Ladik, Konia, and others, as Anatolian Prayer rugs. Individual collectors will give each rug a definite name. When the lovely old Turkish pillows (approximately $2 \times 3$ ft.) came in numbers up to 1930, it was not possible to accurately determine the village or section where each of these came from; so we, in the trade, referred to them as Anatolians. Collectors gave them definite names, such as Ladki, Melez, Bergamo, etc. but they could seldom be sure of the exact location from which these small mats came. After World War I, thousands of new rugs forsaking old Turkish designs were made in floral Persian designs. For these, the name Sparta and Anatolian was the general name. See Plate 132.

# ANIMAL CARPETS

## *(Persian Family)*

**Availability:** In new rugs in a number of types, but principally in Tabriz, Ispahan, Nain, and Teheran rugs. This is not the typical rug of these types, but many do come. On a recent trip abroad, I bought a new $9 \times 12$ ft. Sarouk in ivory ground in animal carpet design. In classical old rugs, similar to the very famous rugs in museums of the world, none have appeared in 40 years.

**Where made:** New animal carpets are made in towns of rug's weave, for exam-

ple; Sarouk in Sultanabad, Tabriz in Tabriz, etc. It is not known in what city these famous old animal carpets were made, but presumably in northern Persia and most likely in Tabriz and Ispahan.

**Characteristics:** Because the Metropolitan Museum of Art of New York, the Victoria and Albert Museum of London, and other great museums of the world have a number of carpets listed as Animal Carpets, some information is appropriate even though they are not listed in any particular weave. Most of these are huge carpets. Most are old carpets or rugs, about one hundred to three hundred years old, on which animals are protrayed. Some are believed to be late 15th century. Some will have numerous animals in the field and in the borders. Interspersed with the flowers, palmettes, cloud banks, and scrolls, are tigers, Cheetahs, wolves, oxen, deer, antelopes, the Chinese unicorn, dragons, and oftentimes birds. When human figures on foot or horseback are shown, these are referred to by some authorities as "Hunting Carpets." The main border often has arabesques and palmettes as the main motifs. The medallion is a feature of most of these animal carpets. The animal figures are used in conjunction with floral ornamentation and also Chinese cloud bank design. (See Plates 2 & 3 of Animal Rugs in the Metropolitan Museum.) As stated, most of these are very large carpets. The smallest in a museum (to my knowledge) is the one acquired from the Yerkes sale in 1910, (size approximately $7 \times 5\frac{1}{2}$ ft.) for $5,600. Some of the larger animal carpets are valued at hundreds of thousands of dollars.

**New rugs with Animal Design:** Very few new or semi-antique rugs have been imported to America in the "Animal" or "Hunting" design. Unless the animals are inconspicuous and secondary, the average seeker of Oriental Rugs for floor covering objects to these designs. I have had and seen a few semi-old Bijars with many small lions in gold color, arranged with a floral design. Lately I found abroad a few Sarouk carpets with ivory background, depicting animals and hunting scenes, in which these were not too prominent. These cost no more than the other Sarouks in the group. The beauty and colors of the rug were the reasons for purchasing, and not the animal design.

Until recent years, there were hundreds of new Persian rugs in the Free Port of London warehouse, with large animals and human figures. Most of these were from Ispahan, Tabriz, or Teheran. They were rather finely woven, but the vast majority were too garish to appeal to American buyers. A few years ago I was asked by one of the greatest artists in the world to appraise a hunting carpet. He had bought it in Austria and had an idea it was worth many thousand dollars. It was a rather coarse Tabriz or Teheran and one of the most unattractive and unsalable rugs I have ever seen. Perhaps a conversation piece, but the conversation by most anyone who knew rugs would be derogatory. He, no doubt, had seen a great hunting carpet in the Vienna Museum and thought this valuable, just because it was a hunting carpet design. I know very few people who would want to live with it. Of course, this is only my opinion and taste. Moral: Do not buy a rug just because it has some fine sounding name. First requirement: the rug must be beautiful.

# ARAK RUGS

## (From Iran)

**Availability:** In limited numbers in new rugs in sizes approximately $9 \times 12$, $9 \times 15$, $9 \times 17$ ft., and a few other large sizes. No small rugs or runners are made in this type.

**Where made:** The City and District of Arak (formerly better known as Sultanabad), now being called just Arak, is one of the four pincipal rug weaving districts in Iran. The full details of rugs woven in Arak is given under Sultanabad. All Sarouks are made in this district.

**Characteristics:** In rugs, the name Arak is used to indicate a certain quality of carpet made there. As you will learn, more than half of the output from this district is in Sarouks. The Arak rug is next in quality to Sarouks in this district. The best of these approach the Sarouk in quality and cost about two-thirds the price of a Sarouk. The designs may be the same general all-over floral design as Sarouks (See Plate 53) or with an open ground in rose to red field with a floral center and corners. Border will generally be blue and occasionally ivory. Many will be in the same design as Sultanabads, Mahals, or Muskabads. See Fig. 3 in the chapter on Persian Rugs. The nap is heavier than Sultanabads, Mahals, or Muskabads. Good quality wool is used, and the dyes are generally vegetable. Warp is cotton. Rugs are durable. Paper scale patterns are used in weaving these. Rugs by this name first appeared about 1920 and ceased being made about 1932. You will not find the name in any of the old rug books. The quality of these was inferior by far to those being made today. They were invariably chemically washed and painted after coming to New York. They were in the same general designs as Sarouks but sold for half the price. Production of the new type of Arak rug started again about 1948. Fewer of these have come since 1955 and these weavers are now making more Sarouk rugs. Those made since World War II are not heavily treated, but have only the Persian wash or the light, plain New York wash. See Sultanabad Rugs, and Plates 73, 80, 85, and 86. With Europeans and Persians buying so many rugs, most of the looms that wove Arak quality rugs are now weaving Sarouks.

# ARDEBIL RUGS

## (From Iran)

**Availability:** Made in great numbers in new rugs in many different geometric Caucasian designs, in sizes approximately, $2\frac{1}{2} \times 4$, $5 \times 3\frac{1}{2}$, $7 \times 4\frac{1}{2}$, $9 \times 5$ ft. and up to $8\frac{1}{2} \times 11$ ft. Also a very few as large as $9 \times 12$ ft. are made. Before discussing this rug, let me warn you not to be confused by this name. The Ardebil rug is a new type that has come on the market only since 1950. There has been so much reference to the world's rarest rug, the very large Ardabil Mosque Carpet in the Victoria & Albert Museum in London (Plate 4), with its large medallion. Every dealer is prone to call every rug from the Meshed district that has any semblance to this design, an Ardabil rug. He should say Meshed or Ispahan Meshed with

*171*

the Ardebil design. When a Tabriz rug of any quality appears with a similar design, the same thing happens. The new Ardebil rugs are as different from these as Caucasian rugs are from Persian rugs.

**Where made:** Some 90 miles east of the City of Tabriz, and 20 miles south of the Caucasian Border (S.S.R. Azerbaijan), is the town of Ardebil where these rugs are being woven in great numbers today in many sizes. About half of the output is in sizes about $7 \times 4\frac{1}{2}$ ft. and the rest in the sizes indicated above.

**Characteristics:** See Plate 10. In thickness, design, colors, and weave, they are very similar to the thinner type Caucasian rugs of old: such as Cabistans, Kubas, Daghestans, and Shirvans. I have seen none with the Chichi or Prayer Daghestan designs. The backgrounds are generally some shade of red, but many are also coming with an ivory field. None have come with the blue field to date, though much of the design is in blue, ivory, green, and canary.

The warp is cotton and the nap is usually a very good quality wool. The Ghiordes (Turkish knot) is used. I have seen some few with so-called dead wool, where the weavers no doubt bought their wool yarn in the Tabriz market. This would result in rug showing wear quickly. The dyes are good in most instances, but you will do well to examine closely for loose colors. The rugs will have been lightly Persian washed, or lightly treated in New York, and if the dyes are loose, you will find some little bleeding. If they are not loose when you examine the white nap adjacent to the red and other colors, there will hardly be any danger of their colors bleeding when they are sent to the cleaners.

Designs are strictly geometric in most cases to the same extent that old Caucasian rugs were. They are not quite as finely woven as most of the better old Caucasian rugs of the type listed above, but are as good as most made in the period 1925–1933 in Caucasia. Of course, they will not be as soft as the old Caucasian rugs which are now extinct except from private estates and collections. Since this is a new item, it is entirely possible that larger rugs and other types of Caucasian rugs may in the future be made in this section just south of the Caucasian border. Designs of most of these are in larger geometric designs than shown in Plate 10.

# THE ARDABIL MOSQUE CARPET

## or

# THE GREAT CARPET FROM THE MOSQUE AT ARDABIL, PERSIA

### *(Size—34 ft. 6 in. × 17 ft. 6 in.)*

This great rug is so well known the world over. It is one of the features in the Victoria & Albert Museum in London, England. It is one of the most celebrated rugs in the world. Only a few others of the most famous carpets approach it. Because it is so well known and because so many dealers impose on its great name by referring to some new rug as an Ardabil Mosque design, (and some few go so far as to say Ardabil Mosque carpet) I give you the information that is available in most every rug book on this rug.

*172*

The word "availability" is out of order. A second carpet closely resembling this carpet in design was in the famous Yerkes collection which was sold some 40 years ago. It is still in America, and at the moment I do not recall in whose collection or which museum. A second identical carpet was purchased and used to repair this rug. Price was 12,500 pounds, or $62,500, some sixty years ago (1893). I believe the museum spent some $90,000 just to restore it at that time.

**Where made:** There is much debate as to where this rug was woven. Most authorities believe it was woven in Kashan. Some attribute it to Tabriz or even Ispahan. It and its companion were acquired from the Holy Mosque at Ardabil, Persia. It is over four hundred years old, having been woven in 1540.

**Characteristics:** (See Plate 4.) Size is 34 ft. 6 in. × 17 ft. 6 in. The field is a deep blue, covered with an intricate maze of floral stems. A large circular medallion is yellow with a lobed outline, from which radiates sixteen panels which are in yellow, red, and green. The corners are in yellow and in the same design as the circular medallion. The border has a row of panels—one oblong and the next one round—and alternating in green, yellow, and red. It would take pages to fully describe this rug. There are 340 knots to the square inch, and the warp is silk. There is a cartouche with an inscription of an ode by a Persian poet, and then follows the name of the weaver and the date.

For more details on this rug, you can purchase a book through the Victoria & Albert Museum, London, England, entitled *Guide to the Collection of Carpets*. My guess of the price of this book today is not over one dollar. A number of wonderful copies of this rug have been woven during the past 50 years.

# AUBUSSON RUGS

## *(Made in France)*

**Availability:** A limited number of old French Aubussons are available from estates. Most of these are badly worn; nevertheless, they are very expensive. With rare exceptions, they are in large carpet sizes. Aubusson is not truly an Oriental Rug, but since they are sold only by Oriental Rug dealers, and since they are handmade, most people classify them in the same category as Oriental Rugs.

**Where made:** All real Aubussons were woven in France. There are two types of French rugs—the napless tapestry like Aubusson rugs, and the thick, hand woven Savonnerie rugs. Both carry out the same general design effect and color schemes. (See Savonnerie Rugs.)

**Characteristics:** Most of these Aubusson rugs come with a cream field and have delicate shadings of rose, tan, plum, green, wisteria, blue, and other colors in the design. Usually there is a realistic cluster of roses in the center with others in the corners. The borders are curving, not straight line. Generally the field is a cream or grey. Many of these have come with a great deal of soft old plum or a near-brown color in the borders, corners, and center.

None have been made in France for over 30 years, except by government subsidy for gifts to foreign governments or for government buildings. Though wages in France would be less than half of the wages in America, my guess would be that to weave a new Aubusson in a size approximately 12 × 20 ft. would cost

$10,000 today in labor alone. Certainly at $2 a day weaving wages, the rug would be prohibitive in price. Most of the old ones that appear are too worn to be used as floor covering even after extensive renovation. I myself ruined a wonderful one in my living room. They belong in a little-used music room, or a guest room, but principally in historical houses that are roped off and viewed from the doorway.

I bought many of these during the period 1928–33. This was the period when the Russians confiscated all the rugs, valuable art objects, and furnishings from palaces and great homes in Russia and sold them to raise gold. They were inexpensive then due to the depression. Today any good Aubusson sells for $2,000 to $10,000. The few that I get require so much repairing that the cost to renovate them would be several hundred dollars. Even so, the rug would still not take heavy duty. I prefer to sell those I acquire to small New York dealers who seem to do well with them.

I have not attempted to include a plate of an old Aubusson, but a general idea of design may be seen in Plate 183. New rugs are being made in Pakistan or India and sold under the name "Jewel of Kashmir." They are flat stitch rugs. In fact, they are Aubussons made in Pakistan. (See Jewel of Kashmir and Plate 183.) These are sturdier and more practical than even a new Aubusson. Even though I say old Aubussons are not durable, I must add that many of these have been used in homes for 40 or 50 years. Most of these were in music rooms or bedrooms, without heavy traffic. Otherwise, they are completely worn out.

# BAHKTIARI RUGS

## (Persian and Iranian Family)

**Availability:** In the American market in limited numbers, in sizes approximately $6\frac{1}{2} \times 4\frac{1}{2}$ ft. A limited number of semi-antique and new rugs are coming to America. Perhaps only twenty-five to fifty a year, in the dozar sizes ($6\frac{1}{2} \times 4\frac{1}{2}$ to $7 \times 5$ ft.) are to be found at the New York importers. Occasionally one appears about $7 \times 10$ ft. Also each year a few come in sizes approximately $10\frac{1}{2} \times 14$ ft. and slightly larger. In the European market there are twice as many as in the New York market. On each trip to London we see quite a few in unusual sizes, $6 \times 10$ ft., $7 \times 10$ ft., and a few much larger. Most are made in $6\frac{1}{2} \times 4\frac{1}{2}$ ft. size.

**Where made:** In Iran these are woven in approximately one hundred and twenty villages.

**Characteristics:** They are slightly better than the quality of a good Hamadan, and about the same as rugs we call Sena-Kurds. For the hobbyist and collector it should be noted that the rugs called Bahktiari, in the period 1920–1932, are somewhat different in quality and design from those that have been made since 1935. The Bahktiari of thirty years ago were superior to those being made today. One reason for this was that early rugs were thick, antique rugs with a wonderful natural silkiness. The original Bahktiari rugs first appeared in America about 1924. Experts, collectors, and rug dealers alike were baffled as to the exact origin of these rugs. I recall many dealers referring to them as Kurd Shiraz. They had the general appearance of a Shiraz. They were thicker, and definitely Nomad tribal

rugs. When the book and moving picture named *Grass,* written and taken by two Americans, came out, we had a real insight into the wild tribes of the Bahktiari Mountains. The wool of these rugs was superb. They came in deep, rich blue or red, and in scores of designs—some with a floriated pear design and others with all over design. Most of them had larger designs, approaching the geometric. While the majority came with rich blue or red fields, many also came with ivory, and all had a good deal of green, gold and yellow.

The first Bahktiaris, which came by the hundreds for a few short years, were mostly $6\frac{1}{2} \times 4\frac{1}{2}$, but many also came in $8 \times 4$, $10 \times 5$, and $14 \times 5$ ft. sizes, and hundreds of variations of these. Also many runners $10 \times 3\frac{1}{2}$ ft. to $13 \times 3\frac{1}{2}$ ft. The people were shepherds living in tents and their rugs were woven on flat looms, which accounts for so few large rugs. Over the past forty years many of these shepherds have settled in the villages known as the Chahar Mahal district some sixty miles southwest of the City of Ispahan. The main population of these tribes still roam the valleys and highlands with their herds. In these some one-hundred-and-twenty-five villages, at least twenty-five different designs are woven. In the old rugs only the Ghiordes knot was used. Today some of the village rugs use the Sena knot.

A. Cecil Edwards in his late book agrees. He says: "The so-called Bahktiaris are not woven by the Bahktiari tribe at all. They are woven in villages—in the Chahar Mahal district." Shahr Kurd and Qaverukh are the largest weaving towns, with about five hundred looms in each. They still use the horizontal looms even when they weave a large rug (which is not very often). The predominant design is the so-called garden design. (See Plates 13 and 14.) They have either square panels or oval panels, containing flowers. Many have a floral medallion, others have semi-geometric and semi-floral medallions. Red, blue, and ivory are used extensively. More green, gold, and yellow are found in these rugs than in most other types.

A small, narrow strip (which is a pillow or tent bag, approximately $15 \times 36$ inches) is one of the choicest of all small rugs. (See Plate 155, Varamin.) Originally they were imported as Varimin mats. (Varimin is part of the Bahktiaris.) These have not been available since 1931, except from estates. They have an extraordinary background and wool quality, and a patina unsurpassed by any rug. I myself, along with all the experts I knew, called this small, choice pillow Bakhtiari. Varamin and Bahktiari are very close. Few know the name Varamin. The early Bahktiari rugs used wool for warp. Today, most of the new and semi-antique rugs have changed to cotton warp.

**Conclusion:** You can find a few new and semi-antique Bahktiari today in a size approximately $6\frac{1}{2} \times 4\frac{1}{2}$ inches and larger in some stores. Occasionally from an estate, we get a very choice old one in good condition. Not all the antiques were choice or rare even when perfect. Bahktiari are medium priced rugs—except for topmost quality of the type.

# BAKRA RUGS

## (Moroccan Design Made in India)

**Availability:** Ten years ago there first appeared in the New York market, thick, coarse rugs in ivory with primitive design in black and white, woven in Morocco. Since then, the rug weaving firms in India have copied and duplicated these so that it is not easy to tell the two apart.

**Where made:** The Bakra rugs and others with the same general design are made in India and imported by two large factors, each with their own trade name. Rugs are made in most all the standard sizes, $3 \times 5$ ft., $4 \times 6$ ft., $6 \times 9$ ft., $8 \times 10$ ft., $9 \times 12$ ft., and $10 \times 14$ ft.

**Characteristics:** The majority have an ivory field and in design are similar to Plates 31 and 32. Others have entirely different designs but the effect in general is the same. The field is ivory with the design usually in blacks and browns. Rugs are quite coarsely woven with a strong, heavy (thick diameter) wool, which gives them body. The wool is good, so their durability is quite good, and in fact better than many inexpensive Persians with more knots to the inch. These rugs are inexpensive and go with modernistic furnishings, camps, or bedrooms.

# BAKSHIS RUGS

## (Persian Family)

**Availability:** There are only very few antique rugs by this name even from estates or private collections. Even in 1900–1925 they were not available, hence the one or two appearing each year are quite ancient and usually quite worn. This was true of the type which collectors called Bakshis, and which invariably employ the small Feraghan (herati) design. Few dealers or collectors have bothered to give this name to the medallion type Gorevan or Herez which was later made in this town.

**Where made:** In the town of Bakshis, which is in the Herez District and which for 40 years has woven the geometric medallion rug marketed as Gorevans or Herez.

**Characteristics:** These old Bakshis of the period 1800–1900 were almost invariably in runners about $3\frac{1}{2}$ ft. wide and in long narrow carpets, *i.e.,* $6 \times 11$ ft. to $7 \times 16$ ft. They followed the Feraghan rug with the small all over herati design. The tones of these old ones were very pale faded blue, buff, and mauve. Some of the buffs when new were a magenta or red that faded to this pale color. Design of early rugs invariably used the Feraghan design. (See Plates 36 and 37 for Feraghan design.)

In all my 37 years of buying I have never seen one of these imported from Iran. Prices for these were high even 40 years ago. Since 1900, thousands of new coarse rugs to excellent rugs in carpet sizes have been woven in the village of Bakshis and marketed as Gorevan or Herez rugs. The designs, of course, are the geometrical designs that we find in the Herez and Gorevan rugs. There are a dozen villages in the Herez district, all making the same general type, and it would in-

deed be difficult to tell whether one of the Herez is made in Bakshis, Herez, Gorevan, or one of the other towns in the Herez district. Plates 26 and 27.

Even in 1900 Mumford said: "The Bakshis of today, which no dealer will call Bakshis, is loose, full of colors which, besides being inferior quality, are ill-combined." He was referring to the Herez type.

**Conclusion:** Bakshis is a name that has little significance in the Oriental Rug field today. Many of our best Herez rugs of the past ten years have been woven in this village.

# BAKU RUGS

## *(Caucasian Family)*

**Availability:** None made since 1920 and none imported since 1930. Fewer of this type of Caucasian rugs have appeared in the past sixty years than almost any other type of Caucasian rug. I have seen only three or four of these from collectors' estates since World War II. Only the old ones are valuable. (See Part I, chapter on Caucasian Rugs.) Although new Caucasians were made for the first time in 1960 since 1931, none of the few seen are in the Baku design.

**Where made:** In and around the City of Baku in Eastern Caucasia on the Caspian Sea. This is now part of the Russian State of Azerbaijan. The Shirvan District was adjacent and it is little wonder that these two rugs have much in common. While geometric in general characteristics, these show more Persian influence than any other Caucasian rugs. The thicker Karabagh should be included with these two, with its angular floral designs.

**Characteristics:** Rugs are from medium-fine to very finely woven with a short to medium nap. Except for its own design, it has very much the same characteristics as the Kabistans, Kubas, Shirvan, Daghestans, and Chichi rugs. Plate 147 is the one typical Baku design. Each of the few that exist in private collections which I have seen or have sold, has had a blue field with the larger angular pears in rows as the principal design. Most of these will have an angular (floriated) center piece and corners, surrounded by the pears. The color effect of these large pears and other designs are cream, light tan, light blue, rose, and lesser amounts of navy, green, and ivory. The sizes are usually 5 × 4 ft. to 9 × 4 ft. I recently had one 5 × 17 ft. and sent it to my agent in London. He handles more Oriental Rugs in Europe than any other individual (perhaps ten times as many) and yet he had not seen a Baku for sale in many years.

While the new weaving in Caucasia is in its infancy as we go to press, and even though I have seen none in Baku designs thus far, it is likely that some few new ones will appear in the next few years, if European buying power continues. (See chapter on Caucasian Rugs, Part I.)

*177*

# BALKAN RUGS

## *(Made in Bulgaria)*

**Availability:** In good numbers in European market, in many sizes and types.
**Where made:** Formerly some were made in Russia and Yugoslavia, but only Bulgaria has exported great numbers of these.
**Characteristics:** Rugs are all handmade, quite well made with a good medium heavy pile of excellent wool. Most everyone, even rug dealers, will mistake these for the Persian Tabriz rugs. The majority seen were 7×10 ft. to 10×14 ft. All received the same objection: a mechanical, machine-like make. This is the same objection Americans have to most new Tabriz, only it is more pronounced in these Bulgarian rugs. When the producer's agent came to America and called on me with colored plates, soliciting an order, I told him he would have to change designs and get away from the mechanical look. Of course, no American can order these rugs because the duty (tariff) would be double that of rugs from Iran. Bulgaria and satellite countries do not enjoy the Most Favored Nation clause. Duty would be 45% instead of $22\frac{1}{2}\%$.

# BALUCHISTAN RUGS

## *(Made in both Iran and Afghanistan)*

**Availability:** A more correct spelling is perhaps Baluchi rugs. Also spelled Beloochistan and often referred to as Baluches, Beluches, or Beloochees. Very few have been brought to America in the past 20 years, but many hundreds are made each year. A great number of these are sold to Europe. The largest city in Eastern Iran is Meshed, and most of these are marketed there. Many find their way to Pakistan and Afghanistan. I have bought many Baluchi rugs as Afghans, and they were exported from Afghanistan. The dull, dark, sombre colors of most of these account for the lack of popularity in America. Ninety percent of these are made in sizes approximately 5×3 ft. to 6×3½ ft. A few are made in a size about 7×4 ft. and there are even a few about 5×9 ft. to 7×10 ft. Except for one group of some 150 very good, semi-antique Baluchis that one importer had in 1959, there have been practically none of these imported to America. This group would have been quite salable but the price was too high. The wholesale price was that of a Sarouk in the same approximate size. I turned down the offer to take them on consignment. Most of the Baluchistans offered in America since World War II have been from estates, and 9 out of 10 of these were too worn to be worthwhile.
**Characteristics:** Baluchi Tribes still live in their black tents. Their rugs are woven on horizontal (flat) looms. (See Plates 16 and 17.) There are several different tribes of Beluchi with different names. The principal colors used are three shades of dark red, two shades of blue, tan, or brown, with tinges of ivory and other colors. The color effect generally is that of dark, sombre red, mahogany, wine or brown, but the general effect is that of a purplish blue. Many come with a dark blue field, but when combined with the wines and reds, the blue seldom predominates, but gives the effect of purplish blue.

*178*

The several choicest and most beautiful of old Baluchis I have seen have had this blue field with an all over mina Khani design in wine, and small rows of flowers in between in ivory. The border is usually a geometric vine effect fringed with latch hooks. (See Plate 17.) Others come in the same general colors, wine or wine red; fields are with the same general geometric designs that we find in Afghan rugs. Even the all over floral designs are angular and almost geometric. A few appear with the herati design, but more angular than in most Persian rugs. Many are in a prayer design. Most of these have a natural camels' hair field on which is a large tree of life design (almost geometric in shape), and in dark blue, wine, browns, and some very dark green. In the upper corners, on each side of the prayer arch are two small rectangular areas including a small tree of life form. A full list of the many designs would require several pages, but one will have little difficulty recognizing a Baluchistan rug once he has seen two or three of these. One might confuse some few of these with Afghan rugs, but even the buyers in Iran and Afghanistan will do that. Up until World War II, all Baluchistans came with woolen warp, and had a wide kelim effect on each end. Today many of these are being made with cotton warp, which makes for a straighter rug that will lie flat.

When I first started in business in 1924, there were thousands of inexpensive Baluchistans in the New York market that could be retailed for $29 to $60. Practically all of these were being chemically bleached to soften their colors after they arrived in New York. They were, for the most part, very inferior rugs, and you may be sure that 95 percent of these are threadbare and worthless today. Most of them have gone in the trash can. This was due mainly to the chemical washing.

At the same time, a few very choice Baluchi were to be had. They were exquisite rugs with a wondrous, natural sheen. They retailed for $75 to $150 for the 5×3 ft. to 6½×3½ ft. size. Any coming from estates in good condition are most likely to be very good examples because the poorer qualities will have worn out. A prime old Baluchi is a choice and exquisite rug.

In the period 1920–1932 many exquisite, pan velvet quality, small saddle bags about 20″×20″ and about 32″×32″ were available. Few rugs had a nicer natural sheen than the best of these little mats, which were a collector's joy. These are seldom seen today.

Conclusion: There will be very few of these in the American market, because they do not go with other rugs as well as most types, and because they are too dark and sombre. The rugs from Afghanistan are far more beautiful, and many of them are not so sombre.

# BENGALI RUGS, CHINESE DESIGN

## (Made in India)

Availability: In good numbers, at one New York importing house only. A new creation of the last few years. In sizes 4×2.6 ft. to giant sizes.
Where made: In India.
Characteristics: In three color combinations—all in the same design shown in Plate 190. The field is almost a pure ivory with all designs in two shades of blue. Two other color combinations are with cream or very light tan field, with the

designs in shades of soft cocoa or green. Rug is well made and nap is 100% wool, and has good medium-thick nap. Rugs are sold in natural color and are not even lightly treated. Standard sizes are 3×5 ft., 6×4 ft., 8×10 ft., 9×12 ft., 10×14 ft., 11×18 ft., and 12×20 ft. Prices are moderate.

# BERGAMO RUGS

## (Made in Turkey)

**Availability:** Only in antiques and only from private collections. None made in the past forty years. A collector's item. One of the rarest of Turkish rugs. Most Bergamos were in sizes 3×3 ft., 5×5 ft., 6×5 ft., and usually in nearly square sizes. I say "available only from private collections" because even at the turn of the century these were sought by collectors, and seldom did the layman have an opportunity to buy a good Bergamo. I have been fortunate in acquiring three or four good ones from estates each year since the war.

**Characteristics:** Color Plate 121 is of one of choicest and rarest of Bergamo designs. Bergamos are a distinct type in weave. Their deep, rich coloring accentuated by their soft, lustrous wool, their depth of pile and their square shape, immediately attract the attention of the most casual observer. There is a great diversity of pattern in these rugs. Some few are in Prayer design, but the majority have non-prayer designs, which usually have a large central geometric medallion, fringed with latch hooks. The field around the medallion is usually covered with many small designs, such as the figure "S." Again, the field might consist of a series of different colors with the latch hooks design worked in, and with eight pointed stars or other geometric figures or angular floral designs on each of these squares. Rich blue, red, crimson, ivory, and yellow and a good bit of green and lavender are the colors most used. Bergamos and Ladiks have a lot in common, especially in the use of the Rhodian lily and pomegranate designs.

They were very rare 60 years ago, one of the 20 rarest and most valuable of all scatter sizes. They are quite coarse to average in weave. Fig. 22, Part I, Turkish Rugs, is typical of many Bergamos. Designs and colors are right. Fig. 22 is an almost exact duplicate in size, colors, and design to Plate 169 which is from the Victoria and Albert Museum in London. It is also similar to a Bergamo in the Metropolitan Museum of Art in New York.

This rug should not be confused with a cheap article made right after World War I in Greece and Turkey and sold as Pergamo. Pergamo is the real old town where Bergamos were made. These poor, cheap rugs named Pergamo were not made there, and had none of the characteristics of the real Bergamos. You will not be confused because these poor ones were made for only a few years and most of them have already worn out. They seldom appear, even in used rug sales. Plate 120 is listed by the Metropolitan Museum as a Bergamo or Konia. I would prefer to call this a Dirmirji. All of these are closely related.

# BESHIR RUGS

## (or Beshir Bokhara Rugs, Turkoman Family)

**Availability:** In limited numbers in tent bag sizes as well as rug sizes from Afghanistan.

**Where made:** Old ones were made in Russia's Turkman (Turkestan) just north of the Afghanistan borders in a settlement called Beshir on the River Oxus.

**Characteristics:** Many authorities call all Beshir rugs Ersaris. (Read Ersari Rugs, See Fig. 32, Chapter I.) There seems little doubt that Beshir rugs really are a type of Ersari, so the name Beshir and Ersari have come to be interchangeable on many that we have in the past called Ersari. This is especially true of all small rugs. Their color scheme is principally dark red, plumish wine, and brownish.

Many of the large carpet sizes, such as 8 × 18, 9 × 17, 6 × 15 ft., and similar sizes were different in design from any other Bokhara types or any other large carpets. Rugs in the above sizes have not been made in the past 45 years. These large sizes in plum-like wine field often have an all over angular floral design in blue and green with much yellow. The collector's favorite item is a prayer design similar to that shown in Part I, Fig. 32, Turkoman Rugs. The rug shown in Plate 174, while made in Afghanistan, has the design that tempts one to say Beshir. I am sure that the weaver of this rug is a descendant or a member of a family that wove in Russia rugs we called Beshir.

# BIBIKABAD RUGS

## (Iranian Family)

Also spelled Bubukabad—this is one of the three types that we class as Sena-Kurds.

**Availability:** In great numbers in new rugs in the New York market. Ninety percent of the output is in carpet sizes, 6 × 9 ft. and larger. About two-thirds of all these are in 9 × 12 ft. and very large carpets. A very few come in scatter sizes.

**Where made:** In the towns of Bibikabad and Ainabad, located some thirty miles northeast of Hamadan, where these rugs are marketed. Both towns make the same type and all are sold as Bibikabads.

**Characteristics:** Rugs are not finely woven but have a good weave for the very heavy nap of excellent wool. They are one of the most durable of all rugs in the medium price range. There are two general qualities. Those which are made by the individual families are generally known as Bazaar quality. The best of this type are woven in factories under supervision of Master weavers, and these are known as contract goods.

The designs in both qualities are very similar, as all follow one general design, but the Bazaar rugs are usually somewhat coarser, more colorful, and not as beautiful nor quite as heavy as the contract quality. The plate shown in Part I and Color Plate 15 are the typical design and colors of most of these rugs. The larger carpets will have more borders than Plate 15 (which is a 6 × 9 ft. rug) and the larger expanse of the main part of the field with the small Feraghan design makes for an even more beautiful carpet. The main part of the field is in some

shade of red or light wine and often has a slight purplish cast. The small central pendant is in ivory and light blue. The four large corners usually have three colors in each; navy, ivory, and green. Light blue may replace navy in the corners. Field, center, and corners are covered with the small all over herati (feraghan) design in green, pink, and tinges of ivory and blue, brown, and canary. Green usually predominates in this herati as well as in the turtle design in the main border. Oftentimes there is enough rose in the design to give the rug a real rosy cast. In addition to the main border which is seldom over six inches wide with the turtle design in green, there are usually two narrow borders in green, two in canary, two to four in blue, and two to four in rose or deep red. The colors in the contract quality are often soft enough to be used in the same room with semi-antique rugs. (See Color Plate 15.) Colors will seldom be as soft as this particular Plate 15. Also see Fig. 5 in Part I, Persian Rugs.

Up to 1952, many of these came with blue (navy) field, with blues the predominating colors. A blue rug of this type is seldom to be had today. The field will usually be in a medium wine or light plum shade. Some will have a red field and a few will have an ivory field. The small feraghan design over the field will have much pink, red, green, and flecks of ivory. The main border will have much green, pink, and red. The family made rug costs $75 to $150 less than the best contract rug of this type. There has been a slight lowering of the quality in both grades of this rug in the past five years. The Jufti knot, where one knot is tied on four warp threads instead of two, has found its way into these two villages. The discriminating dealer can still buy very excellent rugs in both qualities. Where I could formerly buy seven out of ten that I inspected, today I buy about one out of ten.

**Size:** Approximately one-third of the output will be in $9 \times 12$ ft. sizes. Very few of the $9 \times 12$ ft. sizes will be exactly $9 \times 12$ ft. The largest selection is in $6 \times 9$ ft., $8 \times 10$ ft., and $9 \times 12$ ft. carpets. In the larger rugs there are no standard sizes, but typical sizes are $9 \times 15$ ft., $9 \times 16$ ft., $9 \times 18$ ft., $10 \times 18$ ft., and $10 \times 20$ ft., with a few as large as $12 \times 20$ ft. and even up to $11 \times 23$ ft. In the better quality, from time to time, a few in such unusual sizes as $5 \times 4$ ft., $6 \times 6$, $7 \times 7$, $8 \times 9$, and $10 \times 12$ ft. appear in the New York market. A limited number of dozar sizes ($7 \times 4\frac{1}{2}$ ft.) still appear. Up to 1955, a good number came in the $5 \times 3\frac{1}{2}$ ft. size and many runners in the size about $10 \times 2.8$ ft. came in this type. Up to 1950, a few extra length runners up to 20 ft. in length were made.

**Conclusion:** A Bibikabad is a very excellent new rug for hard usage. It is one of the best values and most attractive in the price range. I have never had a Bibikabad show signs of getting thin even when it had hard usage for thirty years. When these rugs first came to America, they were called Sena-Kurds, since they were a Kurd type rug with a cotton warp. None of the writers of old books even discussed the Bibikabad rug. For the past 40 years it has been one of the best known.

**Other rug books:** Mumford in his great book of 1900, made no mention of this name. Nor did Dr. Lewis, Langston, or Ellwanger. The only line to be found about this rug is in Hawley's 1913 edition: "Now and then are seen comparatively scarce rugs such as Tehran, Gulistans, Bibikabad, etc. Some of them are no longer produced and others are woven in such small numbers that but few are exported."

A German book by Heinrich Jacoby, written recently, does not even mention Bibikabad. Yet it is one of the ten standard types of Persian rugs in carpet sizes.

*182*

Only Herez, Kabuterhangs, Sarouks, and Kirmans are produced in greater numbers; and only Herez, Sarouks, and Kirmans are better known. A. Cecil Edwards, the Englishman, in his recent book, of course, devotes full space to this rug and covers it in detail.

# BIJAR

## (Iranian Family)

**Availability:** Only a few hundred new Bijars were imported in 1960. Most of these were in sizes $2\frac{1}{2} \times 4$ ft. and $5 \times 3\frac{1}{2}$ ft. All were new rugs. From 1940 to 1955 a good many new Bijars in $8 \times 5$ ft. and $10 \times 5$ ft. and a few in the $9 \times 12$ ft. size came to America. No old Bijars have been imported since World War II. Comparatively few have come in the market from estates or private collections. In the period 1924–1930 old Bijars came in many sizes in great numbers. The vast majority came in approximately $7 \times 4$ ft. sizes, but they came in many unusual sizes as well. Most of the carpet sizes before 1930 were in $8 \times 12$ ft., $8 \times 13$ ft., $9 \times 15$ ft., and $11 \times 18$ ft. with a few larger in size. There were many wide runners, $3\frac{1}{2} \times 10$ ft., $4 \times 12$ ft., $4 \times 19$ ft. and all the in-between sizes; always $3\frac{1}{2}$ ft. wide or wider. After World War II up to 1955, large numbers of new Bijars, in sizes $5 \times 10$ ft., $5 \times 8$, $5 \times 3\frac{1}{2}$, and $4 \times 2\frac{1}{2}$ ft. came to America.

**Where made:** In the town of Bijar in Iran, and by tribes in vicinity of this town. Very little weaving has been done in the Bijar section in the past five years. Some one to two hundred Bijars in the $9 \times 12$ ft. sizes came between the years 1947 and 1955. Hardly a large Bijar has been imported since 1955.

**Characteristics:** New Bijars, believed to have been woven in the period 1938–1945, were tightly woven rugs, of board-like construction, with a thick pile. Bijars were one of the most durable types. (See Plate 12.) The new ones, after the war, were more finely woven than the old ones, but not as desirable. The majority of these came with red fields. Most of these rugs employed the herati (feraghan) design over the main part of the field, and often included a small medallion and corners. (See Plates 18 and 19.) A few of the $9 \times 12$ ft. and approximately $10 \times 5$ ft. sizes came in other designs, such as the Shah Abbas design. These ceased coming to America initially because they were not in great demand by American retailers for a number of reasons. They were too costly compared to other rugs such as Kasvins and Sarouks. The colors of most were too bright, and the $9 \times 12$ ft. rugs were too irregular in shape. As a class, their sides and designs were more irregular than any other type of rug. Cotton has been used for warp since World War II. Old Bijars used only woolen warp.

**Old Bijars:** Old Bijars were one of my favorite rugs. They were the best of the Kurd Tribal rugs. In spite of their coarse weave, no other type was more beautiful, or more durable. They were made in many different and exquisite designs. I have often regretted not making a collection of Bijars during the period 1923–30. No other rug used so many different Persian designs. It is impossible to give space to each design. Among those most often seen in that period were the small all over herati (feraghan) (Plate 19), and the same feraghan design combined with small central medallion and corners (Plate 18), the Shah Abbas, and the Mina

Khani. Perhaps my favorite design was the plain open ground field, with a central floral medallion and corners. The field of these was mostly red, but a few had a light blue field, or a light camel tan field. The latter would usually have exquisite canary or gold corners. Others came with the so-called lightning design. One of the most beautiful of all designs was the French realistic rose cluster design, which Cecil Edwards refers to as the "Gol-i-Frank or European Flower" design which was originally copied from French fragments of tapestries. There are different theories as to how these typical French rose designs came to be used in Persian rugs. Collectors like to possess what is called a Sampler, where the weaver has woven into a rug about $5 \times 3$ ft. to $6 \times 4$ ft. each of the designs his family uses. Plate 22. One such rug will have a small section of the field with the herati, another section will use Shah Abbas, and a half dozen or more border designs. This is, in effect, all the family designs combined in one rug and was passed on from one generation to another to copy.

**Conclusion:** The very few new Bijars that are being woven today are not coming to America. Persian and European buyers absorb them. Rare old Bijars are seldom available from estates. When a good one is found, there are few more delightful rugs, and none more durable, in spite of their coarse weave.

# BIRJAND RUGS

## (Persian and Iranian Family)

**Availability:** Birjand rugs are one of the cheapest quality of the grades sold as Masheds today. A few lots of these have come to the New York market, but they have had a cold reception. A few of these go to the European market, but the majority are sold to the Persians themselves, mostly in Teheran. Most are carpet sizes, $7 \times 10$, $9 \times 12$, and $10 \times 14$ ft. In late 1960 these cheap grade Masheds began to reappear in New York.

**Where Made:** In the City of Birjand which is some 150 miles south of the Shrine City of Meshed. The large district is Khurasan and Meshed is the capital.

**Characteristics:** These are among the poorest rugs being made in Iran today. The knots are tied on four warp threads. A poor grade of wool is used, and then it is steeped in lime water before being dyed. This adds up to a very loosely woven, poor wearing rug. The principal color is cochineal red. While this color can be in a pleasing shade, those coming in the Meshed rugs of Birjand (sometimes sold as Birjands in the Free Port of London and in the Teheran market) are usually in a shade approaching magenta. Plates 72 and 81 are of better rugs, but these designs are also used by the Birjand rugs. For full information on all rugs from this section, read Ispahan Meshed rugs, Turkibaff rugs, Khurasan rugs, and Meshed rugs. See Plates 72 and 81.

Unless there is some tremendous change in the method of weaving in this great district of Iran, they will seldom be seen in the American market. Some smart operators or master weavers can, over the next few years, make improvements that will make these rugs popular. The general designs are far more salable than those of the Gorevans, the Kabutahangs, and other inexpensive rugs, but they will be rejected for poor durability and undesirable color combinations.

**Note:** In late 1960 and early 1961, we find large numbers of these being imported by New York importers. My favorite Fifth Avenue, New York City department store, sent their young buyer to Iran, and he came back with a number of carpets from the Meshed District, some of which were Birjands. I was distressed to see his advertisement in the *New York Times,* advertising these as "Ispahans." They are attractive rugs but they wear thin very quickly. I have never heard a dealer say a good word for any of the rugs from the Meshed District except the "Turkibaff quality" which most dealers have insisted on calling "Ispahans." Even this is bad enough, but when a good store, or any store, advertises the cheap grade Misheds, Khurasans, and Birjands as Ispahans, the trade has reached a low level.

# BOKHARA RUGS

## *(Iranian Family)*

A beginner can be easily confused by the name Bokhara. All the different types of rugs that are classed as Turkoman rugs (Turcoman or Central Asiatic family in the rug books) are known by the laymen and most dealers as Bokharas, and this is a general term. For detailed information about the many special types of so-called Bokhara rugs from Soviet Russia's Central Asia States (now called Turkmen S.S.R.) and the many types from Afghanistan, read the chapter on Turkoman rugs and Afghan rugs in Part I. Also read the details under many different types listed in Part II which most of us call the Bokhara family. Some few will insist that these should be called Tekkes, Salors, Yomuds, Ersaris, Khivas, Afghans, Pindes, Beshires etc., instead of "Khiva Bokhara," "Royal Bokhara," etc. Any usage that has been so generally used and accepted for some 60 years should be accepted, just as our dictionaries bow to the general usage of a word.

I cover each of these different types under each name. Remember there is a City of Bokhara in Soviet's Turkmen. Few rugs were ever woven there, but it was the market place for many types of Turkomen rugs, and the reason why the name Bokhara was given to these rugs.

This particular heading covers only new Bokharas which have been made in Northern Iran (Persia) in recent years. (See Color Plate 20.) They are the one rug imported as Bokharas on invoices and sold simply as "Bokharas." Color Plate 20 is a typical Persian Bokhara both in color and design. The design is that of a Tekke or Royal Bokhara but the weavers are Yomuts.

**Availability:** In good numbers in the New York market in Tekke designs (better known as Royal Bokhara designs); in sizes approximately $5 \times 3\frac{1}{2}$, $6 \times 4$, $8 \times 5$, $6 \times 9$, $7 \times 10$, and $8 \times 11$ ft.

**Where made:** These rugs are being woven in northeast Iran. Two of the three Tribes are Yomuds (Yomuts) and one is Tekke. They crossed into Iran from the Turkmen Socialist Soviet Republic (S.S.R. of Turkmen).

**Characteristics:** All three areas weave their rugs in the Tekke design with three or more rows of Tekke octagons. This is the same design used by old Tekkes, which are better known as Royal Bokharas. These Yomuts in Iran have abandoned their old designs of latch hooked diamonds and use the same Tekke designs

(quartered) octagons. All rugs are woven on horizontal flat looms and it is amazing that they can make these rugs as large as $8 \times 11$ (most of largest are actually about $7.8 \times 11$ ft.).

Rug colors are in a wine red field and perhaps not as deep a wine or mahogany as so many of the old Tekkes have. The octagons are quartered and contain more ivory than most old Tekkes. They are not as fine as most of the old Tekkes, but they are nicely woven and somewhat heavier than the Tekkes from Central Asia. The wool used is excellent and I have not discovered any bad dyes to date. Most of them still use woolen warp. Prices are quite moderate and less (or no more) than other new rugs of same fineness.

The Yomuts (Yomuds) in Afghanistan are also weaving many of their new rugs in the Tekke design (Royal Bokhara design). It will not be easy for the beginner to know the difference, but there are different earmarks. As a rule, the ones from Afghanistan will be slightly coarser, more tightly woven or compact, and heavier. But I must quickly add an exception to the above rule. In the Free Port of London warehouse I have examined some few Yomuts from Afghanistan in Tekke design that were finer than those from Iran. They compared most favorably with the weave of the old time Tekke rugs. You will not mistake the "Mori" rug, in Tekke or Royal Bokhara design for other types of Bokhara in this design as the Mori has a nap of Cashmere (Kashmir) wool and the feel of silk.

## BORCHELU RUGS

### *(Iranian Family)*

Classed as Sena-Kurd. Iranians often spell it Bozchelu.

**Availability:** In limited numbers of new rugs in so-called Dozar sizes, approximately $6.8 \times 4.8$ ft. In greater numbers in $5 \times 3.4$ ft. rugs and short runners $(6.6 \times 2.6$ ft.) and a very few about $10 \times 5$ ft. No carpet sizes are woven.

**Where made:** In the district by this name, some 40 miles east of the City of Hamadan. Marketed in the City of Hamadan.

**Characteristics:** The Borchelu rug is the only rug in the great Hamadan weaving area with curvilinear design. An exception is the Kasvin made in the City of Hamadan itself. The field is usually ivory, but also comes in blue or rose. Invariably the rug has a floral medallion and corners in blue, rose or red (most often blue or ivory). (See Plate 25 of a $6.6 \times 4.6$ ft. rug.)

The short runners do not come in blue. The floral design over the field and corners is in red, rose, and blue, with perhaps more green and canary or gold than any other rugs from the Hamadan area. Borders are usually blue or ivory. Rugs are quite colorful when new. A very few semi-old soft rugs in dozar size and $5 \times 3\frac{1}{2}$ ft. size have come to America in recent years. Occasionally a parcel in size about $3.4 \times 3.4$ ft. (all new) appear. There is a great difference in quality between the excellent dozar sizes ($6\frac{1}{2} \times 4\frac{1}{2}$ ft.) and the downgraded $5 \times 3\frac{1}{2}$ ft. and $6\frac{1}{2} \times 2\frac{1}{2}$ ft. sizes.

A Borchelu is a heavy quality rug of better than average weave with excellent wool. Thousands of rugs that formerly came from this district were dark colored rugs, often using black and brown, and sold as Hamadans.

*186*

**Conclusion:** This is a good rug to buy if you find your colors. The rug is too popular among wealthy classes of Persians who like primary colors, to permit American buyers to import them in numbers. Germans also out-bid American buyers on these.

You will find no mention of this name in any of the American rug books or old European books. The reason being the lack of transportation and roads in Iran. They were known as Hamadans (or Sena Kurds by me and some of the collectors I knew). Today the name Borchelu is well known in the trade.

## CABISTAN RUGS *(See Kabistan)*

### *(Made in Caucasia)*

Spelled both ways. Americans have inclined to the use of "C" but I think "K" is perhaps more correct. (See Plates 157, 158, 159, and 160.)

## CARABAGH RUGS

### *(Made in Caucasia (Russia))*

(SEE KARABAGH RUGS.) Many collectors still use this spelling of Carabagh. In my first book, 1931, I used this spelling because most of the collectors I knew had used it. Karabagh is more correct.

## CHAUDOR RUGS

### *(or Chodor Bohkara Rug Turkoman Family)*

Chaudor rugs are a subdivision of the Yomuds. This name was unheard of in America until the Englishman Hartley Clark devoted his book exclusively to "Bokhara, Turkoman and Afghan Rugs," in 1922.

Amos B. Thatcher, in his little book devoted exclusively to Turkoman rugs in 1940, embraces all of Clark's ideas. He changes the spelling to Chodor. One of the irregular shaped octagons is used by these weavers. These rugs generally have more brownish wine tones than most Yomuds, and less of the cucumber green so often found in Yomuds. (See Yomud Rugs.) The color of these might be called a chestnut brown. If you call these Yomud (Yomut) Bokharas you will not be wrong as Chaudor is a sub-division of the Yomud Tribes.

*187*

# THE CHELSEA CARPET

## (Persian Family)

Because I have shown this carpet in Part III, Plate 5, under this name, a line about this famous rug, which may be older than the Ardebil Mosque Carpet, is in order. There is a disagreement as to where this rug and the Ardebil Carpet were woven. Both are believed to have been woven in the same town. Some believe the Ardebil was woven in Kashan, others in Herat, and still others in the town of Ardebil, Persia. The Ardebil Carpet was in a palace at Ardebil when it was acquired for the museum.

The *Museum Guide Book* (Victoria and Albert Museum, London) simply lists this rug as "Pile Carpet, Persian, early 16th century." It has come to be known as the Chelsea Carpet by reason of its being bought by the museum from a dealer in the Chelsea district of London. Details from the *Guide Book* follow: "The combination of Chinese with Persian motives, conspicuous in Persian art in more than one epoch, is very evident in the design of this carpet. The design is a peculiar red, inclining to a carmine. The medallions contain arabesques, palmettes and floral stems. . . . The red ground is covered with trees, bearing flowers and fruit . . . with lions and leopards (some preying on oxen and deer) gazelles, hawks swooping down on herons and other birds. In the middle is a small tank or pond containing fish, with a large vase on either side supported by lions and Chinese dragons."

Like the Ardebil, the warp and weft are silk. The Chelsea Carpet counts $21 \times 22$ knots to the inch, which is 50% finer (meaning more knots) than the Ardebil.

# CHI-CHI RUGS

## (Caucasian Family)

**Availability:** Chi-chi Rugs are a collector's item and very rare. None have been imported in 30 years, and none were made in the past 30 years. A very few came from private collections or estates in sizes $5 \times 3$ to $6\frac{1}{2} \times 4\frac{1}{2}$ ft. Most of them are quite thin and somewhat worn, but a good example even though thin, is rare and valuable. I have had six in perfect condition since World War II. These were rare 50 years ago. The rugs are never made larger than $7 \times 5$ ft.

**Where made:** Up to 1924 these were made by the Tchechen Tribes which inhabited the wild area just north of Daghestan District (now part of the Russian Soviet Federated Socialist Republic). I have seen no new Chi-chi in the past 36 years. Not even during Russian Five Year Plans (1924–32) when thousands of new Caucasians were made, did new Chi-chi come. None of the new Persian Ardabil Rugs which are using old Caucasian designs are coming in the Chi-chi design. None of the few new Caucasian rugs which were woven in 1960 for the first time in years, employ the Chi-chi design.

**Characteristics:** The several types of Caucasian rugs of rather fine weave and short to medium nap are much alike in quality and weave. Except for their designs, it is difficult to tell whether the rug is a Kuba, Kabistan, Daghestan,

*188*

Baku, or Chi-chi. Plates 148 and 149 in this book gives the one general design in which 90 percent of all Chi-chi were made. Plate 82 in Lewis' book, Plate 42 in Hawley's book, and the Plate in Mary Beach Langtons' book opposite page 118 (listed Tzi-Tzi) all have the same design in the field and the same main border design as my Plates 148 and 149. The field on both Plates is blue and the colors of the design are typical. These rows of small jewel-like designs are to be found in every Chi-chi. The majority seem to be latch-hooked side octagons with small geometric tree and pear forms. Many other small geometric mosaics are between these. About one-fourth come with the field red instead of blue. Mr. Shearer of Houston, Texas has the best red Chi-chi I have seen. The wool quality is excellent. Weave is medium to rather fine. Dyes are invariably old vegetable dyes. Lewis' book in stating the number of knots to the inch is entirely wrong. All are at least twice as fine as he indicated.

# CHINDA QUALITY

## (Indian Family)

**Availability:** In new rugs, in all the standard sizes 2×3 to 12×20 ft.
**Where made:** In India, in the Mirzapur area, in a modern factory.
**Characteristics:** Chinda is a trade name. Chinda quality is one of the very best being woven in India today in Chinese design. They are heavy quality, tightly woven with good wool, and, use excellent chrome dyes. The large importing house that brings them to America says that all are woven in authentic 18th century design. There are at present some eight different colors and designs offered in Chindas. They are listed as 9563 Ivory, 9670 Rose, 9671 Green, 9565 Beige and four others. Sizes made are 2×3 ft., 2×4, 3×5, 4×6, 6×9, 8×10, 9×12, 12×15, 11×18, and 12×20 ft. I quote from a memorandum furnished me by the well known importers in New York who bring them to the New York market (exclusive with this one firm):

"Faithfully reproducing all the desirable details of the glamorous carpets from China, CHINDA carpets are woven in a sparkling assortment of frosty pastel color tones in the finest of fine India carpet wools. Washed to a shimmering luster, all CHINDA carpets are hand woven in authentic 18th Century designs by the most skillful weavers of the Orient."

# CHINESE RUGS

## (Chinese Family)

**Availability:** *Antique Chinese Rugs*—only from estates of collectors. Seldom worthwhile. (See Figs. 38 and 39, Part I and Plates 191, 192, and 193.)

*Used Chinese Rugs*—From estates only. Hundreds of thousands of Chinese rugs made in China were sold during the period 1923–1932, in many different qualities in scores of sizes, with the vast majority in the 9×12 ft. size. These are continually coming into the market from estates. Some are in excellent condition, but the ma-

jority are from badly worn to slightly worn. Some are in nice design, others in color combinations that make me wonder who would buy them when new. (See Chapter on Chinese Rugs, Part I and Plate 179.)

*New Chinese Rugs*—have seldom come to America from China proper for the past 25 years, since during the Japanese war all the looms were destroyed. During the late war none were made. Today, America excludes all Communist China goods. In 1960, at the Free Port of London, Culver Street warehouse, I saw many very superior quality Chinese rugs for sale. The wholesale price was around five dollars per square foot—which in itself made them prohibitive to ever sell in numbers in America. (See Chinese Rugs, Part I.)

## CHINESE DESIGN ORIENTALS

### *(from India)*

SEE Chinda and Bengali, Plate 190.

## CHINESE DESIGN ORIENTALS

### *(from Japan)*

SEE Peking, Plate 188 and 189, Fuigi Royal, Plate 194, and Imperial, Plate 187.

## DAGHESTAN RUGS

### *(Caucasian Family)*

**Availability:** None have been made in the past 30 years. The few used antique rugs of the type that appear are usually from private collections in sizes $4 \times 3\frac{1}{2}$ ft. to $6\frac{1}{2} \times 4$ ft. A good Daghestan was rare forty years ago, and they were seldom acquired at that time by the beginner. A choice example in good condition is indeed rare. None of the few new Caucasians which just appeared again in 1960 are copying the Prayer Daghestan design. (See Chapter Caucasian Rugs, Part I.)
**Where made:** In the Daghestan District which is in the middle eastern part of Caucasia. It is now a Soviet Russian State.
**Characteristics:** The rugs are from rather finely woven to very finely woven with a short, compact nap. Many of the rugs that we call Kabistans, Kubas, and Shirvans are no doubt Daghestan rugs. All these rugs have the same general characteristics as to weave, thickness, wool, and many even have the same general design. I have followed in the footsteps of most of the old authorities and call most of these Kabistans instead of Daghestans. The one design which all agree is a Daghestan, is the Prayer design Daghestan, Plate 150. It will not be mistaken for the other Caucasian rugs made in this section of Caucasia. All of these come in this same general design. The same design is the plate rug in the Victoria and Albert Museum in London; also in the Metropolitan Museum in New York.

The identical design is shown in Dr. Lewis' book, Plate No. 80, and the same is true in other books. Most of these have an ivory field, but there are a few in private collections with a gold or blue field. As Mumford said in his first edition in 1900: "The similarity of so many Kabistan rugs to the Daghestans in quality, design and colors enables dealers to sell the one for the other." A full coverage of this subject of Daghestans, Kabistans, Shirvans, Kubas, and Chi-chis (they should be included under one heading) is included under Kabistan Rugs. This one design that we have discussed and shown in the plates, we invariably call PRAYER DAGHESTAN. It usually has the ivory field (occasionally a gold field) with an all over design of tiny compartments of small lozenges, on each of which is a small three-petal flower in angular form. The latch-hook design is more used in the borders of Daghestans than in any other rug. The Prayer niche always has five sides as shown in Plate 150. This same general design without the prayer niche is found in the non-prayer Daghestans. Plate 151, I have listed as Daghestan. It might be a Kabistan or Shirvan, but any one of these three names is close enough in non-prayer. This rug was made prior to 1910, perhaps as early as 1850.

During one of the Russian Five Year Plans (1929–34) many of these were made in very fine quality, with excellent wool and with a slightly heavier nap. It is strange that so few of these have appeared in estates. They are easily distinguished from the really old rugs, as these newer rugs used cotton warp.

**Conclusion:** No one will object if you choose to call many of the rugs that we class as Kabistans or Kubas, "Daghestans," but the one definite, unchallenged Daghestan design is the one we have pictured and described. (See Kabistan Rugs.)

# DAMASCUS RUGS

*(so-called "Damascus Type")*

*(Turkish Family—Asia Minor)*

**Availability:** No rugs by this name have been imported in the past 50 years, and none have appeared in the closing of estates in many years. We give this name a few lines only because a few rugs by this name were exhibited by collectors many years ago. The last private exhibit of rugs by this name was at the Metropolitan Museum by Mr. James F. Ballard, over 40 years ago.

**Where made:** In the Asia Minor section of Turkey (Turkey in Asia). Many years ago it was thought that these rugs were woven in Damascus, but it is now a known and accepted fact that these were woven in Northwestern Asia Minor (Turkey) and that Damascus was merely the port through which they were shipped.

**Characteristics:** The chief characteristics of these so-called Damascus rugs is that they used fine Angora wool, and they are readily distinguished by their unusual color scheme of cherry red, light blue, yellow, and sage green. The designs are mostly geometric. Those exhibited in museums usually have a field with a large square inclosing an octagon with oblong panels at each end. The field may be divided into squares inclosing hexagons. Other small designs on the fields will be stars, angular rosettes, flowering shrubs, and conventionalized trees. Still others showing more Persian influence would use Chinese cloud banks, serrated leaf.

palmettes, carnations, roses, and hyacinth. Most of the experts I know would give these the name of Konia today.

# DERBEND RUGS

## (Caucasian Family)

**Availability:** None by this name has been imported in the past 35 years, and none has been seen by the author in any private collection in recent years. All were scatter sizes as no large rugs were ever woven in this type.

**Where made:** In the seaport town of Derbend. Just east of the Daghestan district and barely northeast of the Shirvan district.

**Characteristics:** Mumford said of these in his 1900 edition: "They are poor Daghestans and not particularly good Nomads. They usually have as a main design a large star design or some other geometric figure repeated three or four times traversely on a field of red or blue. . . ." This might have been the description of a Kabistan or Kuba or some Daghestans.

**Conclusion:** Since none have been imported under this name and since early authorities said they were coarse and mediocre, the name has disappeared from the trade. No doubt many of these were brought in as Kabistans or Daghestans.

# DERGEZIN RUGS

## (Iranian Family)

A type of Hamadan or Sena-Kurd. Often spelled Dargazine.

**Availability:** Great numbers of new Dergezin rugs and runners are made, and most of these come to the American market. No carpet sizes are made. Two-thirds of all new runners imported are Dergezin and two-thirds of the output of the entire Dergezin District are in runner sizes. The other third are in small mats $2 \times 3$ ft., $4 \times 2\frac{1}{2}$ ft., and $5 \times 3\frac{1}{2}$ ft. sizes. Also in very small Dergezin mats 16 to 20 inches wide and 24 to 30 inches in length are made. The greatest number are made in short runners $6.6 \times 2.6$ ft. to $7 \times 2.8$ ft. and runners 9 to 10 ft. in length and 2.5 ft. to 2.10 ft. wide. Three-fourth of all the extra length runners 12 to 25 ft. in length are Dergezins. Beginning in 1958 a good many came in Kellai sizes (Kelligis sizes) $4 \times 11$ ft. to $5 \times 15$ ft.

**Where made:** In the Dergezin District, some fifty miles north of the City of Hamadan. One of the villages is also named Dergezin. All of these are marketed in Hamadan. There are some fifty villages in this district weaving Dergezins.

**Characteristics:** Dergezins are thick rugs of good average weave with a medium-heavy nap of excellent wool, good dyes, and excellent wearing quality. The designs shown in Color Plate 58 are typical of all these rugs. The field is invariably in some shade of red or ivory with floral sprays and designs somewhat like those found in Sarouks. The designs are usually in colorful shades of blue, green, and ivory with a lesser amount of other colors. While most of these rugs follow the same general design, they show many variations. One will have much open ground

and another will have a well covered field. In spite of the fact that most of these are quite colorful, they are the most popular of all runners in the market. A few years usage tones these down to much softer colors. A few of those with ivory field come in colors soft enough to be used near a Kirman. Most of them will last a lifetime on stairs or in halls.

**Miscellaneous:** If you are seeking a long runner for the stairs or long hall, the odds are that you will find what you need in a Dergezin, and seldom in any other weave.

# DIRMIRDJI RUGS

## *(or Dirmirdji Kulah Rugs)*

## *(Turkish Family)*

**Availability:** Rarely from an estate or collector. They are invariably in sizes about $5 \times 4$ to $6\frac{1}{2} \times 5$ ft. None have been made since 1925, and none imported since 1929.

**Where made:** In the Asia Minor section of Turkey.

**Characteristics:** A thick rug of better than average Turkish weave, along the same lines as a Bergamo but, as a rule, a little thicker and a little heavier, but not as valuable or beautiful as a choice Bergamo. A Dirmirdji rug has more bluish green, green, and yellow than any other rug made. The field is invariably in the hearth design, an oblong sexagon having corners with the general design almost identical to Plate 49 in the book *The Ballard Collection of Oriental Rugs*. Mr. Ballard presented this rug to the Metropolitan Museum of Art. It shows almost the exact design, which for the past 38 years every dealer and collector I know has called Dirmirdji. Mr. Ballard lists it as follows: "Turkish, Bergamo? Konia? XIV Century." This is Plate 115 in this book. I have had a total of about 20, and perhaps have seen another 20 of these. Each usually has the central part of the field in a brownish brick with a tinge of plumish red. The corners are in green or bluish green, and the main border invariably in a clear yellow. Much of the design is in green and bluish green. In others, the main part of the field is in bluish green. The rug has at least a bit more floral tendency than even the Bergamos. It has excellent wool quality and vegetable dyes.

Plate 115 is listed as Bergamo or Konia by the Museum. I beg to disagree, and say that this is the rug every dealer and expert I have known during the past 35 years called Dirmirdji, or Dirmirdji Kulah. Of course, the name Anatolian would satisfy most Museums. The exact location within 50 miles in many rugs is unimportant to most.

**Other rug books:** Mumford in his first edition and Hawley in his 1913 edition discussed these but gave no description as to design or colors. My guess is that at the time neither had seen one of these rugs. Mr. Mumford stated (in 1900) that these were easily mistaken for Ghiordes, a statement that I cannot understand, even though the town of Dirmirdji is close to the town of Ghiordes. Also, he stated that they were selling about 20% higher than Ghiordes. A good Ghiordes sells for $1,500 to $5,000 while the best Dirmirdji sells for $150 to $250 today.

Even at the turn of the century, a good Prayer Ghiordes sold for $1,000 to $2,500. **Conclusion:** Even though this is a scarce and rare rug, it has never been a favorite with the collector; and its unusual colors were never in great demand by the layman because they do not go with other rugs. A full collection would, of course, want to include one of these. I have devoted too much space to this rug, as it is one of the least sought after of all old Turkish rugs.

## DOZAR RUG

There is no rug by this name. Dozar refers to size only; a rug about two square meters or 6 × 4 ft. The importing houses and retailers use this name today to refer to a large scatter size rug, *i.e.*, Hamadan Dozar, Sarouk Dozar, or Kirman Dozar.

## ERSARI—OR BESHIRE BOKHARA RUGS

### (Made in Central Asia, Russia, and Afghanistan)

**Availability:** While none of these have come to importing houses in New York in many years, I have personally imported these in good numbers in antique and semi-antique rugs each year through 1960. Most were in old tent bags, which are called Juvals. They were approximately 4 × 2.6 to 5 × 3 ft. and in the small tent bags called Torbas approximate 3 × 1 ft. to 5.5 × 1.8 ft. All of these came from Afghanistan. Some few newer, larger rugs, undoubtedly woven by members of the Ersari Tribes in Afghanistan are also available.

**Where made:** The Ersari Tribes are the largest of the Turkoman Tribes and inhabit the regions north of Afghanistan on both sides of the Oxus River. Many of them now live in northern Afghanistan which accounts for my importing many old Ersari in 1958, 1959, and 1960. No one ever heard the name Ersari until the book, *Bokhara, Turkoman and Afghan Rugs* (published in 1923 by Hartley Clark, an Englishman who spent many years in Central Asia) came into the hands of the American collectors and dealers. Since the old rug books available afforded limited coverage, all quickly adopted Clark's ideas and the new name Ersari. Most authorities did not go so far as Mr. Amos Thatcher did, when he called all the rugs that we had previously called Beshire Bokharas, "Ersaris," but they were glad to discover a new name. Hartley Clark explains the two names as follows: "There is a small Ersari settlement called Beshir on the River Oxus, and the name has, from trade usage, acquired more notability than it merits from a rug-making point of view." The rugs are not expensive. Best perfect semi-antiques in 5 × 3 ft. size will sell for about the price of an average new Sarouk.

**Characteristics:** The principal colors are wine, rosy wine, and tanish brick. They are very close to the Yomuds, but the better Yomuds are slightly finer and tighter. They have a medium-short to medium-thick nap. Designs are geometric, or geometric flowers. The design I think of as being typical Ersari is the large tent bag shown in Plate 172. Thatcher's Plate 36 is almost identical. Amos Bateman Thatcher in his book *Turkoman Rugs* gives the name Ersari to all the types that were previously called Beshire rugs. Some would call the rug in my Fig.

32, Part I, a Prayer Ersari. I list it as a Prayer Beshire. I do not think it too important which name we choose. In 1958 I bought a half-dozen to a dozen old tent bags practically identical with each of the Plates in Thatcher's book, numbers 56, 37, 38, 43, and 44, together with a number of others that I called Ersari. In 1960 I again bought a number in the design of my Plates 172 and 173.

The wool is excellent and vegetable dyes are used. The warp is a brown or grey wool, often made of camel's wool.

Even the collector and expert will or should not be emphatic in the line of demarcation between Yomuds, Ersari, Chaudor, and Beshires. If you had only the old rug books written prior to 1922 you would call all of the first three Yomud Bokharas.

Even Hartley Clark, the Englishman, who in his first published book in 1922 devoted exclusively to "Bokhara, Turkoman and Afghan Rugs," said: "Some people regard the various Ersari setttlements, e. g. at Sakar Bazar, Bourdalik, Chakir, Kizil Ayak, Khoja Salih, etc., as distinct minor tribes. However, both ethnographically and from a rug-making point of view, they are better grouped together under the name of Bokhara Turkomans. They are now only semi-nomadic, and are practically a settled race which has become sedentary and taken to agriculture."

This was the situation and facts recorded about a situation then existing, some 40 years ago. With all the means of travel and these sections opened up by present-day means of transportation, we have learned much more about these Turkoman Tribes, most of which are no longer tribes.

## ESKI-SHEHIR RUGS

### (Turkish Family)

There have been no rugs made by this name for the past 28 years. Right after World War I, heavy, medium quality rugs made in a town by this name were sold under the trade name of Eski-Shehir, though they were better known as Spartas or Ispartas. (See Plate 132 which is typical of many of those made in the period 1923-32.)

With the tremendous buying splurge by European countries, some few new Turkish rugs are beginning to appear. Those few that I have seen will not find a ready market in America. If Europeans continue on a high level of prosperity, especially West Germany, Italy, Switzerland, and the Scandinavian countries, Turkish weaving may see quite a revival but my guess is that it will be only temporary.

## FARS RUGS

### (Iranian Family)

See Shiraz Rugs and Plates 99, 100, 101, 103, and 104. Fars is one of the five largest provinces in Iran. The City of Shiraz with over 100,000 population is the

market place for all the rugs woven there and by the different tribes in the area. All these rugs have been known as some type of Shiraz and never have been offered in America as Fars. See Shiraz Rugs, Qashqai (Kaskai) Rugs and Mecca Shiraz. All of these belong to the Fars Tribal Group. The Fars which occupy a large area north of Shiraz some $140 \times 200$ miles, are divided into two large groups of tribes, the Qashqai (Kashkai) with some 200,000 members in four or five tribes, and the Khamseh in two large tribal groups with some 70,000 people.

All of these rugs are classed as some type of Shiraz——see Shiraz, Mecca, and Qashqai (Kashkai). They are sold under the above names, and not as Fars rugs, which is the general name.

# FERAGHAN RUGS

## *(Persian Family)*

**Availability:** Feraghan Rugs are available only from estates and private collections. A collector's item fifty years ago and expensive at that time. In fact, since 1900 it has been one of the four or five most sought after Persian rugs, particularly by collectors. Most of those appearing today are in the scatter size, approximately $6\frac{1}{2} \times 4\frac{1}{2}$ ft. because these are the sizes (and the very few smaller sizes) that the art collector bought and preserved. Most are somewhat thin and the majority are worn. The larger sizes are invariably worn thin, yet command big prices. Very, very few Feraghans in large sizes were ever made.

**Where made:** In the plains of Feraghan, northeast of Sultanabad (Arak) in an area approximately $20 \times 40$ miles. The town of Sarouk is close by and a few of the very old rugs are called Sarouks (and a few Sarouks are called Feraghans). Many Feraghans were made in the town of Muskabad, where now only Muskabads are made. The district now weaves only Sarouks, Mahals, and Sultanabad qualities.

**Characteristics:** Feraghan rugs are not thick even when new. They are from medium-fine to very finely woven, and have a close, firm nap. These, like the Senna rugs, have a frosty feel to their wool. Wool and dyes are invariably good. There is a wide diversity in the designs used, but the two principal groups are those with the small all over design and the others with a central medallion surrounded by a uniform plain field, usually in red or ivory and occasionally in green. (See Plate 83.) In the first group, the small all over Feraghan (herati) design is the one most used and best known. (See Plates 36 and 37.)

Other designs used were the small Gula Henna design. A few came with the Mustaphi design. (Plate 85.) These and most of those with the small all over design usually have a blue field, but some are in soft, dull brick red. The medallion with the open ground field is usually in red. (See Color Plate 83.)

One very marked characteristic that seems ever present in these delightful rugs is the use of a satisfying apple green in the main border. This green, like the black in most rugs, wears down more quickly than the other colors in the border and gives the embossed effect, leaving the other colors high, while the green is much lower. A green-bordered Feraghan is much more valuable than one with the rose or blue border. As a rule the most valuable and costly of all Feraghans

is the medallion with the open field in red or ivory and the border in green. Often-times the medallion will be in green. (See Plate 83. Plate 86 is in the same general design as Plate 83 and it is equally rare and choice.) A few new ones were made in the period 1920-1930 but none have been made since that time. The old ones were very rare and very valuable during that period. Very few large Feraghans were ever made. Most of the large rugs that dealers sold for Feraghans during the period 1900 to 1930 were Sultanabad or Mahal quality (most of them made in the town of Muskabads, where Feraghans were also made). I have never seen over 20 real Feraghans in large sizes.

**Conclusion**: Unless you are a hobbyist, you should not be interested in buying a Feraghan. If you insist on one, you must be prepared to take a somewhat worn rug. The seeker of the same general effect as the small Feraghan (herati) design can find a perfect antique Hamadan or Sena-Kurd or Sultanabad with the same color effect, but not with the green border.

# FUIGI ROYAL

## (Chinese Design Rug)

## (Japanese Family)

**Availability**: This very superior quality rug, in antique Chinese design, was first made in 1958 and just beginning to be available, when the prices went up, thus curtailing the future importation of these in numbers. The first shipments were in round rugs 3 ft. and 4 ft. in diameter. Regular rectangular sizes are beginning to come.

**Characteristics**: Rugs are tightly woven with a heavy pile of excellent New Zea-land wool. Superior chrome dyes are used. All the small, round rugs have come with tan or soft, light gold fields, with blue borders. The few larger rectangular sizes have been in the above colors, and also in light beige or creamy ivory field. All used the old antique design. Quality-wise, these rugs are better than 95% of the thousands of real Chinese rugs imported to America in the period 1924-1935. They are made by the same Japanese firm that weaves the superior rugs sold in America as "Imperials." These sell for about the same price as a good Sarouk, and should give a lifetime of service. The New York importer of these refused to re-order in number when the prices increased. The future of these is uncertain.

# GEUNGE RUGS

## (Also spelled Geunja, Gendje, Gengha, Gendshe or Ganja)

## (Caucasian Family)

**Availability**: None have been imported under this name in 36 years or more. No writer has ever given very definite information on this rug. All are in scatter sizes up to about 8×4 ft. and in runners 9 to 13 ft. long and about 3½ ft. wide.

*197*

**Where made :** In that part of old Caucasia now known as Azerbaijan, lived Tribes that wove these rugs, which were marketed in the ancient City of Elizabethpol, once called Geunge (Ganja).

**Characteristics :** Since all of my writings are based on what I know from experience, I will not try to give you definite information about this rug. Mumford did not mention it in his first book. Hawley in his book said. "They resemble Kazaks more than anything else, and are frequently mistaken for them." And he adds. "In Kazaks a thread of weft, as a rule, crosses only twice between two rows of knots, which are firmly pressed down; but in these rugs, a thread of weft crosses four to eight times between two rows of knots which are not firmly pressed down." He spells the name of the rug Genghas, which isn't much help. Dr. Lewis spells it Genghis (following Mumford's spelling) which listed these as being made by Persian Tribes. This section of the country once belonged to Persia.

Henry Jacoby, the German author, in his book *How to Know Oriental Rugs*, published in 1952, spells it Gendje. I agree with him when he says that they are more closely clipped than Kazaks, that they had a finer warp thread than the Kazaks, and that they were more closely knotted. Hawley and others have said that they were much coarser than Kazaks and for many years I accepted that point of view. The only rugs that I have known experts to call Geunges, were rugs nearly as fine as Kabistans, a least bit coarser and barely heavier, but tightly woven. The principal design of these has a field with diagonal stripes and tiny designs. Stripes are in ivory, red, light blue, yellow, green, and gold. See Color Plate 154. This small prayer rug is the choicest and best example of Geunge I have ever seen.

**Conclusion :** If you are a collector, you may wish to procure a rug by this name. If you call the Caucasian rug with the diagonal stripes over the entire field a Geunge, you will be following the practice of the best collectors and experts in the period 1917 to 1933.

When Henry Jacoby says that these were woven in sizes 56″ by 10 to 13 ft. and some larger, he certainly has information that I must question, and which I have never found anywhere, not even at any of the importers in London. (Germany, until 1955, was buying almost exclusively from the London Free Port and still is the largest buyer there.)

# GHIORDES RUGS

## *(Turkish Family Non-Prayer Rugs)*

**Availability :** Occasionally from an estate in approximately 6 × 4 ft. size. In spite of the great name that the Prayer Ghiordes has, the Non-Prayer (hearth design) ranks near the bottom of the list of old Turkish rugs, both from the collectors point of view and in value. A very few come from estates and usually are somewhat worn as they have not been preserved like the rarer Prayer Ghiordes. They are always in scatter sizes and usually about 6 × 4 ft.

**Where made :** In the Town of Ghiordes in Turkey.

**Characteristics :** First, eliminating any made in Ghiordes since World War II as junk, and in no way passable rugs, we will consider only the old rugs made prior to World War I. These are invariably in the hearth design, with a little part of the

*198*

field in open design, and with a combination of floral and geometric medallion. The main part of the field is usually in ivory or magenta. Corners are in different colors; blue, green, or magenta, and covered with small Turkish geometric flowers. The main border is entirely different from the borders of the Prayer Ghiordes, and almost invariably has a large, sawtooth design fringed with innumerable latch hooks. It also has many small geometric flowers or mosaics interspaced. Some might interpret this as a large geometric vine. Many of the old writers refer to these non-prayer or hearth designs as Odjaliks (better spelling is Ojaklik) and call the prayer rugs of all types Namazliks. Some authors even have invented the name Kis-Ghiordes, but such a name for this non-prayer Ghiordes is wrong.

**Conclusion:** There is no need to devote great space to these rugs. They are at the bottom of the rung of all old Turkish rugs, and seldom appear today because they were used as floor rugs and have worn out.

I give no space other than this line to a very cheap grade of Turkish carpet made between 1920–1930 which adopted this rare name for the poorest quality Turkish carpet of that time. They were perhaps the cheapest of the many qualities of so-called Anatolians, or Sparta carpets, using mechanical (too stiff and angular) floral design. None of these low grade carpets have been made since 1930, and you may be sure they are worn out by now.

# GHIORDES PRAYER RUG

## (*Turkish Family*)

**Availability:** Only from collectors estates or private collections. Even the collectors of good means seldom felt they could afford one of these. Always in sizes approximately $6\frac{1}{2} \times 4\frac{1}{2}$ to $7 \times 4.10$ ft. It is the rarest of all Turkish rugs, from the 17th century to date, and perhaps the rarest of all prayer rugs. The Non-Prayer Ghiordes are worth only a fraction of the price of a good Prayer Ghiordes. Perhaps one good one comes on the market each year.

**Where made:** In the Town of Ghiordes in the district in Turkey known as Asia Minor. (That part of Turkey in Asia.) The ancient name was Gordium.

**Characteristics:** The Ghiordes rug is not only one of the rarest of Turkish weaves, but maintains this standard among any of the Oriental Rugs made. To the collector it is the acme of perfection and excellence. Ghiordes are today probably one of the most sought after fabrics by hobbyists, but generally any such effort is in vain. (See Color Plates 126 and 129 and Plates 127 and 128. Also Figs. in Part I, Chapter on Turkish Rugs.)

In many museums, especially the Metropolitan Museum in New York, we find excellent examples of these century-old rugs. Other museums that feature these are the Victoria and Albert Museum in London, the Corcoran Gallery of Art in Washington, D. C., the Musée's des Arts Decoratifs, in Paris, The Kaiser Friedrich Museum in Berlin, and a half dozen others in America. Collectors and connoisseurs invariably endeavor to include this weave in their collection if possible. Those who have searched for these gems know the difficulty encountered in such an undertaking. They are certainly not to be found in the open markets. Ghiordes rugs, especially in the prayer type (and it is this type that is most sought after),

offer the greatest variety in designs and color. It is the ground of these fabrics that make them so distinctive. This glorious field may be of deepest red, ruby-like; or it may be the softest old ivory; or it may be numerous shades of blue, green, or canary. Above this solid ground color appears a very distinctive niche, peculiar to Ghiordes rugs. The angles at the base are invariably broken. Instead of forming a point, like the niche in so many prayer rugs, it is broken at the top also, forming an obtuse angle. From this point in the niche sometimes hangs a very graceful, so-called lamp, and frequently when this appears we have forms running the length of the solid ground color, known as pillars. The whole effect of this lovely center is that of an entrance to a mosque. Over the arch, in the spandrels, generally appear some fine interwoven designs or some variation of the trefoil design. Above the spandrels and below the field invariably appear panels, in contrasting colors to the field, upon which we generally find floral forms. The border designs are floral, but the flower forms usually consist of broken blossoms and leaves arranged in almost square shapes. Occasionally the main border consists of a series of stripes, generally in two colors; but as this border is more popular with Kulah rugs, it is well not to get confused. No Ghiordes rugs are in a perfect state of preservation, but are generally quite thin. Of course, there are a few exceptions, but almost regardless of their condition, their exquisite design and glorious color combinations brand them as the Turkish acme of perfection.

All the old Ghiordes were in sizes about $6 \times 4$ to $7 \times 5$ ft. There are a few imitations seen from time to time, but very few. Most museums value these small rugs at about $5,000, but a good example can at times be had for $2,000.

Mr. Shearer's Ghiordes (Color Plates 126 and 129) are perhaps as choice examples of Ghiordes as in any museum. Our limited number of color plates did not permit us to show his Blue Ghiordes (prayer) rug. All three are in superb condition. Plates 127 and 128 are of Ghiordes given to the Metropolitan Museum of Art by Mr. James F. Ballard.

**Advice:** Do not seek a Ghiordes unless you are a collector. Do not buy one unless you have a trusted expert to help you. There were a good many made between 1900 and 1930 that could fool the beginner. It takes years of knowing these before even the collector can avoid pitfalls. Fortunately, most of these inferior new rugs have worn out and have not been preserved as have the old 17th and 18th century rugs of this type.

# GOREVAN RUGS

## (Iranian Family)

**Availability:** In great numbers in new, coarse, colorful thick rugs, in sizes approximately $7 \times 10$ ft. to $9\frac{1}{2} \times 12\frac{1}{2}$ ft., but seldom in $8 \times 10$ ft. sizes. Until 1955, many lovely old Gorevans in the above sizes came in slightly thin to excellent condition. Today they (the semi-antique) come one by one, and are very scarce.

**Where made:** There is the town of Gorevan (also spelled Georavan) in the Herez district. The Herez district comprises many villages and all weave the same type rug which is sold all over America today as Herez. Today, Gorevan in the trade means a quality, the poorer quality of rugs sold by nearly every dealer as Herez.

They are sold to importers in Tabriz as Gorevans, imported as Gorevans, and then advertised as Herez. For the past 35 years Herez has meant a better quality.

**Characteristics:** A thick, rather coarsely woven rug, almost invariably in geometric medallion design; or a medallion approaching the geometric in blue, tan, ivory, rose, and green, with many other colors. Over the red field are multi-colored stiff angular flowers and vines. All have a field in some shade of red—dark brownish red, brick red, etc. The main border is almost invariably in blue, with the Turtle design in many colors. Occasionally, large rosettes and serrated leaf design is used for the borders instead of the Turtle design. The large corners are usually in a combination of ivory, rose, blue, or green instead of blue. Ivory predominates in the corners. Gorevan and Herez use the same general designs. (See Figs. in Part I, Persian Rugs and Plates 21, 26, and 27.)

In spite of the coarse weave and its low price, a Gorevan with good wool and good dyes will last indefinitely. In the period 1954–58 and continuing to a lesser degree in 1959–1960, there was a real deterioration in Gorevans. Where they had always used the wool from nearby Nomad Tribes and dyed their own wool, they bought their ready-spun and ready-dyed wool in the Tabriz market. Much was skin wool (dead wool) removed from butchered sheep with lye and dyed with poor Swiss dyes. Instead of the clear reds from their own vegetable dyes, the fields of these rugs had a brownish, muddy red and the blues a dead look. An expert can usually detect dead wool by feeling it; and we have returned many rugs to New York importers because of this wool. Thousands of Gorevans that we sold from 1924 to 1935 will still not be worn out. A Gorevan with skin wool will often wear thin in two to six years. I have made good on three or four of these a year during the past few years. It is a disgusting practice, because every week we take in trade one or two coarse Gorevans that we sold thirty years ago, and they may be slightly thin, but they are seldom worn badly.

I am glad to report that after four or five years, in which great numbers of such poor Gorevans came to the New York market, they now are beginning to come in clearer colors, and about half of them with good wool. Such things usually right themselves and most New York importers are not going to bring in these inferior Gorevans, especially when they find the retail stores rejecting them. There are some stores however that will buy and sell anything that they can advertise cheaper than the usual price for rugs by the same name. Plate 26, showing a Gorevan, is just as much a Herez design as a Gorevan design. This is true of Color Plate 27 and all plates showing Gorevans and Herez.

**Conclusion:** Buy a Gorevan from a good store or reliable dealer who will stand behind any rug he sells. Most of the large department stores are not going to make good on one of these after a few years. The red tape in seeking a replacement through a large department store will discourage most people. A good dealer will have no alibi if the rug begins to show any wear in a few years. For full coverage see Herez Rugs.

# HAMADAN RUGS
## *(Iranian or Persian Family)*

**Availability:** In great numbers in many sizes and in many types of new rugs, in a limited number of semi-antique and antique rugs. Two thirds of the scatter sizes ($5 \times 3\frac{1}{2}$ ft. and $6\frac{1}{2} \times 4\frac{1}{2}$ ft.) coming from Iran are from the Hamadan district. Ninety percent of all the small $2 \times 3$ ft. and $4 \times 2\frac{1}{2}$ ft. sizes, and runners in the $6\frac{1}{2} \times 2\frac{1}{2}$ ft. sizes and $10 \times 2.6$ ft. are from the Hamadan district. Also, ninety percent of all runners coming from Iran in 11 to 30 ft. lengths are from the Hamadan district. About twenty-five percent of all importations from Iran in carpet sizes $6 \times 9$ ft., $8 \times 10$, $9 \times 12$ ft. and extra sizes up to $12 \times 20$ ft. are also from the Hamadan district.

**Where made:** Hamadan City and the District of Hamadan is perhaps the largest of the five large rug weaving districts in Iran. The City of Hamadan, with a population of over 100,000, is located in a high plateau section of Northeast Iran some 200 miles south of the Caspian Sea. It is the ancient City of Ecbatan where Esther and Mordecai are buried. Here are woven thousands of rugs, and still greater numbers in the hundreds of districts and villages within a 75 mile radius, all of which are marketed in Hamadan.

**Characteristics:** See Plates 15, 23, 25, 28, 29, 30, 33, 35, 47, 50, 58, 59, 60, 61, 62, 63, 65, and 66. It would be impossible to identify all the scatter sizes that come from

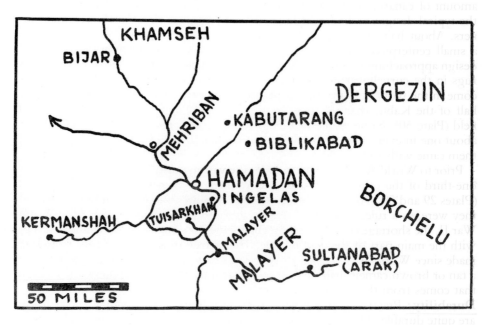

MAP 6. THE HAMADAN RUG WEAVING AREA. Hundreds of small villages are not shown. (See General Map of Persia (Iran), Map 2, Part I.)

*202*

the many villages. Certain types are imported to America under their own district or village name. Bibikabads (Plate 15) are woven in two towns. Ingelas (Plate 23) are rugs woven in a number of villages, mostly in scatter sizes. Borchelus (Plate 25) are woven in a district. These and Ingeles are mostly in scatter sizes and short runners. These three we call Sena-Kurds instead of Hamadan. See details under these three names and under Sena-Kurd rugs. Kasvins (Plate 35) are a quality unlike any other Hamadans, and superior in quality, being about the quality of a modern Sarouk, are woven in the City of Hamadan. (See Kasvins for further information.) Dergezins (Plate 58) come from many villages in a district by that name, which make mostly runners in one general design. (See Dergezin Rugs.)

Kabutarhang (Plates 47 and 50) come from a town by that name where only carpet sizes are made. These are sold under this name but they are also sold as Hamadans. Hamadan rugs from the hundreds of other villages are mostly in scatter sizes and runners; and while each village makes a slightly different design, they all are sold as Hamadans. It would be most confusing to give them any name but Hamadan, which has been done for the past seventy-five years. Rugs woven in nearby villages and imported as Husianabad come in dozar sizes $7 \times 4\frac{1}{2}$ ft., $5 \times 3\frac{1}{2}$ ft., 10 ft. runners, and in limited numbers in carpet sizes. (Plate 30.)

All are medium thick to quite heavy rugs from coarse weave to rather fine weave. The Ingeles rugs and Borchelu rugs are usually quite finely woven. Practically all the new rugs come in some shade of red as the main color in the field, with the main borders either in ivory or blue, but most often in ivory. (See Plate 50.) The design most used in the scatter rugs is the small repetitive herati (feraghan) design, which will be in a combination of blues, pink, green, ivory, and a lesser amount of canary, gold, brown, and plum. The plates showing Husianabads are the typical designs to be found in thousands of scatter sizes, small mats and runners. About half of these will have the small repetitive herati design broken by a small centerpiece and corners. The Dergezins are invariably made in a floral design approaching that of the modern Sarouk. The Borchelus are the only scatter rugs in the curvelinear design (floral medallion). One-third of the Borchelu rugs come in the ivory field instead of the bright, colorful, red field. (Plate 25.) About half of the Kabutarhang carpets come in ivory field, the others in a bright red field (Plate 50). None of the new rugs in any size come with a blue field except about one in every fifty of the Bibikabad carpets (Plate 15). Ten years ago half of them came with a blue field.

Prior to World War II and up to 1948, the vast majority of dozar sizes and about one-third of the other small sizes and runners, came with a blue background. (Plates 29 and 59.) About half of these were in semi-antique and antique rugs and they were, as a rule, superior in quality to those being made today. Since World War II, the shortage of indigo from which blue dyes are made has eliminated rugs with the main part of the field in blue. This is true of all types of rugs from Iran made since World War II. (See Kasvin Rugs for details on this rug.) Plate 66 has a tan or brown camels' hair field. It would require 100 plates to show each design that comes from the Hamadan district.

**Durability:** Practically all of the rugs from this district, including the coarsest, are quite durable. The reason lies in the rugged wool available in this high plateau country. They get thin eventually, but even the least expensive Hamadan will wear a very long time. There has been a general cheapening of quality in the major-

ity of these made during the past ten years. This has been due to the use of the Jufti knot (a knot tied on four strands of warp instead of two). Perhaps twenty-five percent of the knots in most Hamadans made in recent years are false or Jufti knots. Also, there have been some poor Swiss dyes used instead of vegetable or Alarizin dyes. Especially was this true in many small sizes about $4 \times 2\frac{1}{2}$ ft. and $3 \times 2$ ft. in the period from 1954 to 1958. When these poor dyes are used you can quickly detect the bleeding or loose colors. Importers had difficulty in disposing of these, and so perhaps the weavers have learned their lesson. But almost anything sells in the New York City and Boston markets at a price, and so the importers are not particular on this point. A good dealer will not buy them. The plates I have used are the most typical types and designs of this rug. There are many other designs, but once you have seen a few new Hamadans, you will easily recognize their characteristics. The Husianabads (Color Plate 30) are most typical of new Hamadans.

**Chemical treatment:** Prior to World War II, three-fourth of all Hamadans were both chemically washed and painted. Anyone who bought these no longer has a rug with a nap, and they now look faded and sickish. Since the war, no Hamadans are heavily treated and none are painted. Most have the light Persian wash that barely tones down the bright shades and does little, if any, harm.

**Other rug books:** Mr. Mumford in his first book, 1900 edition, wrote: "The real camel's hair examples are very rare, and vast prices are demanded for them." Mr. Mumford is the greatest of all rug book authors in my opinion, and I owe him much, but he made some mistakes and later corrected them. All other writers who later wrote books in the period 1905 to 1920 followed Mumford's book, and indicated that the typical Hamadan was a camel tan colored rug. Mumford remarked in his personal notes which I inherited that all succeeding writers followed him as he said: "Hook, line and Sinker." As a matter of fact, not more than one out of twenty-five of the early Hamadans were tan, and for the past thirty-five years not one in 5,000 will be in camel tan.

# HERAT RUGS

## (Persian Family)

**Availability:** Not more than a half dozen in the past 25 years are available from private collections. They will be found only in the great museums of the world and a few collections in America. There is much uncertainty as to their origin. Not even the rich, private collector has sought these during the past 35 years. All are over 200 years old. All were in large sizes.

**Where made:** The City of Herat is in Afghanistan but was once a part of Persia (Iran). The rugs are believed to have been made in the Khorassan (Khurasan) District of Eastern Persia for the palaces in Herat from which they were bought. I have done much research on Herat rugs and agree with A. Cecil Edwards, the English authority, when he says in his book published in 1954: "It is generally accepted in the West that these East Persian carpets were woven in Herat, at that time the administrative Capital and Principal City of Khurasan. We may, however, properly question the claim of Herat City to these carpets because as far back as

man can remember, no carpets have been woven there; nor does any tradition of weaving exist there. And I know of no locality in Persia where carpets were once produced and which today is producing none." Mr. Edwards continues: "I suggest moreover, that because the Persians used the name Herat in referring to some of the carpets, they did not necessarily mean that the carpets were woven in Herat City. . . . Perhaps what happened is something like this. The wealthy inhabitants of Herat, the capital of Khurasan, and its richest city, must have needed carpets for their homes; so the merchants of the city ordered them from the weaving districts of Quinat (in Khurasan). When in time some of these carpets were sold by their owners to the West, they were called Herat carpets because they had come from Herat, and not because they were woven there."

It is difficult for me to understand where the German writer, Henry Jacoby, secured his information when he wrote: "The City of Herat was the former capital of Afghanistan and until its fall in 1735, the seat of a great rug industry." Thorough research does not justify such a conclusion.

**Characteristics:** The field of these rugs was generally blue or a red with a purplish tint, the result of using cochineal as a dye for their red, rather than the madder so generally used in Persian rugs. This is true of most rugs made in the Khurasan District even today (some type of Meshed, Ispahan-Meshed, or Khorasan rugs). The design used in most of these rugs in the field and often in the border, is the so-called herati design. Herat is the City and herati is the design name taken from these rugs. The terms "herati" and "feraghan" are used to describe the identical design. The small, angular design encloses a small rosette or floral design and is surrounded by four leaf designs. The same design is used in most Feraghans and Tabriz rugs. It is the design that is most used in Persian rugs today, especially in the Hamadan district.

Herat rugs were good, average weave to very finely woven rugs. The wool was very lustrous and reminded one of an excellent Khorasan. The above design was the one most used, but some came with the medallion design, where the medallion and corners would be in red or blue, and the field between these in lighter colors. Those in this design are often hard to distinguish from some of the old Ispahans.

# HEREKE RUGS

## *(Turkish Family)*

**Availability:** Only from private estates of real collectors. None have been made in thirty years. The few good ones that appear were probably made not later than 1914. Most of these were silk rugs.

**Where made:** In the town of Hereke, in a factory established by the Sultan of Turkey and subsidized by him.

**Characteristics:** The majority of these used Persian designs instead of their own Turkish design. Master weavers from Kirman were imported to weave and supervise the weaving. This accounts for the fact that many of these—perhaps half of the output—were in Kirman design. Many did employ the designs of the famous Turkish Ghiordes. All were in silk and most of these were very finely woven; in fact, they were the finest woven rugs ever made in Turkey, and perhaps even finer than most Persian silks.

Many of these were in extra large carpets, woven for government palaces and gifts to foreign rulers. The finest example of a Hereke I have ever seen is owned by Mr. Henry Norell of London. Mr. Norell has been my purchasing agent for over thirty years, as well as my very close, personal friend. He has also been the dominant figure in the European market for all of these thirty years. His rug, Plate 64 (and Mr. Norell is also shown beside the rug), is perhaps the finest woven rug in existence. He states that it has some 800 knots to the square inch. I have not personally counted, but I have witnessed different people counting the knots to the inch as the rug hangs in his home in London. I must admit that it is the finest rug I have even seen. The Ardebil Carpet has about 343 knots to the square inch, and the Chelsea Carpet has around 470. These are two of the greatest rugs in the world, both in the Victoria and Albert Museum.

This Hereke, I would have called a Polonaise, but Mr. Norell has definite information that it was woven in Hereke. Unlike most Herekes, it does not follow either the Persian Kirman design or the Turkish Ghiordes design. The colorings and characteristics are that of an old Ispahan in design, but more especially the famous old Polonaise rugs. It is embossed, and sections without pile are in gold and silver threads, like the Polonaise rugs.

The Shah Abbas and Chinese cloud bank, as well as animals are gracefully used with the small intricate floral and rosettes. One might also call this an Animal Carpet. The field is in soft pastel silver like wisteria, with the Shah Abbas motifs and cloud banks in silk; while the outer edges of these designs are in silver or gold thread. There are many muted colors. The main border is in soft, medium blue leaf designs and is also embossed with silver and gold threads (used extensively). Plate 137 is of an Ancient Prayer Hereke believed to be from the early 17th century.

# HEREZ RUGS

## *(Persian or Iranian Family)*

**Availability:** In great numbers in new rugs in many different qualities from very coarse rugs to very excellent rugs that are most durable and desirable. Thousands of the cheaper qualities, imported as Gorevans in the approximate $9 \times 12$ ft. size, are sold as Herez. Until recently some 10,000 of these came to America each year, but Germany and other European countries are taking the majority of these since about 1956. Large numbers are also available in $6 \times 9$ ft. size and $8 \times 10$ ft. size. These smaller sizes are almost invariably in the better so-called contract quality (Mehriban quality—one of the towns weaving Herez rugs). This is true of the larger than $9 \times 12$ ft. new Herez rugs. Many large carpets in sizes $9 \times 14$ ft. to $11 \times 22$ ft. are available in good to excellent Herez. Great numbers of smaller rugs and runners made in Karaja (in the Herez district) are available in the following sizes: $2 \times 3$ ft., $2.4 \times 4$ ft., $4\frac{1}{2} \times 3$ ft., and $6.2 \times 4.10$ ft., and in runners about $5 \times 2$ ft., $8 \times 2.4$ ft., $11 \times 2.10$ ft., and $14 \times 3$ ft. All the above sizes refer to new rugs. A limited number of semi-antiques come from Iran in the $9 \times 12$ ft., $8 \times 11$, $7.8 \times 11$, $11 \times 14$ ft., and a few larger sizes. Most of the real antiques come from estates and are slightly thin. A very few old rugs in the $6 \times 4.10$ ft. size, $4\frac{1}{2} \times 3\frac{1}{2}$ ft. size, and in runners $11\frac{1}{2} \times 2.10$ ft. and $14 \times 3$ ft. come from Iran.

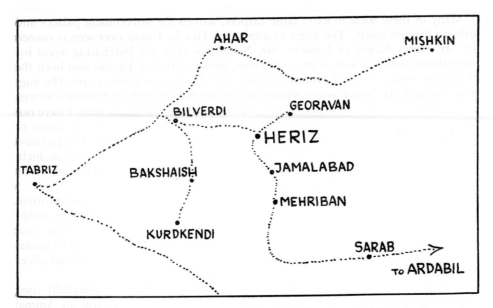

MAP 7. THE HEREZ WEAVING DISTRICT. The city of Tabriz is the market place. (See General Map of Persia (Iran), Map 2, Part I.)

**Where made:** In the Herez district, which is about 40 miles east of Tabriz, and which comprises an area of some 40 miles by 40 miles, containing many rug weaving villages—all weaving the same general type. The town of Herez is the largest and has around 900 looms; Mehriban had approximately 600 looms; and Bahkshaish (Bahkshis) and Gorevan each had 500 looms. Asleh, Sarai, and Sainsarai have over 100 looms. The larger town of Ahar to the north, has in the past two years begun to weave Herez rugs in superior quality. These are being sold as Ahars or Herez. (See Plate 9. See Ahar.) There are many other small villages in this area weaving these same rugs. With the exception of a very few scatter sizes, the Herez district produces some 10,000 carpets, about half of which are in the 9 × 12 ft. size. The Herez district includes the Karaja section, a town by that name, where it and the several surrounding villages weave small rugs and runners that are sold as Herez or Karajas. (Plates 74 and 75.)

The Serab District, from which was derived the name Serapi and where, until recently, many short runners and long runners in camels' hair were woven, is considered as part of the Herez District; but since these rugs are so entirely different, they are not discussed under Herez, but under Serab Rugs. Very few are being woven today. (Plate 109.)

**Characteristics:** While no two Herez rugs are exactly alike, most of the rugs imported as Gorevans and Herez are very similar in design. Most of them will have a large, somewhat geometric medallion. (See Fig. 4 in Part I and Plates 9, 21, 26, and 27.) The field of these new rugs will be in some shade of red, rose, or rust, covered with a conventionalized angular floral design in blues, pink, green, ivory,

brown, tinges of canary, and plum. The medallion will be large and covered with other designs. Blue generally predominates in the medallion of this rug, but there is much red, rose, ivory, green, and often other colors. The corners are usually in ivory with some blue and green, and covered with the same angular design that covers the field. A few come with the corners in light blue instead of ivory, but this will usually be a semi-antique Herez or Gorevan. The main border is invariably in blue, and the majority of these will have the turtle and rosette designs. The main border in some will have the large rosette and serrated leaf design. Some Herez will come with an all over, stiff, angular floral design without the medallion and corners. (Plate 26.)

There are many qualities of rugs sold as Herez. Never did one need more strongly to emphasize the fact that name does not determine quality, as with this name. The name Herez, up to about 1935, indicated an excellent quality rug. Gorevan indicated a thick coarser rug; but the Gorevans, in spite of their coarseness were, up to World War II, the most satisfactory of the less expensive carpet sizes, in $6 \times 9$ ft., $8 \times 10$ ft., and $9 \times 12$ ft. rugs. These almost invariably wore a lifetime. I have taken in trade many Gorevans that I sold in the period 1924–1930 which were in very excellent condition and resalable. Some of them may have been slightly thin, but they were seldom badly worn. I doubt if the new, cheaper grades of Gorevan being made today will do half as well. Practically all the new Gorevan qualities being made for the American market are in the $9 \times 12$ ft. size. Those being made for the European market are in the $7 \times 10$ ft. size and $9 \times 12$ ft. size.

The Gorevans are rather coarsely woven with a good thick pile. If good wool is used, the rug will still be very durable. The Herez quality vary from good average quality to rugs like the Ahar, which approach the quality of a modern Sarouk. Up to the advent of the Ahars in 1958, the Mehribans, which are also called contract quality Herez, were perhaps the best of the New Herez. Lately, I have seen in London, Herez rugs of very superior quality that were undoubtedly woven in the town of Herez. These were in the quality of the Ahar, but they are more geometric design (typical Herez designs), rather than the curvilinear design of the Ahar. The Germans prefer a good Herez to a Sarouk. They prefer its design to almost any rug, and perhaps the improvement in quality is due to West Germany being so prosperous today. Prior to World War II, there were no new Herez in the larger, present day sizes that are now so plentiful. American Importers contracted with owners of looms to weave many sizes that had never been woven in Herez carpets. Such sizes as $9 \times 15$, $9 \times 18$, $10 \times 15$, $10 \times 20$, $11 \times 20$ ft., and all in-between sizes came in these Mehribans, also a plentiful supply of these in $6 \times 8$, $6 \times 9$, and $8 \times 10$ ft. size. They almost invariably came in deeper red tones or with a bluish red tone, rather than the yellow red or rusty red tones as so many of the old Gorevans and Herez have. The wool used was, as a rule, excellent. But of late, a few of these have appeared with skin wool (wool from butchered sheep). These will wear thin in a few years, whereas a good Mehriban type Herez will wear a lifetime. All the Mehribans are given the light Persian wash before being shipped to America. (Plate 21.)

A sizeable number of these come in nearly square sizes, $6 \times 6$, $8 \times 8$, $8 \times 9$ ft., and other "squarish" sizes. Prior to World War II, if you wanted a large Herez, you would find it usually only in a wide rug. A Herez 15 ft. in length would almost

always be 11 to 12 ft. wide, and 18 to 20 ft. Herez would usually be 12 to 14 ft. wide.

**Prewar Herez and Gorevans:** Almost any quality Gorevan or Herez made prior to the last war would give a lifetime of service. Those Gorevans were much better woven than today. They used much better dyes, and they had much lighter colors as a rule. The fields were a nice soft rose, or a rusty brick and had nice clear colors. The weavers in these villages bought their wool from the nearby Nomad tribes and dyed their own wool. The wool was excellent, being long fibre and silky. Such is not the case today with so many of the rugs being woven in these villages. Few rugs are more decorative and delightful than a lovely old Herez. In the period 1946 to 1955 these old and semi-old Herez came to the New York market by the hundreds (most of them in Gorevan quality). By carefully screening out the worn or slightly worn rugs, one could buy as many as 100 lovely old perfect Gorevans or Herez in one week. Since Germany has entered the market so heavily, one has difficulty in finding even one or two semi-old Herez or Gorevan in all the importing houses combined. But we must not forget that the old ones have been bought up in Iran and the supply is pretty much exhausted.

**Caution:** Beware of the cheapest grade Gorevans which will be advertised as Herez. The objection is not their coarse weave, but rather the fact that many of the village weavers are buying their wool yarn already spun and dyed in the Tabriz market. Much of this is skin wool (dead wool) and is dyed with Swiss dyes. This is a short fibre wool, that has been removed from butchered sheep by the use of lye. The Swiss dyes make for dark, brownish red or muddy colors. Even the blues look dead and muddy. That was true of 75% of the Gorevans coming to America in the period 1954–1960. I believe that Germany's heavy buying has resulted in a great improvement and abandonment of this practice. It is apparent at the New York importing houses that these low grade Gorevans are beginning to come once again in clearer colors. When dead wool is used in any rug, it shortens the life of a rug that should last a lifetime to a point where it gets thin in two to five years. I have even replaced several of the better Mehriban (so-called contract quality Herez) that have become thin in a few years. No other possible reason can be ascribed to this wear except the use of skin wool. The really bright note is that during the past two years I have seen more real Herez (not the Gorevan) qualities being made in superior quality than at any time since the 1924–1930 period. Also the Gorevans seem to be discontinuing the use of Swiss dyes. This is especially true of hundreds of Herez that I inspected and selected in the Free Port of London. A good rule to follow is not to buy a cheap new quality rug advertised as Herez unless you know that the dealer will stand behind it, and will unquestionably replace it if it begins to show wear within five years. If the rug has dead wool it will begin to get thin in two to five years. If it shows no thinness in that time, you can feel certain that it is going to be a "long-lived" rug.

Another thumb rule is: do not try to buy one of these for $250 or under, unless the dealer will give you an unconditional guarantee. It is better that you buy a real Herez ranging from $400 to $600. This is where I stick my neck out in mentioning price, as these good qualities could be much higher for the $9 \times 12$ ft. size within a few years if the standard of living in Iran continues to increase.

**Jufti or False Knot:** The reason why the poorest grade of Gorevan have become so coarse, is the use of the jufti knot. (Where the knot is tied on four warp

threads instead of two.) Over fifty percent of the knots in these coarsest types will have the jufti knots.

**Small rugs:** While a few excellent small rugs and runners are made in the Herez District proper, most of the runners and scatter sizes in the Herez design are woven in the Karaja district. They are imported as Karajas and sold as either Herez or Karajas. (See Karaja Rugs. Plate 74.) All these small rugs and runners have the same general design as shown in Plate 74.

# HOLBEIN RUGS

## (Turkish Family)

An old Turkish rug. The oldest Asia Minor rugs known. They were imported to Europe throughout the 15th century.

**Characteristics:** A typical example is shown in the Flemish Painter Holbein's masterpiece in the museum at Darmstadt. This type of rug, resembling the latter day Bergamo rugs, was used for decorative purposes by most of the early Flemish painters. Italian masters of the same period also used this same type rug.

The designs were purely geometric with squares and stars and other motifs intermixed. This type rug of the 15th century became known as Holbein because they appeared in the paintings of the famous artist by this name. (See Color Plate 121.)

# HUNTING CARPETS

## (Persian Family)

**Availability:** *Old Hunting Carpets* are famous museum types, non-existent except in museums or private collections.

*New or Semi-Antique.* Occasionally some new rugs appear with animals and figures, which might be called Hunting Carpets. Such rugs would have no greater value than another rug of the same quality. Often the animals and human beings are so grotesque and conspicuous that the rug is less valuable, because of them.

**Where made:** No one definitely knows where the ancient Hunting Carpets which are now in the museums of the world, were made. Many authorities attribute these to Kashan. Actually, most new or semi-antique hunting carpets will usually be a Tehran, Tabriz, Kashan, Ispahan, Qum, or Nain.

**Characteristics:** The most famous and valuable of all Hunting Carpets is perhaps the one in the Austrian Museum, Vienna. It is exceptionallly finely woven, with $27 \times 29$ knots to the square inch. It is Persian and shows lions, leopards, wolves, bears, antelopes, hares etc., and mounted huntsmen with spears. It is believed to have been woven around 1550. The main part of the field is a deep crimson. The entire rug is silk warp, weft, and nap. The rug would be in a museum regardess of its design. The hunting scenes do not make it the rare and valuable rug it is. No plate of a Hunting Carpet is shown. (See Plates 2 and 3.) Most animal and hunting carpets have the same characteristics. Add a few men, or a man on horseback to an animal carpet, and it is called a hunting carpet.

# HUSAINABAD RUGS

*(Iranian Family)*

*(Also spelled Hoseinabad)*

**Availability:** In great numbers in very excellent rugs, a type of Hamadan, in dozar sizes, approximately $7\frac{1}{2} \times 4\frac{1}{2}$ ft.; and in slightly lesser quality in $5 \times 3\frac{1}{2}$ ft., $4 \times 2\frac{1}{2}$ ft., and $2 \times 3$ ft. Also in runners $6\frac{1}{2} \times 2\frac{1}{2}$ ft. and approximately $10 \times 2\frac{1}{2}$ ft. There are a limited number in $9 \times 12$ ft. and about $8 \times 17$ ft. Also a few extra length runners up to 20 ft.

**Where made:** In the Town of Husainabad, near the City of Hamadan, 30 miles southwest of the city. Some of these are made in the city itself. *National Geographic* spells it Husainabad. Most importers spell it Hoseniabad.

**Characteristics:** Husainabads invariably are in red fields (rose to red) and employ the small all over herati (feraghan) design. Color Plate 30 is the typical design. Many have the small all over designs broken with a small blue or ivory center and corners. Borders are almost always in ivory with the conventionalized vine and pear design. The colors of the designs are a combination of ivory, light blue, pink, green, and tinges of navy, tan, and canary. Rugs are thick and of medium to good tight weave. The wool is usually good. The larger scatter sizes $(7 \times 4\frac{1}{2})$ ft. are, as a rule, in better qualities than the $5 \times 3\frac{1}{2}$ ft. size or smaller rugs and runners; but all are durable rugs. The $7 \times 4\frac{1}{2}$ ft. size is one of the most popular of all moderate-priced new Persian rugs.

There are no semi-old or antique rugs by this name. Very few carpet sizes ($9 \times 12$ ft. and $8 \times 17$ ft.) in this type have been made in the past two or three years. Until then, there were a great number to be had in the $9 \times 12$ ft. size and in long, narrow sizes such as $8 \times 15$ ft. to $8 \times 19$ ft. These last sizes were also plentiful in the New York importing houses until about 1957. At the moment I have no explanation of this change; but it is likely that fewer are being made and that European buyers are also taking much of the output. (Read Hamadan Rugs.)

# IMPERIAL RUGS

*(Japanese Family)*

**Availability:** In most of the standard sizes, $2 \times 3$ ft. to $12 \times 20$ ft. These come in French Savonnerie designs, in four colors and also with the open field, with floral sprays in two corners, and much hand carving. One of the heaviest quality rugs made today.

**Where made:** In Japan.

**Characteristics:** See Plates 185, 186, and 187. The Imperial is a new rug first produced since World War II. It is a unique type rug, hand woven in Japan by expert weavers, of strong New Zealand wool. It is a very heavy compactly woven rug, of great durability. There are four main designs used in these rugs. (Plates 185 and 187.) The French (Aubusson) design rugs usually have an open field with medallion, with some borders more ornate than others; some borders being with slightly less design.

*211*

The plain open field rugs are in four colors with floral design in corners only, and some hand carving on opposite corners. The colors used are primarily four basic colors, such as rose, light blue, green, and beige. These can be made to order in any colors desired. Special orders require 6 to 8 months for delivery.

I intended to use a color plate for Imperial, but with the continued increases in prices, they have now reached a price comparable to a Persian Kirman. It is my belief that the sale of these will be greatly reduced. One of my close friends for the past 37 years is the principal importer of these rugs. His fears are that these, like Kirmans, are pricing themselves out of the market.

# INDO-AUBUSSON RUGS or JEWEL OF KASHMIR RUGS

## (Indian or Pakistan Family)

**Availability:** In limited numbers at one importing house in New York. All are new rugs and are the flat stitch tapestry rugs. The only Indo-Aubussons on the market are offered under the trade name of "Jewel of Kashmir" rugs, in sizes 4×2.6 ft., 5×3, 6×4, 6×9, 8×10, 9×12 ft., and a very few in larger sizes. Indo-Aubusson is also the trade name of a thick, Savonnerie type produced by a British firm in large numbers.

**Important note:** I think of an Aubusson as being like the French Aubusson, a tapestry type without pile. A large British firm making rugs in India imports these to America under the name of "Jewel of Kashmir." (Plate 183.) This same fine company also sells one of their thick, excellent Orientals made in India under the name of Indo-Aubusson, in many patterns and colors. See Color Plates 1, 6, and 11 all of which employ the Aubusson or Savonnerie design. Since we have always known the French rug with pile as a Savonnerie rug, I personally advertise this rug with the trade name "Indo-Aubusson" as an Indo-Savonnerie. It is a Savonnerie type and not an Aubusson type. Again, the flat tapestry rugs should be called Aubussons, and the thick French design rugs should be called Savonnerie.

**Characteristics:** The true Aubusson type rugs are in old French Aubusson designs in pastel shades, and like the old French Aubussons, they are a flat stitch rug (without nap—on the order of a needlepoint). Plate 183 is a typical design. This rug has as the principal color a beautiful pale green with the design in cream, pale rose, wisteria, and tinges of blue. Others come with the background in pale blue, beige, or tan. One of the principal designs used is 9612. (Color Plate 1.) This is a thick rug with pile, but the flat stitch "Jewel of Kashmir" use the same design.

These "Jewel of Kashmirs" are actually more durable than the real Aubussons. No French Aubussons have been made for the market in thirty years because even at two dollars a day weaving in France (and today it is more than two dollars) the cost would be many thousands of dollars. These "Jewel of Kashmir" rugs have amazed me by their durability. I had occasion to take two of these large rugs in trade, which I had sold some years previous, and was amazed to find that, in spite of heavy traffic in living room and dining room, they were in excellent condition. They are ideal for bedrooms, music rooms, or with French furnishings.

Remember, "Jewel of Kashmir," Plate 183, is a trade name. Other firms may start to import these or similar rugs under another trade name. One can easily

become confused by this name, Indo-Aubusson. It is odd that the British firm should call their pile rug (with the heavy nap) an Indo-Aubusson, since Aubusson means "a pileless carpet."

# INDO-CHINESE RUGS

## (Indian Family)

**Availability:** In new rugs in several different types in all the standard sizes, $2\frac{1}{2} \times 4$ to $12 \times 20$ ft.

**Where made:** In India.

**Characteristics:** These are rugs made in India in the Chinese design. The Bengali (Plate 190) rugs are in typical old Chinese design. The Chinda are one of the best qualities produced in India. Other rugs from India with typical Chinese design are beginning to come to New York. Many of these are made in an almost plain field and with the only design a floral spray in two corners and sometimes in the four corners, and referred to as being Chinese designs. These are not Chinese designs as we knew them in the past, but in the late twenties and early thirties, many Chinese (made in China) did come in these designs—open field with very little design.

We refer to one of the less expensive rugs which we have made to order in India as "China Design"—the trade name we get from the maker in India. This type of rug is available in many different qualities, from the least expensive of all rugs in the size, with some jute mixed with wool, to the finest and heaviest quality rugs, like the Chinda. No real Chinese rug has, in my memory, ever been superior to the best of these.

In late 1960, another type rug in antique Chinese design appeared in the $9 \times 12$ ft. size and in several colors. In quality, texture, and design, they resembled the Fette type Chinese rugs which were so popular for many years with Army and Navy personnel stationed in China and the Philippines.

# INDO-FERAGHAN

## (Indian Family)

**Availability:** None have been made since World War II, and I have had only one from a private sale. Most have a blue field with the small all over herati (feraghan) design. They were not as finely woven as the really fine Persian Feraghan, but they had a somewhat longer, although not really thick nap. The warp and weft were cotton. All were in large sizes, larger than $9 \times 12$ ft. Designs generally are the same as shown in Plate 37, Persian Feraghan.

# INDO-ISPAHAN

## (Persian Family)

**Availability:** None have been made since World War II. Rugs came in extra large sizes, larger than $9 \times 12$ ft. They used the old Persian designs and colors found in famous old Persian Ispahans, and were very finely woven and excellent rugs. I have seen a very few come from estates, and they are the equal of and often better than many fine old Persian rugs.

# INDO-KIRMAN

## (Indian Family)

**Availability:** None have been made since 1945. I have seen none appear from estates in fifteen years.
**Where made:** In India.
**Characteristics:** Up to about 1946, one British importing house, with showrooms in New York, offered these new rugs in the same general colors and design as the Persian Kirmans. The fields were ivory with the Kirman design of floral sprays, either in an all over design, or with a small floral center. They had the old straight-line borders, as did all prewar Kirmans. The quality was about the same as a good Kirman, but not quite as heavy as the best contract quality Kirman of today. Warp and weft were of cotton. The wool quality was excellent. These did not come with the open plain field around the medallion, nor with the French Aubusson border design.

With Persian Kirmans pricing themselves out of the market, it is to be hoped that some enterprising company will soon make these again. It is possible that India will resume making the facsimile of Kirmans in weave, colors, and designs.

# INDO-SAROUK

## (Indian Family)

**Availability:** None have been made since World War II. Only limited numbers were made prior to that time, in the period 1925–1938. Most of these were made in the $9 \times 12$ ft. size. I have not seen one of these in a used rug sale or in an estate.
**Where made:** In India.
**Characteristics:** These rugs followed closely the modern Persian Sarouk. They were tightly woven, a good medium heavy rug; practically all had a rose field and used the all over floral design. They are very similar to the typical Persian Sarouk shown in Plate 53.

# INDO-SAVONNERIE RUGS

## *(Indian Family)*

**Availability:** In great numbers in many different qualities, under many trade names in all the standard sizes and in many different colors and different designs. All are in the light and pastel shades, and all employ or show influence of the old French Savonnerie rugs and French Aubusson rugs in their designs. Many have pretty much the same colors as the light pastel Kirmans, but the designs, of course, are different from Kirmans. Standard sizes are 5×3 ft., 6×4, 6×9, 8×10, 9×12, 10×14, 12×15, 11×18 ft., or 12×18, 12×20, and 12½×23 ft. The two largest concerns importing these use these standard sizes. One of them has 12×18 as a standard size, while the other makes an 11×18 ft. rug.

Any unusual size can be ordered from either of these two companies in any of their designs, for delivery in approximately six months, with the assurance that the design, colors, and quality will be same as ordered. At this time, I have on the looms through one of these companies, close to 1,000 of these rugs being woven on my special orders, in sizes that are not carried in their regular stock.

**Where made:** These are made in different cities and towns in India, in large rug weaving factories (in the Mirzapur District), where these concerns have their own dyeing plant, their own yarn mills, many looms, and all the other set-up for washing the wool and weaving excellent rugs. The best qualities are made in these factories where the best wool and dyes are used. Thousands of these rugs in lesser qualities are woven in the individual cottages. I for years have ordered over 1,000 of these very inexpensive types each year through my agent there, in two different designs and color combinations. Even though they are woven in many different cottages, the colors and designs in each are the same.

**Characteristics:** There are several qualities of excellent to superior rugs in the Savonnerie designs, being brought to America from India by at least four different companies. Each of these companies have different trade names, and each has several different designs and color combinations. One of these firms gives their rugs the name of "Kalabar." The Kalabar is a very excellent rug costing about the same price as the average new Sarouk. There are at least four different colors and designs in the Kalabar, each of which is given a number, such as Beige 9670 and Green 9690 (the numbers are not the correct ones but are given for example).

Another very large British firm with showrooms in New York, imports their best quality under the name of Kandahar, and their next quality under the name of Indo-Aubusson. (See Color Plates 1, 6, and 11.) We in turn call these Indo-Savonneries, as they are pile rugs instead of flat stitch rugs, as are the real Aubussons. There are several designs and colors, and they are listed as Ivory Design 9612/4562 (Color Plate 1), or Indo-Aubusson design 21/4756 Nile Green. (See Color Plate 6.) This same large British firm brings in many cheaper qualities, all of which have soft, pastel colors.

Another importer brings these in under the trade name of Malabar in pastel shades of green, blue, rose, and tan. These cost slightly less than the four best qualities discussed in the above paragraph. All of these better rugs use a fine quality of wool and excellent dyes. The Kandahar are invariably lightly washed. The Kalabar is sold unwashed, but most retail stores have these lightly treated.

*215*

The Indo-Aubussons (remember, that is a trade name for the thick Savonnerie types) like Plates 1, 6, and 11, are sold in natural colors without any treatment.

There are thousands of these rugs from India in many different designs in the cheaper qualities to be found in the London market, and a limited number of superior qualities. Most retail stores want a standard design which can be matched up with other sizes in the same rug.

**Miscellaneous:** The better qualities of these, with their light pastel shades, are very beautiful rugs, and are to be preferred to the Bazaar quality Kirman, even though the latter cost much more. They will outwear the Bazaar quality Kirman. I do not say that they will outwear the finest quality of Kirman, which cost twice as much as the very best of these Indo-Savonneries. These rugs are sure to be more popular each year with the better quality Kirman pricing itself out of the market.

**Runners:** Runners have never been made in these Indo-Savonneries until I first ordered a number of them made up in early 1959. In 1960 I placed orders for a few hundred of these in beautiful pastel shades for delivery in early 1961. Sizes vary from 6 ft. to 23 ft. in length, and 2.6 to 2.10 ft. wide. I predict that these will be one of the most popular type Oriental runners ever brought to America, and imagine that many other dealers will place similar orders once they see these. See Plate 2 which is Indo-Savonnerie in design 9612. These runners are made with only the small fleur-de-lis and with the medallion shown in Plate 1 omitted.

## INDO-TABRIZ

### *(Indian Family)*

**Availability:** None of these have been made since World War II. Rugs came in extra large sizes; the last three that I bought were about $10 \times 20$ ft. They had soft rose fields usually with an intricate floral design combined with the Shah Abbas motif. Others came with the small herati (feraghan) design, Plate 37.

## INGELES RUGS

### *(Also spelled Engeles and Injilas)*

### *(Iranian Family)*

One of the three types that I class as Sena-Kurds.

**Availability:** Ingeles rugs are being made in good numbers in excellent quality in sizes $4 \times 2\frac{1}{2}$ ft., $5 \times 3\frac{1}{2}$, $6\frac{1}{2} \times 4\frac{1}{2}$, and $6\frac{1}{2} \times 2\frac{1}{2}$ ft. Until recently many runners approximately 10 ft. long and up to 20 ft. in length were woven. Very few of these have come in the past few years. A limited number of small mats are made in the $2 \times 2.8$ ft. size, and perhaps as many as twenty in the $9 \times 12$ ft. size a year.

**Where made:** In a town by this name a short distance south of the City of Hamadan.

**Characteristics:** Ingeles rugs as a class are the best of all the many types coming

from the Hamadan District (an exception is the Kasvin). Ingeles are the best of the three types which we class as Sena-Kurds. These rugs are tightly woven and have a heavy pile of excellent wool. Dyes are vegetable. The field of most of these is in a rich red (not a yellow red but a blue red) and usually a rather deep red. (Color Plate 23.) The main border is either in blue or ivory. A very few come in an ivory field. Only two designs are used: the small all over herati (feraghan) design and the small pear design. The herati is used almost exclusively in the dozar sizes ($6\frac{1}{2} \times 4\frac{1}{2}$ ft.) while in the $5 \times 3\frac{1}{2}$, $4 \times 2\frac{1}{2}$, $6\frac{1}{2} \times 2\frac{1}{2}$ ft., and runners, most will come with the small pear design. These often have a small blue or ivory centerpiece with small corners in the same colors. The main border usually has the turtle design. (Both designs are shown in the Fig. in Part I.) Plate 43, of a $9 \times 12$ ft. Ingeles, is typical in design, but rugs as large as this are seldom available.

# ISPAHAN RUGS

*(Also spelled Isfahan)*

*(Persian or Iranian Family)*

**Availability:** Ispahan is a complicated subject because there are three distinct types of rugs known as Ispahan. Perhaps it is the most famous rug name of all. Rarest Ispahans are those made in the 16th and 17th century. Practically all of these are in the large museums of the world and in the hands of wealthy private collectors. They are just about as well known as the paintings of the worlds best artists. These famous Ispahans have not been made since about 1725. (Plates 2, 3, 4, and 5.) New semi-antique Ispahans are available in limited numbers in the European markets, and in the Teheran markets in sizes $7 \times 4\frac{1}{2}$ ft., $7 \times 11$ ft., and a very few in larger sizes. Prices are about the same as other finely woven new rugs, such as Kashans and Qums. No rugs were made in Ispahan for nearly 200 years from about 1725 to 1900 (exception: a few for their own use). These are seldom available at New York importing houses. They were thin, finely woven rugs. (Plate 49.)

Most of the rugs sold in America during the last forty years as Ispahans have not been Ispahans at all, but rugs made in or near the City of Meshed, the technical name being Turkibaffs. They are about twice as heavy as the real Ispahan (new or old). All are in carpet sizes $9 \times 12$ ft. or larger. Your dealer will insist that these Turkibaffs should be called Ispahan. We call them Ispahan-Meshed in our commercial listings. They are worth a fraction of the rare antique 17th century Ispahan and less than the new real Ispahan. (See Plates 54 and 81.)

**Where made:** It is not definitely known where the ancient Ispahans were made. Some believe the first two types were made in the beautiful city of Ispahan. We know that the second type was and is made there. Those made since 1920 are marketed in Teheran (the large Capital City of Iran) where the rich Persians buy them. I first saw these in the London market in the period 1924 to 1935. The third type, the Turkibaffs, are made in the City of Meshed several hundred miles east of Ispahan.

**History:** There is no definite proof as to when or where any of the great carpets were made. The Ardabil Mosque Carpet (Plate 4) in the Victoria and Albert

Museum is dated 1540. But, the other great carpets of 250 to 400 years ago, the Ispahans, the Herats, the Animal carpets, the Hunting carpets, and the Polonaise rugs, have not been definitely placed by any writer. There is often a question as to whether the carpet is Herat or Ispahan. Of course, it could have been woven elsewhere, but we do know that under the rule of Shah Tahmaso or Shah Abbas, art reached its highest peak in Persia, and that there was a royal factory set up. When the Afghans captured the city in 1722, the end of the greatest art producing Persia ever knew was at hand.

Many of the famous 16th century and 17th century, so-called Vase carpets, as well as most of the Animal carpets and Hunting carpets, are believed by some authorities to have been woven in Ispahan. (Plate 24.) Other leading authorities are inclined to agree with Mr. Wilhelm R. Valentiner when he wrote in a catalogue for the Metropolitan Museum of Art in 1910: "The names popularly given to the old productions taken for the most part from the modern types, have been found incorrect. Examples of this are the so-called Ispahan rugs which were certainly not made in Ispahan but in Herat, and the so-called Polonaise or Polish Carpets which were woven in Persia." Most of the museums of the world, the Victoria and Albert, the Metropolitan in New York, and most of the others simply refer to these as Pile carpet, 16th century, or Pile carpet, 17th century. Some may refer to these as Animal carpet, 16th century, Vase carpet, 16th century, etc.

There are probably 1500 rugs of this period, in all the types, in museums and private collections. Unfortunately, only a small percentage of these are real masterpieces. Others are valued by their owners for their great age, and are worn out rugs, many of which are lacking in beauty. If you have never seen one of the great masterpieces, you owe it to yourself to see one of these great carpets at the Metropolitan Museum of Art the next time you are in New York. There is a vast amount of information none of which is too definite if one wishes to read it. Space does not permit us to cover the details here on such a large subject. (See Plates 2, 3, 4, and 5.) Most of the old Animal and Hunting carpets as well as the Vase carpets (Plate 24) are believed to be Ispahans.

**History of later day Ispahan:** Weaving was resumed in Ispahan right after World War I. A few were made for their own use. All of these were in sizes about $7 \times 4\frac{1}{2}$ ft. These have never come to America in numbers because they were made for Teheran dealers and for the European market, where duty is paid on weight. About 1925, they began making a few in carpet sizes in $7 \times 10$ ft. to $7 \times 11$ ft. and a very few as large as $10 \times 14$ ft. All of the some 2,000 looms are in the individual homes and there are no factories. For the history of so-called Ispahan rugs as sold by most dealers in America, see Ispahan Meshed Rugs, Plate 81.

**Characteristics:** The very old Ispahans, or those believed to be Ispahans, were very finely woven rugs (the world's most famous rug, the Ardabil Mosque Carpet has about $17 \times 19$ knots—343 knots to the square inch). The finest woven of all these is the Hunting carpet in the Austrian Museum which has $27 \times 29$ knots to the inch. Most of the others are about $17 \times 19$ knots to the inch. But fine weave alone does not make them beautiful and rare. It is wonderful art, the total picture presented and especially the wonderful wool and dyes used that make them great works of art. We have already told you about the Vase carpets, the Hunting carpets, and Animal carpets. Most of these will have the Shah Abbas design combined with an intricate floral surrounding a central floral design. Others will have

a larger Shah Abbas as the main motive. All of these had silk, cotton, or linen as warp.

**Characteristics of the newer Ispahans 1920–1960:** Ispahans are a finely woven rug (about same weave as contemporary Kashan or Kirman) with a short clipped pile. When I went on my first buying trip abroad in 1928, I saw my first new Ispahan rug. None had come to the New York market. The main reason for this was that these rugs were too bright to be sold in their new colors. Their poor wool quality and their thinness did not permit them to be chemically washed in New York. This wash was almost a prerequisite for the New York importers in those days. These would not even have withstood the light lime washing. Their combination of colors was bad. Many would be on ivory field with garish new yellows, golds, greens, and reds. Their designs were not liked by most Americans. They used many large human figures and Tree of Life designs which were too large. The other half of these would have a design somewhat similar to the Kashan, the small floral centerpiece and corners with floral designs over the field. Many were in Prayer design, but too many of these had large animals or human beings. By careful screening I was able to buy about 25 of these each year up to World War II. I have not seen many of them in the London market since then, and most of them are now being bought by the wealthy Persians in Teheran. The quality has been slightly improved. Since World War II, I have not bought a dozen of these, because I could always find a better, a finer, and a more beautiful rug of the same fineness in a Nain rug, a Qum, or a Kashan rug. Too often, a poor quality wool is used in these new Ispahan. All used cotton warp and weft.

# ISPAHAN-MESHED RUGS

*(Offered by most dealers as Ispahans)*

*(Persian or Iranian Family)*

**Availability:** In very limited quantity in new rugs in carpet sizes (majority in 9 × 12 ft. sizes and larger) in the American market. In larger numbers in the European market, and in still larger numbers in the Persian market. A good number of these in semi-antiques and old carpets were imported right after the war. Those that we call Ispahan Meshed are the Turkibaff family, and the better rugs of this type are excellent.

The name "Ispahan-Meshed" is my own innovation. The better rugs are correctly named Turkibaffs from Meshed and the poorer qualities we correctly name Meshed or Khorassan (Khurasan). For the complete story on these rugs, one should read details under Ispahan, Meshed, and Khurasan. This is a medium-priced rug, with the best of the perfect old ones costing less than a new Sarouk.

**Where made:** In the City of Meshed, the capital of the large eastern district (nearest Afghanistan) of Khurasan, and in a few nearby villages. The rugs which we classify as Busheds and Khorassans are made in the towns of Bijand, Turshiz, and scores of other towns, and in the large mountain district known to Persians as the Qainat, the largest town there being Qain. The Turkibaffs are of entirely different construction, and are much more durable than any of the other rugs from this

district. Meshed is one of the most famous of all Shrine Cities for the Moslem world.

**Characteristics:** Plates 54, 72, and 81 are typical designs that you will find in so many of the Ispahan-Mesheds (or rugs sold by most dealers as Ispahan). Plate 72 has the large, intricate floral medallion fashioned after the design of the famous Ardabil Mosque Carpet. This medallion is used in many of these carpets, and unfortunately, also in the cheaper Meshed and Khurasan grades, as well as in this excellent Turkibaff quality. The background or main color of nearly all of the rugs from this district will be in a cochineal red, which is one of the chief characteristics of these rugs. Only these and the Kirmans (both are made in the eastern section of Iran) use this color red, while all other sections of Iran use madder as the principal red. This cochineal red looks more like a red with a little purplish cast, almost magenta. In both the plates shown, the main part of the field is in this color with the corners, center, and main border with a blue background. The designs of these are in lighter blue, rose, green, canary, brown, ivory, and tinges of madder.

In addition to the above two designs (shown in the plates), and many variations of these medallions, a good many will come with the all over designs. Generally, these will employ the small repetitive herati (feraghan) design, or the old Shah Abbas design intermixed with a floral design. A few will come with the blue field, and fewer still with a cream or tan field, surrounding the medallion in the plates shown.

**Quality:** The best of the rugs sold as Ispahans (or Ispahan-Meshed) are very superior to the rest of the rugs woven in this huge area, spreading over many hundreds of miles. The reason is that they are entirely different. Mesheds and Khurasans use the Sena knot, but these rugs are very loose because they tie the one knot on four warp threads, using the Sena knot (Persian).

The Turkibaffs (the real name for our Ispahan-Meshed) use the Turkish knot and tie it correctly on two warp threads. This rug was introduced in Meshed by the Tabriz merchants. In Tabriz, the weavers use a hook to tie the knot, and cannot weave the jufti or false knot with a hook. Thus these rugs, the Turkibaffs made like Tabriz, are thick, tightly woven, compact rugs. There are a good many factories (each with 10 to 40 looms) run by the owners who are master weavers. Those woven in the homes are seldom as good as those from the factories.

The principal dye, as already explained, is cochineal red. For many generations, dyers have insisted on steeping their wool in lime for 24 hours, because they believe that this is the only way to get an even color with their cochineal red. Of course this hurts the wearing quality of the rug and makes the wool brittle.

**Caution:** In spite of the cochineal red fields and the steeping of the wool in lime before dyeing, the real Turkibaff is a beautiful rug and will last a long time. When it gets thin it will wear still another lifetime. The note of caution is that most dealers have the habit of calling all the four qualities (each of which also varies) Ispahans. I refused to call even the best of these Ispahans, because the real Ispahan is a very finely woven and very short pile rug. The most correct name would be Turkibaff Quality Meshed. To avoid long explanations in letters as to the difference between the real Ispahan and the Turkibaff, I have for years called these Ispahan-Meshed. Since the dealers call most types of Meshed "Ispahans," the name Ispahan-Meshed for the better quality is most fitting. TURN NOW AND READ MESHED RUGS, KHURASAN RUGS, AND ISPAHAN RUGS.

An important point is that the Turkibaffs use a better wool. The wool clipped in May is a longer, stronger fibre wool, and this is generally used in making the Turkibaffs. The Fall wool is very fine and soft, but not as long lasting. One can never be sure which quality of wool is used in even the finest and heaviest of these.

# JOSAN RUGS or JOSAN SAROUK RUGS

## *(Iranian Family)*

**Availability:** In large numbers in 2×3 ft. and 5×3½ ft. sizes, and in limited numbers in the 6½×4½ ft. size. The vast majority are new rugs and a very few are semi-old. Runners and carpet sizes have never been made.

**Where made:** In the Village of Josan some 60 miles south of Hamadan. The district and the largest town are named Malayer. In this district there are some 100 towns weaving rugs. (See Malayer Rugs.)

**Characteristics:** The village of Josan is renowned for producing some of the best rugs made in Iran today. The weave, knot, and characteristics are the same as Sarouks, and so we have acquired the habit of referring to these as Josan Sarouks. The designs are different from the new all over floral design Sarouks, but are almost invariably in the old medallion designs, in which most of the real antique Sarouks were made 75 to 100 years ago. (See Fig. 8, Part I.) The medallion is not overbold and the fields are covered with intricate floral designs. (See Plate 55.) Most of them have red or rose as the principal background colors, but many are coming today with an ivory field, and a very few with the blue field. They are thick rugs of good compact weave and finer than the average Sarouk.

While these are better than the average Sarouk, the rugs made in Malayer and some of the villages in the image of the real Sarouk, are not as good or as costly as the real Sarouk or the Josan. The Josans are among the very best new rugs to be had in the sizes. Wool quality and dyes are excellent.

# JOSHAGHAN RUGS

## *(Also spelled Joshaqan)*

## *(Persian or Iranian Family)*

**Availability:** In limited numbers in finely woven new rugs, in sizes 5×3½ ft., 7×4½, 7×10 to 8×11, and 9×12 ft., and a very few in the 10×14 ft. size. Practically all are new rugs, but a very few semi-old ones appear. Rarely is there an old rug that is a true Joshaghan from an estate. A limited number of these come to New York, but the majority go to the Teheran or London markets.

**Where made:** In several villages some seventy miles south of the City of Ispahan. The principal village is Joshaghan with several hundred houses.

**Characteristics:** Joshaghans are made in only one general design, and once identified can readily be recognized by their general design which has been used for some 200 years. The motifs used are small angular floral designs set in the

shape of diamonds, and either repeated over the entire field or with a diamond centerpiece. The corners are covered with this same general design. (See Plate 56.) This is an antique rug. New Joshaghans still use the same design but the field will usually be in red. The rug has varied in quality over the years but the designs remain the same. Those woven since 1955 are finely woven rugs about 14×14 knots to the inch. These have a short, medium pile similar to the Kashan or Qum. Ninety percent of all those made since the war are in some shade of red with the designs in ivory, blues, greens, and tinges of other colors. Borders are usually ivory or blue. A few come with an ivory field. I have seen some of the finest old Joshaghans with a blue field.

Right after World War II, on my first visits to London, a good many of these in the 9×12 ft. sizes were available, and of very poor quality with about 8×8 knots to the square inch. This now has changed and they are again making rather fine new rugs. Since duty is paid on weight in Europe and these are fine and not over-heavy rugs, they are readily taken by the European buyers. However, the majority go to Teheran merchants for sale to well-to-do Persians.

**Miscellaneous:** Very few of these real Joshaghans ever came to the American market, and even the collectors and experts did not know them. Mumford said in his 1900 edition, in discussing these which he spelled "Jooshaghan" or "Dju-shaghan," that "the name is brought in for every emergency." I have seen a hundred old, choice rugs that were not Joshaghan in design or in any character-istic, which dealers and hobbyists had called Joshaghan because they wanted a new name. Many of them had never seen a real Joshaghan. Today, and for the past 35 years, none of these dealers would make such a mistake, because the type is too well known and too easily recognized. Communication systems are better in Iran and many people have visited this section. I doubt if an American buyer ever set foot in Joshaghan before 1940. Warp and weft are cotton. The wool is good to excellent. The Joshaghan shown in Plate 56 is the finest woven, and al-together the choicest example of a Joshaghan that I have seen.

# JUVAL

Some writers refer to different types of small, narrow Turkoman tent bags as "Juval." For example, Yomud Juval, Ersari Juval, etc. I prefer to simply call them "tent bags." (Plate 179.)

# KABISTAN RUGS

*(Also spelled Cabistan. Kabistan and Kuba are one*

*and the same)*

**Availability:** Only from estates and collections. Finely woven, short napped, geometric designed rugs. None made or imported since 1935. Best examples were made before World War I. Because thousands of these were sold to American homes during the past 70 years, a good number are available from estates. Most

of these will be somewhat worn but still beautiful. Even the thin and poorer examples command high prices today by reason of European buyers coming here in numbers each year and seeking old Caucasian rugs as they are not available elsewhere. Most are scatter sizes $5 \times 3\frac{1}{2}$ to $6 \times 9$ ft. Most are $6 \times 4$ to $8 \times 4$ ft. A few are as small as $4 \times 2\frac{1}{2}$ ft. Seldom one as large as $6 \times 9$ ft. is seen. The close relationship between the several Caucasian names (types of rugs) will confuse even the expert.

**Where made:** In what is now Russian Soviet Federated Socialist Republic. Some of these were woven in Azerbaijan S.S.R. (just north of Iran). In the past we have referred to all this section as Caucasia. Kabistans and Kubas are one and the same. All Kabistans are in fact Kubistans or Kubas. Mr. Mumford in his first book (1900) says "An error in a single letter . . . Kubistan would have told the story . . . the name Kabistan has become a fixture in the rug trade . . . here permitted to remain only on the ground before defined, because a substitute of the right name for the wrong would be confusing to many." Forgetting the present day Soviet name, and going back to the old names, the largest rug weaving district was Daghestan, which is some 200 miles wide. The Southern part of this Daghestan Area is called the Shirvan District and the town of Kuba is in the Shirvan District. In the eastern section of this district on the Caspian Sea is the City of Baku which is famous for one design, the large angular pear design. In speaking of Kubas, Daghestans, Bakus, and other Caucasian rugs, the Victoria and Albert Museum, London, in its book *Guide to the Collection of Carpets* has this to say. "The chief drawback to these classifications is that the characteristics of more than one district are not infrequently combined in a single carpet." It goes on to say, "The general term Caucasian meets the difficulty presented by the frequent shifting of boundaries in the past and comprises a group of carpets in which the main characteristics are the same." But their book did list the Prayer Daghestan exactly like my Plate 124 as a Prayer Rug, Caucasian (Daghestan). So there is little wonder that even the experts cannot draw a definite line between Daghestans, Kabistans (Kubas), and Shirvans.

That is all right for the Museums, but most people and especially the hobbyist will want a specific name. I submit one thumb rule that most of the experts have followed during the past 40 years. Some few might vary my rule of naming these rugs but in the main, they will agree.

**History:** To give you the history of the people of Caucasia would require many pages. With some 300 different tribes inhabiting the country, formerly speaking over 100 idioms of language until the Russians took them over in 1857, it would intrigue the historians talents to describe the many people who overran the country—like the Mongolians, Turks, and Persians—each leaving some mark and many of its people to inter-marry. These invasions have been reflected in their rugs but during the past two hundred years (until about 1935) when rug weaving came to an end, there has been no perceptible change in the design of the different types. The one change was the use of cotton for warp and weft during one of the five year plans for weaving, about 1930–35.

**Characteristics:** See Plate 120 and 121. Kabistans (or Kubas) like the Daghestans, Shirvans, Chi Chis, and Bakus, are from a good weave to very finely woven and have a short nap (short nap when new and shorter when worn). Their designs are mostly geometric and when small flowers or Persian influence

*223*

is shown as with some Shirvans these are angular (or Geometric flowers). The large serrated sided star is often used as the main motif with many smaller geometric figures, animals, and birds (these in geometric forms). The elongated star is often used. Oftentimes there is a geometric center design with the rest of the field covered with small octagons and geometric rosettes. If we tried to specify all the old geometric designs we would confuse the reader. White is often used as a background in many of these that we call Kuba. On these there are three large diamond shaped sections in the field, each outlined by a sawtooth band in blue, red, or green (two to five inches wide). See Color Plate 119. Small geometric flowers are enclosed in these and cover much of the field. The many designs used by Kabistans, Daghestans, and Shirvans almost defy description. The Persian pear design in a geometric form is used—but mostly in those we call Bakus and Shirvans. In my first book (1932) my plate 46 which I called Shirvan, I now prefer to call Kuba by reason of its outside border. (Georgian Border.) See Fig. 17, Part I of a Kuba.

After repeating that you will have difficulty in telling the difference between Daghestans and Kabistans (Kubas), here is my own thumb rule. Taking the short nap type of old Caucasian rugs and eliminating the Baku as being in only one general design, the local angular florated pear design (a similar design is shown in all the books) then doing the same with Chi Chi rugs (see Color Plate 115), that leaves only the Daghestans, Kabistans, Kubas, and Shirvans. Again Kuba and Kabistans are one and the same, but dealers and collectors call certain designs Kubas instead of Kabistan. I call those in the same general design shown in Color Plate 119 a Kuba. I even call all of those with the Georgian border (like the outside border of Fig. 17, Part I) a Kuba. I proceed to call one certain rug a Daghestan and that is the rug about 5×4 ft. shown in Plate 150. All the books, the Metropolitan Museum in New York, the Victoria and Albert Museum in London, all agree on this one design as being Prayer Daghestan. The field is generally in ivory but some few in gold, blue, or red. That leaves only the name of Shirvan and Kabistan. My thumb rule here is that those with more of an all over design and showing more Persian influence (more flowers in angular shapes) I call Shirvan. Those with the all over effulgent star which some have referred to as a small Russian coat of arms design, I class as Shirvans. All the strictly geometric design rugs are today being called Kabistans. Again, there is a little question that many and even perhaps most of these are really Daghestans, but again I repeat, "The close relationship existing between Kabistans and Daghestans will always mystify one as to correct classification."

If you want to be real technical, you can take Mumford's (1st edition 1900) opinion of the difference between these two, when he points out "That a difference is that Kabistans are overcast at the sides, or if selvaged, the selvage is made with a cotton weft." This will not be of much help as these old rugs will as a rule have been refinished on the side with a wool overcasting. Mr. Mumford wrote this sixty-one years ago. He goes on to say that "Genuine rugs of either variety will wear away down to the warp and retain their harmony of color, enhanced rather than diminished by age and service." That is what makes these old, thin Caucasians so delightful and so sought after today.

I have neglected to tell you that one of the designs most used in these rugs is the latch hook. The crab border and diagonal stripes are favorite border designs.

**Sizes:** Most of the Daghestans, Kabistans, and Kubas will come in sizes about $5 \times 3\frac{1}{2}$ ft., $7 \times 4$ ft., $8 \times 4$ ft., and $9 \times 4\frac{1}{2}$ ft. and many in-between sizes. Smaller than $5 \times 3$ ft. seldom appear. I have seen some few about $6 \times 9$ ft. What few runners ever came were about $3\frac{1}{2}$ ft. wide. A few very old rugs over 100 years old occasionally appear in sizes $6 \times 15$ ft. and $7 \times 18$ ft. (from estates).

**Miscellaneous:** Thousands of newer Kabistans marketed as Kubistans were made by the Russians in two different five year plans. The first output (1925–1930) were not quite as fine and were a little heavier than the old ones and used woolen warp. Then, the next few years saw thousands of very finely woven (even more finely woven than the choice old ones) Kabistans with a slightly heavier and more compact nap, which reminded one of the real fine old Kashans in texture. These were always lightly chemically bleached. We had never known of any Caucasian rugs being chemically washed up to that time. Some few of these are beginning to appear from estates and while they are not as old and can readily be distinguished from the real antiques, they are very excellent rugs.

**Caution:** Many new rugs copying these Kabistans and Kubas are being made in Northern Persia in the town of Ardebil just south of Caucasia. See Ardebil Rugs. I have found a few cases where dealers have sold these as Kabistans. No reliable dealer is going to do this.

# KABUTARAHANG RUGS

## *(Iranian Family)*

## *(Also spelled Kapoutrahang—a type of Hamadan rug)*

**Availability:** In large numbers especially in $6 \times 9$ ft., $8 \times 10$, and $9 \times 12$ ft. sizes. In the past five years hundreds of larger sizes were made from $10\frac{1}{2} \times 14$ ft. to $12 \times 20$ ft. Today it is the best selling inexpensive Persian rug in the carpet size. In the past two years the demand for these has exceeded the supply. No scatter sizes are woven. Fewer of these were made in 1960. Weavers have deserted looms for more pay elsewhere.

**Where made:** In a town of 4,000 people, some 25 miles northwest of the City of Hamadan and in many surrounding villages—Kahanabad, Famenin, Amirabad, and a dozen other smaller villages—are woven the same type of rug in the same general design shown in Plates 47 and 50.

**Characteristics:** Occasionally a few are made without the small floral central pendant (medallion) or corners, and with the all over floral designs, very much on the order of the Sarouk designs. They are made in two general colors, one with the bright red field, and the other with an ivory field. The center, corners, and the floral stalk design that covers the main part of the field, invariably have lots of green, blue, rose, ivory, and red. Most of these are very colorful rugs even after being Persian washed, as are 95 percent of those that are brought to this country. The borders are blue or red, but a few may be in ivory. All are thick, heavy rugs of quite coarse to good average weave. Wool is usually of good quality and the rugs are quite durable.

**Miscellaneous:** During the past five years these have replaced the cheaper grade

Gorevans (sold as Herez in America) as the best selling rug in the American market in the 6×9 ft. to 9×12 ft. size, and also in the larger sizes. At first, 95 percent of these came only in the bright red field. In the past few years about half of the production has been with an ivory or cream field. These became so popular because the lower priced Gorevans deteriorated so very much in quality, and the prices of Gorevan went up so much. Now, the same thing is happening to the Kabutarahangs. The demand is so great that prices have gone up and the quality on many has gone down. There is not enough local wool to make the 10,000 carpets that were being made, so the operators, master weavers, (owners of rug factories), or individual weavers, buy any type of wool that they can find in the Hamadan market. Unfortunately, some of this is skin (dead) wool. I have not had any of these go bad, but this is only because we have tried to screen out the better rugs of this type. The Jufti (false) knot (a knot tied on four warp threads instead of two) has resulted in a more loosely woven rug. But as long as the wool quality is good, these rugs have such a good, long pile that they should wear well.

**Scarcity:** Until 1960, I could select from hundreds of these rugs in the 8×10 ft. and 9×12 ft. size. In the past two years one could not buy one-third the number of these rugs that were available a few years ago, and less than one-third of that number have come to America. Again, it is the result of Europe being so prosperous and the Persians having so much money that they take much of the output. The opportunity to make much more money in other work has resulted in more than half the weavers in this section deserting the looms. The prices on Kabtarahangs, Sarouks, and Kirmans have increased more in the past two years than any other types. There is also a decided deterioration in quality in the majority of this type during the past few years.

# KALI—KELLAI—KELLAYI

A dimensional term. Refers to a long, very narrow carpet, 5 to 7 ft. wide and 12 to 20 ft. in length.

# KANDAHAR RUGS

## (Indian Family)

**Availability:** Kandahar is a trade name for a heavy quality rug made in India today in the French Savonnerie designs, and in an open, almost plain field. A large British firm, with showrooms in New York, has these woven in India. It is their best quality. They are made in several colors and mostly in carpet sizes, 9×12 ft., 10×14, 12×15, 12×18, and 12×20 ft. Some few smaller sizes are produced. They can be made to order in any size desired.

**Where made:** In one of the large rug making factories in India. Rugs are all handmade of course. There is a town of Kandahar in Afghanistan, but the rugs are woven in India.

**Characteristics:** Plate 1 of a Savonnerie is one of the several designs in which

Kandahars are made. Colors are usually light pastel shades of ivory or cream with design in other pastel shades. Color Plate 1 is of the Indo-Aubusson quality, but Kandahar, which is their best quality, is also made in this design, and in many other designs in the same general light colors and with soft green, blue, and other colors as the principal color of the field.

In addition to Savonnerie designs, it is made with an open field with floral sprays in two of the four corners. A Kandahar is very compactly woven, of very heavy quality, and a very fine quality of wool is used. Excellent chrome dyes are used, which permit these rugs to be lightly washed just as all Kirmans are. I know of only one other importing house at this time which brings in a quality as good as this Kandahar quality. That is the Chinda, which is the very best quality of another large firm. I will not place one ahead of the other, or argue about the difference between these two. Both are superior rugs and I believe that both will give a lifetime of service, perhaps more. (See Indo-Savonnerie Rugs.)

**Miscellaneous:** Thirty years ago, the name Kandahar meant something entirely different. It meant an inexpensive rug in a Persian design which almost invariably had a rose field (with slight magenta cast) and an all over Mina Khani design in green, blue, etc. They were not very well received in this country and soon disappeared. I believe this was due to their rather domestic (mechanical) look or too set a design. The same firm that now brings these Savonnerie types also produced this first type of Kandahar—both being trade names.

# KARABAGH RUGS

## *(Caucasian Family)*

## *(Also spelled Carabagh)*

**Availability:** Only a very few choice antique Karabaghs come from estates and private collections. A good, old one is rare, expensive, and a collector's item.

**Where made:** In the southern part of what used to be called Caucasia, now the Russian States of Armenia, Azerbaijan, and Nakichevan.

**Characteristics:** These and the Kazaks are the best of thick rugs that came from Caucasia. Karabaghs have been called the floral Kazaks. (Plate 165.) Many of these are not as heavy as the Kazaks. Some of them used stylized flowers (very angular) in large clusters. While the Persian floral influence is apparent to some degree, all the forms are stiff and conventional. Since these are very close to Kazaks, the rule is that when a rug, very much Kazak in quality and colors, has some floral forms, call it Karabagh. Some of these also come with stylized animals. The wool and general appearance is that of a Kazak. A large pear design is often used (again, it is angular). In Plate 165 we find the angular pear design. This is one of the few good prayer rugs in this type.

**Note:** The new rugs are not in the same category as old ones. New rugs lack certain qualities which would permit them to sell in numbers in this country. Also, all new Caucasian rugs in their first appearance in 1960 are too costly. (This is covered in Part I, Chapter on Caucasian Rugs.)

*227*

# KARADAGH RUGS

## *(Persian Family)*

None have been imported by this name in fifty years. Collectors and hobbyists once called runners with geometric designs to which they could not give a definite name " Karadagh," but I think they were guessing. Mr. Mumford, in his first edition in 1900 said: "Karadagh weavings are not often seen in the market." He wrote this sixty years ago. No rugs by this name have been imported, to my memory. It is all right to call a Karaja a Karadagh, but I have not seen it done in the past 30 years.

Heinrich Jacoby says this in 1952 about Karadaghs: "In the trade the finer qualities are usually described as Karadjias (his spelling of Karaja) which is merely a dialect form of Karadagh." But the town of Karaja and several villages are where the Karajas are made. If there are any rugs coming to Ardebil or Tabriz as Karadaghs, it will be news to most buyers in Tabriz. What little information is available describes these as being very much like the Caucasian Karabaghs, thick rugs with both geometric and floral designs. I am not going to give further space to this rug, since none have been imported by this name in the memory of any active dealer, and also because none by this name have appeared from estates. But one could get into a very technical discussion on differences between Karadagh, Karabagh, Karaja, and Karaje. These last two are not the same. However, it seems quite certain that the new Ardebil rugs are successors to the Karadaghs.

# KARAJA RUGS

## *(Persian or Iranian Family)*
## *(Not to be confused with old Karaje Rugs)*

**Availability:** In large numbers in new rugs (geometric designs) in the following sizes: $2 \times 2.8$ ft., $2.4 \times 4$, $4.6 \times 3.6$, $6.4 \times 4.10$, $5.6 \times 2$, $8 \times 2.3$, $11 \times 2.10$ and $14 \times 3$ ft. Also there are a few semi-old rugs in the above sizes. Prior to World War II, a limited number were made in carpet sizes approximately $8 \times 11$ ft. Only a very few of these (in large sizes) have been made in the past few years.

**Where made:** In the northwest section of Iran and the northern part of the Herez district in village of Karaja, and several surrounding villages. This is not far from the Caucasian border and the rugs show Caucasian influence, and are more geometric than floral.

**Characteristics:** Karaja rugs are in the same general colors as Herez rugs. The field of all new rugs is almost invariably in some shade of red, rosy red, and light to dark brick red. In the runner sizes, some come with an ivory field. Main borders are navy. A few of those made before the war had blue fields. Each rug has three geometric medallions (irregular sided rectangles); the center one is almost invariably in blue and the other two usually in green. Small angular floral designs in green, blue, ivory brown, pink, etc., occupy the rest of the field. Medallions have other designs superimposed in ivory, rose, blue, and tinges of other colors. (See Plates 74 and 75.) The runners will have several of these medallions.

*228*

The dozar sizes 6.4×4.10 ft. and the tiny mat sizes 2×2.8 ft. are, for some reason, more finely woven than the others. Only one weft thread is used. These rugs are often referred to as the Kazaks of Persia because they are more geometric in design than any other Persian rugs. The nap on the above two sizes and on the short runners is clipped shorter than other Karaja sizes, and shorter than Herez. Like all types of rugs, they vary as to quality, especially in the $4\frac{1}{2}×3\frac{1}{2}$ ft. sizes, which as a rule, are much coarser and heavier than the 6.4×4.10 ft. sizes. The runners vary in quality. A few come longer than 14 ft. Also a limited number are made in size 12×4.6 to 14×5 ft. All in the same general design shown in Plate 74.

There is a difference in the weave between Karajas and Karadaghs, but the designs are the same and all are sold as Karajas or Herez today. Most of the smallest rugs and 6.4×4.10 ft. are Persian washed in Iran. Rugs shown in Plates 74 and 75 are typical in design. The field is red. The middle motif is in blue and ivory. End motifs are in green and the main border is blue.

Karajas are not to be confused with Karaje rugs. Karajas invariably have geometric designs and the warp is invariably cotton. The Karaje are Kurdistan, and invariably had a woolen warp. These have not been made nor imported for over thirty years; when they have appeared, they have generally been called Kurdistans. (See Karaje.) The difference between "a" and "e" makes a great difference here.

# KARAJE RUGS

## *(Persian Family)*

**Availability:** None have been imported by this name in thirty-five years. Practically all were in runner size, and if one is found in an estate, it will generally be called a Kurdistan. Dealers who have been in business only thirty years probably have never seen or known what this rug is like. They are not to be confused with present day Karaja rugs.

**Where made:** By nomad Kurdish tribes some 50 miles north of Hamadan.

**Characteristics:** Karaje rugs are a thick runner compactly woven (one weft thread between every two rows of knots). While Mumford did not mention this name in his first edition, Hawley gives several different designs. In my 37 years of buying, I have never seen one in the wholesale market as Karaje—yet many of my old teachers and then the world's most famous authorities, gave this name to a certain kind of runner. I say certain kind of runner, because most of those, so named, had a somewhat geometric series down the center, and the majority had a blue field. I now realize that these authorities were not certain that these were correctly called Karajes. Plate 51 is a typical, old Karaje runner.

# KASHAN RUGS

*(Also spelled Keshan)*

*(Persian or Iranian Family)*

**Availability:** Kashan rugs are, as a rule, a very finely woven rug. None were made for 200 years until 1900. They are being made today in good numbers, and available in the New York market in limited numbers in dozar sizes ($6\frac{1}{2} \times 4\frac{1}{2}$) and $9 \times 12$ ft., (and occasionally in a few larger sizes and in a few smaller sizes, $5 \times 2.6$ ft. and $5 \times 3.4$ ft.). All the above are in new rugs. Most of the present output goes to the European market and the Teheran market. These are bought by the wealthy Persians themselves. There is always a good number of these available in the European market (the Free Port of London warehouse). Most of these are also in the $6\frac{1}{2} \times 4\frac{1}{2}$ ft. rug and the $9 \times 12$ ft. carpet sizes. It is here that I find half a dozen to a dozen semi-antique carpets in the $9 \times 12$ ft. and $7 \times 11$ ft. size as well as a dozen in the $6\frac{1}{2} \times 4\frac{1}{2}$ size. All the above are rugs which American dealers refer to as European type Kashan.

The original type Kashan with merino wool has not been made since 1930. A few of these appear from estates from time to time. They bring very high prices if not worn out. Up to 1930 they were the finest and costliest of all new Oriental Rugs.

**Where made:** In the City of Kashan which is about 150 miles due south of Teheran, the capital of Iran. Kashan is a city of some 40,000, which is one of the most unusual in Iran in that it is built below the ground surface, downward instead of upward. To reach the third floor, you walk down three. Their living quarters are arranged in galleries around a garden, usually 20 to 30 feet below the ground level. There are no factories, but most of the homes have two looms; some few have four looms. Even though the town is at an altitude of over 3,000 ft., the heat is so intense and the moisture so far below ground, that the unique, below-surface homes were built. Also in the 20 nearby villages of Armaq, Alibad, Abuzaidabad, Fin, Nushabad, and others, Kashans are woven which are equal to those made in the city itself. The towns of Aron and Nasirabad also weave Kashan rugs, but in less fine quality. Another town of Natanz (several villages in one) weaves only fine rug sizes about $7 \times 4$ ft., and while most of them weave in typical Kashan designs, some of these are entirely different from those pictured in the plates. (See Color Plate 111.)

**Characteristics:** Today's Kashan and the so-called European type Kashan are most often found in the designs as shown in Color Plate 40 and Plates 38, 39, and 41. Plate 111, a Prayer Kashan, is a design made during the past 40 years and only in sizes up to $7 \times 5$ ft. These are referred to as European type, because up to about 1933, these which are in antique design went to the European market. Most of the Kashans that came to America were made with merino wool and often followed the all over floral design which the Sarouks had adopted about 1915. European Kashans adhered to the traditional design. Ninety percent of those made today for Europe or America (and none are actually made for the American market) come with some shade of red field. A few come with the cochineal red field. Before the war about half of these came with a blue field, but since World War II, not one in twenty has a blue field. All are woven from paper scale models.

*230*

The above plates, with the exception of Plate 111, are most typical, and even with the medallion design in these, the center and corners and field are so tied into each other that even the person who objects to a medallion design and seeks an all over design, usually finds that this gives the all over effect. In recent years I have had several rugs on the order of Plate 111. Some of the $7 \times 4$ ft. size and $9 \times 12$ ft. size will come with an all over design combining the Shah Abbas, rosette, even Chinese cloud bank, with intricate floral designs. Some come with an all over floral design very much like the Sarouk, with a little open ground between the floral stalks or sprays. This is a carry-over from the time when the merino wool Kashans during the period 1915 were made in the Sarouk designs for the American market. At the same time, the designs shown above were made for the European market. That is how the term "European type Kashans" originated. The Kashans up to 1930 were twice as fine and cost about twice as much as the Sarouk.

The Prayer Kashan shown in Plate 41 is a very fine example and shows the typical prayer design—the one most used. It is one of the best examples of a Prayer Persian rug made since 1930, the exception being a very few Nains in prayer design. Kashans as a class are very finely woven rugs with some $14 \times 14$ knots to the inch, and the best even finer. A few of the coarser rugs from some of the villages will have only 8 to 10 knots each way. They have a medium short nap. The dyes are invariably good and mostly vegetable.

I have not given a plate of the design in which most Kashans have been woven during the past ten years for home (Teheran market) consumption, since we have helped to make the Iranians (especially in the capital city of Teheran) so rich by our own government's aid. These have a medallion center and corners, but have an open plain red field. The borders are the same as other Kashans. These are in bright red: the brighter they are, the better the Persians like them. These are in the same general texture as detailed above. Still another type of Kashan is one that has the all over Sarouk design, and which is much heavier than the above Kashans—nearly as heavy as the Sarouk, but much more finely woven. These invariably have a rose field. Perhaps most of these were made before the war, as they usually have a little age. The new Kashans, like all short or medium pile rugs, have a harsh feel and are too stiff and bright to be sold in the American market, unless they are Persian washed or lightly lime washed in New York or London.

I have been fortunate enough to find at least a dozen in semi-antiques in the London market each year. There is seldom a single Kashan in the $8 \times 10$ ft. size. This is understandable when we realize that the Kashans are made mostly for Europe or Iran, and that they prefer and need the $7 \times 10$ ft. rug, while American homes want the $8 \times 10$ ft. rug. This has been true with all types of rugs and continues so in the European market today.

**Merino wool Kashans:** It is a well established fact that no rugs had been woven in Kashan for 200 years prior to 1900. It seems quite certain that the world's most famous rug, the Ardabil Mosque Carpet in the Victoria and Albert Museum, was woven in Kashan about 1540. Nothing except cloth had been woven there for a long time prior to 1900. A textile merchant in Kashan, finding himself overloaded with the merino wool from Manchester, England (the very finest wool ever put in any rug, and wool so lustrous that it is often difficult to tell whether

it is silk nap or really wool) and finding the textile (hand woven cloth) business at low ebb, had his wife weave a rug with this wool. It brought a handsome price, and quickly a few other looms were started. In a short time, the finest carpet sizes ever to come out of Persia were being woven in Kashan with this merino wool. These rugs were clipped with a short to medium-short nap. Today, whenever one of these appear from an estate, in spite of hard usage, it is seldom worn out, and is often in excellent condition. The wholesale price for these up to 1930 was invariably not less than $10 a square foot or $1080 for a 9 × 12 ft. rug size. About four years ago, a famous 5th Avenue store advertised a number of these fine Kashans from an estate at the following prices: A 9 × 12 ft. at $4,900, a 10 × 13 ft. at $7,900, and a number in the dozar sizes (7 × 4 ft.) at $495 to $895. These prices were very much out of line, because the discriminating buyer could occasionally find the same quality dozar sizes for less than half the price, and the 9 × 12 ft. rug for $1,500. These high prices were due to the merino wool, the age of the rugs, and the scarcity. They were over-priced. The European type Kashans can be had for much less than a fine new Kirman. It further goes to show how the old books are completely out of date when one remembers that in the period 1920–30 the Kashan cost twice as much, or more, than the Kirman of that period.

# KASHGARS

## (Turkoman Family)

Kashgars are more like a Chinese rug than a Bokhara. None are available, and I have seen a few rugs that were called Kashgar but there is not enough definite information on these rugs, and the rug is too unimportant and unknown to give it space. We seldom come across the name.

Most of these look very much like Samarkand, and were usually sold as such in Constantinople in the old days. All were coarse weave, having a short nap. They were very coarse, poor rugs.

# KASHKAI RUGS

## (Persian Family)

Same as Qashqai, or Mecca Shiraz. Also see Shiraz. Some importers spell the name Kashkai—a corruption of Qashqai. I have talked to a native who insists the spelling should be Ghasghai. (See Color Plate 102 and Plate 104.)

# KASHMIR RUGS

## (Same as Cashmere)

SEE Soumak Rugs.

*232*

# KATCHLI BOKHARAS
## (Turkoman Family)

Katchli indicates a certain design, and there are no rugs by this name. The design appears only in three types of Bokhara rugs. We refer to them as Yomuds in Katchli design or Afghan in Katchli design. The Prayer Tekke Bokhara (better known as Princess Bokhara) has the Katchli design. (See Figs. 26 and 28, Part I, and Color Plate 180. See Plate 175 for a typical new Afghan rug in the Katchli design.)

**Availability:** In new rugs from Afghanistan, and in a few semi-old rugs from there. Very few real antiques come from estates. The name should be "Hachli," which is a Turkish form meaning "cross" or "having a cross." All come in sizes about 5×4 ft. to 8×6 ft.

# KAZAK RUGS
## (Caucasian Family)

**Availability:** Only from estates and private collections. Some are in perfect condition, but the majority are slightly thin and worn. The majority are in sizes 5×4 ft., 7×4½, and 8×4½ ft. A few are smaller and there is rarely one as large as 6×9 ft. We have had a few as large as 7×12 ft. A good one is a collector's item. European buyers come to America and buy these regardless of condition. Those we have pictured are thick, perfect, antique Kazaks. I have personally sold many old Kazaks to European dealers at higher prices than we can sell to retail buyers here.

**Where made:** *New Kazaks:* In 1960 the Russians set up factories and began weaving new Kazaks in several designs in great numbers. Most rug books tell you that the name is derived from "Cossacks," which is not the case at all. Some of these were woven in what is now Georgian S.S.R., Armenian S.S.R., and Kazakstan, S.S.R.

**Characteristics:** Kazaks and Karabaghs are thick piled Caucasian rugs. The Kazaks are geometric in design while the Karabaghs show some Persian (floral) influence. They were made in many designs and are among the boldest and most colorful of old Caucasian rugs. Few rugs have a heavier nap of finer wool. In spite of a medium to coarse weave, they have proven to be one of the most durable rugs ever made. Their patterns are generally large. See Plates 145, 152, 153, 155, and 156. The field is often divided into three connecting panels like the design in Fig. 18, Part I. The border shown there is the crab border so often found in these rugs, but usually drawn more realistically.

The Prayer arch shown in Fig. 14, Part I, is the only prayer niche used in Kazaks. Oftentimes the field has very few colors, such as Color Plate 153. Others have the "Sunburst" design, which some collectors call Tcherkess rugs, but which, in reality is a Kazak. These rugs also employ eight-pointed stars, "S" forms, lozenges, latch hooks and small geometric animals, birds, and human figures as their design. Most of these come with red or blue, but some few have an ivory

*233*

or green field. The bold designs are in contrasting colors. A distinguishing characteristic of these is that they have a fine, red woolen weft thread. The nap is very lustrous.

**Miscellaneous:** Kazaks are one of the most delightful and sought after rugs today, not only by Americans, but by European buyers who come to America in great numbers to seek old Caucasian rugs . . . the only source of old Caucasian rugs now available. A good Kazak is as valuable as a fine old Kashan or Kirman. The West Germans and Italians are buying these old Kazaks from dealers and taking them to Europe. It is amazing that the wholesale dealer from Europe is willing to pay more for one of these than the average American buying at retail will pay.

**Note:** As to the new Kazaks being made today in Russia for the first time, I will not repeat what I wrote in Part I, chapter on Caucasian rugs. I will repeat however, that there will have to be a great improvement in quality and general appearance in these rugs before they will find a sizeable market in America.

# KAVIN RUGS

## *(Iranian Family)*

## *(Also spelled Kasvin)*

**Availability:** In great numbers in new rugs in most of the standard sizes and in large carpet sizes. They were first made in good numbers during 1928–40, then in great numbers after World War II. The only old Kasvins to be had are those from American estates with 10 to 30 years usage. Occasionally a semi-antique in $7 \times 4$ ft. or $9 \times 12$ ft. size comes from Iran. The vast majority of Kasvins are in carpet sizes, $6 \times 9$ ft. and larger.

**Where made:** Kasvin rugs are made in the City of Hamadan only. There is a town named Kasvin in Iran, but no rugs are woven there. It is really a Hamadan rug, entirely different, much heavier, and tighter than any other type of rug made in or near Hamadan (except the Ingeles). It was first named "Alvand" from the high mountain that overlooks the city. But the name Kasvin has become so well established in America that they are now called Kasvins in Hamadan and imported as Kasvins. There is a famous ancient town of Kasvin some 80 miles northeast of Hamadan, but few if any rugs have been woven there in the past 200 years. I have had dealers tell me that their rug was a real Kasvin. What he could have meant was that the pre-war Kasvin was much finer and more closely woven. A. Cecil Edwards in his late book on Persian rugs (only Persian weaves are covered) relates how experiments were begun in 1912 to create this new Kasvin. He calls it the town rug, because it was woven only in Hamadan, while most of the scores of types of Hamadan rugs are woven in hundreds of surrounding villages.

The small booklet, *The Gift of the Orient*, published by the official organ of the importers, *The Oriental Rug Magazine* was completely wrong, as every one of its members who import hundreds of Kasvins from Hamadan know. The several large importers who bring in most of the Kasvins will affirm that they are all

made for them in the city of Hamadan. Under Kasvin, the booklet says in part: "Another type of rug which takes its name from the place in which it is woven is the Kazvin, woven in Kazvin, at one time the summer capital of Iran. The weave of this rug rivals the finest Kashan technique, and the designs are equally commendable, which undoubtedly accounts for its growing popularity in this country." I disagree with that statement, first because 99% of all Kasvins that have come to America have been woven in the City of Hamadan, and the finest Kasvin has never approached the quality of the finest Kashan.

**Characteristics:** A Kasvin is one of the most durable rugs ever made. It is a tightly woven rug with an extra heavy nap of good wool. The thickness and general texture reminds one of the thick, new modern Sarouks—perhaps the Kasvins are slightly heavier. The designs are principally in the old classical designs. Plate 34 is a typical design of many Kasvins that came until about 1957. Most Kasvins are still being made in this general design. Prior to World War II many Kasvins came with a blue field, and after being Persian washed had nice soft colors. After World War II, 90 percent of all these came with a very bright red field. Most of these had the Central floral piece (medallion) and corners as shown in Plate 34. The design over the field and throughout the rug contained much green, a good deal of pink, blues, ivory, and tinges of other colors. Even after the Persian wash these had very bright colors—much too bright for many homes. On one day I have seen in one importing house in New York in the period 1954–59, 200 of these very bright rugs of excellent quality in giant sizes, and wondered how my friends could be so foolish as to have these rugs made in these colors. Other places had large numbers of rugs in the same bright colors. A few months later all of these rugs were sold. Most of them had gone to their Boston office. Oriental Rugs are so popular in Boston that dealers can sell brighter colors there than in any other town. The people who bought these five years ago are just beginning to be rewarded, as these rugs tone down. The same situation was true of several other importing houses.

An innovation in the designs of many Kasvins came into being in 1959 and 1960. Color Plate 35 shows a new Kasvin in the design of the modern Kirman with the open field and Aubusson type border in light colors (ivory field). Only about one out of ten of these in ivory have their designs in soft colors. The importers have not yet been able to have their operators in Hamadan eliminate the very bright red from most of these ivory field Kasvins. Other Kasvins have different designs somewhat like those found in the Kirmans, with a small central floral pendant and corners, and with a more intricate floral design over the field. At first these had the old straight line border, but now many use the classical period designs in their borders. Now these ivory Kasvins are being made in Aubusson type borders, much like so many new Kirmans. The Kasvin as a class (and these vary in quality like all rugs) are much more durable than the light colored Kirman as a class. With the price of a Kasvin so much less than one of the better Kirmans, this rug is a wonderful addition. A Kirman costing the same as a Kasvin will not last one-half as long. I have taken in trade a number of Kasvins that I sold 20 to 36 years ago, and not once has a single one of these rugs shown the least sign of getting thin. Again, the finest quality of Kirman will wear a lifetime and longer, but it is pricing itself out of the market at nearly double the price of a good Kasvin. A lower price Kirman wears thin in a short time.

# KELIMS

## *(Persian, Caucasian, Turkish, or Turkoman Family)*

**Availability:** Kelims are available only from estates, and if these have been used on the floor they are badly worn. None are believed to have been made in any of the countries in the past thirty years, and none have been imported during the past twenty-five years.

**Where made:** Different types were made in each of the four countries.

**Characteristics:** Kelims are woven with a flat stitch somewhat similar to our Navajo Indian rugs—though the coarsest Kelim is as fine as a Navajo rug. They are double-faced, and are smooth with a flat stitch on both sides.

Kelims were made in Persia, Caucasia, Turkey, and to a limited extent, in Central Asia. Most of those that are found for sale today are pre-war, and very few new ones are seen. Naturally, with the great amount of commercial weaving being done today, any weaver would be foolish to weave a Kelim for the market for two reasons. First, there is no regular demand for them, and second, the same amount of labor used would bring a greater return if rugs other than a Kelim were woven. The exception is a fine antique Sena Kelim from Iran. A very choice and rare example of a Sena Kelim is shown in Plate 69. There are several types, the Sena Kelim being by far the finest most beautiful and most expensive. They are suitable for hangings as tapestries, as couch covers, or small ones for table covers. They resemble Sena rugs in colors and design.

In the Orient they were used as floor coverings the same as rugs, or as coverings. Except for the Sena Kelims, the patterns are chiefly geometric. Some authors called the heavy type of Kelim, "Kis Kelim." "Being woven by the girl as a bride's gift to her husband." H. G. Dwight in *Persian Miniatures* doubts the correctness of the name, and says he never heard of it outside of a rug book. I agree with Mr. Dwight, and believe the name to be an invention, just as the name Royal Sarouk is often applied to any ordinary Sarouk for selling purposes.

Most of those that came from Turkey were in prayer design. They are generally very inexpensive. The Sena Kelims and Turkish Kelims are in small sizes, generally not larger than $7 \times 4$ feet, while some of the others are in very large sizes up to $7 \times 14$ ft. Many of the heavier Kelims were used as rugs. Many of the larger ones were used as portieres. They came in two sections; that is, two complete strips about three or four feet wide by seven to twelve feet long, and joined together in the center.

# KENARI

Kenari is a term used to denote a runner $2\frac{1}{2}$ to $3\frac{1}{2}$ ft. wide and 8 to 25 ft. in length.

# KHALABAR RUGS

## *(Indian Family)*

**Availability:** In all the standard sizes, $3 \times 5$ ft., $6 \times 4$, $6 \times 9$, $8 \times 10$, $9 \times 12$, $10 \times 14$, $\overline{12 \times 15}$, $\overline{11 \times 18}$, and $12 \times 20$ ft. Also available in sizes approximately $12\frac{1}{2} \times 22\frac{1}{2}$ ft. The rug is made in at least four colors, each an old French Savonnerie or Aubusson design. Each design is offered by one importer who brings these from India as Khalabar design 9679 Rose, or design 9686 Beige—with an all over design; or design 9670 Beige (cream) and design 9706 Green. These designations and designs may change. These can be woven to order in six or seven months in any size other than the regular sizes, which are usually in stock.
**Where made:** In Mirzapur, India.
**Characteristics:** Plate 184 is one of the several designs used. A Khalabar is an excellent quality handmade Oriental Rug, in the old French Aubusson or Savonnerie designs. The rugs are thick and of superior wool and chrome dyes are used. The importer's booklet says: "Modern dyeing methods in our factories guarantee commercially sunfast colors. In our Chinda and Khalabar qualities chrome dyes are used exclusively."

# KHIVA RUGS or KHIVA BOKHARA RUGS

## *(Turkoman Family)*

SEE AFGHAN RUGS. Today, all come from Afghanistan.
**Availability:** In good numbers in new rugs in many sizes, and from time to time, in sizeable numbers of semi-antiques. To say "Khiva-Bokhara" is perhaps, like saying "Boston-New York" but the practice of calling all types of Turkoman rugs Bokharas, has been general for the past 60 years. Today, the family should be called the Bokhara family instead of the Turkoman family. While Khivas and Afghans are supposed to be two different rugs, they are so alike that neither in buying thousands of such rugs, nor by research in the books, can I accurately point out the difference. My own idea is that they are one and the same. Call them by either name if you wish. (See Fig. 33, Part I, Chapter on Turkoman Rugs. See Afghan Rugs.)

All are geometric and are in some shade of red—generally wine red. The best semi-antique Khivas sell for less than an ordinary modern Sarouk.

All have a design with one to several rows of large octagons.

# KHURASAN RUGS

## *(Also spelled Khorassan)*

## *(Persian and Iranian Family)*

**Availability:** We must deal with three different types in discussing Khurasan Rugs. These are: (1) the rare collector's items so highly regarded by collectors

*237*

in the period 1900–1930—these were rugs 60 to 100 years old; (2) the great number of semi-antique rugs and new rugs of mediocre quality that were available up to 1939; (3) the new rugs being made in the Khurasan district today. All are known as Khurasans, Mesheds, or Birjands. Unfortunately, some stores advertise all rugs coming from the Khurasan district as Ispahans.

No rugs have been imported as Khurasans in the past 20 years. The choice old rugs were rare 35 years ago, and seldom does one appear even from an estate. The lesser semi-antiques that are very poor quality, yet beautiful and decorative, are available in a limited number as used rugs, but always they are quite worn and not valuable. Most of the new rugs made in Khurasan are called Meshed. In Persia and European markets, the poorest rugs are the Birjands from this area. With the increase in price of all inexpensive carpet size 9 × 12 ft. or larger, the cheaper grades of Mesheds have once again appeared in the New York wholesale market. They are, as a rule, very coarse and unsalable in America and are bought by Persians in Teheran. A few go to the European market, and some few come to New York.

**Where made:** In many towns in the large district of Khurasan in the eastern part of Iran. The City of Meshed is the capital and the market place for all rugs made within 100 miles. While all new rugs made in the many towns in this section are sold as Meshed rugs, the rugs made in the city itself are much superior and are called, in the Persian market, Turkibaff. (See Ispahan Meshed Rugs.) They will be on the importers' invoice as Turkibaffs or Meshed, but the American dealers insist that the Turkibaff (or city rugs) are Ispahans. The rug books have always spelled the name of the district Khorassan, but the map will show it as Khurasan. Meshed rugs, Ispahan-Meshed rugs, Turkibaff rugs, and Khurasan rugs should be covered in one heading together, but I have listed each in this Part II. The poorest of all are the Birjand rugs made in a town by this name. They, too, are sold as Mesheds.

**Characteristics:** The first type—the very choice old Khorassans. Because these are less durable than most other rare Persian rugs, those that have been used as floor covering are badly worn. Only from the estate of the expert, who has kept the rug as art and withheld it from heavy usage, does one of these occasionally appear in good condition. I have seen only three or four of these in collectors' quality in good condition since World War II. Reading under Herat rugs, you will see that it is believed that many of the famous old Herats were actually made in the Khurasan district. These rare old Khurasans are not as valuable as the ancient Herat rugs, nor are they in the giant sizes. Most of these are in the scatter sizes, and in unusual sizes, such as 9 × 5, 12 × 6, 6 × 4 ft., and a few larger carpets (the larger sizes were not collector items, excepting the Herats).

The principal designs used in these rare rugs were the herati (feraghan) design and the large pear design. The pears are floriated and covered with small floral design, and often had a smaller pear superimposed on these at about a 45° angle. Some few came with much open plain field (with considerable shadings) with only a large pear in each corner as a field design. (Plate 71.) Others had three conventionalized floral motifs on this plain field. The color in the field of this rug was a faded or very mellowed cochineal red (almost like a faded magenta). Others in this general design come with a camel tan field.

It was the exquisite silkiness of these rugs, the result of fine plasm wool (under-

belly wool) that made some of them so sought after by collectors, and that placed them on a par with a rare Feraghan. These rugs employed a certain weave used by no other rug. An extra filling of yarn (weft) regularly used about every quarter inch, gives the rug a depressed effect when examined from the back. If the rug is opened on the nap side, every few rows or knots will stand together in separate rows. In the old rugs, a single weft was used between every three or four rows, and then three or four lines of weft was used between these two rows of knots. In my early days, this made the identification of a Khorassan one of the easiest. Today, the new rugs from this district do the same thing, but instead of using three or four fine weft lines between every third row of knots, they use a heavy coarse warp thread. Regardless of this peculiarity, the better old Khorassans were compactly woven and the wool was ultra fine and soft. More than half of these very old, choice rugs came with a field of blue, even though cochineal red has been their main color for over one hundred years. Perhaps the lack of durability of wool dyed with cochineal, as explained under Meshed and Ispahan Meshed, eliminated rugs made in these colors, while those with blue fields survived.

**Khorassans in 1924-40 period:** Plate 71. These did not compare in quality, rarity, or value with the above rugs. They were much coarser and more loosely woven and very inexpensive rugs. but also very beautiful and very decorative. They had a medium-short pile, one-half to two thirds as heavy as the rugs that were being imported as Mesheds at that time. Very few of these came to America. In fact, seldom was a rug imported as a Khorassan. These thin types went to the European market while the thicker, heavier Meshed came to America. But, in the free port of London warehouse, I have bought hundreds of these exquisite inexpensive rugs mostly in carpet sizes in many different designs and colors. They were quite loosely woven, but they served for a longer period than I expected they would. Many of these became thin in a few years, but they have gone on to last 25 years after getting thin. While the majority came in designs like Plates 71, 72, and 81, many others came with the small herati design and other unusual designs without the medallion. One would have expected most of these to have the cochineal red (almost a magenta or plum like red or rose), but more than half that I bought came with more blue, and many with the dull tans, dull buffs, and much light tan or canary. We found quite a few in the $6\frac{1}{2} \times 4\frac{1}{2}$ ft. and $5 \times 3$ ft. size, but 90 percent were in carpet sizes. Since World War II, we find very few, but in their place the thicker, much poorer new rugs marketed under the name Meshed. (See Meshed Rugs, Plate 72.)

There are no new rugs imported to America since World War II under the name Khurasan. A few of average quality come under the name Meshed, a few very excellent rugs in the Turkibaff quality, and from time to time, a sizeable parcel of the junkiest, ugliest new rugs by the name of Meshed are imported. Most of them are being sold in the City of Teheran to the Persians who are not concerned about durability. See Plates 71, 72, and 81, for Turkibaff as well as Meshed. Both use the same general designs. With communications in Iran so much better, this can change in a year or so, and weavers in the Khurasan district could discard their present method of treating their wool and change the color scheme of their rugs. The new rugs from this district are too poor for the American market.

**Late note: January 1962:** With prices on all types of Persian rugs rising sharply, and with the cheap grade of Gorevan and the cheap grade of Kabutarahang pric-

ing themselves too high, some importers searching for sale bargains are beginning to bring these in again. Beware of the cheap grade of Meshed or Khurasan, or the cheap grade sold as Ispahan, which is a cheap Meshed (Birjand).

# KIRMAN RUGS

*(Also spelled Kerman)*

*(Persian or Iranian Family)*

**Availability:** *New Rugs.* In great numbers in new rugs in all the standard sizes, and many in-between and unusual sizes. It must be remembered at all times that names do not determine quality, and Kirmans vary greatly. The new Kirman for the American market is different in quality and general designs from those made for the European market. Most of those coming to America are in light colors which become pastel shades after being lightly lime washed in New York. Today, most Kirmans coming to America are the better contract quality.

**Semi-antique and Antique Kirmans:** No antiques have been imported in 30 years. It is seldom that a semi-antique rug comes directly from Iran. A good number of old Kirmans and so-called "Kirmanshah" Kirmans—Plate 70 and

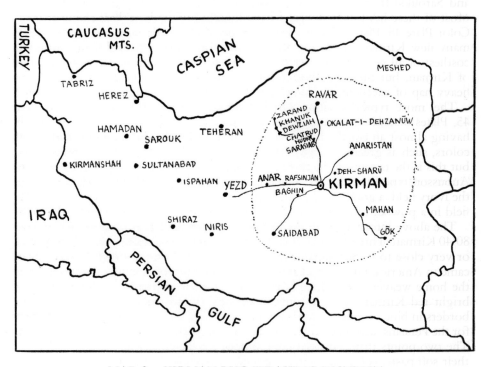

MAP 8.   KIRMAN RUG WEAVING DISTRICT.

240

Plates 78 and 79—come from estates. Almost without exception, they are thin to badly worn rugs. Yet these thin, worn Kirmans are one of the most preferred by many decorators of used or antique rugs. The old, thin Kirmans sell for high prices. The rarest of all Kirmans is the old Laver Kirman (Color Plate 77). This is a very rare and old Kirman.

**Where made:** In the city and province of Kirman in the southeastern section of Iran. The city has around 2,000 looms, and the surrounding villages of Mahan, Chatrud, Ravar, and others have a few hundred looms each. All weave Kirman rugs. Kirman is a mud built city with a population of some 60,000 people, and at an elevation of some 6,000 feet. Most of the weaving is done in the homes, with about two to four looms in each house. There are approximately 20 factories in the city of Kirman, some of which are owned by American importers. The methods in the factories are the same—all rugs are hand woven. Usually the factory makes only the better qualities, or the 80/40 quality. Recently, wages in and around Kirman have risen, due to a large American corporation spending millions of dollars there. The result has been a sharp increase in the price of Kirmans of all qualities. Laver Kirmans were woven in the town of Ravar, which is north of Kirman.

**Characteristics:** *New Kirmans.* When one requires a rug with ivory or cream field and the design in pastel shades, there is usually only one rug answering to this description—the Kirman. Today, the many rugs coming from India are also coming in the soft, light colors and pastel shades. Also, a few other types (Kasvins and Sarouks) from Iran are beginning to copy the Kirman designs and colors. Most of these have not yet been produced in colors quite as soft as the Kirman. Color Plate 45, Plates 67 and 82, and Fig. 6, Part I, are typical designs found in many new Kirmans. Kirmans are as a class one of the two or three finest and costliest of all new rugs woven today. As stated above, there are many qualities of Kirman, but the better qualities are a rather finely woven rug with a good heavy nap of excellent wool.

The most typical designs are shown in Fig. 6, Part I, and in Color Plate 45, Plates 67 and 82. These are usually in ivory or cream field with the designs having almost an equal amount of light blue and rose, and tinges of many other colors, such as green, red, and canary. Often there is an equal amount of green, but this is the exception. Plate 45 is the open field type Kirman with the so-called Aubusson type border, or as some call it, "the broken border." In addition to the ivory field, a good number are made in both of these general designs, with the field in a powder blue or some shade of green or rose.

The above information refers to the better grade of Kirman rug, the 70/35 or 80/40 Kirman. Three-fourths of all Kirmans coming to America are in this quality, or very close to it. Several years ago more than half the so-called Bazaar quality came to America, but this fact is no longer true. Europe is taking these rugs. Also the home weavers are making other types of Kirmans for the Teheran market— bright red Kirmans with an open plain field—with medallion and corners and borders in blue or green. This last type is being made somewhat finer and thinner for the Persians' use. They are doing the same in Kashans for Persian consumption. The two points that make Kirmans the most salable rugs in America today are their soft pastel colors and their fine quality. American's will not pay so much for bright colored fine rugs, and, can get a better value in Kasvin, Kashan, and others.

*241*

**The Bazaar Quality in New Rugs:** This term is applied to the rugs sold in the Bazaars in Kirman. These are woven in the homes. They use the native wool which is not nearly as good as the wool brought in by the factory owners from Kermanshah, or the Hamadan district. Much of the wool in the Bazaar quality rugs is from the great wool-producing section of Khurasan to the north. When they buy their red or rose wool yarn from the local market that comes from Khurasan, it often has been steeped in lime water before dyeing in order to get an even shade. We have discussed this procedure under Khurasan, which is the main objection to rugs from the Khurasan district. Kirmans made with this type of wool will wear down quite readily; in fact, much more quickly than many rugs costing one-third as much. The quality of wool is the essence of durability more than fine weave. The good 80/40 Kirman with good wool should last a lifetime and longer, while a Bazaar quality Kirman may be thin in ten years. Recently, a Persian taking his M. A. at Syracuse University, brought in a Kirman to show me, and inquired why it had worn thin in 5 to 8 years. He lived there and did not know this simple answer: poor quality wool in a Bazaar rug. So, the wool quality is the most important thing about a Kirman for durability.

**Standard sizes:** Most new Kirmans are made in the following sizes: $2 \times 3$ ft., $2 \times 4$, $5 \times 3$, $6\frac{1}{2} \times 4$ to $7 \times 4$ ft., $8 \times 5$, $6 \times 9$, $8 \times 10$, and $9 \times 12$ ft. Today more than half the output for the American market is being made in giant sizes ($10 \times 14$ ft. to $12 \times 20$ ft.) with a limited number as large as $15 \times 27$ ft. There are no standard sizes for runners, but most are about 30 inches wide.

**Weave and dyes:** We have said that Kirmans as a class are finely woven. In the trade we refer to them as being a good excellent quality if they are 80/40. The 80 means that there are 80 warp threads to the gireh, and 40 means the number of vertical knots to the gireh. Translated into inches it means that this rug has $15 \times 15$ knots, or over 200 knots to the square inch. The lesser qualities are termed 70/35 and those few that are made finer are 90/45 or 100/50. If one is woven that fine, it cannot be a thick rug. The 80/40 is just about the perfect combination for weave and thickness. The dyes are, for the most part, good vegetable dyes, but some excellent chrome dyes are also used. The dyes of the wool yarn purchased from Khurasan are good, but the wool has been weakened by the steeping in lime water.

Kirmans of today are entirely different from those made up to World War II. In fact, there have been many changes in the general designs of Kirmans from decade to decade since Kirmans first started weaving rugs for export about 1870. Rugs were woven for their own use, but Paisley shawls were almost exclusively woven in Kirman prior to 1870. I have no plate of the oldest type Kirman, which usually had a cream field with an all over design of realistic vases of flowers. Plate 77 shows one of the earliest and choicest Kirmans made. This was probably made in the town of Ravar, from whence we get the name Laver Kirman, as it was made long before 1870. Plates 78 and 79 are of two semi-antique Kirmans of the classical period. Plate 78 is about 1915, and Plate 79 probably around 1925–39.

Plate 70 is an old Kirmanshah (in typical design of this Kirman in the design that became known as Kirmanshah). No rugs of this type have ever been made in Kirmanshah, which is a town some 900 miles to the east, and in a district where only coarser nomad tribe rugs have been made. Further, it seems rather certain that Kirmanshah is a wool market and not a rug weaving town. For some fifty

years or more, American dealers have called these rugs with intricate covered field and medallions, "Kirmanshah," even though they were made in the Kirman district. The name is generally accepted, and I see no reason why it should not be accepted. After all, we call the Prayer Tekke rug "Princess Bokhara."

In his book, *Persian Miniatures*, published in 1917, H. G. Dwight the author, says: "The truth is that Kermans, Kirmans, Kirmanshahs, and Kermanshahs are all the same. They have nothing whatever to do with Kermanshah or Tabriz. As for Kermanshah, which does happen to be an important wool and trading center, it is harldy an exaggeration to affirm that no rugs are, or ever were, made there. . . . The name grew out of the ignorance or perverted ingenuity of dealers who knew nothing about so remote a town as Kirman, who were confused by its similarity to the name of Kermanshah, and whose romantic eyes were attracted by the terminology of the latter."

No one can read Mr. Dwight's books on Persia without being convinced that he knew more about Persia than all the book writers combined—including yours truly. And it is common knowledge among rug dealers and buyers today that no rugs are made in Kermanshah.

**Paper scale models by great artists:** Few people realize that the designers of Kirmans actually draw out and color a full paper scale design of the Kirman to be woven. There have been and are a number of famous artists in the Kirman area who produce these patterns. All weavers in the Kirman area use this full paper scale model.

**Many changes in Kirmans over the past 60 years:** The designs of today's Kirmans are entirely different from those prior to World War II. The Kirmans described in the old standard rug books (Mumford's, Lewis' and Hawley's), are entirely different from anything that has been sold on the market since 1925. I am quite sure that, with rare exceptions, the modern Kirman is an improvement over the Kirmans that have been made since I entered the business in 1924. They are also better rugs as a rule: the exception being some very fine Kirmans in the dozar size made prior to World War II. If you refer to the old books, you will find much written about the Kirmans of fifty to one hundred and fifty years ago, having the same old ivory field, but with realistic rose designs, or with an all-over design consisting of vases containing roses. They did not conventionalize their flowers, but made them realistic. Many depicted birds, animals, and human beings. Others used the intricate vine and floral design with the medallion. This last type was generally sold in America in the old days as Kermanshah. They were actually made in Kirman. Many years ago Kirman was the headquarters for the shawl industry. Most of you have seen the so-called Paisley shawl. These were woven in Kirman to compete with the Kashmir shawl of India. When the demand for shawls declined, the Kirman weavers began making rugs in great numbers around 1900. Many of the designs in these early Kirmans were borrowed from their shawls. The beauty of these early Kirmans was that they had a two-tone effect, blue and light blue, rose and light rose, green and lighter green, and in most cases the design was not outlined as is done in most other Persian rugs.

World War I disrupted the industry and marked the end of the rugs following the shawl designs. These rugs were too thin for the American trade, and of course, all very finely woven rugs are thin. The American importer wanted rugs that he could have chemically treated to soften their colors, and to give a sheen to

the nap. These thin, fine rugs could not be treated. Hence, there came a new era, and different, thicker rugs were made in and around Kirman. For ten years after World War I, Kirmans were woven in the classical old designs. But, with so many of these designs with medallions and so many of them with too much design, Kirmans were then woven in the detached floral designs—similar to the modern Sarouks. In the period from 1925 to about 1937, comparatively few Kirmans were woven with the ivory field, but they adopted the blue ground and the rose ground of the Sarouks. Ninety-five percent of these were chemically washed and painted, and they did not give a good account of themselves. I can think of the first of these Kirmans I encountered in the home of a surgeon in Syracuse, and it was already beginning to show wear in a few years. I sold that doctor a natural colored Kirman (about 1926) and it shows no wear whatsoever today while that washed and painted Kirman has long since been replaced by me with an excellent Kirman which is going to last him more than forty years. Also, during the depression years, many of these Kirmans were cheapened in quality. The European market did not like this modern type of Kirman with the all-over detached floral design similar to the Sarouk. However, I did see more of the cheap quality Kirmans at the Port of London Authority (which I visited once or twice a year) than I found in America.

World War II again disrupted the industry in Kirman, and America was the only foreign market. The entirely new type of Kirman was brought out. Again, remember that those made for the Iranians in Teheran were entirely different from the ivory ground Kirman with the pastel shades. The Iranians like the bright red field, usually the plain field with the medallion design.

**For the Teheran market:** An entirely new type of Kirman, as far as design is concerned, is being produced in large numbers for the wealthy class of Persians in Teheran. Instead of the heavy fine 80/40, and instead of the Bazaar quality in light colors, much of the production that went into the Bazaar quality rugs is now being put into a much finer rug 90/45 to 100/50, and with a bright red field—an open field in bright red to a cochineal red (almost a magenta) and blue border. These, and the Kashans being made for the same Persian market, are following the red, open field idea in rugs for the Teheran market. Another design popular with Persians is shown in Plate 82.

**Advice:** Unless you are able to buy the best quality Kirman, you will do better to buy another type of Persian rug. If you want the pastel colors in a rug costing less than the best Kirman, then buy one of the good qualities from India in Kirman colors. Occasionally you can find a Kasvin, a very durable rug, in colors approaching those in a Kirman. (See Plate 35.)

# KIRMANSHAH RUGS

*(Also spelled Kermanshah)*

*(Persian Family)*

**Availability:** A very few rugs by this name are from estates: mostly in sizes $6\frac{1}{2} \times 4\frac{1}{2}$ ft. and carpet sizes. None have been made in recent years. Most of those offered from estates or as used rugs will be thin. None were ever imported by this name. Plate 70 shows the typical Kirmanshah design.

**Where made:** In the City of Kirman or in the nearby towns. Kirman is in the southeast part of Iran, while Kirmanshah is in the southwestern part of Iran, some 900 miles apart. Kirmanshah is a Kurd Tribal village, a wool market, but few rugs have ever been woven there, and none resembling the so-called Kirmanshah in weave, texture, colors, or design.

**Accept the name:** Here again, even though Kirmanshah rugs as we have known them in America are a Kirman in a particular design, I see no reason why we should not accept the name after 60 years of usage, just as we call all Kuba (Kubist-an) rugs, Kabistans, and as we call Tekke rugs "Royal Bokharas," and other similar design and trade names which are given in this volume. But, if you try to inform someone who bought (as they tell you) a "Royal Kirmanshah" fifty years ago that their rug is really a Kirman, and not a Kirmanshah, they won't believe you. People like to believe any fabulous story the dealer may have told them in the early days of rug selling, and don't want to be disillusioned.

**Characteristics:** Kirmanshah rugs are finely woven, with a short to medium pile, usually with an ivory or cream field, an intricate floral medallion and corners, and very intricate vine and floral design over the field in light blues, blue, rose, tan, and lesser amounts of green, red, plum, and canary. (Plate 70.) The native wool around Kirman was not as stable or as durable as it was in some of the other sections of Persia, and these rugs invariably wore thin in thirty years or less. After getting thin, they continue to look beautiful and wear another thirty years. A very few of these come with considerable blue and rose, or red in the field. As stated above, the Kirmanshah (as Americans knew them) were in fact, rugs made around Kirman.

In the period 1925–1938 a good many Kirmans were made in designs very closely resembling those of old Kirmanshahs, for the European market. These designs were known in the European market as "Kirmans with a classic design of conventional medallion and corners."

**Miscellaneous:** To substantiate my statement that the rugs we have known as Kirmanshahs were never made in the town of Kirmanshah, it is clear that Kirmanshah is the market place for the wool of the surrounding Kurd Tribes, and that very few rugs have ever been woven there. Those few were coarse type rugs with woolen warp, and in no way resemble the so-called Kirmanshah rug. I never could understand how Mr. Walter Hawley could make such a mistake. The Kirmans use a Persian or Sena knot, while the Kurds use the Turkish or Ghiordes knot. The Kirmans have invariably used a cotton warp, and all Kurds have, until recently, used a woolen warp. The best book on Persia and Persian art that has ever been my privilege to read, is *Persian Miniatures* by H. G. Dwight, published in 1917 by Doubleday, Page and Co., Garden City, N. Y. No one can read this book without knowing that this author knows Persia. (See quotation under "Kirman Rugs" above.)

Mumford's book, our first book on rugs by an American, in his 1900 edition recognized this fact and said: "It has been customary, until very lately, among the rug dealers of the West and Constantinople as well, to attribute Kirman rugs to Kermanshah."

**Remarks:** The Kirmanshah design rugs were very popular in the period 1890 to 1925. Most of these had a light lime wash in those early days. It was the Laver Kirman (a name developed from the rugs made in the town of Ravar or Ravere)

that the collectors preferred, in fact the hobbyist sought no other type Kirman. Today the old Kirmans of any type, regardless of condition, are sought after and sell at high prices regardless of their thinness. Of course, when a rug has a really worn out look, it becomes practically worthless.

# KIR-SHEHR RUGS

## *(Turkish Family)*

**Availability:** Only from private collections in old rugs. They are always in prayer designs, in sizes 5×3 to 7×4 ft. No good ones have been made since 1915, and the very poor ones made after World War I have worn out. A good one is a rare collector's item.

**Where made:** In a town by this name 75 miles southeast of Ankara, the capital of Turkey.

**Characteristics:** They invariably appear in prayer design, and the color combinations employed are not to be found in any other Turkish weave, especially in such prominence. Their brilliancy is renowned: yet the effect is harmonious. Peculiar to this rug is a green (grassy green) which is invariably used; also a magenta such as we find in Khorassans. We invariably find, just inside the main border and extending to the field, a series of stripes, usually in colors of magenta and white, which serves as a frame for the rug. Upon these stripes, at regular intervals, there appears a floral form. Another almost unfailing characteristic is the tri-cleft floral form which extends around the inmost line of the center up into the prayer niche itself. Above the spandrel and below the field generally appear horizontal panels, usually of different but harmonizing designs. These rugs are often classified as Mudjar, but their coloring and arrangement of design, even to the eyes of the novice, would separate them immediately as a distinct type. All were rugs in sizes 5×3 ft. to 7×4 ft.

While these rugs are rare and collectors' items, they are not as valuable as some of the other prayer rugs from Asia Minor, such as Ghiordes, Kulahs, Ladiks, Bergamos, Meles, Mudjars, Oushaks, and some few others.

# KIS-KELIM RUG

A KIS-KELIM is supposed to be a type of flat stitch rug or Kelim. Most authorities disassociate themselves from such a name. In 1900 Mumford said it was a heavy piece, or winter spread. Walter Hawley's book in 1913 said it was a Turkish Kelim in prayer design, known as Kis-Kelims, or girl rug. Henry Jacoby said in 1914: "Kis-Kelim, meaning little Kelim, is probably intended to denote that these rugs are of small size and not full sized."

I agree with H. G. Dwight, who wrote in 1917 (referring to rug books): "They all mention a variety which they call Kis-Kelim. I, for one, have never heard of it outside of a rug book or rug shop." At least it is an unimportant item, and none have been imported by that name in the past forty years.

# KONIA RUGS

## (Also spelled Konieh)
## (Turkish Family)

**Availability:** Only from private collectors' estates. It was a collector's item forty years ago, and thus seldom fell into the hands of the beginner. None have been made since 1915 and none have been imported since 1928. They are made both in prayer and non-prayer designs and only in scatter sizes. No large rugs were made in this type.

**Where made:** In a town by this name in Asia Minor (part of Turkey).

**Characteristics:** (See Plate 114.) Konias, like their neighbors, Kir-Shers, adhere very closely to type; and their strict adherence to autumnal colors, such as golds, browns, and yellows easily distinguish them from other Turkish rugs. They are, of course, geometric in design and the non-prayer rugs often came with two large octagons joined together in a pole medallion effect. In each of these are other Turkish motifs (geometric). The field of these non-prayer rugs are usually in an apricot or almost gold field or in a light blue field. More Konias were made with the very silky angora wool than any other type of Turkish rug. In addition to geometric motifs, they frequently employed the Rhodian lily (in angular form) which is a characteristic of Ladkis. They are never finely woven; in fact, they are quite loosely woven. Their warmth of color and their softness of wool and extreme pliability make them very desirable and greatly admired. Plate 115 is not what I would call a typical Konia. I would prefer to call it a Dirmirdji.

Due to the isolated location of the City of Konia, very few of these rugs have ever reached the markets. The most interesting came in prayer designs, and due to the arrangement of the prayer niche, which was generally flat, rather than noticeably pointed, it rose only more than half-way. The rug left the spandrel of unusually large size upon which three leaf forms sometimes appear, each with a stem and one common base, forming a square cross. These forms oftentimes appear in the extreme center, sometimes without a stem. Above the spandrel there usually appears a horizontal panel upon which an octagonal center figure may appear, or floral or geometrical forms. Latch-hook designs and eight pointed stars are employed, and sometimes the tree of life is used. Numerous borders appear, generally in floral design, but crude. There are no carpet sizes in this weave. Sizes varied from pillows about $2 \times 3\frac{1}{2}$ ft. to rugs $8 \times 4$ ft.

# KUBA RUGS or KUBISTAN RUGS

## (Caucasian Family)

All the rugs called Kabistan during the past sixty years are, in reality, Kubas. The Russians call them Kubistans. Certain designs of this type are called Kubas. The design on the field of Color Plate 161, we have always called Kuba. But one name is as good as another for this rug. We also follow many of the old experts of yesterday and call those with the outer border in Fig. 17, Part I (which we

call the Georgian Border), Kuba rugs. (See Kabistan Rugs, Daghestan Rugs, Shirvan Rugs, and Chi-chi Rugs.) I have covered the subject under Kabistans and so do not repeat the same facts under Kuba.

**Availability:** Only from estates and private collections. None have been made since 1933 and none imported in the past 27 years. Most of those appearing will be slightly thin to quite badly worn. A good example in good condition is a rare and valuable rug today. The sizes of most of these will be 5×3 ft. to 9×4 ft. There are a few slightly smaller, and still fewer slightly larger. Fifty years ago, a few long narrow carpets such as 6×15 to 8×18 ft. came in very old rugs. I have seen only two or three of these from estates in the past 25 years in these rare old sizes.

**Where made:** The old ones were made in the town of Kuba and its vicinity.

**Characteristics:** Kuba rugs are rather finely woven to very finely woven and have a short to medium nap. Wool, dyes, and wearing quality are invariably excellent. All are in geometric designs. Kuba is fully covered under Kabistan.

Today rugs are being woven in the Town of Ardebil, Iran, just south of the Caucasian border, in the same general designs as the old Kabistans and Kubas. But these Persian rugs, sold as Ardebils, have cotton warp. There have been a few instances that have come to our attention where dealers have sold these new Ardebils to the new customer as Kabistans or Kubas.

See Kabistan for full details. Most collectors call the border and field design shown in Color Plate 161 a Kuba, instead of Kabistan, even though Kuba and Kabistan mean the same thing.

# KULAH RUGS

## *(Also spelled Kula)*

## *(Turkish Family)*

**Availability:** Only from real collectors' estates as this was a wealthy collectors item 50 years ago. A very few appear and are usually very badly worn. They rank among the best of old Turkish prayer rugs.

**Where made:** They are made in the town of the same name in Asia Minor, part of Turkey.

**Characteristics:** With their close neighbors, Ghiordes, Kulahs share the position of being one of the rarest and most sought after of all Oriental Rugs. Although showing marked characteristics of their own, they nevertheless resemble Ghiordes in a great many respects. (See Color Plate 131 and Plate 130.) Plate 130 has as its principal background and color, a golden brown with much old blue in the design. Their location, which is only about fifty miles from Ghiordes, undoubtedly accounts for their similarity in appearance. The favorite and most typical appear in prayer designs. A dependable significance is noted in the arrangement of the Kulah arch over the Ghiordes. Where the Ghiordes arch invariably appears in broken angles at the base, the Kulah adapts a more regular and straight line effect. The peak of the Ghiordes arch rises high into the spandrel, while the Kulah arch rises only half as high, the appearance being more flat. The arch of the Ghiordes

at the peak is angular, forming an obtuse angle, while the Kulah arch forms a more definite point. Another distinguishing feature we find in the Kulah is the border arrangement. Here, instead of a wide main border, we find a series of narrow borders generally alternating in blue and white. The two plates shown of Kulahs are exceptions. The numbers of these borders vary, but generally we find five to seven. Some Ghiordes also appear with this border, but it is the exception. Where the field of a Ghiordes is more likely to be devoid of design, the Kulah generally has some floral forms worked upon the field, sometimes covering the field. A design we find often is one representing a plot of land with cypress trees. A great many Kulahs introduce colors of lighter shades, such as yellow, gold, brown, white, and apricot. Yet some Kulahs are not as regular or smooth at the back as Ghiordes, being more ribbed, or in more definite lines, such as the Ladik weave.

An entirely different type in every detail is a rug often called Dirmirdji Kulah. They are far less expensive, the best prayer Kulah being worth several times the best Dirmirdji. Other experts insist that this rug should be called Kulah and not Dirmirdji.

# KURDISTAN RUGS

## *(Persian Family)*

## *(This name requires clarification)*

**Availability:** Today, no new or old rugs are imported under this name. A few wide runners, 3½ to 4 ft. wide and 8 to 15 ft. in length, a few dozar sizes (7×4 ft.), and a few unusual sizes come from estates from time to time to which only the name Kurdistan can be given. Also a few old Kurdistan Saddlebags (back removed) in sizes 2×2 ft. and 2×3 ft.

**Clarification:** A few old saddle bags will appear in estates that are also real Kurdistans. Every type of rug made by the many different Nomad Tribes of Persia belongs to the Kurd family. Bijars, Suj-Bulaks, Mosuls, Bakhtiaris, Shirazes, Afshars, Qashqais, Serabs, the old time Karajes and Karadaghs all belong to the Kurd family. These were made in widely separated sections of Iran. All of the old rugs of the above types used the woolen warp thread. Every Persian rug that used woolen warp was a Kurdistan rug. Today, with the exception of the Shiraz rugs and a very few others, cotton is used as warp by the Kurd type rugs. Even the fine Sena rug, which has always used cotton or silk as warp, has been described as being a member of the Kurd family by all the books. But since all of the above type rugs are imported under their real name, such as Bijar, Shiraz, Serab, etc., and since we cover these under their individual names, I will cover only those three specific types that are sold as Kurdistans. Few people realize that Kermanshah is a Kurd village, and that, if any rugs are woven there, they are coarse, thick rugs with woolen warp, and not the Kirman type Kirmanshah rug that we have known in America (See Kirmanshah).

**Where made:** Most of the three principal types of rugs to which we have given the specific name of Kurdistan, have been woven in western Iran. The choicer

rugs were woven in northwest Iran between Lake Urnia and the City of Hamadan. The coarser, poorer types were woven by the Tribes in the general vicinity of Kirmanshah, eastward to the Turkish border and in the general area 40 miles east of Hamadan extending to the Turkish border. These were generally sold as Mosuls.

The third type, the large camel saddlebags and small saddlebags, came from a great general section of Iran, overlapping both areas. See Plate 76 which shows the two most typical designs used in large saddlebags. The top mat with diamonds and latch hooks is typical of many thousands that were available until 1935.

**Characteristics:** *Type I.* The choicer Kurds generally came in runner sizes, but a few came in rug sizes. Also a very few long narrow carpets came, perhaps the largest 8×19 ft. but more often 6×10 to 6×14 ft. These had a heavy pile of excellent wool and all were rather well woven, from average coarse to quite finely woven rugs. It is impossible to give a full range of all the designs used, but many employed such well known designs as the Mina Khani, the Herati, and the pear. Oftentimes one came with small all over clusters of plants; or one was covered with a large tree of life design. Others came with a medallion center, while the main part of the field had the herati, or some form of floral design. The coarse types, sold as Mosuls, were so entirely different that there was no chance of confusing one with the other. So, the only rule that I have ever seen followed by collector or dealer was that, if the rug had woolen warp, and it was not a Bijar, Shiraz, or one of the easily identified types, it was the practice to call it a Kurdistan rug. The two that are the closest and most difficult to distinguish between are the Suj-Bulaks and the Kurdistans. The above rule is still a good one to follow. Plate 51, old Karaje runner, is a Kurdish rug.

*Type II.* The easiest to identify of all the Kurd types are the well-known small saddlebags, both in the small sizes of 20″×20″ to 2×2 ft. (used on donkeys) and the larger camel bags (saddlebags that were used on camels) about 30″×26″ to 36″×30″ (upper rug in Plate 76). Most of these came with an all-over diamond shaped series of latch hooks in a combination of green, blue, ivory, rose, red, canary, lavender, and brown. Many had a two panel design with a medallion on a soft gold or apricot field, and a 6 inch panel at the lower side in a different design. (See lower rug Plate 76.) Green, blue, yellow, white, and red were used in all of these. Always present is much green and ivory. Until about 1936 thousands of these could be bought in New York or the European market. After removing the web back and making them into small rugs by fringing two of the ends, they were a delightful and exquisite small rug. They varied in quality, but many of them were pan velvet-like. I, myself, have sold tens of thousands of these, and yet practically none appear in used rug sales today. The reason is that the heirs do not include these but keep them for their own use. Most of them were placed in doorways and heavy traffic eliminated them. None are to be bought in Iran or any market today. Modernization and better means of travel, as well as the settlement of these tribes into villages, have eliminated the making of these.

*Type III.* In the southeastern section of Iran nearest Iraq and Turkey were formerly woven many thousands of very coarse rugs—marketed in Hamadan and Bagdad as Mosuls. They were very coarse rugs with a heavy pile, and they came in many nondescript designs, but most usually with a central, angular medallion. They came in all colors and many had camel's hair fields. In the old days,

these retailed for $29 to $49 in the American market. The high prices of wool (they could sell the wool for nearly as much as they could get for the rug with the same amount of wool) and the settling of these tribes in villages, has reduced the number of these coarse, cheap rugs to comparatively few. All of these Mosul types were and are in sizes approximately 6½ × 3½ ft.

# KUTAIS RUGS

## (Caucasian Family)

Since no rugs have been imported by this name in 40 years, I am going to devote only a very few lines to it. I doubt if any rugs have ever been imported by this name.

Walter Hawley's book (1913 edition) first listed this name. Neither Mumford nor Lewis included this name in their early editions. Lewis in a later edition followed Hawley's line. Hawley said they bear a resemblance to the Kazaks. He says the peculiarity of the pear design is their most distinguishing feature.

It is my belief that the only rugs (probably not more than six) that Mr. Hawley ever saw by this name were in the hands of some hobbyists who in reading about Caucasia, found some Kazak that they could call Kutais. But regardless of this, the name is unknown to dealers and hobbyists during the past fifty years and was not known to the great authority Mumford in 1900.

# LADIK PRAYER RUGS

## (Turkish Family)

**Availability:** Ladik Prayer rugs are one of the rarest of all Prayer rugs. They are available only from collectors' estates, and only from the best collectors, as a good Ladik in 6 × 4 ft. size retailed for $500 to $1,700 fifty years ago. There were poorer examples for less. None have been imported since 1928 and these were new, inferior and not rare or choice rugs. They have worn out, but the rare old rugs have been kept intact by art lovers (not walked on) and so occasionally one appears in good condition. Even a good, worn, thin example is valuable. All were in sizes 6 × 4 ft. to 7 × 4.6 ft. The rare type Ladiks were woven prior to 1875. Don't look for this rug for floor use, but only as an object of art or a collector's item.

**Where made:** In a town in Asia Minor part of Turkey, by this name (the old name of the town was Laodicea).

**Characteristics:** All are in prayer designs except the small mats (pillows) about 2 × 3 ft. and all are in the dozar sizes (approximately 6 × 4 ft.). Color Plate 116 and Plates 117 and 118 are typical in every respect, with the possible exception that more than half of these have the main part of the field without design. The prayer niche is typical and each is in this shape unless, by chance, it is one that has three prayer niches. (Plate 117.) The section above the prayer niche is typical in colors and design. The panel below the red field with the van dykes and pomegranites

are found in each of these. The three borders are those found in just about every Ladik. The main border is the rosette and Rhodian lily, and the two narrow borders are the designs to be invariably found in these rugs. Often, the main border is in an exquisite golden yellow, or gold, or canary. Again, the main part of the field may be in blue. None of these rare old Turkish Prayer rugs are really finely woven, but the Ladik is perhaps the tightest and most compact.

The color plate in Mumford's 1900 edition is along the same color scheme. The field is a deeper red and the section over the prayer niche (spandrel) is in an apple green. To my mind, Prof. Fisher's rug is a more beautiful example. The color plate of the prayer Ladik in Walter Hawley's book (1913) is indeed that of one of the most beautiful Ladiks. This rug has the three prayer niches and the exquisite canary border. (See drawings of Turkish prayer designs in Part I.) This shows the three prayer niches similar to one shown in Hawley's book. Ladiks and Meles have always been two of my favorite rugs. Only two or three prayer rugs are rarer and slightly more valuable, but none more beautiful.

Plates 116 and 118 are of the real rare old Ladiks. I have known these Ladiks and their whereabouts for the past 40 years. Plate 117 is, of course, the excellent specimen in the Metropolitan Museum.

I wish I could have included Mr. Scherer's Ladik and a second Ladik owned by Prof. Fisher. They compare favorably with any shown in the rug books or appearing in any museum.

# LARISTAN RUGS

## (Both Persian and Indian Family)

**Availability:** Neither the Persian rugs by this name, nor the rugs by this name from India have been imported in 30 years. A few of each type come from estates. The so-called Persian Laristans have invariably come in scatter sizes—seldom larger than $6\frac{1}{2} \times 4\frac{1}{2}$ ft., and the Laristans from India have invariably come in carpet sizes, $9 \times 12$ ft., and much larger carpets. Very few rugs have ever been imported to America from Persia as Laristans, while thousands of carpets from India were imported by this name in the period 1923–1931. Laristans from India were a definite and well known type. Certainly no rugs by this name have been imported from Persia in the past 30 years. I would not devote lines to Laristans from Persia except for the hobbyists and connoisseurs who, I am sure, have been as confused by this name as I was for many years.

**Where made:** Persian Laristan. There is no definite answer, unless we accept the version that existed for years as stated by Mumford in his 1900 edition. Under the heading "Niris P. 214." "Niris—these rugs are made by the hillsmen in the uplands around the salt lake Niris in Laristan. A city of similar name is near by. . . ." These rugs are one of the several varieties which have been grouped together by English rug men under the name "Laristan." Niris, as you will note from the map of Iran, is close to the city of Shiraz, and the large Qashqai tribes and the Khamseh tribes (both north of Shiraz) and on the east are the Afshar tribes. There is very little information (none in most rug books) on this name. Dr. Lewis in his book says; "Laristan, Luristan and Niris are the same." (See Niris.)

Laristans from India were woven in a factory—operated by an American firm, M. Berran & Co., 330 Fifth Ave., New York. Factory means they hired many weavers. Rugs were all handmade Orientals.

**Characteristics:** *Persian.* If you agree with Mumford and the British, then turn to Niris. However, I recall seeing collectors who, in trying to widen the scope of names in their collections, called a thick nap rug a Kurd Shiraz type, a "Laristan" which we later learned to call Bahktiari. They also called a heavy Shiraz type (not the Niris) "Laristan." Rugs from the lowlands to the north were, therefore, listed as Laristan. A Persian Laristan was a rather indefinite name.

**Indian Laristan a definite type:** These were always in carpet sizes. In weave they reminded me of a good average Kirman of that period. These were made in two qualities, and, as far as I can remember, only in two colors and design. The best quality wholesaled for $4 per square foot, and the second quality at $3 a foot. Of course, these were prices 30 years ago. They were rather finely woven and had a medium pile, about the same as a Kirman of that period. All were lightly treated. They were not painted as were most Kirmans of that period. I was called in to see rugs within four blocks of my house, and in the living room was the first chemically washed and painted Laristan I had ever seen. They came in one of two colors, one an unusual rose colored field (almost a strawberry color) and the other in a golden tan to cream. The design most used was an all over sizeable design or the so-called vase design—a copy of floral designs as shown in so-called vase carpets in the Metropolitan Museum in New York, or in the Victoria and Albert Museum in London. These designs were in blue, green, and gold, canary, browns, etc. It is pleasing to note that Laristans which appear in estates are in very excellent condition, and are not worn thin as are 95 percent of the Kirmans appearing in estates. Those in a rose field did not always come in vase carpet designs—but employed florals on some open ground. Those with golden tan fields almost invariably came in the vase carpet design.

# LAVER KIRMAN RUGS

## *(Persian Family)*

**Availability:** Only from estates. Laver Kirmans are the oldest type of Kirman. These were made in the town of Ravar and the name has been mispronounced down through the years in Europe and America as Laver. Plate 77 shows a wonderful Laver in prayer design. Old Lavers are the choicest of all Kirmans. (See Part I, chapter "About Oriental Rugs.")

# LESGHIAN RUGS

## *(Caucasian Family)*

LESGHIAN is a name to which I will give little space. Every book lists the name, but not one describes the rug in any detail. None have been imported by this name in 40 years.

They were woven by a number of tribes in the Daghestan district. Henry Jacoby states: "They are all Namases and Sedjades and are hardly distinguishable from the Daghestans. In the market, indeed, they are rarely so distinguished, and are scarcely known under their own name." The only other point of identification is in Walter Hawley's book: "Both warp and weft are of fine, brown wool, as is rarely the case with any other Caucasian rugs excepting Shushas."

I doubt if this name has ever appeared on a customs invoice. It is another name for the collector trying to add a name to his Caucasian collection. There is no harm done if one wishes to call a rug a Daghestan; another, very little different, a Kabistan or Kuba, and still another, so very much like these, a Lesghian.

The few plates used to show rugs by this name have used four or more large intricate geometric stars in many colors. Each star enclosed other geometric designs. Many other small geometric motifs covered the rest of the field. Plate 158 is a design of a rug listed as Lesghian by some collectors.

# LILLIHAN RUGS

## (Persian Family)

**Availability:** Very few rugs have been imported by this name since World War II. The few that do come in are in sizes $4 \times 2\frac{1}{2}$ ft. and $5 \times 3\frac{1}{2}$ ft., and all of these are in natural colors. Between 1923 and 1935 thousands of rugs came to America by this name in sizes $5 \times 3\frac{1}{2}$ ft. $7 \times 5$ and $9 \times 12$ ft., and all of these were chemically washed and painted. Those that show up from estates as a rule have little value, by reason of the chemical washing and painting process, and being somewhat worn if not completely worn out.

**Where made:** Approximately 25 miles south of the city of Sultanabad (Arak) is the Kemereh district, with its principal town of Lillihan. The Kemereh district with seven small villages around Lillihan is inhabited by Persian Armenians.

**Characteristics:** When I first started in the rug business, Lillihan was a well known name in the New York market. It was called the poor man's Sarouk. This was true because it was in the same general design (all over floral designs as Sarouks) and like Sarouks, practically all were both chemically washed and painted. (Plate 69.) They did not resemble Sarouks in weave, but had the basket weave of a Hamadan or Sena Kurd. For many years I believed them to be a rug from the Hamadan district. These were better woven by far than the average Hamadan of the 1924–36 period and are not quite as fine as today's Ingeles (Sena Kurd). The nearest thing in weave, design, and quality in today's market is the red Dargazine, or the Mehriban from the Hamadan district. The vast majority came with a red or rose field, and after being bleached they were painted to a plum shade, or a rose or red with a plum cast. Since World War II no rugs have been imported by this name, except the few in $4 \times 2\frac{1}{2}$ ft. and $5 \times 3\frac{1}{2}$ ft. size. A few in the old antique design made prior to 1925 appeared in sizes about $6 \times 5$ ft. several years ago. What few rugs have been woven in Lillihan and other villages, have been bought by Persians in Teheran. Some of the weavers have turned to making Sarouk rugs.

# MAHAL RUGS

## *(Persian or Iranian Family)*

**Availability:** Mahal rugs come in good numbers to the American market, in carpet sizes only. No scatter rugs are woven. The largest number are in sizes 10.8 × 14 ft. and 9 × 12 ft. size, a few in $7\frac{1}{2}$ × $10\frac{1}{2}$ ft. and a good number about 11 × 17 ft. Most are new rugs, but nearly all are in antique design. Mahals, Muskabads, Sultanabads, and Araks are pretty much the same design but vary in quality. (See Sultanabad for full coverage. Also read Arak Rugs, Mushkabad Rugs, and Sarouk Rugs.)

**Where made:** There is no town by the name of Mahal. All are woven in the villages near Arak or Sultanabad. In the city of Sultanabad (today it is called Arak) only Sarouk rugs are woven. Most of the Mahal qualities are woven in the town and districts of Mushkabad, Feraghan, Dulakhor, and Japalak. The name Mahal was originated to indicate a quality, and Mahal means village rug. Mahal, Mushkabad, Salavan, and Arak are all trade names of different qualities.

**Characteristics:** These are a rather coarse rug of average thickness, but not so heavy as the Sarouk. (See Plate 80.) The fields of all the new ones are in some shade of red, with the main border blue or ivory. The designs in most of these are an all over one, usually a sizeable design with the Shah Abbas intermixed with the floral designs. The designs are too numerous and varied to list in detail. See Sultanabad rugs, as these Mahals employ the same general designs. It is hard to give a good line of demarcation between the Mahal and the Mushkabad—it is simply a matter of the Mahal being slightly better. Actually, most of these rugs are imported to America as Mushkabads, and they are graded Sultanabads, Mahals, and Mushkabads by the retailers. A few are brought in under the name of Araks, but they are a better quality. The new rugs in their natural colors are very bright, and in spite of their coarseness, will give good service—if good wool is used. The danger today lies in the fact that poor skin wool may be used in some of them. There are hundreds of homes in Central New York that have used old Mahals and Sultanabads for the past 40 years, and while thin or worn out today, they have given wonderful service. Many of the old ones were often sold as Feraghans as they came with a blue field with an all over herati design. A fine Mahal is identical to a coarse Feraghan. Some of the old Mahals were excellent; the new ones in most cases are going to give good service, but there is some gamble in buying one that is too coarse, and especially if it has been lightly washed either in New York or Persia. Perhaps the danger is only if the rug has dead skin wool and is also lime washed. Up to World War II, most of the new ones that came to America were both chemically washed and painted. There is no danger of a Mahal being painted today, as the cost is too great.

Fig. 3 of a Sultanabad in Part I, a is typical Mahal design. Also Plates 73, 80, and 85 (each of a Sultanabad or Mahal).

# MAKRI RUGS
## (Also known as Rhodian Rugs)
## (Turkish Family)

**Availability:** Makri rugs are available only from collectors' estates, as these were rare a collectors' item fifty years ago. Always in sizes about 6×4 ft. or smaller. Walter Hawley in his 1913 book said: "Of the many beautiful rugs formerly woven in Rhodes, only a few now remain, and these are in the hands of collectors." He lists his plate rug as a Rhodian rug. We have owned only three good ones in the past 15 years. The one shown in Plate 140 is a wonderful specimen and in perfect condition. Plate 141 is the smallest Makri we have seen. It is a prayer design in perfect condition and a rare specimen.

**Where made:** Probably on the Island of Rhodes, or in seacoast towns south of Smyrna.

**Characteristics:** Whether we call them Makri rugs or Rhodian rugs, they have a definite characteristic and design that make them readily identified once you have seen one. In colors they more nearly approach the combinations in Meles. They are rather loosely woven, with a long, silky nap. Plates 140 and 141 are typical in design and color. It is the same general design shown in Hawley's book, plate 31 and the same as plate 67 in Lewis' book (this last rug has only two panels). Our Plate 141 shows the field divided into three panels which terminate at one end into three definite prayer arches and, at the other end, what would appear to be prayer arches, but more flat at the apex. Some writers have suggested this as representing a Cathedral window. Yes, this rug does give that appearance, but certainly no Mohammadan depicted a Cathedral in a rug. The rugs are very colorful but they have a warm, quiet, rich, exquisite colorfulness like most of the ancient Turkish rugs. The center panel in Plate 141 is in red with the fringed sexagons and half sexagons in ivory, gold, and blue. The two outer panels are in blue. The left panel has the four elaborate sexagons with fine fringe design outlining these in an exquisite gold (perhaps apricot or a golden buff is more correct). The stars and designs which each of these inclose, are in red and ivory. The angular, floral designs in the right panel are in the same gold, ivory, and red.

The sections (or small spandrels) above the prayer niches are gold over the two blue panels, and blue over the gold panel in the center. The main border is ivory, with the design in gold, red, and blue. The outer border is in the same exquisite gold. Even though Melez and Makri have some features in common, the two are different and one cannot mistake one for the other.

# MALAYER RUGS
## (Persian Family)

The district and town of Malayer is about half way between the city of Hamadan and the city of Arak (Sultanabad). The northern part of the district makes rugs very much like, and indistinguishable from, Hamadans. The southern

section makes rugs very much like Sarouks. That's why you hear the name "Malayer Sarouk" or "Josan Sarouk." The very best of all Sarouk types made today are the small Josan Sarouks. The town of Josan is in the Malayer district. (See Josan Sarouk. See Plate 55 and in Part I, Fig. 8, Persian Rugs.)

# MECCA RUGS or MECCA SHIRAZ RUGS
## *(Persian or Iranian Family)*

SEE SHIRAZ and Qashqai rugs, Plates 102 and 104. These are also incorrectly called Kashkai. Both types are available in many sizes, from $20 \times 20$ inches to $8 \times 11$ ft. Very few are larger than $7 \times 10$ ft. Qashqai is the correct name and spelling. There are no rugs that are correctly called Mecca rugs, but I see no objection to this name since it has been used for many years. A type of Shiraz made by the Qashqai tribes (and there are several branches of these) is called Mecca Shiraz. This started over one hundred years ago when hundreds of thousands of Mohammedans made their pilgrimages to their Holy City of Jiddah—also called Mecca. These people carried their most precious possessions there, including additional rugs for sale. Since many of these rugs back in 1875 to 1915 were some type of Shiraz, the Qashqai dealers often created quite a racket in selling rugs at high prices as coming from the Shrine at "Mecca." It was done in Cairo, in Istanbul, in London; and the dealers in America received some fancy prices for Qashqai Shiraz rugs. Mumford in his first edition of 1900 exposes this fraud. Hawley's 1913 edition also covers it.

**Characteristics:** (See Qashqai, Plates 102 and 104 and Shiraz, Plate 103.) This is the very best type being marketed in Shiraz today. It is an excellent rug, tightly woven with medium thickness, excellent wool, and has a woolen warp. The new ones have the light Persian wash. A limited number of semi-antiques of this type appear in the market. Prices are slightly less than a good quality Sarouk. Plate 104 is a typical design found in many Qashqai (Mecca Shiraz) but no two designs are exactly alike. Color Plate 102 is of a very rare antique Prayer Mecca Shiraz (Qashqai tribes), and is the choicest rug of the type I have ever seen. It is exactly the same design as the color plate in Mumford's rug book, 1900 edition. Only two small designs (five inch areas) are in ivory instead of blue. The rug in my plate is as perfect as a new one. I have never in the past forty years seen one close to Mumford's plate until I acquired this from an old collection. It seems a very reasonable and very definite conclusion that these two rugs were made by the same weaver, somewhere between 1850 and 1890. Many of these, along with all Niris rugs, were for many years called Laristans by the English dealers. The Niris are somewhat similar in texture and yet different. (See Niris.)

Color Plate 102 being practically exact in design and colors in every detail, I quote extracts from Mumford's description of his Plate XVII, as he wrote in 1900: "Antique Shiraz Prayer Rug. . . . The design is what is known as the arch design in prayer rugs. . . . The idea is that of a jardiniere from which springs a profusion of flowers. . . . The accuracy of this border—and in fact of the entire carpet—is almost phenomenal. . . . There is apparent in this rug the thing that makes the Ardebil carpet so remarkable—the precise balance of design."

*257*

All of the looms of the Fars Tribes are horizontal flat looms. One wonders how they produce rugs as large as they do. The weave is from medium to very tight, but the rugs do not have quite as heavy a nap as Sarouks. The weave somewhat resembles a good average Tabriz in texture. The wool quality is better than most Sarouks and Tabriz. Plate 120 is typical, but the Qashqai make extensive use of the pear design in many shapes. Others are more geometric in design than Plate 104. One may have the main designs (the entire field) outlined by two large fringed octagons, which enclose other floriated geometrics—sexagons with latchhooks. Another may have three, twelve-sided (indented octagons) geometrics outlined by ivory latchhooks, and enclose angular flowers in these, and is also surrounded by angular flowers. There are scores of border designs: eight-pointed stars in ivory, serrated leaf and cup design on an ivory field, and numerous others. The Mecca or Qashqai are much more tightly woven than other Shiraz rugs, and have a thicker pile.

# MEHREVAN RUGS and MEHREBAN RUGS

## (Persian Family)

There are two distinct rugs and types of rugs by this name. The *first type* is, in fact, a Herez. Most people spell this town MEHREVAN, and the town north of the district of Hamadan is spelled MEHREBAN. I have been trying to follow *National Geographic* spelling. On two different *National Geographic* maps, the town in the Herez District is spelled differently. Mehrevan, and then Mehraban. It isn't too important how we spell it as long as we keep in mind the fact that there are two towns and that two different and distinct types are made.

**Availability:** (First Type). *Mehrevan in the Herez District.* In large numbers in sizes $7 \times 5$, $6 \times 9$, $8 \times 10$, $9 \times 12$, $10 \times 14$, $9 \times 15$, $9 \times 18$, $10 \times 20$, and many in-between sizes up to $11 \times 23$ ft.

**Where made:** In the town of Mehrevan (or Mehreban) in the Herez District. (See Herez map.) Mehrevan is second only to the town of Herez, which has 800 looms, while Mehrevan has 600.

**Characteristics:** (See Plates 21, 27, and Fig. 4, Persian Rugs, Part I.) Mehrevans are one of the best qualities of new rugs marketed as Herez. We in the trade call them Mehrevans or contract quality Herez. Some few, made in the town of Herez, are better, but Mehrevan also produces many top quality Herez. All are thick, rather tightly woven rugs, and always in geometric medallion types as shown in the plates, with the field in some shade of red. The Mehrevans seldom come in a yellow-red, or rust, but in rosy red, or deeper blue-reds.

By contract quality we mean certain sizes are contracted for in a specified quality. It is only with the advent of the contract quality Herez (Mehrevan) that such sizes as $9 \times 15$, $10 \times 18$, $9.8 \times 17$, $11 \times 20$ ft. and other such long narrow sizes became available. Prior to World War II, all Herez types which were 15 to 20 ft. in length would be 12 to 15 ft. in width. Try as different New York importers did, they had not been able to get these weavers (the factory owners) to make rugs in these long, narrower sizes. The quality of these rugs has been excellent.

**Caution:** This is a rug that will, as a rule, last a lifetime, unless dead wool (butcher-

ed sheep wool) is used, and unless Swiss dyes are used. It is exceptional to find either of these bad elements in this type of Herez, but some few weavers are doing just that, with the result that the rugs which would probably have gone 30 years before getting thin, wears thin in a few years. The bad dyes—loose blue and loose red—is easily detected. A reliable dealer can eliminate the rugs with wool having a dry, dead feel. The main "safety valve" is to buy from a reliable store—and that does not necessarily mean a big store.

## MEHREBAN IN THE HAMADAN DISTRICT

**Availability:** In large numbers in mats to large scatter sizes and runners. A few as large as $6\frac{1}{2} \times 10$ ft. and a limited number in somewhat larger sizes but very few of these larger sizes come to America.

**Where made:** In the district by this name which begins just north of the market city of Hamadan and extends some 40 miles to the Northwest, and which includes some 40 villages.

**Characteristics:** These are among the best rugs being marketed in Hamadan. They adhere to their old designs, and there are scores of these used by the many villagers. They use only old vegetable dyes and have not yet resorted to the jufti knots. They use their own wool from their own sheep and produce a very honest rug. The principal colors used are indigo, red, madder, and blue. (See Plates 23, 59, 60, 89, and 90.)

## MELEZ RUGS

*(Also spelled Meles)*

*(Turkish Family)*

**Availability:** Only from estates of private collectors as these were a rare collector's item fifty years ago. No good ones have been made since 1900. The few very poor ones made after World War I were not comparable with earlier Melez and have worn out. A few of the old masterpieces have been preserved and not walked on, while others appear that have been misused, and they are quite worn. These are both in the prayer and non-prayer design. Sizes are always $4\frac{1}{2} \times 3\frac{1}{2}$ to $6 \times 4$ ft. with a few old pillows in $2 \times 3$ ft. size.

**Where made:** In towns some seventy five miles south of Smyrna, Turkey, and twenty miles inland from the Mediterranean. Their market place was a town of Melassa or Melez.

**Characteristics:** Plates 134, 135, and 136 showing Melez Prayer designs, are the most typical design of Melez. Color Plate 136 is not as typical in design as the prayer rugs in Plates 134 and 135, but Prof. Marchant's Melez Plate 136 is one of the choicest Melez in existence. I have known this rug and the great collector to whom it previously belonged since 1920. Plate 133 is typical of the non-prayer Melez. It is typical in colors and design and a very wonderful and rare example. The Melez rugs adhere to type and color combinations probably more closely than any other rug, yet offer a great variety of designs and appear usually in the

prayer design. Today, a good Prayer Melez ranks close to Ladik and Ghiordes in rarity. One of the most marked characteristics of the Melez rugs is the peculiar arrangement of the mihrab, which is best described by Walter A. Hawley: "In typical examples the lines defining the mihrab descend from the niche to meet the sides of the narrow field at an angle of forty-five degrees, and are then deflected towards its center, to return again to its sides." Such is the typical Melez mihrab. Around the inside of the mihrab, and extending down the sides of the field and at the base, appear bud-like forms with stems attached to the sides, base, and mihrab. Above the mihrab, the spandrel is generally in ivory, and may be covered with flower-like forms arranged in orderly, perpendicular rows, or the typical Melez design will appear attached to ends of a lattice work figure. (See Plates 134 and 135.) The main borders of Melez vary considerably. A design of eight-pointed stars, alternating with floral forms which are generally quartered, is one type commonly seen; or frequently large floral forms or palmettes appear connected by floral sprays. A favorite ground color for borders is a buff to golden canary, but deeper shades are used, according to the general color effect. Where a deep velvety red is used in the field, the border color is generally darker, resulting in a more harmonious effect. One secondary border used in Melez is almost as typical as the mihrab arrangement. The ground color of this border is almost always ivory upon which appear small, probably floral designs of alternating colors. These designs have the appearance of being quartered or four pointed. A web of varying width, generally of red, appears at the ends. The non-prayer type of Melez shown in Plate 133, portrays this rug in its characteristic state. You will also note here the typical secondary outside border I have described above.

A choice Melez is invariably found among the great collections and it should be, because a more pleasing and interesting weave is not to be had. Few in the great collections are in such perfect condition as are those shown in the plates in this book.

## MESHED RUGS

### (Persian and Iranian Family)

**Availability:** These I regret to say, are once again beginning to appear in good numbers in the New York market in new rugs, 9 × 12, 10 × 14 ft., and a few in larger sizes. The European market takes about 25 percent of the output while the Persians themselves buy most of them because they are so very cheap. New York importers need many cheap, promotional rugs, but the importers find difficulty in getting rid of these poor grade rugs. Quality of different parcels vary, but on the whole they have been so cheapened in quality that they should not be sold by any reliable store. Hardly a dealer speaks well of these. Nevertheless, one of my very favorite stores in New York City let their young, inexperienced buyer go to Iran and buy the low grade Mesheds. Worst of all, he advertised them as Ispahans. Any good rugs coming from this section of Iran will be sold as Turkibaffs, Ispahans, or Ispahan Mesheds. Read details under each of the above rugs. Too many dealers are inclined to call all of these rugs Ispahans. An Ispahan is a very fine, thin nap rug.

**Where made:** In the Khurasan district, which occupies the central eastern and northeastern section of Iran. The Kirman district is to the south. Khurasan is one of the five largest rug weaving districts in Iran. Meshed is the capital and one of the great shrine cities of the Moslems. Meshed rugs are not woven in the city of Meshed, but out in the many towns over a large area of some $200 \times 150$ miles. The City rug (those made in the town of Meshed) are the Turkibaffs, a much superior rug to those marketed as Khurasans or Mesheds. Perhaps the poorest of these being made today are woven in the city of Birjand.

**Characteristics:** Meshed rugs have a very coarse to good average weave with a medium-thick pile. Some of these of the period between 1924 and 1940 were well woven and very good rugs. Those woven since World War II, marketed as Meshed or Birjands, have been cheapened in quality and colors, and many of these are very sleazy rugs. The principal color used today is the cochineal red (almost a magenta red). To be sure, there is considerable blue in the medallions, corners and borders, as well as lesser amounts of pink, green, browns, ivory, and canary. The designs most used are shown in Plates 72, 54, and 81. Remember, in design these are very much like the better qualities of Turkibaff or Ispahan Meshed from the same district. Good numbers of these rugs, in fact, rugs of all qualities came from this district up until World War II. Until recently, mere trickles of these came to New York and the reason was the low quality. I have seen a few groups of these with an all over floral design combined with Shah Abbas and Arabesque designs in a horrible shade of cochineal red (and yet some of these shades can be lovely and perfect with certain decorations) with all the other colors in the rug very garrish. There are three principal causes for the low quality of the Meshed rugs. The first is that these weavers have always tied their Sena knot (Persian knot) on four warp threads. We call it the Jufti, or dishonest knot, when used in other Persian rugs. But the weavers in the Khurasan villages have always tied their knots on four warp threads, and it is an honest knot for them. Also, they made the weave coarse and used a poor grade of wool that is further damaged by steeping the wool in lime water for 48 hours. The weavers in the City of Meshed (making Turkibaffs—so-called Ispahans) use the Turkish knot, an honest knot tied on two warp threads.

**Caution:** The names Meshed and Khurasan as applied to rugs today, mean one and the same thing. (See Plates 54, 72, and 81.) Until 1940, we called the thin type rugs from the district Khorasan, and the thicker type of these coarser rugs were called Meshed. That is a good rule for the layman to follow.

# MING RUGS

## (Chinese Family)

**Availability:** Rarely, and then only from an art collection.

**Where made:** This information refers to the oldest Chinese rug known to have been woven in China during the first half of the 17th century. I do not claim to be an expert on old Chinese rugs, and my writings are based mostly on experience, personal knowledge, and established facts. I have found very few so-called experts who actually knew much about period Chinese rugs, though I have found some

few glib-tongued dealers willing to name any old Chinese rug as a Ming Chinese.
**Characteristics:** Many of these used silk for the nap. Silk or cotton was used for
the warp. These were rather loosely woven and thin type rugs. According to most
of the early writers, the essential feature is a central medallion, either round or
octagon, with the field either plain or covered with a pattern: often the tiger skin
pattern. Other Ming examples have all over designs often octagonal in shape,
and within these might be other motifs such as small flowers or small geometrics.

The borders of most of these rugs used a stupe, with a design of frets. Fig. 38
in Part I is an old Chinese, but not old enough to be from the Ming period.
However, it has designs that you might find in an old Ming. Plate 193 is of very
old Chinese rugs that are probably as early as the Ming period. Plate 192 is of
a rug that was probably made in the 18th or 19th century.

# MIR-SARABEND RUGS

## (Persian Family)

**Availability:** This name is applied to the choicest of the real old Sarabends,
available only from private collectors or collectors' estates. None have been made
in the past 40 years, and none imported in 35 years. All so-called Mirs were made
before 1910. For full information see Sarabend.
**Where made:** These are supposed to have been made in the town of Mirabad,
a town in the Sarawan (Sarabend) district which is 30 miles southwest of Arak
(Sultanabad).
**Characteristics:** Color Plate 68 is typical in colors and design of old, rare Mirs.
The Mirs are more closely woven, have a shorter nap, and are in most every
detail superior to the later day Sarabends. This is said without disparaging the
good examples of later day Sarabends. (See Sarabends for full details.) Plate 106
and Color Plate 68 show typical Mirs. Plate 105 shows a Mir with an adaption of
the Feraghan design. This is the exception, as the pear design is the typical Sara-
bend design. (See Fig. 10, Part I.)

# MORI RUGS

## (West Pakistan Family)

**Availability:** Mori rugs are a new creation which appeared about 1955. They
are available in large numbers in the Free Port of London Warehouse (Port of
London Authority, Culver St. Warehouse). The vast majority are in approximately
6×4 ft. sizes but good numbers are in sizes 5×8 ft. to 7×10 ft. and a limited
number about 9×12 ft. A year ago I saw three of these in the 10×13 ft. size but
the largest size available on my last trip was 9×12 ft. These are the nearest rugs
in color and quality to the famous old Tekke rugs (Royal Bokharas).
**Where made:** In West Pakistan.
**Characteristics:** (See Plate 88.) A Mori rug is a very finely woven new rug which
is invariably in the same general design and colors as the Tekke Bokharas (better

known as Royal Bokharas). The field of most of these is in some shade of wine red, burgundy, rosy wine, or in ivory, or light tan. One-third of these came in the light background with three or more rows of small octagons. Each octagon is quartered and in ivory, blue, or green, and usually burnt almond or Turkoman rose. Rugs are very finely woven with some 250 to 400 knots to the square inch. This is an entirely new creation which first appeared in the European market, and which had not been imported to America until 1960, when I imported the first of these. The nap is entirely different from anything we have known since 1930, when the Kashans were made with Merino wool. These Mori rugs have a nap of fine Cashmere wool which gives the rug a pan-velvet effect. They are as fine as the finest old Tekkes (Royal Bokharas). They are new and refined and should be well received by buyers who like fine Bokhara rugs. The beginner as well as many dealers are going to be confused when these appear in America in numbers as they will. The Bokhara from Persia is in the same general Tekke design, and so are some of the Yomuds and Afghans from Afghanistan. The Moris are much finer, employ smaller octagons, and have softer colors. The Cashmere wool should make their identification fairly easy. The Mori and the best (finest) Yomud in Tekke design from Afghanistan are approximately the same in price—perhaps the Mori is slightly more expensive. These are very fine rugs with over 300 knots to the square inch, and still cost less than one of the better modern Kirmans.

## MOSUL RUGS

### (New Ones—Iranian Family—old ones both Turkish or Persian)

**Availability:** In limited numbers in new coarse rugs in the American market invariably in sizes about $6\frac{1}{2} \times 3\frac{1}{2}$ ft. Up to 1930, these came in this same size in many coarse Kurdistan (nomad tribal) rugs from both Turkey and Persia. The new ones are the poorest of all types marketed in Hamadan, and as a rule, the poorest of all types imported to America. Fortunately, not too many of these are being imported.

**Where made:** They are made in the western section of Iran; adjacent to Turkey and marketed in the city of Hamadan. Mosul is a trade name and not the place where the rugs are, or were ever made. Every one in the trade knows these simple facts, but some of the old books gave incorrect information on this name. H. G. Dwight, in his *Persian Miniatures,* chapter on rug books, has this to say in criticizing one author of an Oriental Rug book (published in 1917): "The sole connection that a Mosul rug has with Mosul is that a certain class of small Kurdish rugs were once collected in the city of Mosul by Jewish dealers, on behalf of their principals in Bagdad. Since 1900 this trade has passed to the other side of the mountains, and Hamadan is now the market for Mosuls." Most Mosuls are made in the Zenjian District north of Hamadan.

**Characteristics:** To continue the quote of Mr. Dwight: "They are a small, loosely woven, high-piled rug of the poorer qualities, partly from Turkish, oftener from Persian Kurdistan, and from the region around Hamadan, extending even as far south as Malayir." That was the situation on Mosul rugs 45 years ago. In the period 1921–1932, many thousands of these were brought to the New York

market—a few from Turkey. Quality did vary and some were rather good. The great majority of these were both chemically washed and painted, and you may be sure that they have been discarded, or at best, are worn thread-bare today. Those coming to the New York market are coarser than ever, and are usually Persian washed. A good way to describe these is to say that they are the very poorest of all Hamadan rugs. Fortunately, there are not very many of them being imported. The Middle East countries are taking most of these, and Europe is also taking a sizeable number.

Too much space has been devoted to such an unimportant rug. They have bright red fields and come in innumerable designs. Some few of the new ones even use a floral spray on the order of the design in a Sarouk, but most of them have small, angular medallions and corners. I have not wasted a plate on one of these.

# MUDJAR RUGS

## (Turkish Family)

**Availability:** Mudjar rugs are available only from estates or private collections. Practically all are in prayer design, and in sizes approximately 6 × 4 ft. No good Mudjars have been made since 1915. Those made after World War I were very poor indeed, and had little value.

**Where made:** They were made in the city of Mudjar in Central Turkey (Turkey in Asia).

**Characteristics:** Mudjars have a definite prayer arch design as shown in Part I, Chapter on Turkish Rugs. As this design shows, many of these have panels above the spandrel with van dykes designs which are borrowed from the Ladiks prayer rugs. Some have an angular tree of life design on the field as in Plate 146. Plate 146 is of one of the choicest and rarest of Prayer Mudjars in existence. I have known the history of this rug when it was first sold to Mr. W. D. Ellwanger of Rochester, N. Y., a collector and author of a small rug book. My father-in-law acquired it, and it was twice my property. I have just re-acquired it from a collector who sold me his entire collection which he had assembled over the past 40 years. Most Mudjars have a red field and a gold or yellow main border. They are well woven, but not finely woven. But, like all rare Turkish rugs, they are more valuable than most fine Persian rugs. Most choice Mudjars are not as valuable as Ghiordes, Kulas, or Ladiks, but they are indeed a delight to the collector and student of this exquisite art.

# MUSKABAD RUGS

## (Persian or Iranian Family)

**Availability:** Muskabad rugs are available in large sizes, 9 × 12 ft. and larger in new carpets, and in limited numbers of old rugs in good condition to slightly thin rugs. Most of these will be offered as Mahals. I call the best of the old ones

Sultanabad. See Mahal Rugs and Sultanabad Rugs, as the subject is fully covered there.

**Where made:** These rugs are made in towns and villages in the Arak (Sultanabad) area. Only Sarouks are made in the city of Sultanabad (also called Arak), while the many villages weave the other three types, and each of these types in different qualities. Muskabads are woven principally in Mushkabad, and in the Feraghan plains in the villages in Japalak and Mahallat, all of which are within forty miles of the city of Arak.

**Characteristics:** The designs are the same general designs as those used in Mahals, Araks, and Sultanabads. Muskabads are the poorest of the four, but only slightly coarser than the Mahals. All the new ones have a red field, and most of them have an all over design. See Fig. 3 in Part I, and Plates 73, 80, 85, and 86, each showing a Sultanabad or Mahal. Even most of the new ones come in antique designs. The prewar rugs, in spite of their coarse weave, generally wear a lifetime, but many of the new ones are, indeed, very poor in quality. One of the poorest with a light wash is bound to wear thin shortly. Many of the old rugs from Muskabad were sold as Feraghans. As Hawley said in his 1913 book: "but on account of their excellent quality of material and stoutness of weave they are very serviceable." Again, many of these were sold as Mahals, or Sultanabads, and some of the better rugs even as Feraghans. As coarse as the new ones are, if they still used good wool, they would be good floor covering. Some of them have good wool, but many also used dead or skin wool.

## NAIN RUGS

### *(Persian Family)*

**Availability:** Nain rugs are available in limited numbers in new rugs in sizes $6\frac{1}{2} \times 4\frac{1}{2}$ ft. to $7 \times 5$ ft. and $7 \times 10$ ft. to $7\frac{1}{2} \times 11$ ft. I have seen just a dozen in larger sizes, $10 \times 14$ ft. to $10\frac{1}{2} \times 16$ ft. Since these rugs were seldom woven before World War II, there is seldom a semi-antique but I have seen a few.

**Where made:** They are made in the town of Nain, which has a population of some 6000, and lies in Central Iran about halfway between Teheran and Kirman, about 60 miles east of Ispahan. It is an ancient town, which has not changed in a hundred years. Nain had for generations produced a fine quality of handmade woolen cloth, which was used by Persians to make their fine cloaks. But when Persians began to wear European clothes, the cloth industry was hard hit. So the people in Nain turned to carpet weaving just before World War II.

**Characteristics:** Without doubt Nain rugs are, as a class, the very finest woven rugs and carpets which have been made in Iran since the war. I can go even further and say that they are, as a class, the finest that have been woven in Persia during the past thirty-five years. They are also finer woven than 99.9 per cent of all antique rugs. People often ask me which is the very best rug made. That question cannot be answered, as it would depend on so many viewpoints and so many factors. What would be the best and choicest for one would not be for another. *But I can definitely say which is the finest.* It is the Nain. Even among the ancient rugs, there were few rugs as finely woven as the new Nain. I will list a

*265*

few, and I refer to a very few finest of each of these types, namely, Sennas, Kashans, Zeli-Sultan, and Ispahan. Of course, a few of the old silk Polonaise are as fine, or finer, and occasionally one of the old Tekke (Royal Bokhara) or Salor (Bokharas) were as finely woven. *When one says that Nain is more finely woven than the average of these types, he is really making a tremendous statement as to fineness of weave.* The wool quality is also the best. All Nains are finely woven, but some are much finer than others. *Yes, Nain is finer than the new Ispahans,* and when I use the word Ispahan, I mean the real, very fine Ispahan rug with a very short nap, and not the Meshed rugs that are offered by most dealers as Ispahans. These latter rugs are about one-fourth as finely woven and much heavier; as a class, a much less expensive rug. You will find no information whatsoever in Oriental Rug books about Nain rugs. I believe that this is the first article ever written in America on Nain rugs, and to be completely safe I will correct that statement, and say that only in books written since 1940 can there be any information on Nain rugs, because none were woven until just before the last war. The wool fibre in Nain was finer than most Persian wools, and the wool was spun into finer and more even yarn, which resulted in a rug with some 300 knots or more to the square inch, even as high as 500 knots to the inch. The carpet sizes will, as a rule, vary from 250 to 400 knots to the square inch, while the small rugs often have 400 to 500 knots to the square inch. The nap on this and on all very fine rugs is clipped short. There was a total of about 150 to 200 looms in Nain in the period 1946–1949. At most, there were only about 200 Nain rugs, in all sizes combined, being made each year. But regardless of the above, only a mere handful of these came to America. My guess is that 25 a year, at the most, reached America; and this number is perhaps twice too high. That they are made for the Persian, Middle East, and European markets is shown by the sizes in which they are made, which are, as a general rule, about as follows:

6.6×4.6 ft. to 7×5 ft. Most of the larger sizes are in the sizes 7×10 ft. to 7.6× 11 ft. The demand in America would be for 6×9, 8×10, and 9×12 ft. sizes. 8×11 ft. 8.8×12.8 ft. 8.9×13 ft. Only a very few come in these sizes.

Perhaps another reason why these do not come to America is that by reason of being so very finely woven, they naturally have a very short nap. And, even this nap is of the finest wool. The thinness does not lend itself to the regular chemical treatment that such rugs would generally receive in New York. The very fine, new rug is stiff and harsh to the touch. I found some that had only the lightest Persian wash, and they had soft tones and were beautiful. I bought a few that had been used in homes for a few years. The London washed Nains have the loveliest colors.

**Designs and colors:** The designs follow the famous old Ispahans, with a general use of the famous Shah Abbas design and finely drawn flowers, foliage, and vines. Plate 91 has a soft rose field with the Shah Abbas, tulip, and rosette motifs, combined with a finely drawn floral design. The border is on a cream field, with a classical old design which also features the Shah Abbas. Most of these in this general design come with the field in ivory. Plate 92 is perhaps the most typical design used in the Nains. The field is a light tan or cream, and features the Shah Abbas motif and a finely drawn floral design. Others in this design have a rose field background. The center is undoubtedly taken from the old Ardabil carpet. The Nain border is more often red than blue; in fact, blue is a minor color. There

is much buff or canary in the secondary borders. The design shown in the main part of the field in Plate 92 is frequently used over the entire ivory field. These rugs, when new, are harsh to the touch and a little bright in color. They are much more desirable when Persian washed or lightly washed in London. No one has attempted washing these in New York. Don't confuse this with water washing or cleaning. Anyone can clean one of these.

The average good new Nain rug will have about $22 \times 22$ knots to the square inch, which is indeed a very fine rug—in fact the finest as a type being woven today in Iran

# NAMAZLIK

NAMAZLIK is a term used to denote a Prayer rug. It was used by early authors, but is seldom heard today.

# NIRIS RUGS

## *(Persian Family)*

**Availability:** Only from estates and, as very few ever came to America, they seldom appear. These rugs were incorrectly called Laristans by British dealers who bought most of them. There have been no new rugs by this name in 30 years.

**Where made:** They were made in the town of Niris and an area in the vicinity of Lake Niris, some 50 miles east of the City of Shiraz.

**Characteristics:** Although showing a similarity to Shiraz rugs, Niris fabrics are totally different in weave and generally in color combinations. This name is unknown to a great many because of improper classification. The majority I have owned have had an ivory or cream field with a floriated pear design. The principal color of the pears was green. Ninety percent of all Niris rugs which have appeared in America were sold as Shiraz, and it seems incredible that such a distinct and pleasing example should have been robbed of its identity. The favorite and most frequently used design of Niris weavers is the large floriated pear. This we usually find in orderly arrangement throughout the entire field. Shiraz fabrics appear in a great variety of designs such as a small all over pear, connecting pole medallion or central medallion. The designs use birds and animals abundantly: a feature seldom found in Niris rugs. While Shiraz generally has one wide, main border, Niris weavers express their border arrangement differently by using numerous smaller borders, sometimes as many as seven. Upon these borders generally appears a connecting floral arrangement. The sides of Niris rugs are generally multi-colored (barber pole), which is also true in Shiraz rugs and there is usually a short web at the end. The texture of the web in the Niris is much finer than you find in Shiraz; also, where the Shiraz web is likely to show designs worked by hand, the Niris web usually appears in stripes of different colors. The most marked characteristic about Niris rugs is their weave. It resembles Bijar somewhat in its firm appearance on the back, and in the compact manner in which

*267*

the nap is packed down. It is not as thick as the Bijar. We invariably find a copper or burnt orange color in Niris rugs, and often a rather sharp green, both of which colors seldom appear in Shiraz rugs. All that I have have seen have been small size rugs from 3 to 4½ feet wide and from 4½ to 6½ feet long.

## NORDIK RUGS

### (Made in India)

This is a trade name for rugs that are made in India in Scandinavian design—simple straight lines with very few colors. (See Plate 181.) There are a number of designs; for example, design C is made in gold and white, also in green and white. Sizes vary from 3×5 up to and including 10×14 ft. size.

## OJAKLIK

### (or Odjalek, or Odjaklik)

This and various other names ending in "lik" was first introduced by John Kimberly Mumford. All were taken from the Turkish language. Odjalik is supposed to mean a hearth rug. But there were no hearths in Persian homes. At night a guest would be given a rug on which to sleep, and perhaps another for a quilt. So, most of our hearth rugs are nothing more or less than beds. Odjaklik is a name seldom used or heard today, even in the trade.

## OUSHAK RUGS

### (also spelled Ushak)

### (Turkish Family)

**Availability:** There are two different types by the name of Oushak. The first type, the rare old valuable Oushaks, are from 100 to 400 years old. These are rarely available, even from private collections. Sizes are usually 5×10 ft. to 8×17 ft. (See Plates 138 and 130.) The later day type was a very inferior, very coarse, very bright turkey red rug, with bold geometric design in green and blue. Occasionally one appeared with floral designs in bright blues and green. These wholesaled from $1 to $1.50 a square foot, or $108 to $160 for a 9×12 during the period 1923–1931. I have seen only a half dozen of these as used rugs in the past 15 years. No doubt most of these poor rugs have worn out. There are no tears.

**Where made:** In the ancient city of Oushak in Turkey, some 75 miles due south of Istanbul. The nearest rug weaving towns are Gordes and Kula. In the 16th and 17th century, Oushak was the famous carpet center in Turkey.

**Characteristics:** Some authorities believe that the ancient Oushaks were woven by imported Persian weavers. What made these so sought after for period furnish-

ings like Williamsburg, is the definite knowledge as to the age of many of these. Old Dutch paintings of the 15th to 17th century often showed a rug in the picture, and many of these were Oushaks. Plate 138 in the Metropolitan Museum and Plate 139 in the Victoria and Albert Museum, are the famous types. They were quite finely woven like a Persian, and had a short pile. These later day rugs were worth 1/50 or less of a choice old 16th century Oushak, and were suitable mostly for office use, a club or den; that is if one liked very bright colors. The principal colors were red, green, and blue, and the blue was often indigo. There are two principal designs in the older rugs. The colors are mostly blue and red, with the field in red, and medallion and corners in Arabesque form. Much of the field is plain or open. Other designs may be large rectangles over the field. The later day Oushaks are much inferior, very coarse, and heavy. Some of these newer rugs had large leaves over the field. Others were in crude geometric design. These had, at most, three colors: red with olive green and blue.

# PAKISTANI RUGS

## (From Pakistan)

**Availability:** In good numbers in the London market (Free Port of London, Culver Street warehouse) in many sizes.
**Where made:** Paskistani is one of the two general types of handmade Oriental Rugs first woven in West Pakistan about 1957.
**Characteristics:** A rather finely woven rug in many Tabriz designs and in many sizes. Mainly in sizes approximately $4 \times 7$ ft. $5 \times 8$, and $7 \times 10$ ft. Other sizes will undoubtedly appear. (See Pakistan Rugs in Part I.) The Pakistani in the Persian Tabriz designs and the Mori in the Tekke or Royal Bokhara designs are the two types found in good numbers in the London market.

The nap of the Pakistani are wool. These rugs would be mistaken by even the dealer for Tabriz rugs. I looked at different groups of these with the idea of selecting a few, but in the end bought none of these. They are excellently made rugs at a moderate price; perhaps less than the Persian Tabriz. I rejected them because of their mechanical look (stiff angular design).

Without precise information on this, I still can surmise how this came about. The producers bought paper scale patterns from Tabriz weavers and a few from Yedz weavers. They would have done better to have gone to Sultanabad (Arak) where Sarouks are woven, to Hamadan where Kasvins are woven, to Kirman or even to Meshed where Turkibaffs (so-called Ispahans) are woven, and bought their designs instead of the Tabriz designs. Most Tabriz rugs from Persia are not good designs for Americans for the same reasons stated above—their stiff, mechanical, machine-like appearance.

Another design I saw in many Pakistani rugs was the design being used by Kirmans and Yezd for sale to Teheran. The field is a cerise or magentish-like rose with some open ground and with a medallion. The border and corners are somewhat like the modern so-called Aubusson borders of Kirmans. These have colors and designs that make them unsalable in America. None of the Pakistanis have come to the American market up to this time.

*269*

# PEKING RUGS

## *(Japanese Family)*

**Availability:** A Peking rug is a Chinese design rug, hand woven in Japan. It is a new type introduced after World War II and is very much like the old type Chinese rugs. This rug is made in large numbers for one large importing house in New York, in rug sizes 2×4 to 6×9 ft. and in room sizes from 8×10 ft. to 12×20 ft., and occasionally in slightly larger sizes.

**Characteristics:** Rugs are in antique Chinese designs, mostly in light beige, tan, green, and gold. The Peking rugs are predominantly known by their design numbers, as for instance, #500 has a light beige background with soft top colors. (See Color Plate 189 and Plate 188.) Similarly, design #600 has a tan background with soft green and champagne as top colors. Design #200 is in gold. Design #300 is in beige, and design #700 has a green field.

An excellent quality of wool is used. The warp and weft is cotton. Dyes are excellent chrome dyes, permitting a very light lime washing. It is a good medium pile rug, and quite durable. The softness of the colors used in these rugs make them go well with both modern as well as antique furnishings. The Peking is a medium priced rug, costing much less than the Sarouk and half that of a good Kirman. Colors in these rugs will permit their use any place a pastel Kirman can be used.

# PERGAMO RUGS

## *(Grecian or Turkish Family)*

No space should be given to this rug as it is a nondescript. Any person owning one will not be interested in its name. Right after World War II a good many of these were made by Armenian refugees in Greece (Piraeus and Salonika) in small sizes and runners. Some used Beloochistan color and designs, others Caucasian and Turkish, but most used the Persian design. Each had a domestic, machine-made look, and had little to offer in beauty. All were lightly chemically washed. None were painted. They wholesaled for $1.50 to $2 per square foot. Most of these have worn out in 30 years. One good thing stemming from the great depression was the elimination of these rugs.

# PETAG RUGS

## *(Persian Family)*

None have been made in 30 years. Occasionally a used Petag rug appears from an estate. "Petag" is an abbreviation for the name: Persian Carpet Company in Tabriz, Iran. Until about 1930, this company reproduced some of the old antique carpets from the classical period in the best tradition. Excellent, all-vegetable dyes were used with the exception of synthetic indigo. Most experts agree that some of the finest carpets of the past 75 years were woven by their weavers.

# PINDE RUGS

*(Also spelled Punjeh)*

*(Turkoman Family)*

**Availability:** There are none of this type rug available. It is the rarest of all Bokhara rugs. I have seen only two from collectors' estates since World War II. All were made in sizes about $6 \times 4\frac{1}{2}$ ft. In my nearly 40 years in business I have seen less than a dozen good Pinde Bokharas.

**Where made:** In the Punjdeh district of Central Asia: now Soviet Russia's "Turkmen."

**Characteristics:** (See Fig. 29 in Part I, Turkoman Rugs.) All Pinde rugs are very much like this design, and all are in sizes $5 \times 4$ to $7 \times 5$ ft. The color of the field varies in these from a deep rose to almost a wine or plumish wine cast. The design has minor quantities of brown, ivory, dark blue, green, rose, and brown. The field of all these prayer rugs, like Fig. 29, is divided by broad, horizontal and vertical bands, which form, in effect, a cross from which the name Katchli is derived. Most of these Pinde rugs have a panel with a series of small prayer arches as shown in Fig. 29. The small amount of white nap in a Pinde is usually cotton instead of wool. It is the only rug where cotton is used. The cotton will have worn down, leaving the embossed effect, just as the black in many old rugs. I do not know why Mr. Thatcher, in showing the same type prayer Pinde in his book, chooses to list it as "Saryq Namazlyq" (Namazlyq meaning prayer design) and makes no mention of Pinde or Punjeh. I have wondered where Mr. Thatcher got this spelling of Saryq and Namazlyq. Prayer Pinde sounds better to me. He must have received most of his information from Hartley Clark's book. Clark used the name "Saryk Turkomen from Punjeh District." His beautiful colored plate which is almost identical to my plate, lists it "Sarik Turkoman or Punjdeh Prayer Rug."

Again, either name is alright, but I continue to adhere to the name that the best informed and most famous collectors (1910–1935) used, and Pinde happens to be the name. Hartley Clark also lists the Tekkes and Salors as coming from the Punjdeh District.

# POLISH RUGS or POLONAISE CARPETS

*(Persian Family)*

**Availability:** Only in the museums of the world and a few private collections.

**Where made:** In Iran during the 16th century. Some writers have said that a few of these were woven in Poland by imported Persian weavers, but most authorities agree that they were made in Iran. A number of them were presented to European rulers and courts in the 16th and 17th century.

**Characteristics:** These rugs often were woven on silver and gold warp thread with silk nap, and with portions of the nap with gold and silk thread. These rugs used very light tones: green, rose, salmon, silver, and gold. They had an intricate

floral design tied into cloud banks and arabesque. You will not find these in many private collections in America. The art student will want to view these in the museums. It would require several volumes this size if we covered all such rugs in detail.

Polish or Polonaise rugs still exist in numbers. There are some 300 in the world in museums and private collections, but very few of these are in America. Most of them are in European courts, Stockholm, Copenhagen, Munich, and Moscow. All Polonaise rugs belong to the 17th century, particularly the first half. The name Polonaise dates from the Paris exposition in 1878, when several rugs of this type were exhibited by Prince Czartorski of Warsaw. Documents have lately come to light which show conclusively that these rugs were not made in Poland, but were definitely made in Persia.

# PRINCESS BOKHARA RUGS

## (Turkoman Family)

Princess Bokhara and Tekke Prayer are one and the same. (See Tekke Prayer rugs, Color Plate 180 and Fig. 26, Chapter Turkoman Rugs.) No rugs have ever been imported on a customs invoice as Princess Bokhara rugs, but the name is even better known than Tekke Prayer or Prayer Tekke.

Only one book gives a heading to Princess Bokhara, though all American books explain that this and Tekke Prayer are one and the same. Mr. Walter Hawley (1913 edition) lists it as being a separate rug. He says: "A large percentage of these pieces are Namazliks." He should have said that every one of these are Prayer rugs. Namazlik means a Prayer rug. I am not critical of Hawley's book, but am just pointing out facts. Today's modern transportation facilities (planes, railroads, ships) open up information that was not available to the writer of the 1900–1915 period.

# PUSHTI

Refers to size of a small mat, approximately $2 \times 3$ ft. The term is seldom used today. Years ago the trade (wholesale dealers) referred to these small mats as Pushtis, *i.e.,* Sarouk pushti, Kirman pushti, or Hamadan pushti.

# QASHQAI RUGS

## (Some spell it Ghasgai and Also Kashghai)

## (Persian and Iranian Family)

## (Sold in American market as Mecca Shiraz)

**Availability:** Available in good numbers in the European market in small sizes and up to $7 \times 10$ ft. sizes. A limited number occasionally appear at some New York importing house. The Teheran market takes most of these. A few semi-old

rugs are to be found among a group of new rugs. (See Plates 102 and 104.)
**Where made:** Made by Nomad Fars tribes, known as Qashqai who live in the
vicinity of Shiraz, northwest of Shiraz, where these rugs are marketed. The area
begins about 20 miles north of Shiraz extending 100 miles to the north and some
50 miles wide. These tribes are now settled in this area. Many are nomadic but
others are semi-sedentary and live in villages. These are some nine tribes with
a population of some 250,000 people.

**Characteristics:** (See Shiraz Rugs.) These are sold as Shiraz and have Shiraz
design. Actually, none of the Shiraz rugs are woven today in the City of Shiraz.
They are sold in the London market by the name of Kaskai, or Qashqai. They
remind me more of a Niris in weave, being more tightly woven than other types
of new or semi-old Shiraz. Niris is only a short distance east of Shiraz. They have
a short to medium length nap. The field is usually in blue or wine with lots of
ivory. Each rug combines some of these three colors with some green, rose,
gold, canary, plum, and brown. The outline of the field is angular and geometric
in many, and the rug usually has a centerpiece or a hearth design effect. The
entire field is covered with small octagon and star designs, small angular birds,
and occasionally small human forms. Most of them will have the light Persian
wash. Formerly all of these came with woolen warp. Some few are beginning to
appear with cotton warp threads. These last come from villages in the area. Wool
and dyes are excellent. Prices are slightly less than that of good Sarouk. Weave
varies greatly from 120 to 250 knots to the square inch. A few older rugs are
more finely woven. (See Mecca Shiraz Rugs.)

# QUM RUGS

## *(Also spelled Qom, Gum, Goum, Ghum)*

Two different *National Geographic* maps spelled it first "Qum" and later, "Qom."
One is as correct as the other. It would be a long story if we went into the reason
for the different spellings.

**Availability:** In new rugs these are among the finest produced in Iran since
World War II. Very few of these reach America but they are available in sizeable
numbers both in the Teheran market and the London market.

No old Qums are available anywhere. Some few which have had a few years
use are occasionally met with in the London market.

**Where made:** Qums are made in the sizeable town of Qum, which is some 90
miles South of Ispahan. There are approximately 1000 looms in the city with two
looms in each of the rug weaving homes.

**Characteristics:** This is one of the finest and choicest rugs being woven in all
Persia today. When rug weaving began in Qum some 20 years ago, their design-
ers preferred the all over designs and so we get the most beautiful of these in this
rug. Most of these designs are traditional and especially the design that one would
want to call Zeli Sultan. The all over small vase with floral spray design with
small intricate floral designs is typical of these. There are many variations of this
with the majority of these on an ivory field. They have adopted one design very
much like the Joshigan design. Others take the designs found in carpet designs

or garden designs of Bahktiaris and refine these designs, and still others use the older Laver Kirman designs on an ivory field. These are closest in quality to Kashans, but even a dealer will often have difficulty distinguishing a Qum from a Nain, Joshigan, Tabriz, Kashan, and even a Teheran.

If one has for years wondered where the famous old Zeli-Sultans came from, and now sees the many Qums in the typical old Zeli design, they might decide that finally they know where the old Zelis were made. But this conclusion is impossible when we remember that rugs were not woven in Qum until about 20 years ago. Most of these are made in sizes approximately $4\frac{1}{2} \times 7$ ft. and $7 \times 10$ ft. This latter size tells us that they are made for the European market.

So far Americans get very few of these, and the reason is the rather high price and the $7 \times 10$ ft. size instead of $6 \times 9$ ft., $8 \times 10$ ft., and $9 \times 12$ ft. sizes. Persians and Europeans will pay more for these fine rugs than the American trade will pay today.

Finally there are no more delightful rugs being woven in Persia today than the Qums. Each trip abroad, I buy only a few because of the size and the high price. Each time after I quickly sell the few, I wish that I had bought more of these.

## RAJASTAN RUGS

### (Made in India)

See Taj Mahal. This is a less expensive, all handmade plain rug. All details under Taj Mahal apply to Rajastans. There is a quality called Super Rajastan which is roughly between the Taj Mahal and the Rajastan qualities.

The name indicates a quality. Super-Rajastan is a slightly better quality. This quality is also made in the China design and Savonnerie designs.

## RANJI RUGS

### (Indian Family)

**Availability:** This is a new type of rug of contemporary design. The designs are taken from Sweden, Norway, and Denmark, and are available in sizes $2.9 \times 4.8$ ft., $3.9 \times 5.9$, $5.9 \times 8.9$, $8.9 \times 11.10$, $9.8 \times 13.9$, and $10.8 \times 16.9$ ft. There are some seventeen different designs and colors.
**Where made:** In India.
**Characteristics:** Many different color combinations and designs. Designs are in a combination of ivory/blue/green; ivory/gold/topaz; gold/brown/honey; ivory/turquoise/black; and a dozen other combinations.

# RHODIAN RUGS

*(Turkish Family)*

No rugs have been imported by this name in 40 years. These were imported and sold as Makri, the city or market place for these rugs. (See Plates 140 and 141.) Mr. Hawley is the only author (1913) who listed Rhodian rugs, and he adds: "The name *Makri* is frequently applied to these rugs."

# ROYAL BOKHARA

*(See Tekke Rugs; Tekke Bokhara Rugs)*

*(Turkoman Family)*

TEKKE is the authentic name, but Tekke rugs have been called Royal Bokharas for 100 years. The name Royal Bokhara has been attached to Tekke and will not be changed. Of course no rugs have ever been listed on custom invoices as Royal Bokhara, yet the name holds, and always will.

**Availability:** Old rugs are available only from estates, and most of these are worn. A choice one is very rare and beautiful. None have been imported from Russia's (Turkestan) in twenty-five years. Today the name is Turkmen. New Tekkes or new Bokharas being made in Iran (Persia) in Tekke designs are not called Royal Bokharas, but simply referred to as Bokharas. (See Plate 20.)

**Characteristics:** See Tekke Rugs (Tekke Bokhara Rugs). I have not shown an old Royal in color. Fig. 27, Part I gives a typical old design. Nearly everyone has seen and knows these, and so I have the new rugs in this design from Persia in Color Plate 20, and the new rug from Pakistan in the Tekke or Royal Bokhara design, Plate 88. The only book ever to list Royal Bokhara and Tekke Turkoman rugs as two different rugs was Walter Hawley's book (1913). He treats these as two different rugs, and goes on to make another bad error when he says of Royal Bokharas: "Both old and new are found only as sedjadehs." Sedjadehs means a hearth design about $4 \times 6$ ft., and every dealer knows that many were made in a size about $7 \times 10$ ft. and a few even larger (before 1913) and many more later. I blush to point out the error of this great author, Walter H. Hawley, whose book was the best ever written over a period of 50 years. Even Mr. Mumford, the first American author of an Oriental Rug book (without Mumford's book, Hawley's could not have been as good) made comment on the above mistakes by Hawley. (I inherited Mr. Mumford's many books, booklets, and lectures.)

# SALOR RUGS

*(or Salor Bokhara Rugs)*

*(Turkoman Family)*

**Availability:** This very fine rug, being the finest of all Bokharas, comes only from estates. None have been imported since 1935. These came when the Soviets

collected them in one of their five year plans in order to raise gold. These are available only in scatter sizes—$4 \times 2.6$ ft. to $7 \times 5$ ft. The $4 \times 2.6$ ft. sizes were originally tent bags. (See Plate 178.) Most are worn thin, but a few perfect examples appear each year.

**Where made:** Since this rug takes its name from the Salor tribes and not from the town or district where made, the latter is secondary in importance. The Salors were undoubtedly the most aristocratic of all the Turkoman tribes. Most of the fine old Salor rugs we get today were woven when these tribes inhabited the famous and fertile Merv Oasis. Later, the war-like Tekke tribes defeated the Salors and took over this area in 1856. The Merv area is just north of the Afghanistan border in Turkoman (formerly called Turkestan). After this event the Salors split up, some few remained in the Merv area—others went further south just across to the Punjdeh district (Pinde), while some went north with the Ersaris. Of course the name Bokhara was attached to the rug when it was first marketed in the city of Bokhara, to the north.

**Characteristics:** (See Plate 178, which is in soft wine and feels like a silk handkerchief.) I have always thought of the Salor as being the finest of all the Turkoman or Bokhara types. The nap is short and has a frosty feeling. A few have 400 to 500 knots to the inch, and seldom is there one with as few as 225 knots to the inch.

Most Salors are from old tent bags, referred to as Salor Jowal (or large tent bag) about $4 \times 2.6$ ft. The rugs are in sizes about $5 \times 3$ to $7 \times 4$ ft. I do not recall a single, real Salor as large as $8 \times 5$ ft.

The field is some shade of wine. They actually have a rosy wine color, and the color might even be said to have a shade of cerise, or rosy wine with a slight cerise cast. The field is covered with rows of small octagons (guls) which are different from those in the Tekke and other Turkomans. The unfailing characteristics are that the main octagons are not quartered, but the small ones within are, as are the smaller ones between the rows of the main octagons. Also, a main point of identification is the fringed perimeter which surrounds the main octagons. The borders are typical, geometric, Turkoman designs. At the lower end of the tent bag Salors is a border band, usually with a herringbone design formed into diamonds. The other rug sizes usually have a border on each end in diamond shapes. It is not unusual to find small sections in these octagons woven in a silk nap: a light color pink.

Plate 179 shows a rare old Salor in a rare long tent bag, which Messrs. Clark and Thatcher refer to as Salor Torba (a long narrow tent bag). One of the finest of Salors will count close to 500 knots to the square inch. However, 300 to the square inch is still a very fine Salor.

# SAMARKAND RUGS

*(Turkoman Family)*

*(now Soviet Russia)*

**Availability:** This is a name that should be of no interest to one seeking floor covering. None have been imported in 28 years and it is doubtful if any have

been made in 25 years. They are of interest only to the collector who wants to cover every type. I have never been able to work up much enthusiasm even for the better antique of this type, even when I classed myself as a hobbyist or collector.

**Where made:** In central Asia in the vicinity of the city by this name and marketed in the city of Samarkand.

**Characteristics:** The only new rugs by this name I have ever seen, in scores of trips abroad, was about 1935 when I bought a few very coarse new rugs by this name. The largest of these was 5×4 ft. They were about the poorest quality Oriental Rugs of any description. The antique Samarkand, with few exceptions, had little to recommend them. They were very coarse, flimsy rugs and the very few that I have seen in the better collections were also coarse. The unusual designs and the fine silky wool quality and color was the only thing that recommended the best of these. All show Chinese influence, and the field is usually covered with intricate Chinese motifs, usually in reds, blues, and yellows. Almost invariably there is a great amount of yellow in the border.

Designs in the field are round medallions or polygons. Other Chinese motifs such as dragons, Chinese cloud banks, flowers, and birds are used. Again all are loosely woven, third rate rugs. The one interesting point about Samarkands is that they are so different in color from other Oriental Rugs.

# SAMPLER RUGS

## (Persian Family)

A SAMPLER rug is almost invariably in the Bijar weave (See Plate 22.) This Sampler employs in one rug all the designs the family of the weaver uses. The herati is used in the upper field, and this is the design found in so many Bijars. Note that the borders used on all four sides of the upper section are different. The turtle and rosette shown in the top border is the one most used by Bijars. Only one other field design is shown. The irregularities in the corners of the serrated leaf and winecup design border in the lower section are interesting.

This is the method by which the Bijars have passed on their designs from one generation to another.

# SARABEND RUGS

## (Also see Mir-Sarabend Rugs)

## (Persian Family)

**Availability:** There are two types of Sarabend Rugs. First, the rare antique type of this rug is the Mir-Sarabend. (Color Plate 68, Plates 105, 106, and Fig. 10, Part I.) This type has not existed in Iran for 35 years. It was rare fifty years ago, and is available only from estates. Most of these will be worn thin. The example in Plate 68 is in excellent condition. Second, are the later day Sarabends of the

last forty years. (See Plate 108 which is typical of all of these.) Semi-old ones formerly came in numbers in 5×3.6 ft. and in the 6.6×4.6 ft. size. A few came in the 4×2.6 ft. size, and in larger sizes of 8×5 ft. to 7.6×10.6 ft.

For the past five years these semi-old Sarabends have not reached America. A few old and semi-old rugs of this type came from estates. In new rugs, a limited number of the above sizes come to America. They are in large numbers in the European market, and still many more are absorbed in the Teheran market.

**Where made:** In the Sarawan district, some twenty-five miles southwest of Arak (Sultanabad), which is a small district about thirty by thirty miles, comprising some two hundred farm villages. The first and rarest type, the Mir-Sarabend, was woven in the town of Mirabad. Today many villages weave different qualities but all in the same general design. There is no name or district shown on maps (not even *National Geographic* maps), but this mountainous section has for fifty years been called the Sarawan district. Today even Persians refer to it as the Sarabend district.

**Characteristics:** (See Plates 68, 105, 106, and Fig. 10, Part I.) In all types of Sarabend the small pear design has been the principal motif. Most dealers are inclined to call any and every Hamadan rug that has these small pears over the field a Sarabend.

In the older type the Mir-Sarabend, the weave is much closer than the later day rugs. The weft in a Mir-Sarabend is dyed blue instead of being white or grey. The weave is different in the Mir, with every other knot doubled under the other.

The field of the Mirs was either in a red or deep blue (almost a purple blue—a blue not usually seen in other Persians). The design consisted of rows of small pears, with the stems of the pears in alternate rows faced in opposite directions. These rugs adhered strictly to type and design. About the only variation in these old Mirs was the occasional use of the herati design instead of the pear designs. Occasionally a central medallion with the herati over the rest of the field was used (Plate 105). There was also a strict adherence to one border design—the main border being unfailingly ivory—upon which was a continuous vine with one angular pear design. These never came in carpet sizes; they were made mostly in sizes up to 7×4.6 ft. They were never made in Standard sizes 6×9, 8×10, or 9×12 ft. Many of these did come in narrow carpet sizes 5×10, 6×16 ft., and very long, narrow carpets.

The later day Sarabends are easily identified by their pear design. The semi-antiques (prior to World War II) occasionally approached the quality of the old Mir-Sarabends, but practically all were good rugs, though slightly coarser than the Mirs. All used the rose or red field, and hardly one with a blue field was made after 1935. The general design was the small all over design of rows of pears, but many of these had a diamond pendant (tiny medallion and corners) in ivory.

An exception to the above rule were a very few small rugs with an ivory field instead of the rose field. Most of these prior to World War II were is sizes 5×3.6, 6.6×4.6, a very few in 4×2.6 ft., and a fairly good number in sizes about 7×10 ft. Choicest antique Sarabends will have as many as 350 knots to the square inch, while the coarsest new rug of this type will count less than 100. Since World War II these rugs have adhered to the same design, with the same rose or red field. The quality of most have deteriorated badly. I have seen many at a lower price than the cheaper grade Gorevans. The largest sizes are about 7.6×10.6 ft.

I saw a great number in many sizes on my trip abroad in 1960, and I bought not one of them. They were too red and too poor. What a pity such a famous rug should come to such an inglorious position. New York importers have practically ceased importing them.

Do not be confused by a new Sarouk in this design. In the last few years a good number of Sarouks have been woven in this same Sarabend design (all over pear design) in the very best quality of Sarouk. These are much heavier, more tightly woven, and cost three times as much as a modern Sarabend. I suppose that the best name for this rug is Sarabend-Sarouk. They are Sarouks, but the above name best describes them.

I have rightly berated the new Sarabend, but perhaps the very opposite is true. During the past few years Sarouk rugs with the Sarabend design, mostly in sizes $8 \times 5$, $6 \times 9$, $8 \times 10$, and $9 \times 12$ ft. have appeared, and in the very best of the fine qualities of Sarouk (Sarouk Extra 1). Under Sarouk I have called these Sarabend-Sarouks. They cannot be called Sarabends because they are in Sarouk weave, but at the same time they are in the Sarabend design. They are very superior rugs —in fact, the best rugs in the Sarabend design that have been woven in the past fifty years. These are better than most any other type Sarouk and they are indeed better than any rugs that have been made in the Sarabend design during the past 40 years.

# SAROUK RUGS

## (Also spelled Saruk)

## (Iranian Family)

**Availability:** *New Sarouks*. This is a complicated subject because there are so many different types and so many different qualities of Sarouks. In the typical American type Sarouk (which comprises most of Sarouks made during past 50 years up to 1960) the supply has been large in all the standard sizes ($2 \times 3$ ft. up to $10 \times 14$ ft.) and in hundreds of larger sizes. Several thousand Sarouks in many qualities and types are woven each year. American importers have taken 90 percent of the Sarouk output during the past 50 years.

The year 1960 saw Europeans take the Sarouk market away from America. They actually outbid Americans and are willing to pay more than American buyers. The result has been a scarcity of Sarouks in the New York wholesale market in all categories. We discuss this in detail under " Characteristics."

*Antique Sarouks.* None have been imported in the past 30 years. Available only from private collections and estates.

**Where made:** Sarouks are woven in the City of Sultanabad (Arak) and in a score of towns surrounding it. In the small village of Sarouk, which is some 20 miles north of this city of Arak (Sultanabad) were woven the real old Sarouks that first made the name Sarouk famous. The thousands of Sarouk rugs of the past 50 years have been very different from those early Sarouks. With some 10,000 looms weaving rugs in the Sultanabad district, and with only about 850 houses in the village of Sarouk today, it is quite evident that not more than 10 percent

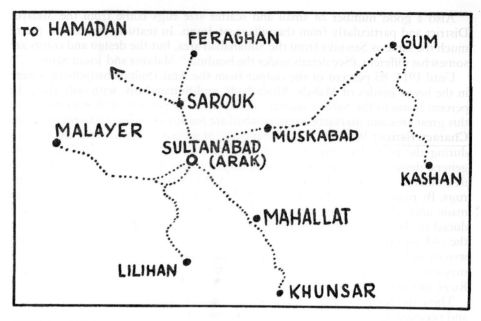

MAP 9. (ARAK) SULTANABAD-SAROUK WEAVING DISTRICT. In this area
are some 30 small villages not shown on the map where Sarouks and Sultanabads are
woven. Mahals and Muskabads are also woven in some of these villages. (See General
Map of Persia (Iran), Map 2, Part I.)

of Sarouks made are woven in the Village of Sarouk. Actually more Sarouks rugs
are made in the City of Sultanabad (also called Arak) than anywhere else. It is
estimated that there are some 2,000 looms in this city, and that most of the over-
size Sarouks are made here. Also, Sultanabad is the market place for all the sur-
rounding districts and villages that weave mostly Sarouks.

Other types, which are Sultanabads, Araks, Mahals, and the Muskabads (all
having somewhat the same general design but varying in quality) are discussed
under Sultanabads. These coarser types use the same Persian Senna knots as the
Sarouk, but are coarser and usually thinner rugs. Few new rugs of this type
(Sultanabad and Araks) approach the quality of the Sarouk.

Unlike the Hamadan district where each village or each district weaves rugs
which differ from those woven in every other village or district, the several dis-
tricts and many villages around Sultanabad produce only Sarouks, Sultanabads,
Araks, Mahals, and Muskabads. The last four are very much the same except for
quality. Actually the name (Arak, Mahal, and Muskabad) refer to different qual-
ities.

In addition to a few hundred rugs woven in the village of Sarouk and the 2,000
looms in Sultanabad, Sarouks are woven in the following districts which lie
within 40 miles of Sultanabad (Arak): Feraghan, Chaharra, Kezzaz, Knossar, Saruk,
and Mahallat. The many villages in these districts are too numerous to mention.

*280*

Also a good number of small and scatter size rugs come from the Malayer District and particularly from the village of Josan. In texture, Josans are pretty much the same as Sarouks from the Sultanabad area, but the design and colors are somewhat different. (See details under the heading " Malayer and Josan Sarouks.")

Until 1914, 85 percent of the output from the Arak (Sultanabad) districts were in the lower grades of Mahals, Muskabads, and Sultanabads, with only about 15 percent being in the Sarouk quality. Today 60 to 70 percent of all rugs woven in this great area and marketed in Sultanabad are Sarouks in many different qualities.

**Characteristics:** While it is true that 95% of all Sarouks imported to America during the past fifty years have all had the same general characteristics (same general design and colors), to properly cover Sarouk rugs, we must discuss some five different types of Sarouks. The early Sarouks were very fine and short pile rugs. By rugs we mean they were all small or scatter sizes. No large Sarouks were made until about the turn of the century. Until that time all Sarouks were produced in the tiny village of Sarouk. Those early Sarouks you read about in all the old standard Oriental Rug books (written from 1900 to 1918) were finely woven and clipped thin. A very finely woven rug is always a thin rug. The vast majority of these were in the medallion design. (See Fig. 7, Chapter Persian Rugs and Plates 52 and 57.)

These old Sarouks, with their intricate large medallion, often in pendant shape and occasionally having two concentric medallions, also came with an ivory field, with rose and blue as the background also used. All of these were in scatter sizes, usually $5 \times 3\frac{1}{2}$ ft. or $6\frac{1}{2} \times 4\frac{1}{2}$ ft. Seldom does a good example of a really old Sarouk appear in an estate. The weave in these old Sarouks was very fine and counted 250 to 450 in the square inch.

*Second Type:* The type of Sarouk that has been made especially for the American market, and which comprised 90 percent of the entire output of Sarouks, is an entirely different type from the early village Sarouk. These new rugs are heavy, tightly woven, with the vast majority in an all over floral design. The design that is most used in the majority of all Sarouks in all sizes made for the American market is the one with the rose field (some shade of rose or a rosy red field), and with the all over detached floral design. The border is almost invariably in a navy blue with some form of floral design. Perhaps 90 percent of all Sarouks imported to America since 1924 have been in the above design. Up until World War II, a good number of these came with the blue field, but since the war, 98 percent have been in the rose or rosy red field with the other 2 percent being in the ivory field. I doubt if half a dozen Sarouks with the blue field have been imported since the war. Scarcity in indigo accounts for this. (See Fig. 7, Part I and Color Plate 53, which are of Persian washed Sarouks.)

Several thousand of these in the same general design have been made for the American market each year for the past 35 years, and these were made in five different qualities which in Persia are known as Sarouk, Extra I, Sarouk Extra II, Sarouk I, Sarouk II, and Bazaar quality. The Bazaar quality varies a good deal. These last are the rugs made by individual weavers or families, and are brought into the market and sold. The better quality Sarouks are usually made in so-called factories (all handmade to be sure), where the dyes, wools, and workmanship are better and the weaving is done under strict supervision. Today, paper scale models are used in weaving most Sarouks. This is especially true of all carpet

sizes. By a paper scale model, we mean that the rug is drawn on a graphed paper in the full size, and that each tiny square of the drawing represents a hand tied knot in the colors shown on the model. This accounts for a number of rugs being very much alike. Oftentimes, several rugs are woven from the one model and a master weaver or a supervisor calls the knots for the several weavers on the different rugs. This is a thicker rug than the old Sarouks and it counts $9 \times 10$ to $14 \times 15$ knots to the square inch.

*There is no such thing as "Royal Sarouk."* ROYAL SAROUKS: I wonder how many hundred times I have heard someone say "We have a Royal Sarouk." There is no such thing. No Sarouk rug has ever been listed on an invoice from Persia as a Royal Sarouk. Any custom official in New York City will tell you this. The minute one says "Royal Sarouk" to any dealer or to anyone with a little rug knowledge, they are simply saying that they have swallowed the hot line of some salesman, hook, line, and sinker. I suppose there is no real objection to a dealer putting an extra handle to the name to make it sound more expensive and superior, but the fact is that is not correct.

The only Oriental Rug authentically called "Royal" is the Tekke rug, which is better known by the name of Royal Bokhara. The hobbyist and collectors who have concentrated on collecting Bokhara types and Turkoman rugs even object to the use of the name Royal Bokhara. However, for 100 years, most collectors have used the name Royal Bokhara.

The other design to be found in Sarouks made for American markets, and one that is especially beautiful, is the plain field with the floral medallion and corners. Most of these come in the rose of the red field but a good number are beginning to come with the ivory field in this design.

**Sizes available:** The all over floral design Sarouk with the rose or red field is made in all standard sizes from $2 \times 2.6$ ft. ($2 \times 3$ ft.) to $10 \times 14$ ft. carpets, and in just about every imaginable large size. It is strange that Sarouks in sizes $9 \times 15$ and $9 \times 18$ and other 9 ft. widths, larger than $9 \times 12$, are so scarce.

**The Chemical washing and treatment of American type Sarouks:** This is done to soften their bright colors and applies only to this type of Sarouk. But remember that ninety percent of all Sarouks have been in this type. If I discussed this subject fully here, I would repeat much of what I have written in Part I, covering the chemical washing and painting process of Oriental Rugs. Since World War II there is little excuse for anyone buying a treated and painted Sarouk, as large supplies of Sarouks with only the light Persian wash or the light New York wash are available. We recommend both of these, and we like the London wash even better. Anyone who takes enough interest to inquire and insist that his rug is not painted, will hardly be sold one by any dealer today. Prior to World War II (1920 to 1941) the Sarouk that was not both treated and painted was seldom seen in any store. But remember, there were thousands of customers in the large cities that insisted on the colors of the washed and painted Sarouk. They were too busy to be bothered with the facts.

People look at me in amazement when I tell them that 98 percent of all Sarouks sold in American stores during the past 40 years were both chemically washed and painted. That was true to a slightly lesser degree of most types of Persian rugs up to World War II. It was almost invariably true with Sarouks, and to a greater extent than any other type of Oriental Rug. One of the reasons why Sarouks

became so well known was that in the large cities such as New York and Chicago, where the washed rugs were so popular, promotional sales by large department stores featured Sarouks as the number one item; that, in spite of this treatment and painting process, they lasted so long. These are two of the principal reasons why they became so well known.

Today, Sarouk is about the only type of Oriental Rug that is being both treated and painted. And quickly I should repeat that only about one-third of the Sarouks are being painted today, and this is done after the rugs arrive in New York and nowhere else in the world. The cost of labor to do this is rapidly eliminating the practice except where it is essential for covering radical changes in color.

Let us go back and briefly see why any artificial treatment was applied. Originally, all Oriental Rugs brought to America and Europe were rugs that the Persians, Turks, and weavers in other lands had woven for their own use. These rugs had been walked on without shoes or used as couch covers, hangings (for partitions), etc., and the colors had mellowed from use and exposure to light. As a rule a new rug is quite bright and stiff looking. The colors are too bright for those who have bought the mellowed antiques and semi-antiques which the weavers had mellowed in their own homes. When the demand for Oriental Rugs became so great around 1900, and when the supply of old rugs from their homes had been sold off, it became necessary to soften these colors overnight. Thus grew the process of chemically treating these rugs. The light process would have done very little harm but, as a general rule, in their early attempts at bleaching the colors, the light process left the rug too dull looking. It also had a tendency to bring out and make objectionable the slight changes of color (shadings) which are present to some extent in just about every Oriental Rug. That was true of the early light chemical process. The process has been greatly improved and there is less need to paint most of the Sarouks. But it is also a fact that the painting over of the sharp changes of color is, undoubtedly, one of the main reasons why many Sarouks are still painted today.

Originally I was opposed to even the light process of light washing of any type of Oriental Rug. I have never once sold the first painted rug. But 35 years of observation has taught me that the light New York treatment does little harm, and that the benefits outweigh the objections. The new Persian wash and the London wash are even lighter than the New York light wash. I have observed hundreds of Sarouks, the very thin type Sarouk made around 1900 (thin when new) which were lightly treated at that time and then were used for some 50 years in American homes. So many of these are still in very excellent condition after all this hard use.

How can you tell? Once you have been shown the difference in these Sarouks, it is quite easy for the layman to tell whether the rug is heavily treated and painted or not. Once I showed you an exhibit which I keep, of a new unwashed Sarouk, a lightly washed Sarouk, a painted Sarouk and a semi-antique Sarouk, you could hardly be misled in the future.

**Note on detecting a painted Sarouk.** 1. A painted rug is much darker on the nap (top side) than on the back of the rug. If you will examine the underside of the rug, you will note the red, deep rose or plum field looks a faded rose or pink. When the rug was washed in chlorine and other acids, both sides were faded, but the nap side has been touched up with a dye to bring back some of the color.

*283*

*Malayer and Josan Rugs—Third type of Sarouk.* (See Plate 55.) Some fifty miles southeast of the City of Hamadan and about the same distance northwest of the City of Sultanabad, lies the district of Malayer, with the principal market town of Malayer, a town of some 15,000 population. In this great area, which is neither in the Hamadan district nor in the Sultanabad district, are over 100 rug weaving villages. The northern part of the district weaves rugs that are very much like the rugs of the Hamadan. The southern section weaves rugs that are very much like the Sarouk in weave, texture and thickness. Both districts use the Turkish (Ghiordes) knot, but even the Josans look very much like the Sarouk in texture. Practically all the rugs from this area that come to America in the Sarouk quality are small rugs, and not carpet sizes.

The village of Josan is renowned for producing some of the finest quality rugs made in Iran today. Most of these will be in sizes approximately $2 \times 3$ ft., $3.6 \times 5$ and $4.6 \times 6.6$ ft. Practically all of these will be in medallion design with the field well covered with an intricate floral design. None of these will be painted. Most of them will have only the light Persian wash. For years most dealers have used the term Malayer and Josan interchangeably. It is not important, but the term Josan or Josan Sarouk is more correct.

A few hundred of these in the $2 \times 3$ ft. size are imported each year. Perhaps 200 to 300 in the $5 \times 3\frac{1}{2}$ ft. size and not more than 100 in the $6\frac{1}{2} \times 4\frac{1}{2}$ ft. size. Most all of these employ the medallion design. (See Fig. 8, Part I, and Plate 55.) The field may be ivory or rose or blue. In the $5 \times 3\frac{1}{2}$ ft. and $6\frac{1}{2} \times 4\frac{1}{2}$ ft. the field will be either blue or rose (rosy red).

*The fourth type of Sarouk:* This is the type that is replacing our so-called American type Sarouk, the second type discussed, with the rose field and all over floral design. Ninety-five percent of all Sarouks have been made in this design during the past 40 years. A great change is taking place in late 1960 and early 1961, and the full impact of this change will not be known for about a year. I stated in Part I that European buyers, especially the West Germans, are buying many more Persian rugs than are Americans. In 1960 they practically took over the Sarouk market. By this I mean that contracts with owners of small factories, employing 20 to 100 weavers, took European orders in preference to American orders for Sarouks for the first time in 50 years. (See Plate 98, for Sarouk in Classical design made for European Market.)

There are three very important points in this switch. First, there are only a fraction of Sarouks made in the so-called American design—the rose or red field with the all over floral design—in 1960. Europeans hate this American type Sarouk as I will detail later.

They are ordering Sarouks in antique designs, like the antique Sarouks in medallion type and those with the all over design, and copying or employing famous old traditional designs. (See Fig. 3, Part I.) They are also getting away from the use of red or rose as the main color. Many are being made with the field in ivory. The design may be all over or medallion. The all over design will combine the old Shah Abbas, palmette, and tulip motifs with intricate floral design. The borders are invariably in traditional designs. The weave is somewhat finer than Type II, being $12 \times 13$ to $15 \times 18$ knots to the square inch.

The first of these to appear in the European market in 1958 were thick rugs, but not as thick as Sarouks made for the American trade. In 1960 the Persians

began making many changes. Not only did they discard the American type Sarouk which has been a thick rug for the past 50 years, but they began weaving Sarouks slightly finer, and clipping the nap much shorter. The factory owner or Persian merchant perhaps doubled his profit, because even in changing Iran, the wool costs more than weaving wages. So we can expect to find thousands of Sarouks made for the European market using the medallion design, employing old Tabriz designs or designs very similar to Kashan. I wonder just how great the changes will be when I make my trip abroad in 1961.

The year 1960 is the year of the greatest changes in rug weaving. American importers will offer few Sarouks in 1961 in the typical designs. With prices on Sarouks soaring because European buyers are outbidding us for the first time in history, no one can predict the future. Sales will decrease in the United States. Perhaps West Germany will slow down its wild spending spree for Oriental Rugs, and perhaps Americans may once again claim a large share of Sarouks— a market they completely controlled until 1958 but have almost completely lost in 1960–61.

To appreciate the change in Sarouk styles one must have visited the London market for over 30 years as I have. A. Cecil Edwards, in his first and only comprehensive English book on Persian rugs ever written (Modern Persian Rugs), makes pertinent statements as to why Europeans dislike the American designed Sarouks and want different designs. Says Mr. Edwards: "The American public must be bored to see in the stores year after year the same rose ground Sarouks in the same type of floral pattern."

He continues: "The responsibility, I fear, must rest squarely on the shoulders of the importers in New York." Mr. Edwards, in discussing dyes and chemical washing, says: "New York importers continued to import their Sarouks as before, knowing that the ground color would partly disappear in the finishing process, and connived with the carpet finishers to paint back the color by hand. They have been doing this for 25 years. In other words they have been content to sell carpets, year after year, in which the color has been painted in. One hesitates to say which is more gross, the immorality or the stupidity of this device. Surely the time has come to put an end to these follies."

In all this I am one of the very few American dealers who agree with Mr. Edwards in regard to the chemical treatment and painting of rugs. Mr. Edwards says in his book published in 1953 that this has been going on for 25 years. He errs, for it has been going on for 50 years. I had been writing and talking against painted rugs for 30 years before Mr. Edwards published his book. I am delighted that we are going to have a change in the designs of Sarouks.

The all over design Sarouk of the past 50 years has perhaps been the most popular of all designs with the American public. These with the light wash and without paint would continue to be the best sellers for the average American buyer, except for the price increase.

But most of the Sarouks in the traditional designs should be an improvement over the so-called American design Sarouk. Many of these Sarouks will find their way to America, and I, for one, welcome the change. Plate 98 is one of these excellent new Sarouks in classical old designs.

*285*

# SARYK RUGS or SARYK BOKHARA
# or SARYK TURKOMAN RUGS

## (Turkoman Family)

**Availability:** Only occasionally from estates in sizes about 8 × 5 to 9 × 9 ft. None have been made or imported in the past thirty years. The name was unheard of until Hartley Clark's book, published in 1923, introduced it. (Read "History" under Tekke rugs.) The finest of these have been mistaken for and sold as Tekkes (or Royal Bokharas), and the slightly coarser ones have been sold as Khiva or Khiva Bokharas.

**Where made:** The name is derived from a tribe and not from a district. Rugs were made in Turkestan, or Central Asia (now the Russian State of Turkmen) in the Pundjeh district on the Murghal River, which is just across the border and north of Afghanistan. There are several villages, the best known being Pundjeh; but the entire district of several villages is known as the Pundjeh district.

**Characteristics:** These rugs invariably have three or more rows of regular octagons (rather elongated in width) arranged in vertical rows on a red field (rose red, or wine, and often called meat or liver color). The octagons are quartered and the quarters alternate from white to a red (or rose or orange). Each quarter of the octagon has one or two "H" shaped figures. Between these rows of octagons are diamond-shaped guls (designs). A special earmark of these rugs is their main border—so different from most Turkomans (Yomuds use it). The border is usually white with a geometric vine, fringed by hundreds of latch hooks. Most of these are finely woven rugs, but they are not, as a rule, nearly as finely woven as the Tekkes (Royal Bokharas), or Prayer Tekkes (Princess Bokharas), or the Salors.

The majority of these have come in nearly square sizes. The very few of these that have come to America have been sold as Tekkes. Even today nine out of ten dealers have never heard of the name "Saryk."

Hartley Clark in his excellent book, *Bokhara, Turkoman and Afghan Rugs,* after describing and introducing the name Saryk, and describing the rug as being as I have described it above: "rows of octagons on a liver red field," then proceeds to show a color plate of a true Pinde (Pundjeh) Prayer rug, and to list it as Saryk Turkoman or Pundjeh Prayer rug. I (and just about every dealer or collector) prefer the name "Pinde Prayer rug," and the Prayer Pinde Bokhara. I have no objection to calling it a Saryk (the tribe by which it was woven in the Pundjeh (Pinde district). But one can become confused. This Prayer Pinde is one of the four rarest of all Turkoman or Bokhara rugs, and there are fewer of these than any other type of Bokhara rugs. (See Fig. 29, Part I.)

# SAVALAN RUGS

## (Persian Family)

SAVALAN is a name to be ignored today. I list it because occasionally some smart dealer lists a rug by this name in his ad. No rugs have been imported by this

name in forty years. It is simply a trade name for a rug made in or near the city of Sultanabad (Arak). Actually, the name is created by the retailer for advertising purposes.

Mumford, in his first edition of 1900, said: "In the American markets the Sultanabads are often called 'Savalans' after the range of mountains which tower to the north of the district. In the wholesale trade they are classed as 'Extra Modern Persians.' "

Actually, the Savalan mountains are a long way from the city of Arak, or Sultanabad. The mountains are far north of the Herez district, a distance of some two hundred miles from the city.

# SAVONNERIE RUGS

## *(Old ones originated in France)*
## *(New ones now made in India and Japan)*

**Availability:** *Antiques.* The name "Savonnerie" formerly meant a handmade rug woven in France, in designs reminiscent of Louis XIV and Louis XV furniture and furnishings. Two types of rugs were made in France. The Savonnerie with a nap or pile, like any Oriental Rug, and the tapestry-like rugs, known as Aubusson rugs. Neither type has been woven in France nor imported to America since 1932. The exception is a few made under government subsidy for gifts to foreign governments and use in government palaces. When the Russians confiscated all furnishings of rich Russians and started their series of five year plans, both of these types appeared in good numbers in the London Port and in the New York market. I bought many of these at the Culver Street warehouse, London, in the 1929–34 period. They have not been available since that time except from estates.

*New Savonneries.* These are new rugs woven in the same manner as the old French Savonneries, but today, they are woven in India and Japan. The vast majority come from India. They are available in great numbers, in many standard sizes, and in many qualities, from $5 \times 3$ ft. to $12 \times 20$ ft. I have many of these woven in unusual sizes, $2 \times 3$ ft., and in runners $2.8 \times 24$ ft., and also large rugs such as $12 \times 24$ ft. and $15 \times 25$ ft. They are sold under scores of trade names. (See Plates 1, 6, 11, and 184.)

**Characteristics:** Some one often asks: "Are Savonneries and Aubussons real Oriental Rugs?" Whether we class the French rugs as Orientals or not, they have always been considered in the same category. Furthermore, the old rugs are among the highest priced handmade rugs. The new rugs, from India and Japan, are definitely Oriental Rugs.

*Old Savonneries.* Most of these came in large sizes. Some were woven with a cream field, soft rose, pale blue, light wisteria, and many other colors. The field had open ground and the delicate French floral designs. The weave is rather coarse, much more so than most Persian rugs, and about the same as the present day Savonneries from India. All had a heavy pile of excellent wool.

New Savonneries from India. There are many qualities sold under many trade names. (See Kandahar, Kalabar, Indo-Savonnerie, and Indo-Aubusson. Also see

Plates in the chapter on Rugs from India, and Color Plates 1, 6, and 11.) All the better qualities have a nap of 100% good wool. They come in many exquisite color combinations and are among the most salable rugs coming to America today. They are not over costly. An excellent Savonnerie from India sells for less than half the old French Savonnerie and for half the price of a Persian Kirman.

One of America's leading statesman, who is also blessed with worldly goods, wrote to me, after he had bought one of my best quality new Savonneries from India, that he and his wife preferred the new Savonnerie, a large size rug, in preference to the real antique Savonnerie his mother-in-law had given them when they were married. (The antique had cost $10,000.)

Most decorators, even those who do not like colorful Persian and Turkish rugs, are enthusiastic about these soft colored Savonneries from India. One of the heaviest and most durable of all rugs is the Imperial which is made in Japan in the Savonnerie design. (See Plates 185 and 186.)

## SEDJADEH RUGS

### *(Also spelled Sejjadeh)*

SEDJADEH is an outmoded name. No rugs were ever made by this name. Early writers used this name to refer to rugs used on seats and divans. The above were the few lines on Sedjadeh in most old books.

Sedjadeh refers to $3\frac{1}{2} \times 6$ ft. to $7 \times 4\frac{1}{2}$ ft. sizes in prayer design. I refer to H. G. Dwight's information in his book *Persian Miniatures* where he says in referring to the rug books: "No one of them has ever yet discovered that a Sedjadeh and what they unidiomatically term a namezlik are both one and the same—namely a prayer rug."

Sedjadeh comes from the Arabic and means "worship." Most writers have indicated it refers to a small prayer rug. It can mean a medium size prayer rug or a very large size prayer rug. Turkish Mosques have large Oushak (Ushak) carpets which have several Prayer panels.

## SENA RUGS

### *(Also spelled Senna and Senneh)*

### *(Persian Family)*

**Availability:** Seldom a Sena of any type—new or old—is imported to America. I have seen a half dozen semi-antiques in the $6\frac{1}{2} \times 4\frac{1}{2}$ ft. size, a dozen new ones in the $5 \times 3\frac{1}{2}$ ft. size, and perhaps twenty in the $2 \times 3$ ft. size. All, though still finely woven, were only half as finely woven as most antique Senas. The rare old, very fine Senas with silk warp have not been imported for 35 years. They were rare 50 years ago, and among the most valuable of all Persian rugs in the $6\frac{1}{2} \times 4\frac{1}{2}$ ft. size. It is one of the two or three finest of all types of Persian rugs. A good one is a rate collector's item.

**Where made:** In a town by this name, 75 miles west of the city of Hamadan and 30 miles east of the City of Kermanahah. A *National Geographic* map spells it "Sehneh." Sena is the heart of Nomad Kurd tribal bands and is in fact a Kurd city. Sena became the capital of the Kurdistan province and for the government buildings a new type of rug was created.

**Characteristics:** The choicest of all Senas are those with silk warp. These are perhaps the finest of all Persians, with some 300 to even 600 knots to the square inch. Senas have a very short, frosty nap. The silk warp is multi-colored, rotating some 12 in rose, 12 in cream, and then repeating this, thus producing a multi-colored silk fringe. The old Senas are one of the finest woven of all rugs, and are different in character and style from every other type Persian rug. They have not changed their design in 200 years, but they have cheapened their quality. New Senas in no way compare in weave, workmanship, or even in design to the famous old Senas of 50 to 200 years ago. Plates 93, 94, and 95 are the rarest and most valuable of Senas. They have silk as warp threads. One often wonders how this Kurdish town with the Kurdish weavers, who would normally weave coarse Kurd type rugs with woolen warp, could weave some of the finest and most exquisite rugs ever produced in Persia.

One of the choicest and finest of these is back in my hands after an absence of 20 years. The size is approximately 7×4 ft. I saw my father-in-law pay $900 (wholesale) for this rug 30 years ago. It is a silk warp Sena and the blue field is almost completely hidden by the small all over feraghan design in red, rose, blue, tinges of ivory, and other colors. The red border features the turtle design.

Plate 93 shows an ancient Sena of museum quality and in good condition. The unusual arrangement of the pear design is seldom seen even in a Sena. The warp is silk. It is one of the oldest and very finest Senas I have seen. I have also seen fine silk warp Senas with this same ivory field, with a large intricate pear design in green, blue, canary, and old ivory arranged in rows.

Another well defined design often found in Sena rugs is the so-called diamond Sena design (Plate 96). The field is open plain ground, in red, blue, or ivory. A diamond-shaped center, as well as the small corners, is in a different color from the field and is usually covered with the small feraghan (herati) design.

Another design found in Senas is the so-called Gol-I-Mirza Ali, or the Gol-I-Frank design, which means European Flower design. This design is seldom seen on any rugs except Senas, Bijars, and Suj-Bulak. It should be noted that the Bijars and Suj-Bulak districts are close to the town of Sena. This design is usually on a blue field with oval floral compartments in light blue. Most of these are outlined in gold, with a realistic cluster of roses in ivory, rose, red, green, and gold.

Another design in later day Senas is known as the Vekilli design. Here, the floral designs combined with Shah Abbas motifs, rosettes, and vines are almost geometric. Perhaps this is the least appealing of all designs used by Senas. Plate 96 shows a small mat in a design much used during the past thirty-five years by Sena rugs in small sizes. The rugs, while rather finely woven, were not to be compared in beauty or quality with earlier Senas.

The finest old Sena with silk warp will often have 500 to 600 knots to the square inch. A good average new Sena with cotton warp will have from 150 to 250 knots to the inch.

# SENA-KELIM RUGS

## *(Persian Family)*

**Availability:** None have been imported in 25 years. The few seen from time to time come from estates. These are the choicest of all Kelims. In old days collectors insisted on having a choice Sena-Kelim. Good examples were scarce 35 years ago.

**Where made:** They are made by Kurd tribes in the western part of Iran. There seems little doubt that their designs were derived from the Sena rugs.

**Characteristics:** Sena-Kelim is a flat stitch rug without nap resembling Sena rugs in design and colors. Rugs have the same general appearance on both sides. In America these are suitable for hangings as tapestry, and in old days were used as couch covers. A small one was often used as a table cover. In Persia they were used as hangings as a partition. They also were used in place of blankets. See Plate 97 which is typical in design of the best of old Sena-Kelims and this rug was preserved by an art collector before the present owner acquired it.

# SENA-KURD RUGS

## *(Persian Family)*

**Availability:** In good numbers in three principal types. This is a name we use as a general classification of several of the finer types from the Hamadan district; namely, Bibikabad (Plate 15), Ingeles (Plate 23), Borchalou (Plate 25), and some of the finest individual rugs from many of the scores of rug weaving villages in this district. Many sizes from mats to extra large rugs are made in Bibikabad. (For information on Sena Kurds, see Bibikabad Rugs, Ingeles Rugs, Borchalou Rugs, Mehriban Rugs, and Dargazine Rugs.) We started using this name 35 years ago before the names Ingeles, Bibikabad, and Borchalou were well known. The rug books written prior to 1925 hardly mentioned any one of these names. We use it so that the rug student who refers to the old books can place this rug in its proper category.

**Where made:** They are made in Iran in the large Hamadan rug weaving districts. (See map—Hamadan district—and details under above rugs.)

**Characteristics:** Remember, no rugs are imported under the name Sena-Kurd. This name was given to these choicer rugs from the Hamadan district long before the name Bibikabad, Ingeles, Borchalou, Mehriban, and Dargazin were ever heard of by American experts and dealers. You will not find any one of these five types described or even listed in the index in any one of the old standard rug books (Mumford, Hawley, Lewis, nor any of the European books on Oriental Rugs.) At that time, when one of these appeared, it was usually referred to as a Kurd Sena, or Sena Kurd. I will not object to anyone preferring the name Bibikabad, Ingeles, or Borchalou, nor should anyone object to our calling these Sena Kurd-Bibikabad type, Sena Kurd-Ingeles type, or Sena Kurd-Borchalou type. (See Plates 15, 23, 25, 89, and 90, Part III.)

In addition to calling the above standard types Sena-Kurds, we class many

of the better rugs from the Hamadan district (woven in small villages) and superior to the usual Hamadan, Sena-Kurds. Most of these will be pre-war rugs. Plates 89 and 90 show two such rugs. Each, with medallion and corners, features the herati (feraghan) design. The border design in Plate 89 is the most unusual in that it looks more like the Caucasian crab design than the Persian turtle.

# SERAB RUGS

## *(Also spelled Sarab)*

## *(Persian Family)*

**Availability:** In limited numbers principally in runner sizes 5×3 ft., 8×3, many in 12×3 to 14×3 ft., a few 4×2½ ft., and a few larger runners. In 1960 I saw, for the first time, a dozen in sizes approximately 10×6.8 ft. Most of these are new rugs, but a good number of old and semi-antique rugs are still appearing. By "a good number" I mean about 100 a year.

**Where made:** In the town of Serab, 60 miles east of the city of Tabriz and 20 miles southeast of the Herez district.

**Characteristics:** All are thick, tightly woven rugs, slightly coarser than a Bijar, heavier than a Bijar, and just as compactly woven. All are made of camels' hair wool, and the principal colors are different shades of undyed camel wool. The two designs in which all of these are made are shown in Plate 109.

The runner on the right has end octagons in light cream; in the center, rosy red. Long runners have these alternating from green, to rose or red, to blue. The main border is in cream (not camel color) with the design in blue, rose, and green. The narrower inner and outer borders are in deeper colors—green, plum, gold, and red. The runner on the right has two shades of camels' hair with the designs in reds, green, blue, tan, and minor quantities of other colors.

# SERAPI RUGS

## *(Persian Family)*

**Availability:** No rugs have been imported by this name in the past 25 years. If any were ever on a bill of lading none of the old-timers have ever seen it. I am quite sure that no carpet sized rugs by this name were ever made. Rather, dealers devised or used this name many years ago instead of the correct name of the carpet; namely, a Gorevan or Herez. I myself followed all my teachers in my first book thirty years ago, and used the name Serapi. I did state then that they were in fact Gorevans. (See Plates 21, 26, 27, and Fig. 4, Part I.)

**Where made:** All the old books tell us that Serapi rugs get their name from the villages of Serab. (See Serab for further details and size of Serabs.) Serab is 60 miles east of Tabriz and 20 miles southeast of the Herez district.

**Characteristics:** All the old so-called Serapi carpets were, in fact, carpet sizes, just as typical Herez or Gorevan as any rug from the Herez district. One must

remember that the village of Serab can be reached by car today. It is an established fact that the only looms in the town are not wide enough to make large rugs. Remember, when the name Serapi was used 40 to 60 years ago, Serab was inaccessible except by camel or mule. I see no harm in using the trade name Serapi if one likes it better than Gorevan, Herez, or Mehriban. However, no rugs 8×10 ft. or larger have ever been made in Serab and none in carpet sizes have ever appeared on a custom's invoice. (See Serab Rugs and Plate 109.)

## SHEMAKHA RUGS

### (Caucasian Family)

See Soumak Rugs.

## SHIRAZ RUGS

### (Persian Family)

**Availability:** This is a complicated subject because there are so many different types of Shiraz rugs.
1. The type best known to Americans is the antique Shiraz which is available only rarely from estates in small mats (saddle bags) to rugs 8×5 ft. Most are in sizes $6\frac{1}{2}×4\frac{1}{2}$ ft. (See Plates 99, 100, 101, and 103.)
2. Large numbers of the new Shiraz rugs made by the Fars tribe (some 300,000 people) are available in hundreds of designs and scores of qualities. Most are in small saddle bag sizes (2×2 ft. up to 8×5 ft.). There are limited numbers as large as 8×11 ft. Great numbers are made in sizes $5\frac{1}{2}×7$ ft. and 6×9 to 7×10 ft. Some 20,000 rugs are made each year by these Fars tribes, but comparatively few of these come to the American market. Thousands are in the European market. (See Chapter of Difference between American and European Markets, Part I.)
**Where made:** The rare antique rugs that were the collector's delight, were probably woven by the Persian village weavers in the Fars district, instead of by the nomad tribesmen in that district.

Shiraz is the largest market city south of the large areas occupied by these several Fars tribes, which are divided into two large groups; the Qashqai with some eight tribes (250,000), and the Khamseh, with three tribes totaling 30,000. The Qashqai live in an area fifty miles wide and one hundred miles long. The Khamsehs are also north of Shiraz and east of Qashqai, in an area sixty miles by sixty miles, and consist of three tribes. Shiraz is the large city and market place for all the many types of Shiraz rugs. Some Persian Arabs who live in the many villages in the Fars district, weave Shiraz rugs somewhat differently. Some of these village rugs use cotton warp, while the tribes and shepherds use woolen warp.
**Characteristics:** (See Plates 99, 100, 101, and 103, and read Mecca Shiraz and Qashqai, Plates 102 and 104.) To detail the hundreds of designs and scores of qualities found in the many types of Shiraz would require hundreds of plates and pages. But all types of Shiraz have certain characteristics that mark them as Shiraz.

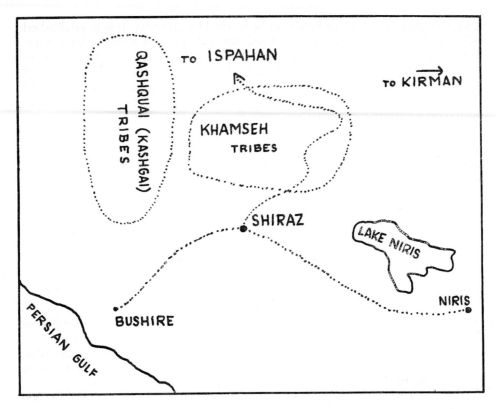

MAP 10. THE SHIRAZ WEAVING DISTRICT. (See General Map of Persia (Iran), Map 2, Part I.)

For one thing, ninety percent of these still have woolen warp. Today, no other Persian rugs use wool as warp except the Bokharas from northeast Iran. These red, geometric Bokharas are easily distinguished from Shiraz rugs.

One might mistake many of the Afshari rugs as being Shiraz, and that will not be a serious error, though most of the Afshari, which are marketed in Kirman, have cotton warp.

One main characteristic of old Shiraz is that no rug had better wool or took on such rich colors or developed a more lustrous sheen with use. One of the choicest old Shiraz is very finely woven, and is almost as pliable as a silk handkerchief.

Many Shiraz have the field covered with pear designs and these are entirely different from the small pears in Sarabend rugs, and are larger and more rectangular than found in other Persian rugs, excepting perhaps the Afshars. Others have rectangular and geometric figures like the Caucasian rugs, but there is little danger of one mistaking a Shiraz for a Caucasian rug. A geometric pole medallion or two or more diamond-shaped figures serve as the main outline in the field, with hundreds of small angular flowers, animals, and especially small

angular birds, which represent nightingales (supposed to mean contentment and happiness). No other rugs use the nightingale. The old books tell us that a Shiraz can be identified by the multicolored (two or more colors—barber pole effect) overcasting of the sides. Today many do come with one color overcasting. Many of these leave small tufts (tassels) attached to the wrapping on the sides.

The checkerboard border design in the ends of most Shiraz are not to be found on any other rug. Also at the ends, between the nap and the flat selvedge, they weave a heavy selvedge in red, white, and blue yarn.

Plate 114 is an unusual Shiraz. The quality and feel to a blind rug man would immediately be recognized as a Shiraz. It is similar to taking a silk handkerchief in hand. The main border is typical. Small extra borders at each end are typical and to be found only in Shiraz rugs. A field of golden canary is exquisite. I envied the owner of this rug and two more much like it. Thirty-eight years later the rugs finally came to me.

The choicest of old Shiraz rugs would have between 250 to 450 knots to the square inch. New rugs from this district will go as low as 40 knots to the square inch and as high as 300.

# SHIRVAN RUGS

## *(Caucasian Family)*

**Availability:** Only from estates and private collections. None have been imported by this name for 30 years. The best examples were made prior to World War I. All were in scatter sizes, $5 \times 3\frac{1}{2}$ ft. to $7 \times 4\frac{1}{2}$ ft. A few so-called Kiaba-Shirvan refer to Shirvans approximately $4 \times 9$ to $5 \times 10$ ft.

**Where made:** Rugs were made in southeastern Caucasia (now S.S.R. of Azerbaijan).

**Characteristics:** These are medium-fine to finely woven rugs with a short, clipped nap. I have already pointed out how closely related Kubas, Kabistans, Chi-chis, Bakus, Daghestans, and Shirvans are in weave, thickness, and finish.

I have outlined the designs of Chi-chi, Bakus, and prayer Daghestans. You should read each of the above types in conjunction with Shirvan. Shirvan is adjacent to the Daghestan district and not too far from the City of Baku.

As stated before, I have never been able to find where any writer had drawn a clear line, differentiating between some of these. I decided that I would research everything written, and after doing so, I hope I have added some clarification to these several types which are so alike in weave. If you begin anew and read what each of the old books say, and search out plates in each book, you will again be hopelessly confused. I found large geometric designs in Hawley's and other books listed as Shirvan, which I would definitely call Kabistan or Daghestan. One must remember that the Shirvan district was once part of Persia, and is closest to Persia, and therefore shows more Persian influence. The rugs of the type which show Persian influence to the greatest degree, I call Shirvans. At this point read Kabistan, Daghestan, Chi-chi, and Baku. After ascribing definite designs to prayer Daghestans, another definite design to Chi-chi, and the large geometric pear design to Baku, I find that it is rather logical to call other short nap, finely woven

Caucasian rugs with all over design, and showing some Persian influence, Shir-vans. Thus, you see, I leave the large geometric designs to Kabistans, Kubas, and Daghestans (other than prayer Daghestans). I do not doubt that some of these with large geometric designs, like Hawley's plate 45, may be Shirvans; but this plate and others are what I have always visualized as a Kabistan.

But only the most technical collector or hobbyist is going to be concerned as to whether it is a Shirvan, Daghestan, or Kabistan. The design in Plate 100 is often called the effulgent star design. I have found a few collectors calling a design such as Plate 101 a Chi-chi. No one should argue over the designation of Plates 162, 163, and 164 as Shirvans.

## SIRDAR RUGS

### (Indian Family)

**Availability:** Sirdar rugs are available in all the standard sizes, $2 \times 4$ ft. to $12 \times 20$ ft. in new rugs in four or more plain colors. One firm in New York imports them.
**Where made:** They are made in India. Sirdar is the trade name for these used by one New York importing house.
**Characteristics:** Sirdar rugs are all handmade in plain, soft colors and in hand embossed or hand carved borders. At present the four colors are ivory, rose beige, honey beige, and soft green. They are one of the better qualities of one-tone rugs coming from India. (See Fig. 35, Chapter Indian Rugs, Part I.)
**Comments:** I have been surprised at how durable these are, and at how little they show dirt. A customer who bought one in 1945 had it cleaned for the first time in 1960, after having used it in the living room for 15 years. I attribute this to the hand-clipped nap.

## SIVAS RUGS

### (Turkish Family)

**Availability:** None have been made or imported by this name in the past forty years. The rug is not worthy of much space. Mumford, in his 1900 edition, did not mention this name. Whenever any old Turkish carpet appears from an estate, and one cannot call it Oushak, it is invariably called Sivas or Smyrna (and there is no real basis for this). Exceptions to this are the many varieties of domestic looking Turkish carpets made after World War II. These old types, and those after World War II (known as Spartas and Anatolians under a dozen trade names), are entirely unlike in color, design, and weave.
**Where made:** Sivas rugs are made in a city in central Turkey (Asia Minor) in the area by that name.
**Characteristics:** The majority were carpet sizes. There is no definite description of these rugs. Some are closest in design to Bergamos, but are not to be compared with these. Some use the large geometric center design. The field is often white. Cotton warp is used and the nap of these is short, while Bergamos have a long

nap. Sivas, as a class, were the finest woven with a shorter clipped nap than all other large size Turkish rugs. Since none have been imported under this name in the memory of any active rug buyer or dealer, it is only on rare occasions when some old, thin, light colored Turkish rug appears in an estate.

## SMYRNA RUGS

### (Turkish Family)

**Availability:** These are available from estates from time to time, in carpet sizes $9 \times 12$ ft. and larger. They are not a collector's item. No rugs have been imported to America under this name in 25 years.

**Where made:** Smyrna is a port city on the Aegean Sea some 200 miles southeast of Istanbul. Today, it is often called Izmir. Rugs from many rug weaving districts were brought to Symrna as a market town for sale and shipment. The coarsest Ushaks and Ghiordes carpets (1924–32 period) were often called Smyrna carpets. So Smyrna really does not denote any special type. Perhaps the Sparta or Anatolian (Plate 154) best typifies a Smyrna rug of the past 40 years.

**Characteristics:** Because many types made in other Turkish weaving centers were marketed in Smyrna, it is not possible to ascribe definite characteristics to the name. The most typical is the all over floral design, the thick, coarse to medium weave, heavy pile carpet shown in Plate 154.

Prior to World War I, the name Smyrna Feraghan was heard. Such rugs (carpet sizes) had been made in Isparta and Sivas with the small all over Persian Feraghan design; and in Europe they were often called Smyrna Feraghan. Also in Sparta and Sivas there were made, in carpet sizes, rugs with small all over Persian Pear of Palm Leaf design, similar to Persian Sarabend. Europeans often referred to these as Smyrna Sarabends. In the same period prior to World War I, the term Smyrna-Sparta was used to indicate medium quality carpets woven in Isparta and Eskisehr. The term Smyrna-Sivas was used to indicate the finest of old Turkish carpets, often carrying a resemblance to Persians. They were finer and had a shorter nap than all other Turkish carpets.

## SOUMAK RUGS

### (Also known as Sumac, Sumak, Shemakha, and Cashmere rugs)

### (Caucasian and Turkoman Families)

**Availability:** These are available only from estates, and most of these rugs are somewhat worn. Rugs usually are in sizes $6 \times 4$ ft. to $9 \times 12$ ft. Small mats are from old saddlebags and narrow strips, about $3 \times 1$ ft., are from old tent bags. None have been imported since about 1932, and none made since about 1925. The few that appear are generally too worn to be resold.

**Where made:** Most of those we have seen in America have come from Caucasia. This is especially true of the choice and desirable Soumaks. On my first trip to

Constantinople (Istanbul) in the twenties, I bought some fifty of the Turkoman Soumaks in sizes about $7 \times 12$ ft. for about thirty dollars. They were in a rather uninteresting diamond design, in Bokhara colors. Those from Caucasia were far more interesting, and many were outstanding in beauty and decorative charm. They were objects of art that appealed to the hobbyist. Shemakha is the capital of the Shirvan district. Rugs are generally called Soumak or Kashmirs.

**Characteristics:** This is a pileless carpet—a flat stitched rug without nap. It is woven on warp threads the same as any other rug and the surface is smooth. The distinguishing feature of this rug is the loose ends of stitch yarn at the back of the rug, about the same effect as we find in the Cashmere shawl. The designs are very much like those in many Caucasian rugs, and were almost invariably geometric in design. None have been woven in 35 years—perhaps very few since 1915—and it seems certain that they will never again be woven. These rugs were very serviceable. They were generally old when brought to America and usually lasted the buyer 30 to 50 years. There is no demand for this type of rug today as floor covering. They are of interest only to the hobbyist or collector, or the individual who has owned and lived with one of these in a library or bedroom for many years.

# SPARTA RUGS

## *(Turkish and Grecian Family)*

**Availability:** Today this rug is of little interest except to the seeker of an inexpensive used carpet. None have been imported in the past 25 years, and the few made were made for home consumption in Turkey. In the period 1924 to 1932, tens of thousands of these rugs in many qualities, all in carpet sizes, came to America.

**Where made:** Sparta rugs are made in Turkey, in the towns of Isparta and Smyrna, and other towns in Turkey. Most of these made in Turkey were called Anatolians. The Armenian refugees who were displaced from Turkey right after the war, settled in Piraeus, Greece, and wove thousands of rugs. Many were also woven in Salonika, Greece. I saw 100,000 of these refugee Armenian weavers in Piraeus (a few miles from Athens, Greece) in 1929.

While the name comes from the town of Isparta, the same general types were woven in a number of places in Turkey and in Greece. They were called Anatolians and Spartas as a general class, but each importer or manufacturer of these had different trade names.

**Characteristics:** Right after World War I many factories and looms were set up in Turkey and Greece to weave rugs. Instead of weaving old Turkish rug designs, the merchants or operators decided to copy Persian designs in carpet sizes. Plate 32 is typical of most of these.

There must have been 25 trade names. I remember one importer calling his best quality Eskishehr, from the sizeable Turkish town 100 miles southeast of Istanbul. This best quality wholesaled in America for $2 per square foot, or $216 for a $9 \times 12$ ft. rug. His second quality was Nazar, or close to that name. His poorest quality which was extremely coarse used a famous name "Ghiordes" and this

wholesaled for $1.25 per sq. ft. They came by the thousands. Many people seeking a soft colored inexpensive rug (these were all treated and bleached but they were not painted) bought anything that was a real, handmade Oriental Rug in those days. But these rugs had two major defects. The majority were not too durable, and worse still, they had a mechanical, domestic appearance. While most of these tried to copy the all over floral design of the Persian Sarouk on a rose or blue field, their appearance was far from that of a Sarouk. (See Plate 132.)

I bought only 12 of these on my first trip to Constantinople, and thereafter I never purchased another. I saw a large store in New York buy 90,000 sq. ft. of these in one order. I had difficulty selling my twelve, mainly because of their domestic look. Even though all handmade, the floral designs were too mechanical or set looking. At least, most every customer would inquire "is that an Oriental or a domestic." Most of these all over the country have worn out. Occasionally we take one in trade, and in the $9 \times 12$ ft. size we have learned to accept them only when we can sell them at a low price, even when in good condition. By low price, I mean $195 to $250 for one of the better ones.

I have given too much space to a dead issue, but only because it was a big issue from 1923 to 1932 when the big depression put these out of business. It is the poorest value of any used rug, or at least the hardest to sell. The coarsest of these would often have not more than 36 knots to the square inch, while the best seldom had over 150.

# SUJ BULAK RUGS

*(Also spelled Souj-Bulak;* National Geographic

*spells it Sauj-Balagh)*

*(Persian Family)*

**Availability:** Available only from estates and private collections. None have been imported by this name in the past thirty years.

**Where made:** These rugs are made in the old capital of the Kurdistans tribes in western Iran. The town of Suj-Bulak is some twenty miles south of Lake Urmia, and some forty miles east of the Turkish border. While no rugs have been imported on invoices by this name in thirty years, these tribes and weavers in Suj-Bulak are undoubtedly weaving a few rugs for their own use, but they are no longer weavers on an important scale.

**Characteristics:** As a rule, they are made only in so-called Kellai sizes; long narrow carpets, such as $6 \times 12$, $8 \times 15$, $8 \times 18$ ft., and similar sizes. A very few smaller sizes have appeared. The field is more often blue than red. The first of three designs I have found most used is the small herati (feraghan) design. While such a rug is not nearly so finely woven as a fine Feraghan in the same design, I have often preferred these for my own use, and thought them more delightful than the real Feraghan carpet.

Another design that we have seen in a number of these old rugs is another all over design consisting of small potted flowers and still smaller flowers and

foliage between these. The field is almost invariably in blue. I have seen no new rugs in this design in 30 years.

A third design and perhaps my favorite, is what I have called the French Rose design. Others refer to this as the European Flower design (or Gol-i-Mirza Ali or Gol-i-Frank design). It is usually on a blue field with floriated compartments, somewhat oval in shape and usually outlined in gold. These contain realistic clusters of rose often on a soft rose field (compartment in rose) and the roses being in light blue, ivory, rose, and gold. The main border almost invariably uses the turtle design. This design comes only in Suj Bulaks, Bijars, and Senas.

A fourth design is the all over Shah Abbas design with other small floral forms in between. Why A. Cecil Edwards referred to this as the Crab design is not clear. He made so many drawings of the Shah Abbas and then turned around and called this the Crab design. Few rugs are more delightful than the old Suj Bulaks.

# SULTANABAD RUGS

## (Persian Family)

**Availability:** In limited numbers as imports from Iran in carpet sizes. The majority are approximately 10.8 × 14 ft. A good number come in carpets about 11 × 17 ft. Occasionally there are a few in the $7\frac{1}{2} \times 10\frac{1}{2}$ ft. size and 9 × 12 ft. size. There are other larger sizes up to 13 × 23 ft. The type was plentiful in the early fifties but is now scarce. There is barely a scatter size in this type. The very few that appear are made in the Feraghan plains (nearby).

The new rugs of this type are imported as Muskabads or Mahals. (Plate 80.) They do come in 9 × 12 ft. sizes and larger. As a class they are inferior to those classed as Sultanabads or Araks. (See Mahal, Arak, Muskabad, and Sarouk.)

**Where made:** The Sultanabad or Arak weaving area, with the city of the same name as the market place, is one of the five largest and principal rug weaving areas in Iran. It is in West Central Iran, some 200 miles southwest of Teheran, and some 100 miles southeast of Hamadan.

Here in Sultanabad and the many surrounding towns and districts are woven all the thousands of Sarouks that have come to America each year. The tiny village of Sarouk could not produce one-fifth of the Sarouks made. The famous Feraghan district lies in the area. Until a few years ago the city was called Sultanabad. Today it is better known as Arak, but most maps and references use both. Some of these towns such as Muskabad, Dulakhar, and Jopolak weave only Mahals and Muskabads. Do not mistake Arak for the country of Iraq.

**Characteristics:** There are scores of designs used in Sultanabads (Araks). The several most used designs are (1) the all over floral design combined with the old Shah Abbas design, rosettes, tulips, and palmettes. (Plate in chapter on Persian Rugs, Part I, and Color Plate 73.) (2) all over Feraghan (Herati) design; (3) Mustaphi design—an all over design that comes only on a blue field, large scroll mosaics combined with realistic cluster of roses or flowers in ivory, canary, rose, blue, and green. (Plate 85.) (4) an all over angular, almost geometric design—a design formerly reserved for all Feraghans; (5) a medium size medallion in ivory or blue with the all over floral design combined with Shah Abbas and other traditional motifs;

(6) large numbers have a rosy red, rose, or red field with a sizeable all over design combining the large leaf, a large herati motif, and a large Shah Abbas design, all of which are intermixed with floral forms.

Below are enumerated the many points (14 in all) that detail the story about this rug.

1. Sultanabads are not finely woven, have a medium length pile and most of the old ones are made of very good to excellent wool. They are surprisingly durable.

2. These rugs usually come with rose or red field with about one in twenty in a blue field. They are about the loveliest of all the less expensive or moderately priced, large rugs. They have designs that are especially suited for the living room. The fact that they have the same designs and colors as the most expensive of rugs (*i.e.,* its half brothers, the Feraghan and Sarouk) makes them very desirable rugs. A lovely old one will please the richest purse in spite of its fairly coarse weave and its low cost. When we say inexpensive we mean that most of the best ones are reasonable, though we know of many of these for which the owners have paid several thousand dollars. The dealer did not pay a huge price, but sold it for a huge profit.

3. You will find few dealers offering you rugs by this name today. Bear in mind that most of the rugs woven in Sultanabad today are Sarouks, Araks, Mahals, and Muskabads.

4. The large rugs that I class as Sultanabads, are called Mahals or Feraghans by most dealers. The name Mahal means a place or village. Therefore, many of the carpets which were woven in and around Sultanabad and marketed in Sultanabad were called Mahals.

5. Mahal today indicates a quality as does Muskabad and Arak.

6. Practically all other large rugs coming from Sultanabad (Arak) and many villages surrounding it, and from the many villages in the Feraghan plains, are Sarouks, Araks, and Mahals, and are imported as such. Some of the small ones come in by the name of the village where woven.

7. My own rule is to call Sultanabad only the better old type rugs, imported as Mahals or other name, but from this district, and to call the poorer old ones Mahals. The new rugs are usually Muskabad quality.

8. Many dealers are prone to call these old Sultanabads or Mahals, the very rare and expensive name of Feraghan. I have never seen many real Feraghans in the large carpet sizes, and they have not existed in numbers. It is in the past forty years, conservative to say, that 95 out of 100 large rugs that have been offered as Feraghans were in fact Sultanabads, or the better quality old Mahals, and these are usually in the Feraghan (herati) design.

9. Sultanabad is a good name, but Feraghan is one of the rarest of all old type Persian rugs, and among the costliest. Many dealers have found it possible to get much higher prices for the old Sultanabad or Mahal by calling it Feraghan, since they all employ the same weave and similar designs in many cases. Where Feraghan leaves off and Sultanabad begins, and where Sultanabad leaves off and Mahal begins is debatable. However, if you are buying a large rug as a Feraghan, the chances are 100 to 1 that it is an old Sultanabad or Mahal.

10. Small Feraghans are much finer and are not to be confused with other types.

11. The old rugs in good condition by either name is excellent. Most of the

new rugs that come from Sultanabad are either Sarouks, Araks, or Mahals. At this present time 90 percent of the output from this city are Sarouks. We sometimes call some of the better Araks and better Mahals that come from Sultanabad, new Sultanabads.

12. Most of the new ones are quite raw and bright.

13. Sarouks and Sultanabads (and of course the cheaper grades) are two of the very few carpet size rugs (6 × 9 ft. or larger) that are to be had in all over floral design. There are occasionally exceptions such as a Tabriz, a Kasvin, a Qum, a Kirman, a Hamadan, or a Nain that come with an all over design. But 99 out of 100 of the first four types of these come with a medallion. About half of the Nains and Qums come with an all over design, but only a few of these two types are made.

Again, Sultanabads are not finely woven, but they do not have a coarse look. The antique and semi-antique are in fact among the most beautiful of all large sizes. The word that best describes these is "choice." To say that they are fine is incorrect.

I have seen many of our wealthier patrons prefer these to their more costly half brother, "The Sarouk." I should add that they prefer the old Sultanabad to the new Sarouk, even though they cost one-third to one-half the price of a new Sarouk. An old Sultanabad in good condition (one that is not worn thin) will generally serve a lifetime. Thousands have done just that. I dare not commit myself that strongly in favor of the new rug of this type from the Sultanabad (or Arak) district. I prefer to call these new ones Muskabads or Mahals, and they are imported as such.

14. It should be emphasized that while the city is called either Sultanabad or Arak, the rug names are not interchangeable. Of course, a rug made in the city of Arak can be called an Arak rug, but that is not done by the wholesalers or retailers. Arak means a quality rather than the name of the rug. It is the second best quality made there being next to Sarouk. Below it in new rugs are Mahals and Muskabads. So, call any choice old Mahal or other rug from this district (excepting the Sarouk) a Sultanabad and classify the new ones as stated. There is no harm in calling a good Mahal a Sultanabad.

**Notes of caution:** An old prewar Sultanabad in good condition is a very beautiful and decorative carpet and will give long service. But a word of caution should be issued in buying a lower grade new rug from Sultanabad, which should be sold as Mahal or Muskabad.

The use of skin wool (dead wool removed from butchered sheep by means of lime) is not unusual today. A rug with this damaged skin wool will wear thin in a few years. The same coarse rug with good wool would have been good for many years.

Another bad feature is the introduction and use of Swiss dyes, which have a tendency to run; also the use of the Jufti knot, which reduces the amount of wool in a given area. So, in buying a new Sultanabad, Mahal, or Muskabad, you do gamble, and the safe thing to do is to buy this inexpensive rug from a reliable store, which will make good if it gets thin in a few years.

If this rug does not wear thin in two to five years, your rug doesn't have skin (dead) wool. Any store that won't guarantee an Oriental Rug for five years should quit selling them.

# TABRIZ RUGS

## *(Persian Family)*

**Availability:** Tabriz rugs are available in large numbers in new rugs in many sizes, many designs, and many qualities. The vast majority of these new Tabriz are in carpet sizes, $7 \times 10$ ft. and larger. With rare exceptions, the only smaller sizes made are in $6\frac{1}{2} \times 4\frac{1}{2}$ ft. size. Few other new rugs vary so greatly in quality and employ so many different designs as the Tabriz rugs. Though made in large numbers today, very few of these come to America. They are absorbed by the Persians and Europeans.

These new Tabriz have a set, angular or mechanical design which gives them a rather stiff domestic look, different from any other Persian. This is the principal reason why so few of these come to America; *i.e.,* they are too hard to sell. There are exceptions, as discussed under characteristics.

A very few large semi-antique carpets came to America after World War II. These were rather plentiful prior to 1940, but since Germany entered the market heavily about 1953, hardly a one of these has come to New York. The very choice Tabriz made prior to 1905 have not been imported since 1930.

**Where made:** They are made in the large city of Tabriz in the Northwest section of Iran, which has been one of the foremost centers of rug weaving for hundreds of years. It is the market place for the many thousands of Herez rugs woven in some thirty villages located some forty miles east of Tabriz. Tabriz is also the market place for Karaja rugs, Ardebil rugs, and Serab rugs.

**Characteristics:** Never was it more important to emphasize the point: "that rugs by the same name vary greatly as to quality and beauty and value." Yes, one new Tabriz rug is several times as valuable as the poorest quality Tabriz. The antique Tabriz will vary even more. When you read in the old rug books about Tabriz rugs, you are reading about the type of Tabriz rugs that have not been imported in thirty years and which rarely appear from estates.

# TAJ MAHAL RUGS

## *(Indian Family)*

**Availability:** Taj Mahal rugs are available in good quantities for use as wall to wall carpeting, or as an individual rug with fringe and sides overcast like any other Oriental Rug.

**Where made:** They are made in India, in a huge plant by a British owned corporation, which is responsible for many of the best rugs being woven in India, or which have been woven in India over the past forty years. We would like to mention names, but if we once did we would have to do so for ALL importing houses.

**Characteristics:** The Taj Mahal is one of the top quality of plain, handmade Oriental Broadloom, or plain rug. As a rule the rug is brought to New York in rolls of approximately 60 ft. length, in widths, 9 ft., 12 ft., 15 ft., and 18 ft., in white background. This can be dyed in New York to any tint of any color you

desire. These dyers are among the best in the world. This handmade Oriental carpeting can be laid as wall to wall carpeting, or it can be used as any other rug with some floor margin showing.

Instead of buying from rolls in ivory in the New York market, and paying some three dollars per yard to have it dyed, this can be ordered made up in India. One can order this in any tint of any color directly from India with the assurance that it will come in the exact tint ordered. Not only is this very durable to the extent that it should wear a lifetime, but it shows soil less than ordinary plain broadloom. The handclipped nap seems to be responsible for this.

# TALISH RUGS

## *(Caucasian Family)*

**Availability:** Talish Rugs are seldom seen even in great collections of rare rugs.
**Where made:** In the hills near the Caspian sea nearest Persia (Iran). The name has never been mentioned in an American rug book, but was first shown in a German colored plate collection which was sold in America 1920–1930. Henry Jacoby also mentions Talish rugs.
**Characteristics:** Plate 167 is typical Talish design and size. It is almost the identical design and color of the plate shown in the Bretano 100 color plates from Germany. The field is a rich navy blue with the main border ivory. All of these are in runners. Other colors are red, yellow, and light blue. Sizes are 3½ ft. wide by 9 to 12 ft. long.

# TCHERKESS KAZAK RUGS

## *(Caucasian Family)*

**Availability:** No new ones have been made in thirty years. They are one of the rarest of old Caucasian rugs. This is a distinctive design of antique Kazak rugs. Most are in a size about 6½ × 4½ and a few about 8½ × 4½ ft. Very few in this design came in period 1924–32. I have seen only three good rugs of the type since World War II, and only a half dozen other worn examples. A good example was rare 50 years ago, and a collector's item at that time.
**Where made:** They were made in Caucasia along the Black Sea by tribes or bands (very proud people who went into exile rather than submit to the Russian Czar). Over 100,000 of these Caucasians immigrated to Armenia where they have intermarried and lost their identity. No good examples of this type have been made since the turn of the century.
**Characteristics:** A Tcherkess rug is thick, heavy rug with the same general characteristics as other Kazaks except for design. This rug always has the same general design, the so-called "Sunburst" or "Russian coat of arms design." Some have called it "The Palace Design." Plate 166 is very close to this design.

Walter Hawley claims that the design is derived from the medallions of the Armenian rugs of the 14th and 15th centuries with its tri-cleft leaves. Always, there

*303*

is much white, red, and blue strongly contrasted. Usually there are two of these medallions, occasionally three and often two and a half. The main border is invariably in ivory and usually in the tarantula design. On either side are narrow sawtooth design borders. Like other Kazaks, the weft thread is red.

# TEHRAN RUGS

## (Most Americans spell it Teheran)

## (Persian Family)

**Availability:** Tehran rugs are not available in America in any type, new or old. They will not even be found in estates. Very few of this type have been imported by New York importers. I do not recall seeing a single rug by this name in the New York wholesale market in the past 25 years. I have seen a limited number of these in foreign markets, most of which were $6\frac{1}{2} \times 4\frac{1}{2}$ ft. and $7 \times 10\frac{1}{2}$ ft.

**Where made:** They are made in and around the capital city of Teheran. With the rapid modernization and tremendous amounts of money being poured into Iran by the United States, weaving in and around Teheran has slowed down in the past few years. Recently I noted in the *New York Times* that serious traffic jams occur in Teheran because there are 100,000 automobiles in this city of 3,000,000.

There are some 2,000 retail stores in Teheran selling Oriental Rugs. Not only the many thousand wealthy families buy Persian rugs for use in their homes, but they buy additional rugs and store them as investments.

Walter Hawley, in his 1913 edition said: "Now and then are seen comparatively scarce rugs such as Tehran, Bibikabad. . . . The typical pattern consists of the Herati design, or some form occupying the central field. . . . The weave resembles that of Iran. . . ." That is the extent of the information on this weave in Hawley's book. I have given too much space to a rug so seldom seen in America, and one which is certain to be made in fewer numbers due to rapid modernization, which is especially evident in this capital city.

**Characteristics:** I cannot give you characteristics that will earmark these, making them as easily recognized as other types, such as Tabriz, Joshigans, Ispahans, Qums, and Kashans. The reason for this is that they are somewhat alike in weave and design. In weave they are rather fine, with a short clipped nap, similar to that of better Tabriz, Joshigans, or Kashans. The wool is rather dry and lusterless, as are the Tabriz. The designs are varied and many. The herati or feraghan design is frequently used as are the interlaced tendrils, scrolls, and the Mustaphi design.

Very little was known about these rugs in the early days, mainly because few were made. Mumford says in his 1900 edition: "In the Tabriz bazaar, the dealer has no idea what is meant by Tehran and Ispahan. After careful inquiry and examination of rugs sold in Persia, I believe that all the fabrics called Tehran and Ispahan are the products of the village of Sarak in the Feraghan district, and for the rest, vagrant pieces which come from the looms of Kirman."

I wonder if Mr. Mumford was not mistaken. I only know that today, no one would mistake a Tehran as being a Sarouk or Kirman. But, all this goes to show that there has been very little definite information ever published on Tehran rugs.

# TEKKE RUGS or TEKKE BOKHARA RUGS
## (Better known in America as Royal Bokhara)
## (Turkoman Family)

**Availability:** The most correct name is perhaps Tekke Turkoman rug. Real Tekke rugs from Central Asia are available only from estates, as very few have been made by the Tekke tribes of Russia during the past 25 years, and none were imported in that time. A limited number of old Tekkes appear each year in sizes 3×4, to 6×4, and even as large as 7×10 ft. Most of these are somewhat worn, but a few appear which collectors have maintained in perfect condition. Also, there are a few smaller rugs in pillow sizes, 12 to 18 inches by 24 to 30 inches. Do not confuse the new Bokharas being made in Iran with the old Turkoman Bokharas.

(See Bokhara rugs made in Iran. Plate 20.) These are in same general Tekke design as the real old Tekkes. Also, remember that new Yomud Bokhara rugs from Afghanistan are being made in the Tekke design. But there is little danger of confusing one of these with the other. It is remarkable that we are able to acquire a dozen good old Tekkes each year in excellent condition.

**Where made:** Tekke rugs were formerly made in Russia's Turkestan (north of Persia and Afghanistan) in the Merv district (Merv Oasis, just north of Afghanistan) which is one of the most fertile anywhere, and in the Ahal Tekke tribe area, just north of Iran. Today this section is known as the Soviets State of Turkmen. The name Tekke is from the name of the Tekke tribes. The non-prayer Tekke is called Tekke. For nearly 100 years they have been called Royal Bokhara. The Tekke prayer rug has been called Princess Bokhara.

**Characteristics:** (See Fig. 27, Turkoman Rugs, Part I.) As a class Tekke or Royal Bokhara rugs are one of the finest of all rugs ever woven. Their nap is short and the design is distinct. The design is invariably geometric with three rows of octagons. The design, whether new or old, has never changed during the past two hundred years, and it is doubtful if it has changed since the first of these were woven. Nor have the colors of these ever changed (the exceptions are in the colors of the new Tekke Bokharas made in Iran since the War). There are many shades of Turkoman reds (shades of wine, rosy wine, and a color often referred to as a liver red or a meat red). Some have a mahogany or even a plum cast. On the wine-colored field there is usually found three rows of octagons extending the length of the field. Once a true Tekke is seen it is never forgotten. The three rows of octagons are the main motif, and these have irregular sides, or four of the sides are indented. The main octagons vary somewhat in different Tekkes. They are elongated—wider than their vertical dimension. Each of these main octagons are quartered with ivory, red, and a little blue or green in the center. Each of the small quarter sections contains about two small geometric forms, perhaps a leaf, and another often looking like the figure H. The Tekkes are the only Turkomans that have horizontal and vertical blue lines connecting each main octagon from one end of the rug to the other. Not all Tekkes have this, but the majority do. Occasionally there are very small amounts of mauve, yellow, dark green, and burnt almond or orange in the octagons. Between each of the rows of

the main octagons is a row of smaller guls (geometric designs) with either the diamond shaped designs similar to the main motif in Yomud Bokharas, or a smaller octagon, which is very similar to the main octagon of the Salor rugs. On most Tekke rugs there is a panel at each end or a border that does not extend on the sides of the rug. The design in these end borders is usually the herringbone design of latch hooks, in the shape of a diamond. Others have a geometric or conventionalized Tree of Life design in these two end borders. The Tekke rugs (and all types of Bokharas) have flat, woven web ends in the same general color as the field extending beyond the pile part of the rug. Many of the small Tekkes have small designs woven in red wool on this web. These web ends often have been removed on many of the old rugs that we get from estates. Sheeps' wool and camels' wool are used. The dyes invariably are old vegetable dyes. Occasionally, an old Tekke has small sections of its design in silk nap. Every one of these with silk which I have seen have been extra fine and very choice. All have had woolen warp except for a limited number made during one of the Russian five year plans, when cotton was used as warp. For several years, from about 1927 to 1934, the Russians organized the weaving of Tekke rugs for the purpose of selling them to Europe and America. They abandoned the woolen warp and wove these rugs with a cotton warp at that time. I saw a few of these in sizes about 9×12 ft., and a few of them in the 10×14 ft. size. Very few of these reached America in those days, as the Tekke is held in high esteem in England, France, Germany, and Italy, and it is the *number one* choice of their people.

Since then no Tekke rugs from Central Asia have been imported to America, with rare exception. We did buy three Tekkes, about 9×10 ft. in size, in the period 1945–1950, but there was not more than a half dozen imported by one small importer. These probably were left over in England or Germany, from the weaving period 1927–34. The new rugs we offer you in Tekke designs are woven in Afghanistan, Iran, or Pakistan today by members of the Tekke tribes, who have fled Russian rule and crossed the border to Afghanistan.

Perhaps if the cold war ends some day and if we ever start trading with Russia, a few old Tekke rugs will come out of Russia. But, I am quite sure that most of these were exported in the period 1925–35 and that few remain in Turkestan or Russia. Very fine superior rugs in the Tekke design and Tekke colors are being woven in Pakistan. (See Mori Rugs, Plate 88.)

## TEKKE PRAYER RUGS

### (Generally known as Princess Bokhara rugs)
### (Turkoman Family)

**Availability:** Tekke Prayer Rugs are available only from estates; none have been made or imported in 25 years. Even so, a limited number of these do appear, most of which are antique and are quite thin and worn. I acquire about a dozen each year, with perhaps two of these being very choice (Museum quality) and in excellent condition for antique rugs. All are invariably in sizes approximately 5×4 ft. (4.6×3.8 ft. to 6×4.6 ft.). A good example is very rare today and is much sought after by collectors and even by beginners.

**Where made:** They were formerly made by the Tekke tribes in that part of Russia (now called Turkmen S.S.R.) just north of Persia and Afghanistan, once shown on the old maps as Turkestan. There were a number of Tekke tribes—two of the most important were known as Merv Tekkes and Akhal Tekkes (these last were just north of Iran and some of these have crossed into Iran). Most of the Tekke prayer rugs (Princess Bokhara rugs) were woven by the Akhal Tekkes.

**Characteristics:** (See Color Plate 180 and Fig. 26, Chapter, Turkoman Rugs.) All are small rugs approximately $5 \times 4$ ft., a finely woven to very finely woven rug with short clipped nap, and always in some shade of red, wine, mahogany, plum, or copperish rose. Some writers have referred to the color as liver or beef red. Fig. 26, Part I, Turkoman Rugs, and Color Plate 180 are both typical in color and design. Each rug has many little variations in the field, in the horizontal and vertical bands, in the borders and in the prayer niche, but all have the same general design. Plate 180 is one of the best examples of Tekke Prayer Rugs and is in amazingly good condition. Invariably the field is divided by horizontal or vertical bands. The formation of a cross by these bands has resulted in these Prayer Tekkes and other Turkomans with these horizontal and vertical bands (Yomuds and Afghans) being called Katchli Bokhara. They should be called Bokhara, or Afghan with the Katchli design. The weavers are Sunni Mohammedans and the cross had no meaning to them as it does to a Christian.

These crossbands with geometric figures are usually in dull blue, green with red, rose, burnt almond, and ivory. The vertical band usually is bordered by small, comb-like motifs. The four quarter sections have the Y shaped motif that is invariably used in some shade of blue.

The outer border is the typical geometric border found in these rugs. This border almost always appears only on the top and sides, and never at the end. The main border (sides) and lower end is the geometric Turkoman tree of life. The small prayer arch extends into the panel of small diamonds or rectangular figures. It is usually outlined in ivory or cream. The apron at the bottom of the rug almost always has the small diamond motifs (perhaps intended as conventionalized rosettes). These motifs are in pink, burnt almond, ivory, dull blue, or green.

The apron in Fig. 26—Prayer Tekke—has star shaped motifs, again perhaps depicting the Tekke's idea of rosettes or stars. The two plates are of typical prayer Tekke or Princess Bokhara. Once you have seen one you should recognize the next one you see. One of the finest of old Tekkes will have 400 knots to the square inch. A good old Tekke will have at least 200.

I have had dealers write to me for an $8 \times 10$, or $9 \times 12$ ft. Princess Bokhara. In doing so they told me immediately that they knew very little about rugs. The best of these Tekke prayer rugs are made with "pashm" or underbelly wool, which explains their silkiness and long life. All are finely woven with from 200 to 350 knots to the square inch. I can't give you a thumb rule as to price. The choicest of these in good condition are valuable, but sell for very little more than a new Kirman rug. A badly worn one is worth very little.

Mr. Thatcher gives these the name Tekke Namazlyq—which means Tekke Prayer Rug. It is interesting to note that while the Tekke (Royal) design is being made in great numbers in northeast Iran, and in West Pakistan, no attempt has, to date, been made to weave this prayer design.

The nearest new rugs to the Princess or Prayer Tekke design are the Afghans

and Yomuds in Katchli designs being woven in Afghanistan. These are larger
(7×4.8 to 7½×6 ft.), much thicker, and heavier than the true prayer Tekke.

# TORBA

TORBA refers to a tent bag, approximately 4×2.6 ft. The term has been used
only by Hartley Clark and Amos Thatcher in their books on Turkoman Rugs.
(Plates 173 and 178.)

# TRICLINIUM RUGS

## (Persian Family)

TRICLINIUM refers to a design and more especially to a set of rugs and runners
that are made for use together in one room. There is no rug by this name, but
the few rugs that I have seen in this design (the four rugs being made together in
one rug) have been referred to by their owners as A Triclinium Rug.

I therefore use the name as a ready reference. I have seen only a half dozen
of these and all but two of these were Bijars. One was a Feraghan and one a Suj-
Bulak. No new rugs have been made in this design for over forty years.

The one type that I give this name to is the rug where the four rugs are made
into one. First, there is the large carpet. At one end of the rug a kellai size carpet
is woven. For example, in a rug approximately 16 ft. by 22 ft. the main rug will
be 10×17 ft.; the rug on the end will be approximately 5×16 ft., and the runners
on each side will be approximately 3×17 ft. All four will employ the same design.

But the Triclinium in Persia has been used to designate places of greater and
lesser honor on rugs of different sizes. This has been the theme of most of the
writers of early books, when Mr. Mumford printed a story to this effect.

As H. G. Dwight says in his *Persian Miniatures* on this subject: "Nor can the
allusion to the triclinium be otherwise than imaginative when the habit of the
Near East is to eat on the floor, squatting about little round tables six or eight
inches high." Mumford's book was written in 1900, Dwight's in 1917.

The real meaning of these sets of rugs—and in addition to the few that are made
up into one rug—was that thousands were made up in sets of four rugs, each an
individual rug. These sets consisted of one large rug, two runners, and one
shorter runner, or kellai size.

In Persia this is called a Dasteh, a team of horses. (It also means a hand full.)
These sets of the same color and pattern were used for furnishings, tents, or rooms
of different sizes. In large rooms, carpets could be pieced together with accom-
panying runners if necessary.

# TURKIBAFF RUGS

## (Persian Family)

**Availability:** In America Turkibaffs are available in limited numbers, in carpet
sizes. Most are in 10×14 ft. and larger. There are, of course, some 9×12 ft. sizes

but few of these come to America. These rugs are imported on invoices as Turkibaffs and then sold or advertised as Ispahans. (See Ispahan Rugs, Ispahan-Meshed Rugs, Khorassan Rugs, and Meshed Rugs.)

**Where made:** Made in Eastern Iran, in the city of Meshed, the capital of the large Khurasan district. The Turkibaffs are entirely different from all other rugs woven in Meshed and the province of Khurasan. The name, Turkibaff, came from the fact that it was started by Tabriz businessmen, who set up looms in Meshed around 1904. Since Tabriz weavers use the Turkish knot, so does the Turkibaff. All other rugs from this area use the Persian knot, and the rugs are referred to as "Faribaff weave," meaning Sena knot (Persian knot). Turkibaff means Turkish knot.

**Characteristics:** The Turkibaffs are a heavy quality carpet and by far the best rug made in the entire Khurasan district. It is the only type from this district that I would want to sell. I would not want to handle the many grades of Mesheds, Birjands, or Khurasans because they wear out too quickly. I think that this is the general opinion of most American dealers. Yet, only in the fall of 1960 I saw my favorite store in New York City, whose buyer is a fine, energetic (and I believe honest) young man, but with very little real rug knowledge or experience, return from Iran with a large number of the cheaper grade of Mesheds. His reason, I am sure, was the urgency of having something to advertise at a low price. The weave in new Turkibaffs varies in these from 120 knots to 250 to the square inch. Some old rugs count more knots.

I must admit I was disappointed when I saw his ad in the *New York Times*, advertising these as Ispahans. Had these been Turkibaffs it would have been all right, but these were mediocre quality Mesheds. In my personal business I would have to make good and replace these in two to ten years. One learns from experience. My young friend's clients who buy these, will also learn by the same method.

Turkibaff really means Turkish knot, and the name indicates that it is not a Faribaff, which uses the Sena or Persian knot. The rug is from very tightly woven to tightly woven, and the nap is from heavy to medium thick. The principal colors are cochineal red in the field with the main border in olive or ivory. All dyes have been vegetable, until the recent introduction of Swiss Indigo, which is to be avoided as the most dangerous of dyes and colors being used in rug weaving in Iran today.

In using the Turkish knot the weaver uses a hook to tie the knots, and so cannot tie the Jufti knot (a false knot tied on 4 warp threads instead of two), as do most of the other rugs in this section. The Jufti knot means a loosely woven rug, and when used in Mesheds and Birjands in conjunction with poor wool the results are fatal. Also, the Turkibaffs use a better quality of wool than other rugs in this province. They use the spring clipping quality which is far superior to the fall clipped wool.

Designs are many and varied. (See Plates 54, 72, and 81.) Mesheds, Turkibaffs, and even the cheaper qualities all use these same general designs. Many of the cheap quality Birjands do employ all over designs. A favorite design is to copy the medallion and corner effect of the famous Ardabil carpet. Others employ an all over design combining the Shah Abbas, palmette and tulip motifs with floral designs. Occasionally you find old Chinese cloud bank designs intermixed.

*309*

No small rugs in this type are coming to America. With Europe buying so heavily and outbidding America, we will not see many Turkibaffs in the market in the next few years. Except for a very few of the best of these, we should not regret this. I call these Ispahan Mesheds, as I do not believe they should be called Ispahans, and I compromise on this name in an attempt to clarify the subject.

## TZI-TZI RUGS

### (From Caucasia)

SEE *Chi-chi* which is the spelling most generally used. Tzi-tzi is used by German writers. (Color Plate 148 and Plate 149.)

## VASE CARPETS

### (Persian Family)

**Availability:** Many new Tabriz in carpet sizes which are made for European consumption copy this design. A better term would be Vase Carpet design. Many new Kirmans made in the classical designs up to 1939 also copied this Vase Carpet design. With the tremendous demand in Europe for Oriental Rugs, and the sharp price increase, Bulgaria in Europe is weaving Oriental Rugs (handmade rugs in Oriental design), and some of these also copy this Vase design. Many of the old Ziegler carpets made in Tabriz and Sultanabad also employed this design. But, when one refers to a Vase carpet, they generally have in mind one of the fifty or so old carpets in this design, one of which is to be found in most of the large museums and in the great collections. The design shown in Plate 24 of a rug from the Metropolitan Museum of Fine Art is typical. The field on practically all of these is in rose to red.

**Where made:** They are made principally in the City of Tabriz, but in types listed above, and you may find it in Qums (Gums), Kashans, Teherans, Joshigans, and others. Design is not confined to any one type. (See Plate 122.) I think of Tabriz as using this design more than all others combined. Also the prewar Laristan from India used this design extensively. Most of them are finely woven Tabriz. You will find no mention of Vase carpets in any of the old books, such as Mumford's, Hawley's or Lewis'. The Victoria and Albert Museum's *Guide to the Collection of Carpets,* says this about these rugs (and there are three examples of Vase carpets in this museum): "Another type of pattern, in which animal and bird life are entirely absent, has given rise in Germany to the name 'Vase Carpets,' a useful if somewhat clumsy term, which is explained by frequent introduction of vases into the design. These vases generally hold flowers. The design has no central device with a balanced arrangement on either side, but is arranged to be viewed from one end." Cecil Edwards in his book, *The Persian Carpet* published in 1953, has this to say: "For one thing, many more carpets in this design have come down to us from the Safavi period than from any other. For it is, by and large, one of the best designs for a floor covering that has ever been devised. It has determined

and defined for all time a large number of classical Persian forms and motives which have been copied and recopied for four hundred years. It has been woven in almost every textile floor covering that exists, and it has been used by printers of furnishing materials the world over."

Henry Jacoby's book says: "These carpets are included in the general classification 'Vase Carpets' even if the vases themselves are missing as often happens, provided the other features are present."

**Note:** It is a queer thing that these new vase design carpets have not been popular as floor covering in America. Just as Europeans dislike our all over floral design Sarouks, Americans are not overly fond of this or most of these in carpet sizes. Perhaps it is something about the rug being too crowded in design.

# VERAMIN RUGS

## *(Persian Family)*

**Availability:** These are available only from estates and private collections. None have been imported since 1933. A few groups of pillows approximately 3 ft. × 15 inches came in 1924–1930 period and were imported on custom invoices as Veramins, but were sold in retail trade as Bahktiaris. In those days a good number of rugs and runners were imported as Kurd Shiraz and sold as Bahktiaris. Some of these might well have been Veramins.

**Where made:** Veramins were made in the town of Veramin, a short distance southeast of the capital city of Teheran. I have seen none by this name in any market since World War II.

**Characteristics:** Plate 112 is the one typical size and general design I know. All of these small pillows have been known by collectors and dealers as Bahktiaris. I will never forget, when in 1925 I saw unbaled several hundred of these at Gulbenkians, 225 Fifth Avenue, then the largest (or one of the two largest) importers of rugs. They were sold to me as Veramins. I asked many people at that time (my second year in the business) about Veramins, but not even the experts had ever heard of Veramin. So, I called them Bahktiaris. I believe this large group which I bought comprised three-quarters of all these pillows that ever came to America. These pillows are very beautiful. When the backs are removed they are one of the choicest of small rugs. They have the most luscious feel and silky patina; in fact, pan-velvet like. The blues and reds are vibrant. The weave is fairly fine and the nap is medium. Perhaps some of the runners that we call Suj-Bulaks or Bahktiaris were actually Veramins. Certainly no rugs are being offered under this name today.

# YEZD RUGS

## *(Persian Family)*

**Availability:** Yezd rugs are available in new rugs in good numbers in European and Persian markets in carpet sizes. They seldom come in sizes smaller than 7 × 10

ft. and generally are in sizes $8 \times 11$ to $11 \times 16$ ft. Comparatively few of these were sold in America prior to World War II, so very few appear in estates. When they do, they are generally mistaken for Tabriz. Seldom does one of these come to the American market because colors and designs are too mechanical.

**Where made:** They are made in the City of Yezd, some 100 miles northwest of the City of Kirman, halfway between Ispahan and Kirman. Comparatively few rugs were woven in Yezd until recent years. Today some 300 to 400 carpets are woven each year.

**Characteristics:** The semi-old and old Yezd were very similar to Tabriz rugs, both in weave and in the principal design used, the herati (feraghan). The majority of these had a blue field with the herati in rose, red, green, and tinges of ivory, brown, tan, etc. (See Plate 110.) When old, both Yezd and Tabriz are quite attractive, but the new ones have a very mechanical design—almost the look of a machine made rug. This was the reason why they were not well received in America. (See Chapter, Difference between the American and the European Markets.) Today many of the Yezd have copied a certain Kirman design that would make them very hard to sell in the American market. The demand for Kirman carpets was so great in the Teheran market that the Yezd merchants imported designers and bought paper scale designs of Kirman. The old herati (feraghan) design has been discarded, and today they are weaving some 300 carpets a year that are very like the type of Kirman rugs that are woven for home consumption. Do not imagine that these are in the light pastel colors in which practically all Kirmans for the American market are woven. Instead, since the Persians like bold primary colors, both Kirmans and Yezd for home consumption are very colorful. The cochineal red, an approach to a magenta like rose or red, is the favored background of these Kirmans and Yezd. The typical Yezd is an open plain field with cochineal red, with a large floral medallion and corners, and a broken border (floral merging with field and not a straight line border); in blues, ivory, pink, green, and tinges of other colors. As indicated, the weave is as fine as a medium quality Tabriz and medium quality Kirman; and nap is medium to medium-short. The fabric is honest and durable. This is one of the few towns where the Jufti knot has not been used. Plate 110 is the typical prewar Yezd with the feraghan designs. This plate might be either a Tabriz or Yezd, so alike are the prewar rugs by these two names. Most rug dealers, if shown a plate of a post war Yezd, would say that it was a Kirman. I regret not to have a plate of the new Yezd. New Yezd have from 120 to 200 knots to the square inch.

# YOMUD or YOMUD BOKHARA RUGS

*(Also spelled Yomut)*

*(Turkoman Family)*

**Availability:** In antiques, semi-antiques, and new rugs, in several different distinctive designs. Many Yomuds, in both old and new designs are coming from Afghanistan to the European market (Free Port of London warehouse). Three of the best known designs and pure Yomuds are shown in Part I, Chapter, Turko-

man Rugs, Figs. 28, 30, and 31. The rarest of old Yomuds is shown in Fig. 30. These were scarce 35 years ago. Even though they are not as costly as Tekkes, Prayer Tekkes, Salors, or Pindes, they are not found in many collections or in private sales. The antique and semi-antique Tent bags in the same general design as Fig. 31 are available in good numbers in Afghanistan, and in limited number in some very old rugs from estates. All of these saddlebags are approximately 4×2.6 or 5×3.3 ft.

The Yomud with the Katchli design as shown in Fig. 28, is also available both from Afghanistan and from estates. Many heavy quality new Yomuds in this design are available. All of these are in size about 6×4 to 8×6 ft.

**Where made:** This heading is to tell you both where the rug is made and also how it gets its name. With the Yomud tribes so scattered over Russia's Central Asia, and with Yomuds and Tekkes now in West Pakistan and Afghanistan in good numbers, and also in the mountains of northeast Iran (see Bokharas from Iran), we cannot pin these numerous tribes to one precise locality or district. It is quite clear that the name of the rug comes from the tribal name and not from a town or district. Originally, most of the old Yomuds came from the section north of Persia and nearest Caucasia. The generous use of the latchhook is due to the proximity of Caucasia, where the latchhook is most used. The old type shown in Figs. 30 and 31 is typical of these older type Yomuds, and shows the Caucasian influence. I do not try to pinpoint the new Yomud weaving in Afghanistan to any definite town, but most of these are being woven in the northern part of the country.

**Characteristics:** All are in some shade of wine red, plum red, or tawny brownish red, and all use geometric designs. In our discussion of availability, we have refered to the five principal and different designs and types the Yomuds weave in different sections of Asia. The three types we get from Afghanistan are the Tent Bags (about 5×3 ft., Plate 177), the Yomud in Katchli design (Fig. 28, Chapter, Turkoman Rugs), and the Yomud in the Tekke Bokhara design (same general design as Color Plate 20 of the Bokhara made in Iran). We do not include those Bokharas made in Iran, even though some of these are woven by members of Yomud tribes who have crossed from Russia into Iran. Added to these three, are many small, long, narrow tent bags in sizes 1×3 ft. to 2×5 ft.

# YURUK RUGS

## *(Turkish Family)*

**Availability:** No good Yuruks have been made since about 1915. So the only good ones are antiques from private collections. Those made right after World War I (1920–1930) were very poor rugs and will seldom come from estates. These were made only in the scatter sizes in both prayer and non-prayer rugs. Prayer rugs were 5×3 ft. to 6×3 ft., while others were 5×4 to 9×4 ft. None of these have been made since about 1930.

**Where made:** Yuruks are Nomad tribal rugs and were made by these tribal weavers in eastern Turkey adjacent to Persia.

**Characteristics:** Like most rare old Turkish rugs, they were well woven with

heavy pile, but not finely woven. We are fortunate to find one with a good nap and not worn down. Fortunately many art collectors have preserved rare rugs. Yuruks used more green than any other Turkish rugs. The prayer design is almost invariably in bottle neck shape, and the field usually in apple green, but it may be magenta or maroon. The choicest prayer Yuruk I have ever seen is one with the field in lavender and an old yellow or buff border. The main border is a wide buff (pale canary) with the design. Plate 123 is typical non-prayer Yuruk. The color of the field is a slight magenta-like red. The designs are in ivory, green, salmon, and plum. It is a thick rug of medium weave. Many of the choicest are actually loosely woven.

## ZARA RUGS

### (Turkish Family)

ZARA rugs are of interest to collectors only. I have seen a number of old Turkish Prayer rugs in both silk and wool, called Zara. I have not seen where any rug books even mention the name. Plate 122 came from a private collection; and where the well known authority of yesterday got the name will always be a mystery to me.

The rug is more of a Mudjar. I have seen several widely different types of Turkish Prayer rugs given this name. It is my belief that the name was created as a selling device by dealers and collectors alike to add another name, and often to outdo rivals in knowledge and scope of collection.

The rug in Plate 122 was called Zara by a dealer and the collector. I would say it was made near Mudjar. A German set of colored plates once listed a Zara, and thus originated this name. For 35 years some few dealers have offered a rug by this name and I can assure you it was an arbitrary name by the particular dealer to widen the scope of a collection.

## ZELI-SULTAN RUGS

### (Persian Family)

**Availability:** These are available only rarely from a collector's estate, and only in dozar sizes ($6\frac{1}{2} \times 4\frac{1}{2}$ ft.). One good one shows up every two or three years. None have been made in the past forty years, and none imported in thirty years.
**Where made:** They are made in Iran, in the large rug weaving district of Hamadan. You will not find this name listed in any Oriental Rug book. Nevertheless since my first initiation into the rug field (1920) the name and definite type has been common knowledge among collectors, as well as among those importers who had a working knowledge of antique types. This is not meant to be criticism of any importer. Most of them have a wide knowledge, but many importers, even native born Persians, have not had the opportunity to learn antique Persian rugs, and cannot even name many types. In 1924 I saw my first Zeli-Sultan rugs in Gulbenkians (then one of the largest importing houses). The manager gave me quite a lecture on this type. Since then I have seen a total of one hundred of these

in thirty-six years. But no one has ever told me with a definite certainty in what village or district these rugs were made. I have always believed that they were woven in a village in the Mallayer district. There is no town by the name of Zeli-Sultan. My answer was that years ago, a very fine type of Hamadan was made and sent to the wife of the then Sultan, whose name was Zeli, and since then all rugs of this special type have been called Zeli-Sultan. There ought to be a definite locality and village to which we ascribe these, and there certainly is—but I have never found the Persian who knew the definite answer.

I am inclined to agree with the German author who has perhaps the best answer to this rather indefinite name on the newer rugs. But the old antiques that came in limited numbers as late as 1928 were entirely different in weave from those seen in the last 20 years. Most of the really old ones did not come in this all over flower cluster design. They often used a design closely resembling a Sena, and the others with some features of a Feraghan. He says: "The name as applied to certain carpets does not refer to their place of origin but to their design. This is a comparatively small pattern of flower motifs (usually roses) endlessly repeated and very much stylized. It is possible that the first carpet in this pattern was ordered by the Shah for his chief counsellor, and that the name, which is an honorary title meaning 'Shadow of the Ruler,' refers to him. . . . Although it is as likely to be seen in a carpet from Yezd or Tabriz as in a Turkibaff, one finds it most generally in Ispahans or Tehrans." I agree with Mr. Jacoby's explanation in general on later day Zeli-Sultans, but when did he ever see a Turkibaff (his spelling is Tarbaff) from Khurasan district in this design? Most of those to be found in later day rugs since World War II are actually in Qum (Gum) rugs. The weave of the old ones always puzzled the experts. But finally, most of the old ones I have seen have been either very fine Sena Kurds made in the Hamadan district, Feraghans, or Sarouks (or at least closest in weave and texture to old Feraghans and old Sarouks).

**Characteristics:** Zeli-Sultan rugs are almost invariably in a size about $6\frac{1}{2} \times 4\frac{1}{2}$ ft., and the vast majority in an easily recognized design—that of all over repetitive vase filled with flowers. One might mistake this for an early Kirman. The rug shown in Plate 107 is one of the most typical designs used by these. Some employ the Feraghan design; and one not familiar with the weave, or not having seen a few Zeli rugs, might want to call it a Feraghan or Sena. But once having seen the weave and the distinctive earmarks in colors and design, an expert will call it only a Zeli-Sultan.

It is very finely woven; in fact, usually as fine as a good example of any of the above three rugs. The nap is short like a Sena. They are very much sought after by collectors. One bad fault of these very fine rugs is that they were made not later than about 1915, and some of these have loose dyes. All are finely woven, and this is the only point to guard against. They will usually be quite worn.

# ZENJAN RUGS
## *(Iranian Family)*

**Availability:** Until recently these were available in good numbers in coarse, crude scatter size rugs, about $6\frac{1}{2} \times 3\frac{1}{2}$ ft., and marketed as Zenzian Mosuls in

Zenjan and Tabriz. Very few have come to America since 1958. Europeans and Persians are buying all of these and fewer are being made.

**Where made:** Zenjan rugs are made in the Khamseh district, north of the City of Hamadan in many villages.

**Characteristics:** They are found in one general size, $6\frac{1}{2} \times 3\frac{1}{2}$ ft., in very coarse rugs, and are woven of inferior pre-dyed wool yarn, bought from a Hamadan Bazaar and dyed with poor synthetic Swiss dyes. The majority of these have a red field with angular medallion and corners, while some have floral designs. They are perhaps the poorest of all scatter size Persian rugs.

## ZIEGLER CARPETS

### *(Persian Family)*

A large British firm by the name of Ziegler & Co. of Manchester, England were large factors in Persian exports and imports from 1860 until forty years ago. They established factories in Tabriz and Sultanabad, and the rugs made in Sultanabad were known in the trade as Ziegler carpets. The carpets were very superior, with the finest work and were well woven. The few old timers still in the business are still enthusiastic when one of these appears from an estate, which is a rare event. The rug is seldom worn thin regardless of its age.

# PART III

## Plates

NO RUG BOOK is complete without pictures of different types of rugs. The public always likes pictures in any book or magazine. The plates showing new rugs are typical and representative. The plates of antique rugs, shown by courtesy of Museums and private collectors, are very choice and rare examples of the types represented.

I wish to say to many collectors, connoisseurs, historical homes, and some museums throughout America, many of whom have acquired their rugs from me, that I am well aware that I could have used many of their rare and wonderful rugs, and the fact that I have not, was due to exigencies of the situation. The effort to go through files, to write to each owner, to have the rug shipped to me, to have the rug photographed and then returned to the owner, required an effort I could not meet. Those rare rugs we have presented, are from a dozen of the finest collections I have ever seen assembled. It is my belief that each of the antique examples of private collectors presented are the equal of those of the same type in the museums in the world.

In most cases these privately owned examples are, as a rule, in better condition than the same type rugs in most museums. Of course, our private collectors do not have the large ancient carpet sizes that the museums have. It would require several thousand plates to give complete coverage. For example, from the Hamadan district alone, we could present 100 different designs. In the Afshari rugs, I could offer 50 different designs, and in Sarouks today perhaps another 50. I could show in Afghans and Bokharas, perhaps 30 different designs. My next effort at publication will be to offer 100 or 200 colored plates of different rugs with descriptions on the reverse side. In the new creation in Pakistan rugs, we could use 25 plates of the designs copied from Tabriz. We deliberately omitted plates of many unimportant types, which are of little interest today to the hobbyist or seeker of floor covering.

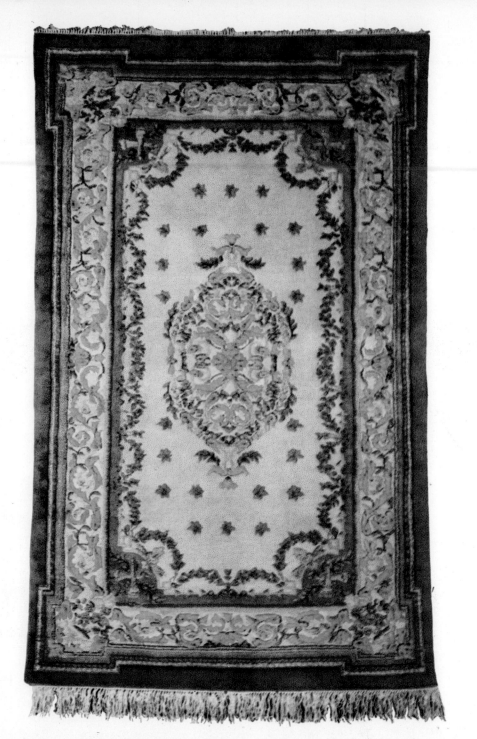

PLATE 1.   INDO-SAVONNERIE RUG. Indian Family. Size 6×9 feet. The import-
er's trade name is Indo-Aubusson design 9612. Larger sizes give more expanse to field.
Same general design is made without medallion, also with open plain field. Also field
may be green, rose, or tan in same design.

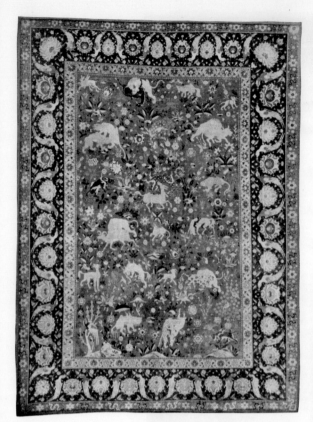

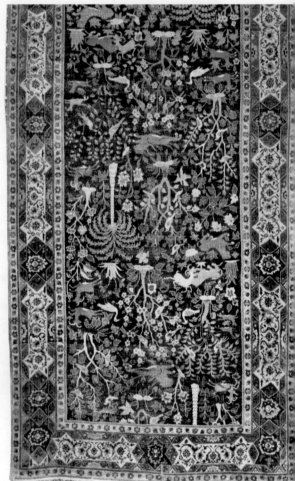

PLATE 2. ANIMAL CARPET. Silk nap. Persi (Kashan) rug. 16th century, Safavid period. (Courtesy The Metropolitan Museum of Art, New York City. I quest of Benjamin Altman, 1913.)

PLATE 3. INDIAN RUG. 17th century. Period of Jahangir (1605–1627). Nap is wool. (Courtesy of the Metropolitan Museum of Art, New York City. Gift of J. Pierpont Morgan, 1917.) While the museum does not list this as such, I would deffnitely call this an Animal Carpet.

322

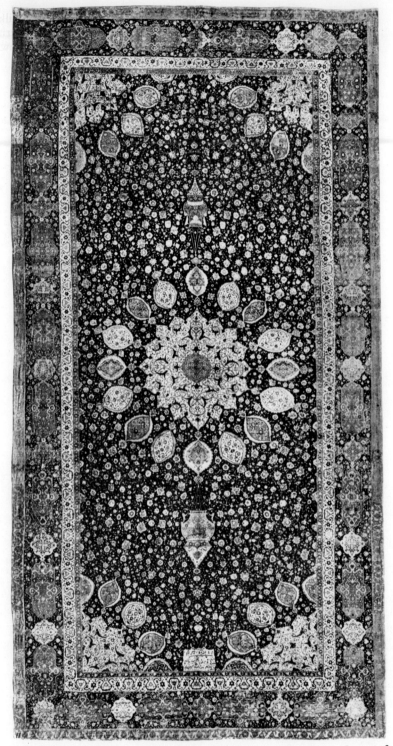

PLATE 4. THE ARDABIL MOSQUE CARPET or The Great Carpet from the Mosque at Ardebil, Persia. Size 17.6 × 34.6 feet. The *Museum Guide* simply lists this as: "Pile Carpet from the Mosque at Ardebil, Persia; dated A.D. 1540." (Courtesy of The Victoria and Albert Museum, London, England.)

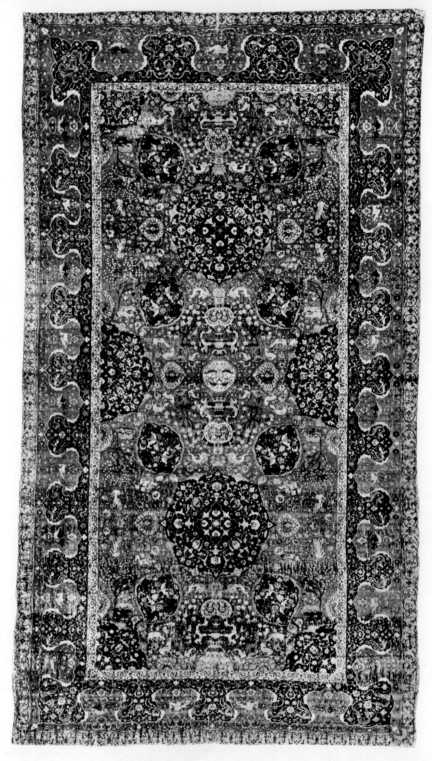

PLATE 5.    THE CHELSEA CARPET. Persian Family. The Museum *Guide Book* shows
this as Plate 2: "Pile Carpet, early 19th century." The rug has 470 knots to the square
inch. (Courtesy of The Victoria and Albert Museum, London, England.)

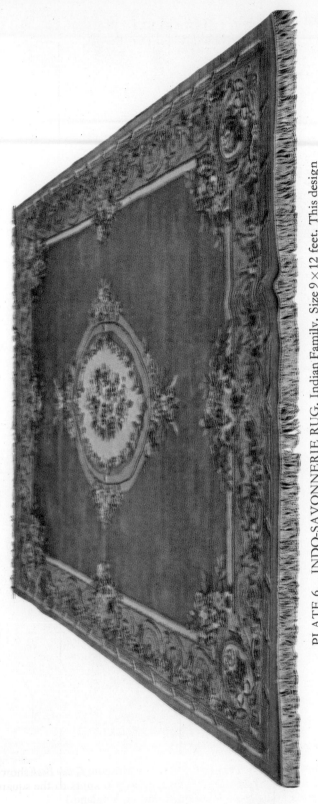

PLATE 6.   INDO-SAVONNERIE RUG. Indian Family. Size 9 × 12 feet. This design 21 is also made with the field in ice blue, soft rose, or sand beige. The rug has a thick nap of 100 per cent wool.

PLATE 7.   AFSHARI RUG. Persian Family. Size 5.5 × 6 feet. Conventionalized pear design.

PLATE 8.   SEMI-ANTIQUE AFSHARI RUG. Iranian Family. Size 4.10 × 5.10 feet.

PLATE 9.   AHAR or AHAR HEREZ RUG. Persian Family. Size 8.10 × 12 feet.

PLATE 10.   NEW ARDEBIL RUG. Iranian Family. The design of old Caucasian
Shirvans and Kabistans are used in this rug.

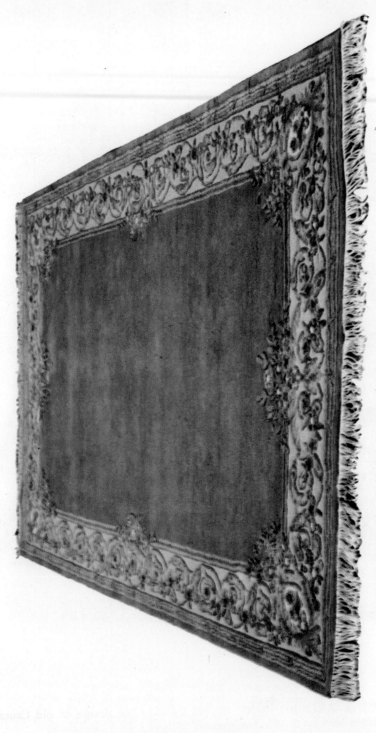

PLATE 11. INDO-SAVONNERIE RUG. Indian Family. Size 6 × 9 feet. Plain field in a Savonnerie rug made in India. Same open field is made in ice blue, green, and ivory.

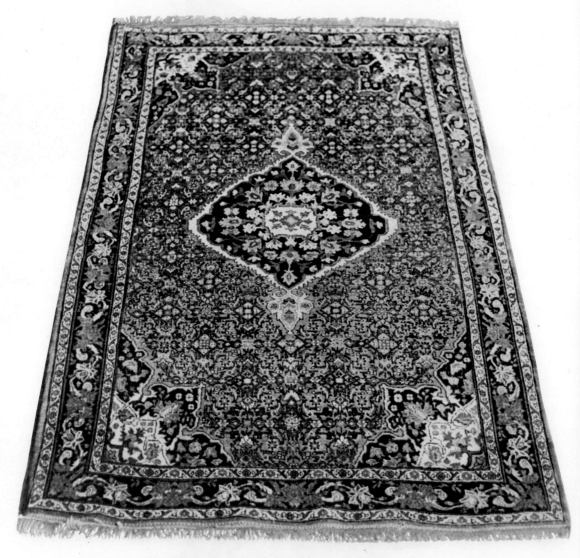

PLATE 12.   NEW BIJAR RUG. Persian Family. Approximate size 4.8 × 7 feet.

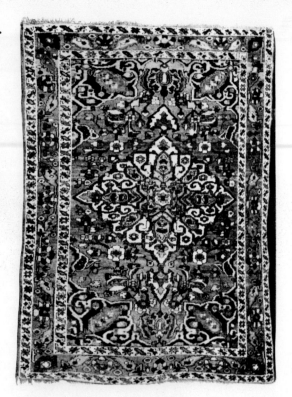

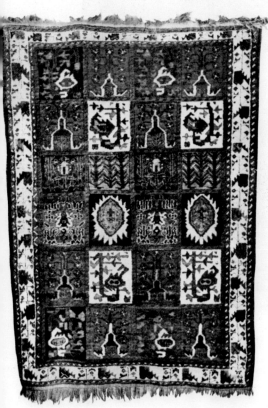

PLATE 14.   BAHKTIARI RUG. Persian Family.  Size 6.4 × 4.5 feet.

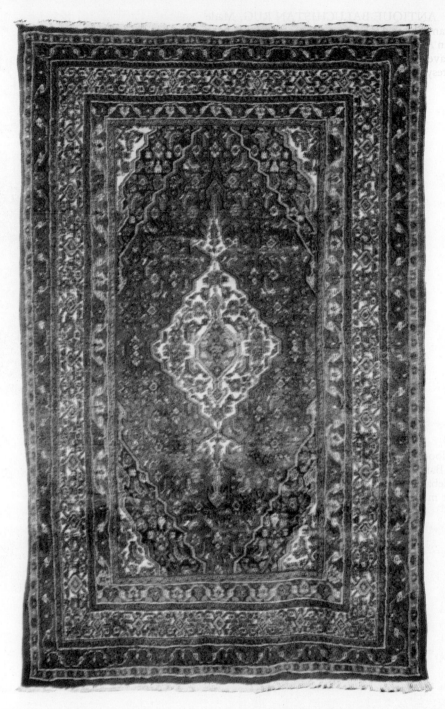

PLATE 15. BIBIKABAD RUG. Iranian Family. Size 9.6×6.2 feet. One of the three types we call Sena-Kurds. Typical design of all Bibikabads. The larger sizes will have more borders—9 and 11—and more green and canary in the borders.

332

PLATE 16. ANTIQUE BALUCHISTAN RUG. Made in Afghanistan. Size 3.4×5.5 feet. Rug could have been made either in Afghanistan or Pakistan (Old Beloochistan) or it could have been made in Eastern Iran (Kurasan District). (Courtesy of Professor Frank Kramer, Gettysburg, Penna.)

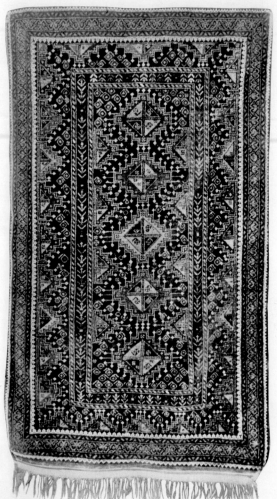

PLATE 17. ANTIQUE BALUCHISTAN RUG. Also spelled Beloochistan. Turkoman Family. Size 3.1×3.4 feet. Many Baluchistans are made in Eastern Iran, but this large saddlebag (canvas back has been removed) is believed to be more Turkoman than Persian.

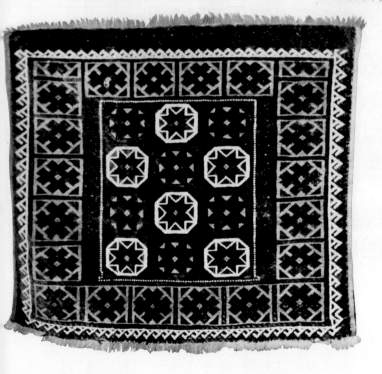

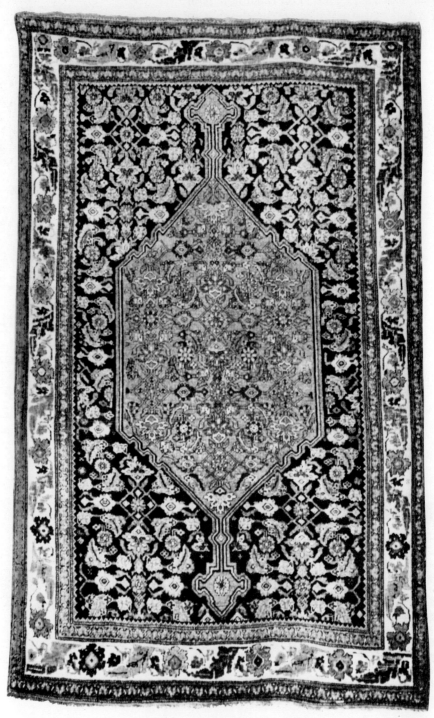

PLATE 18.   ANTIQUE BIJAR RUG. Persian Family. Size 7.6×4.8 feet.

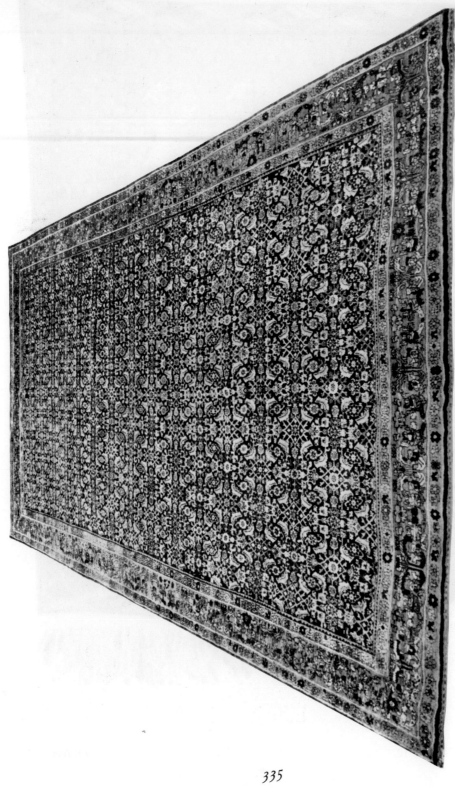

PLATE 19. SEMI-ANTIQUE BIJAR RUG. Persian Family. Size 8.6×14 feet. In recent years most Bijars have used the Feraghan design as shown in this rug.

335

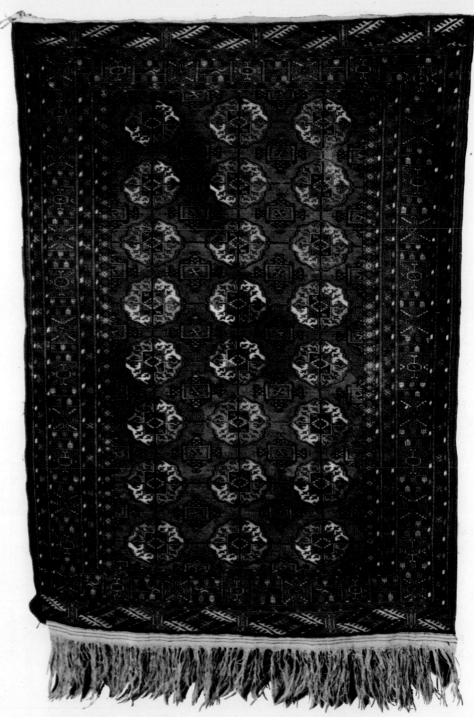

PLATE 20.   BOKHARA RUG. Iranian Family. Size 9 × 12 feet. This rug is made by Yomud tribes in the mountains of Northeast Iran. It is a new innovation since 1945. It is very much like the Tekke Rugs (Royal Bokharas) in design.

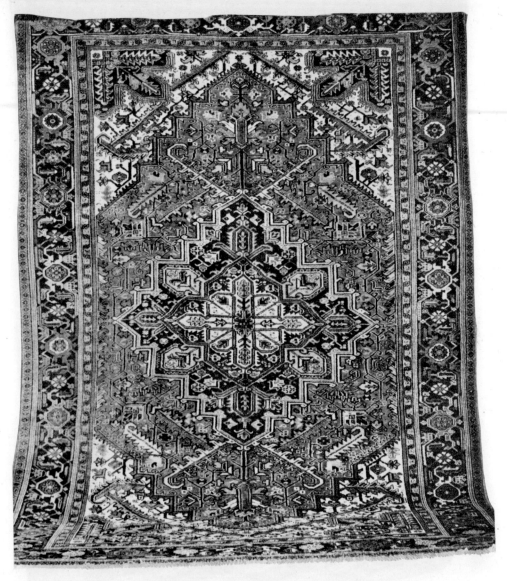

PLATE 21.   NEW HEREZ RUG. Iranian Family. Size approximately 6.3×9.4 feet.
Made in the town of Mehrevan. It is a so-called contract quality Herez rug.

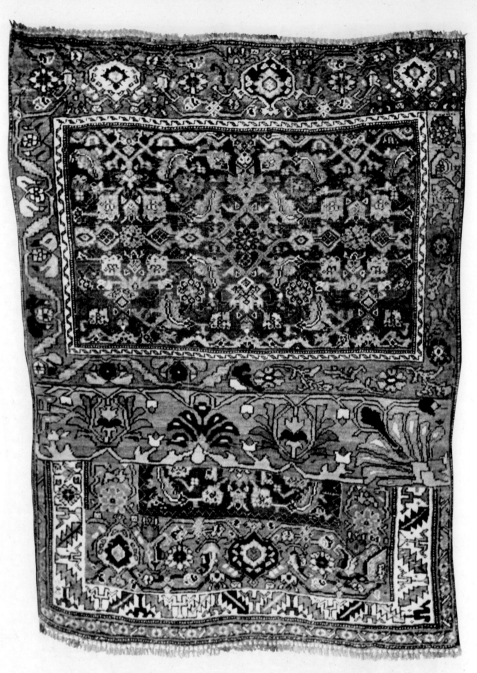

PLATE 22.   ANTIQUE BIJAR SAMPLER. Persian Family. Size 3.10 × 5.3 feet.

338

PLATE 23. NEW INGELES RUG. Iranian Family. Size 6.6×4.10 feet. This rug is typical in color and design (Feraghan design and turtle design in the border) to most Ingeles rugs. Only other design used is a small pear design.

PLATE 24. VASE CARPET. Persian (Jushagan) Rug. 16th century. Claret ground wool. (Courtesy of the Metropolitan Museum of Art, New York City. The James F. Ballard Collection. Gift of Mr. Ballard, 1922.)

PLATE 25.  BORCHALU RUG  Persian Family.  Size 6.10×4.8 feet.  We call these Ingeles, Bibikabads, and Sena-Kurds.

PLATE 26.  GOREVAN RUG. Persian Family. Size 8.6 ×11.3 feet. A limited number of Gorevans and Herez come in this angular floral design. Most Gorevans come in the design shown in Herez Plate 27.

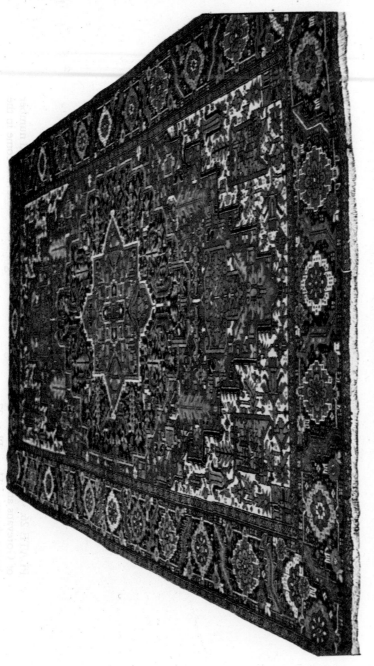

PLATE 27. SEMI-ANTIQUE HEREZ RUG. Persian Family. Medallion design. Corners and borders are typical of most rugs from the Herez district.

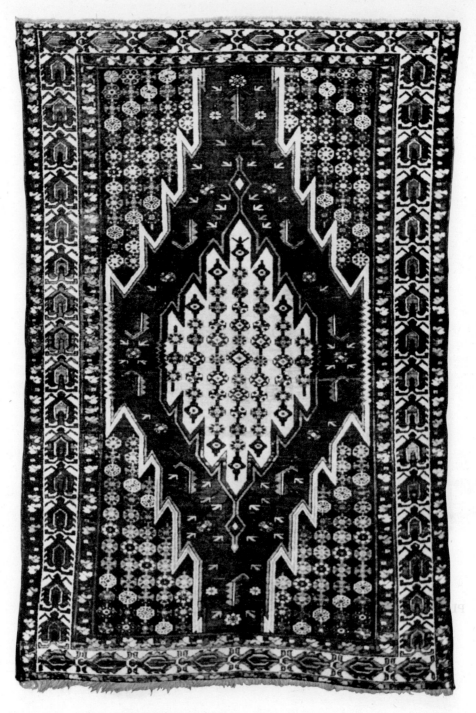

PLATE 28.   SEMI-ANTIQUE HAMADAN RUG. Persian Family. Size 4.6 × 6.7 feet.
This rug is from the Zarand district.

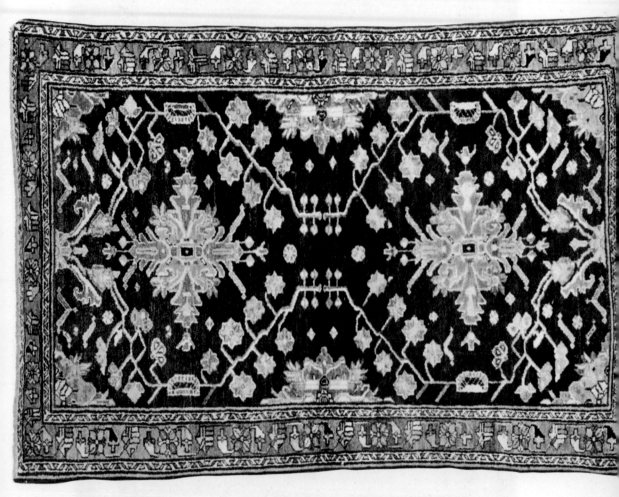

PLATE 29.  SEMI-ANTIQUE HAMADAN RUG. Iranian Family. Size 4.5 × 6.8 feet.

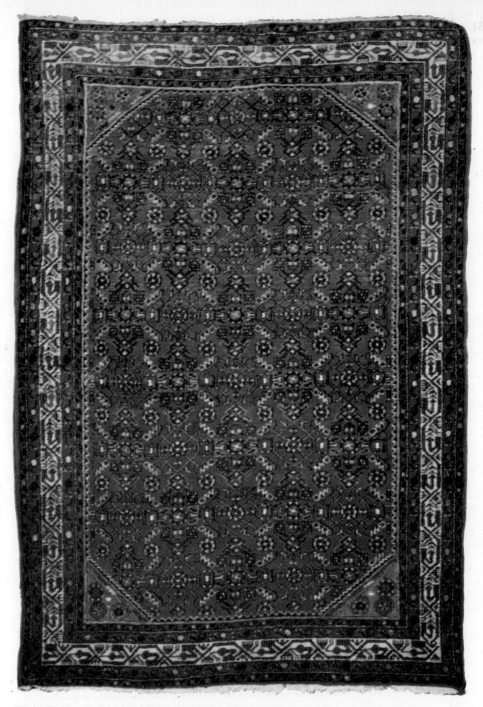

PLATE 30.  HUSIANABAD (HAMADAN) RUG. Iranian Family. Size 7×5 feet. Sixty percent of all new rugs from this district are in this design and colors. Herati (Feraghan) design covers the field. Angular vine and pear are used in the borders.

346

PLATE 31.  BAKRA RUG. Made in India. Size 6×9 feet. Moroccan design.

PLATE 32.  BAKRA RUG. Made in India. Size 6×9 feet. Moroccan design.

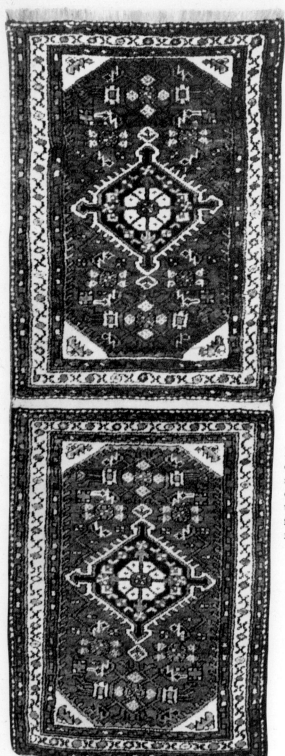

PLATE 33.  HAMADAN MATS. Iranian Family. Size of each mat approximately $2 \times 3$ feet. This illustrates how all small present-day mats are made together and then cut apart. All the effort over the years to get the weavers to leave enough space between mats to allow for sufficient fringe for each has been to no avail. Thousands of such mats are imported yearly.

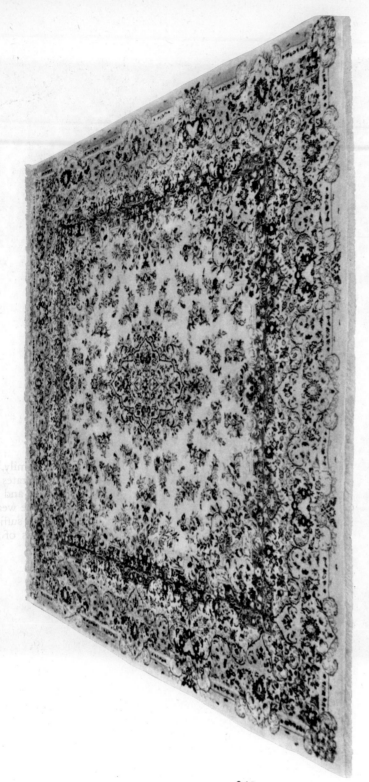

PLATE 34. NEW KASVIN CARPET. Persian Family. Approximately 10×12 feet. This carpet, like Plate 35, also has an ivory field. Until 1960, ninety-eight percent of these came with a bright red field.

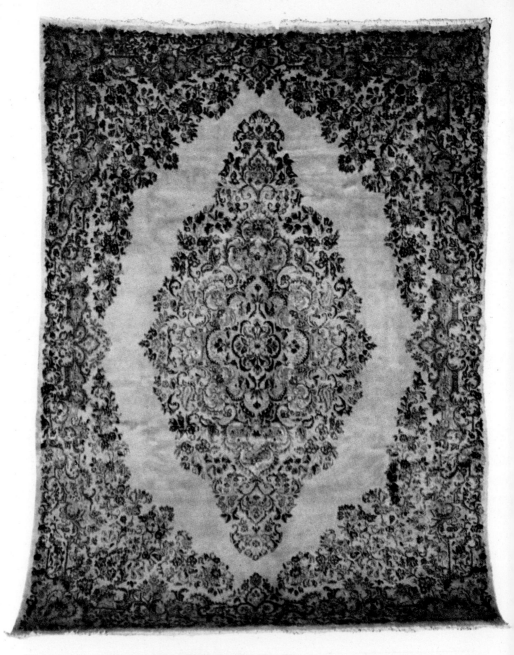

PLATE 35.   NEW KASVIN RUG. Iranian Family. Size 7.8 × 10.4 feet. Kasvins, which have for years been made in brilliant reds, are beginning to be made in colors and designs somewhat like the Kirmans. This rug has Kirman colors and Kirman designs.

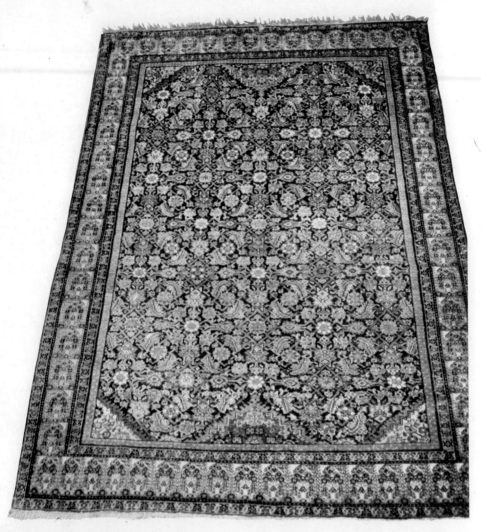

PLATE 36.   ANTIQUE FERAGHAN RUG. Persian Family. Size 4.5×5 feet.

351

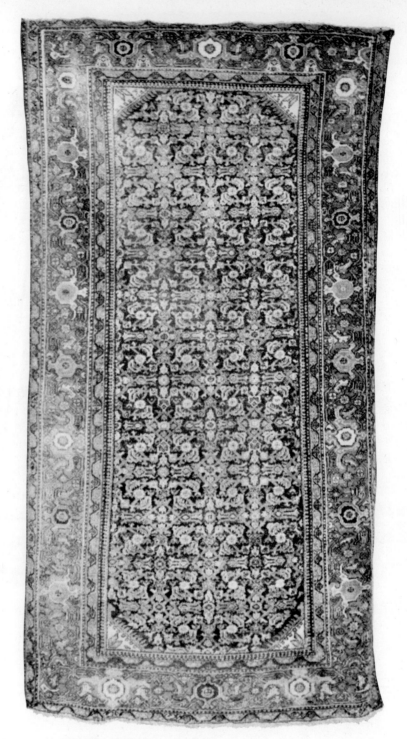

PLATE 37.   ANTIQUE FERAGHAN RUG. Persian Family. Size 6.10 × 3.8 feet.
Typical Feraghan (herati) design.

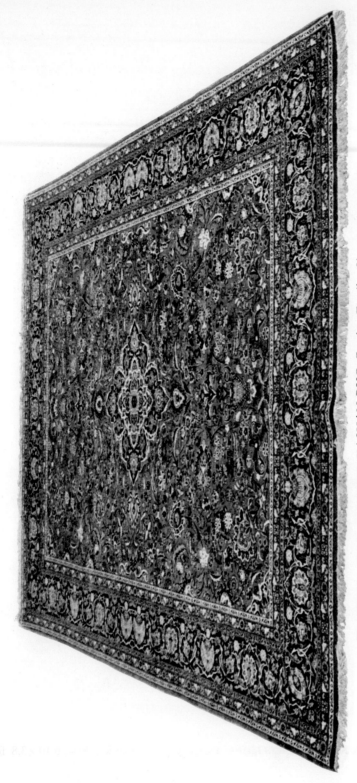

PLATE 38.   SEMI-ANTIQUE KASHAN RUG. Persian Family. Size approximately
10.6 × 14 feet.

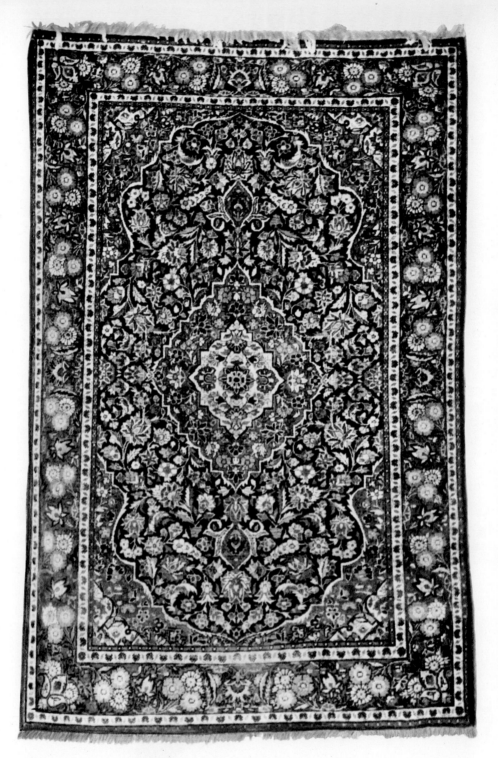

PLATE 39.   SEMI-ANTIQUE KASHAN RUG. Persian Family. Size approximately
4.6×6.6 feet.

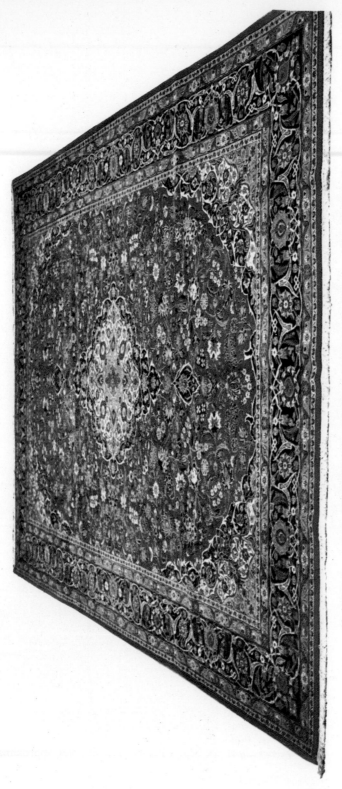

PLATE 40.  SEMI-ANTIQUE KASHAN RUG.  Persian Family.  Size 12×8.9 feet.
Typical and traditional design of fine Kashan rugs.

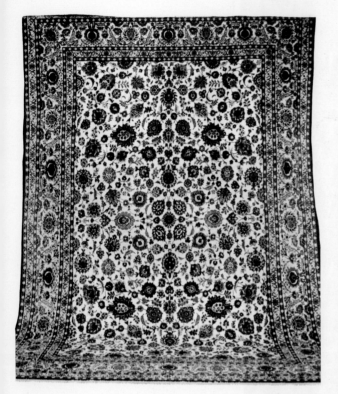

PLATE 41. NEW KASHAN RUG. Persian Family. Size approximately 9×12 feet. A very superior new rug in the old Shah Abbas designs as the principal motif.

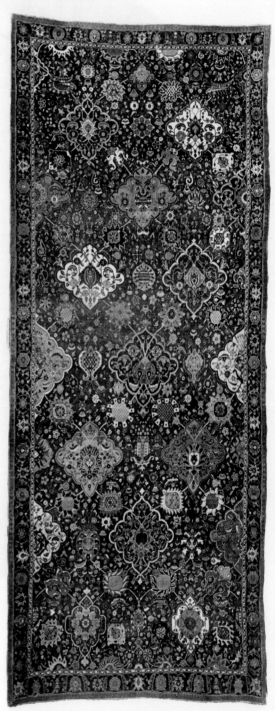

PLATE 42. VASE CARPET (so-called). Persian Family. Size 9.5×24.6 feet. Listed in the *Museum Guide* as Plate 12. Museum lists it as: "Woolen Carpet, red ground. Persian (Kurdistan) 18th century." The *Museum Guide* states: " . . . the vases have almost disappeared, occurring only once in a complete form and twice incomplete." The large, lobed and pointed compartments, palmettes, and floral stems cover the deep red ground. (Courtesy of the Victoria and Albert Museum, London, England.)

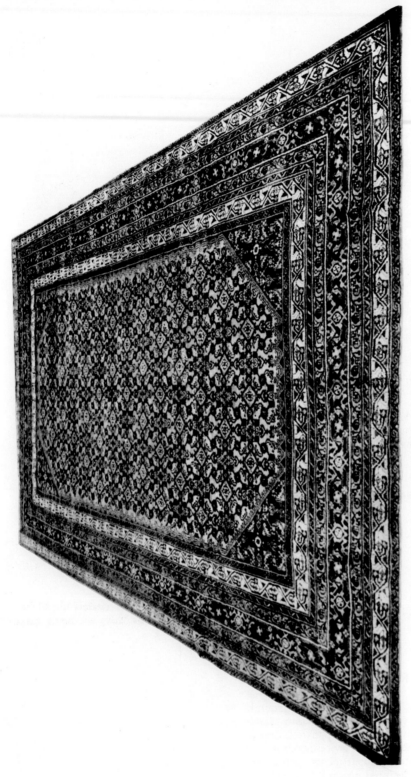

PLATE 43. NEW INGELES RUG. Iranian Family. Size 8.9×12 feet. A type that I have classed as Sena-Kurd. The field is red with a small Feraghan (herati) design. Very few are made in sizes as large as this rug.

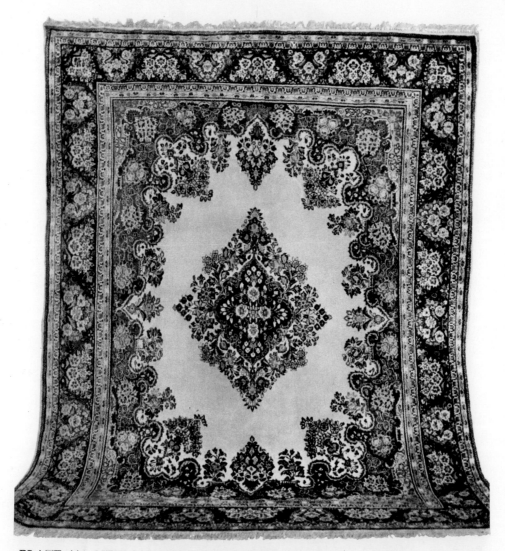

PLATE 44.   NEW SAROUK RUG. Iranian Family. Size approximaiately 8 × 10 feet.
So-called open ground Sarouk. This rug has an ivory field, but many are being made
with an open field for home use and the European market.

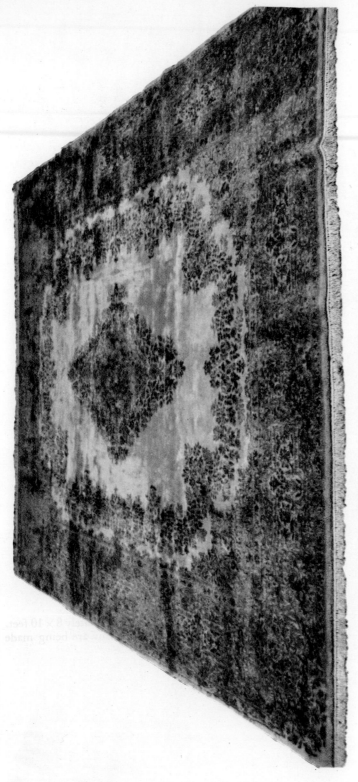

PLATE 45. NEW KIRMAN RUG. Persian Family. Size 9 × 12 feet. Typical modern Kirman with so-called medallion and open field design. The border is a combination of old, straight line and the so-called Aubusson border design. The silky sheen prevents more distinct outline of design and reproduction of color.

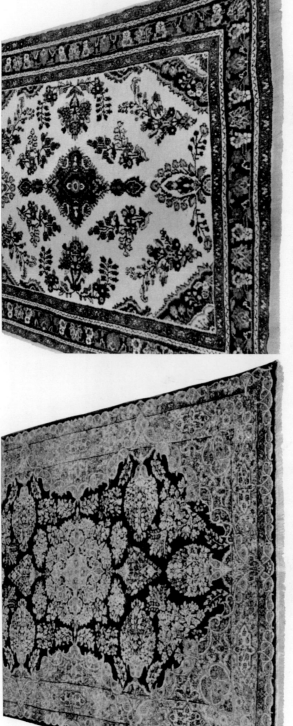

PLATE 47. NEW KABUTARHANG RUG. Iranian Family. Size 6×9 feet. This is a type of Hamadan rug.

PLATE 46. NEW KIRMAN RUG. Iranian Family. Size approximately 5×8 feet. This rug has a blue field, which is seldom seen today in America. Most of these rugs made in a design are in red. A popular design in Iran and Europe, but not in America.

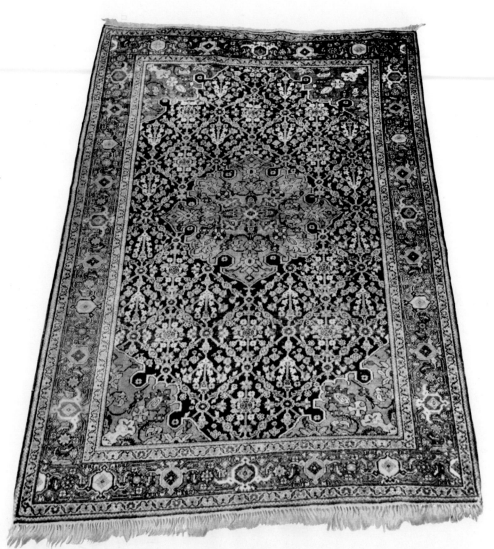

PLATE 48.   SEMI-ANTIQUE SAROUK RUG. Iranian Family.   Size 4.6×6.8 feet.
A blue field with a Guli-Henna design and a border with turtle and rosette design. Some
dealers call this a Temerez rug—but it is a cross between a Sarouk and a Feraghan in
both design and weave. Some in this design also come from the Malayer district.

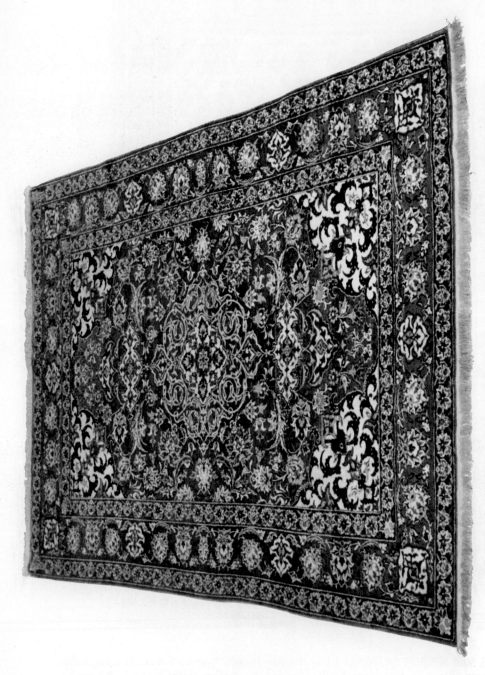

PLATE 49.  SEMI-ANTIQUE ISPAHAN RUG.  Persian Family.  Size 6.10×4.8 feet. This is the finely woven, short nap, real Ispahan.  Not to be confused with the thicker and habitually incorrect rug which is sold as a Ispahan.

362

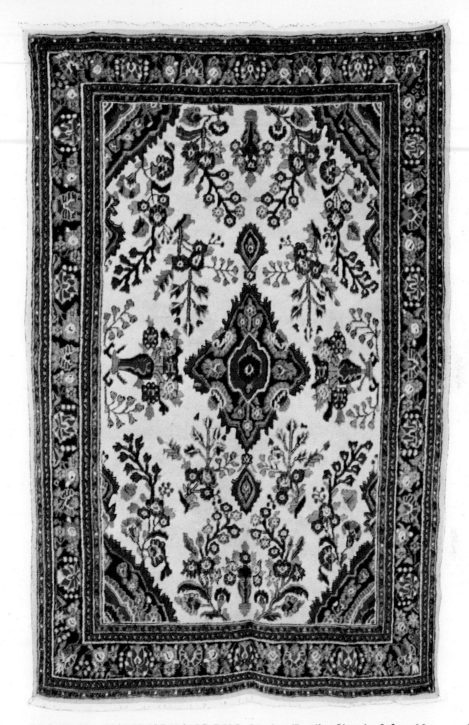

PLATE 50.   KABUTARHANG RUG. Iranian Family. Size 6×9 feet. New rug from the largest village by this name. Spelled many ways—often called Kapout. All are in carpet sizes—6×9 feet and larger—either in an ivory or bright red field.

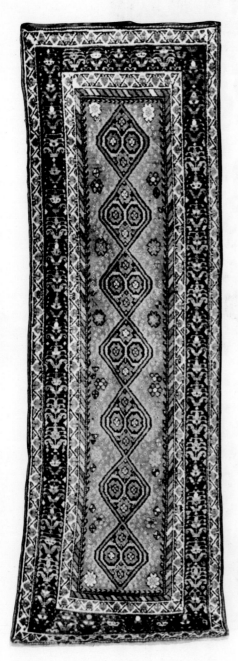

PLATE 51.   ANTIQUE KARAJE RUNNER. Persian
Family. Size 3.2 × 9.9 feet.

364

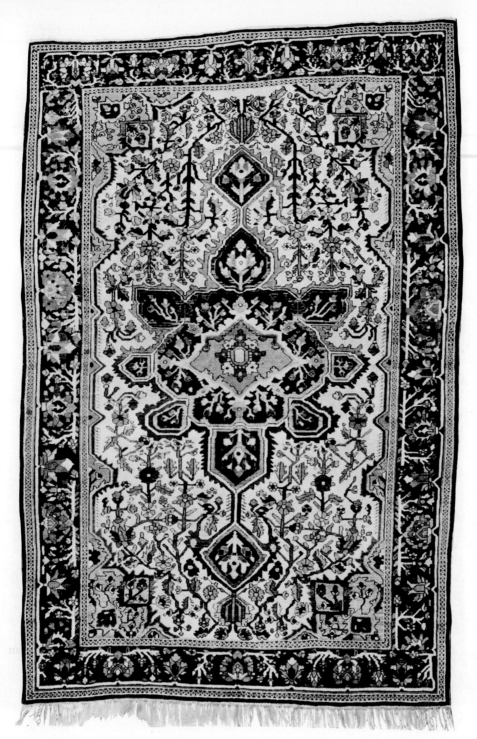

PLATE 52.   ANTIQUE SAROUK RUG. Persian Family. Size 4.6 × 6.6 feet. From the period 1890–1905.

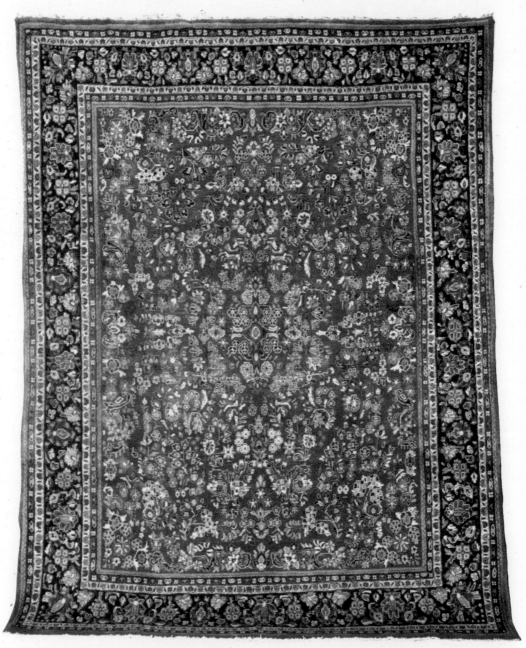

PLATE 53.  NEW SAROUK RUG. Iranian Family.  Size 8 × 10.4 feet.  Typical modern Sarouk with an all over floral design. The color of the field varies from a soft rose to a colorful red.

366

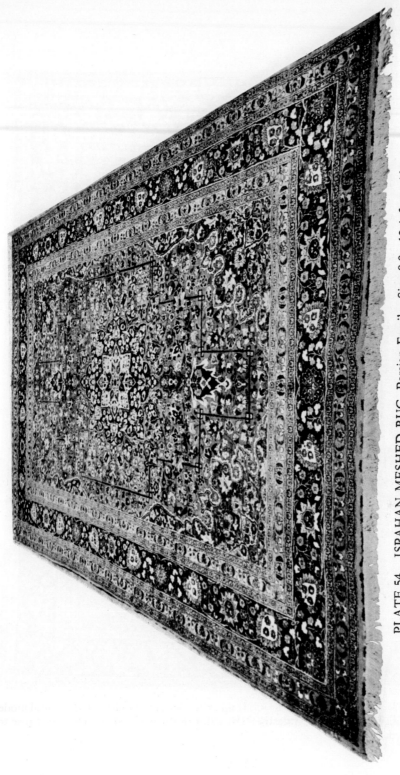

PLATE 54. ISPAHAN MESHED RUG. Persian Family. Size 8.8 × 12.4 feet. Also called Turkibaff. Turkibaff rugs are habitually sold as Ispahans by American dealers.

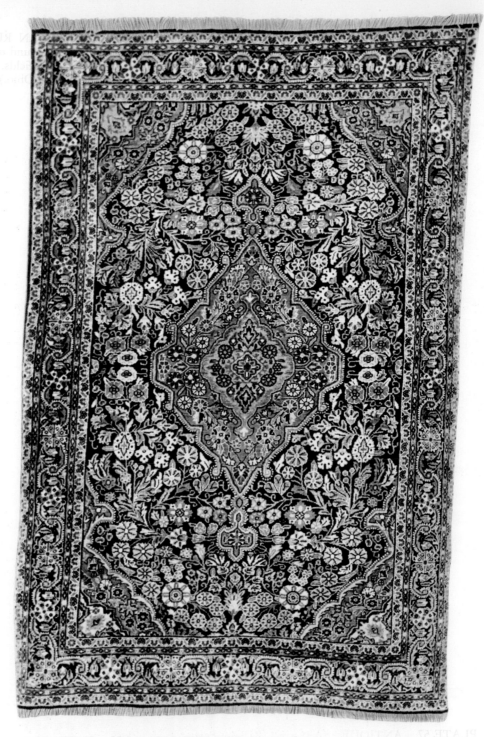

PLATE 55.   JOSAN SAROUK RUG. Persian Family. Size 5 × 3.6 feet.

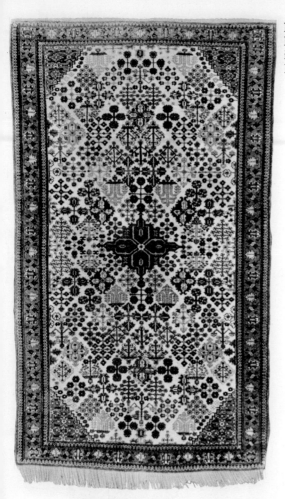

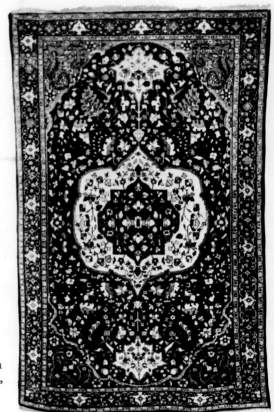

PLATE 56. ANTIQUE JOSHIGAN RUG. Persian Family. Size 3 × 5.3 feet. The background of this rug is ivory. All new Joshigans come in red fields. (Courtesy of Dr. and Mrs. E. R. Torrence, Troy, Ohio.)

PLATE 57. ANTIQUE SAROUK RUG. Persian Family. (Courtesy of Dr. and Mrs. E. R. Torrence, Troy, Ohio.)

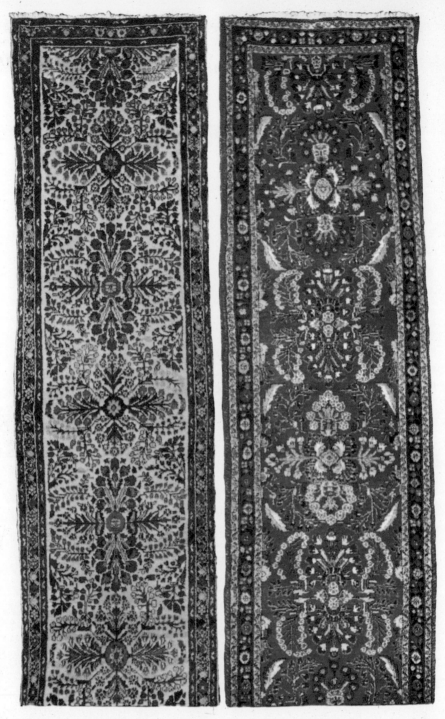

PLATE 58.  DERGEZIN RUNNERS. Iranian Family. These runners are invariably made in the two general colors and designs shown in this picture. The name of the runners comes from a district by this name near the city of Hamadan.

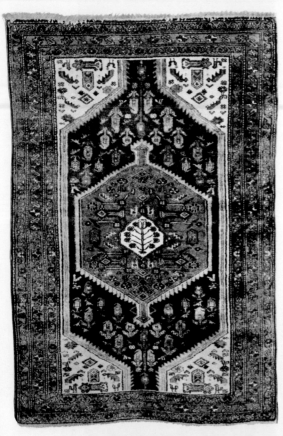

PLATE 59. SEMI-ANTIQUE HAMADAN RUG. Iranian Family. Size 4.6 × 6.6 feet.

PLATE 60. HAMADAN RUG. Persian Family. Size 6.8 × 4.8 feet. Typical pre-war Hamadan from one of the many villages near Hamadan. The field is in rose.

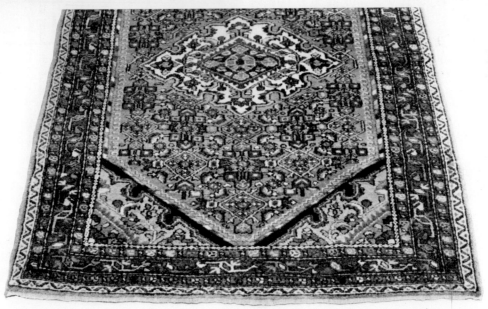

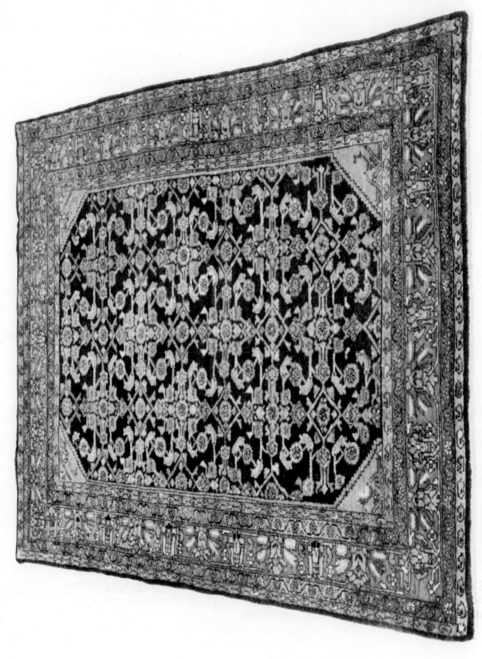

PLATE 61. HAMADAN RUG. Persian family. Size 6.6×4.7 feet. Typical pre-war Hamadan from one of the many villages near the city. The field of this rug is blue.

372

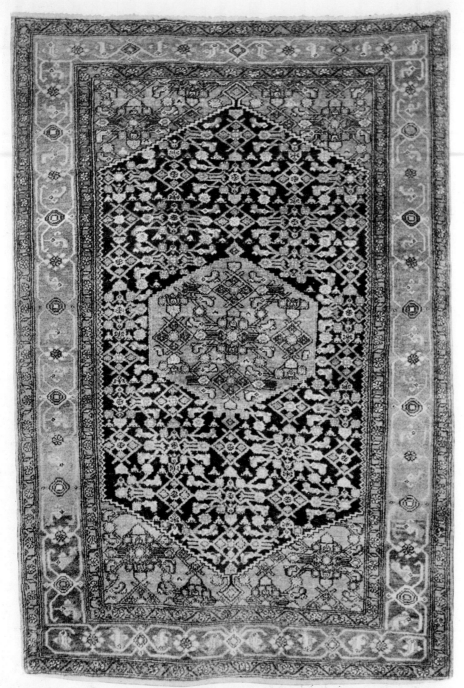

PLATE 62.   SEMI-ANTIQUE HAMADAN RUG. Persian Family. Size 4.6 × 6.8 feet.
The general design in the so-called Hearth design. Herati design covers the entire field.
Turtle and rosette designs appear in the main border.

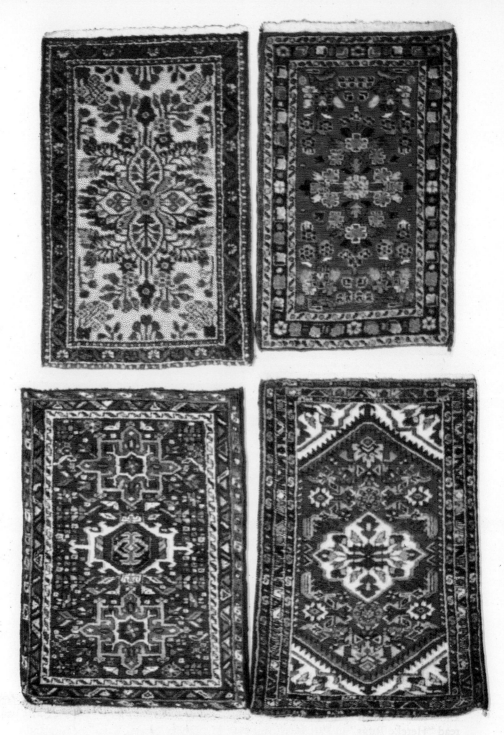

PLATE 63. HAMADAN MATS. Persian Family. Size approximately 2×3 feet. The upper two mats are Dergezins (Hamadan district). The mat at the lower left is a Hamadan, while the lower right is a Karaja. Seventy-five percent of all mats in this size are also in these four general designs.

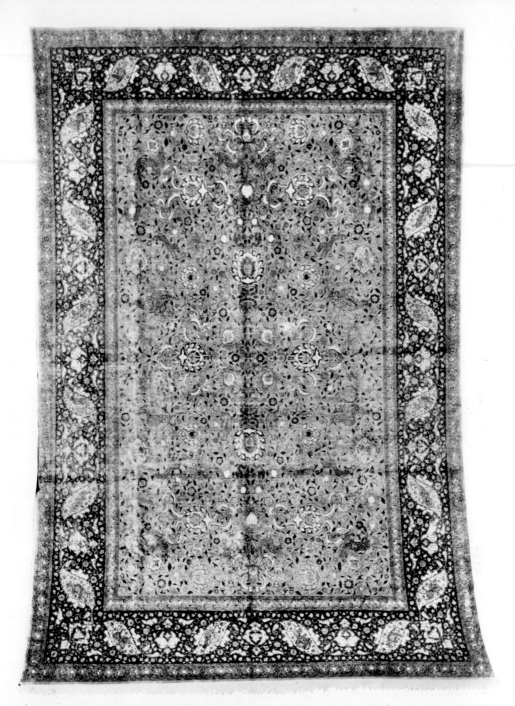

PLATE 64.    SILK HEREKE RUG. Made in Turkey. The rug has approximately 800 knots to the square inch—thus making it one of the finest rugs ever woven. For details, read "Hereke Rugs" in Part II. (Loaned by Mr. Henry Norell, London, England.)

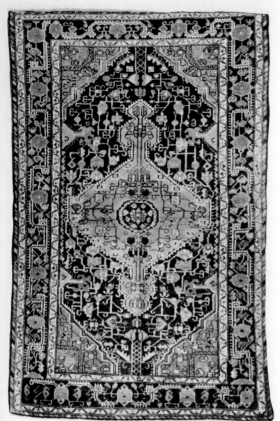

PLATE 65.   HAMADAN RUG. Persian Family. Size
6.8×4.6 feet. A village rug. The technical name in the
Hamadan market is Tuisakhan rug.

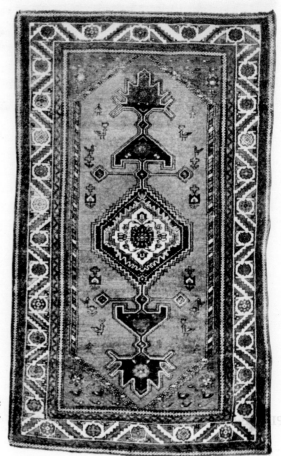

PLATE 66.   HAMADAN RUG. Persian Family. Size
7×4.6 feet. The technical name is Bergendeh rug, Tuisak-
han district.

PLATE 65. HAMADAN RUG. Persian Family. Size 6.8 x 4.6 feet. A village rug. The technical name in the Hamadan market is Tuisakhan rug.

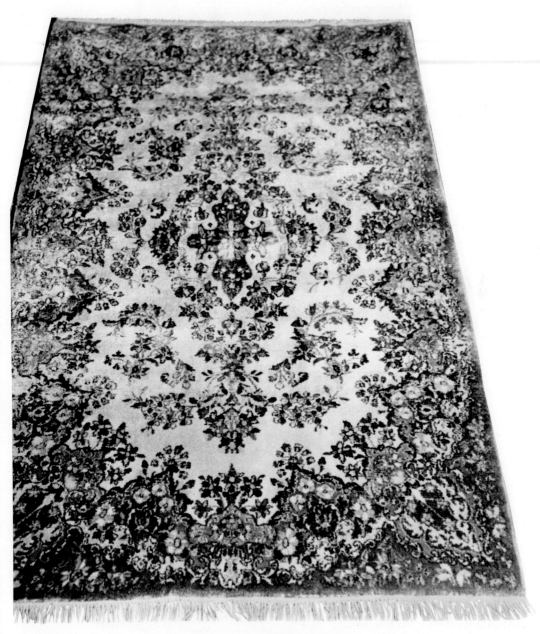

PLATE 67.   NEW KIRMAN RUG. Persian Family. Size 7.2 × 4.4 feet.

PLATE 68.   ANTIQUE MIR-SARABEND RUG. Persian Family.  Size 5.4×11.8 feet. (Courtesy of Mr. José Merhy Curitiba, Parana, Brazil.)

PLATE 69. LILLIHAN RUG. Iranian Family. Size 4.10 × 6 feet. A typical Lillihan of the 1922–1935 period. The high, artificial sheen resulting from the chemical washing, prevents a clear photograph.

PLATE 70. KERMANSHAH RUG. Persian Family. Size 7 × 4.6 feet. This rug is also called a Kirman in Kermanshah design.

PLATE 71. ANTIQUE KHURASAN RUG. (Also spelled Khorassan.) Persian
Family. Size 3.6 × 5.6 feet.

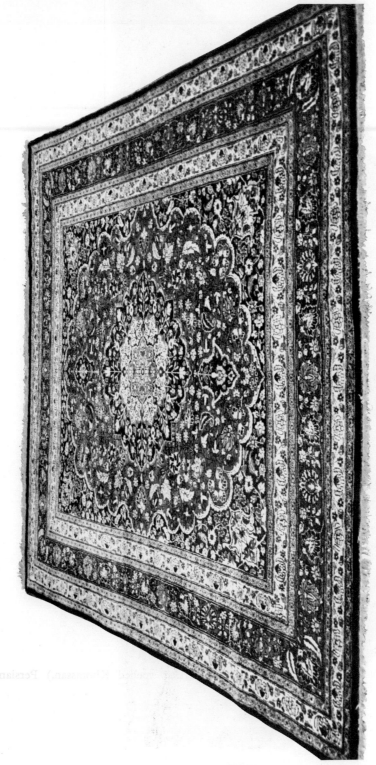

PLATE 72.   KHORASSAN or MESHED RUG. Persian Family. Size 13.7 × 10.8 feet.

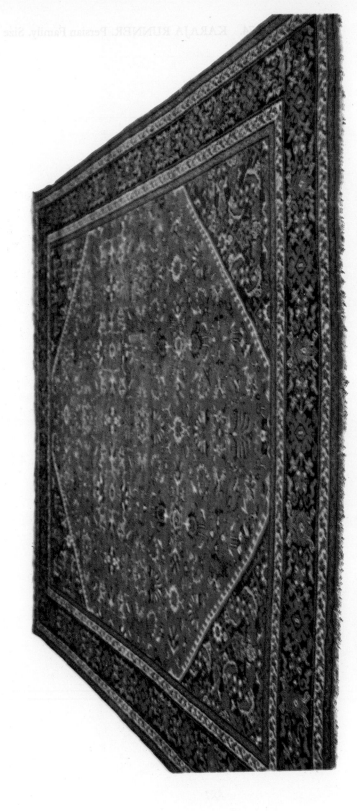

PLATE 73. ANTIQUE SULTANABAD RUG. Persian Family. Size 10.9 ×14 feet. Traditional design in field and border is found in these rugs. (The city of Sultanabad is now called Arak.)

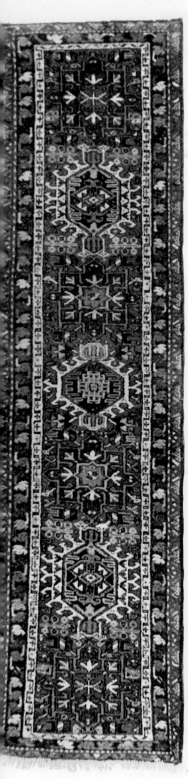

PLATE 74.   KARAJA RUNNER. Persian Family. Size
8.6 × 2.4 feet.

PLATE 75.   KARAJA RUG. Persian Family. Size 4.10
× 6.2 feet.

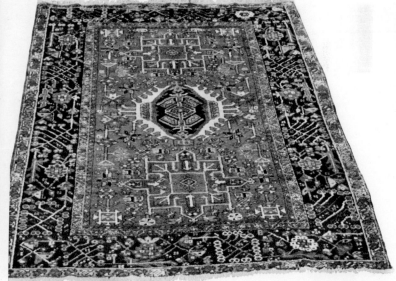

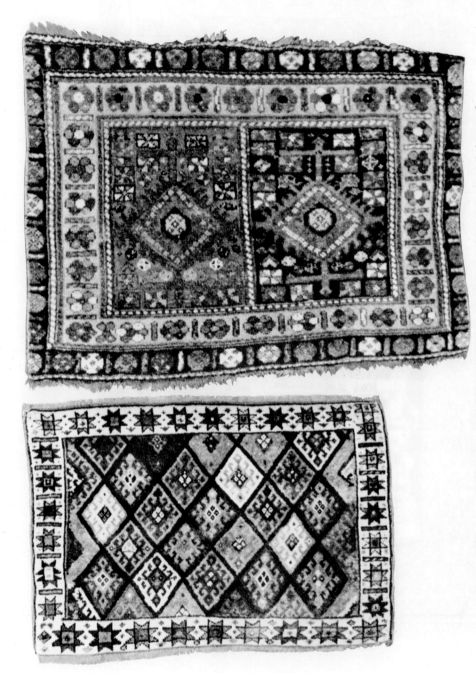

PLATE 76. ANTIQUE KURDISTAN RUGS. Persian Family. Sizes 2×2.9 feet and 2.6×3.5 feet. Both are fronts of old, large saddlebags. The larger mat is often called a Bahktiari.

384

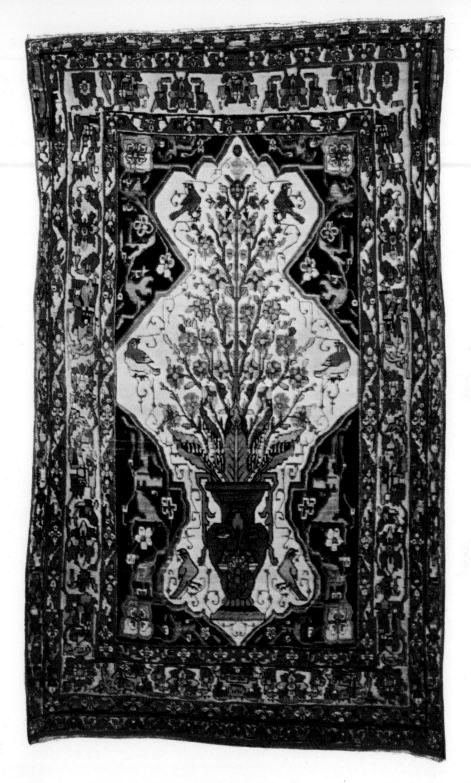

PLATE 77. LAVER KIRMAN RUG. Persian Family. Size 7×4.5 feet. (Courtesy of Dr. and Mrs. E. R. Torrence, Troy, Ohio.)

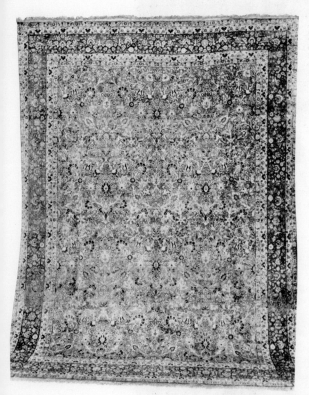

PLATE 78.   KIRMAN OF THE CLASSIC PERIOD.
Persian Family. Size approximately 9×12 feet. This rug
was made prior to World War II.

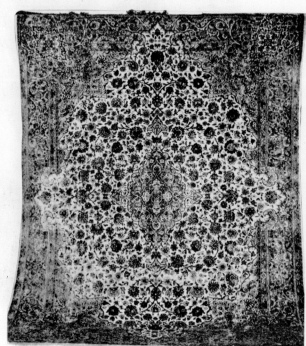

PLATE 79.   KIRMAN OF THE CLASSIC PERIOD.
Persian Family. Size approximately 9×12 feet.

PLATE 78. KIRMAN OF THE CLASSIC PERIOD.
Persian Family. Size approximately 9 × 12 feet. This rug
was made prior to World War II.

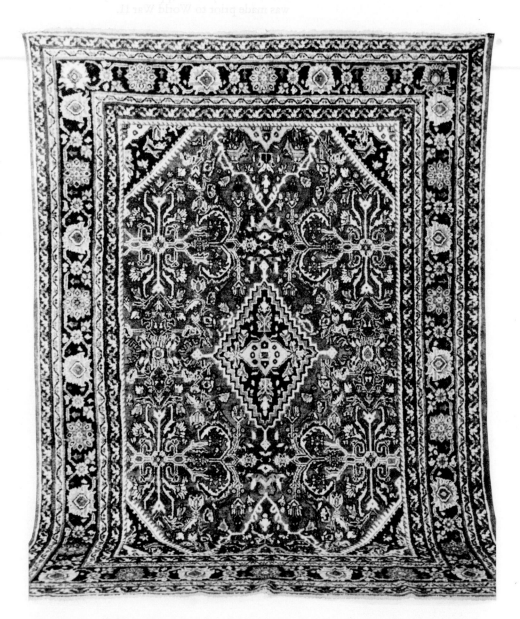

PLATE 80. NEW MAHAL RUG. Iranian Family. Size 9×12 feet. Four different types often use the design shown in this rug with some variations in each. The field is invariably rose to red.

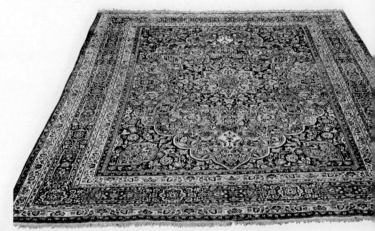

PLATE 81.  MESHED CARPET. Persian Family. Size 10.6 × 13.6 feet. Same general design is used by different qualities of rugs made in the Khurasan district: from the low Birjand quality to the best Turkibaff quality.

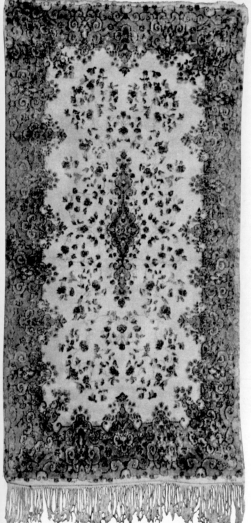

PLATE 82.  NEW KIRMAN RUG. Persian Family. Size approximately 3 × 5.10 feet.

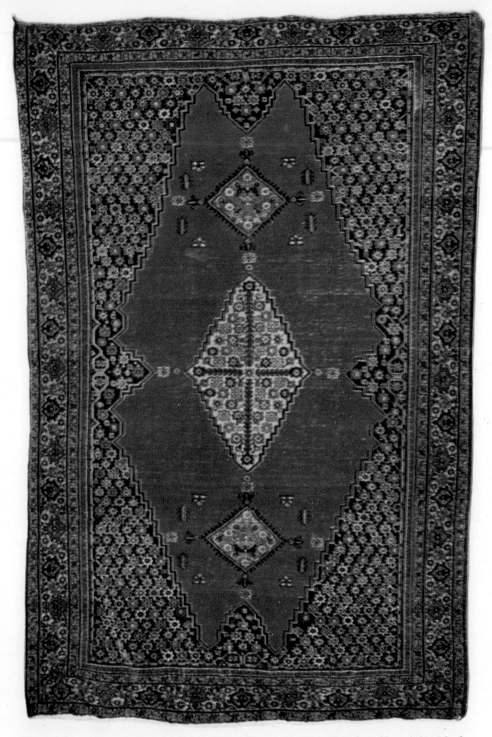

PLATE 83.   ANTIQUE FERAGHAN RUG. Persian Family.   Size 6.6×4.2 feet.
(Courtesy of Professor Robert Fisher, Blacksburg, Virginia.)

PLATE 84. SEMI-ANTIQUE SHIRAZ RUG. Persian Family. Approximately 6.6×5 feet. Clusters of roses in the field show French influence.

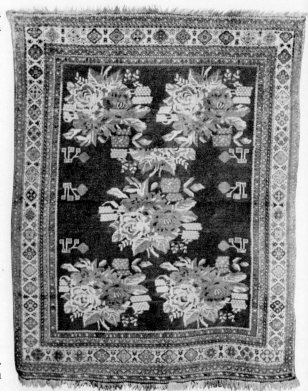

PLATE 85. SULTANABAD RUG. Persian Family. Size 11.8×17.3 feet. The Mustaphi design, shown here on a blue field, is one of the oldest designs.

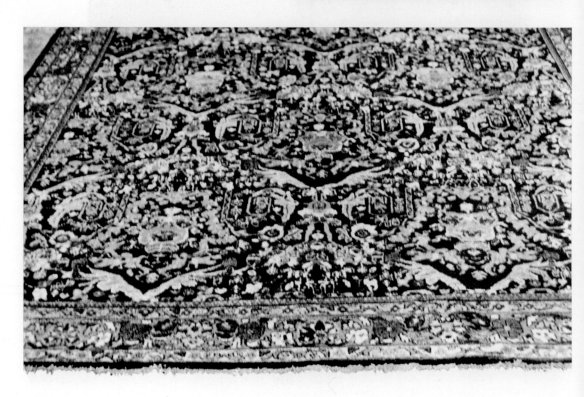

PLATE 84. SEMI-ANTIQUE SHIRAZ RUG. Persian
Family. Approximately 6.6 x 5 feet. Clusters of roses in
the field show French influence.

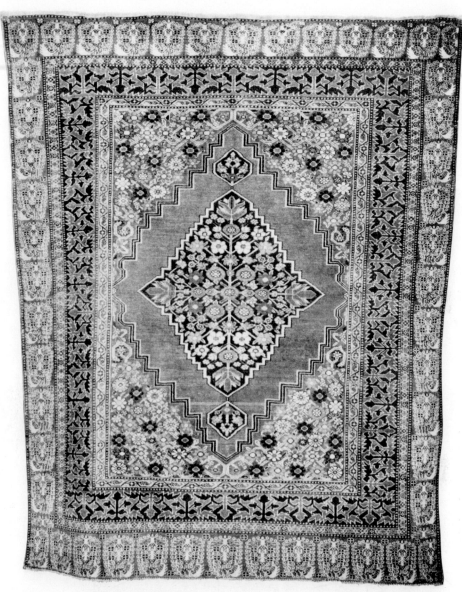

PLATE 86.   ANTIQUE FERAGHAN RUG. Persian Family. Size 4.3 × 5.3 feet.
(Courtesy of Mrs. Robert V. Deverian, Rochester, New York.)

PLATE 87.   OLD TABRIZ RUG. Persian Family. Size 12.4×22.2 feet. One of the few rugs that have closely duplicated the design and colors of the world's most famous and valuable rug, The Ardabil Mosque Carpet in the Victoria and Albert Museum, London, England. (Courtesy of Mr. and Mrs. J. M. Moses, Hamilton, New York.)

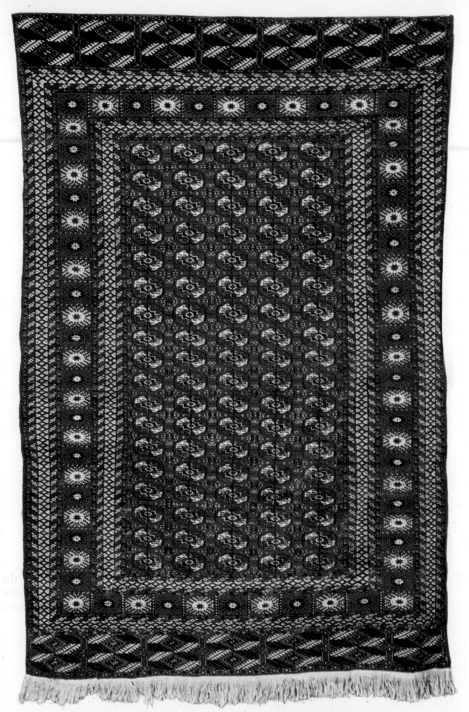

PLATE 88.   MORI RUG—TEKKE RUG. From West Pakistan. Size 6 × 9 feet. A very
fine new rug using Cashmere wool and in the typical Tekke Bokhara design. Also called
Royal Bokhara design.

*393*

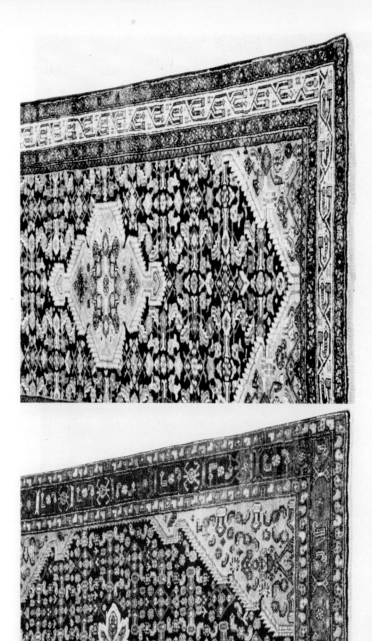

PLATE 89. SEMI-ANTIQUE SENA-KURD RUG. Iranian Family. Size 4.9 × 6.10 feet. An adaptation of the herati design covers the entire field. An excellent rug from one of the villages in the vicinity of Hamadan.

PLATE 90. SEMI-ANTIQUE SENA-KURD RUG. Iranian Family. Size 4.7 × 7 feet. Made in a village near the city of Hamadan. Known to the trade in Iran as a Tajabad, the district where it is made.

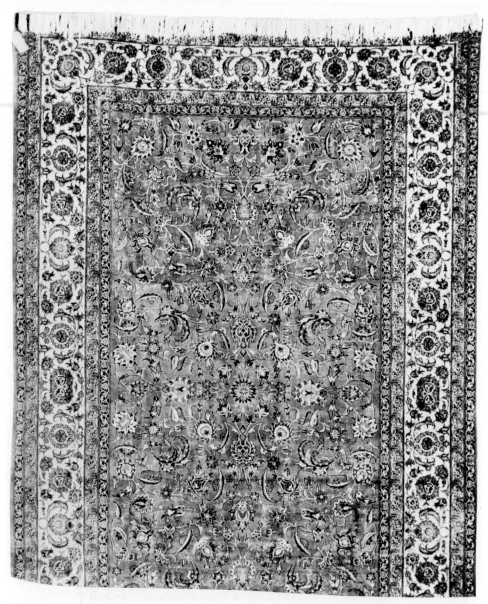

PLATE 91.   NEW NAIN RUG. Iranian Family. Size 7.3 × 11.3 feet.

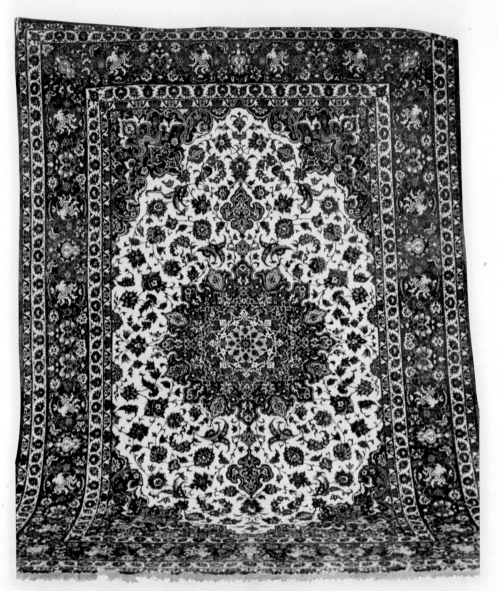

PLATE 92.   NAIN RUG. Iranian Family. Size approximately 9 × 12 feet.

PLATE 93.   ANTIQUE SENA RUG. Persian Family. Size 6.5 × 4.2 feet. Also can be spelled Senna and Senneh. This rug has a silk warp. (Courtesy of Professor Robert Fisher, Blacksburg, Virginia.)

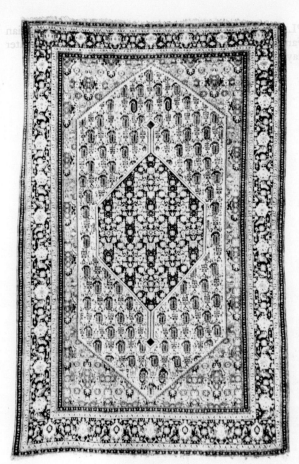

PLATE 94. ANTIQUE SENA RUG. Persian Family. Size 4.2×6.7 feet. A gold field with a diamond center combining the pear design over the field with the Feraghan (herati) design in the center and corners. This rug has a silk warp.

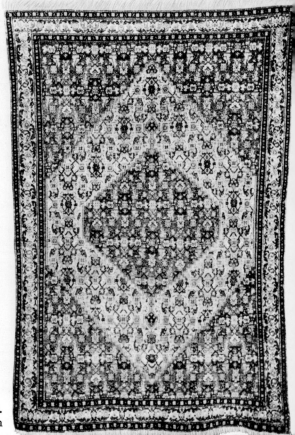

PLATE 95. ANTIQUE SENA RUG. Persian Family. Size 4.5×6.6 feet. A diamond center rug with a Feraghan (herati) design as the only motif. Typical turtle design appears in the border. This rug also has a silk warp.

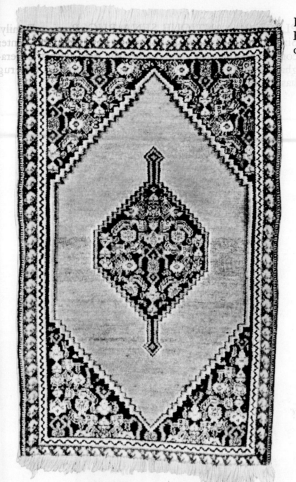

PLATE 96. SEMI-ANTIQUE SENA RUG. Persian Family. Size 2×3 feet. This design has been used in later day Senas made in sizes 2×3 and 5×3.6 feet.

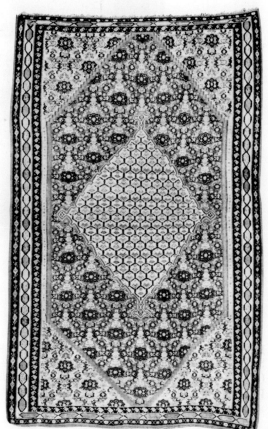

PLATE 97. SENA-KELIM RUG. Persian Family. Size 6.11×4.4 feet. (Courtesy of Mr. William G. Thompson, Hudson, Michigan.)

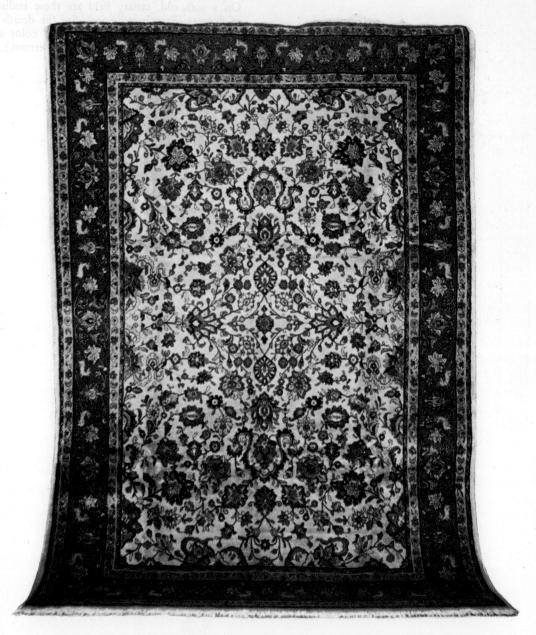

PLATE 98.  NEW SAROUK IN ANTIQUE DESIGN. Persian Family. Size 8×11 feet. This Sarouk in antique design—the design of some classical rugs of the 16th century —is entirely different from the typical American-type Sarouk with its rose or red field.

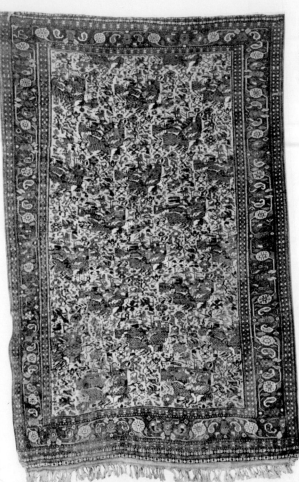

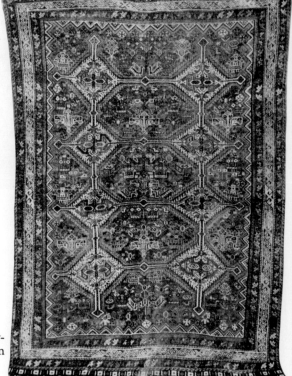

PLATE 99. ANTIQUE SHIRAZ RUG. Persian Family. On a soft, old, canary field are these realistic clusters of flowers (French influence). See the details in Part II. I have seen only three rugs in this color and design. (Courtesy of Mr. and Mrs. Carl Zimmerman.)

PLATE 100. SEMI-ANTIQUE SHIRAZ RUG. Persian Family. Size 4.9 × 6.5 feet. A typical Shiraz rug from the Khamseh tribes (from the area North of Shiraz).

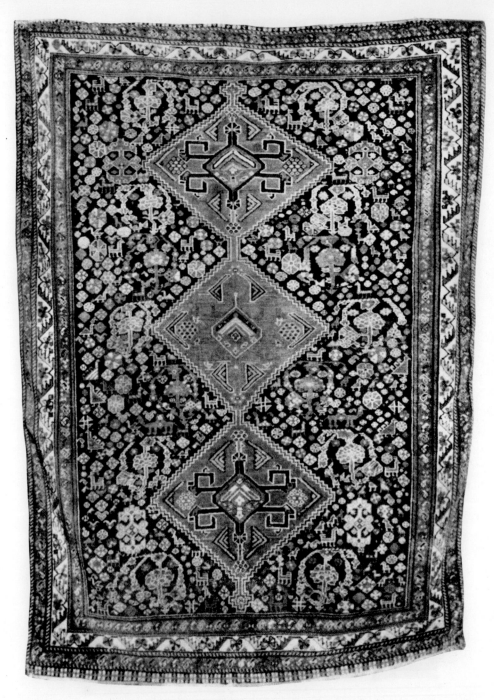

PLATE 101.   ANTIQUE SHIRAZ RUG. Persian Family. Size 5×6.5 feet. This is the old, rare type of Shiraz which was a collector's delight fifty years ago. Probably woven by a member of the Basiri tribe or by Arab women of the Khamseh tribes. Basiri is a sub-division of the Khamsehs

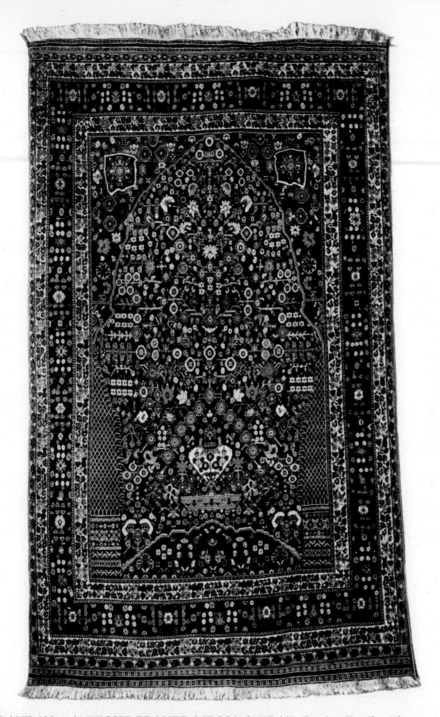

PLATE 102. ANTIQUE PRAYER MECCA SHIRAZ. Persian Family. The correct technical name is "Quashqai Prayer Rug." This rug is an almost exact mate of color plate xvii opposite page 168 in Mumford's first edition of 1900. This rug is believed to have been woven by the same weaver as the Mumford rug. For details see Mecca Shiraz. (Property of the author.)

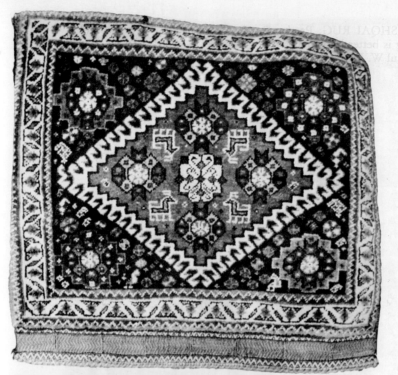

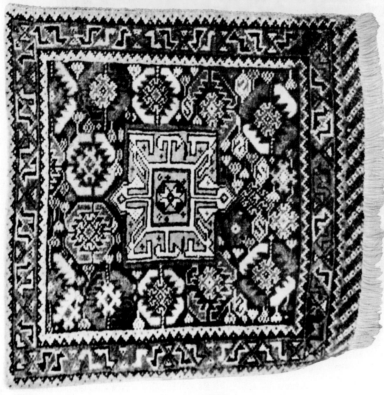

PLATE 103. ANTIQUE SHIRAZ RUGS. Persian Family. Sizes each about 26×26 inches. These are fronts of old saddlebags. The designs are typical Shiraz designs.

404

PLATE 104. QUASHQAI RUG. Persian Family. Size 7.4×5 feet. This rug is better known as a Mecca Shiraz. (Courtesy of Mrs. Paul W. Bentz, Akron, Ohio.)

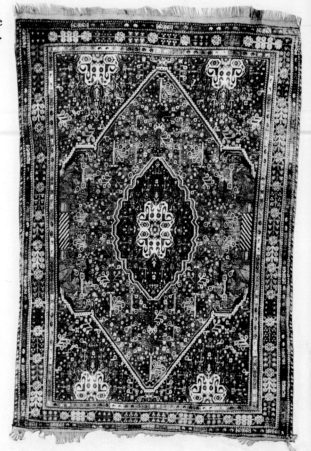

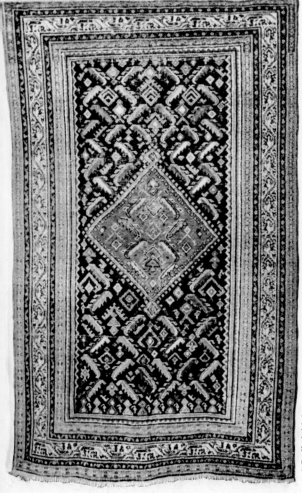

PLATE 105. ANTIQUE MIR-SARABEND RUG. Persian Family. Size 3×4.8 feet. This is the design occasionally found in some of the choicest old Mir-Sarabends. (Courtesy of Mr. and Mrs. Clarence Miller, Elmira, New York.)

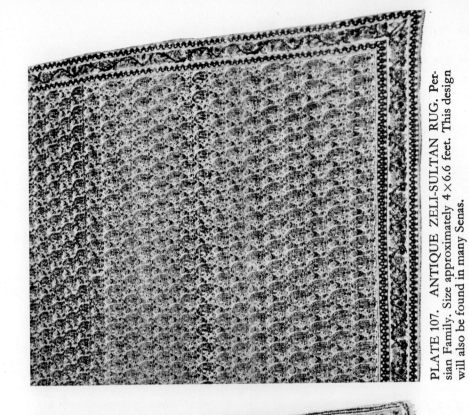

PLATE 107. ANTIQUE ZELI-SULTAN RUG. Persian Family. Size approximately 4×6.6 feet. This design will also be found in many Senas.

PLATE 106. ANTIQUE SARABEND RUG. Persian Family. Size 5×9 feet. Has typical Sarabend pear design and typical Sarabend border designs.

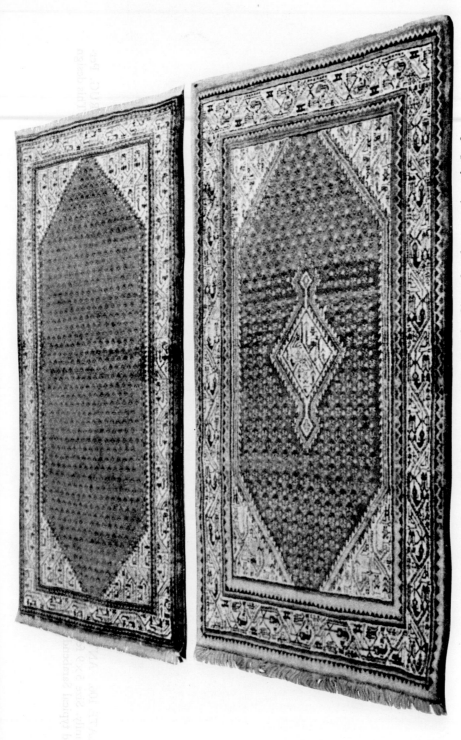

PLATE 108. SARABEND RUGS. Iranian Family. Size of each approximately 5×3 feet. Later day Sarabends employ the above designs almost invariably on a rose or red field.

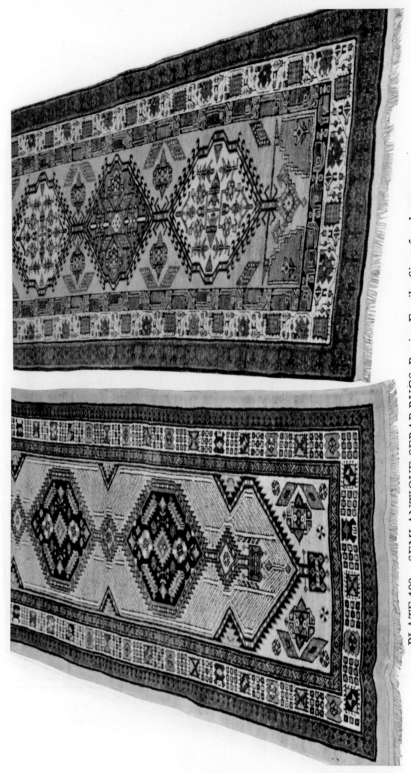

PLATE 109. SEMI-ANTIQUE SERAB RUGS. Persian Family. Size of each approximately 3.2 × 8 feet. Also spelled Sarab. These are the two designs on a camel hair pile and natural tan in which this rug is made.

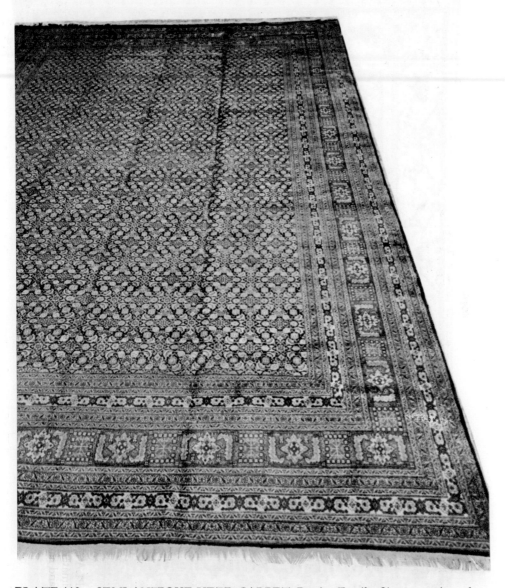

PLATE 110.   SEMI-ANTIQUE YEZD CARPET. Persian Family. Size approximately
11 × 16 feet.

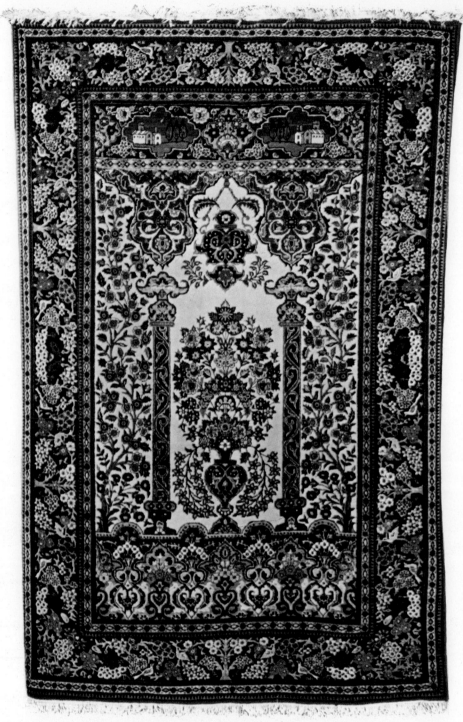

PLATE 111.   SEMI-ANTIQUE PRAYER KASHAN. Persian Family. Size 6.6×4.5 feet. (Courtesy of Dr. and Mrs. Edward L. Askren, Atlanta, Georgia.)

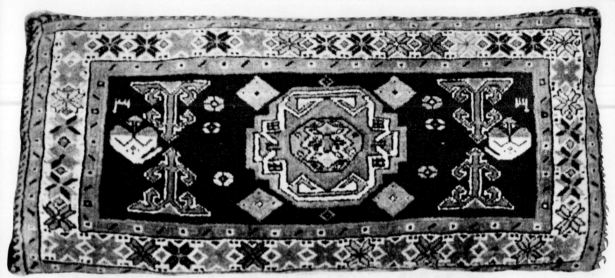

PLATE 112. ANTIQUE VARAMIN RUG. Persian Family. Size 1.1 × 3.2 feet. This is the front of an old pillow. This very choice type has been called Bahktiari in America for the past 37 years.

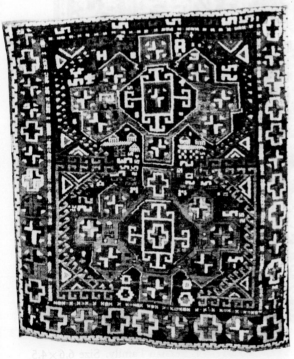

PLATE 113. ANTIQUE BERGAMO RUG. Turkish Family. Size 4.9 × 5.4 feet.

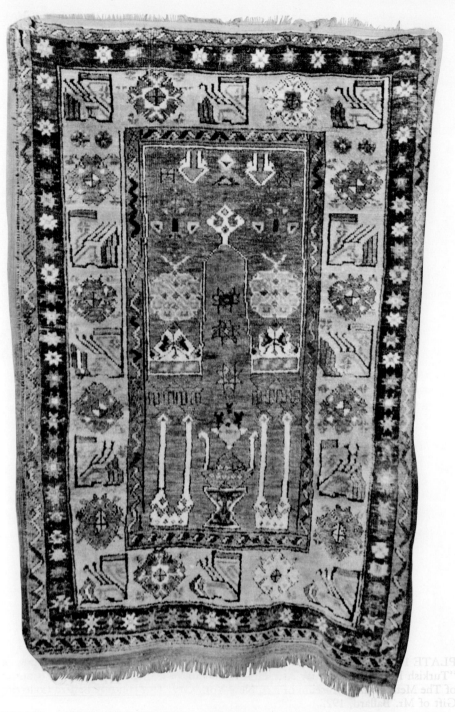

PLATE 114.   KONIA PRAYER RUG. Turkish Family. Colors are tawny rose, tans, cream, and lesser amounts of soft green and blues.

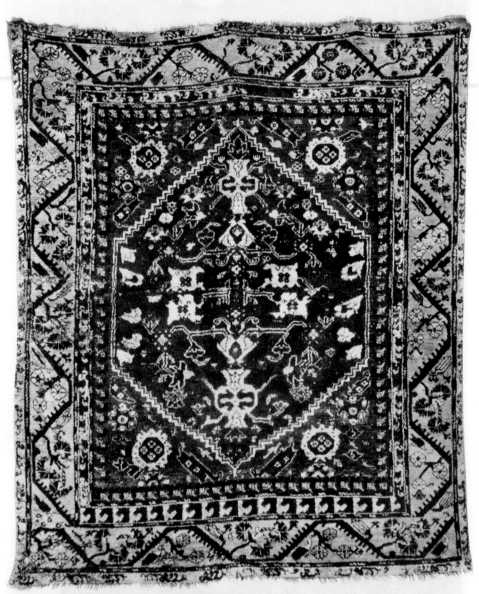

PLATE 115.  ANTIQUE TURKISH RUG.  Turkish Family.  Museum listing is: "Turkish Rug, 18th century.  Asia Minor: Bergamo or Konia.  Rug. Wool." (Courtesy of The Metropolitan Museum of Art, New York City.  The James F. Ballard Collection. Gift of Mr. Ballard, 1922.)

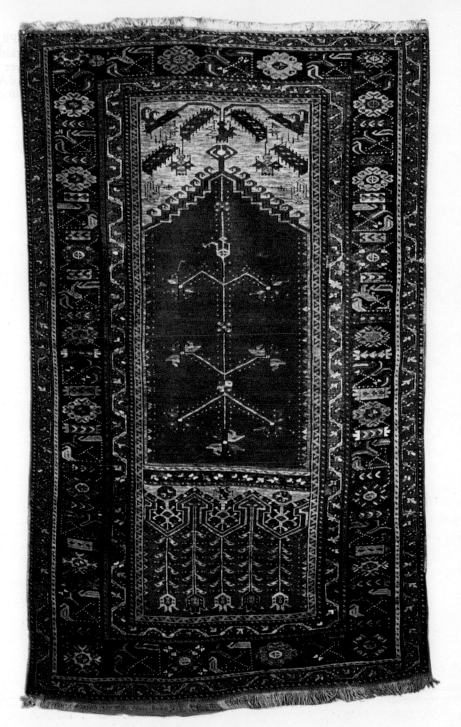

PLATE 116.   ANTIQUE PRAYER LADIK RUG. Turkish Family. Size 6.2×3.10 feet. (Courtesy of Professor Robert Fisher, Blacksburg, Virginia.)

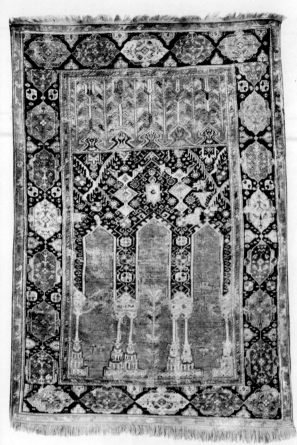

PLATE 117. ANTIQUE TURKISH PRAYER RUG.
Turkish Family. Museum listing: "Turkish Rugs 17th–
18th century. Asia Minor: Ladik. Prayer Rug: Wool."
(Courtesy of The Metropolitan Museum of Art, New York
City. The James F. Ballard Collection. Gift of Mr. Ballard,
1922.)

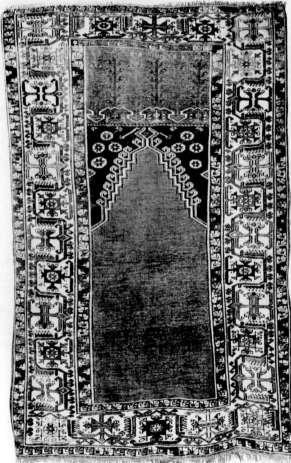

PLATE 118. ANTIQUE PRAYER LADIK RUG.
Turkish Family. Size 3.6 × 5.5 feet.

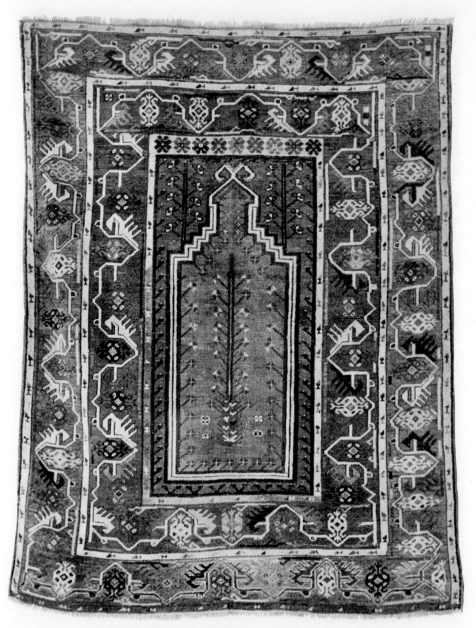

PLATE 119.   ANTIQUE PRAYER MELEZ RUG. Turkish Family. Size 3.7 × 4.8 feet.

416

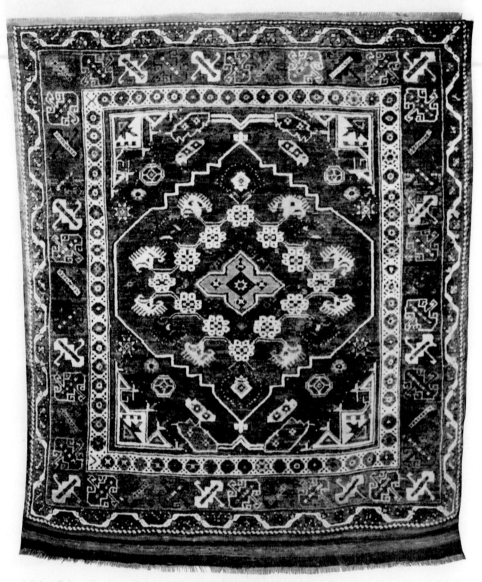

PLATE 120.   ANTIQUE BERGAMO RUG. Turkish Family. Size 5 × 4.8 feet.

417

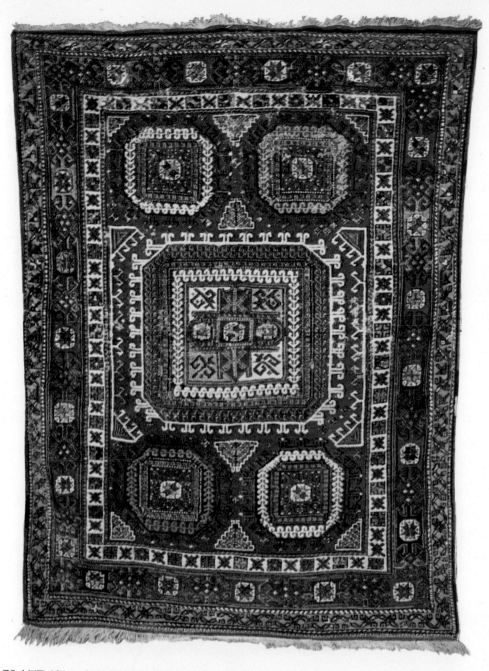

PLATE 121.   ANTIQUE BERGAMO RUG.  Turkish Family.  Size  6.10 × 5.2  feet.
(Courtesy of Mr. Stuart Sherar, Houston, Texas.)

418

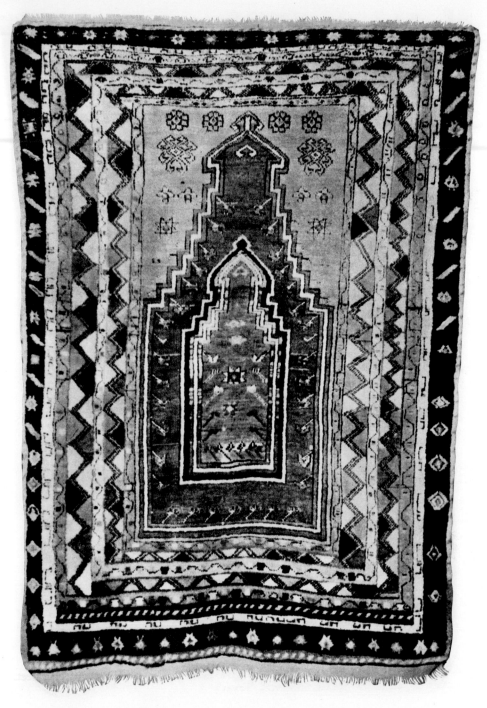

PLATE 122.   ANTIQUE PRAYER ZARA RUG. Turkish Family. Size 2.7×4 feet.
I do not authenticate the name Zara, although I have no objection to it. The rug might
better be classed as a Mudjar and German authorities have used this name for years.

419

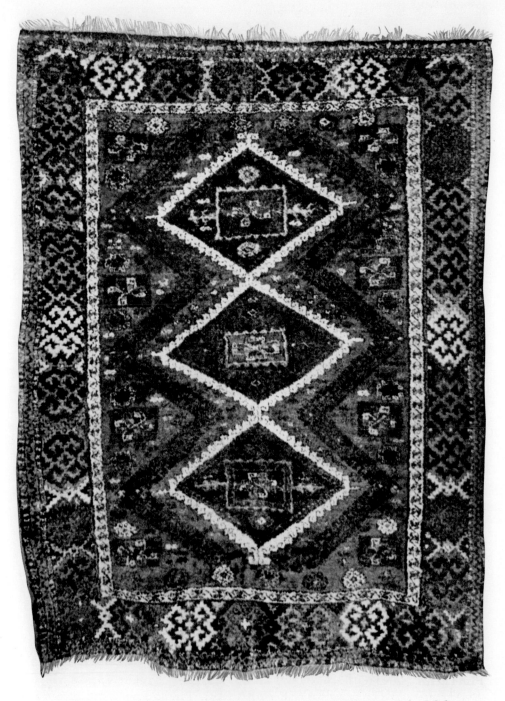

PLATE 123.   ANTIQUE YURUK RUG. Turkish Family. Size 4.4 × 5.8 feet.

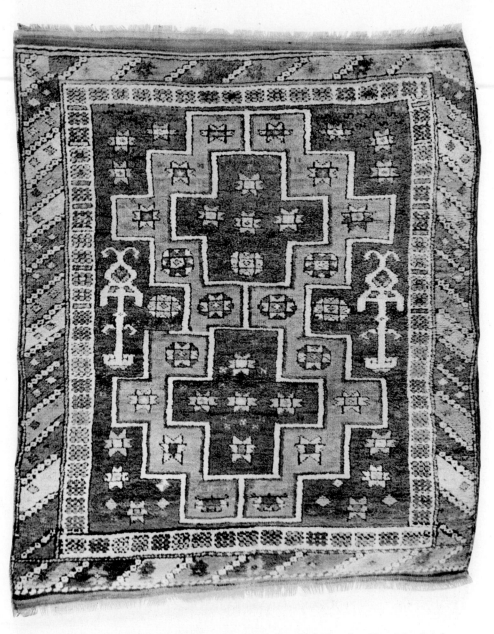

PLATE 124.   ANTIQUE BERGAMO RUG. Turkish Family. Size 4.5 × 5.4 feet.

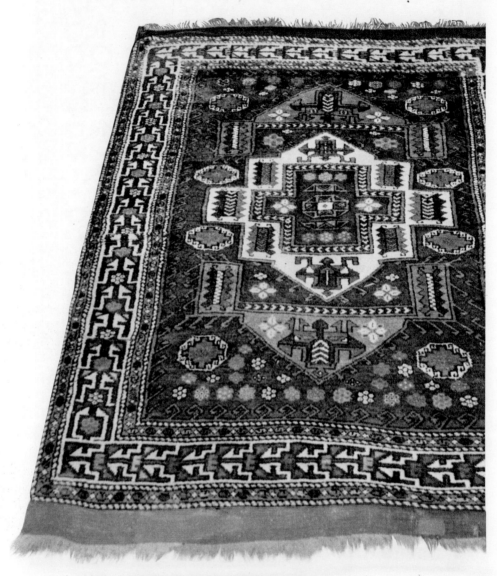

PLATE 125.   ANTIQUE BERGAMO RUG. Turkish Family. Size 5.5 × 7 feet.

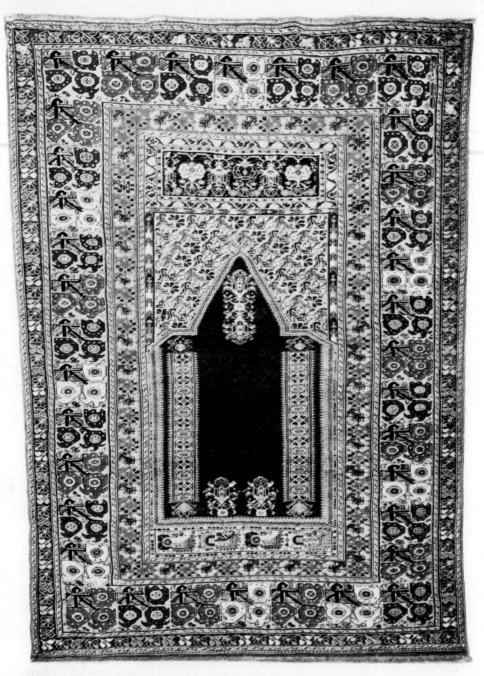

PLATE 126.   ANTIQUE PRAYER GHIORDES RUG. Turkish Family. Size 6×4.6 feet. I regret that our limited number of color plates does not allow us to show Mr. Sherar's green Ghiordes in color. (Courtesy of Mr. Stuart Sherar, Houston, Texas.)

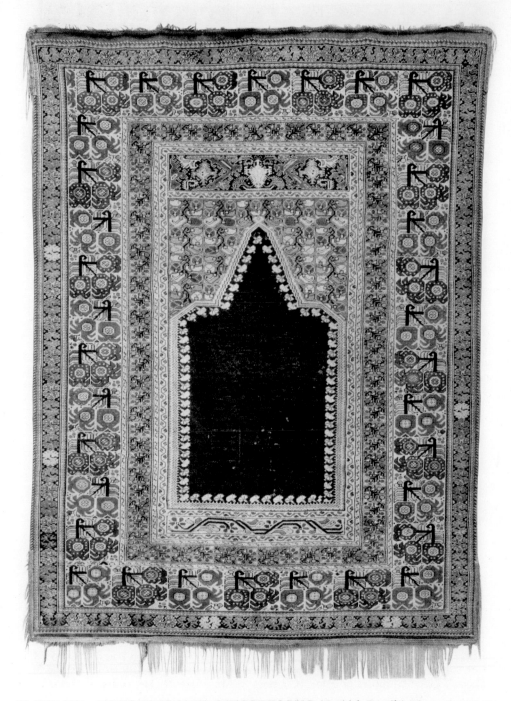

PLATE 127. ANTIQUE PRAYER GHIORDES RUG. Turkish Family. The museum list says: "Turkish rug. XVIII Century. Prayer rug; design in polychrome with blue field; wool. Asia Minor: Ghiordes." (Courtesy of The Metropolitan Museum of Art, New York City. The Theodore M. Davis Collection. Bequest of Theodore M. Davis.)

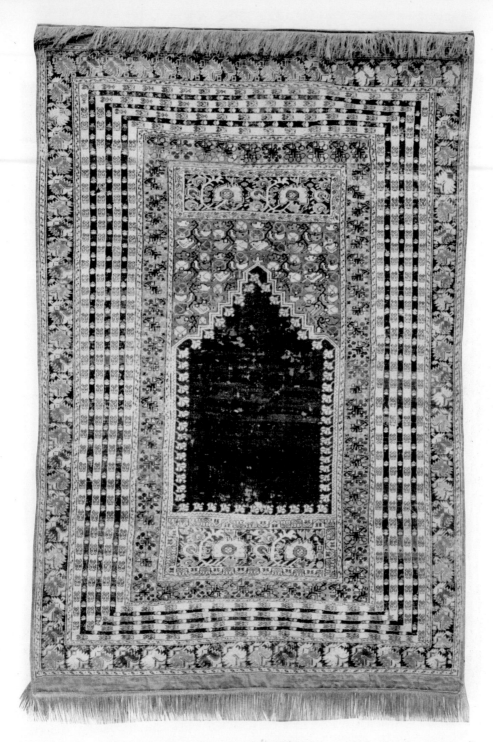

PLATE 128.   ANTIQUE PRAYER GHIORDES RUG. Turkish Family. Museum's
listing: Turkish Rugs, XVIII Century. Asia Minor: Ghiordes. Prayer Rug. Wool."
(Courtesy of the Metropolitan Museum of Art, New York City. The Theodore M.
Davis Collection. Bequest of Theodore M. Davis, 1915.)

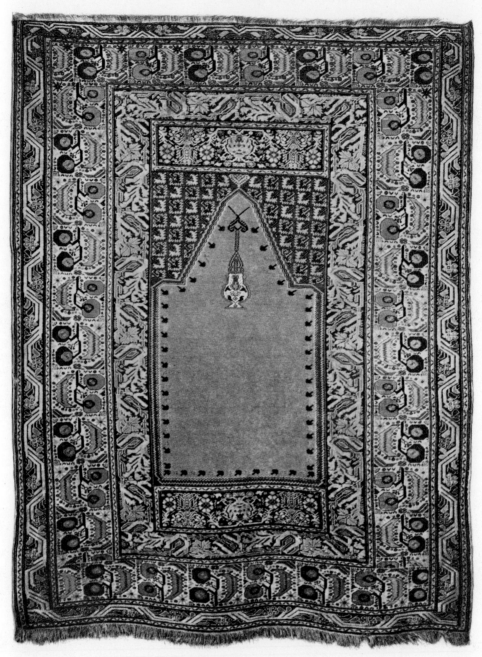

PLATE 129. ANTIQUE PRAYER GHIORDES RUG. Turkish Family. (Courtesy
of Mr. Stuart Sherar, Houston, Texas.)

426

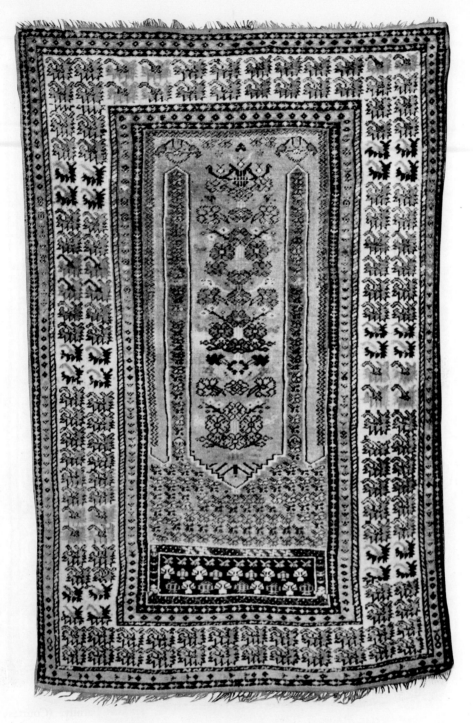

PLATE 130.  ANTIQUE PRAYER KULAH RUG.  Turkish Family.  Size 6×4 feet.
(Courtesy of Mr. and Mrs. George W. Scott, Jr., Lancaster, Penna.)

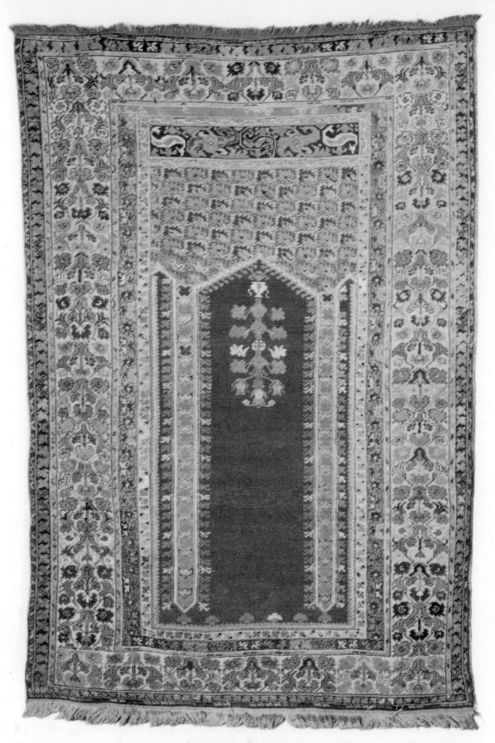

PLATE 131. ANTIQUE PRAYER KULAH RUG. Turkish Family. Size 6.1 × 4.3
feet. (Courtesy of Mr. Stuart Sherar, Houston, Texas.)

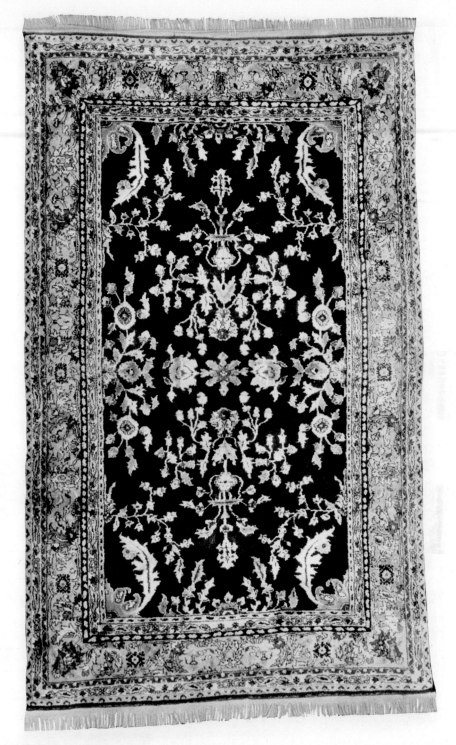

PLATE 132.   SPARTA RUG. Turkish or Grecian Family. Made during the 1924–1932 period.

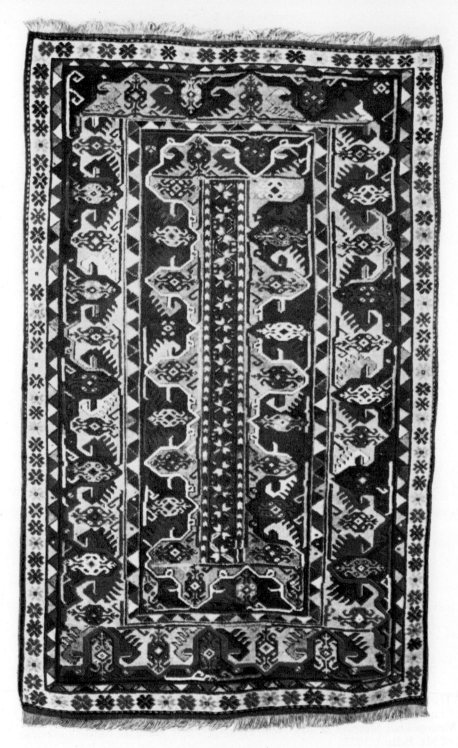

PLATE 133.  ANTIQUE MELEZ RUG. Turkish Family.  Size 5 × 3.4 feet. (Courtesy of Professor and Mrs. Harold Marchant, Detroit, Michigan.)

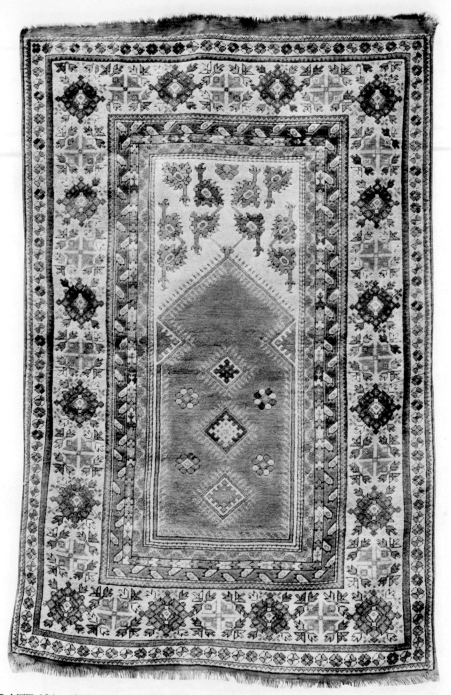

PLATE 134. ANTIQUE PRAYER MELEZ RUG. Turkish Family. Museum's listing: "Turkish Rugs, early 19th century. Asia Minor: Melez. Rug: wool." (Courtesy of the Metropolitan Museum of Art, New York City. The James F. Ballard Collection. Gift of Mr. Ballard, 1922.)

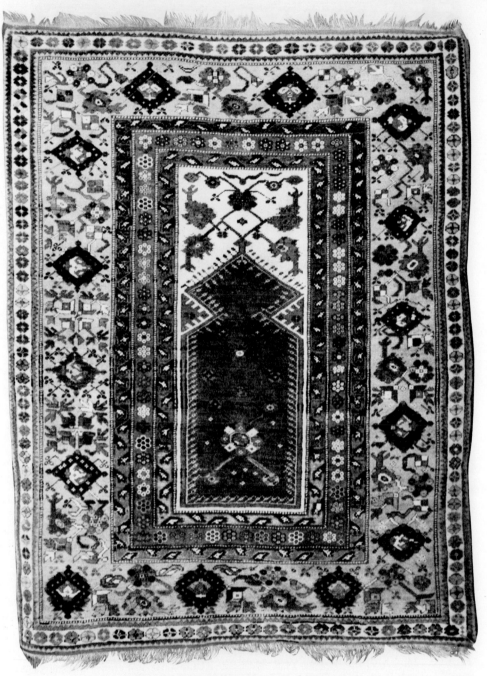

PLATE 135.   ANTIQUE PRAYER MELEZ RUG.   Turkish Family.   Size 4 × 5.2 feet.
(Courtesy of Mr. William G. Thompson, Hudson, Michigan.)

432

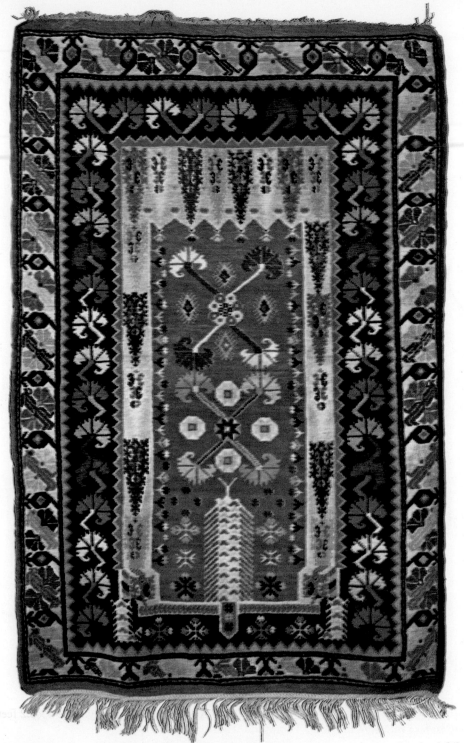

PLATE 136.   ANTIQUE PRAYER MELEZ RUG. Turkish Family.  Size 5 × 3.5 feet.
(Courtesy of Professor and Mrs. Harold Marchant, Detroit, Michigan.)

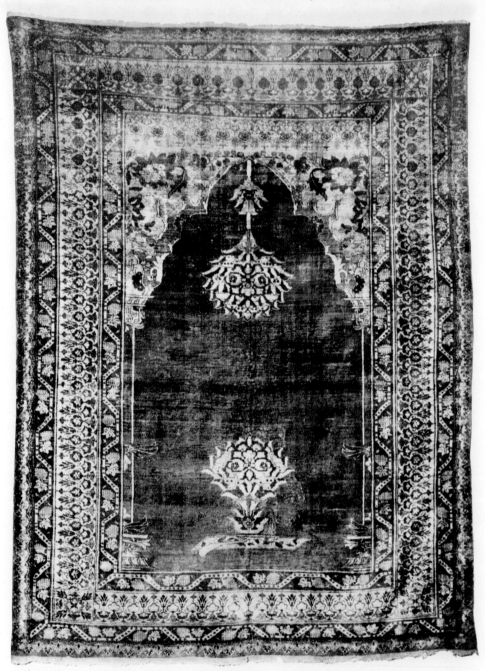

PLATE 137.   ANTIQUE PRAYER HEREKE RUG. Turkish Family. Size approxi-
mately 4.6 × 6.6 feet.

*434*

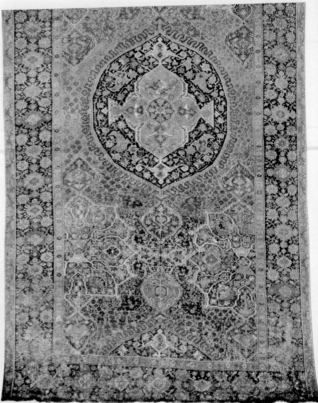

PLATE 138. ANTIQUE USAK (QUSHAK) RUG. Turkish Family. Museum listing: "Turkish Rugs. XVII Century. Asia Minor: Ushak." (Courtesy of The Metropolitan Museum of Art, New York City. Rogers Fund, 1908.)

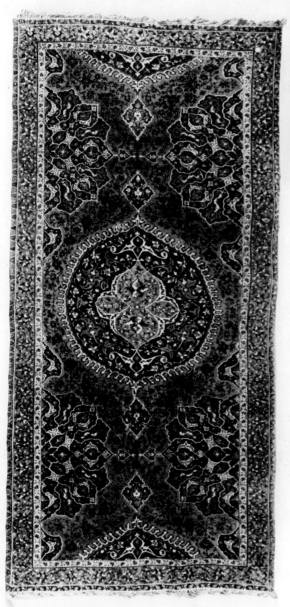

PLATE 139. ANTIQUE OUSHAK CARPET. Turkish Family. Listed by the Museum as: "Woolen pile, Turkish Carpet. 16th Century 8.2×17.4 feet." (Courtesy of The Victoria and Albert Museum, London, England.)

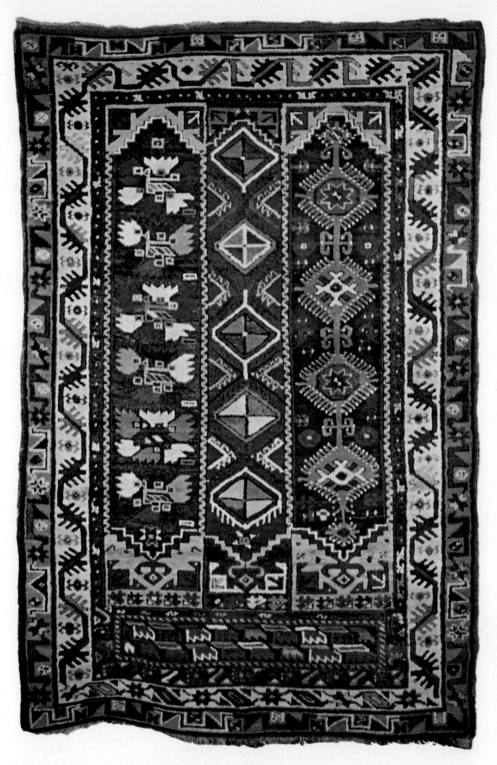

PLATE 140. ANTIQUE PRAYER MAKRI RUG. Turkish Family. Size 6.7×4.3 feet. (Courtesy of Mr. Stuart Sherar, Houston, Texas.)

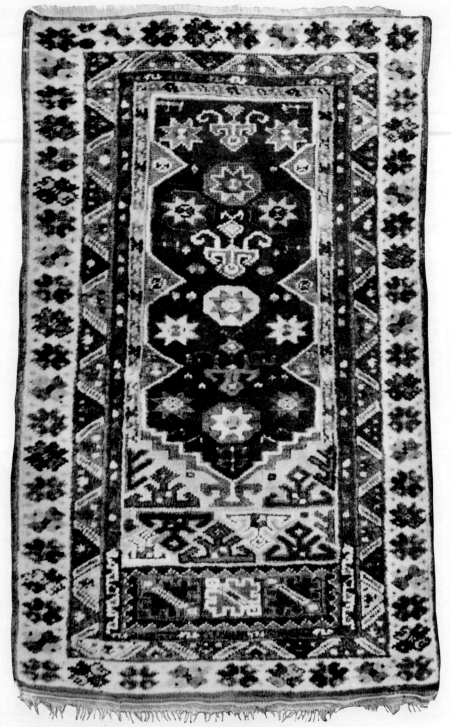

PLATE 141.   ANTIQUE PRAYER MAKRI RUG.  Turkish Family.  Size 2.1 × 4 feet.

437

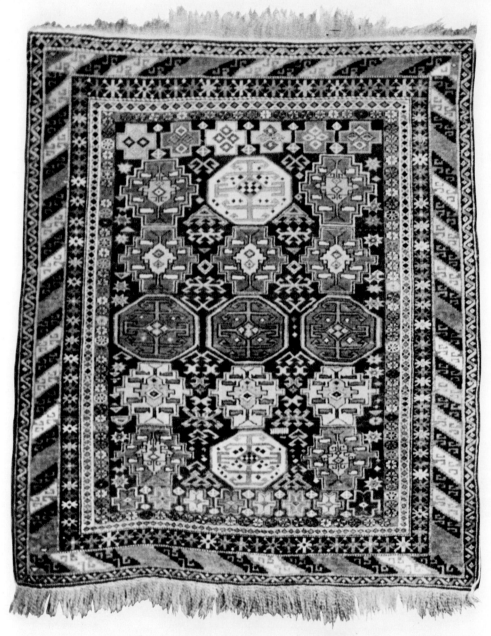

PLATE 142.  ANTIQUE SHIRVAN RUG. Caucasian Family. Size approximately
4.3 × 3.6 feet. Some might prefer to call this a Chi-chi rug.

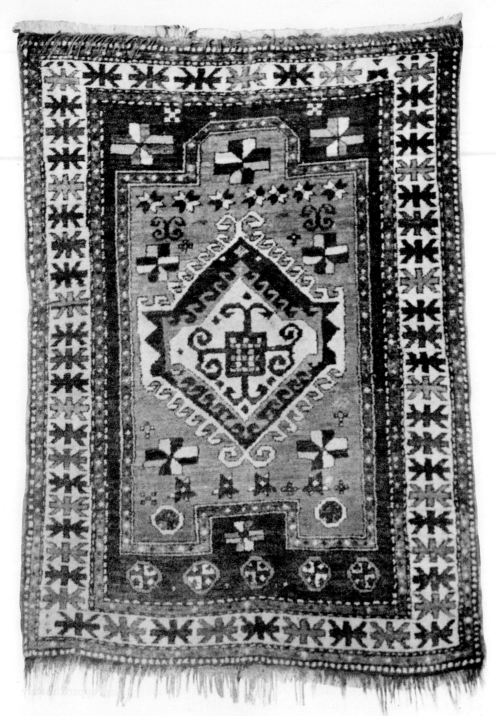

PLATE 143.   ANTIQUE PRAYER KAZAK RUG. Caucasian Family. Size approximately 3.7 × 5.2 feet.

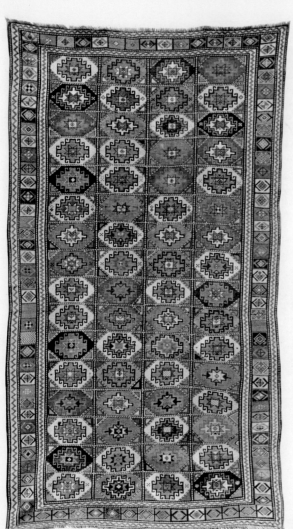

PLATE 144. ANTIQUE SHIRVAN RUG. Caucasian Family. Museum's description: "Caucasian Rugs XIX Century. Shirvan Rug: Ghiordes knots. Wool." I would have called this a Persian Kurdistan, either a Karaje or Karadagh from the design. But since it is in Caucasian weave, the design would impel me to call it a Kabistan. Thus we see designs are not reserved to one weave. (Courtesy of The Metropolitan Museum of Art, New York City. Gift of Arthur Gale, 1949, in memory of Colonel Roy Winton.)

PLATE 145. ANTIQUE KAZAK RUG. Caucasian Family. Size approximately 4.4 × 8 feet.

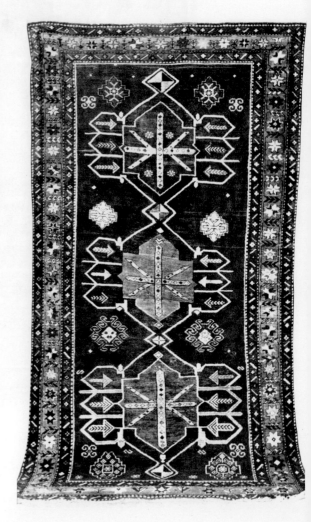

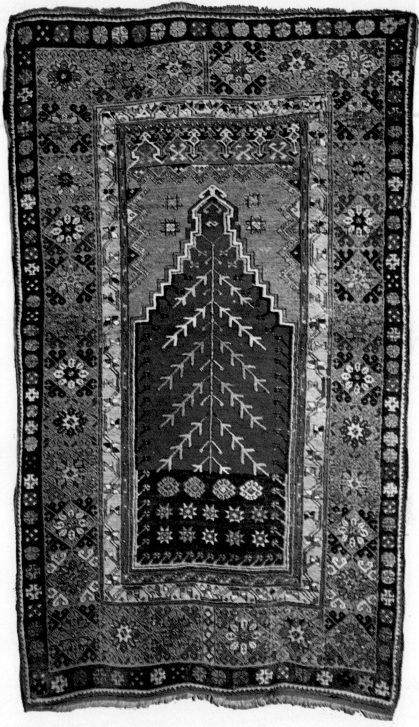

PLATE 146.   ANTIQUE PRAYER MUDJAR RUG. **Turkish Family. Size 5.5 × 3.4 feet.**

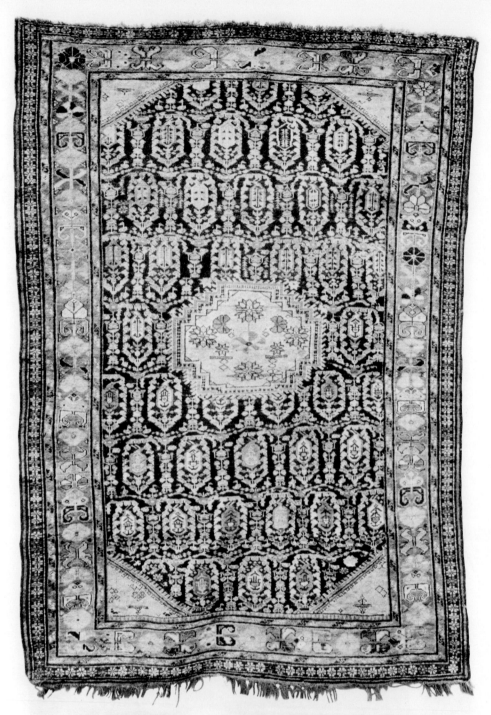

PLATE 147. ANTIQUE BAKU RUG. Caucasian Family—19th century. (Courtesy of The Metropolitan Museum of Art, New York City. The James F. Ballard Collection. Gift of Mr. Ballard, 1922.)

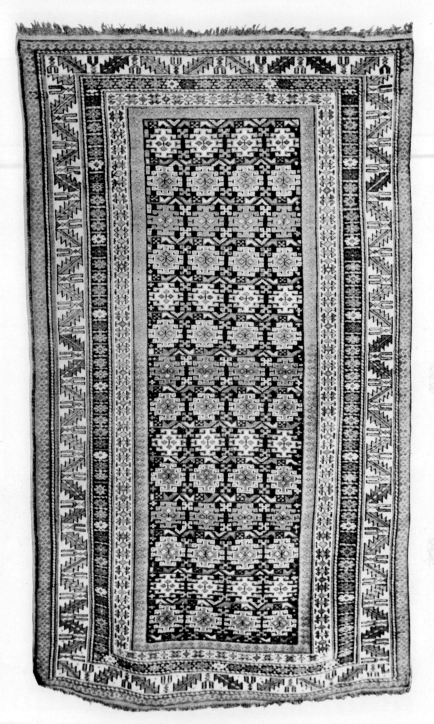

PLATE 148.    ANTIQUE CHI-CHI RUG. Caucasian Family. Size approximately 4.6 ×
6.6 feet. Also spelled Tzi-tzi. This and Plate 149 are the typical Chi-chi designs.

443

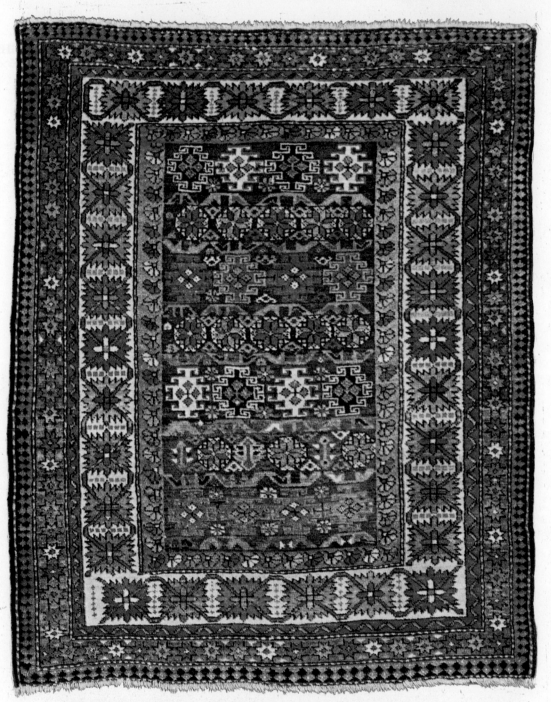

PLATE 149.   ANTIQUE CHI-CHI RUG. Caucasian Family. Size 4.6×2.10 feet.
(Courtesy of Dr. Walter A. Compton, Elkhart, Indiana.)

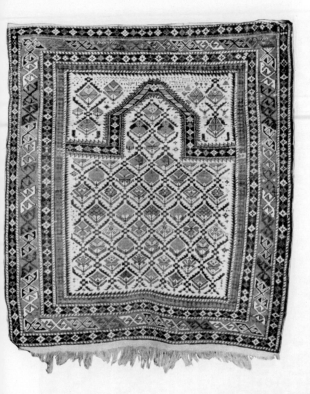

PLATE 150. ANTIQUE PRAYER DAGHESTAN
RUG. Caucasian Family. Size approximately 4.6 × 3.6 feet.

PLATE 151. ANTIQUE DAGHESTAN RUG. Cau-
casian Family. Size 4.7 × 8 feet. This rug might be called
a Shirvan or a Baku, so closely related are these types.

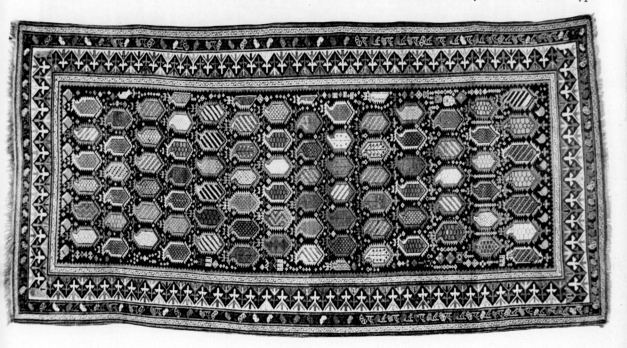

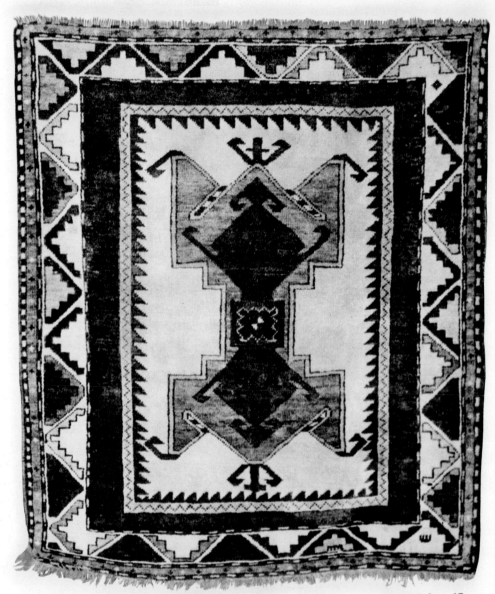

PLATE 152.    ANTIQUE KAZAK RUG. Caucasian Family. Size 4.2×3.8 feet. (Courtesy of Dr. Walter A. Compton, Elkhart, Indiana.)

446

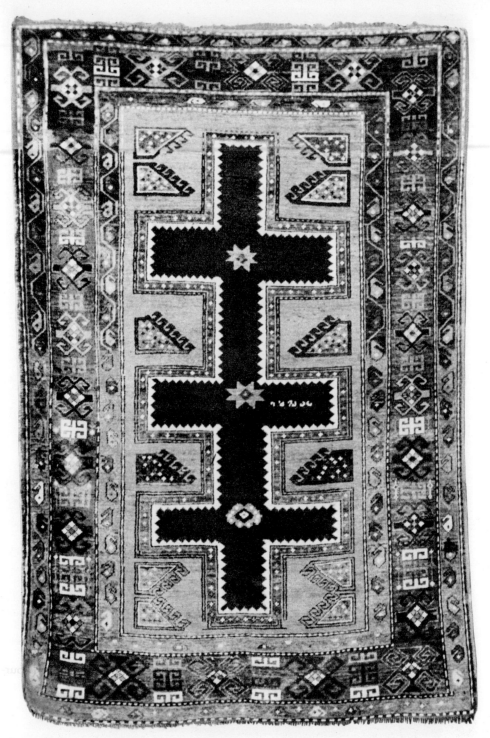

PLATE 153.   ANTIQUE KAZAK RUG. Caucasian Family. (Courtesy of Mr. and Mrs.
A. N. Campbell, White Hall, New Hampshire.)

447

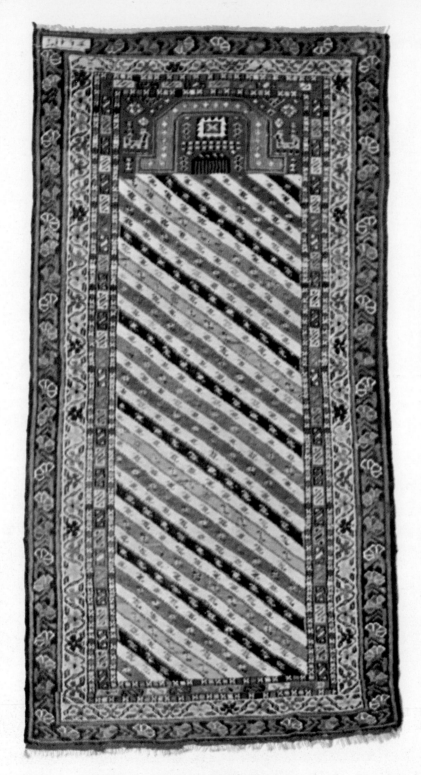

PLATE 154. ANTIQUE GEUNGE RUG. Caucasian Family. Size 4.6×2.5 feet.
(Courtesy of Dr. Walter A. Compton, Elkhart, Indiana.)

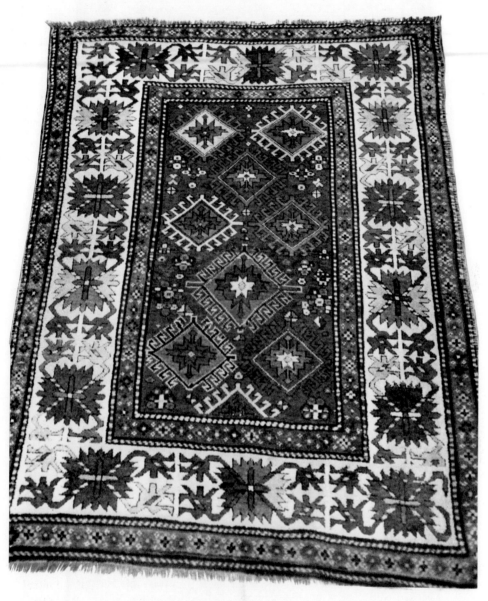

PLATE 155.   ANTIQUE KAZAK RUG. Caucasian Family. Size 4.5×6 feet. A fine example of the use of geometric, latch hook designs in the field. Crab border.

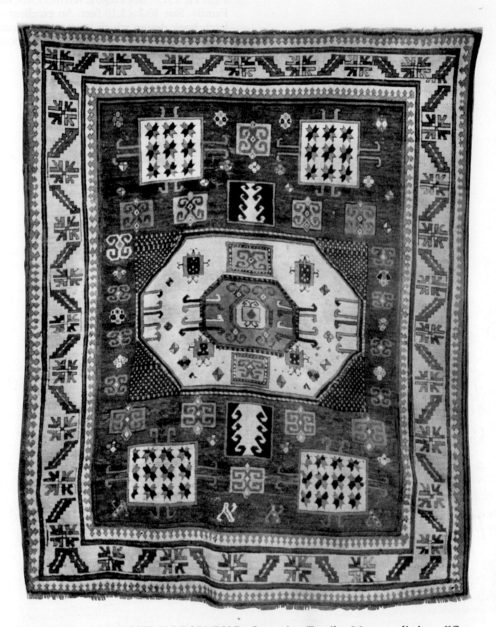

PLATE 156.   ANTIQUE KAZAK RUG. Caucasian Family. Museum listing: "Caucasian (Kazak) Rugs, XIX Century, Rug: wool." (Courtesy of The Metropolitan Museum of Art, New York City. The James F. Ballard Collection. Gift of Mr. Ballard, 1922.)

*450*

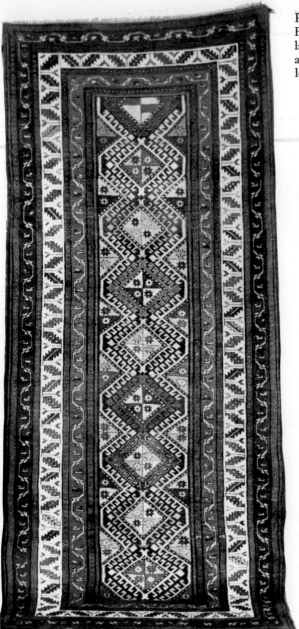

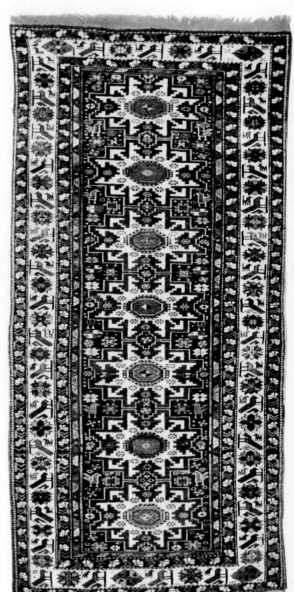

PLATE 157. ANTIQUE KABISTAN RUG. Caucasian Family. Size 10.2 × 3.10 feet. An excellent example of the latch hook design which is extensively used in Kabistans and Kubas. A good example of a main border in serrated leaf and winecup design.

PLATE 158. ANTIQUE KABISTAN RUG. Caucasian Family. Size approximately 4 × 9 feet. This is the design which some collectors call Lesghean.

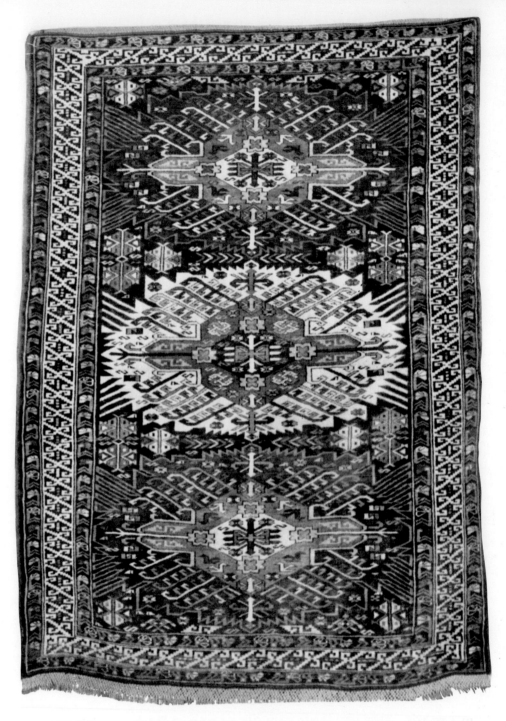

PLATE 159.   KABISTAN RUG. Caucasian Family. Size 5.10 × 4.2 feet.

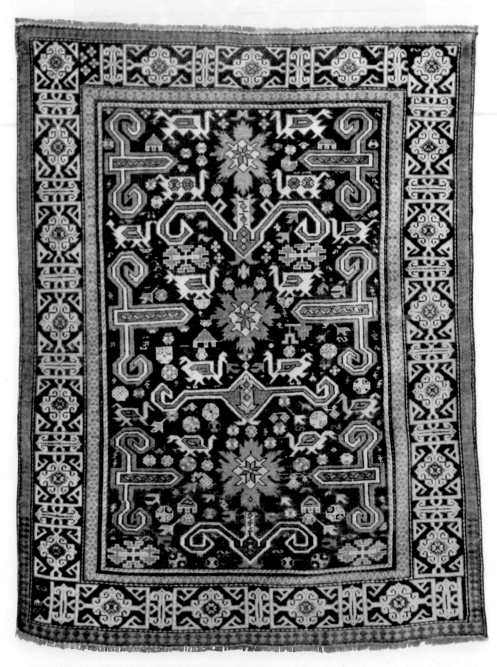

PLATE 160.   ANTIQUE SHIRVAN RUG. Caucasian Family. Size 4.6×3 feet. This rug might be listed as a Kabistan. These two are very much alike in many ways.

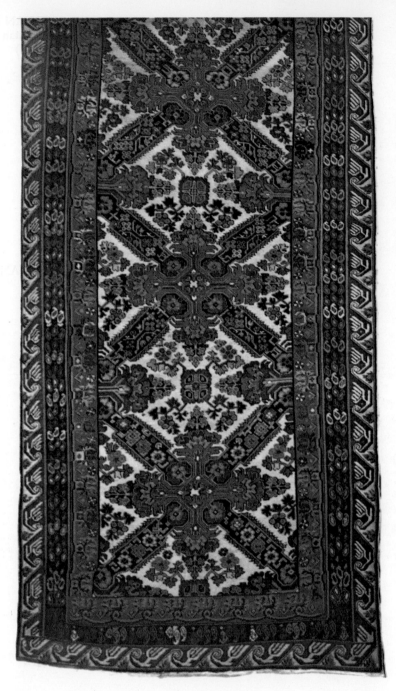

PLATE 161. ANTIQUE KUBA RUG. Caucasian Family. (Courtesy of Mr. Stuart Sherar, Houston, Texas.)

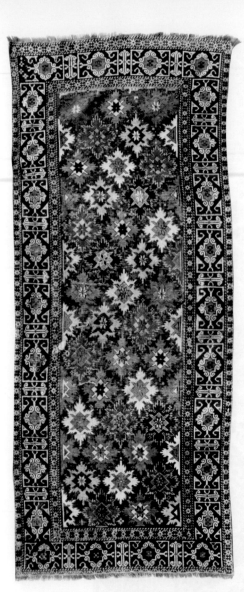

PLATE 162.   ANTIQUE SHIRVAN RUG. Caucasian
Family. (Courtesy of The Metropolitan Museum of Art,
New York City. Rogers Fund, 1908.)

PLATE 163.   ANTIQUE SHIRVAN RUG. Caucasian
Family. Size 6 × 4.1 feet.

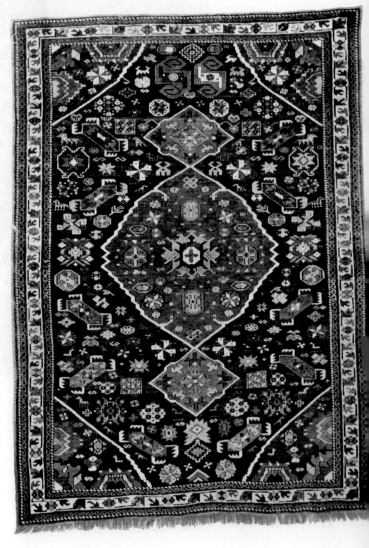

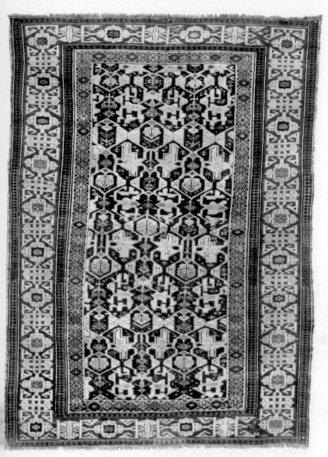

PLATE 164. ANTIQUE SHIRVAN RUG. Caucasian
Family. Early 19th century. (Courtesy of the Metropolitan
Museum of Art, New York City. The James F. Ballard
Collection. Gift of Mr. Ballard, 1922.)

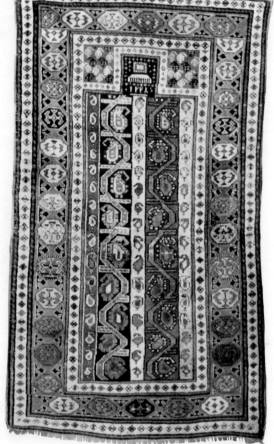

PLATE 165. ANTIQUE PRAYER KARABAGH
RUG. Caucasian Family. Size 2.9×4.8 feet. (Courtesy of
Professor Robert Fisher, Blacksburg, Virginia.)

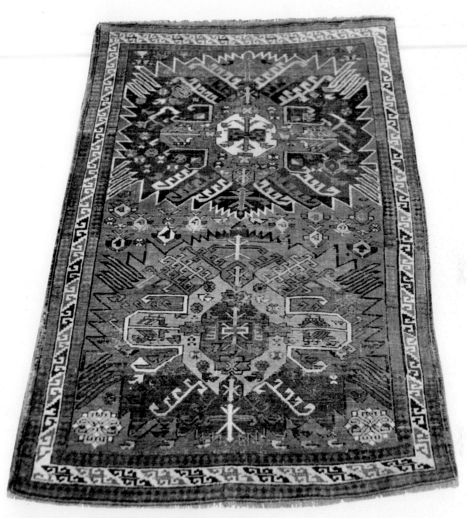

PLATE 166.   ANTIQUE KABISTAN RUG. Caucasian Family. Approximate size
4.6 × 6.6 feet. So-called sunburst or old Russian Coat of Arms design. This design is one
usually found in Tckerkess rugs (a type of Kazak).

457

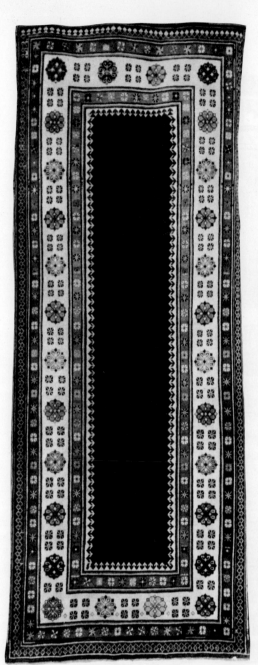

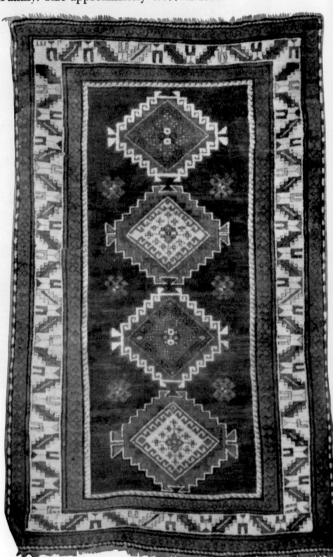

PLATE 167.  TALISH RUG. Caucasian Family. Size 8.7×3.5 feet.

PLATE 168.  ANTIQUE KAZAK RUG. Caucasian Family. Size approximately 4.4×7.2 feet.

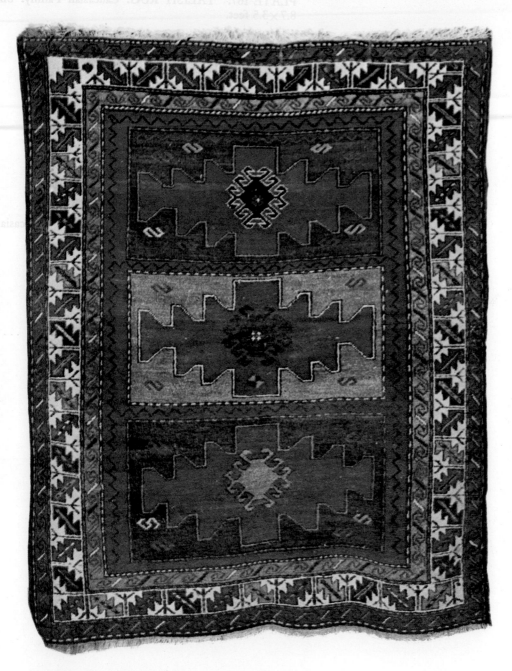

PLATE 169.   ANTIQUE KAZAK RUG. Caucasian Family. Size 5.5 × 4.5 feet. (Property of the author.)

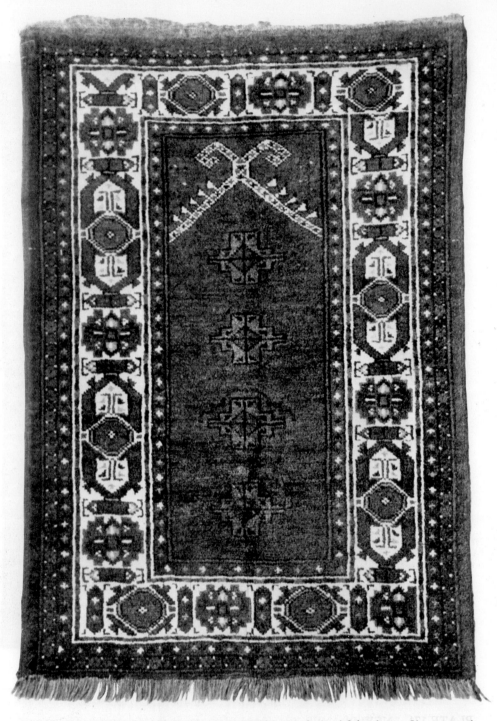

PLATE 170.   NEW PRAYER AFGHAN RUG. Made in Afghanistan. Size approximately 2.6 × 3.6 feet.

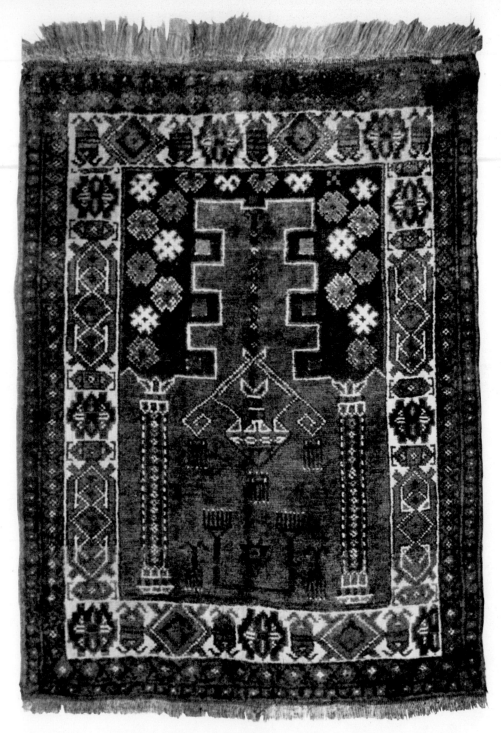

PLATE 171.  NEW PRAYER AFGHAN RUG. Made in Afghanistan. Size approximately 2.6×3.6 feet.  Hutdreds of excellent small Afghans are available in both prayer and non-prayer designs.

461

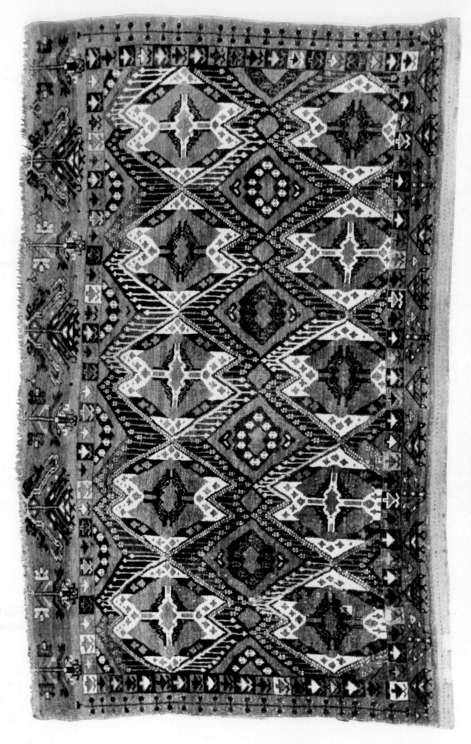

PLATE 172.  ANTIQUE ERSARI RUG.  Turkoman Family.  Size 3.2×5 feet.  Another name for this rug is Beshir.  This is an old tent bag.

462

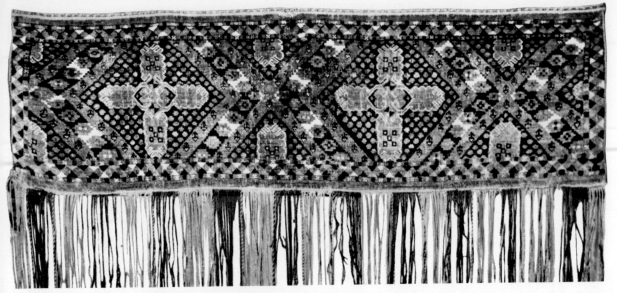

PLATE 173. ANTIQUE ERSARI RUG. Turkoman Family. Size 1.3 × 4.8 feet. An old tent bag. Called Juval for size and usage. Imported from Afghanistan.

PLATE 174. SEMI-ANTIQUE PRAYER AFGHAN RUG. Turkoman Family. Size 7.9 × 4.3 feet. (Courtesy of Professor Frank Kramer, Gettysburg, Penna.)

PLATE 175. NEW AFGHAN RUG IN KATCHLI
DESIGN. Turkoman Family. Size approximately 7×5
feet. (Courtesy of Mr. and Mrs. D. S. Rice, Northport,
L. I., New York.)

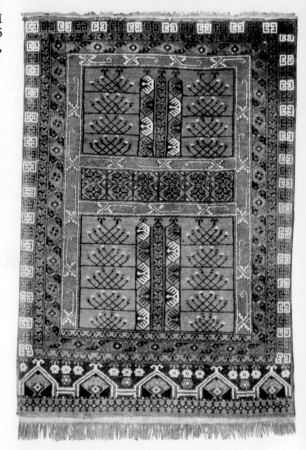

PLATE 176. ANTIQUE AFGHAN BOKHARA
RUG. Turkoman Family. Size 3.3×5.6 feet. An old tent
bag with the canvas back removed. (Courtesy of Mr. and
Mrs. John Colburn, Oneida, New York.)

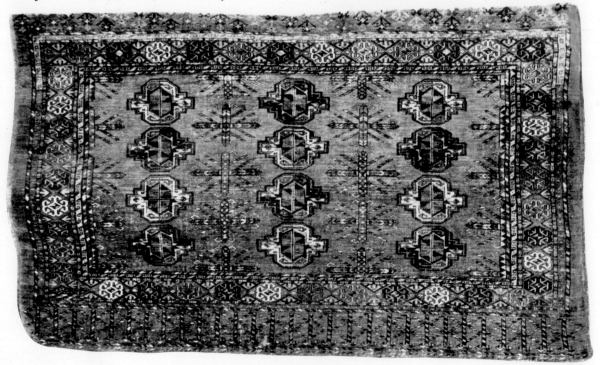

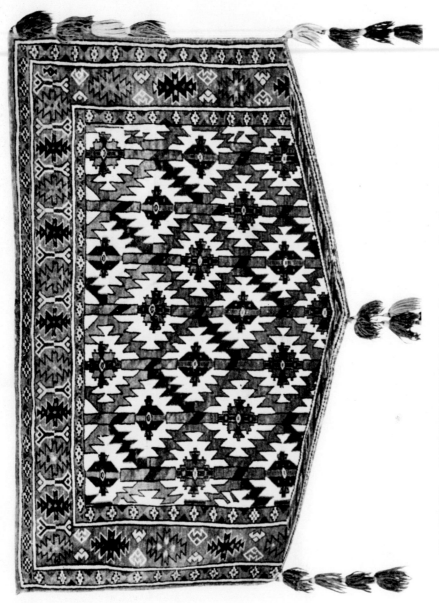

PLATE 177. ANTIQUE YOMUD RUG. Turkoman Family. Size 2×3.9 feet. This rug is also called a Yomud Bokhara. Yomud tent bags are often made in a pentagonal shape. (Courtesy of Mr. and Mrs. John Colburn, Oneida, New York.)

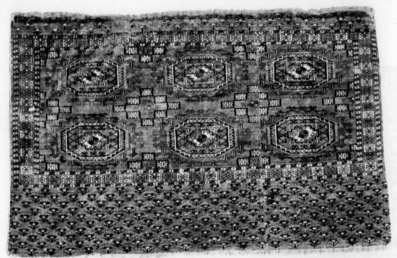

PLATE 178. ANTIQUE SALOR BOKHARA RUG.
Turkoman Family. Size 2.5 × 4 feet. An old tent bag with
the back removed. In their books, both Clark and Thatcher
call this a Salor Torba.

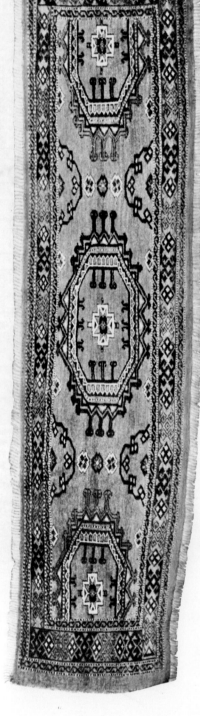

PLATE 179. ANTIQUE SALOR BOKHARA RUG.
Turkoman Family. Size 6 × 1.5 feet. (Courtesy of Dr.
William G. Peacher, Fayetteville, New York.)

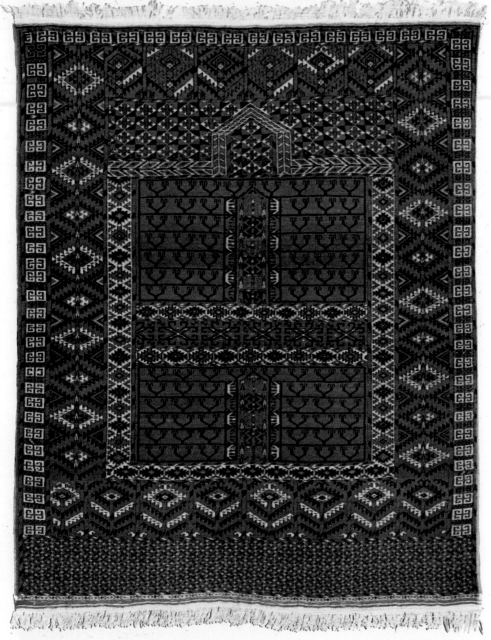

PLATE 180. ANTIQUE TEKKE PRAYER RUG. Turkoman Family. Size 5.2×4 feet. This is better known as a Princess Bokhara rug. (Courtesy of Dr. Walter A. Compton, Elkhart, Indiana.)

PLATE 181.   NEW NORDIK RUG. Made in India. Sizes from $3 \times 5$ feet to $10 \times 14$ feet. This is in a Scandinavian design.

PLATE 182.   SAVONNERIE RUG. From India. Size 8 × 10 feet. All colors are pastel. They come in sizes up to 12 × 20 feet.

469

PLATE 183.   JEWEL OF KASHMIR RUG. Made in India and Kashmir. This rug may be called an Aubusson type rug. Comes with a flat stitch.

470

PLATE 184. KHALABAR RUG. Indian Family. Size 9×12 feet. This rug is in an antique Savonnerie design. This rug has rose as the principal color. Others are in beige, blue, and green.

PLATE 185. IMPERIAL RUG. Japanese Family. Size 6×4 feet. These are made in many sizes and in several colors.

PLATE 186. IMPERIAL RUGS. Japanese Family. These rugs are in Savonnerie designs.

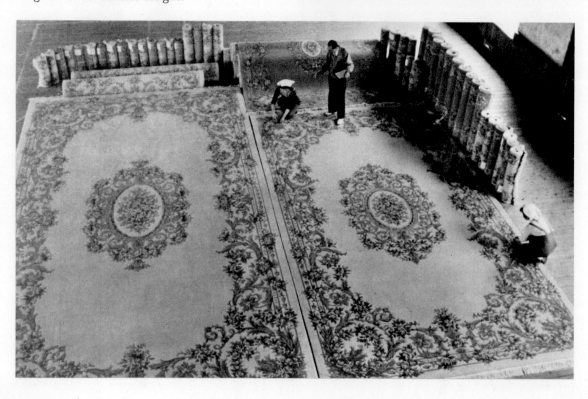

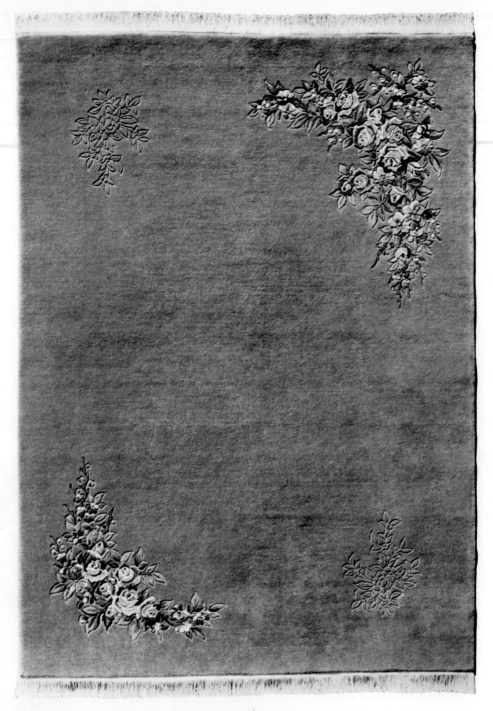

PLATE 187. IMPERIAL RUG. Made in Japan. This rug is in the so-called Chinese design. It is made in the same four colors as outlined in Plate 44.

473

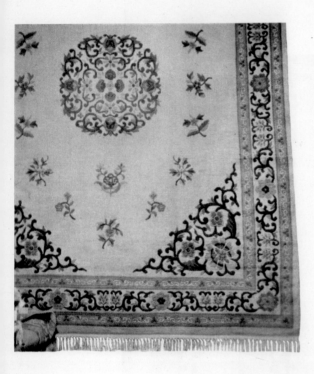

PLATE 188. PEKING CHINESE RUGS. Made in
Japan. The rug at the left is known as design 500, while
the rug at the right is known as design 600.

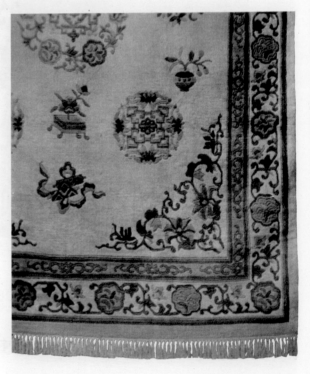

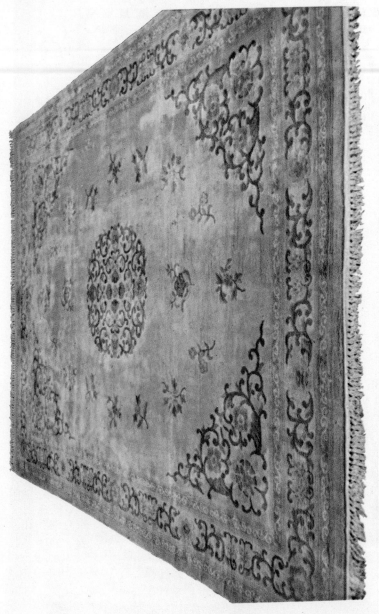

PLATE 189. PEKING RUG. Japanese Family. One of the several designs and colors in which these rugs are being woven. All are in traditional designs.

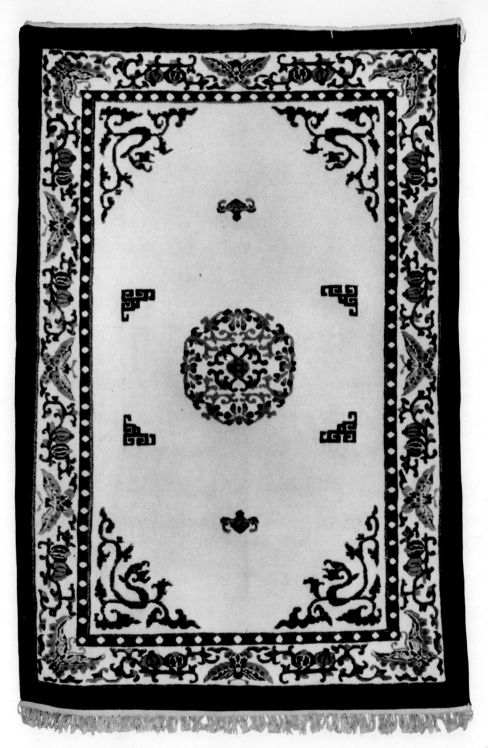

PLATE 190. BENGALI RUG. Indian Family. Size 6×9 feet. This rug is in a Chinese design.

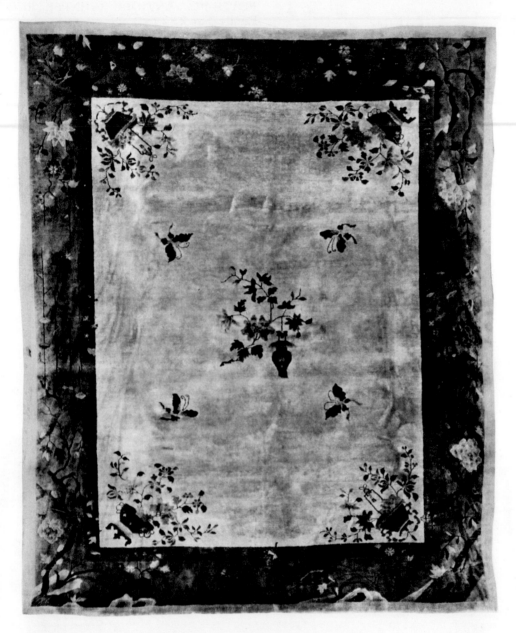

PLATE 191. CHINESE RUG. Chinese Family. Size 8×10 feet. Woven in the 1926–1931 period. This particular rug has a nap of Manchester worsted wool. Only a few rugs like this were made. The rug is as thick today as when it was new—thirty years ago.

477

PLATE 192. ANTIQUE CHINESE RUG. Chine
Family. Size 2×2 feet. This rug was probably woven
the 19th century.

PLATE 193. ANTIQUE CHINESE RUG. Chinese
Family. Size 4×2 feet. Probably from the Ming period,
1600–1650.

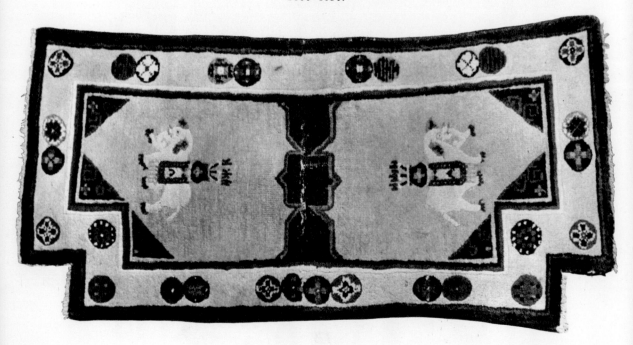

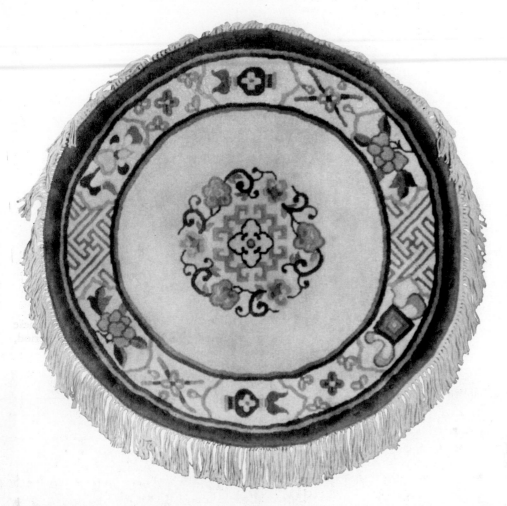

PLATE 194.   FUIGI ROYAL RUG. Made in Japan. Size 4×4 feet. This is in a Chinese design.

479